THE ART OF

ENDINGS AND BEGINNINGS

HARUICHI FURUDATE

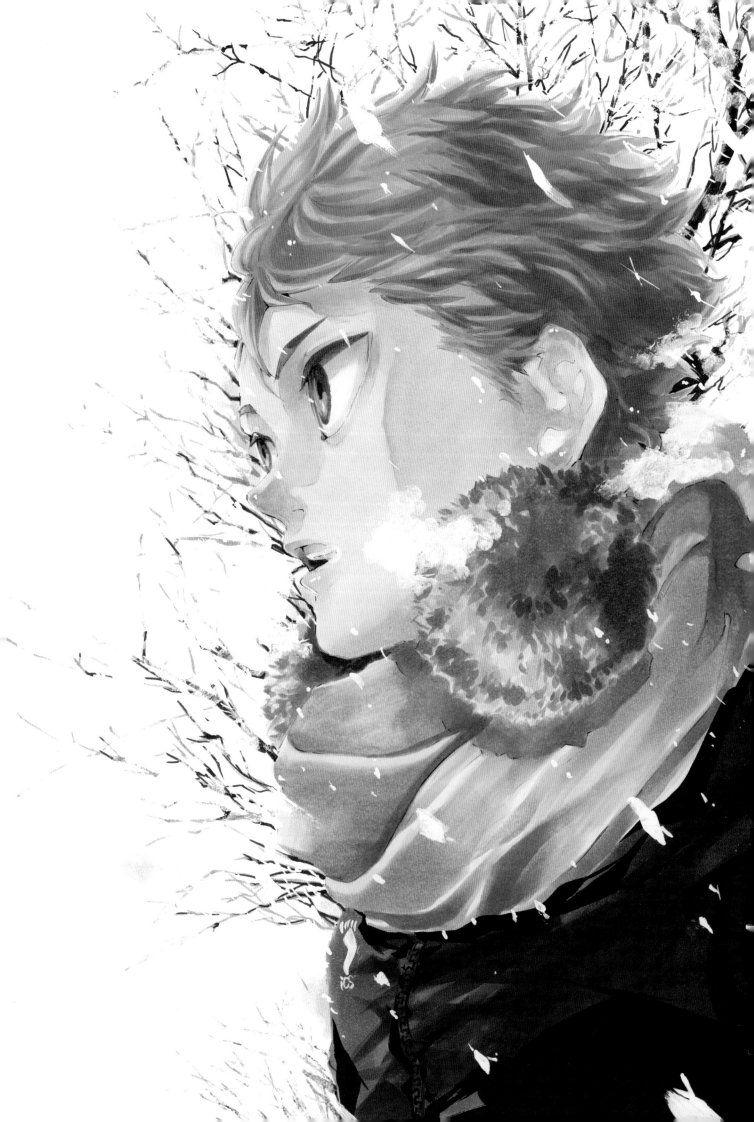

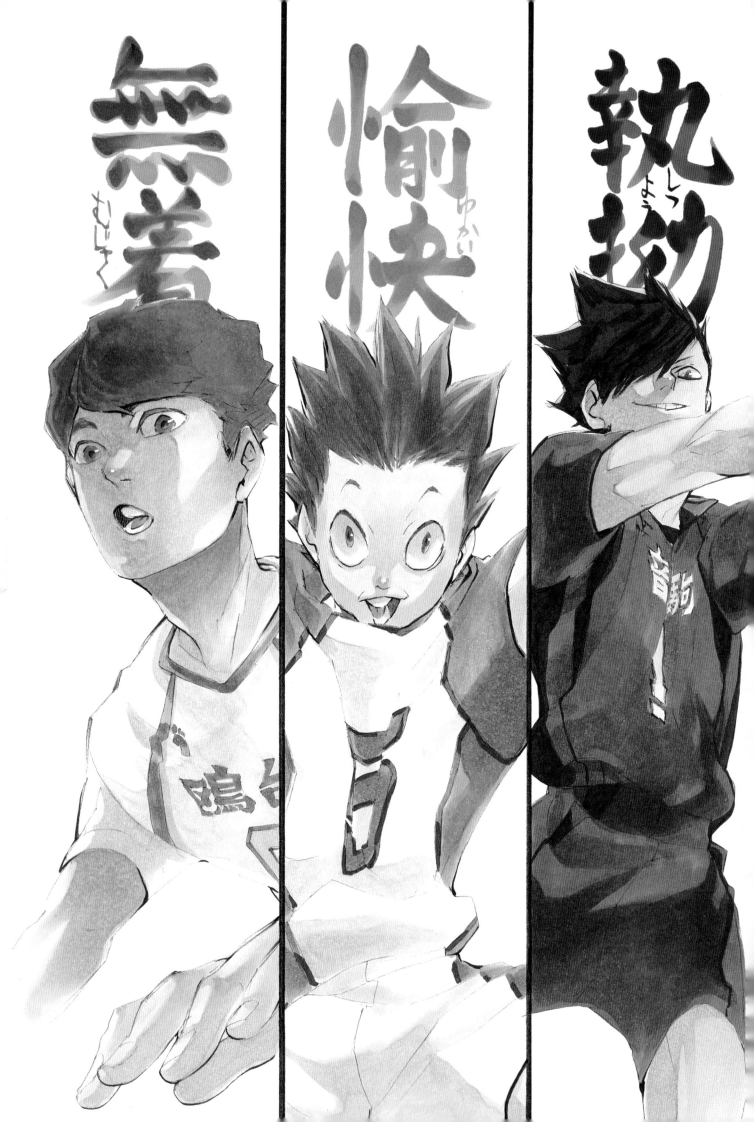

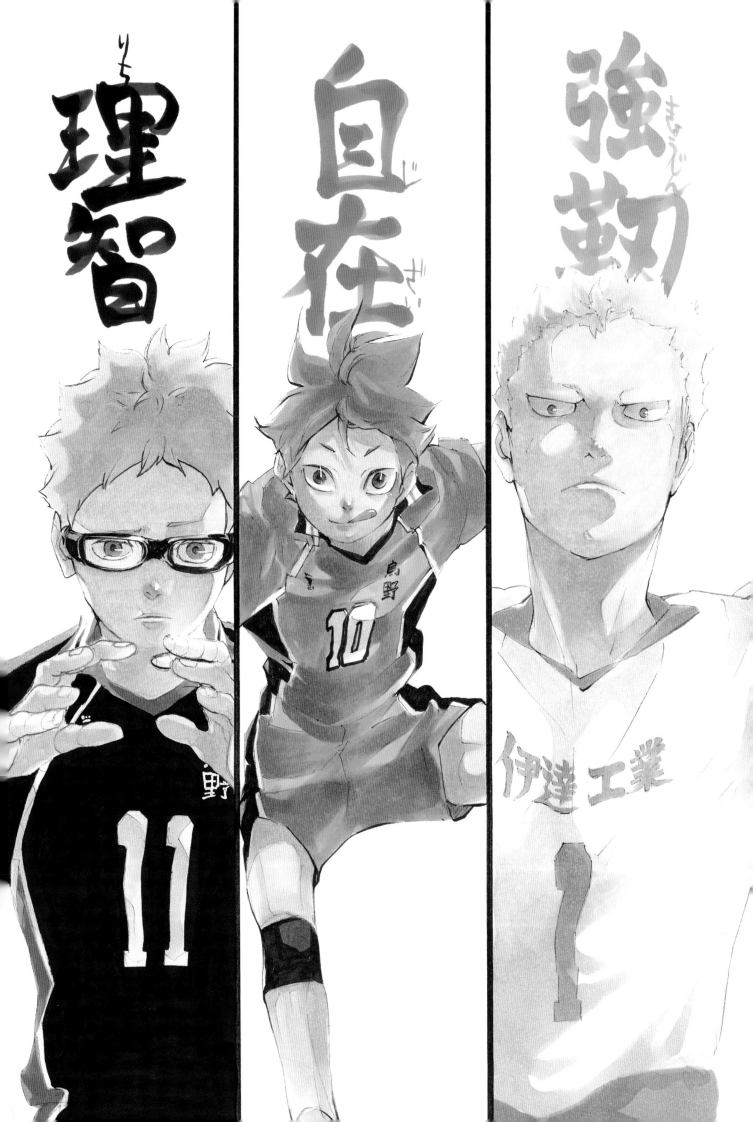

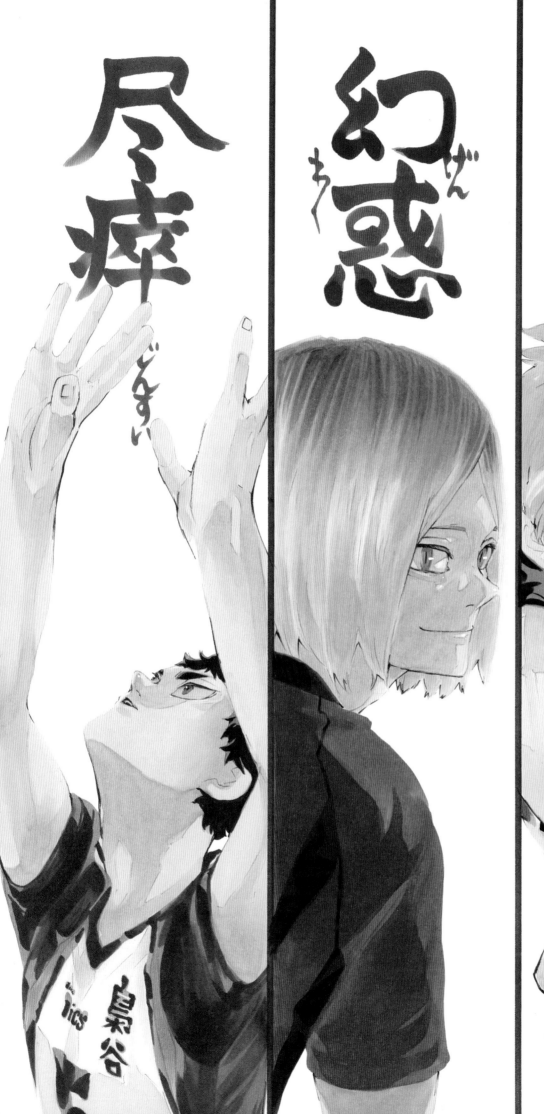
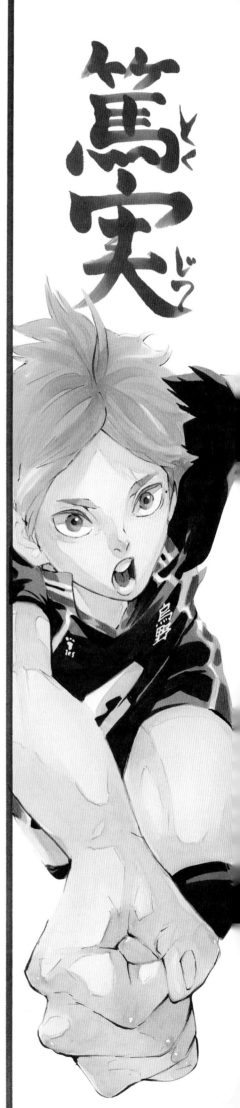

篤実 とくじつ

幻惑 げんわく

尽瘁 じんすい

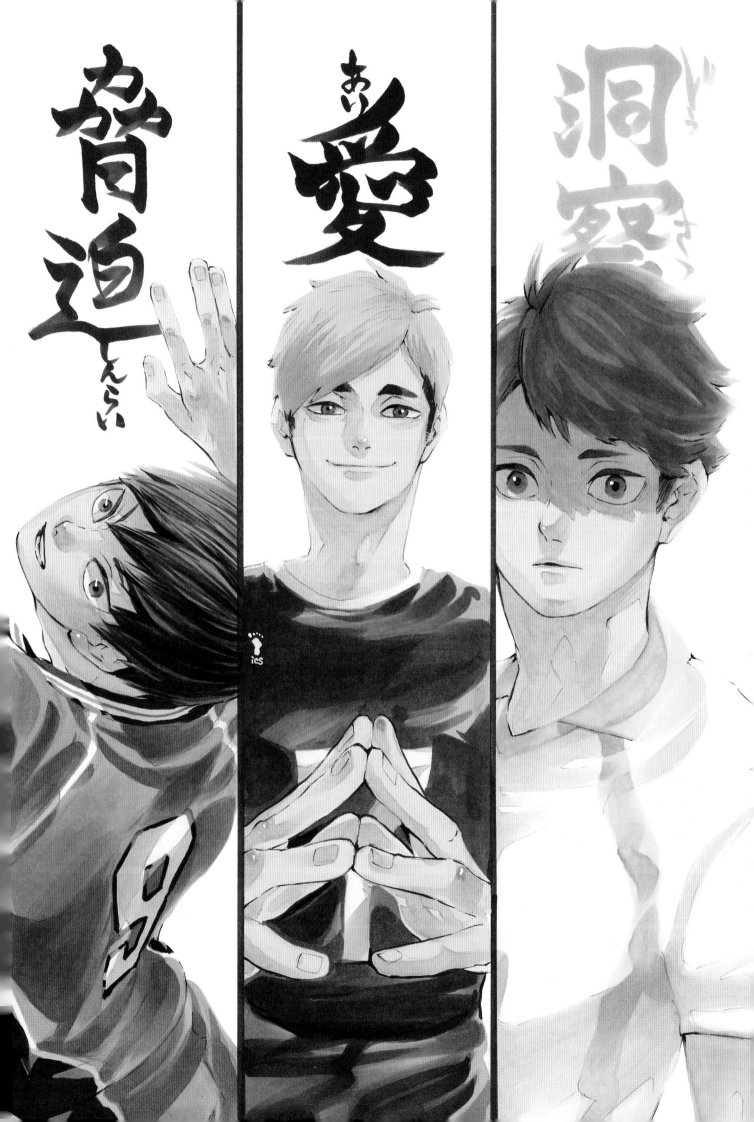

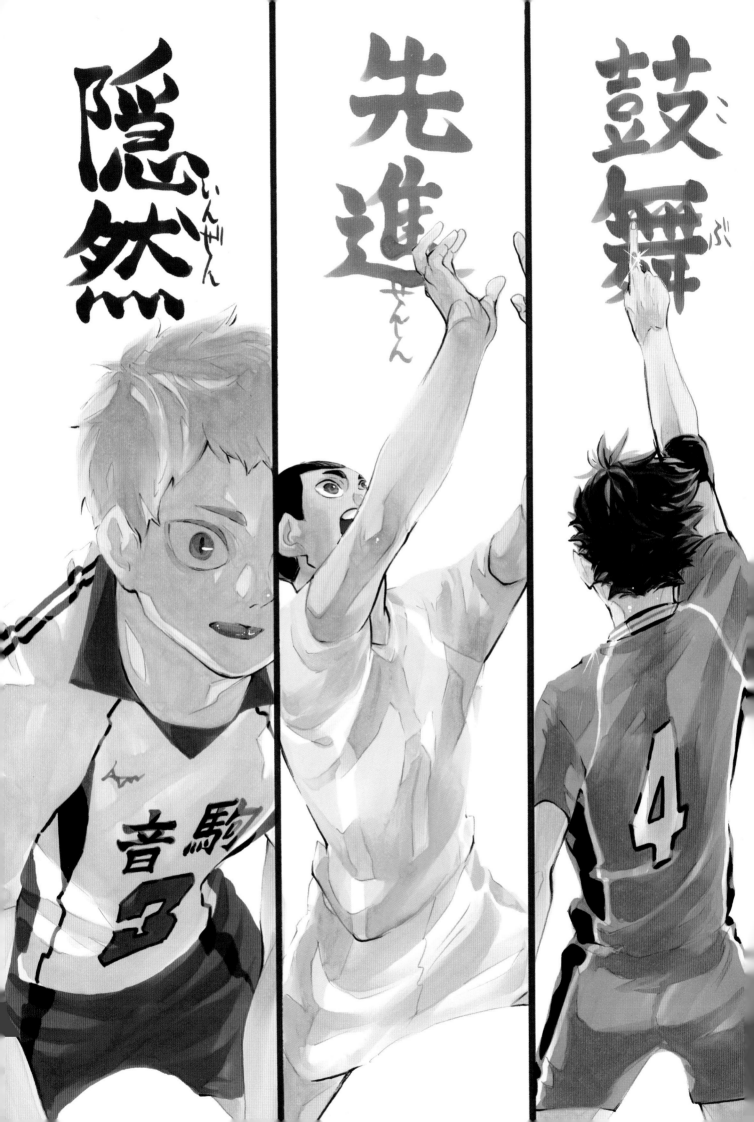

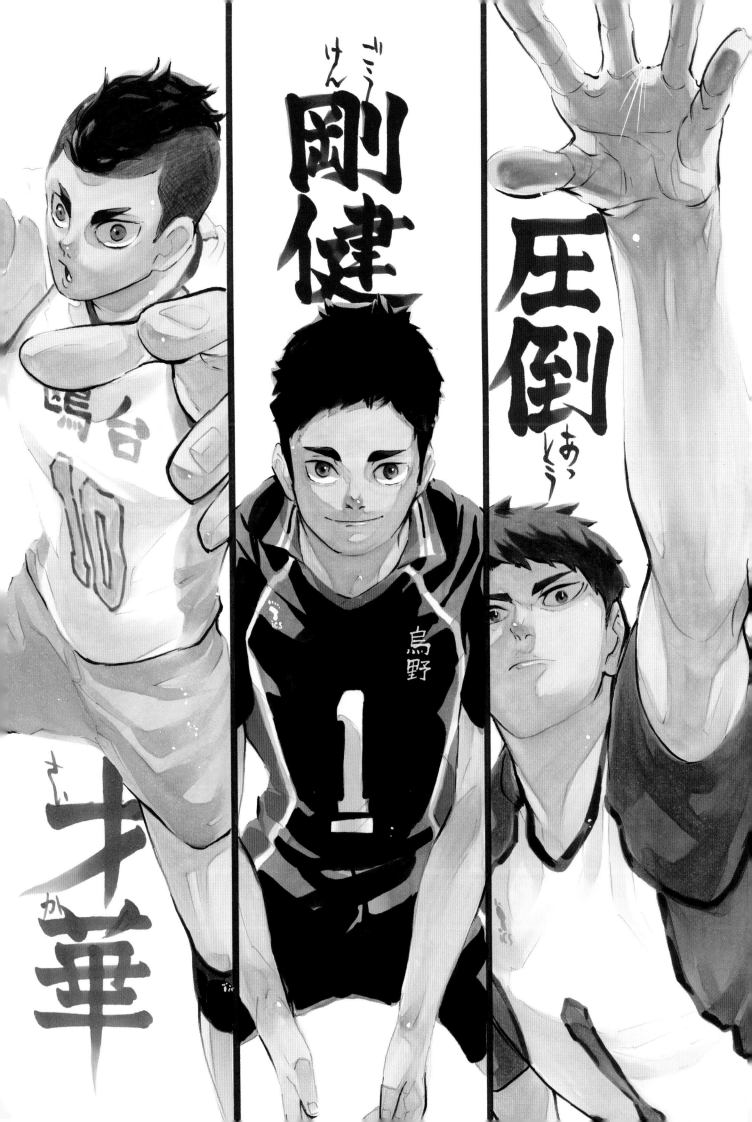

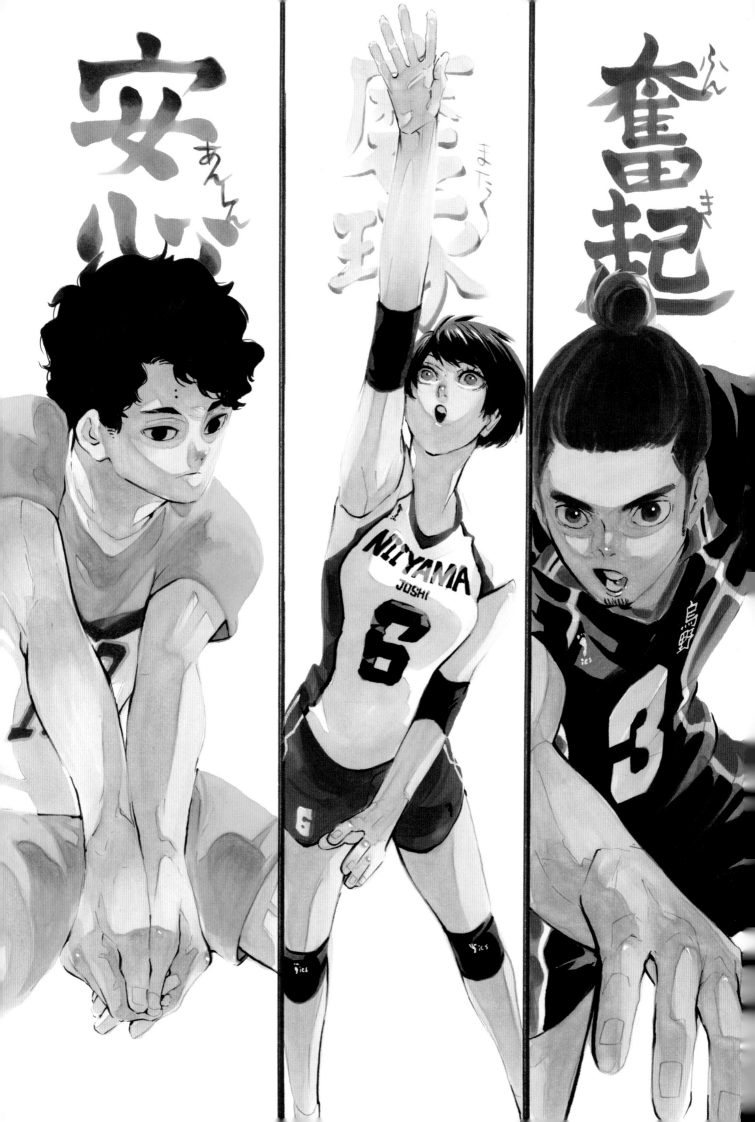

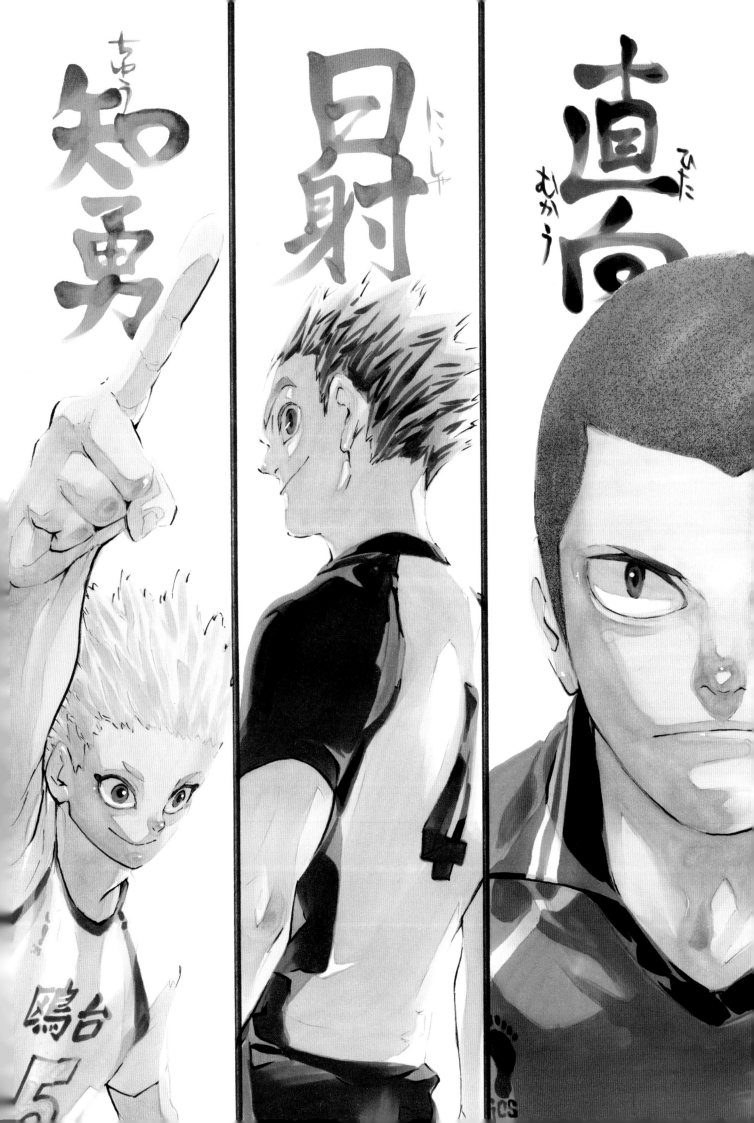

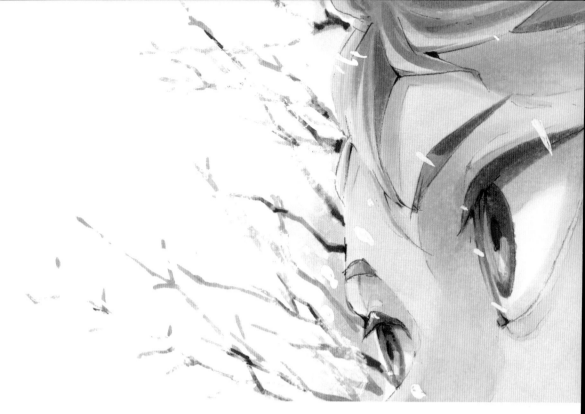

終わり

ENDINGS

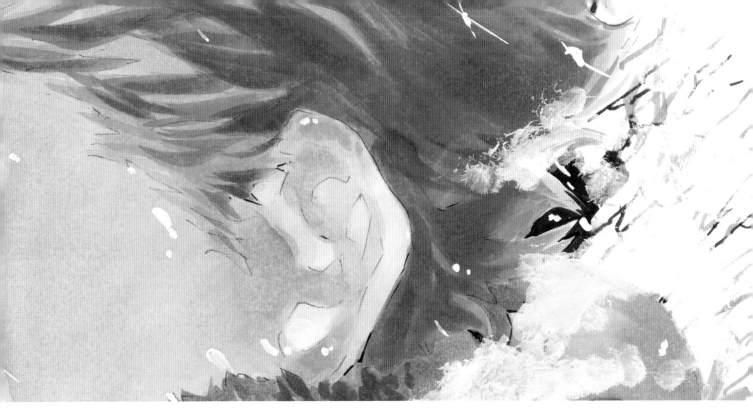

と始まり

AND BEGINNINGS

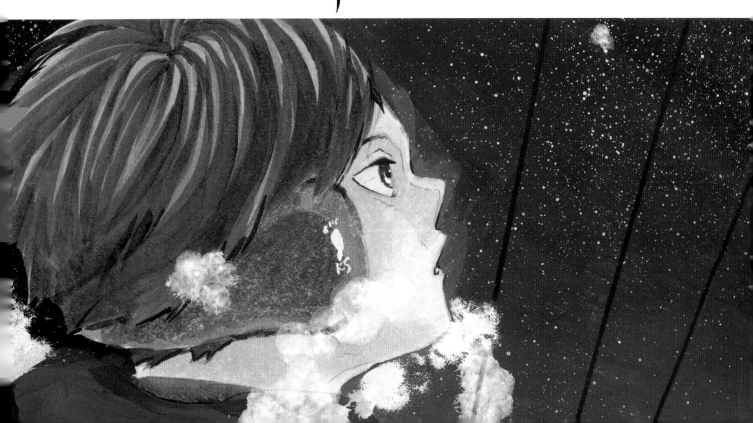

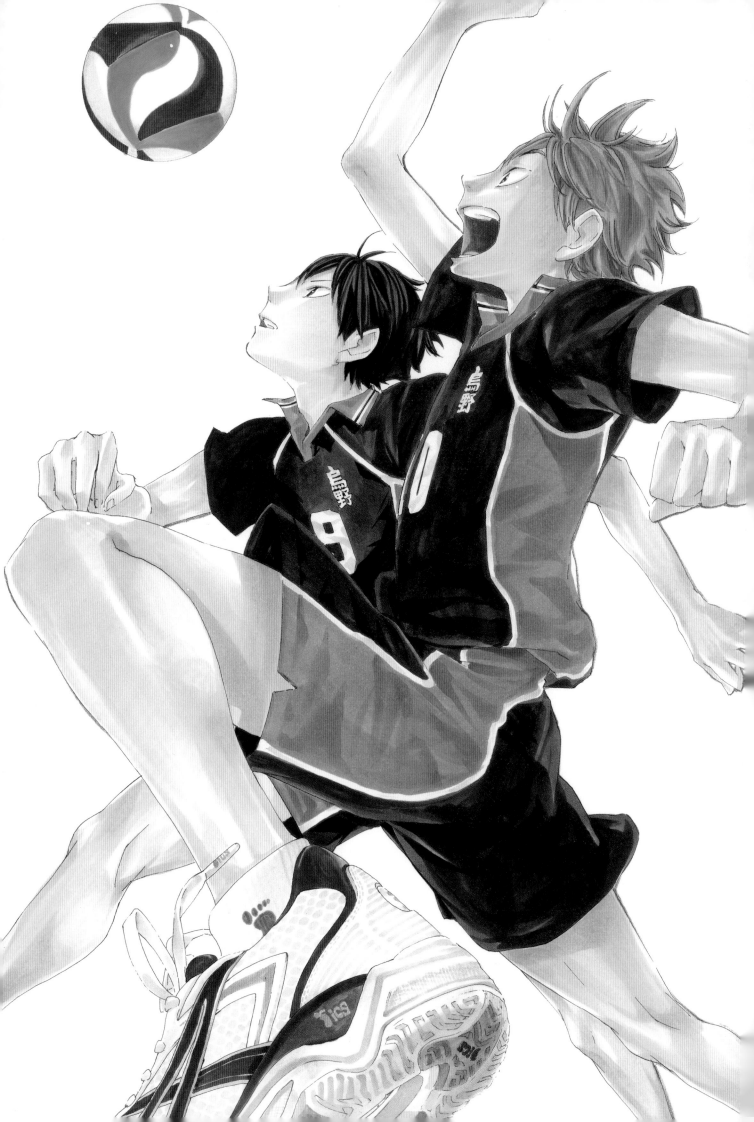

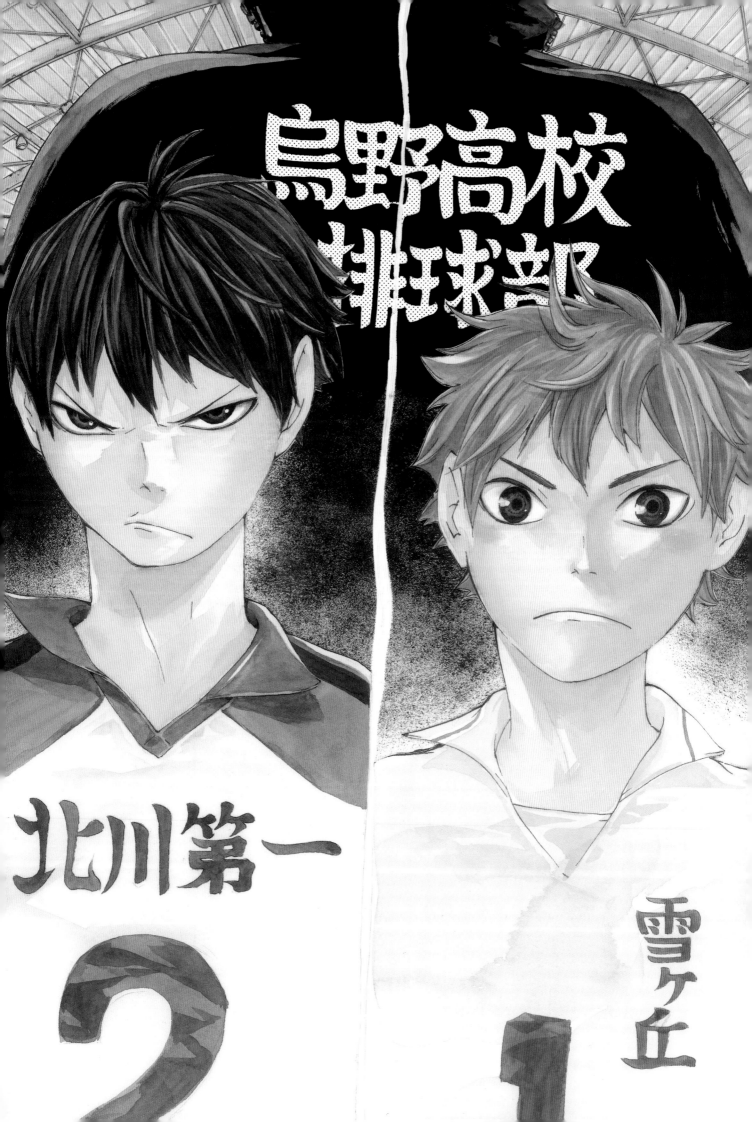

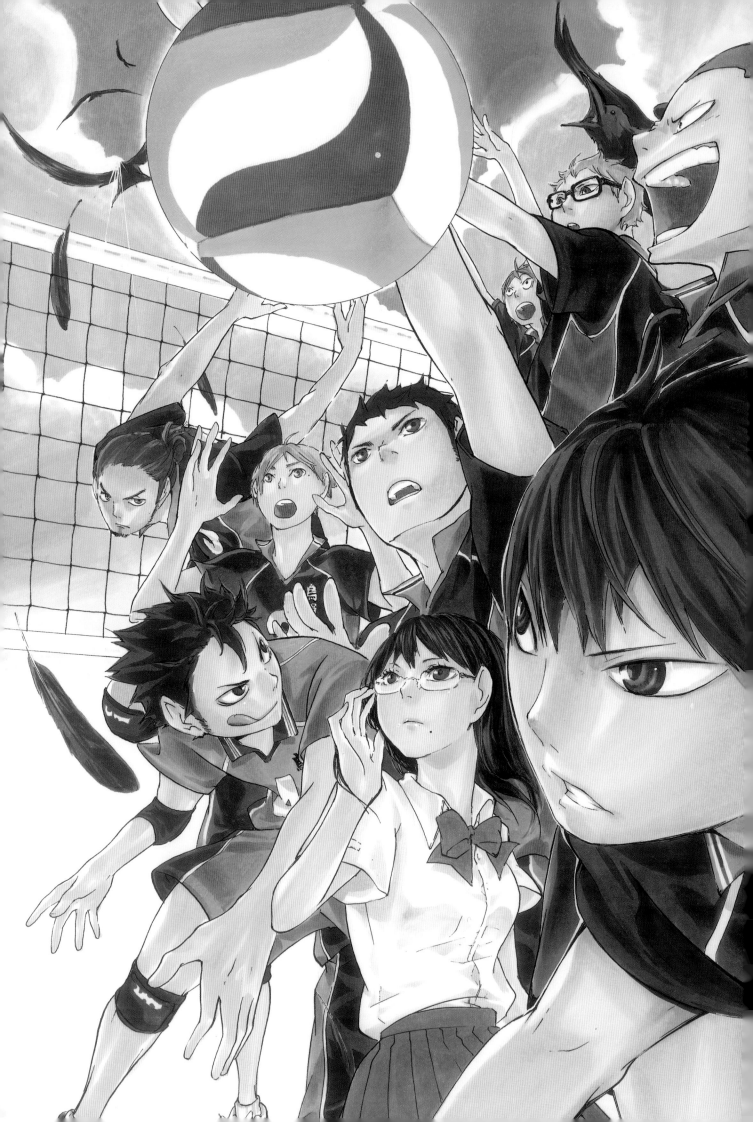

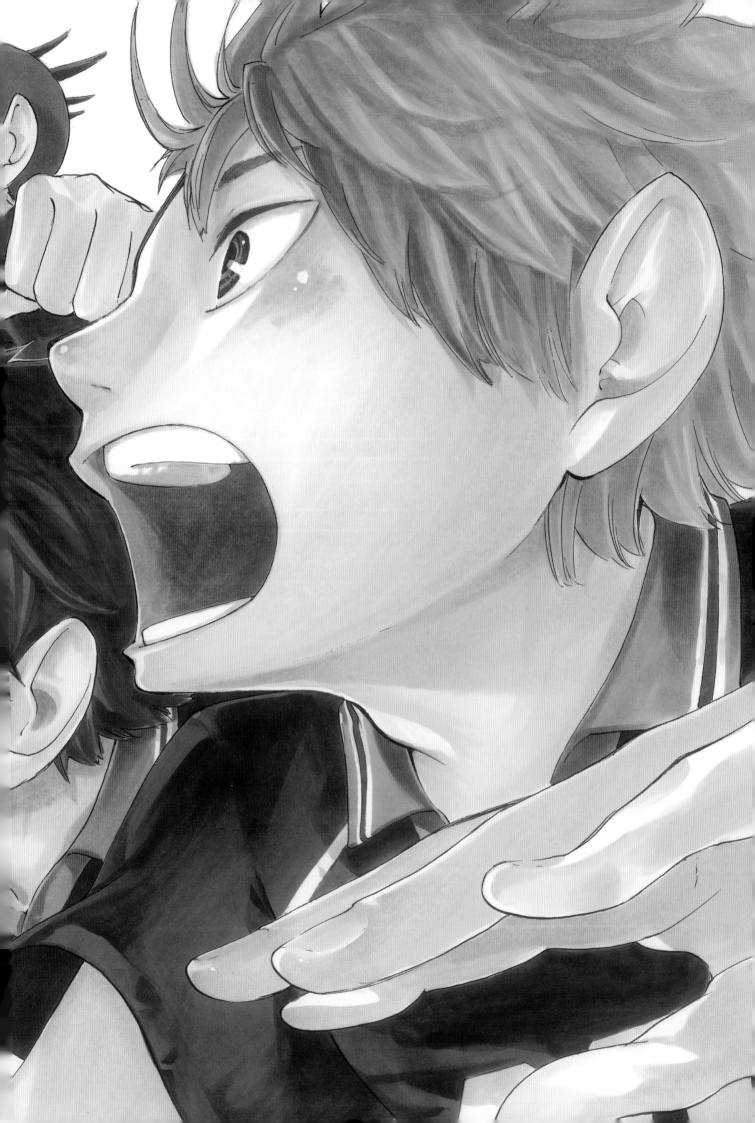

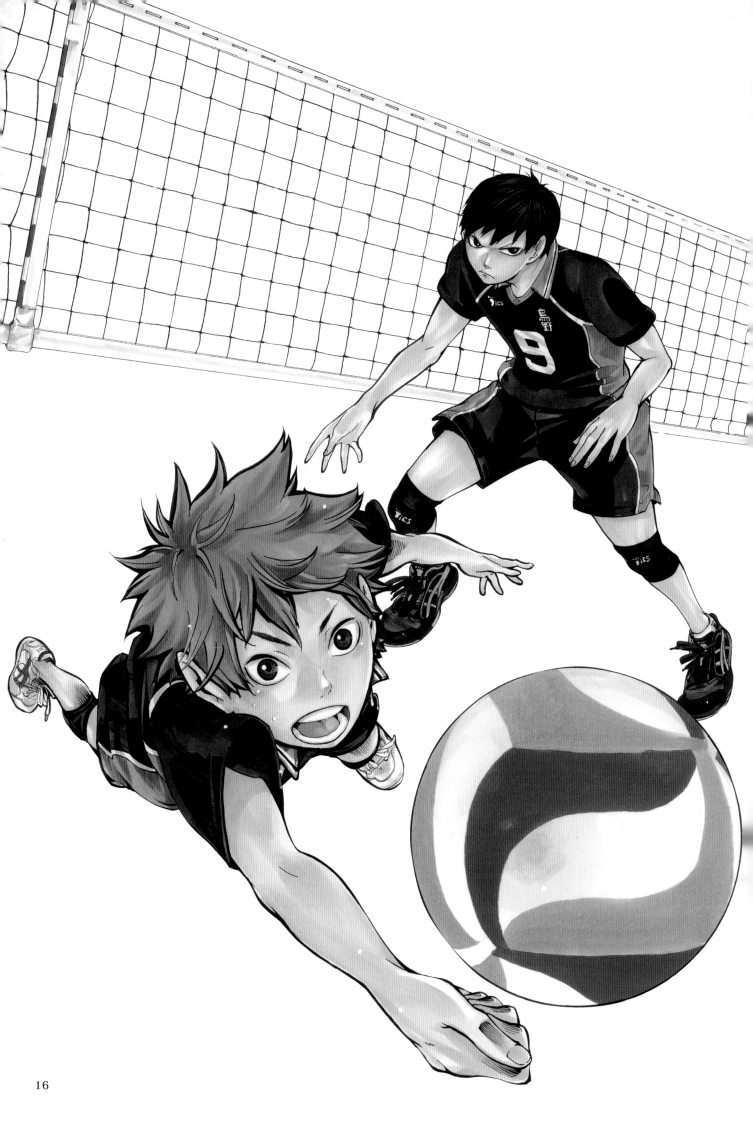

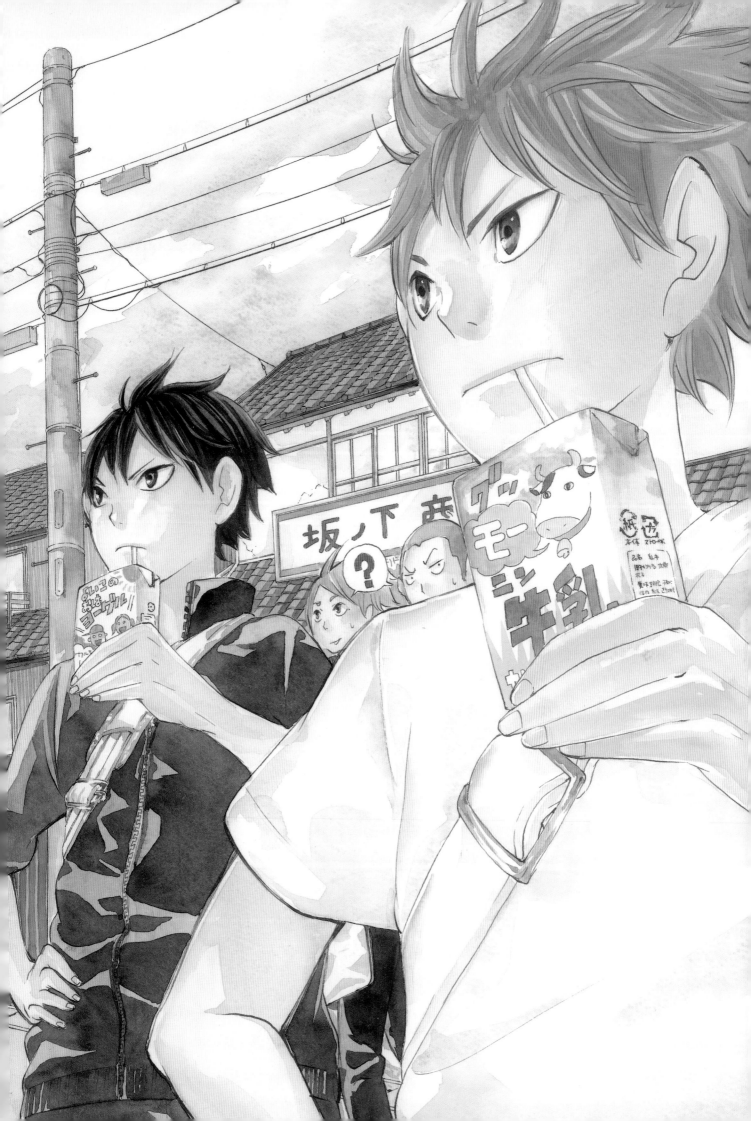

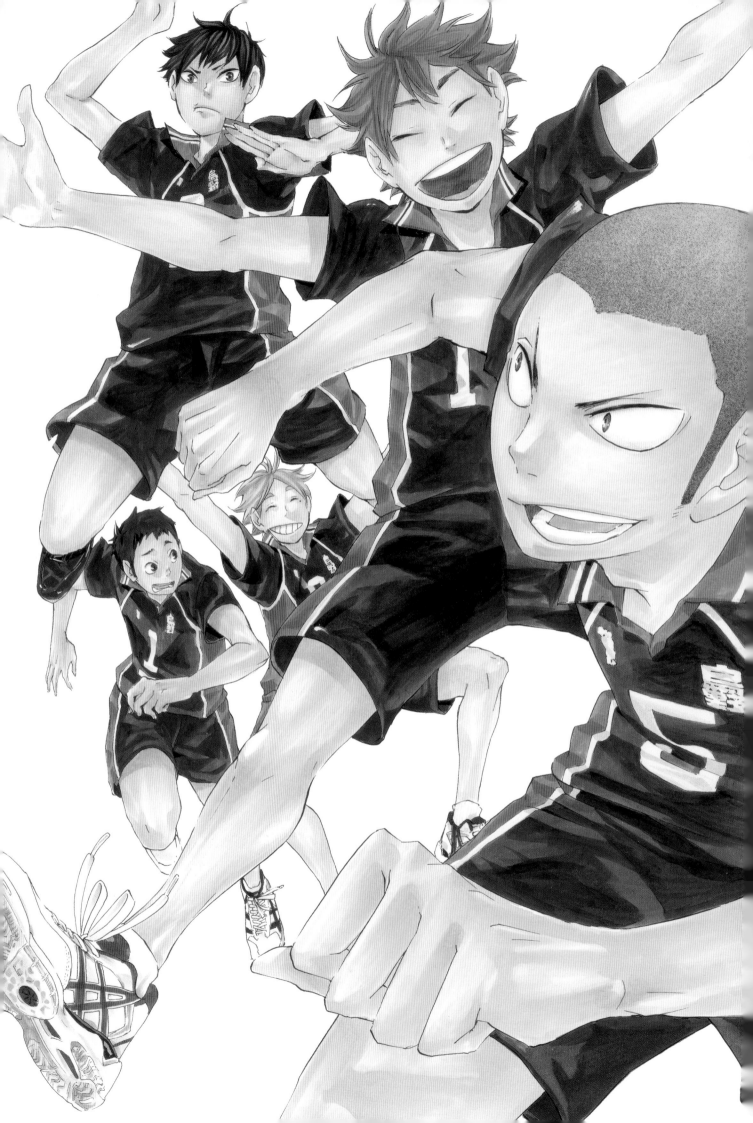

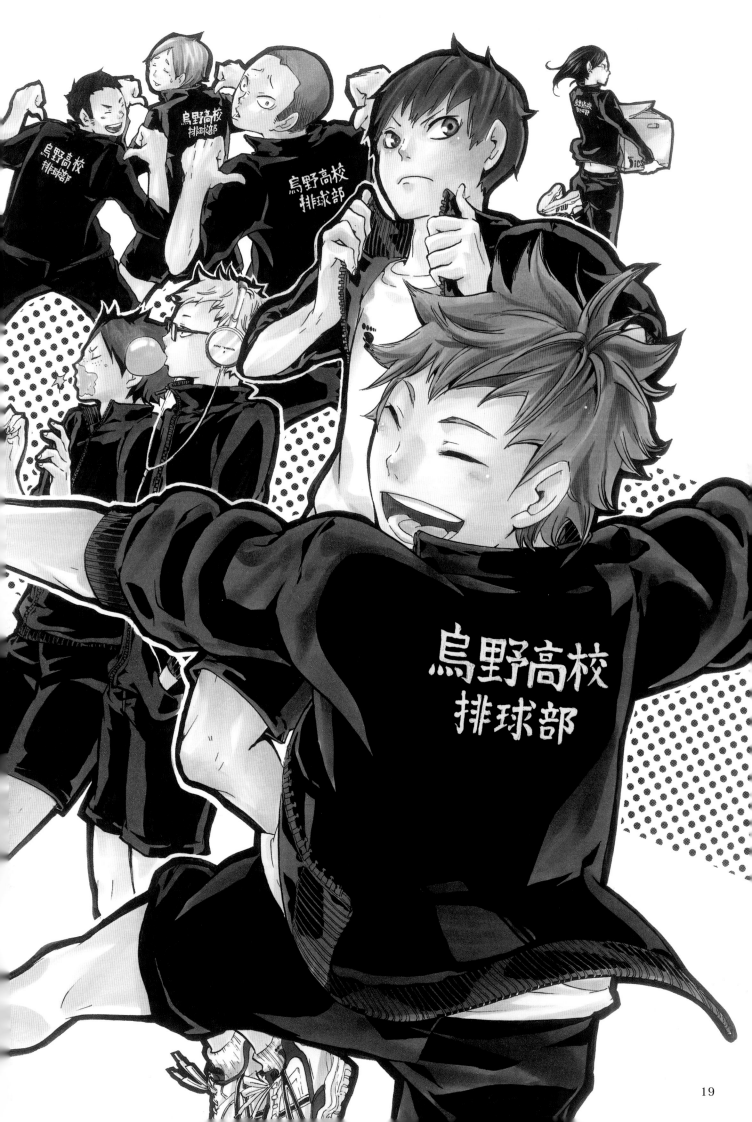

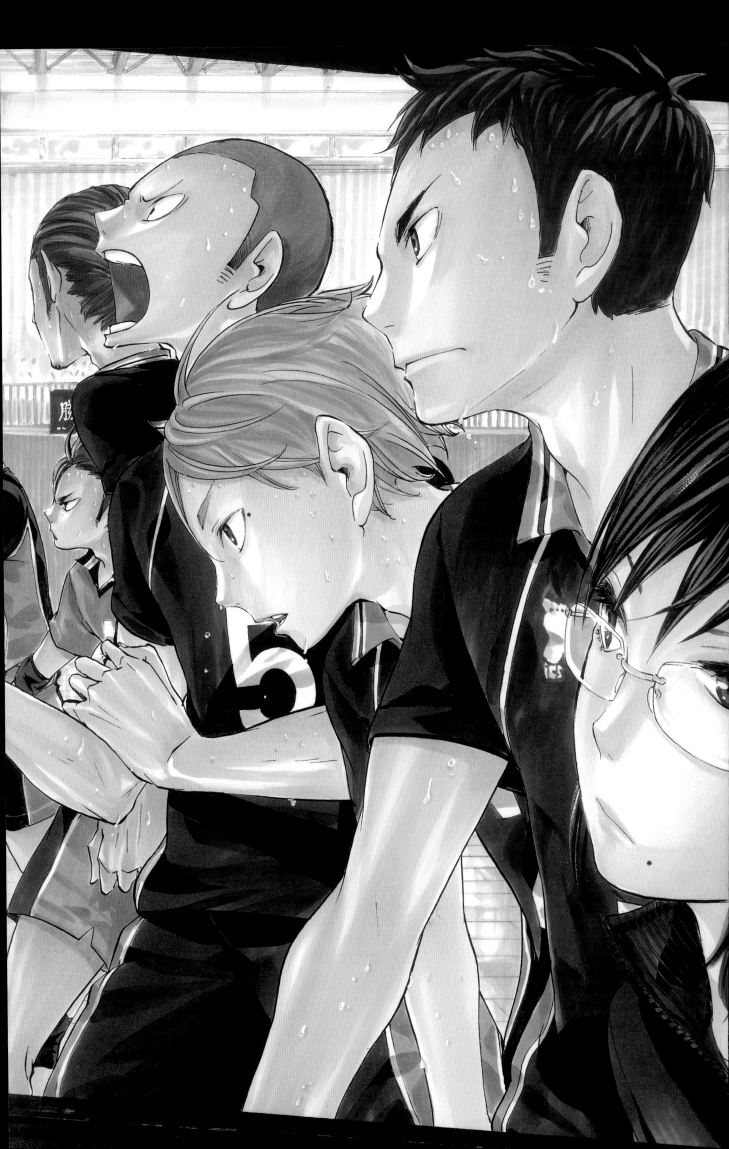

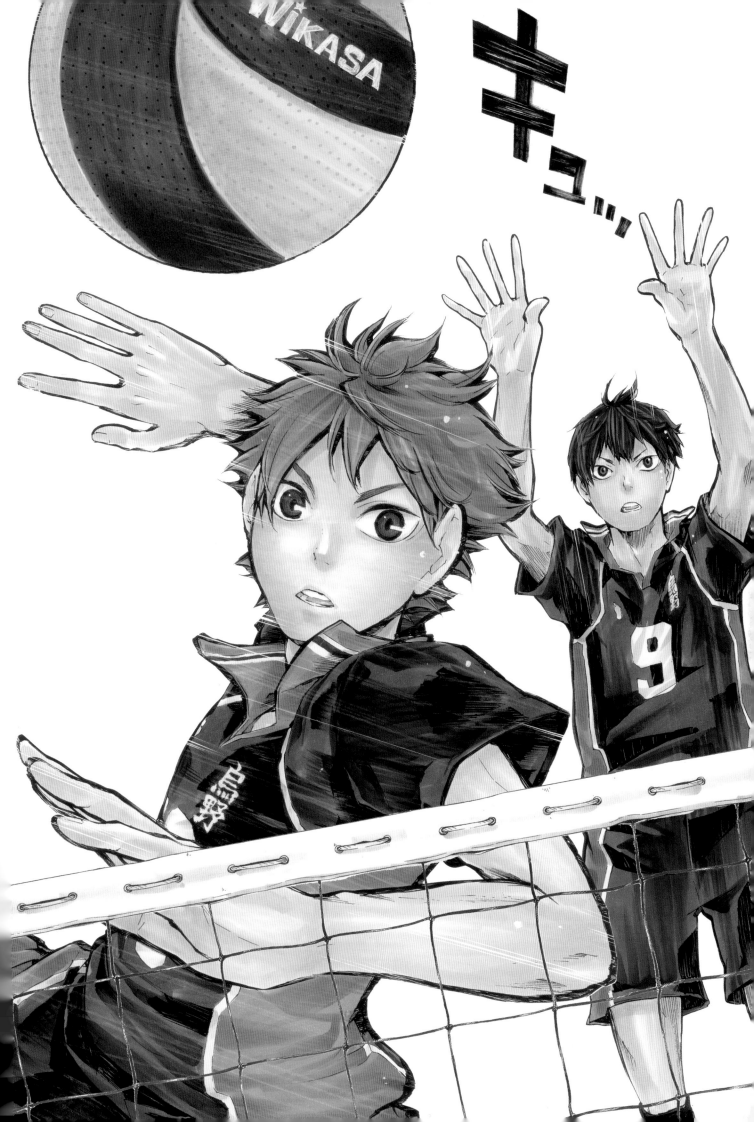

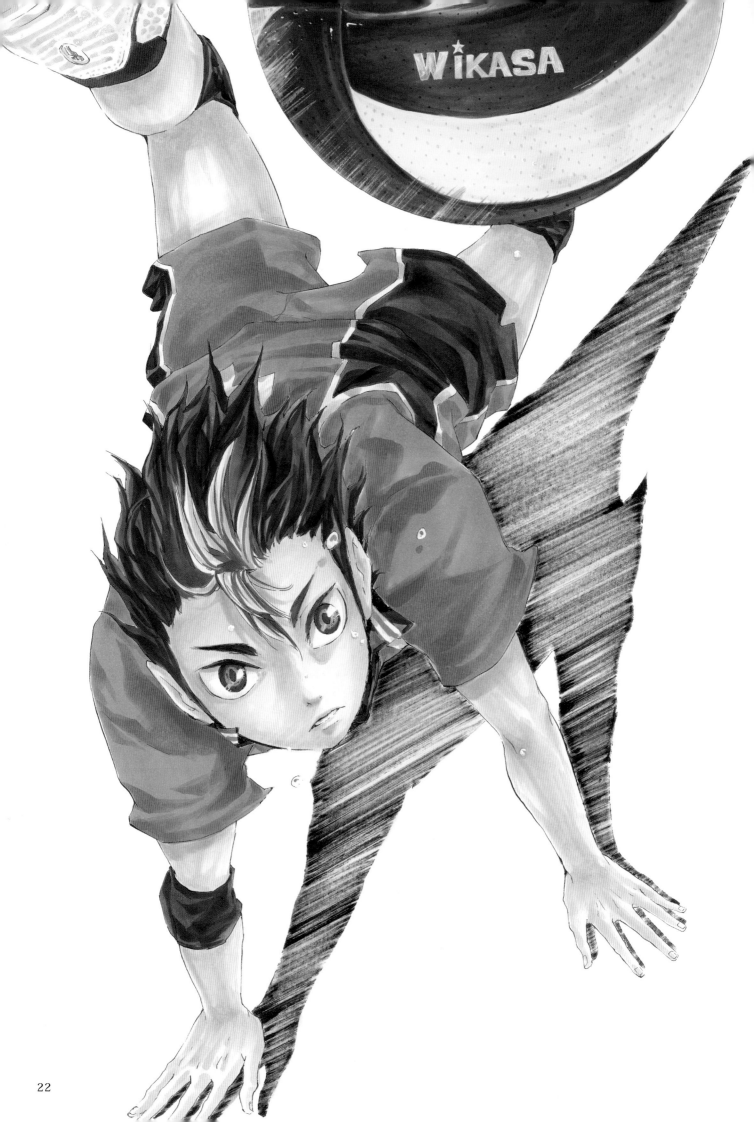

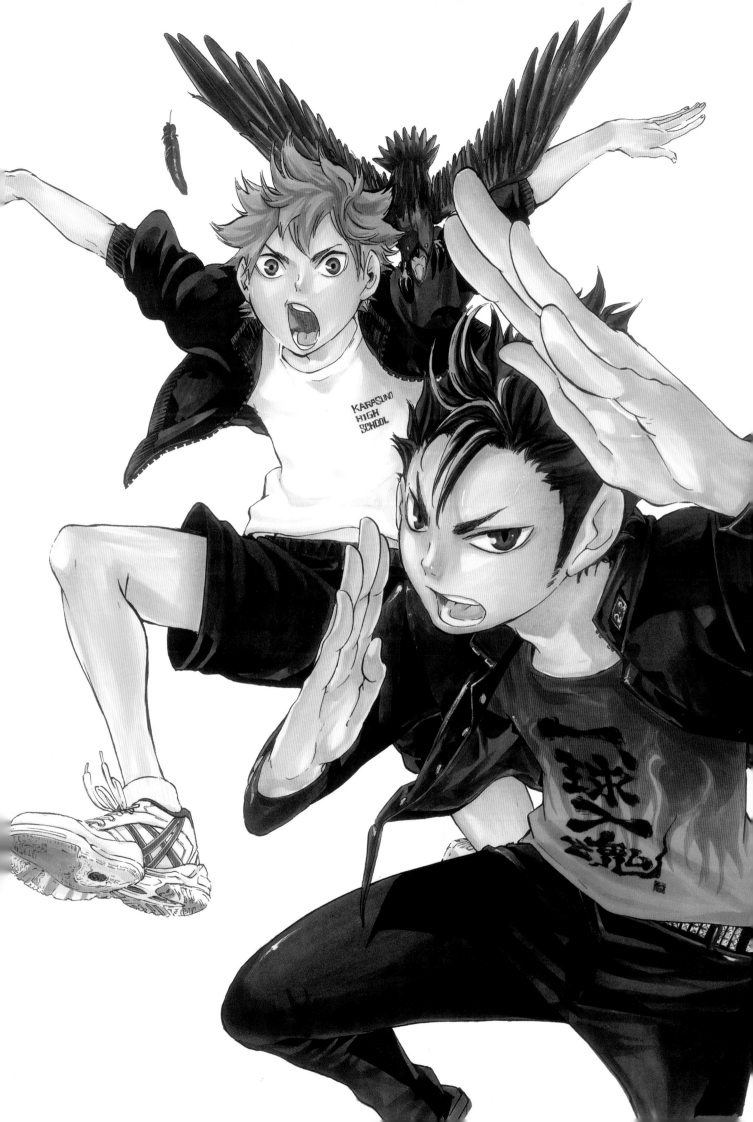

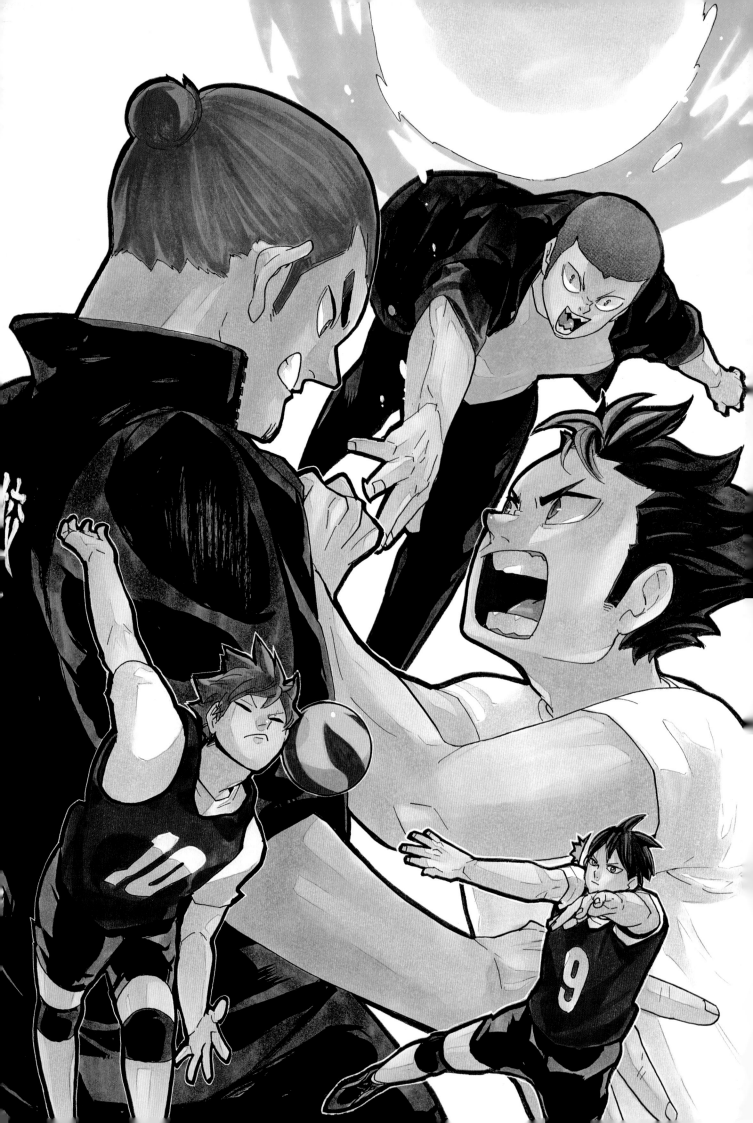

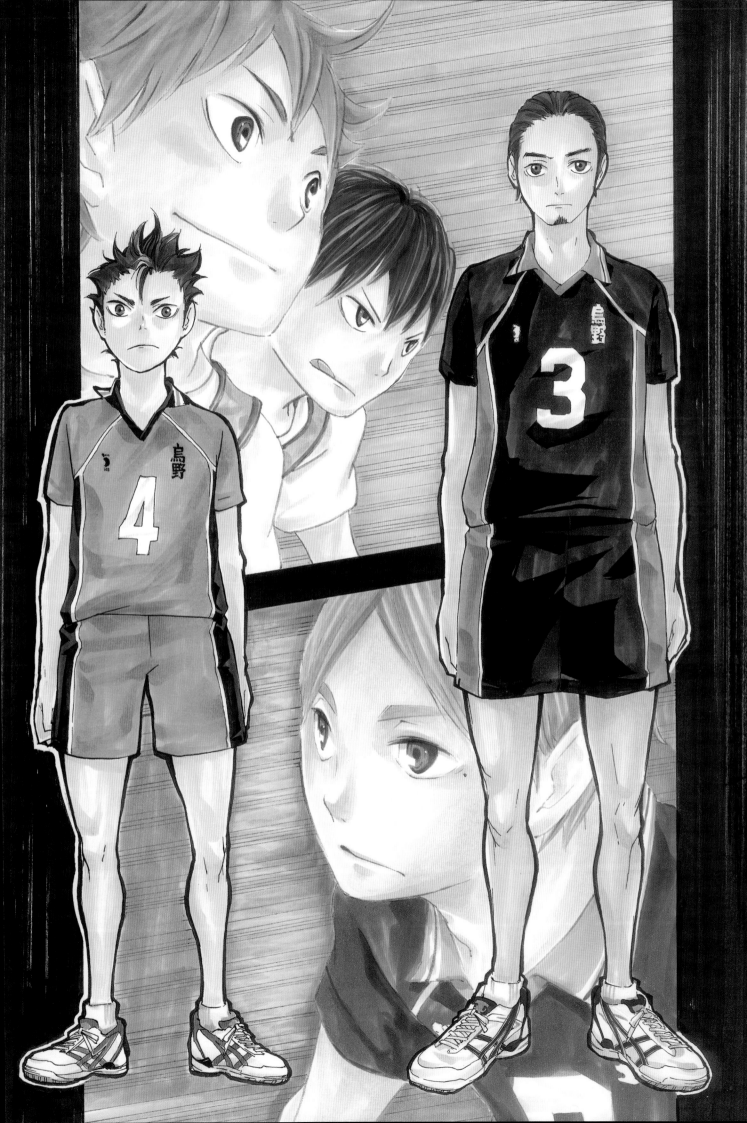

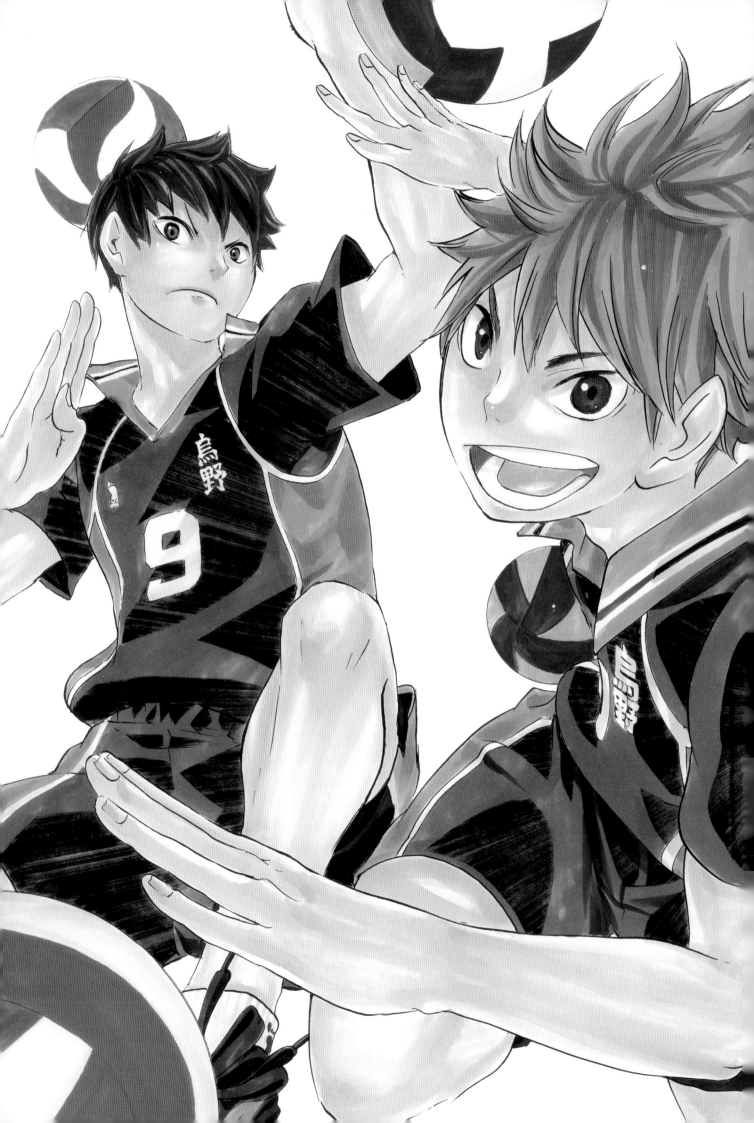

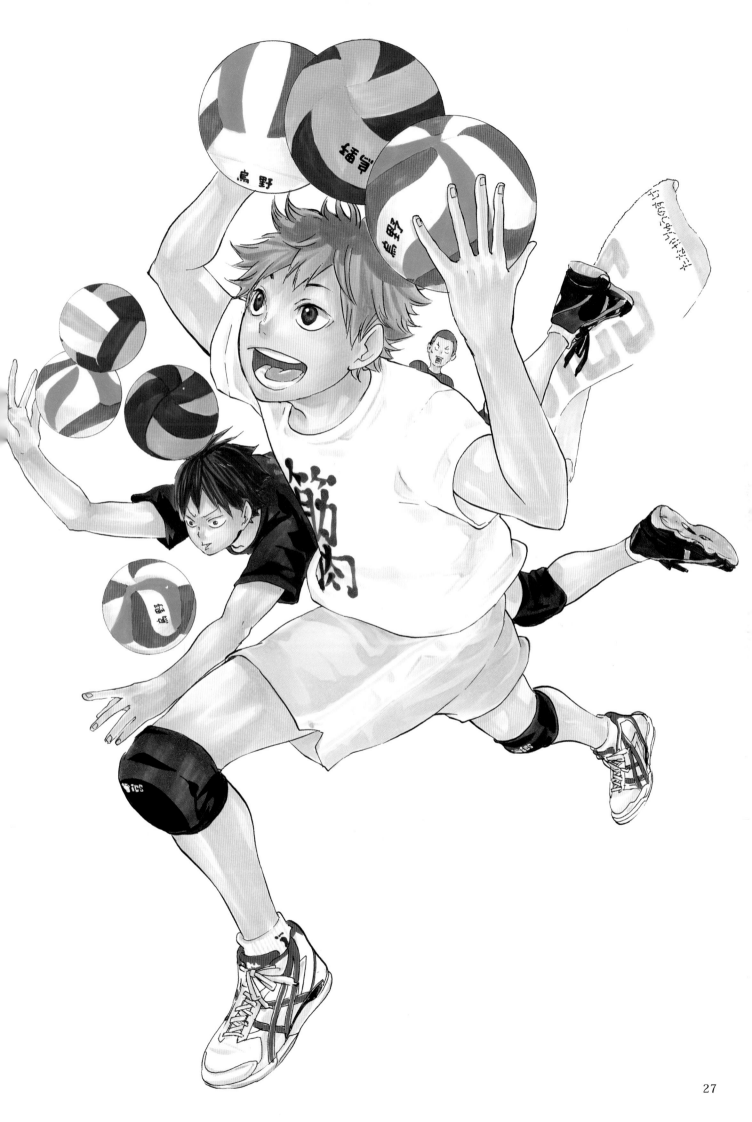

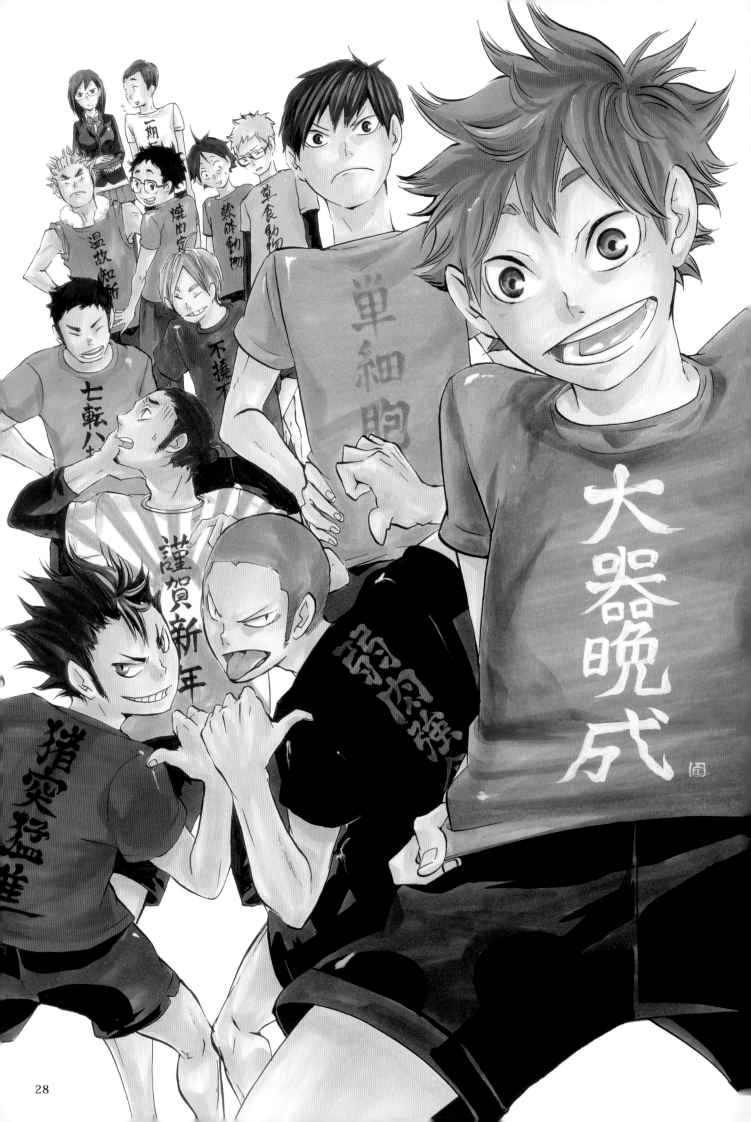

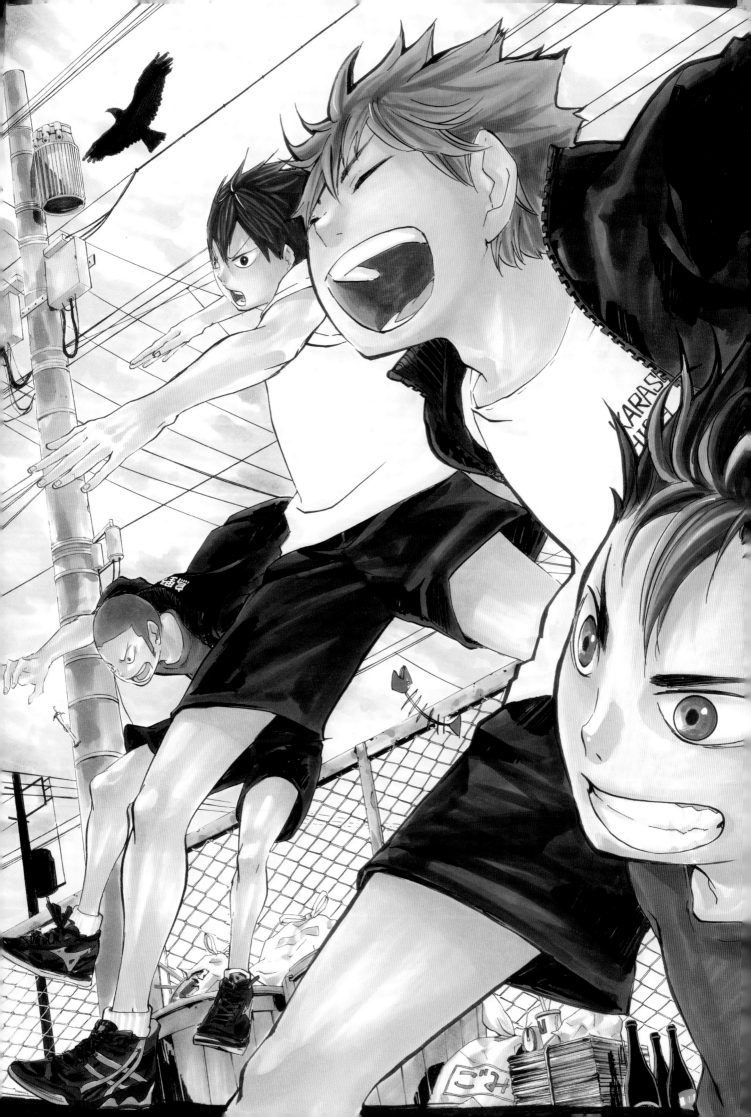

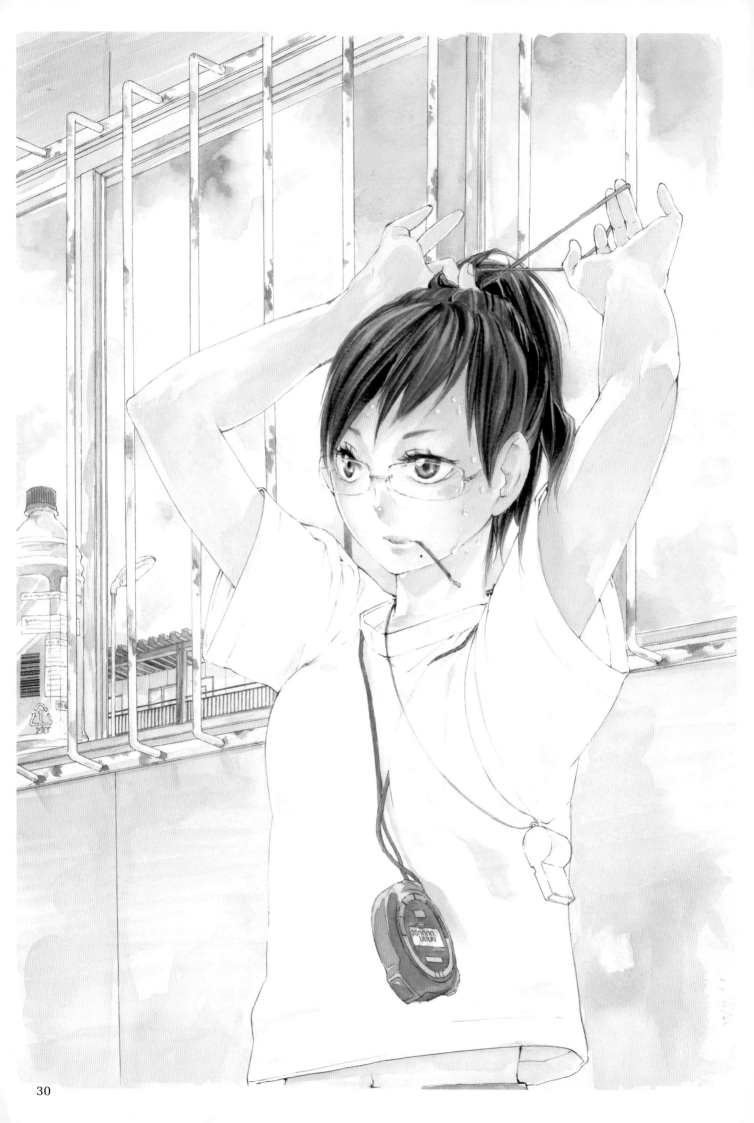

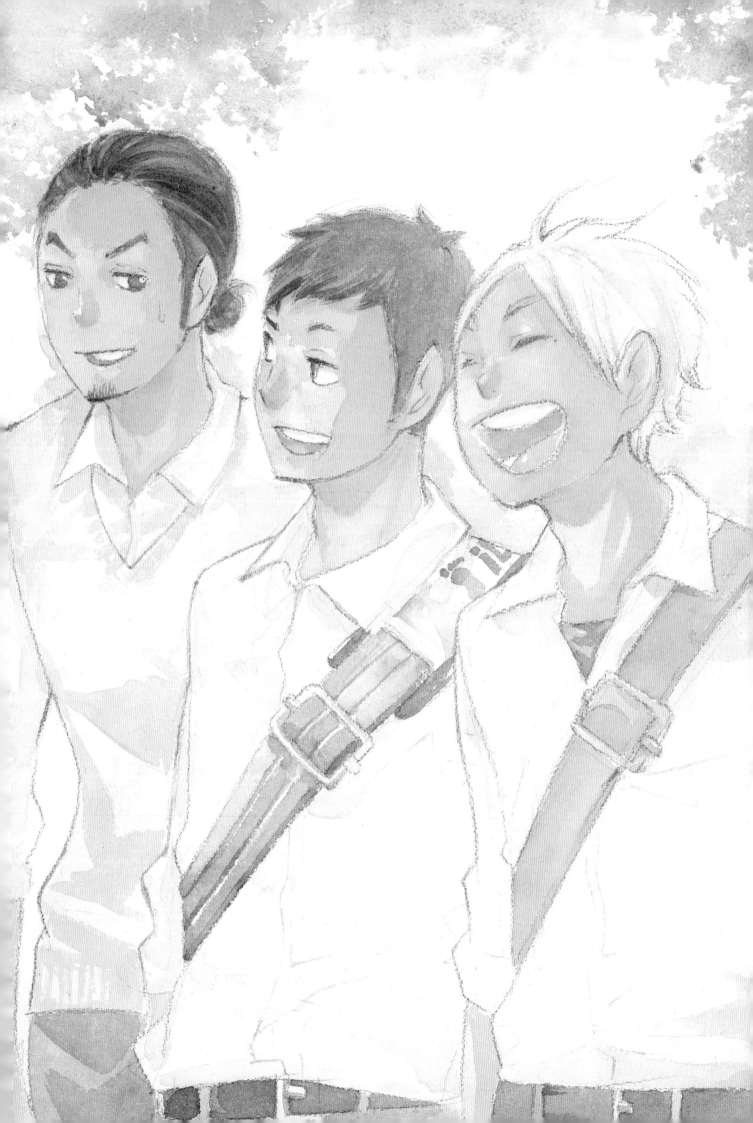

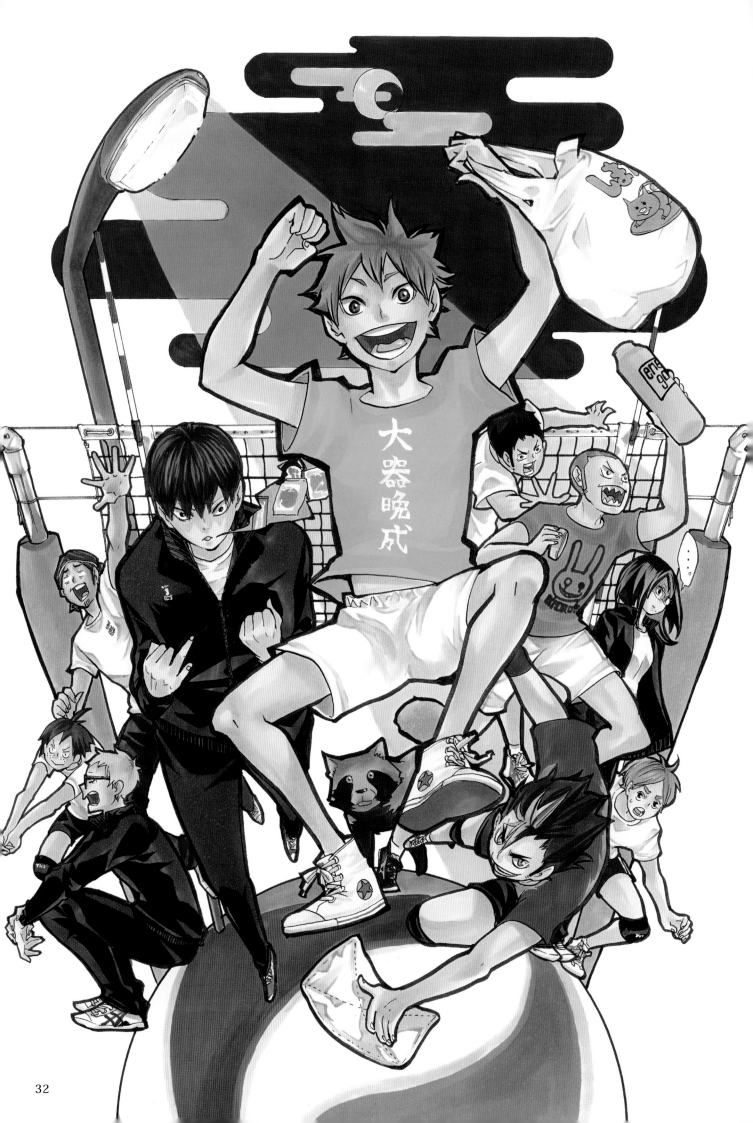

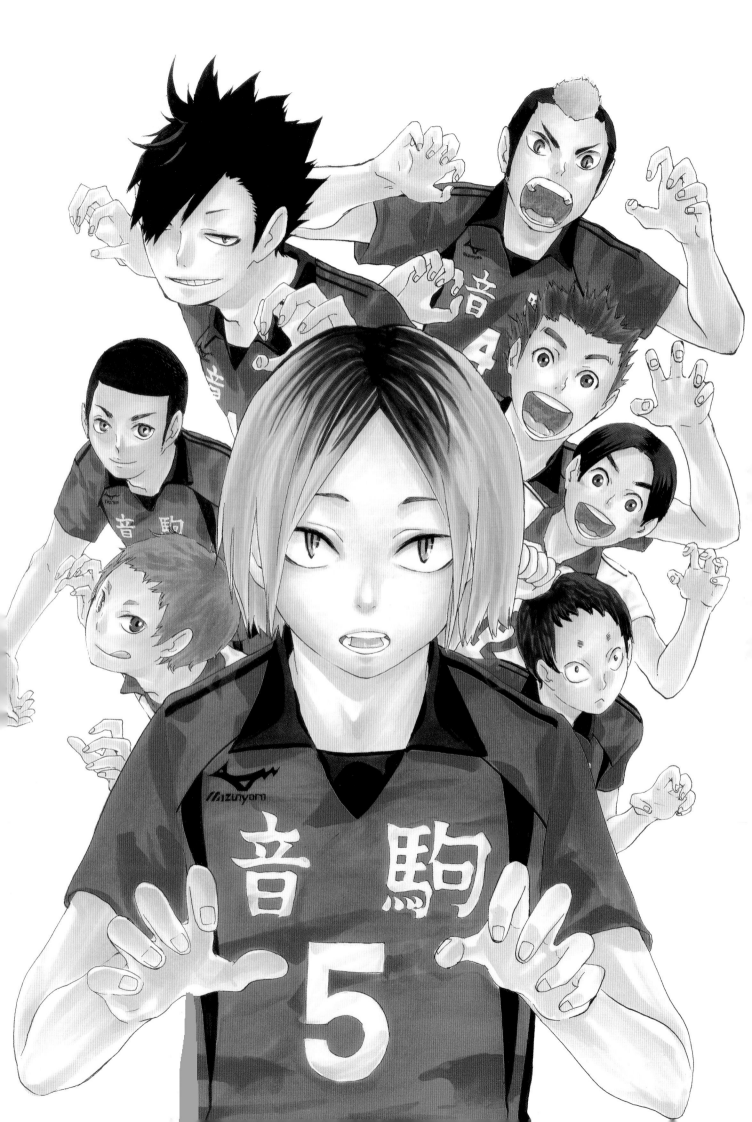

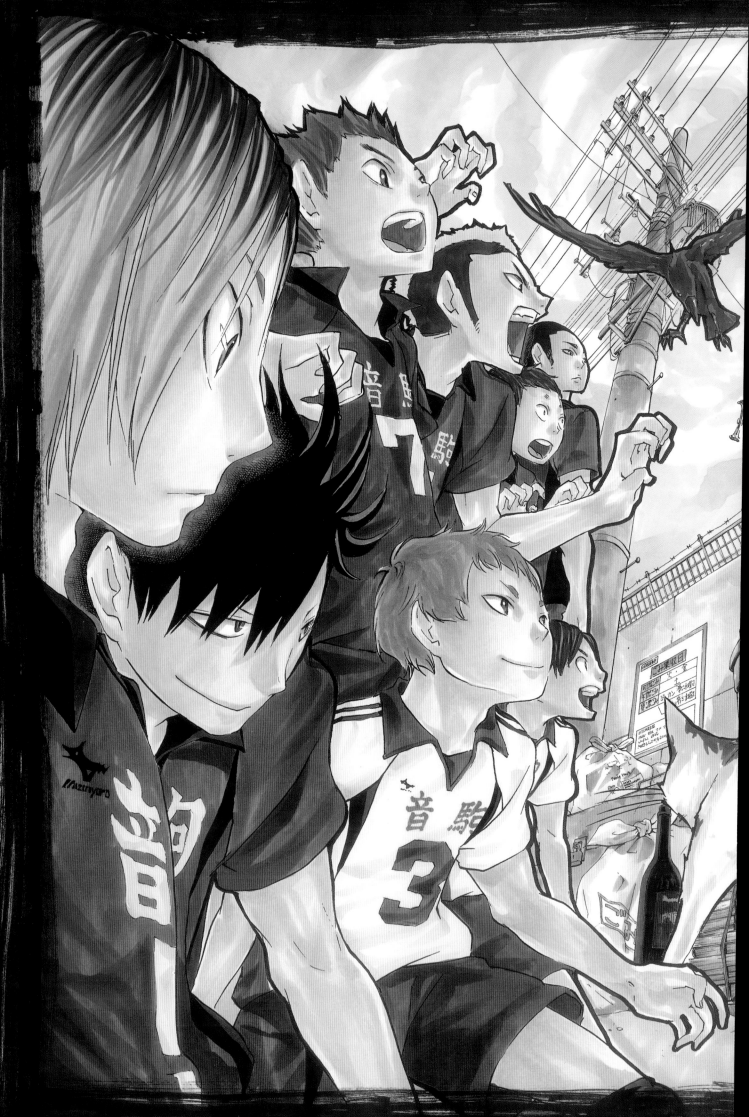

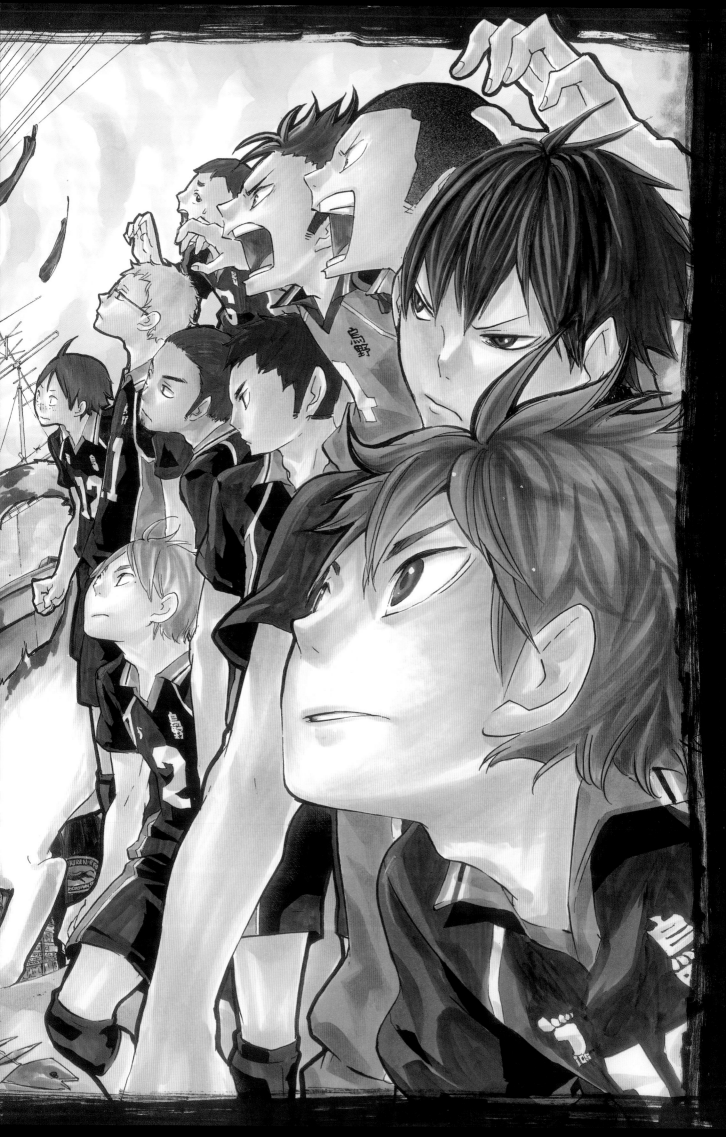

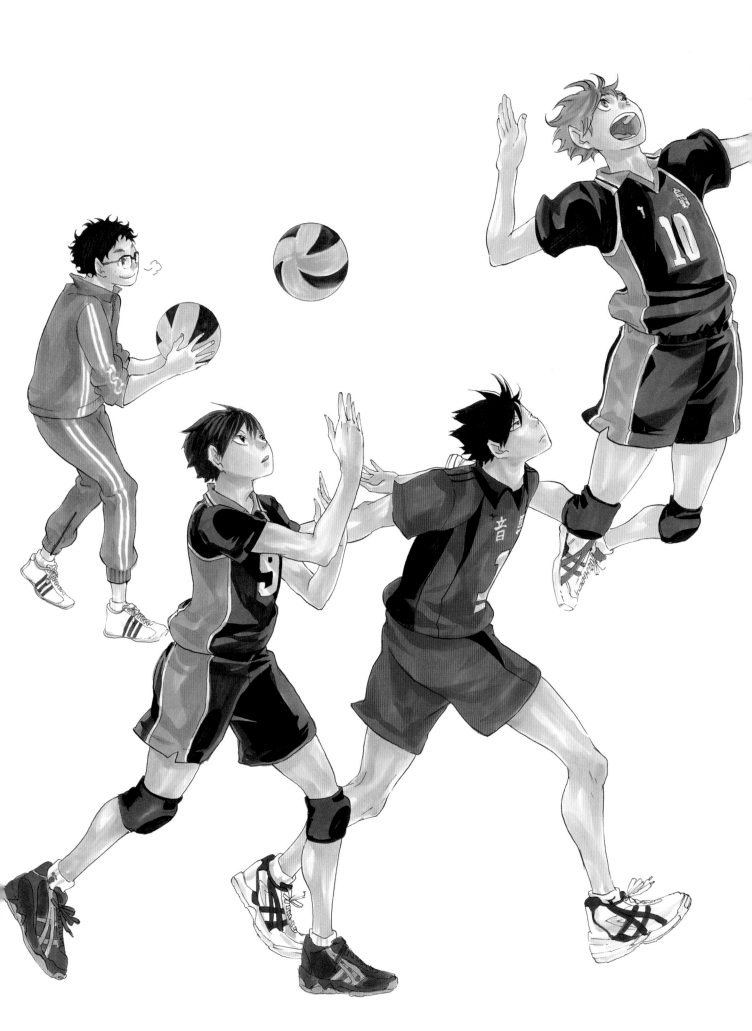

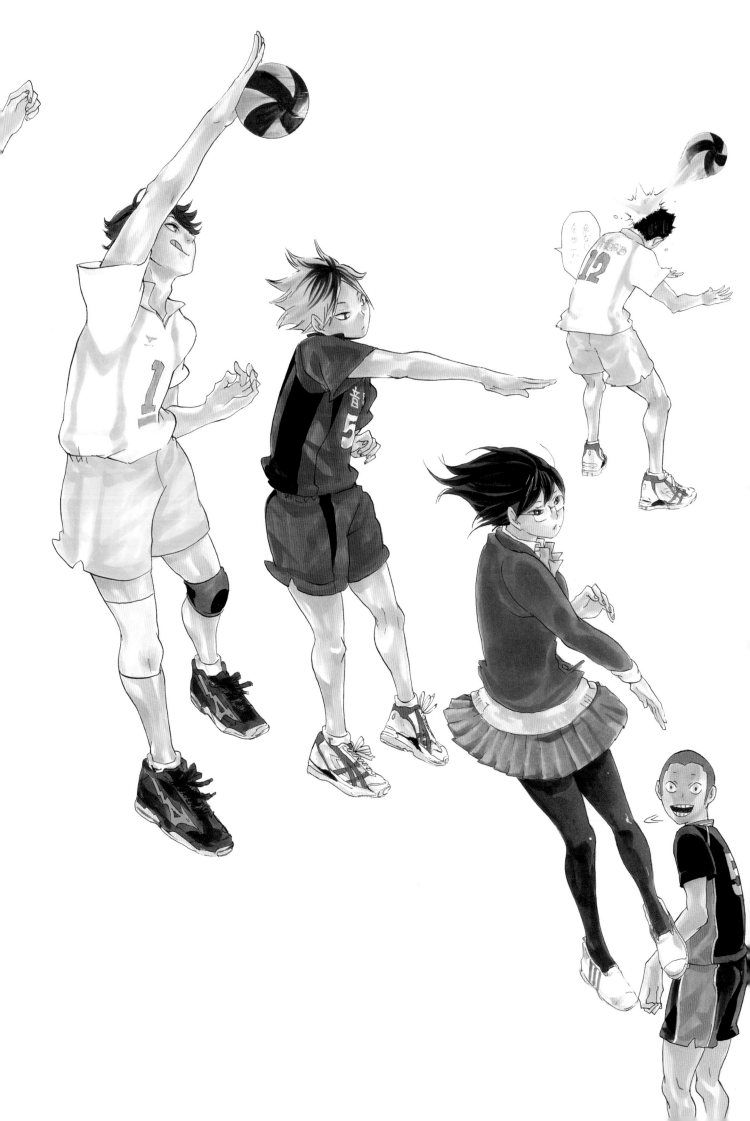

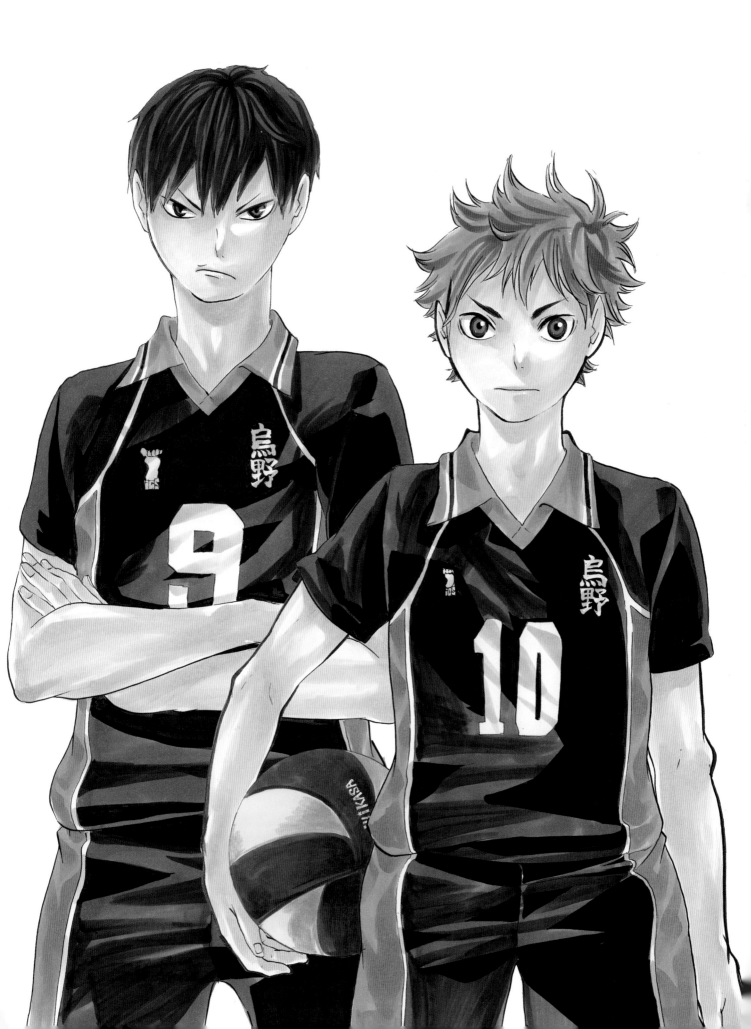

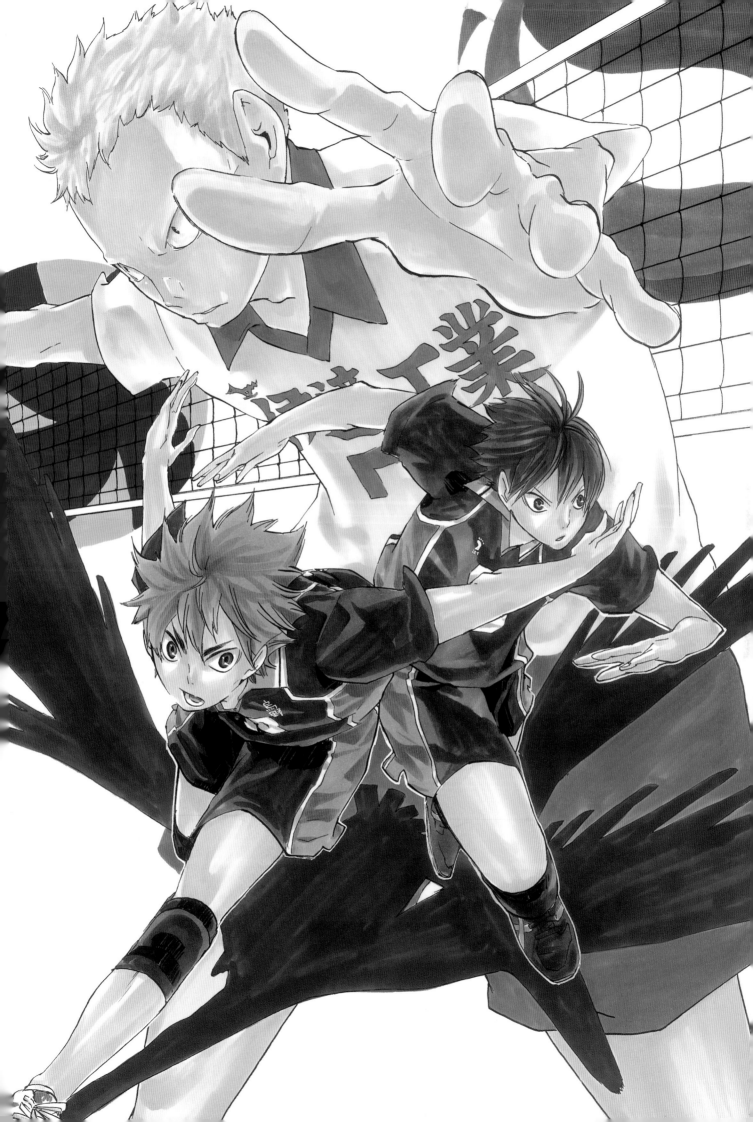

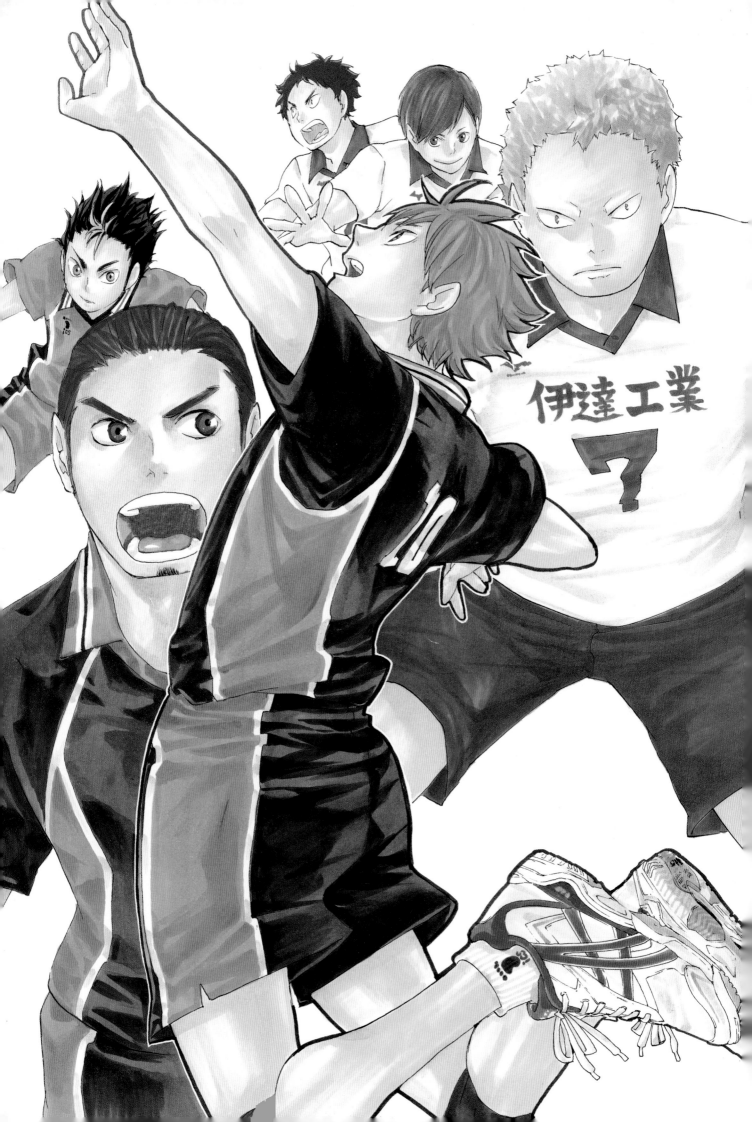

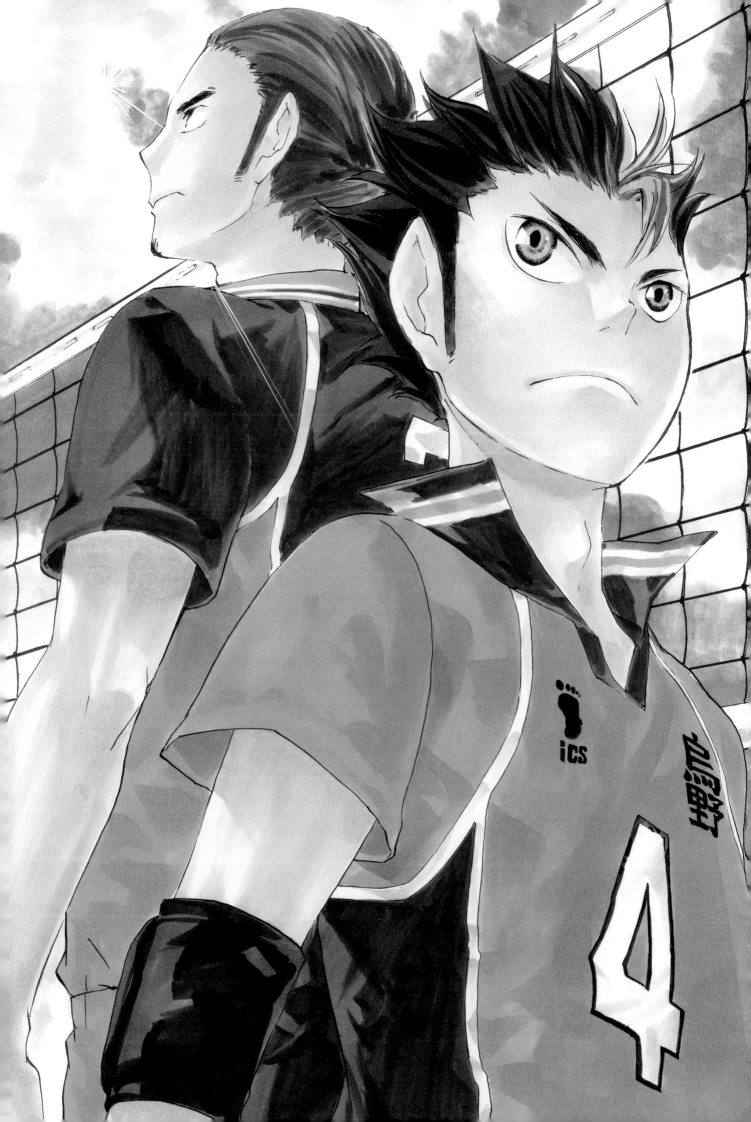

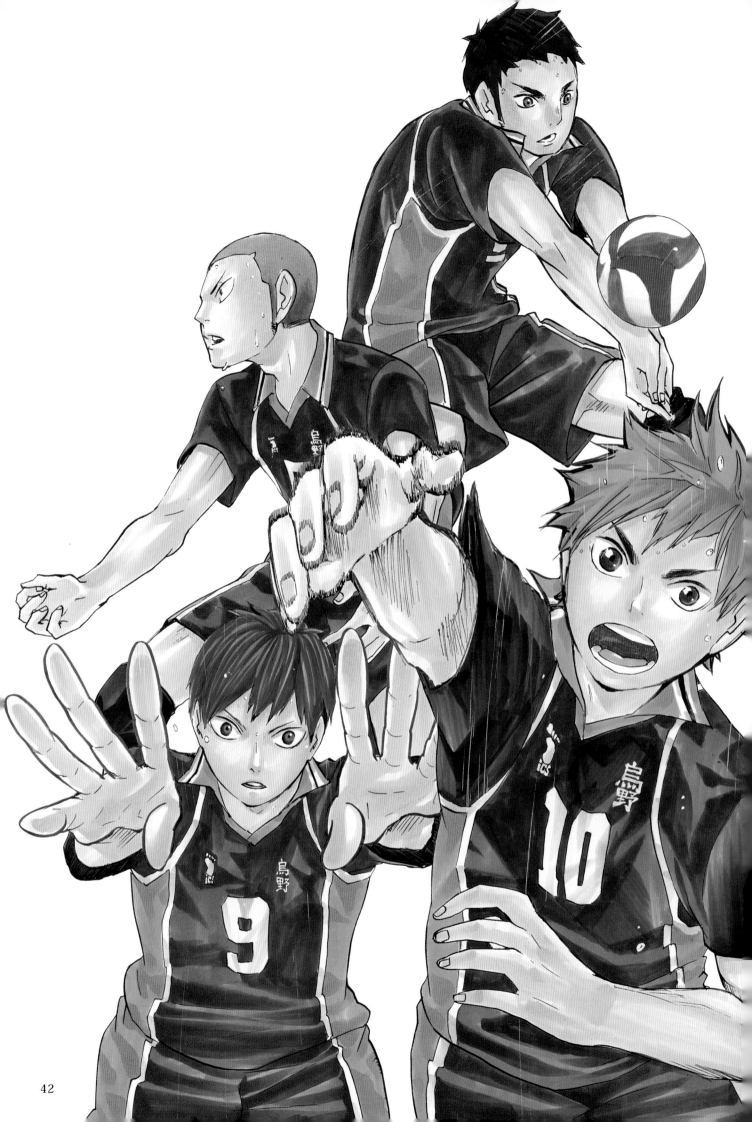

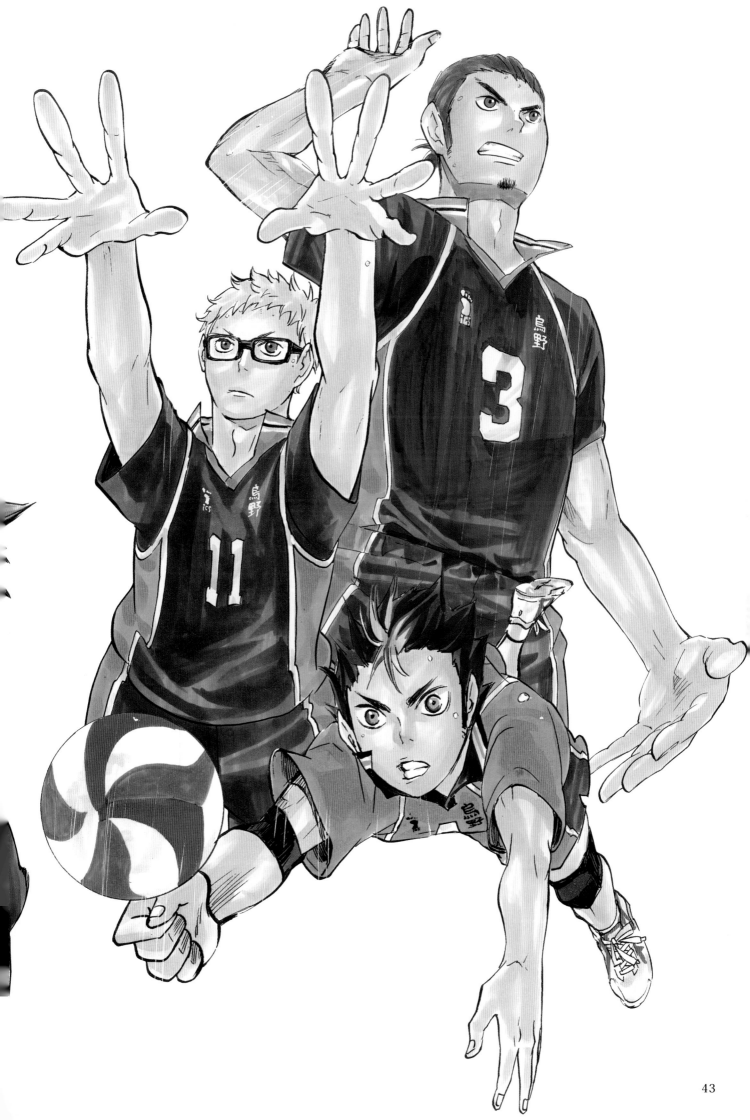

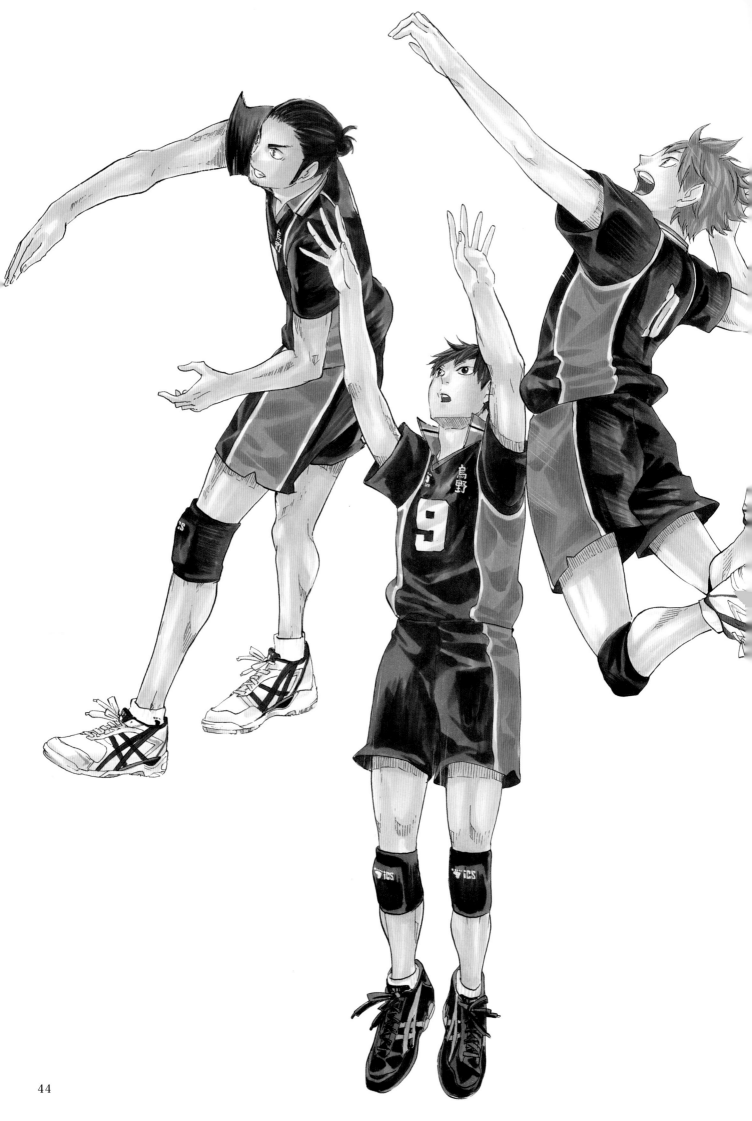

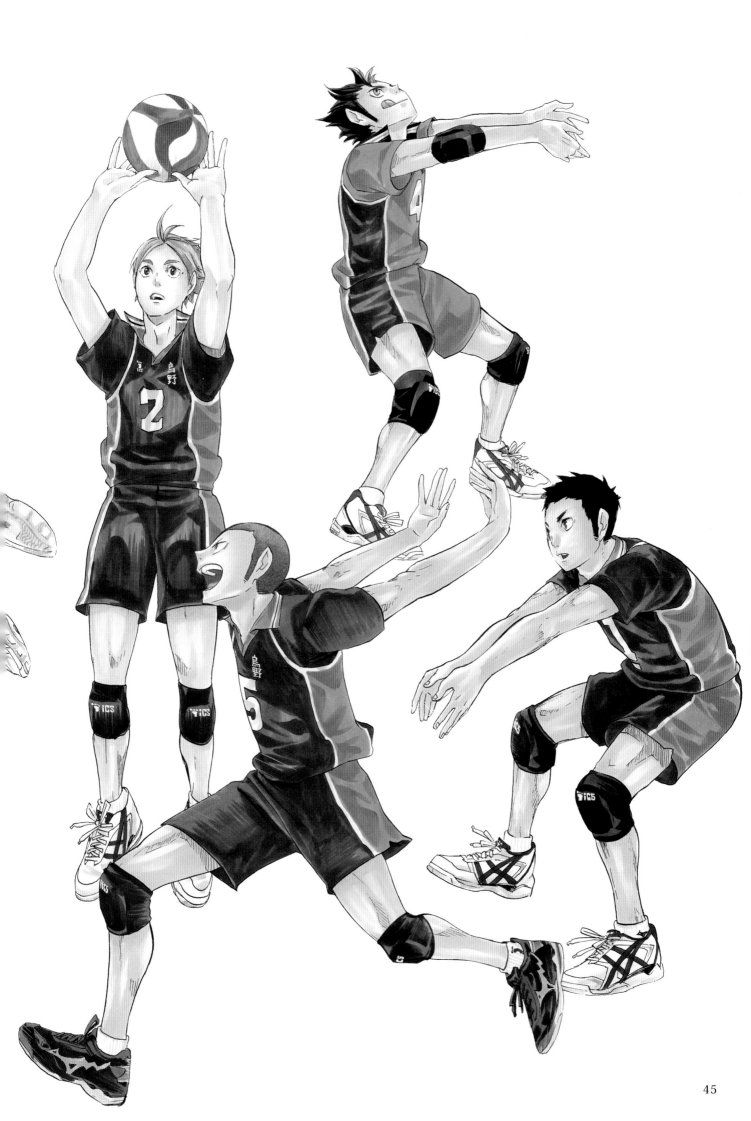

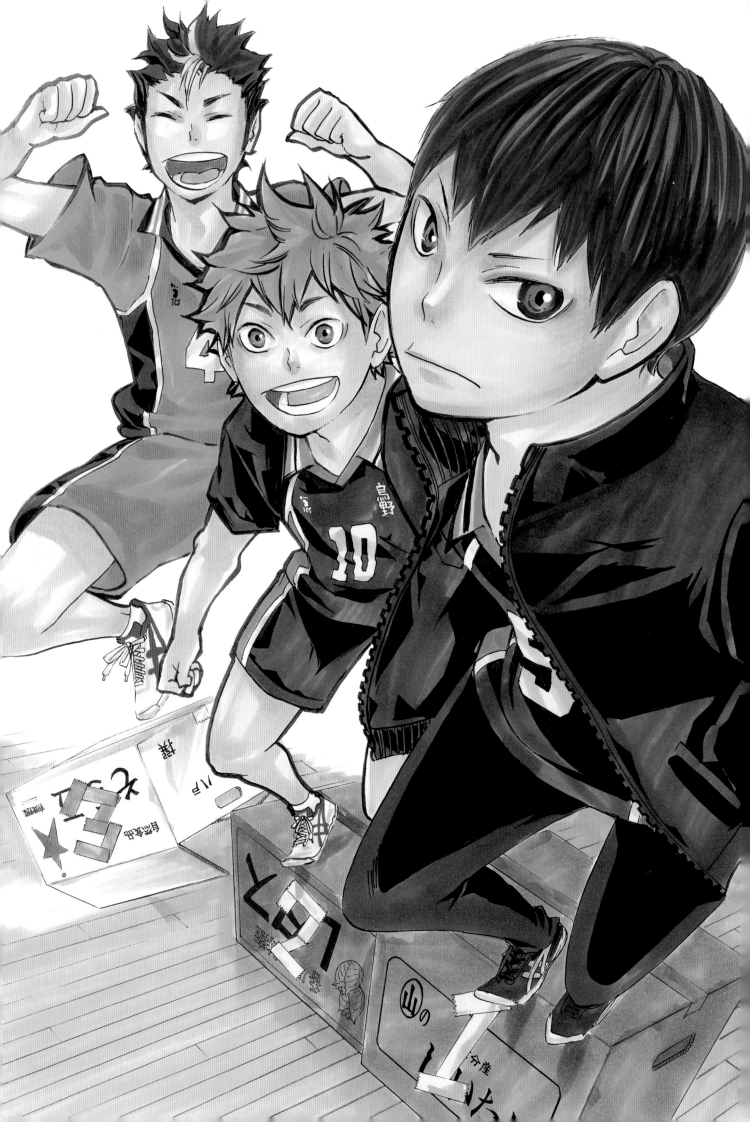

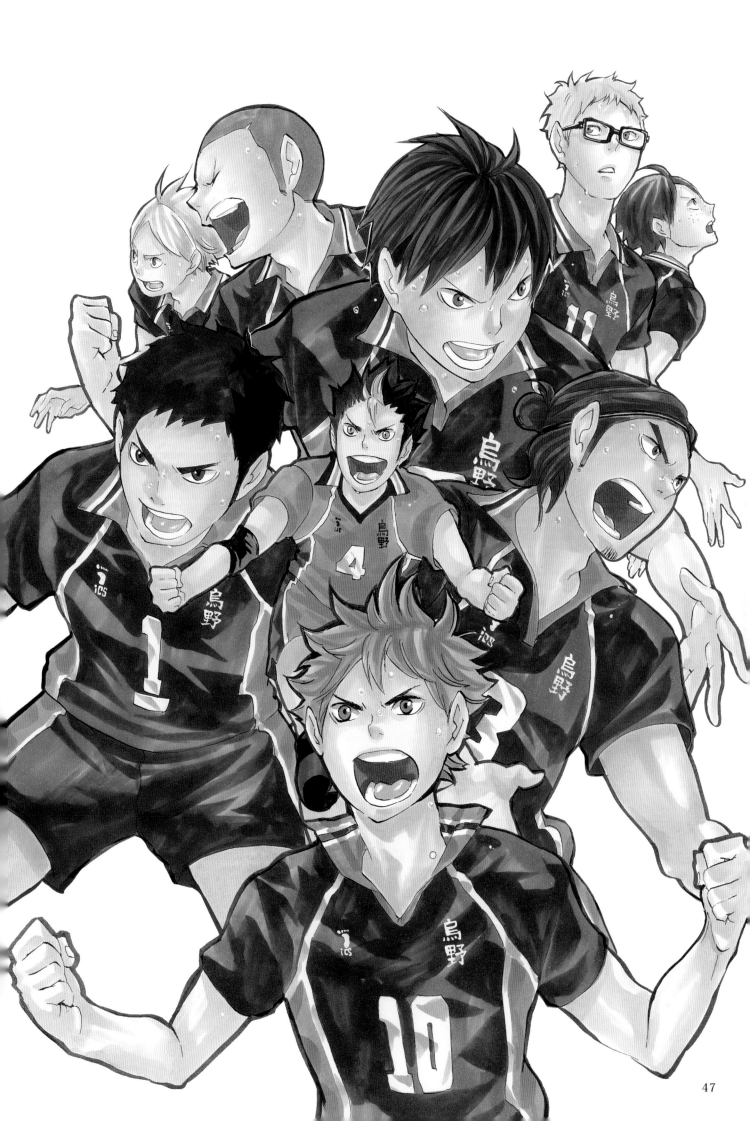

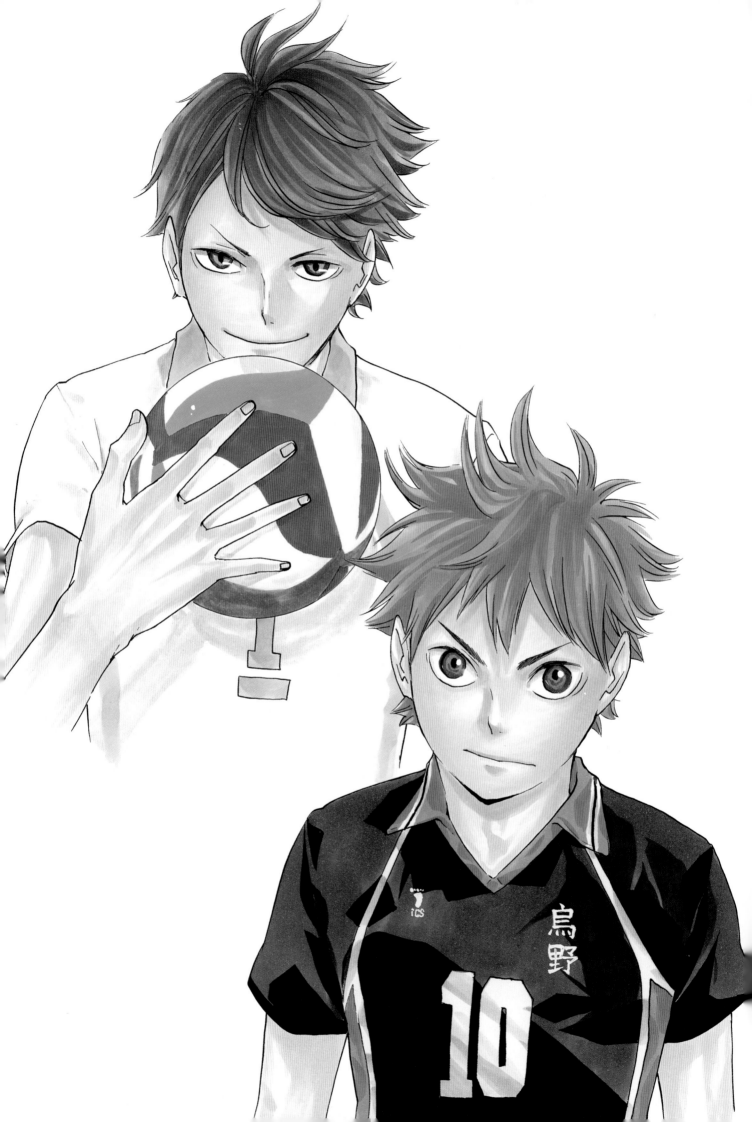

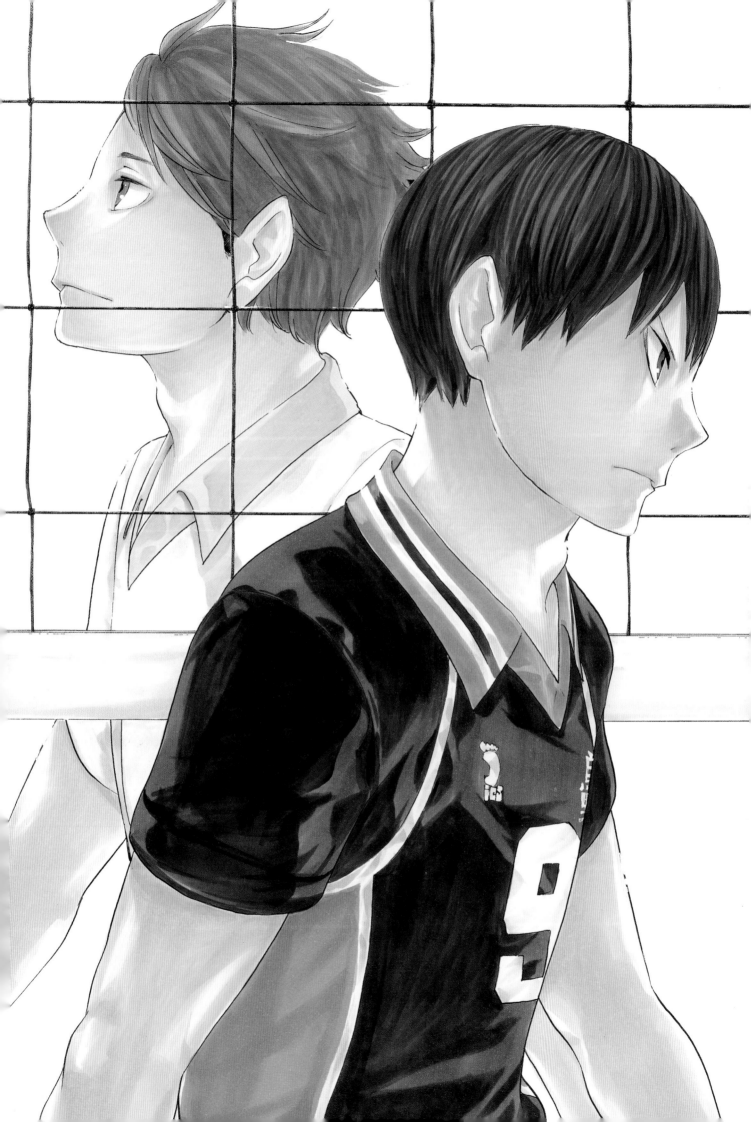

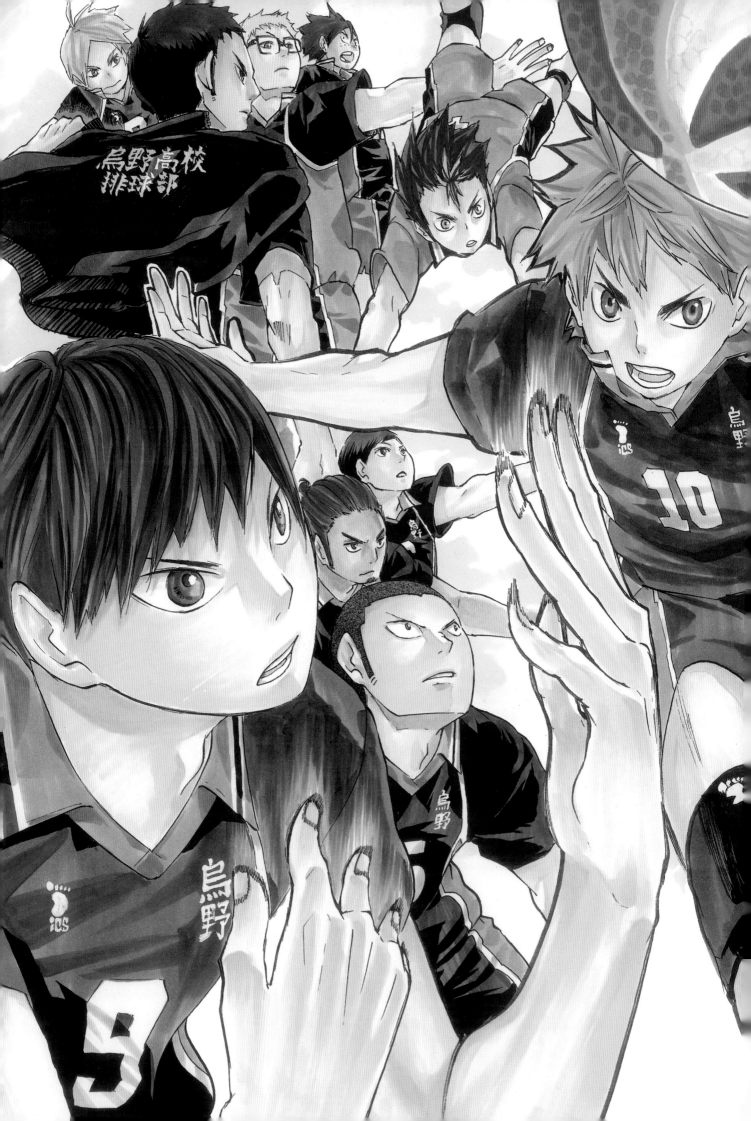

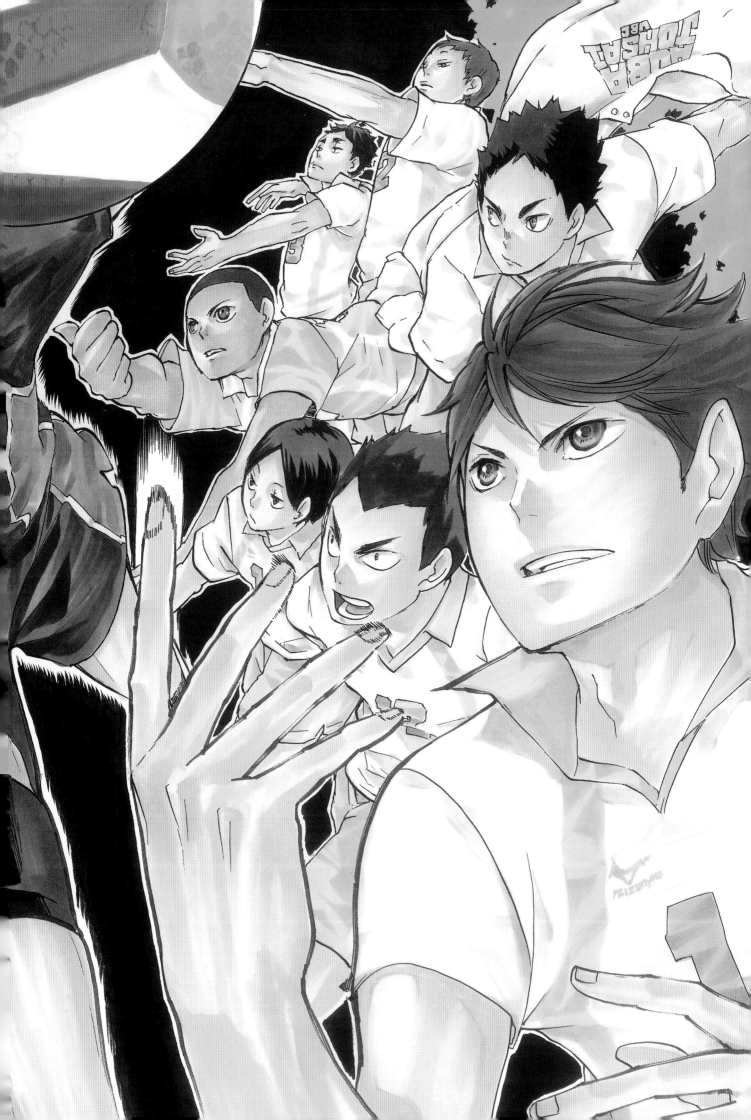

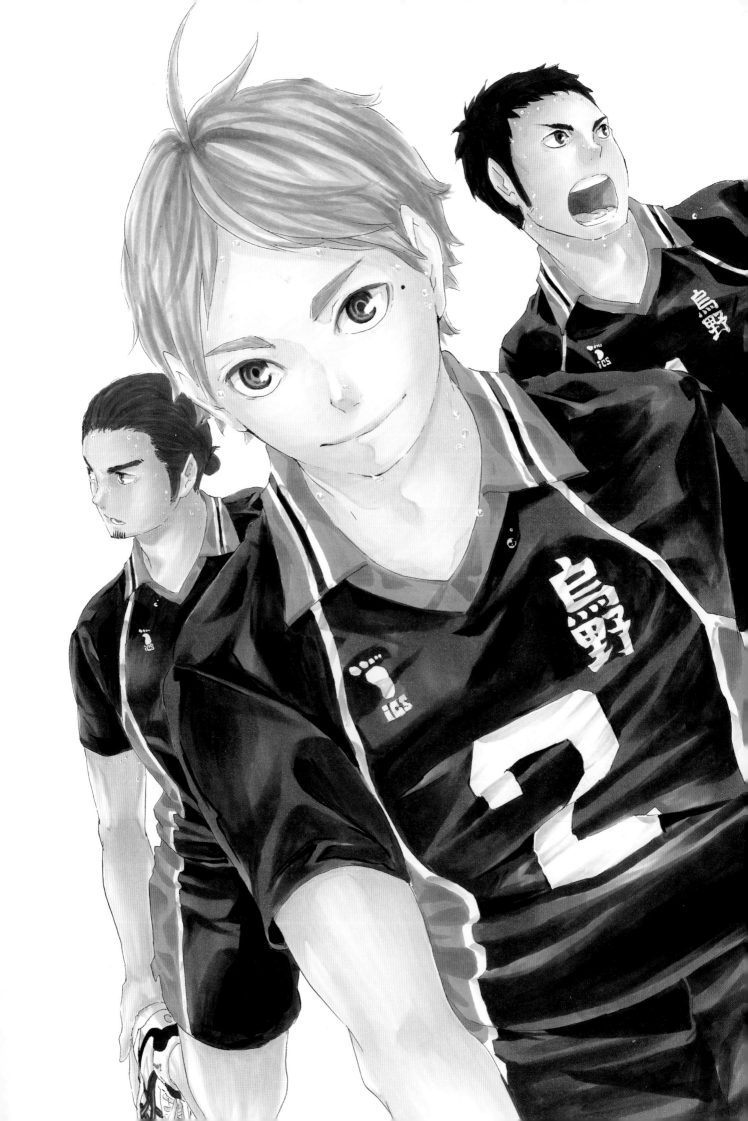

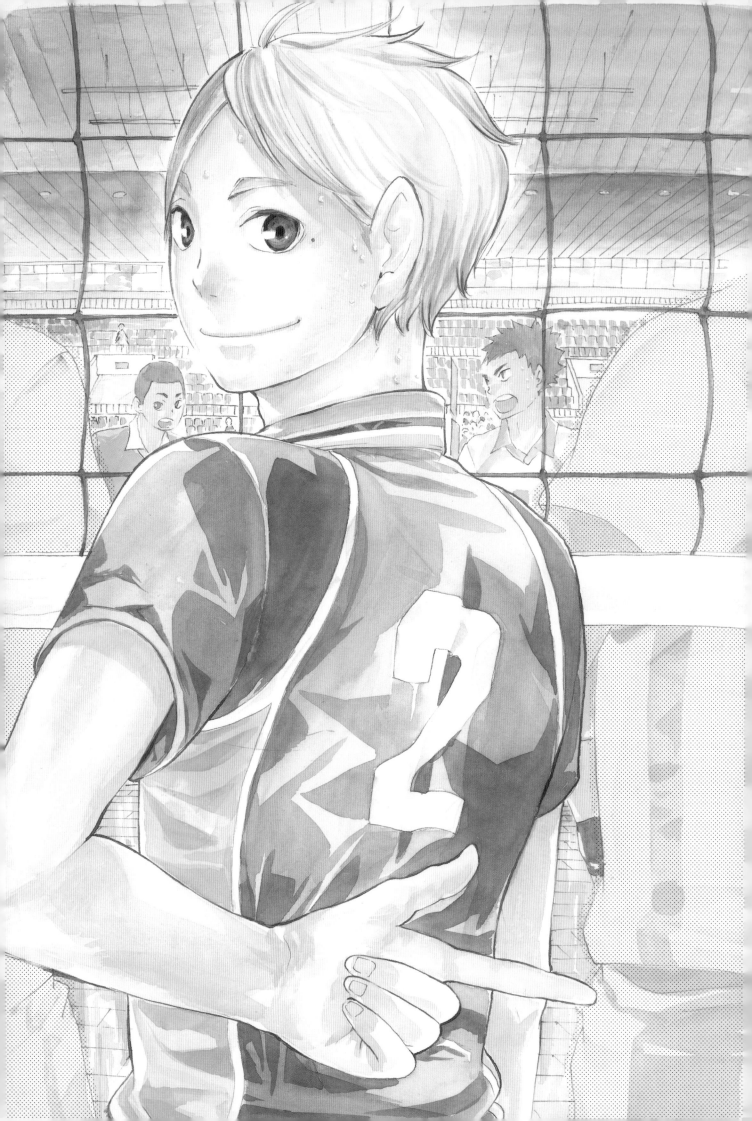

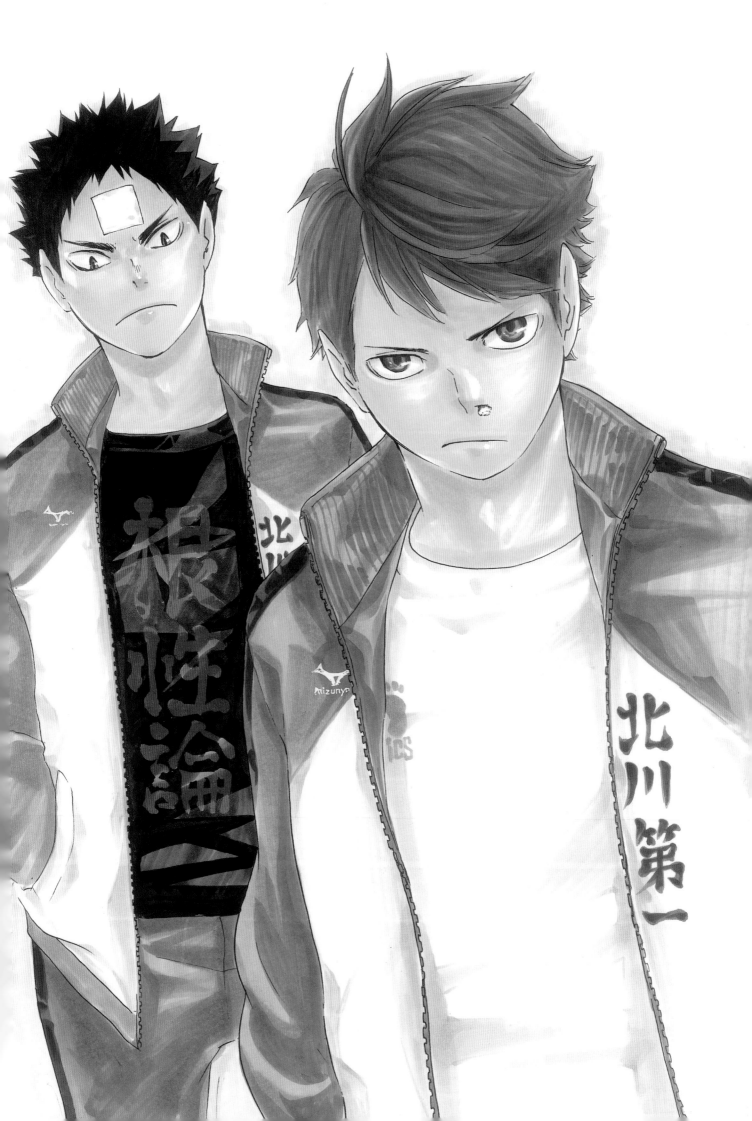

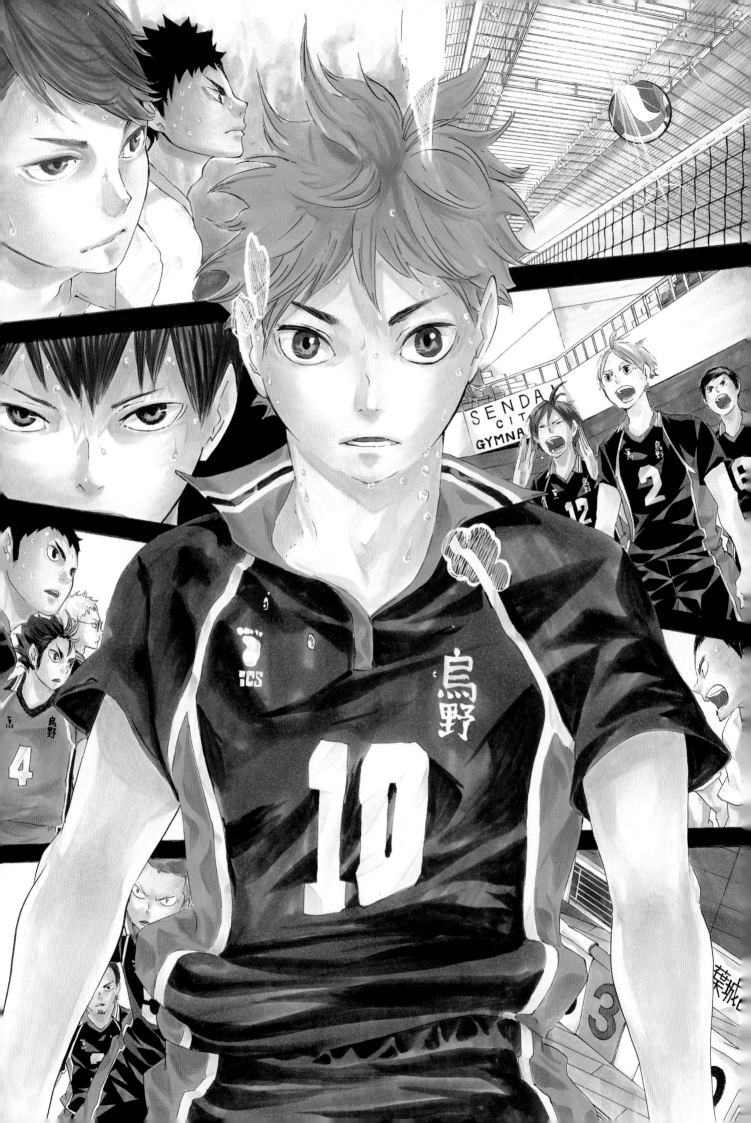

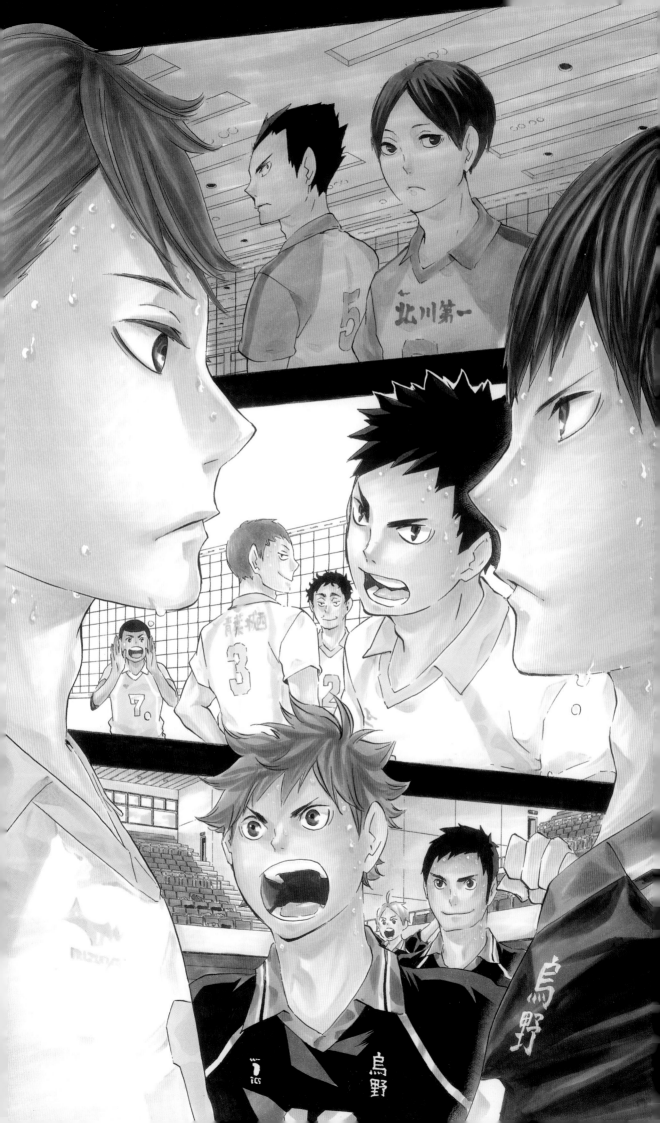

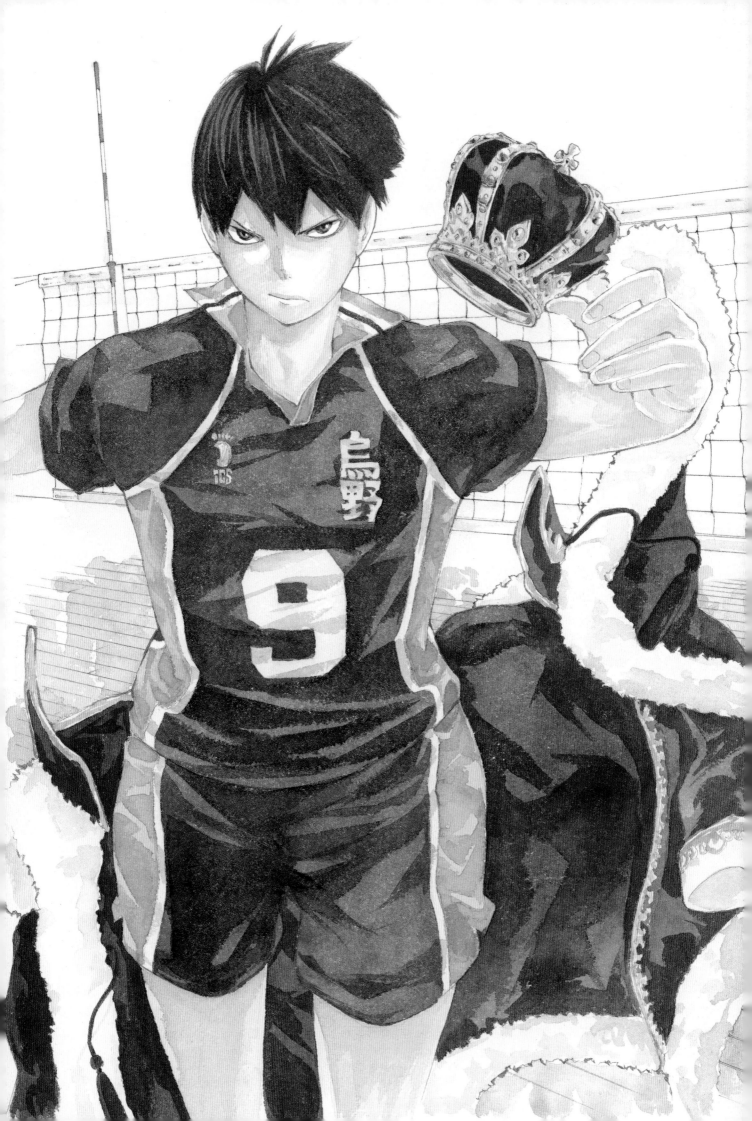

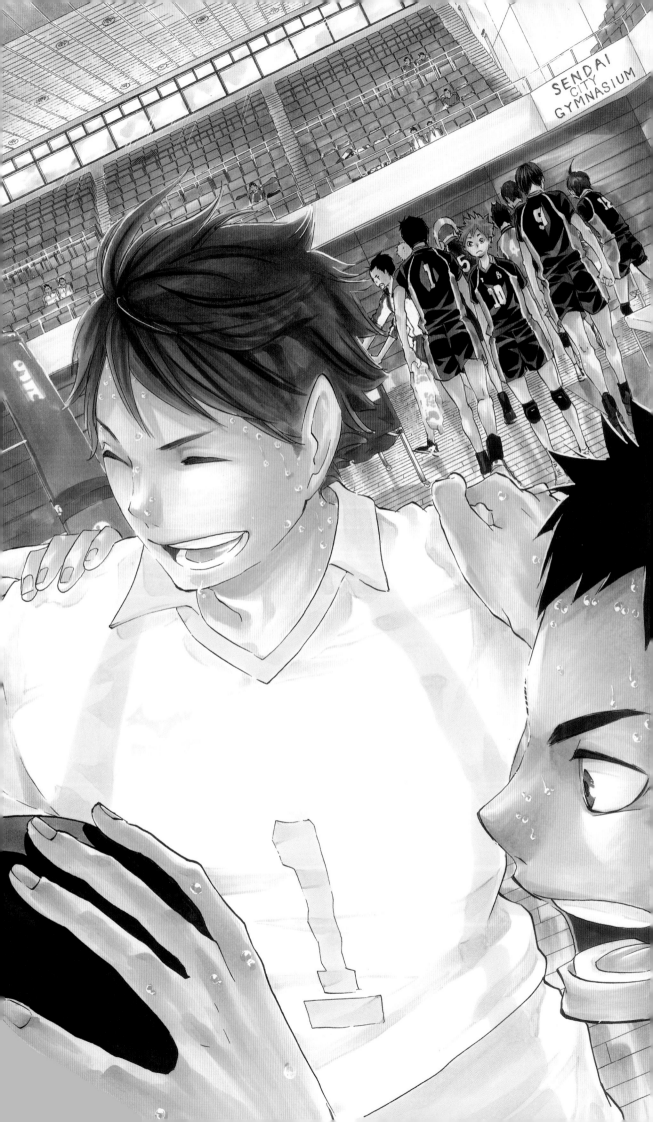

SENDAI
CITY
GYMNASIUM

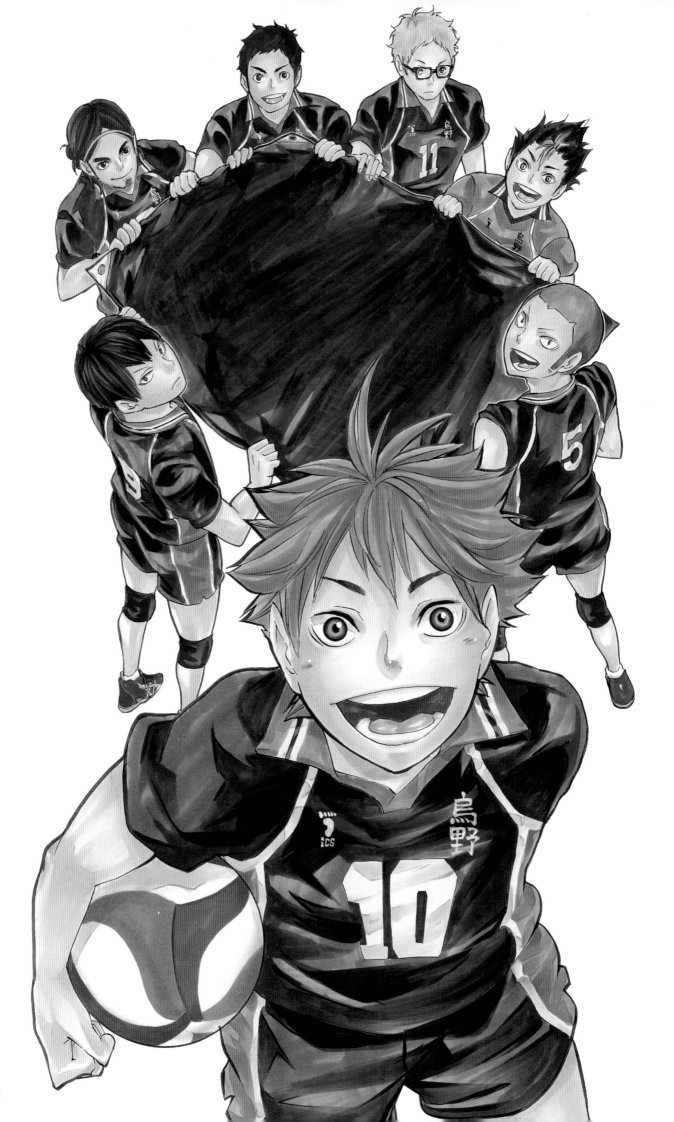

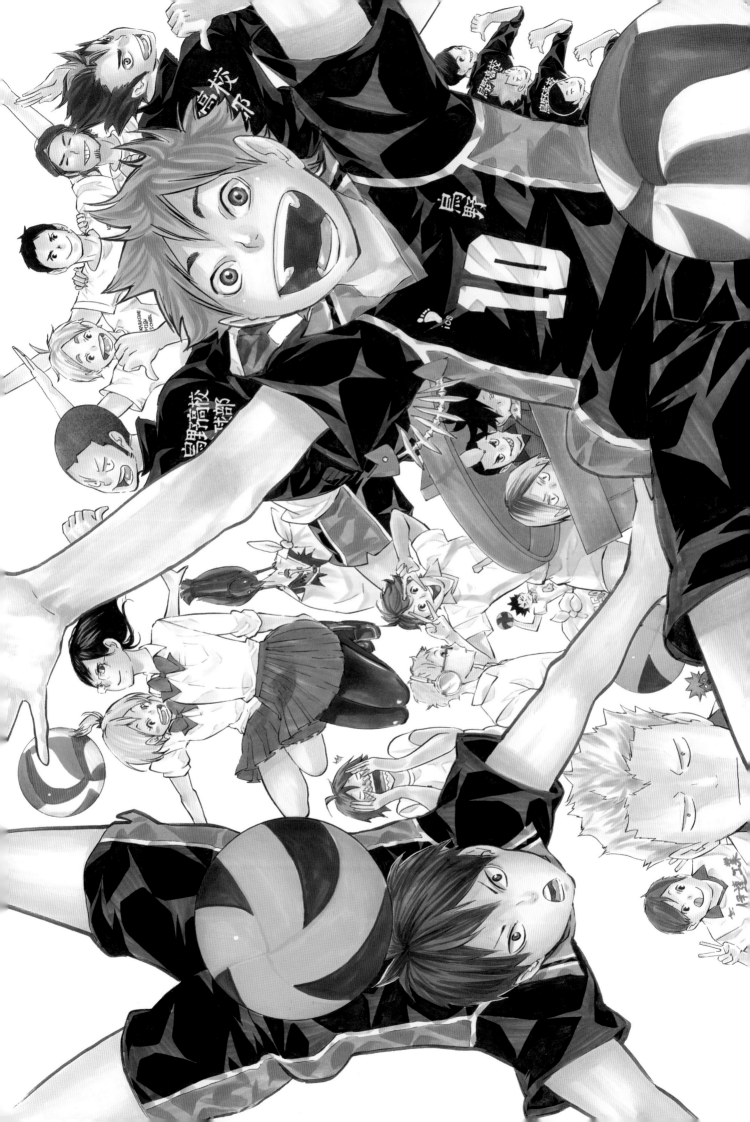

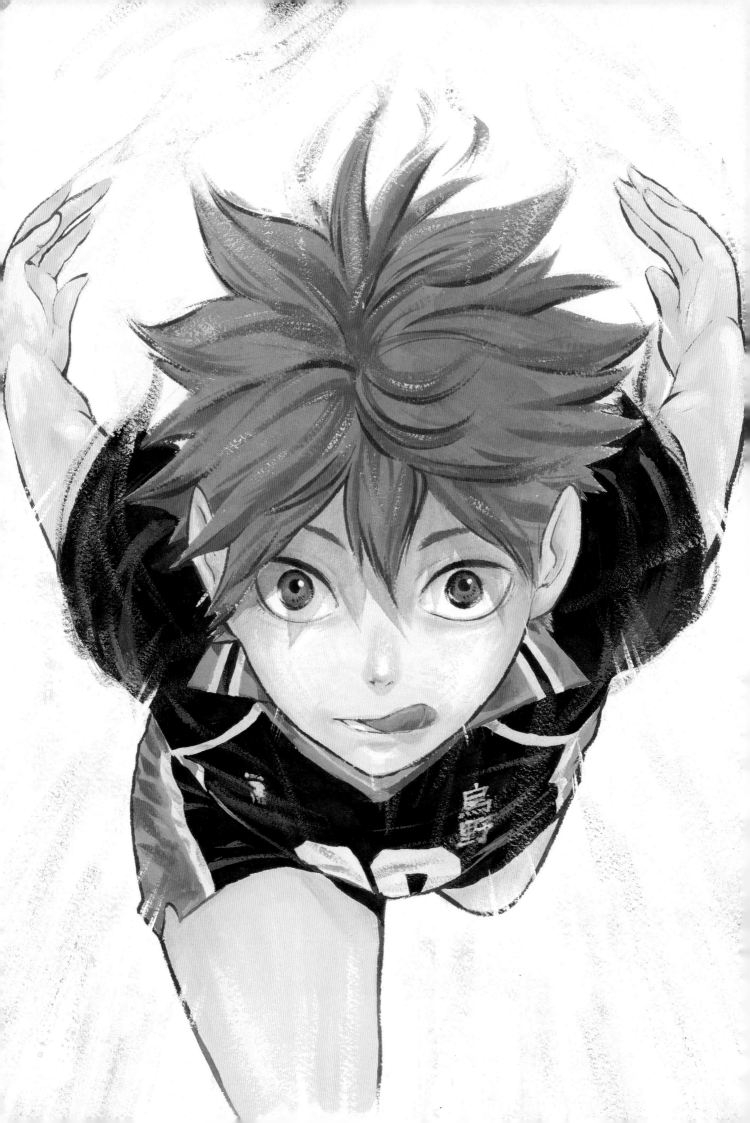

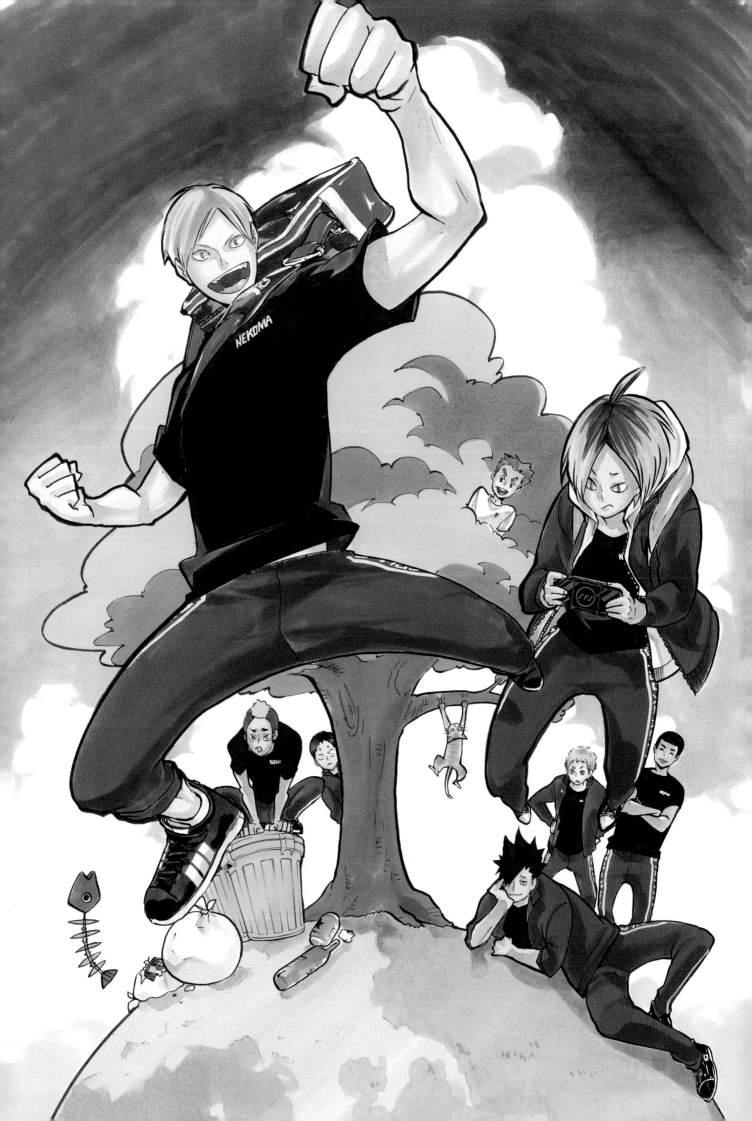

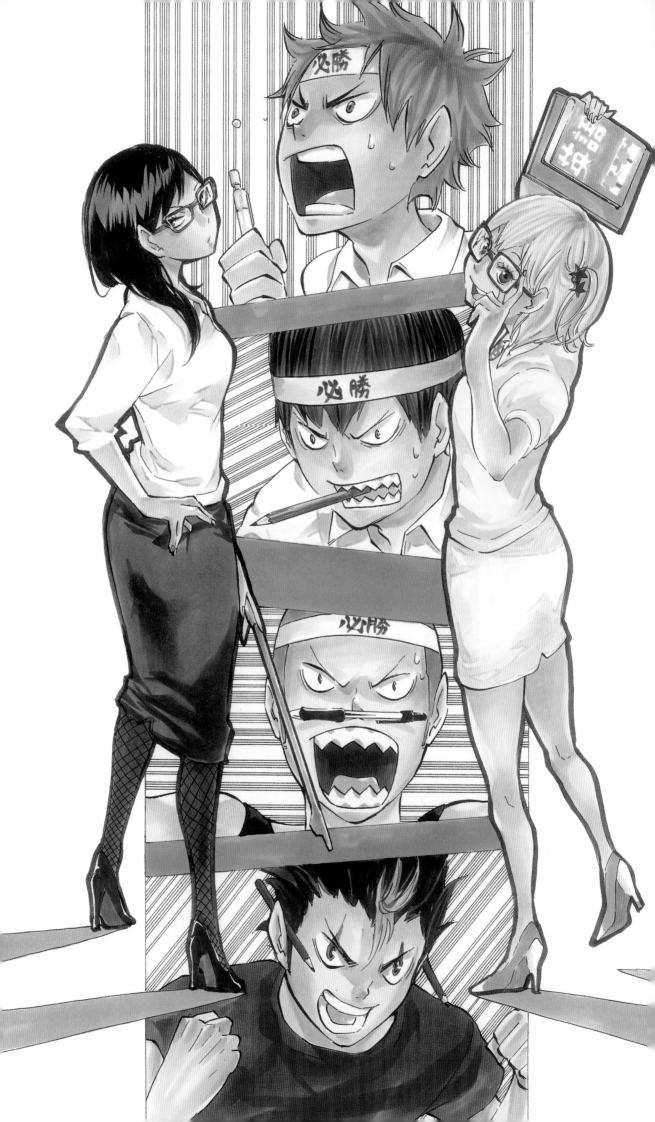

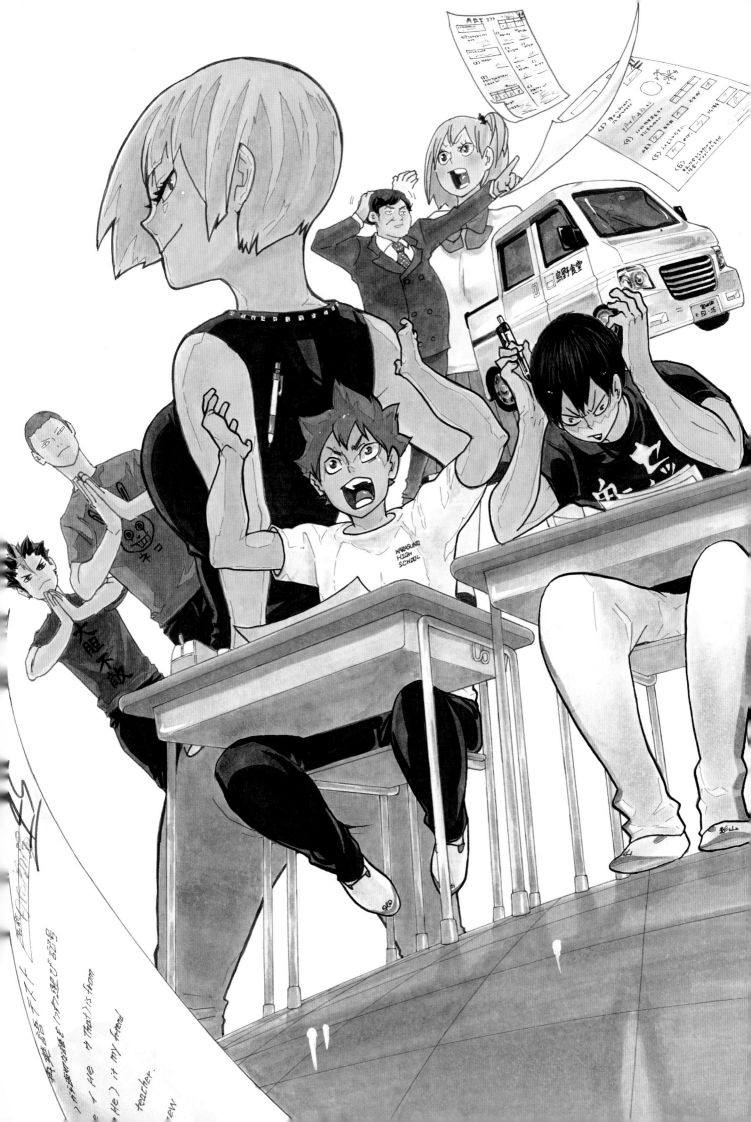

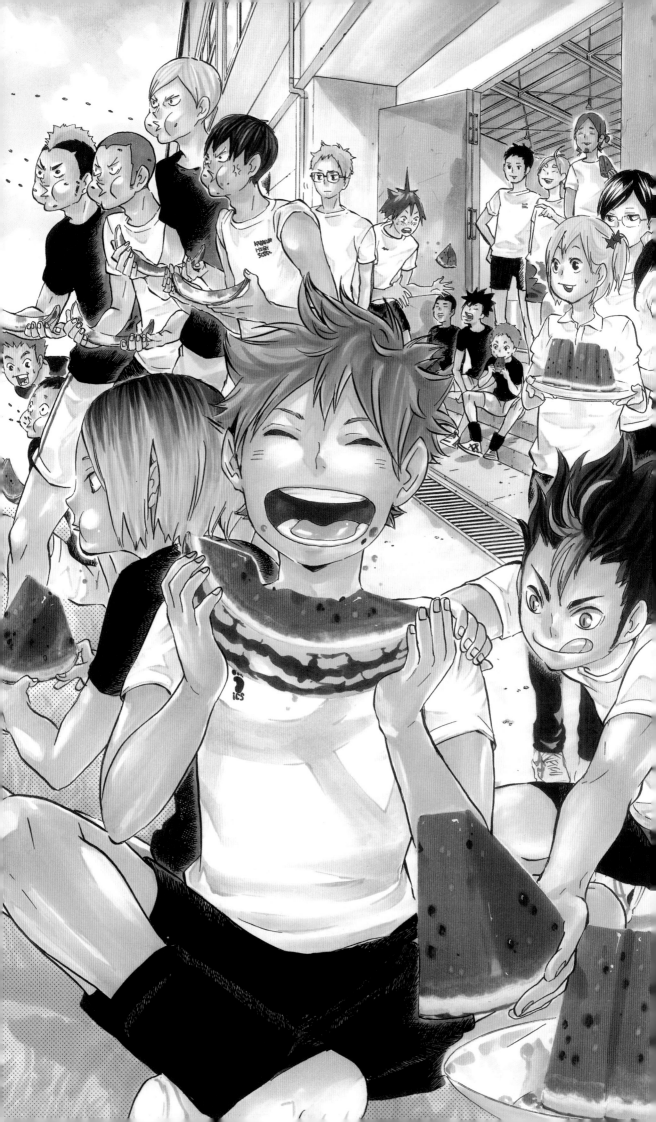

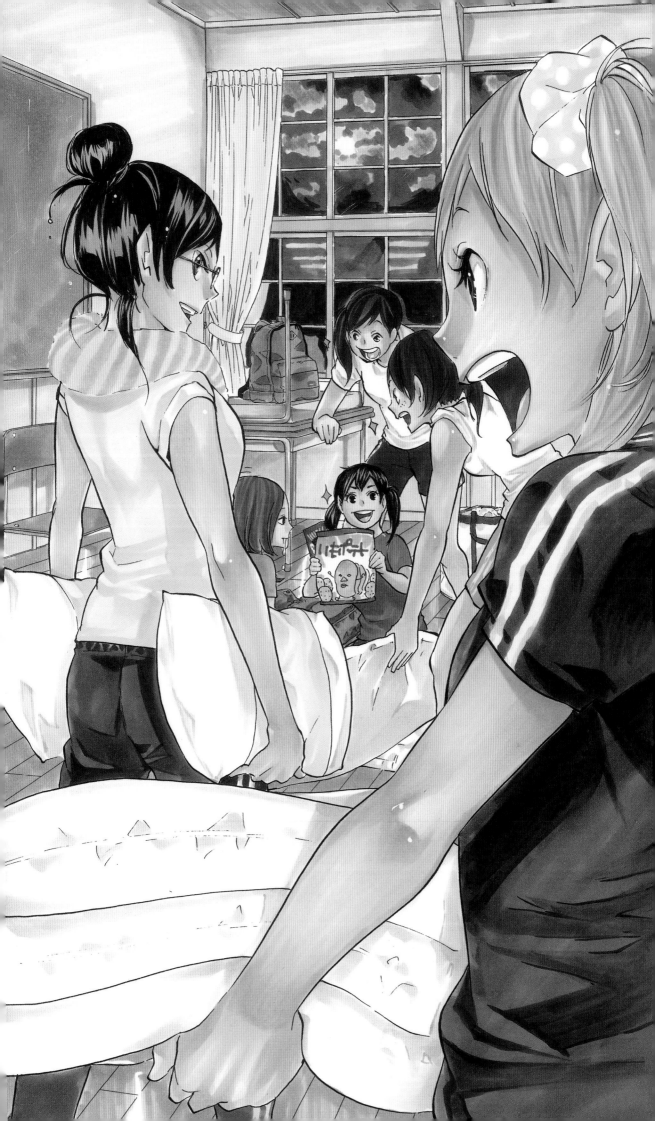

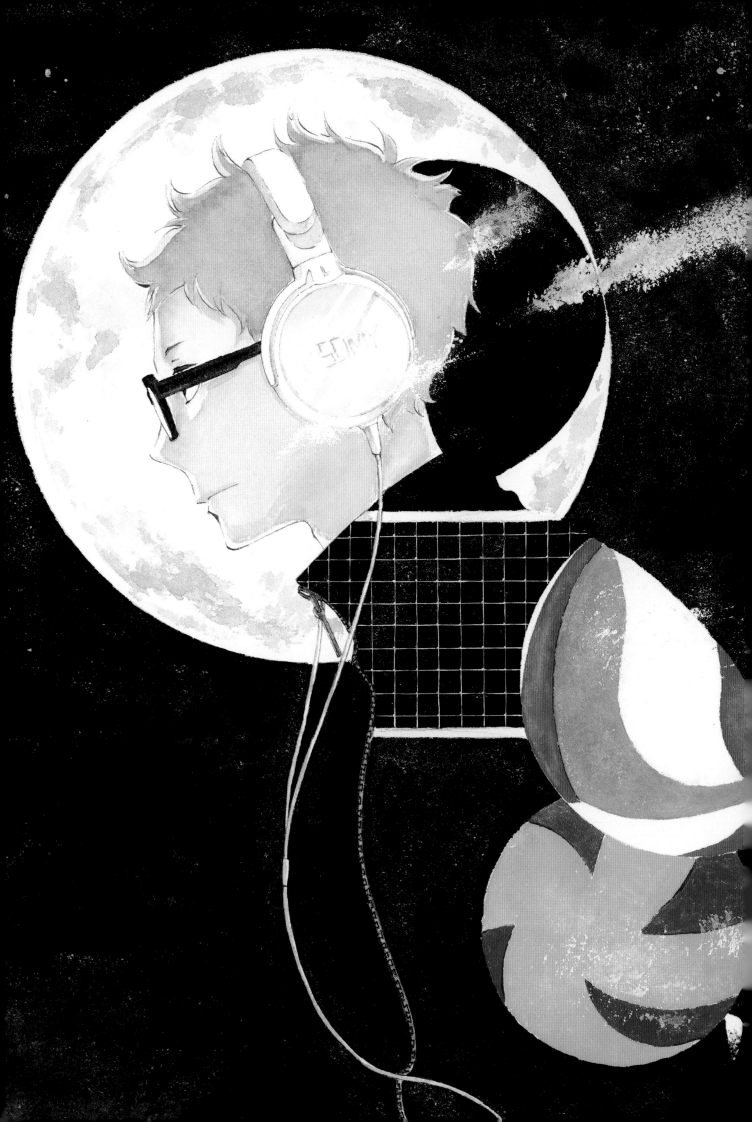

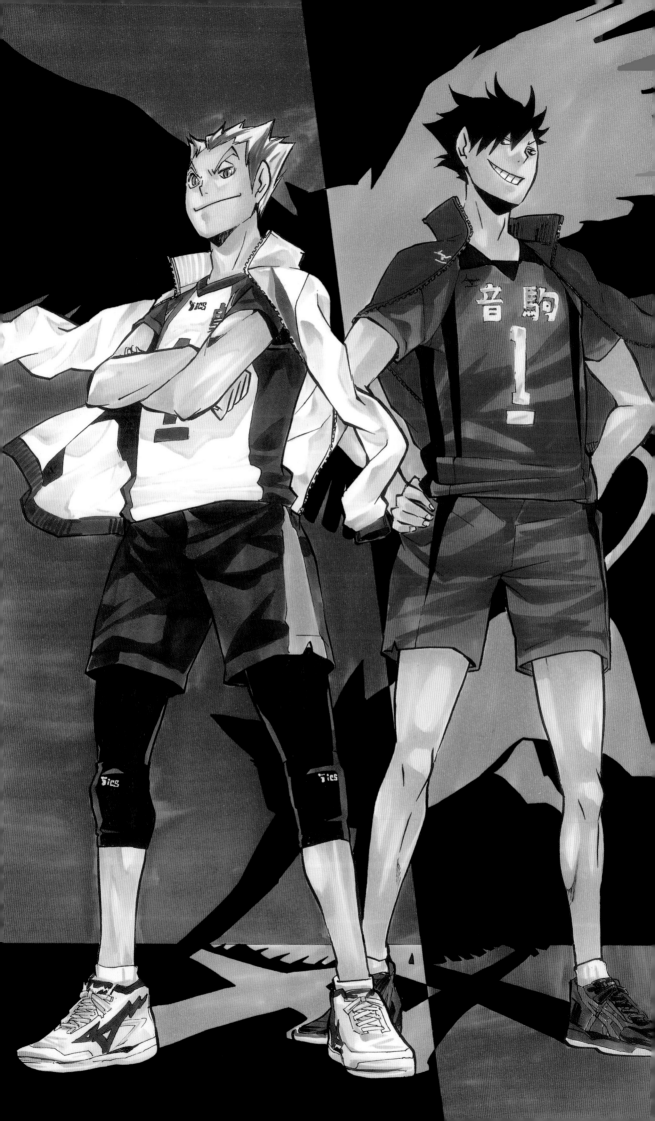

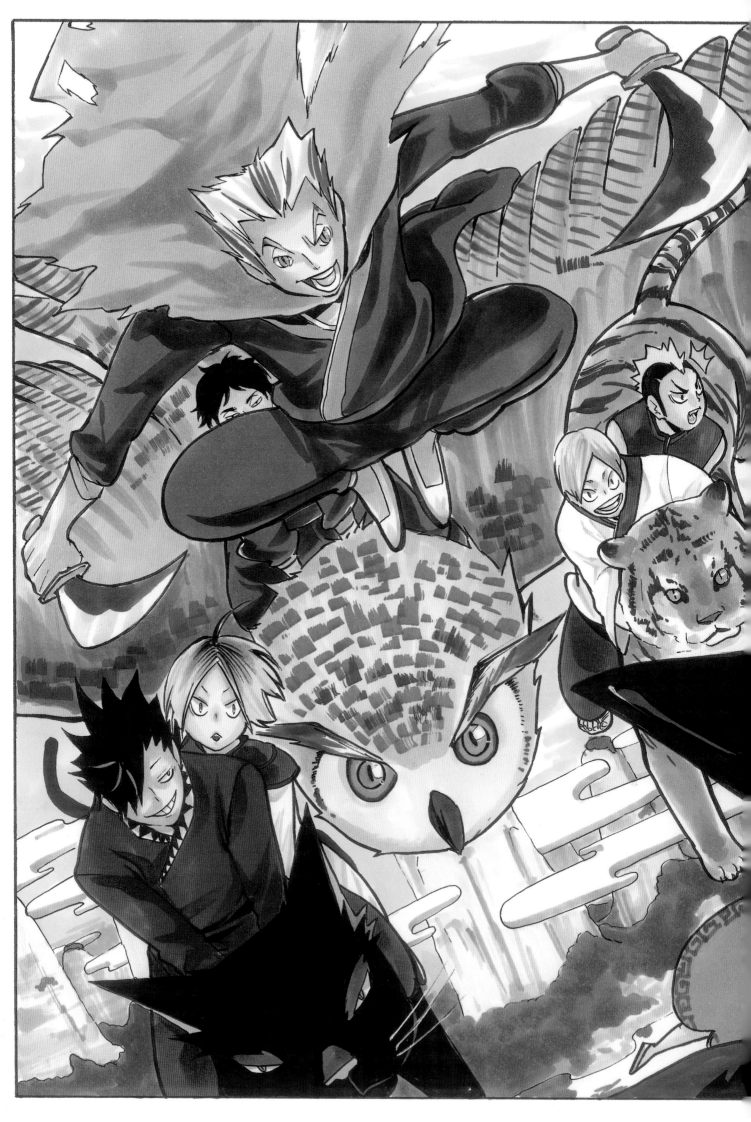

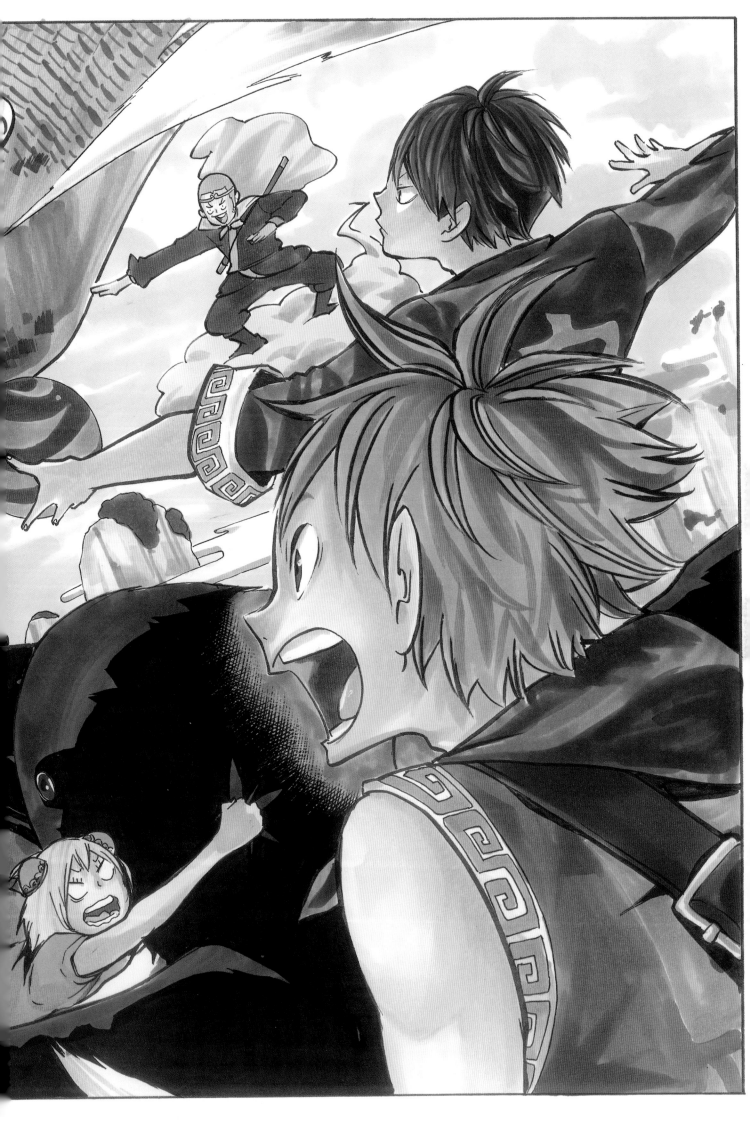

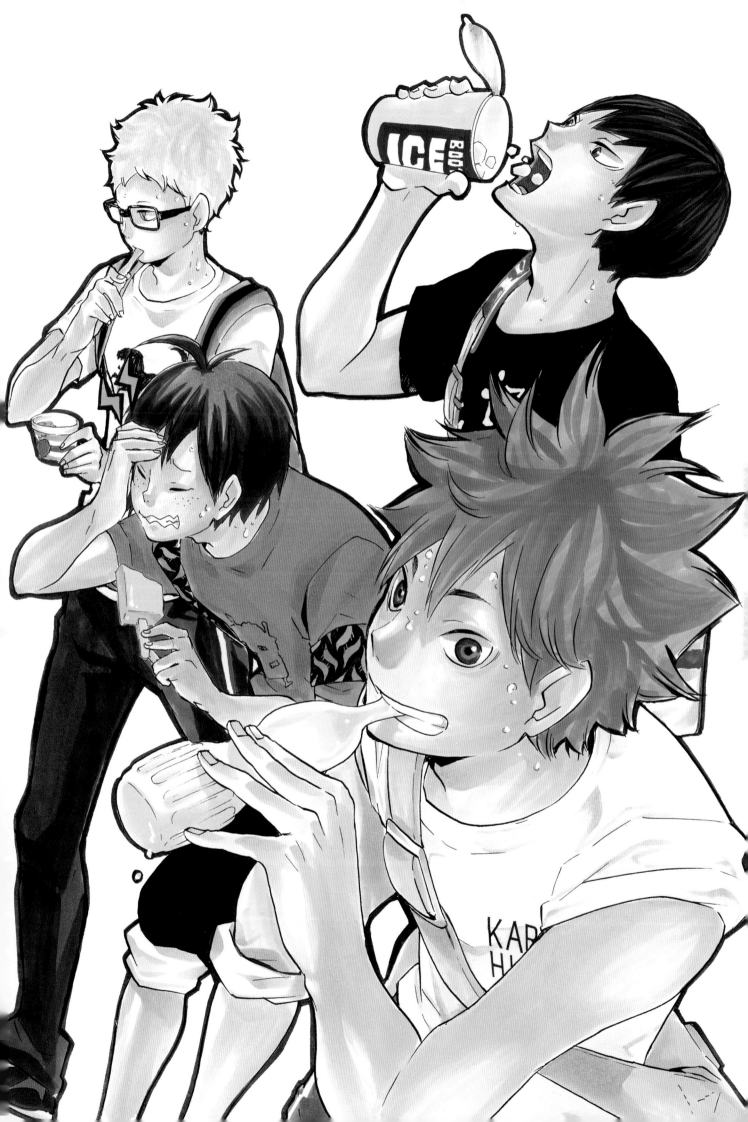

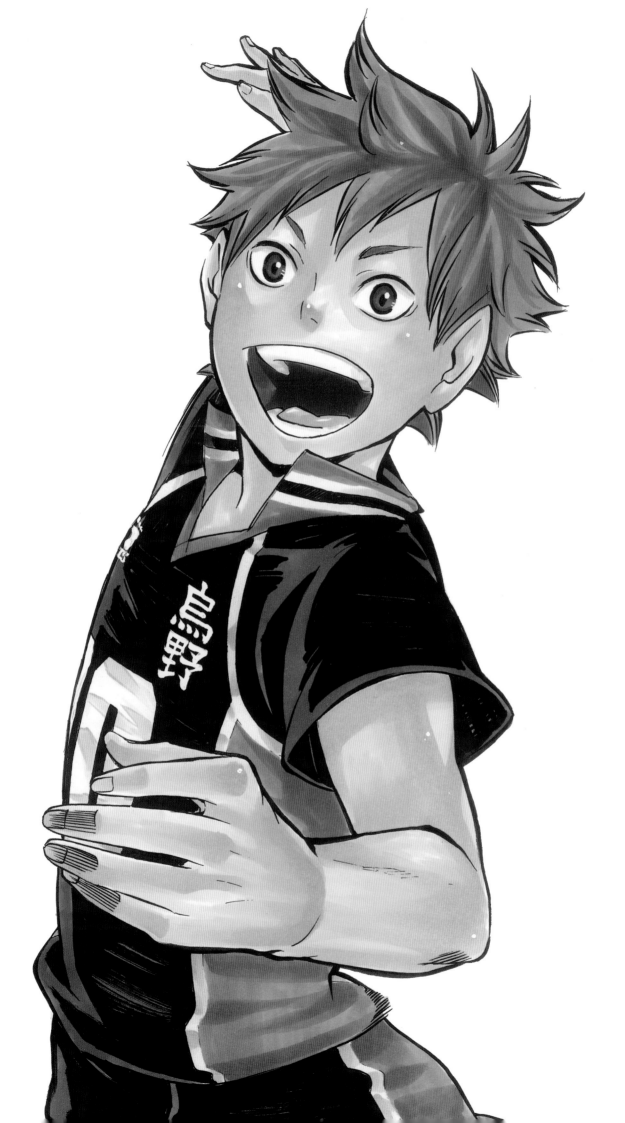

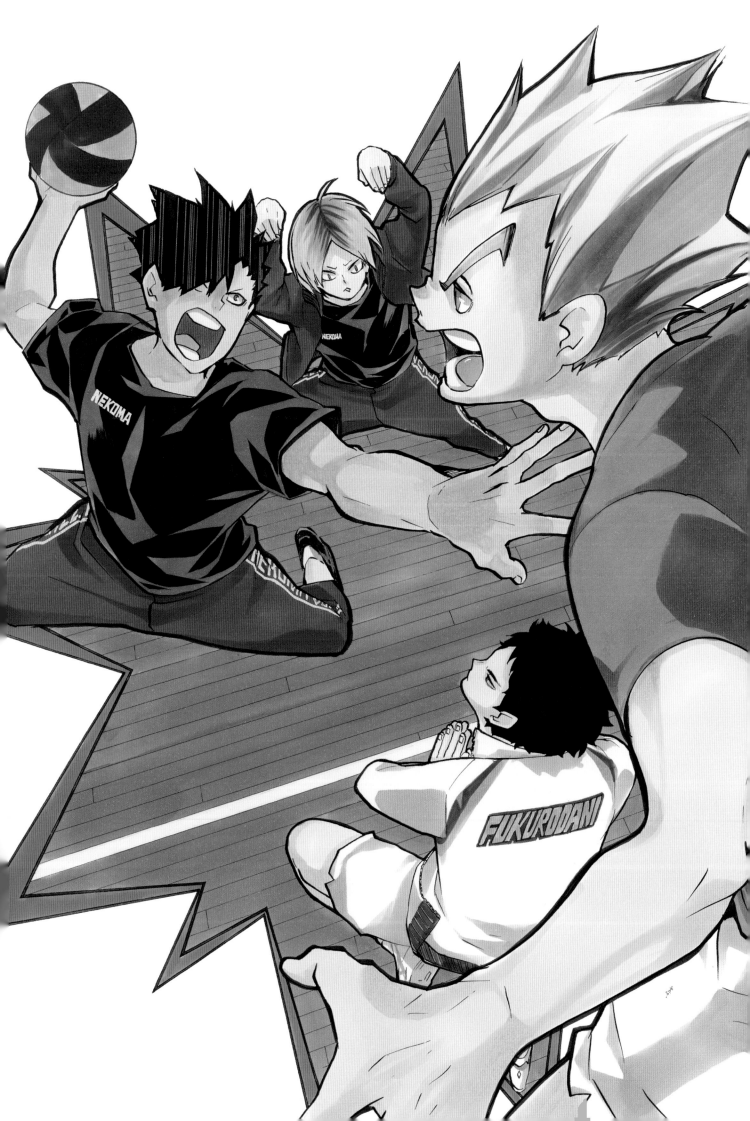

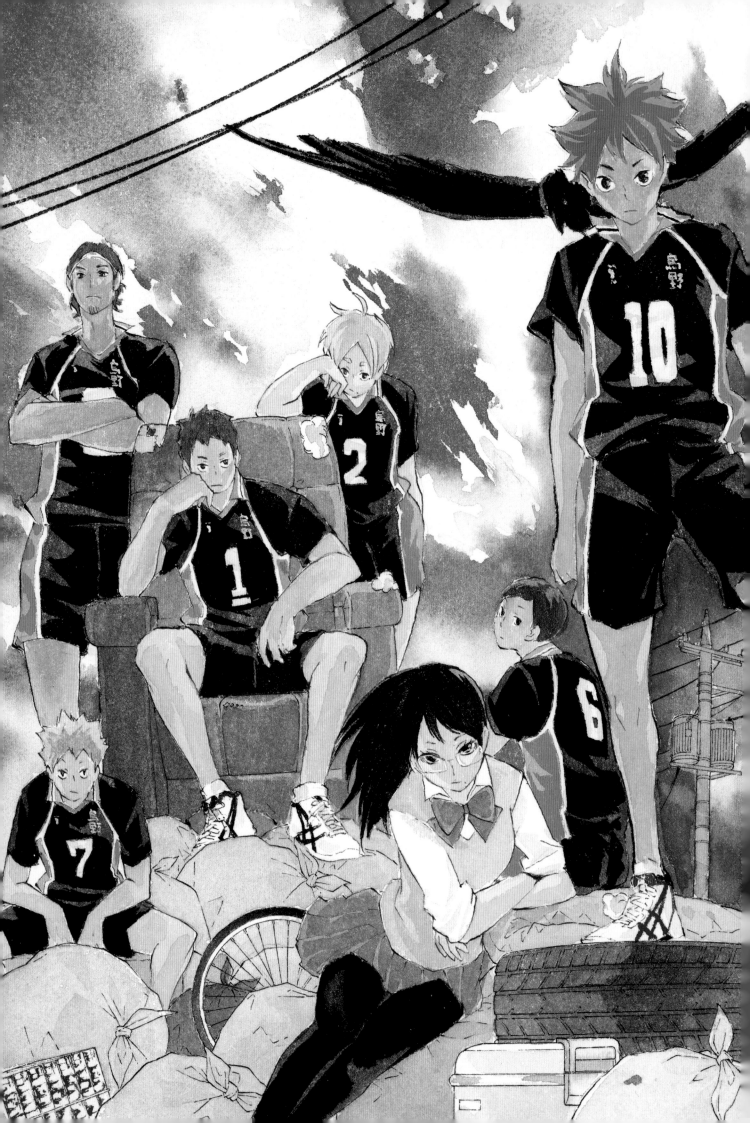

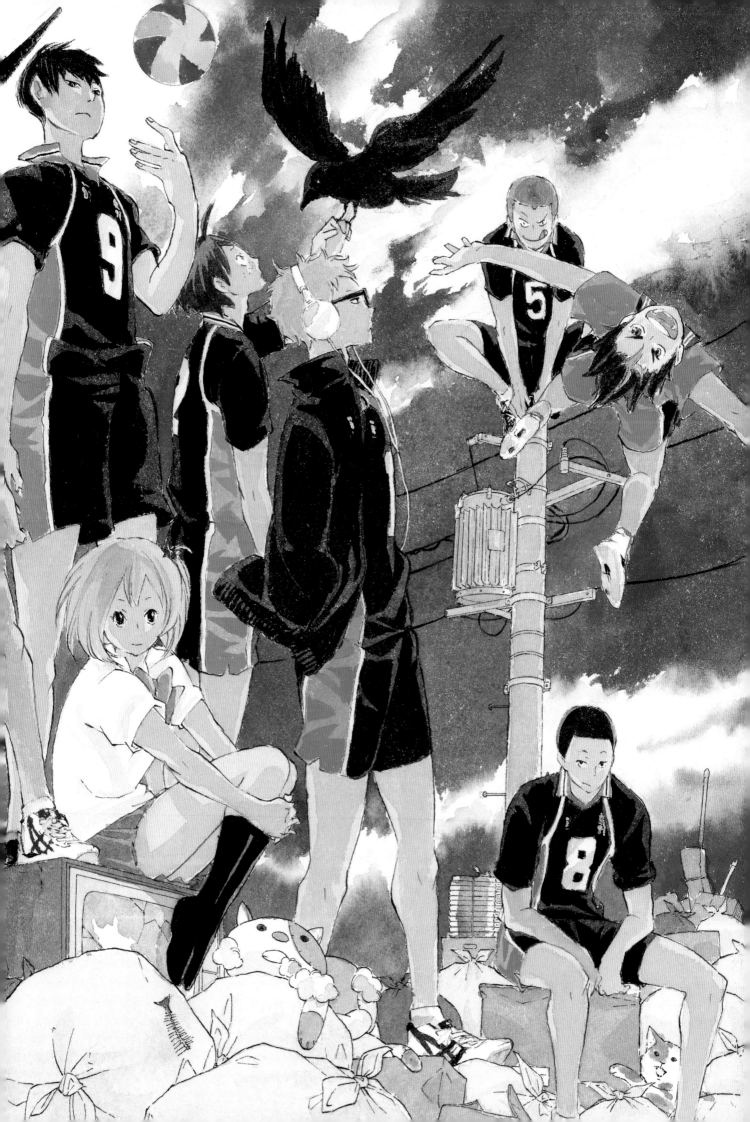

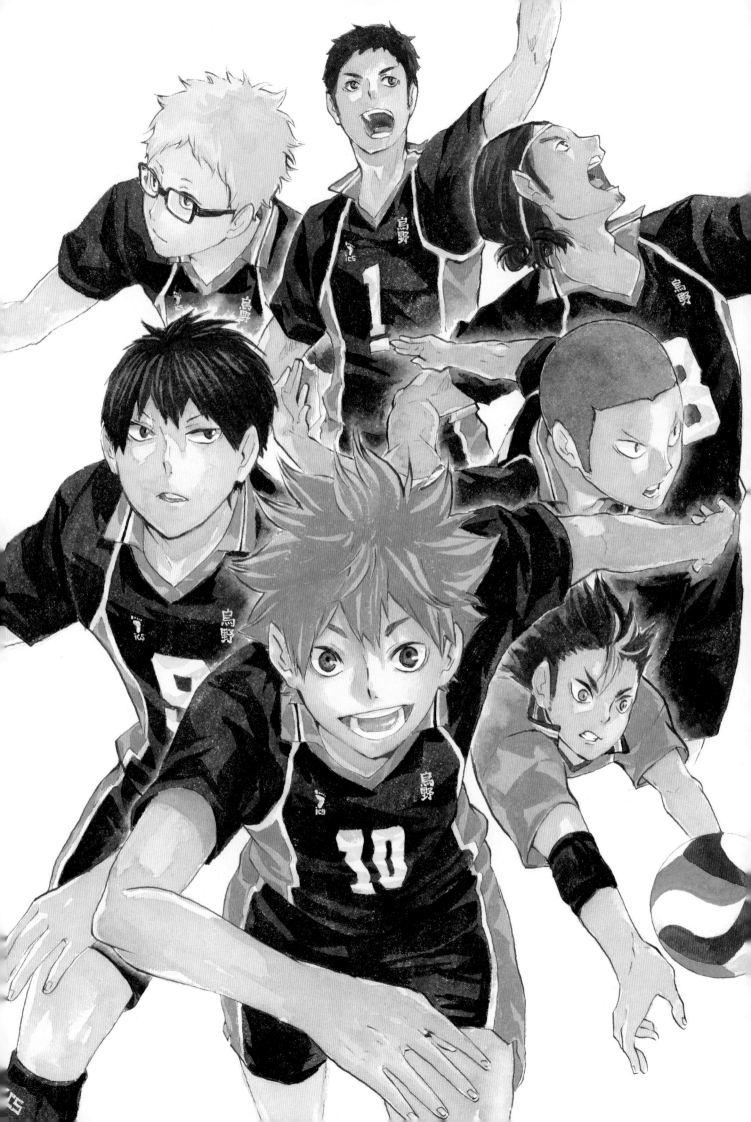

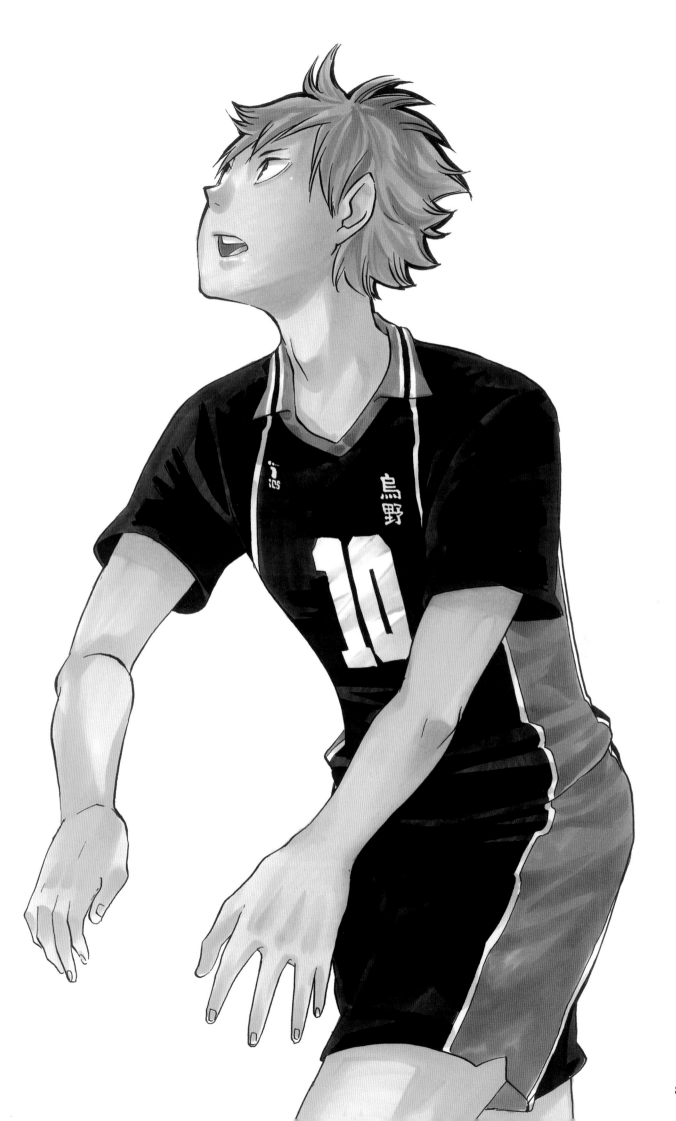

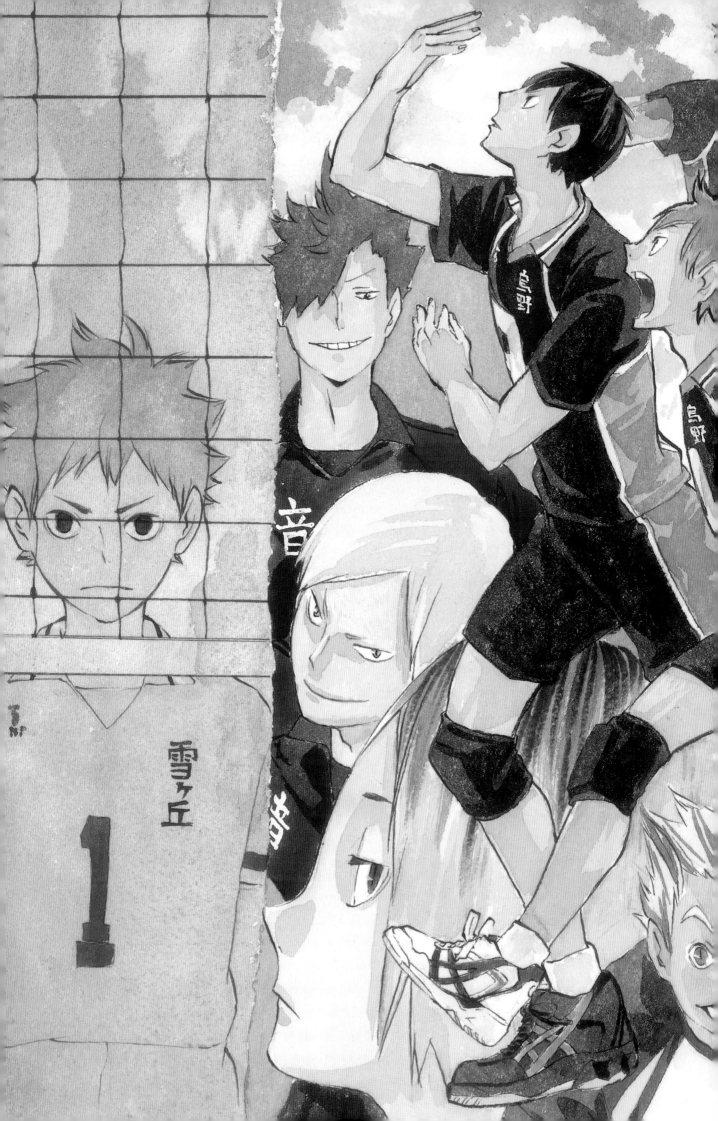

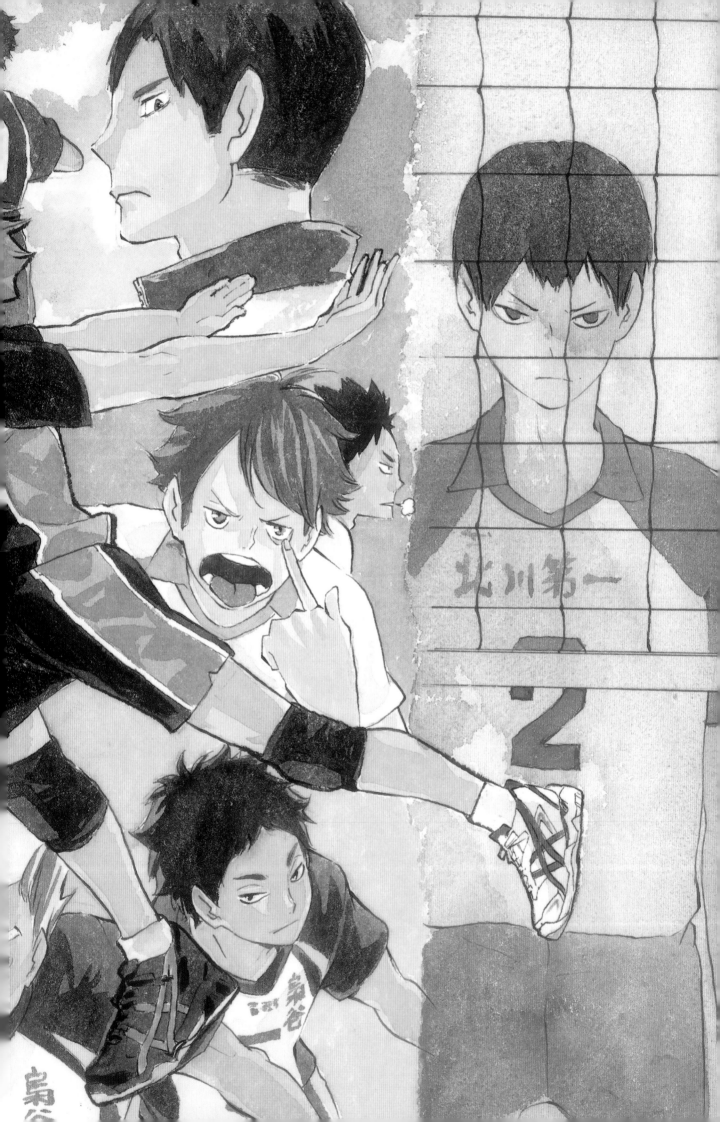

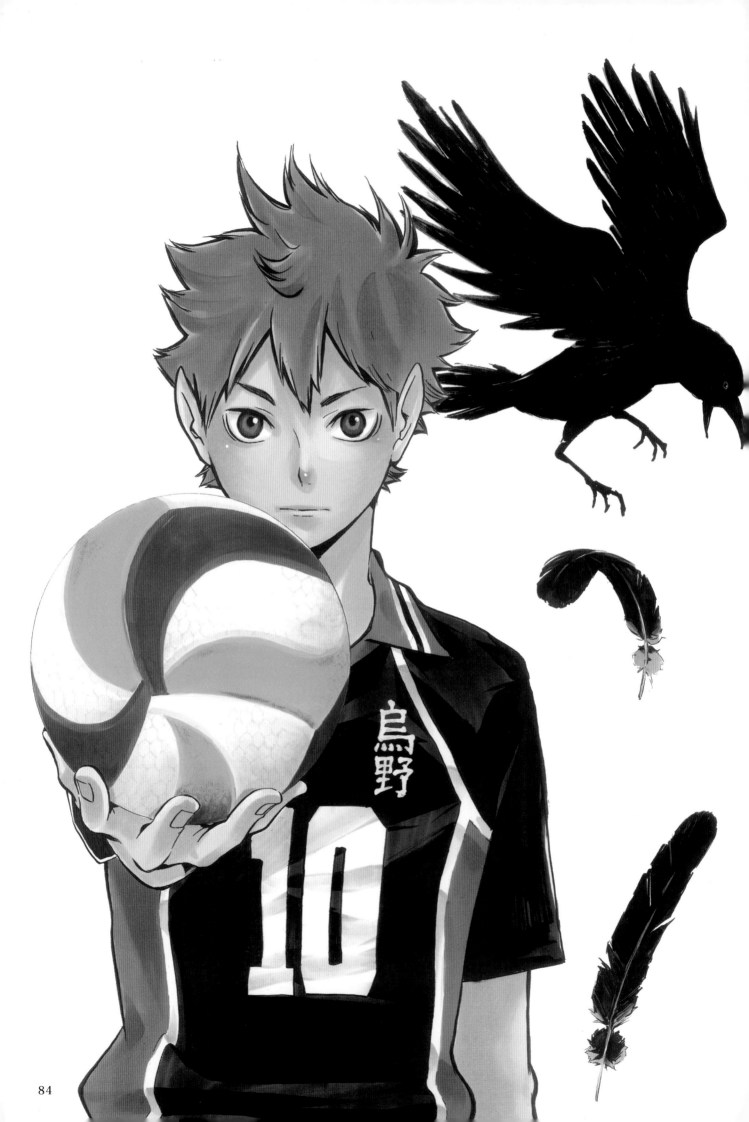

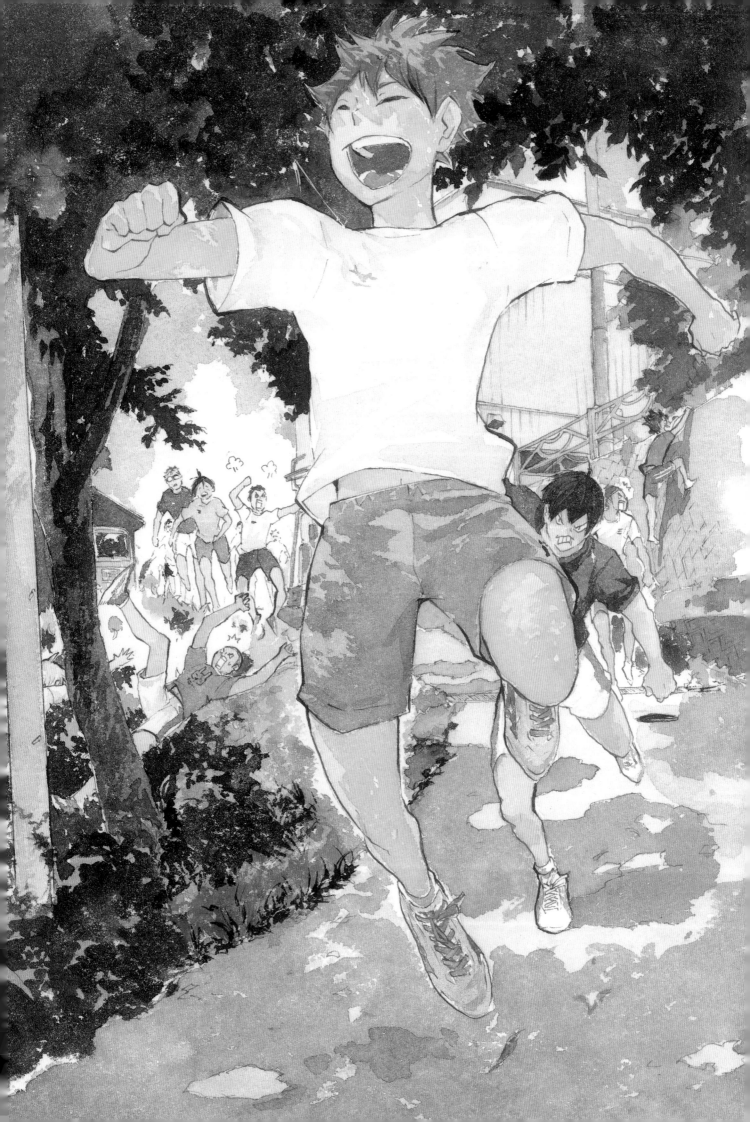

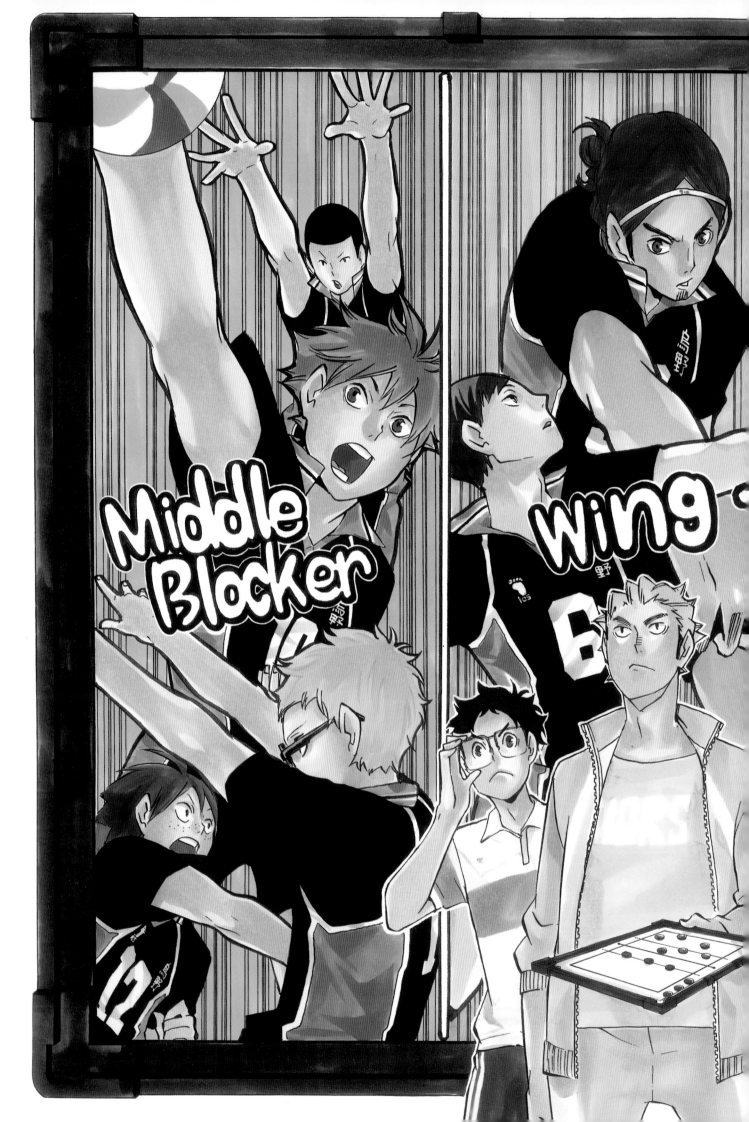

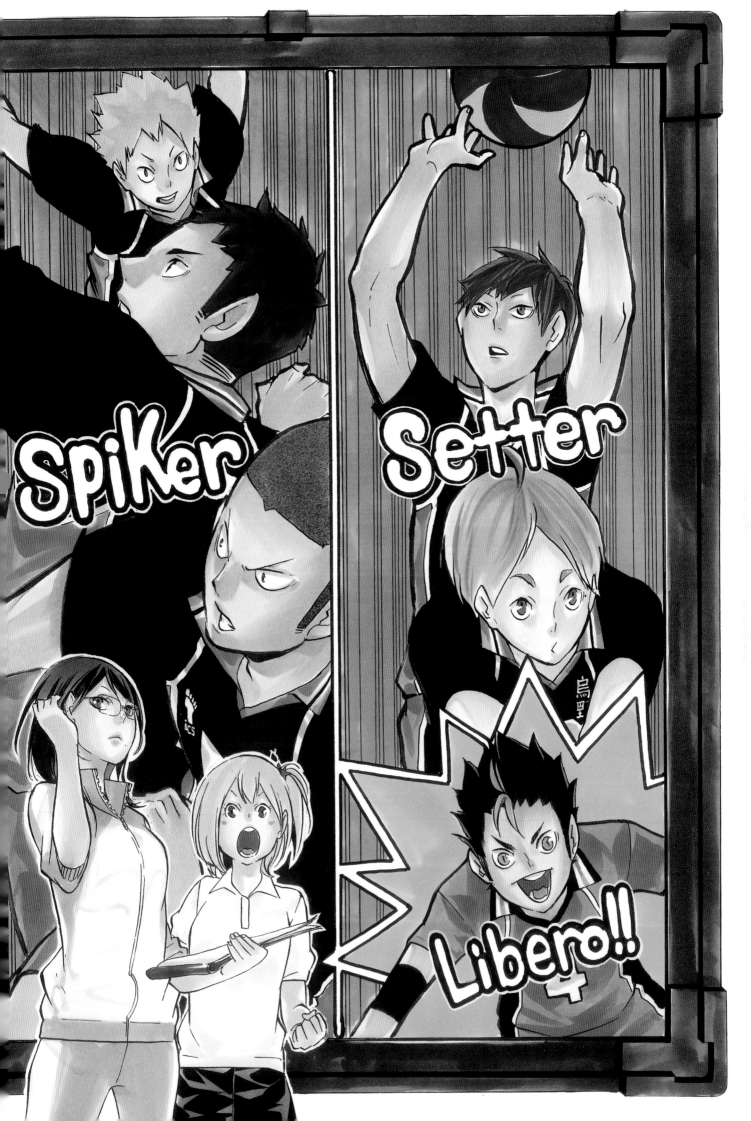

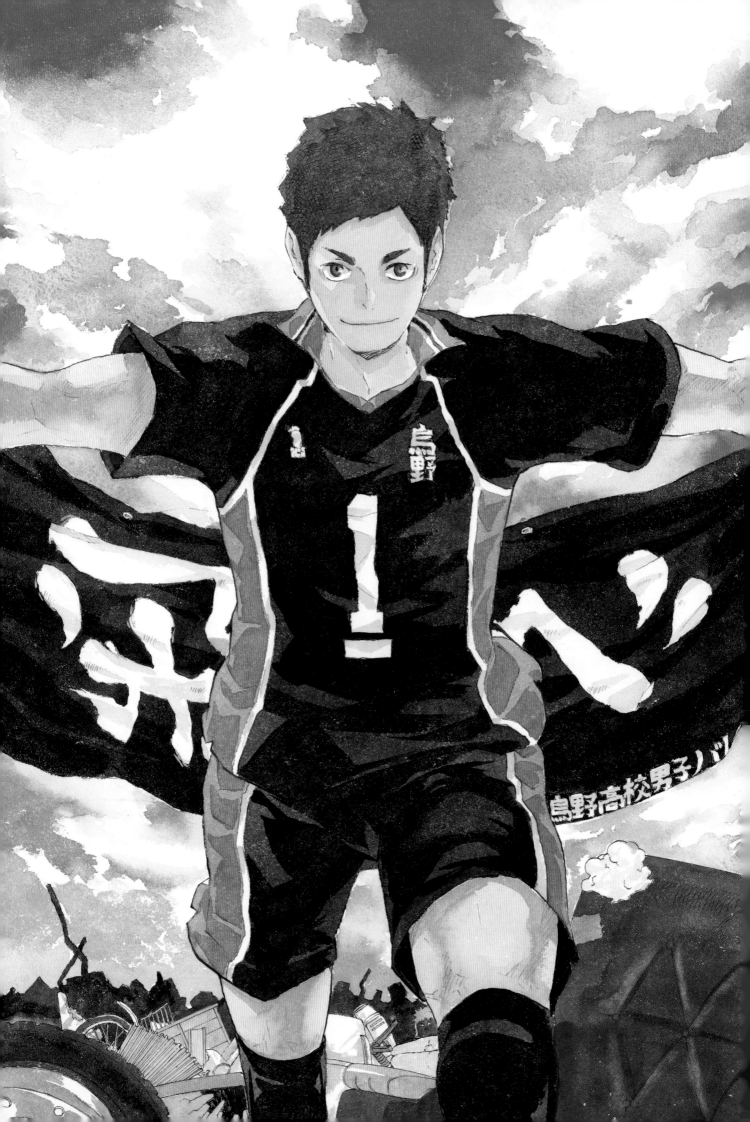

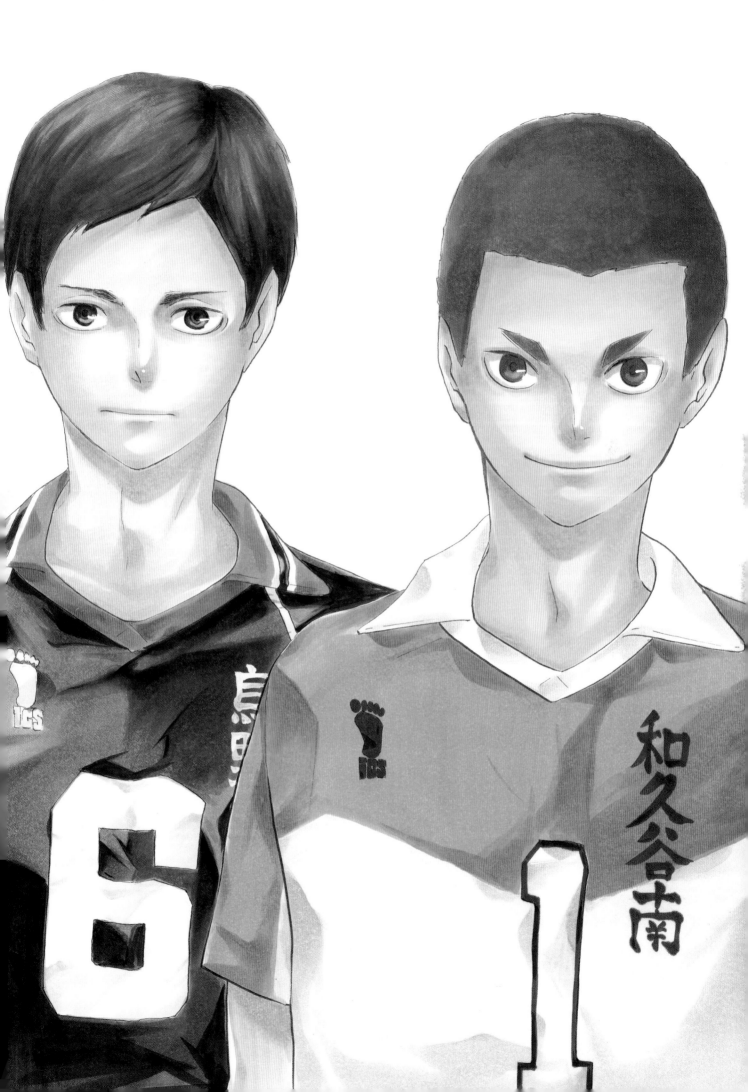

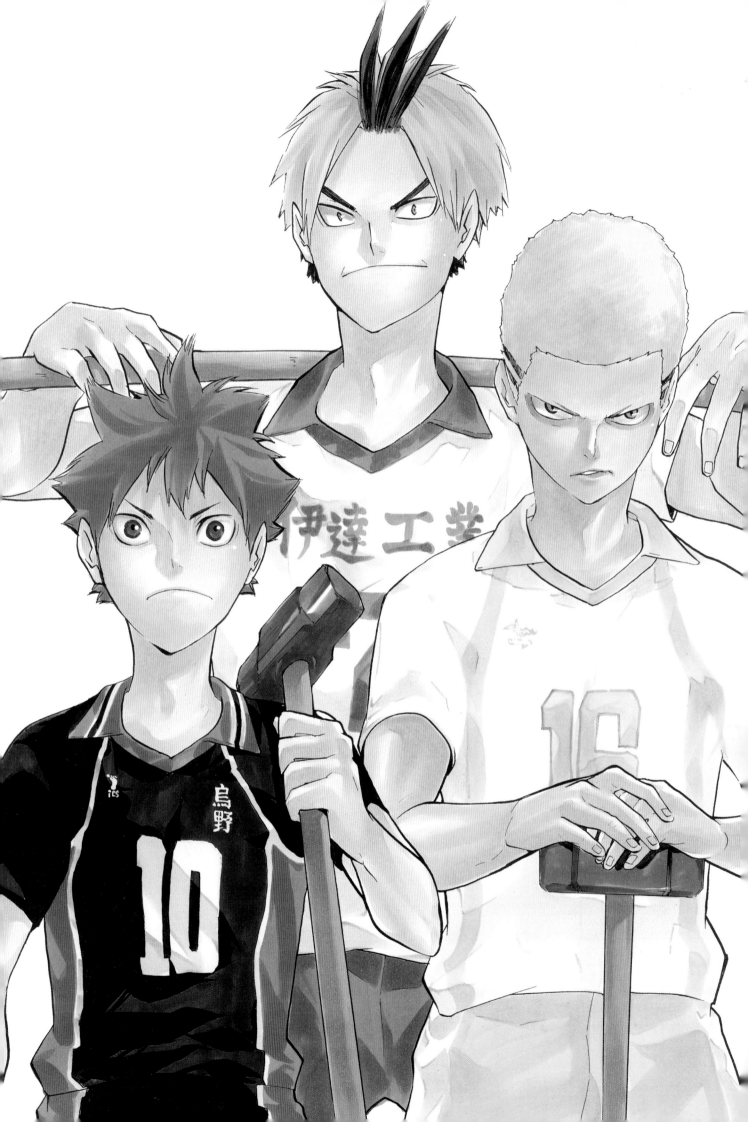

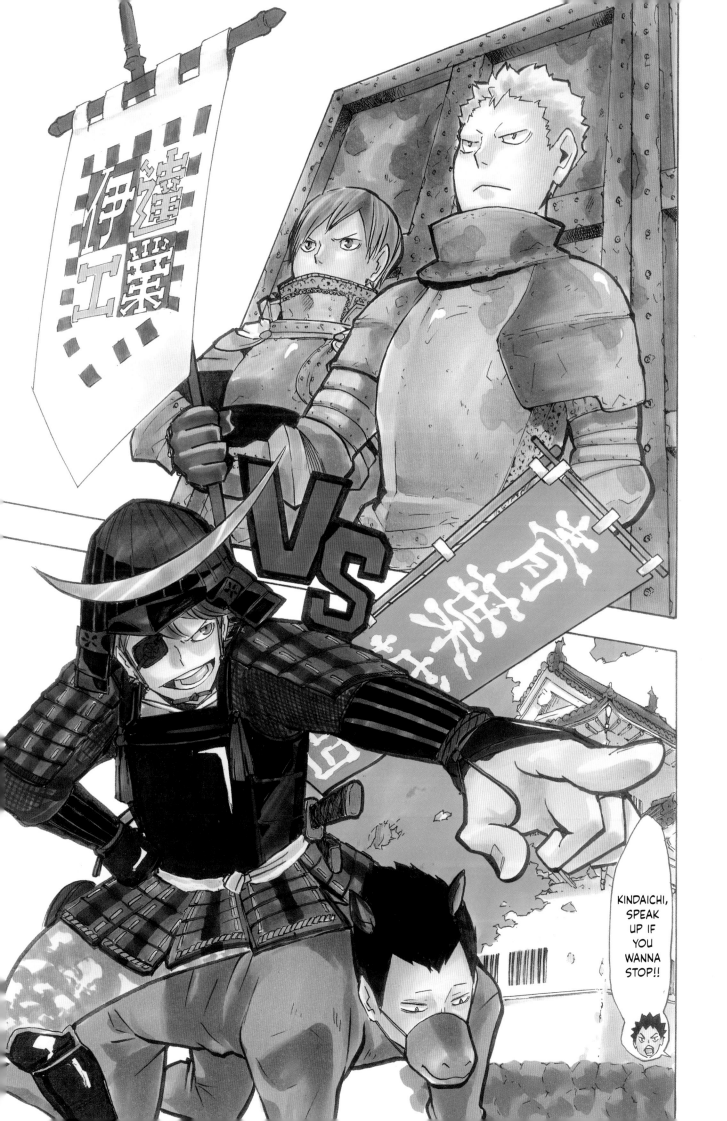

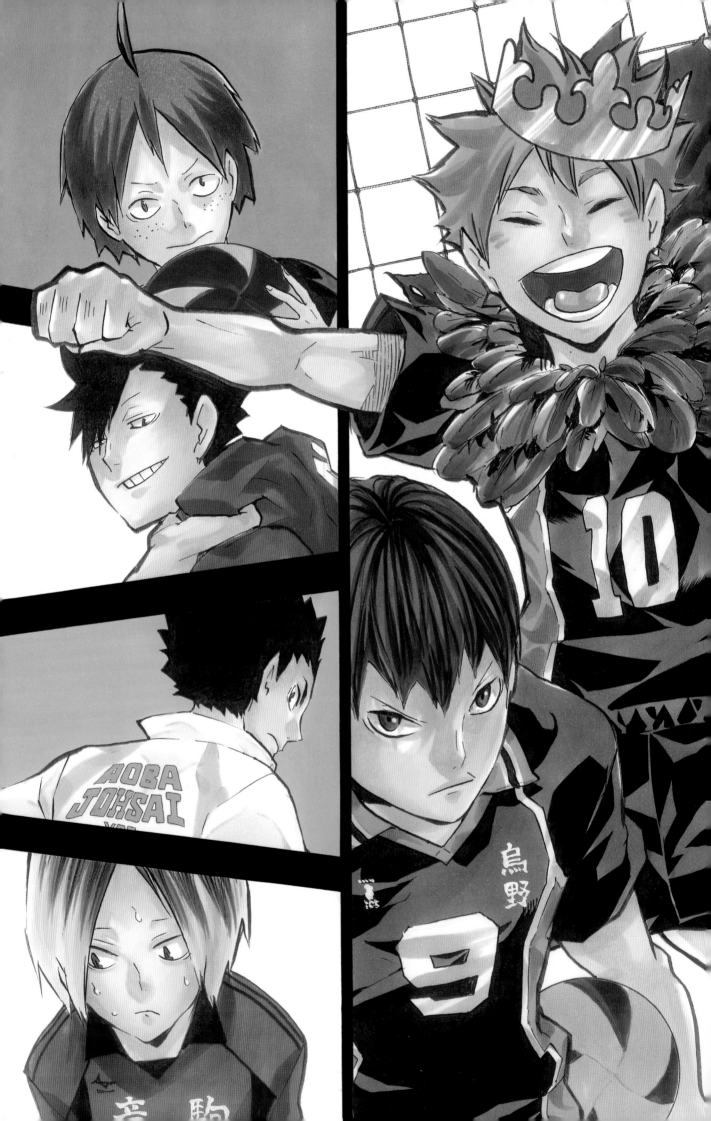

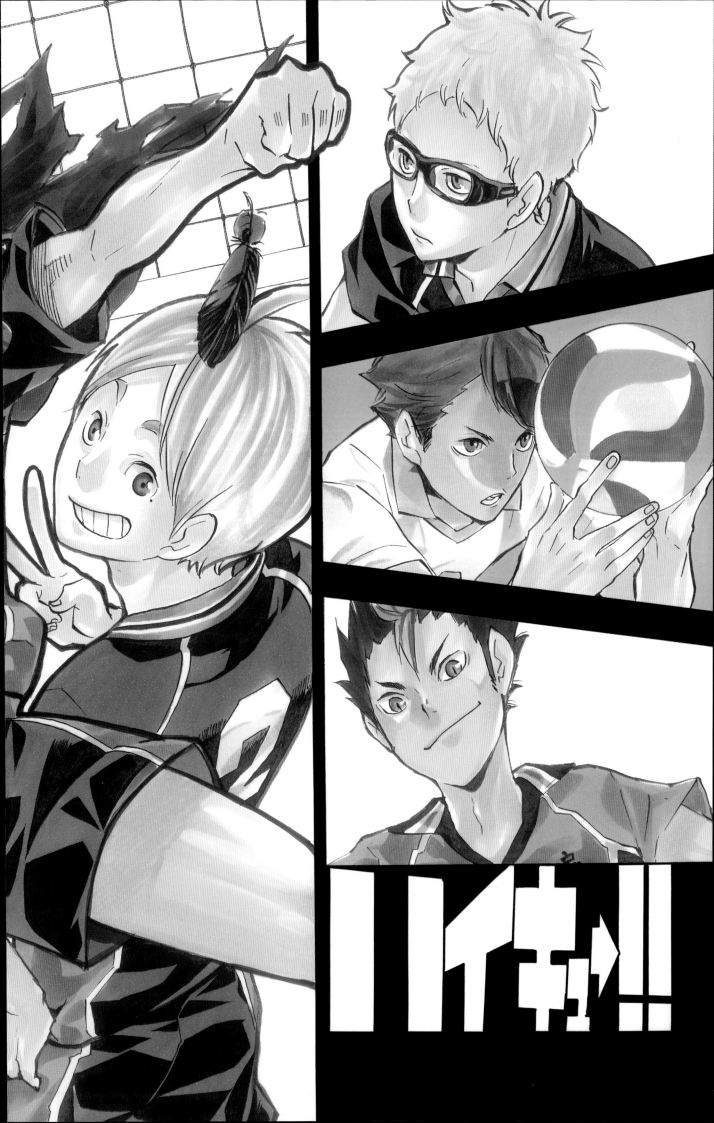

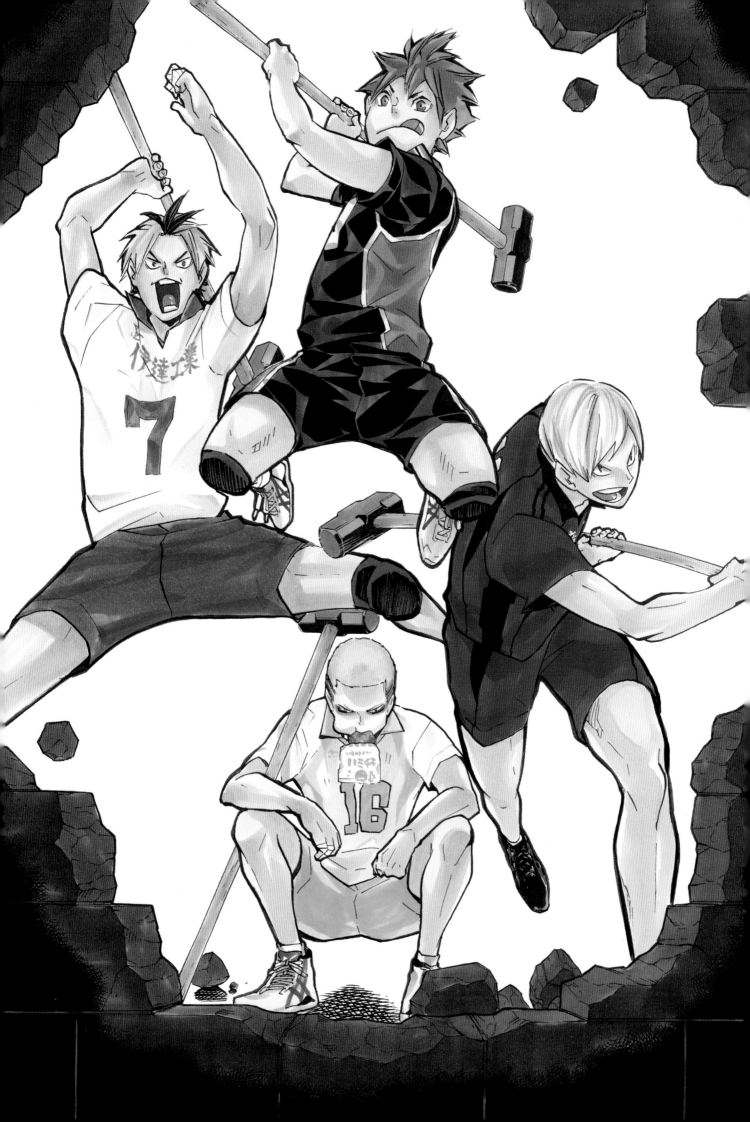

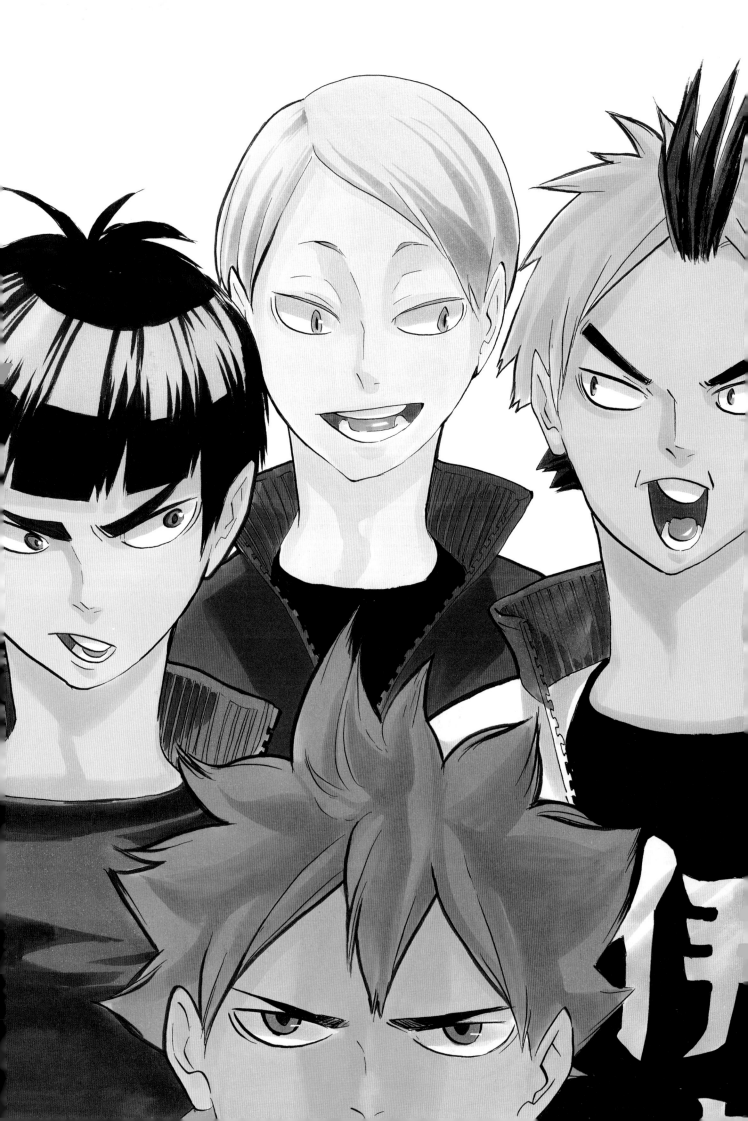

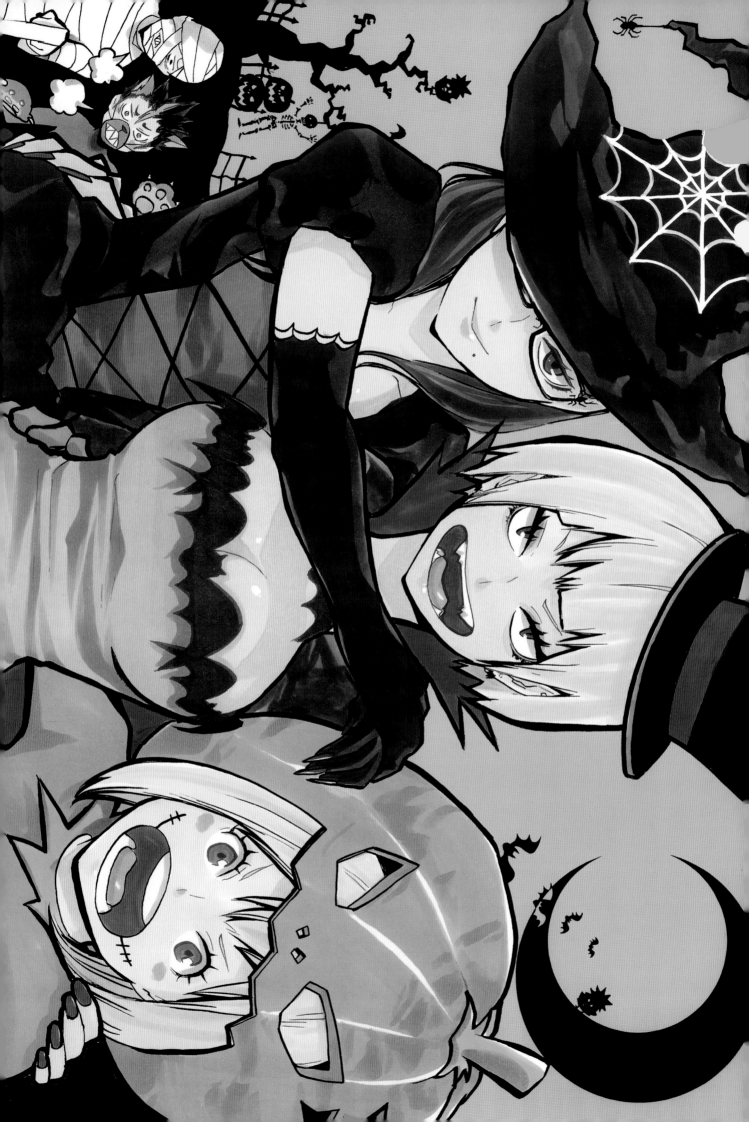

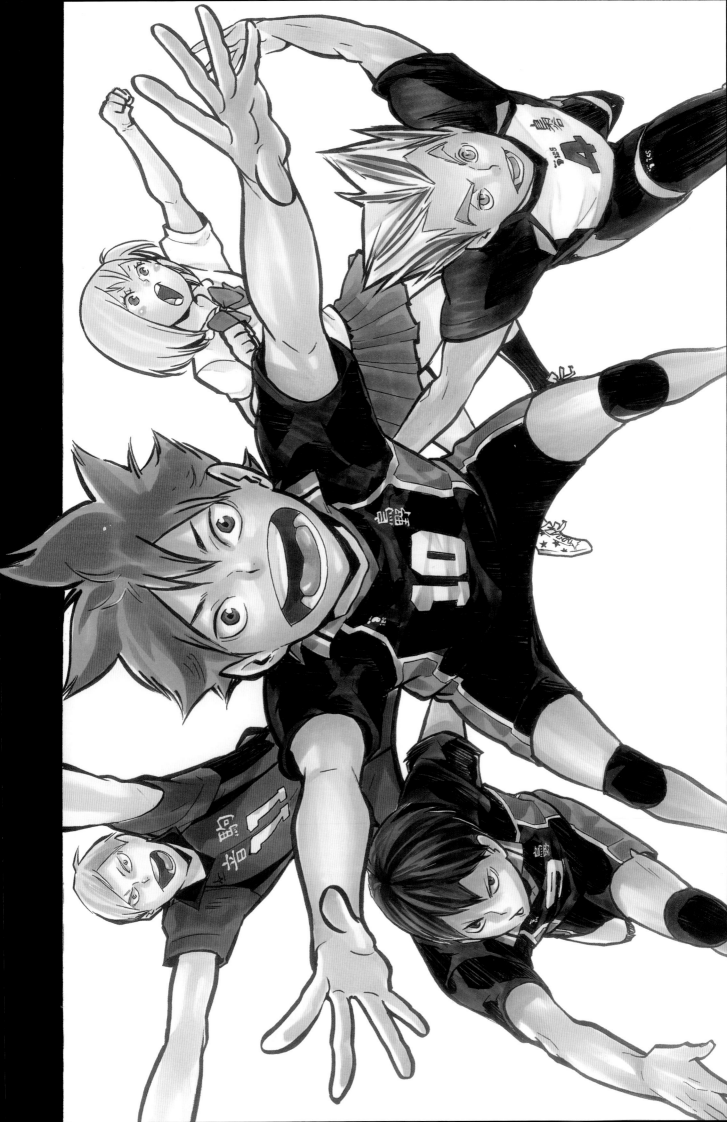

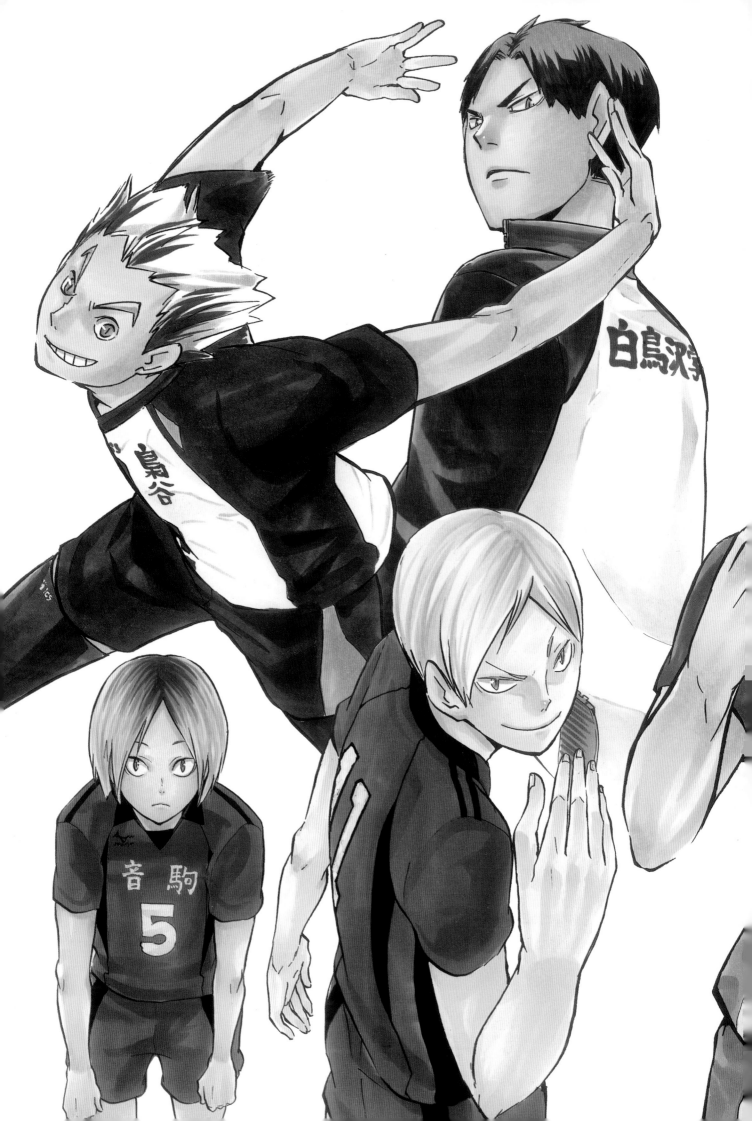

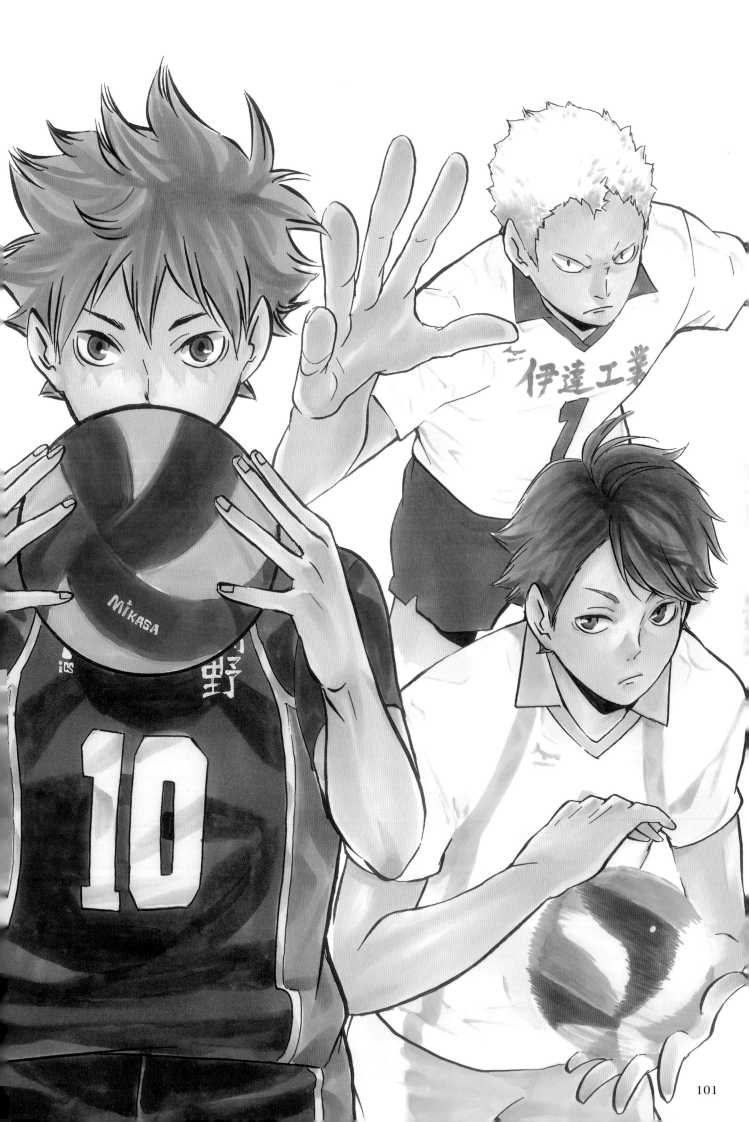

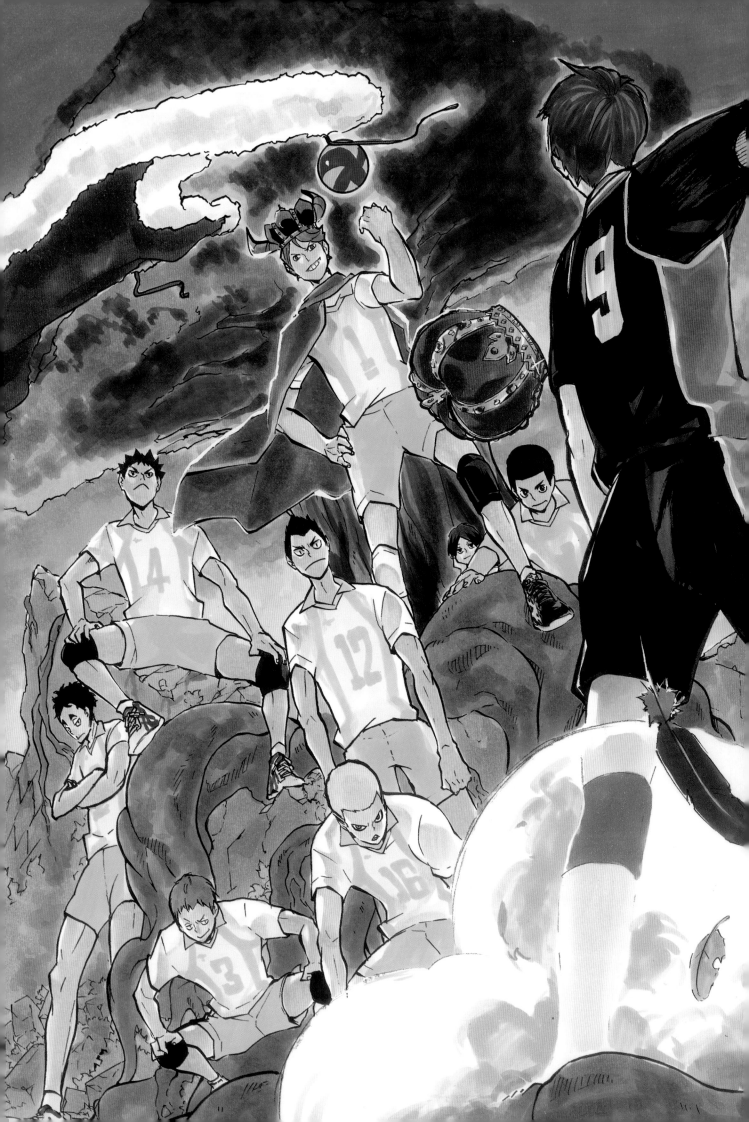

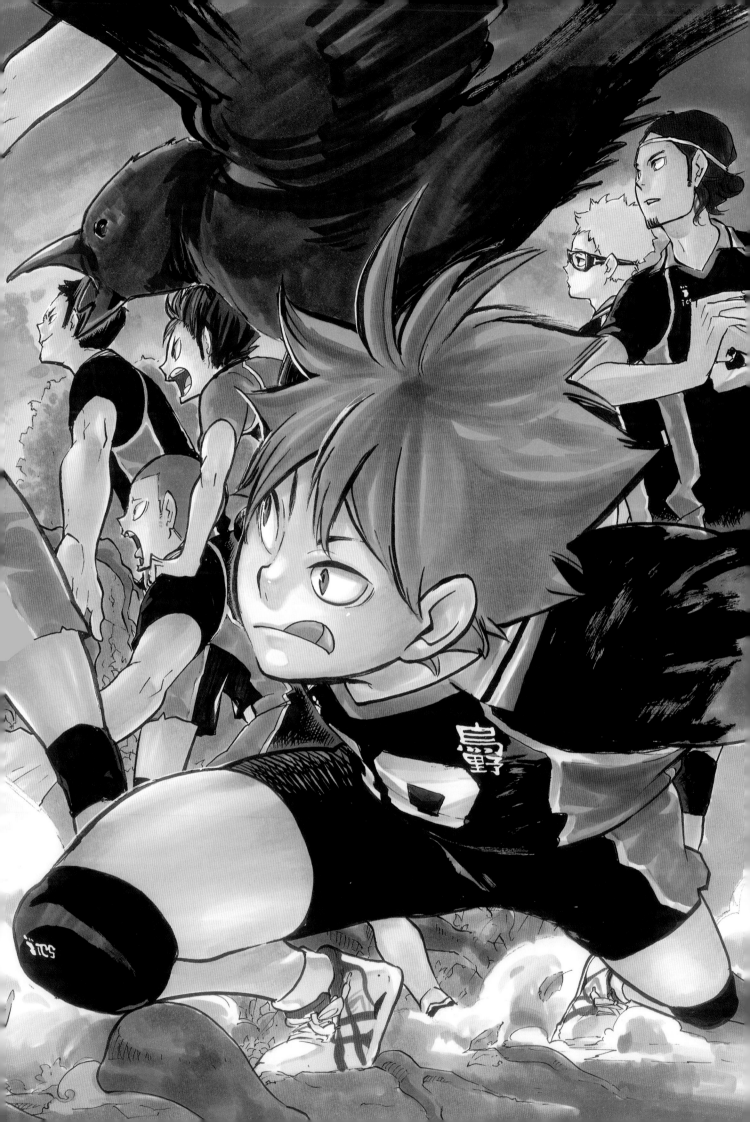

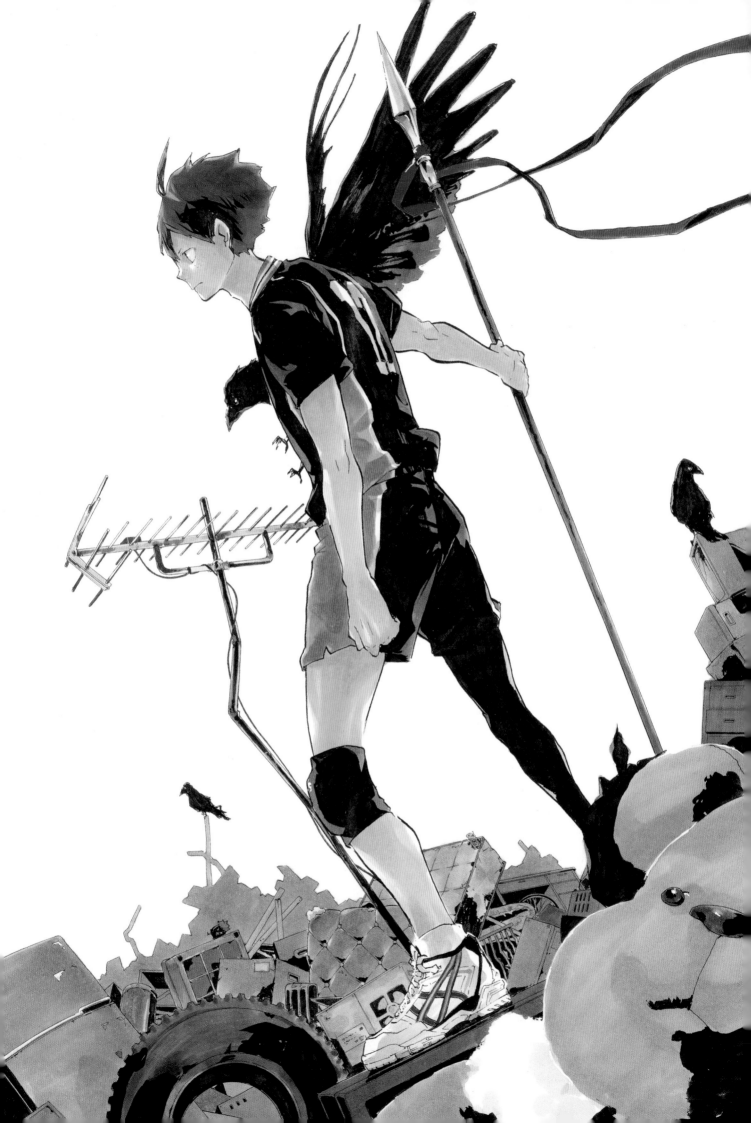

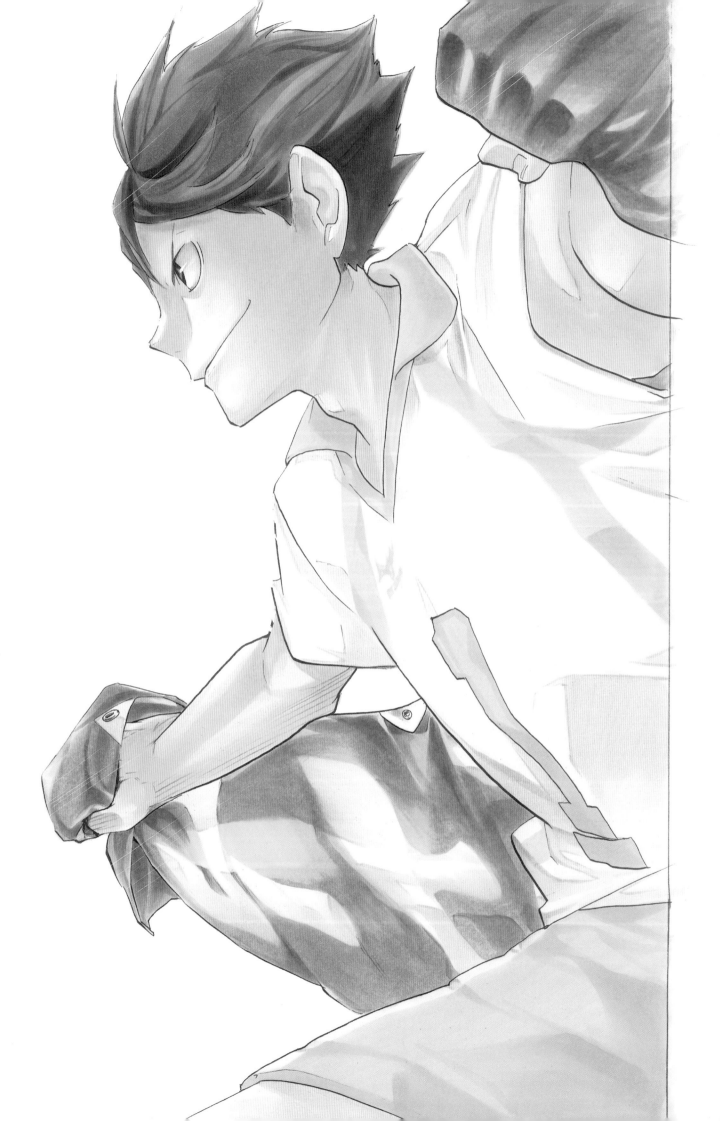

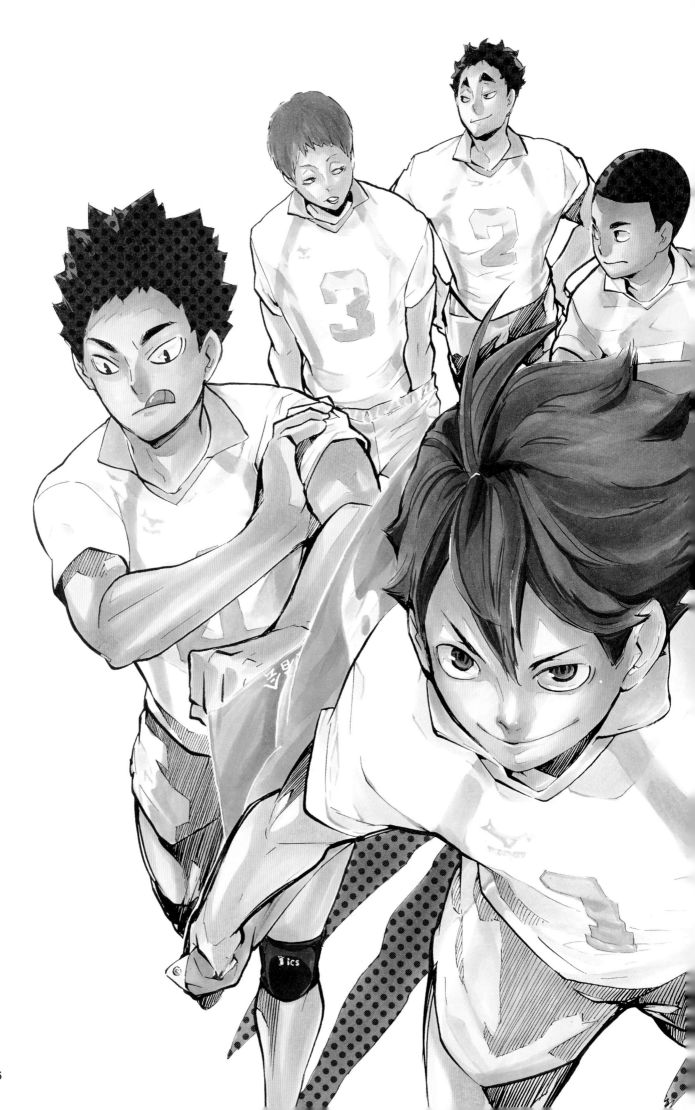

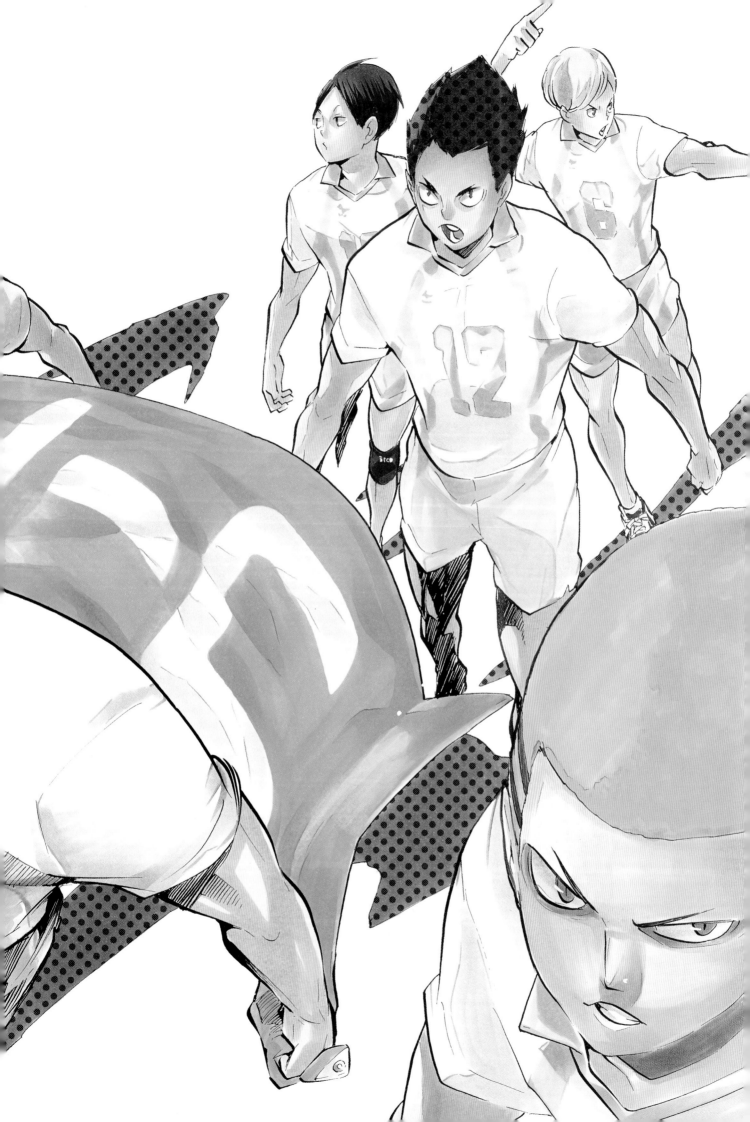

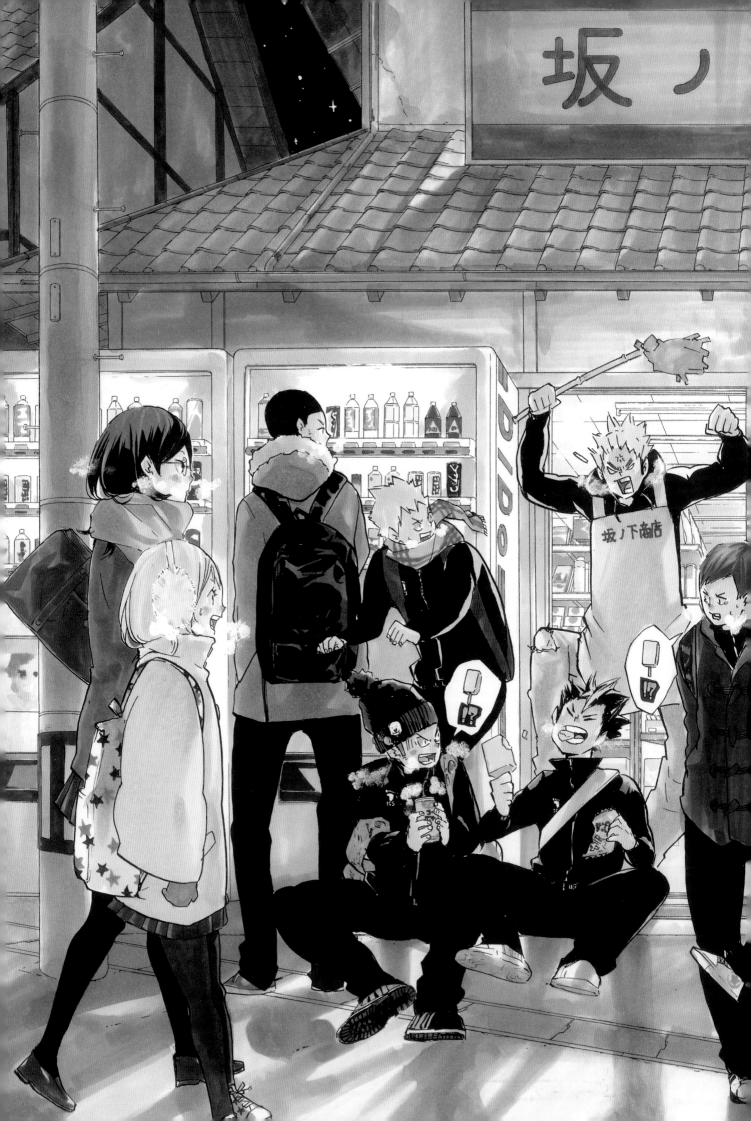

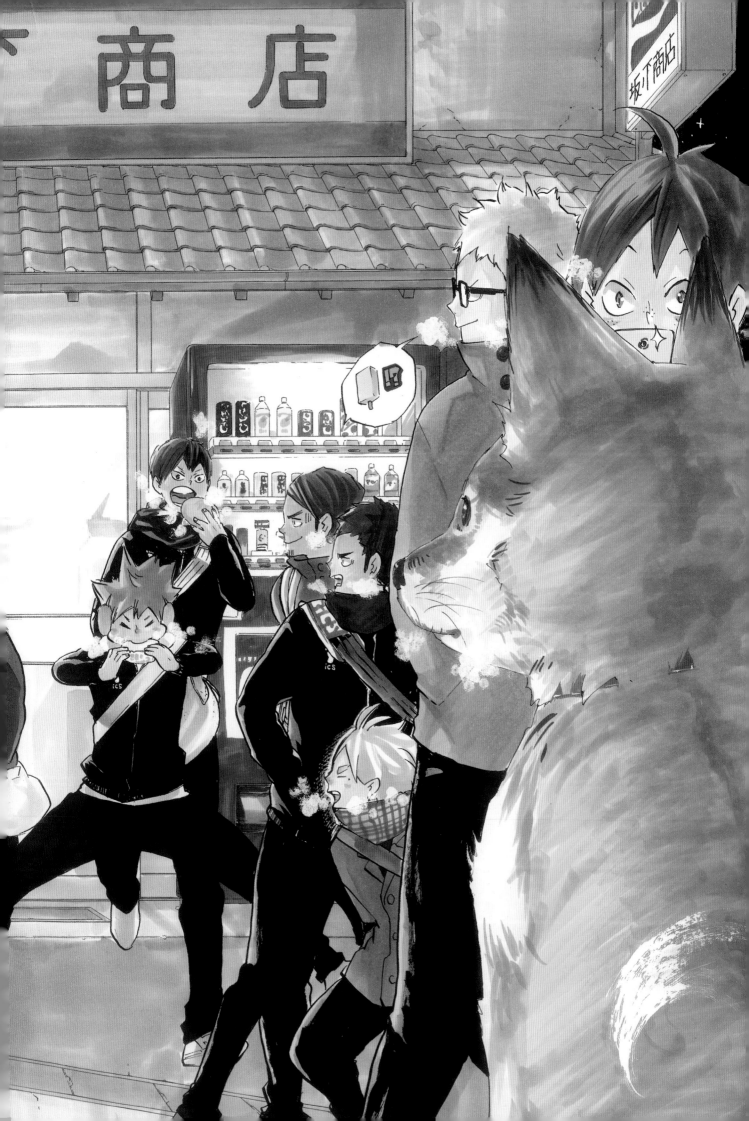

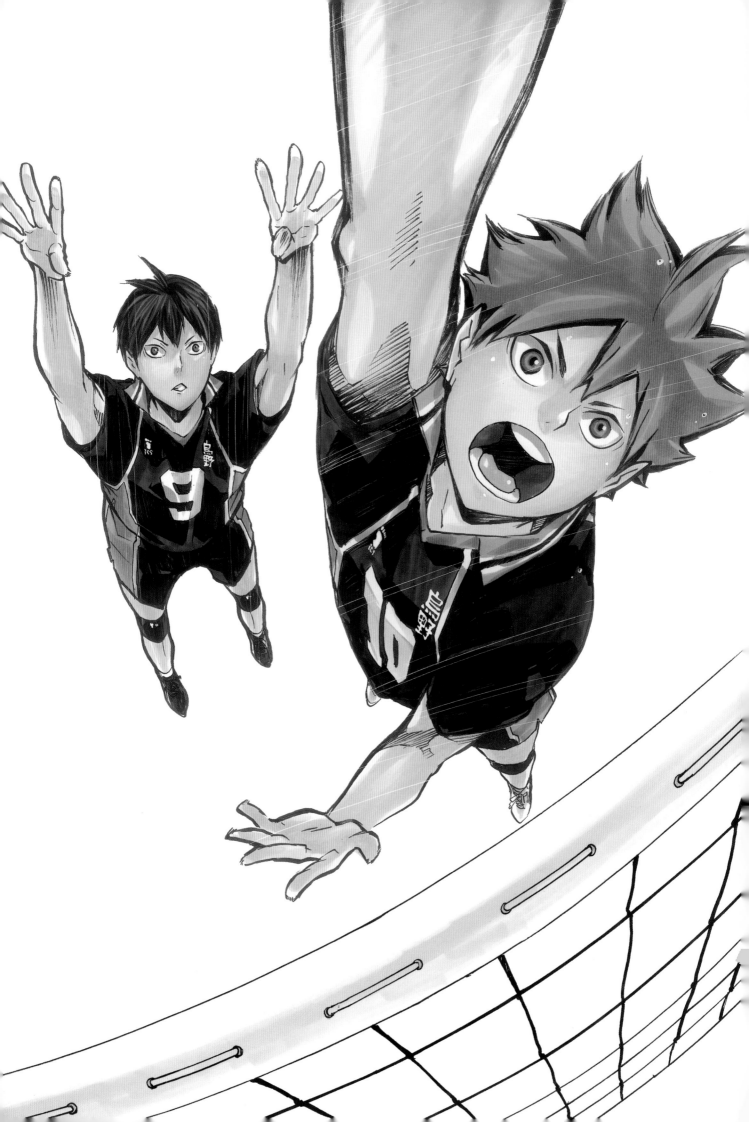

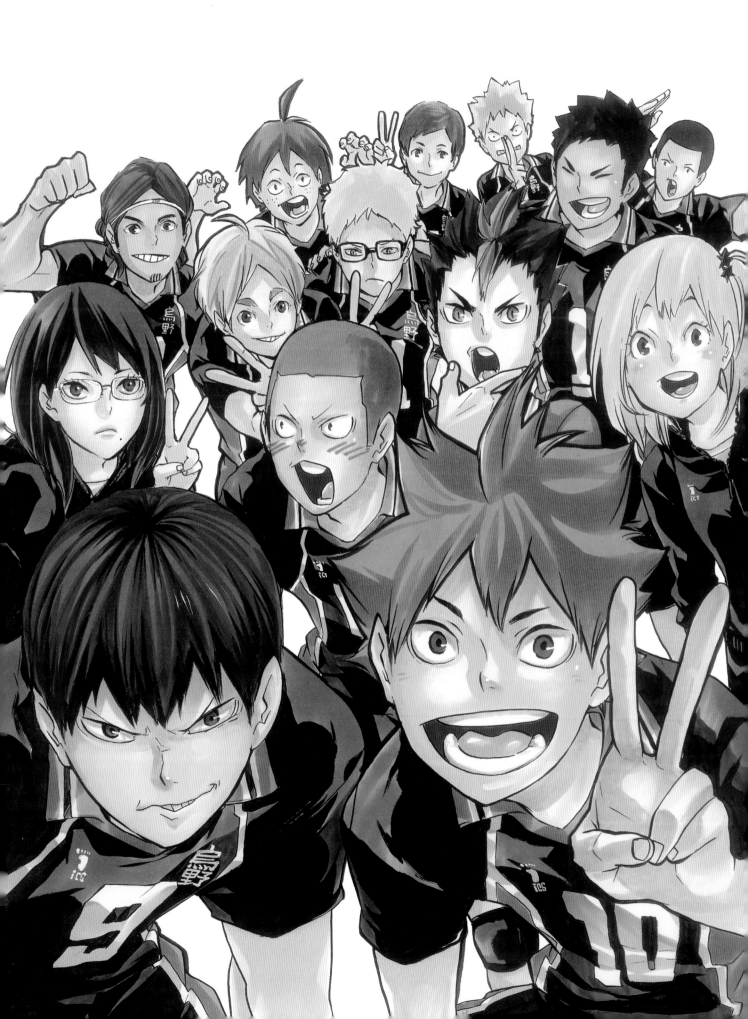

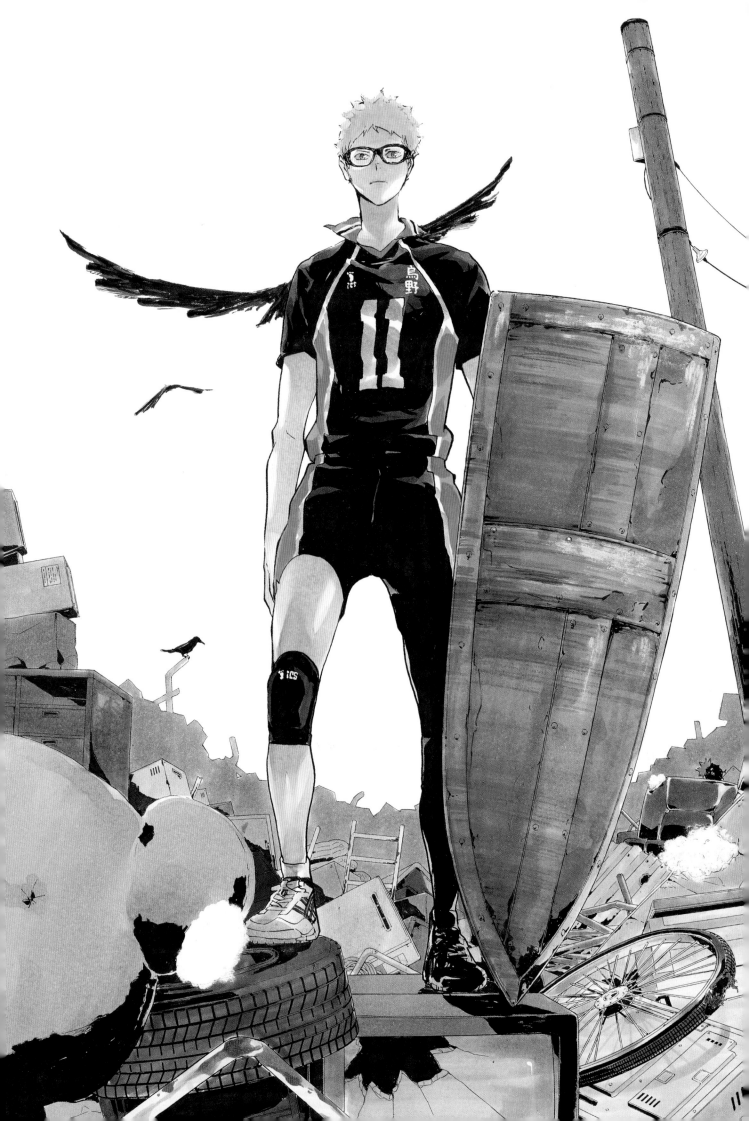

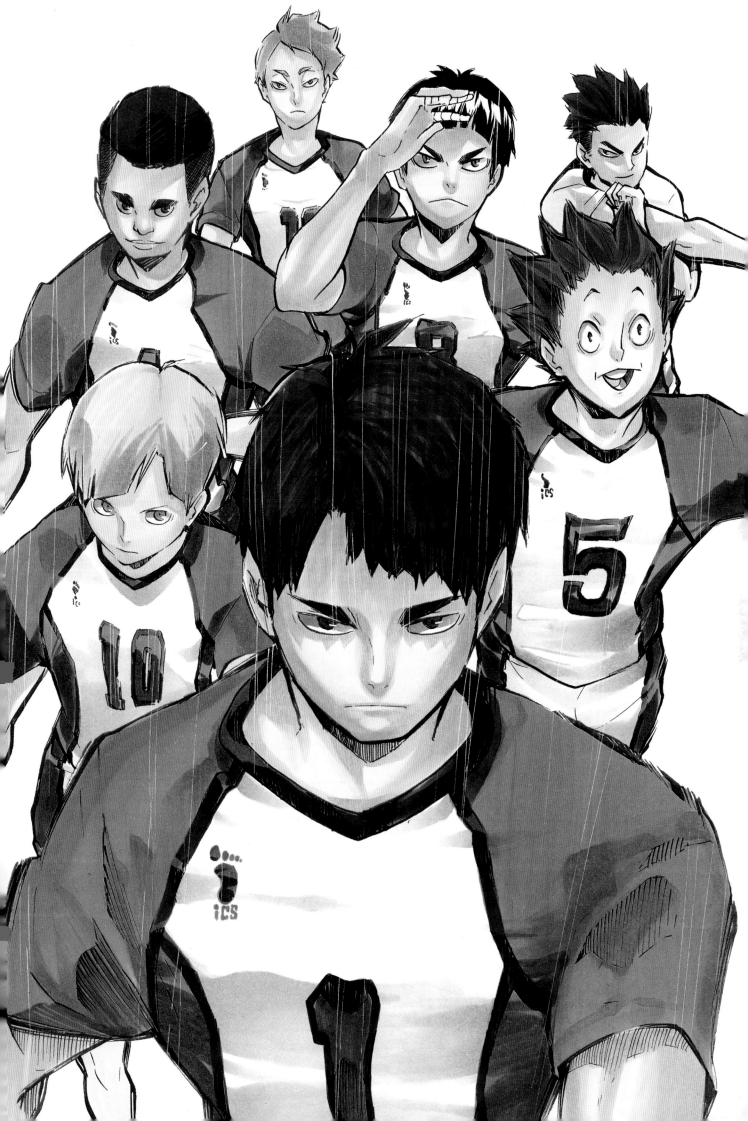

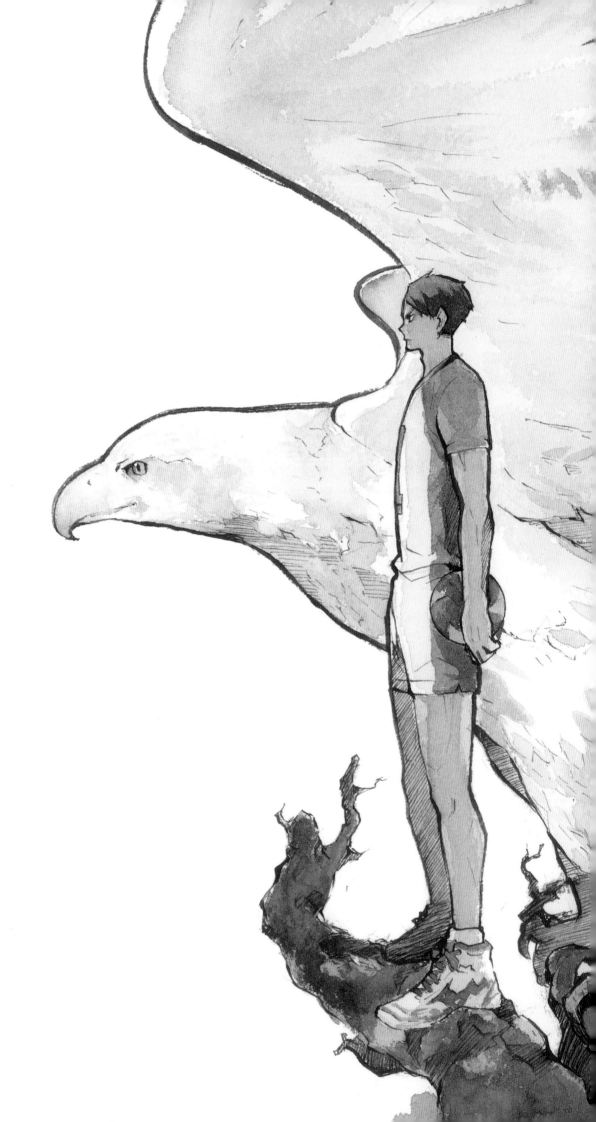

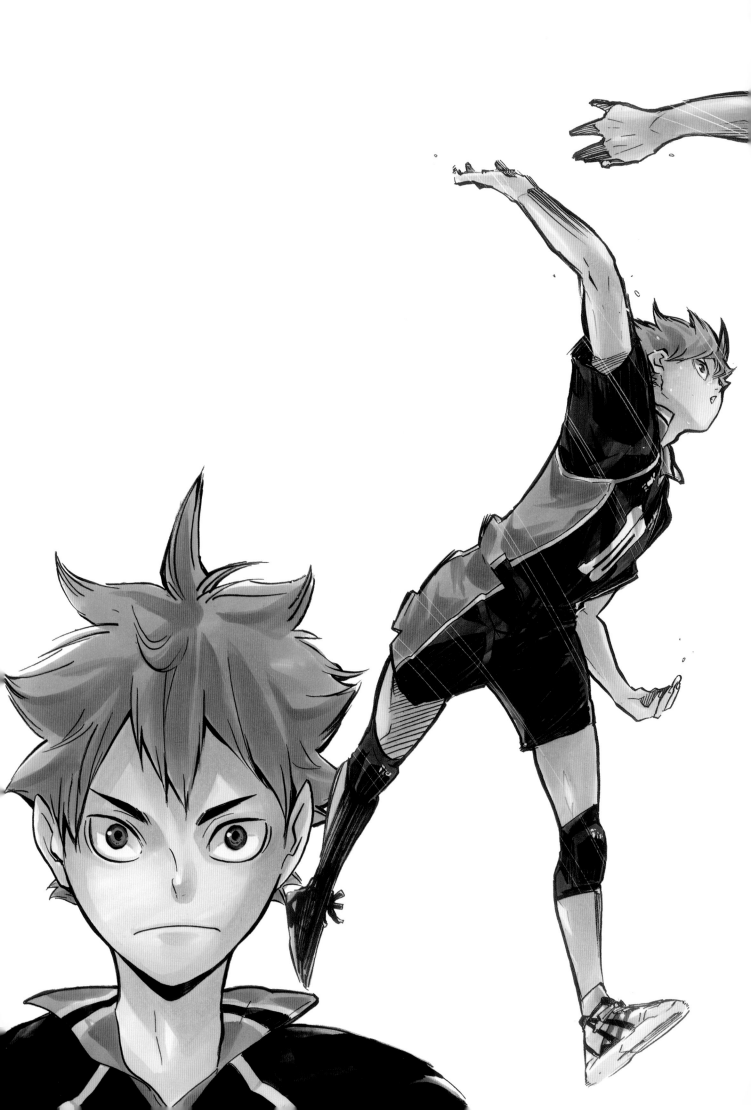

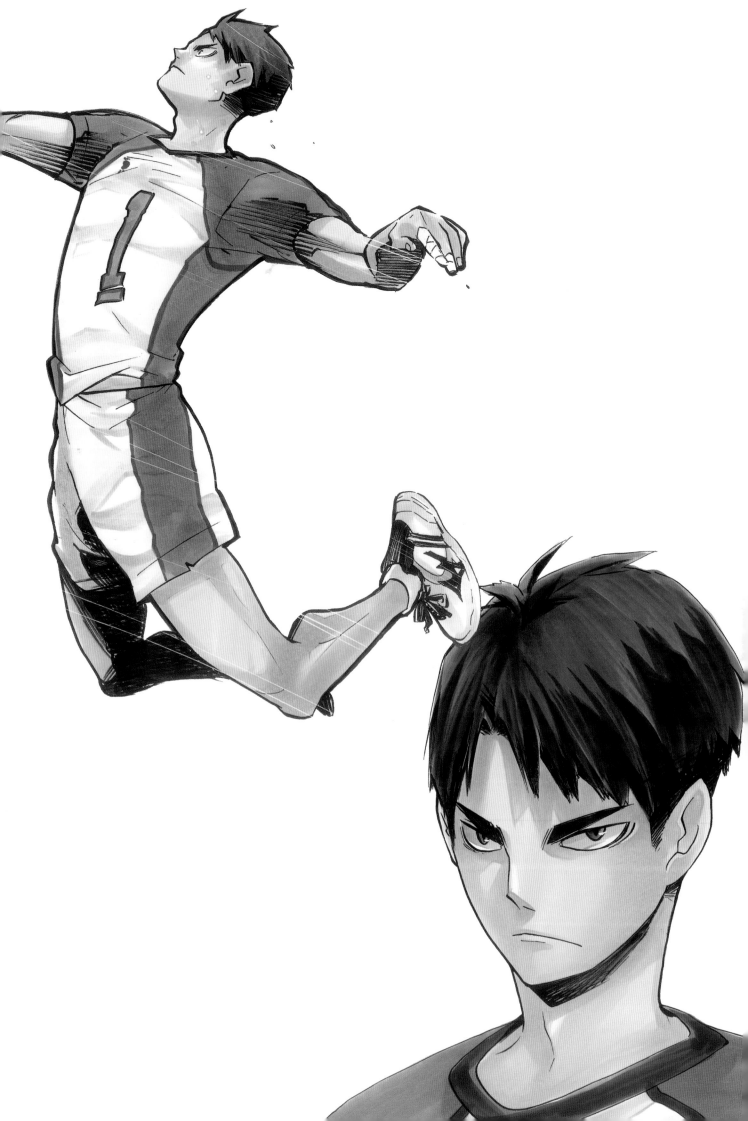

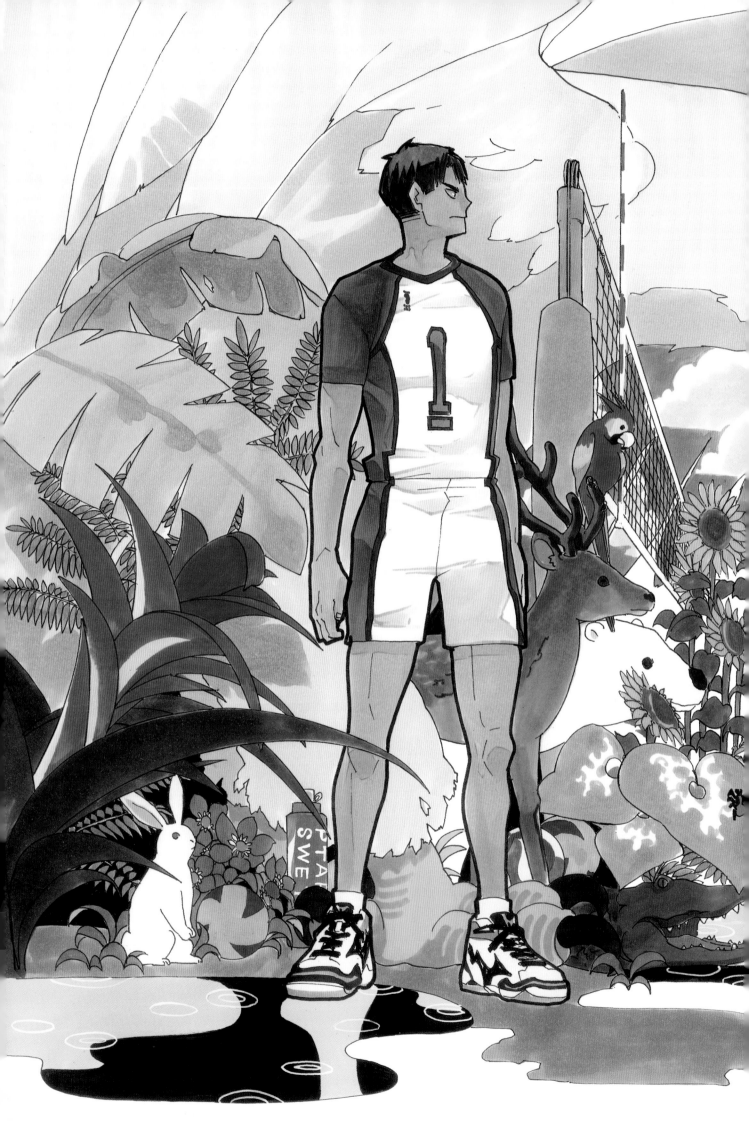

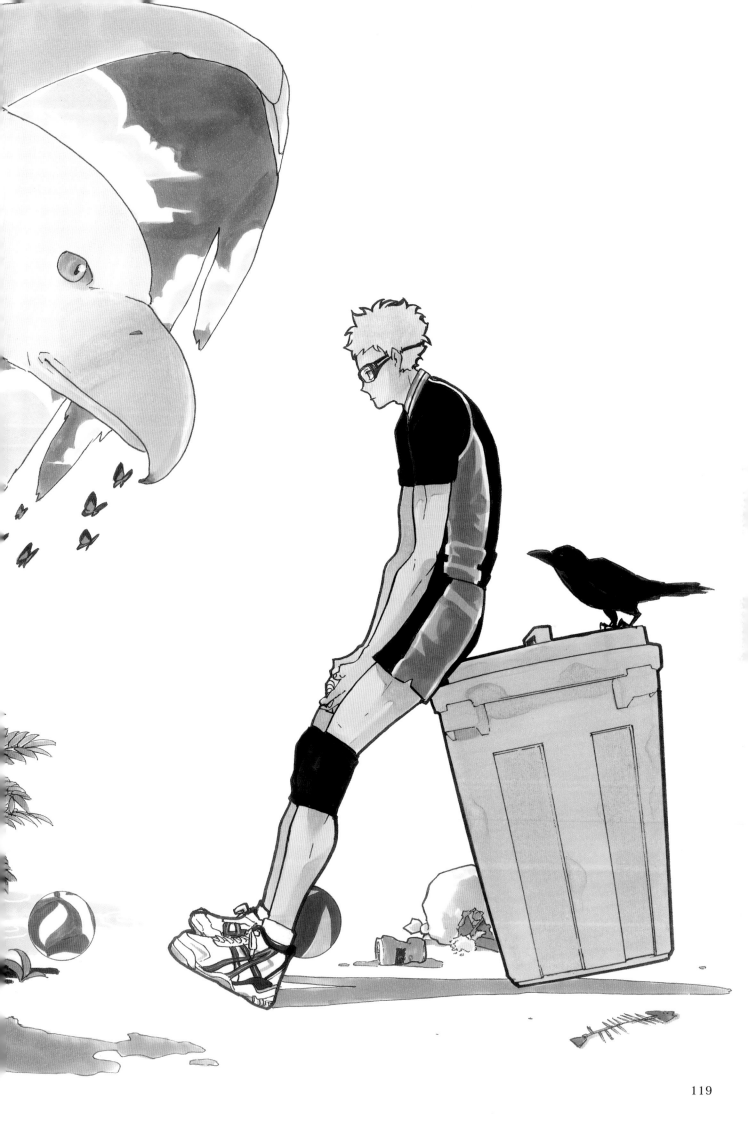

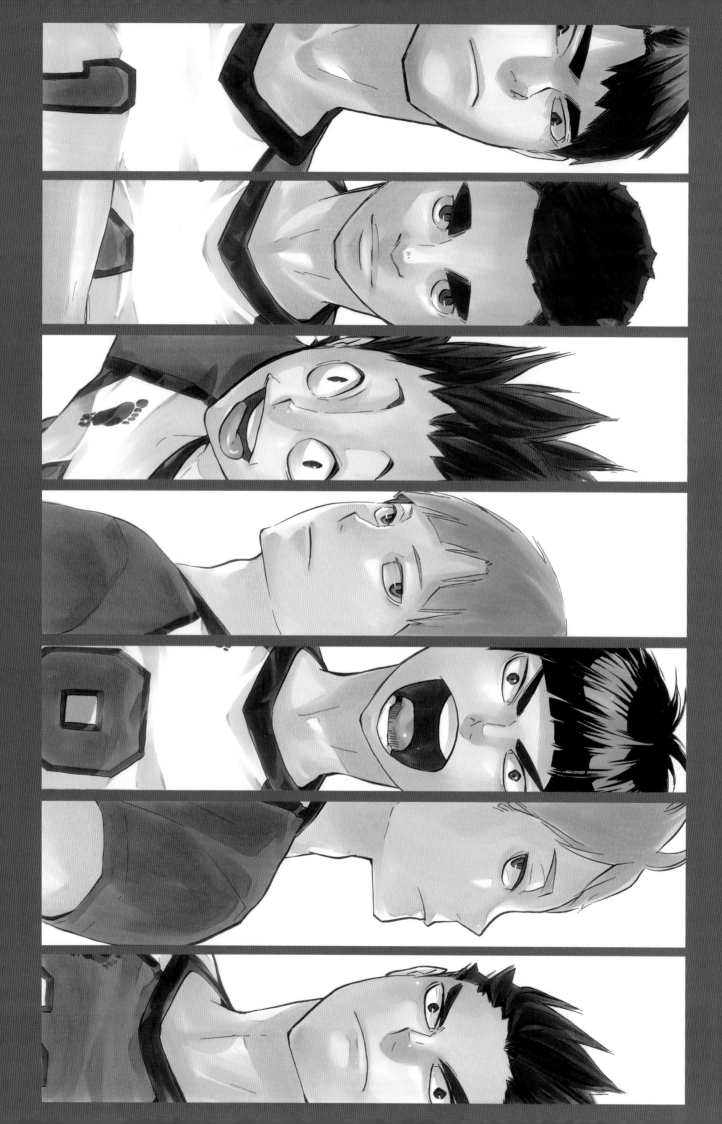

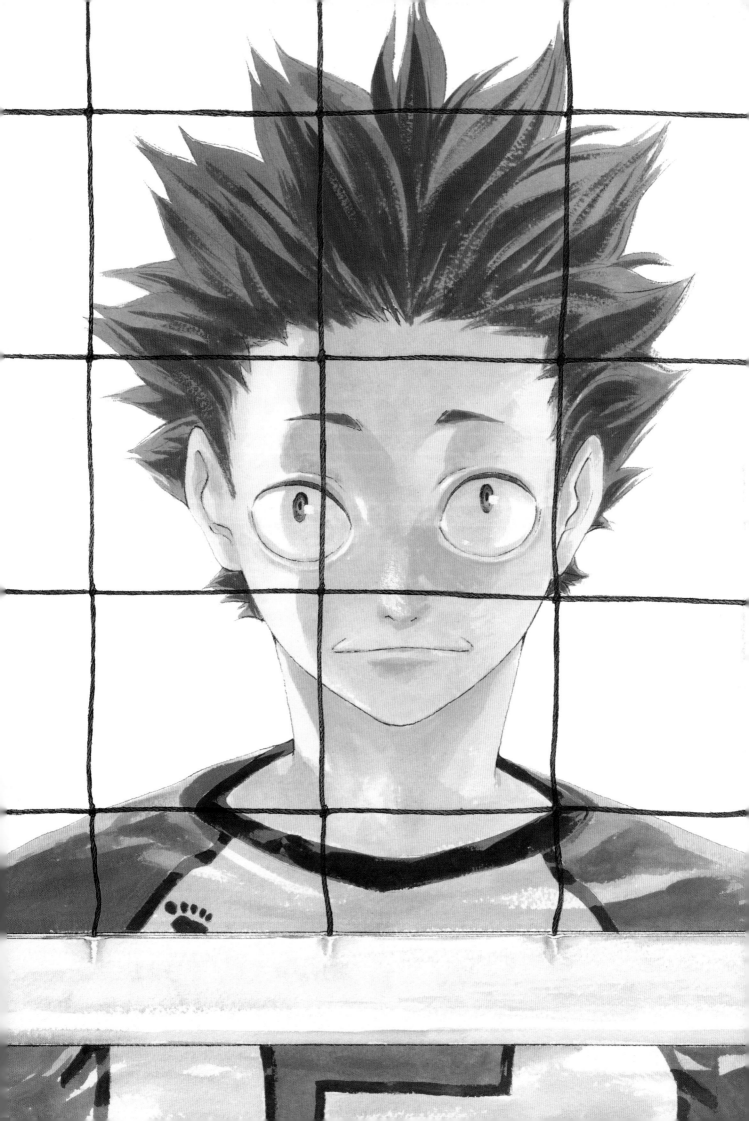

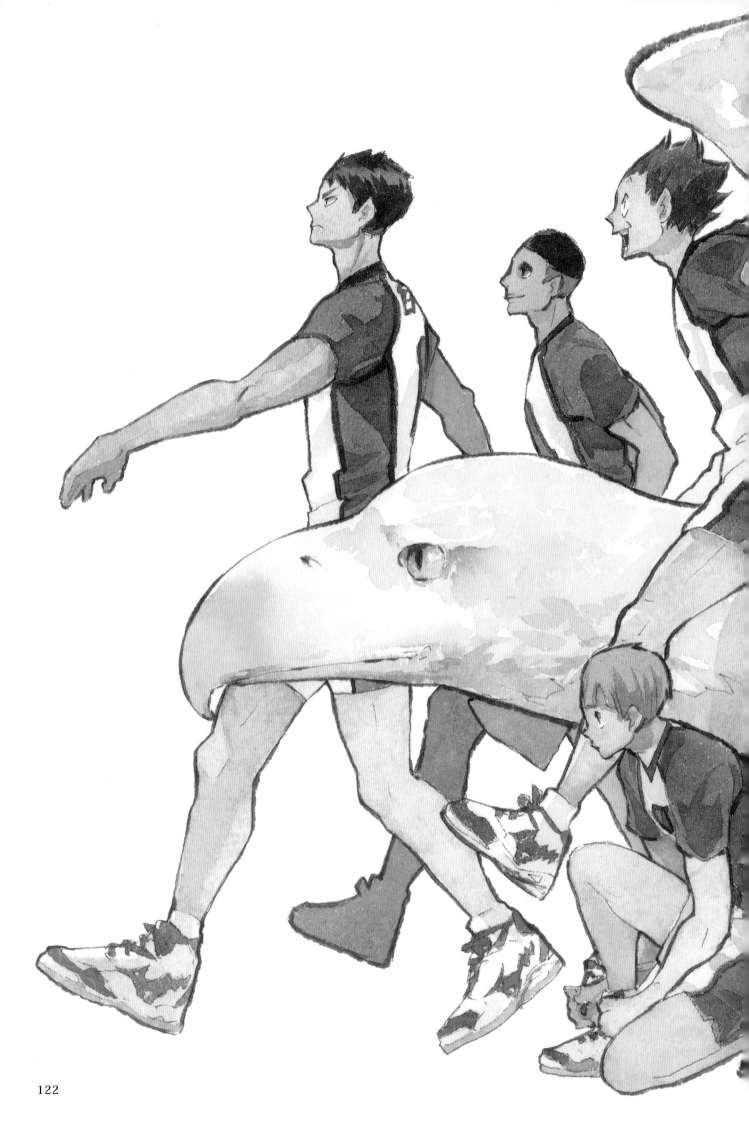

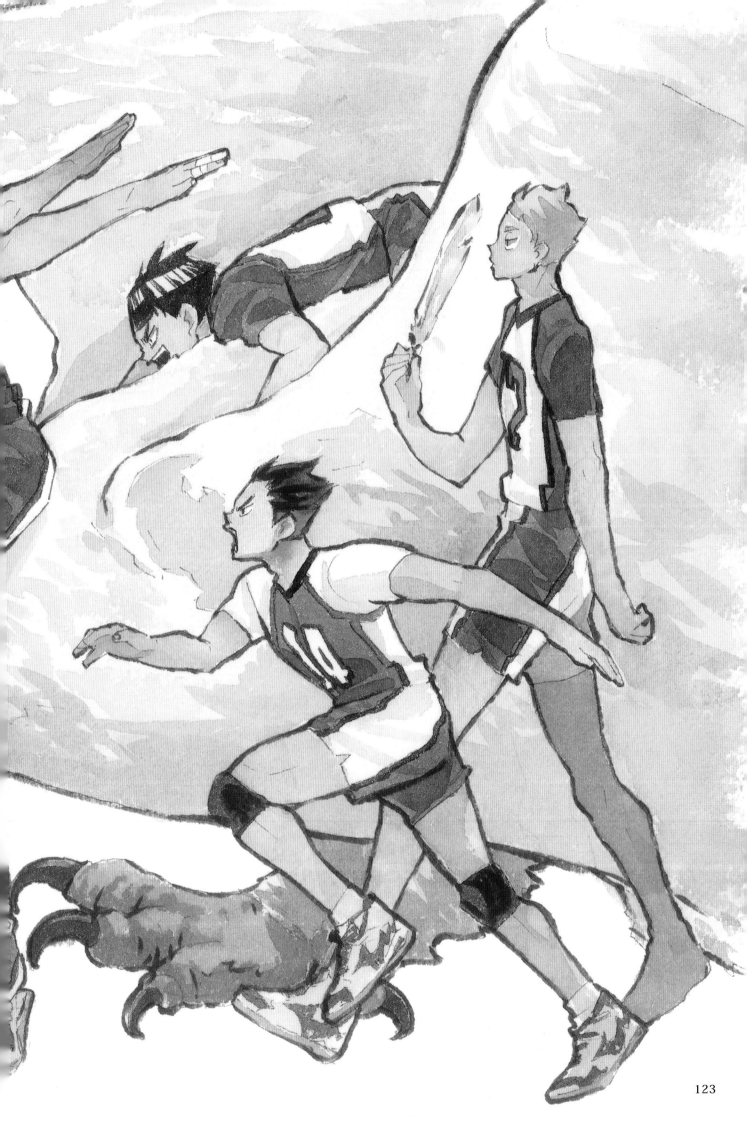

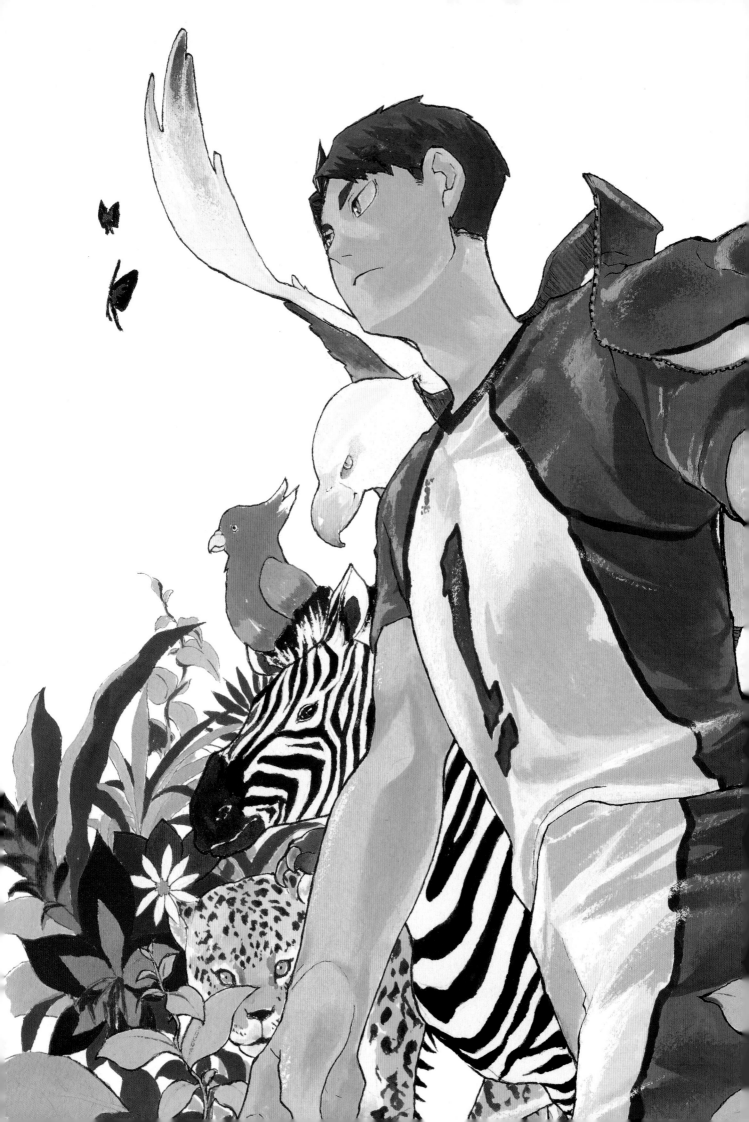

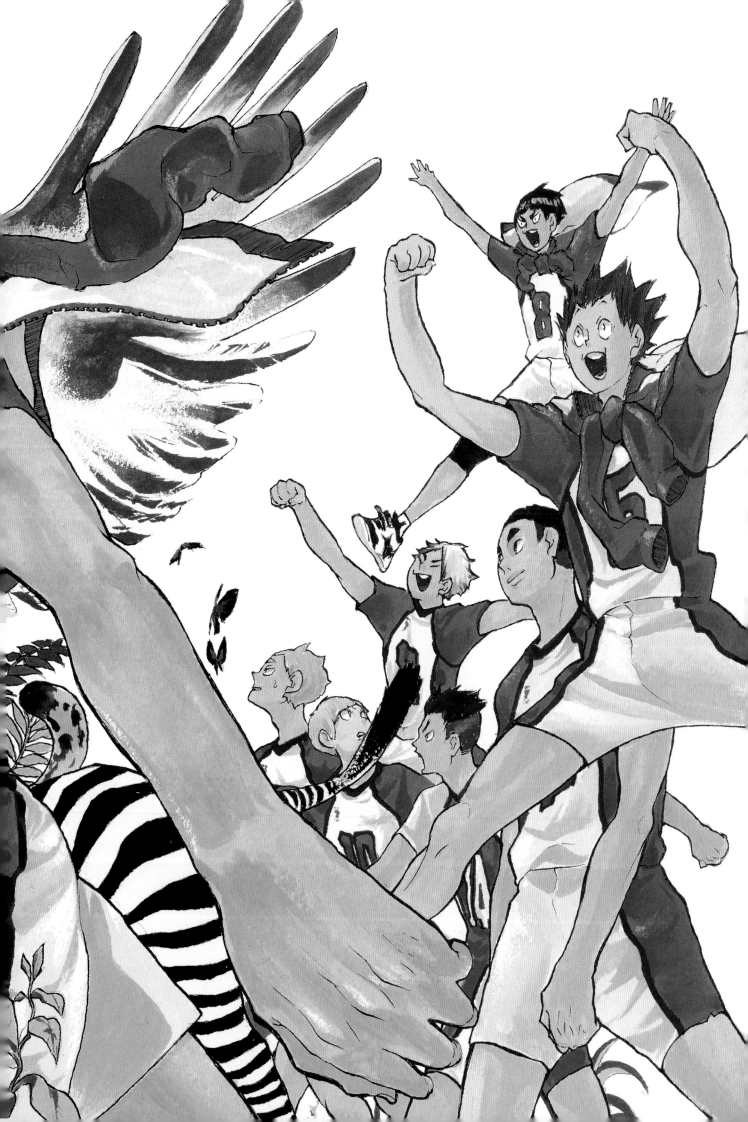

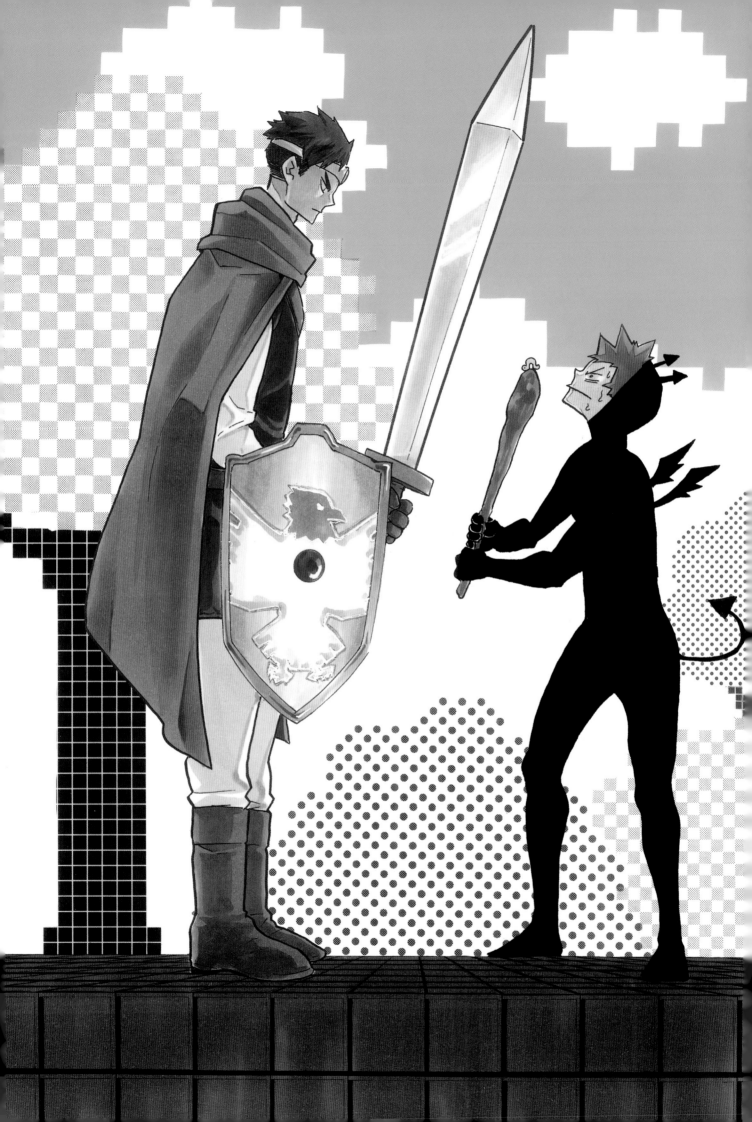

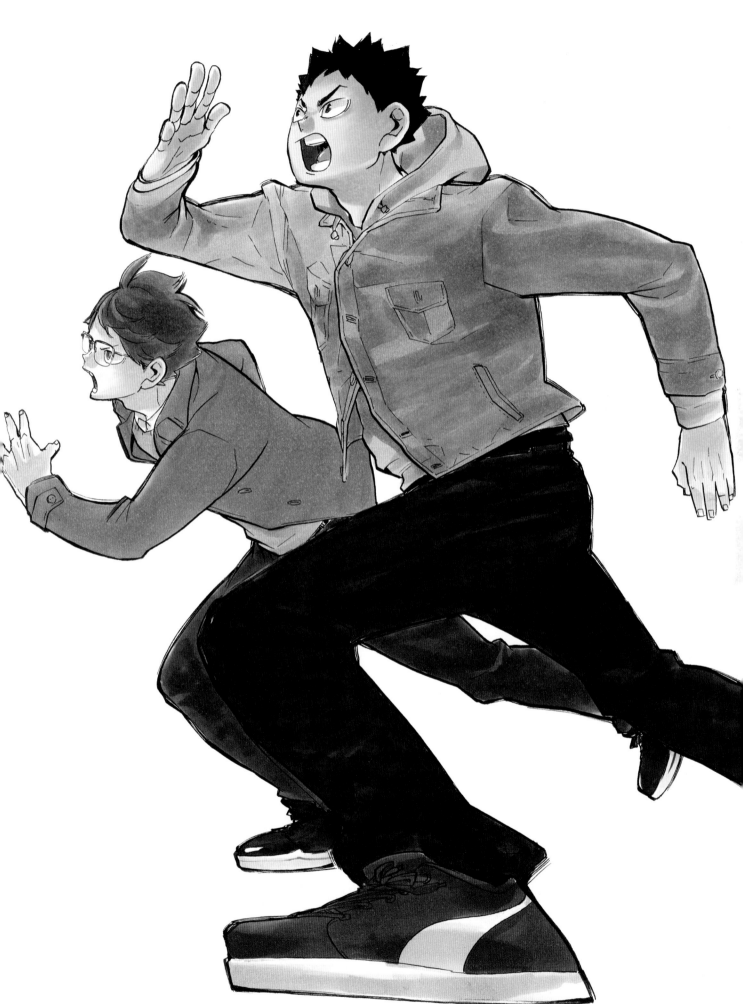

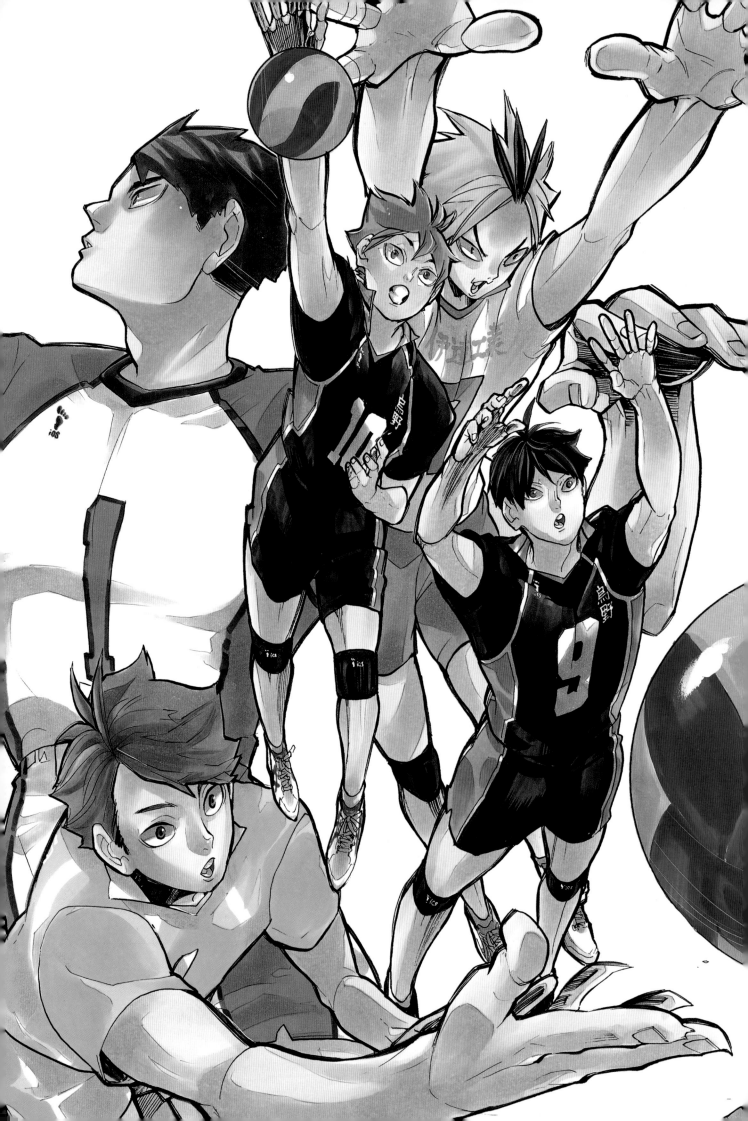

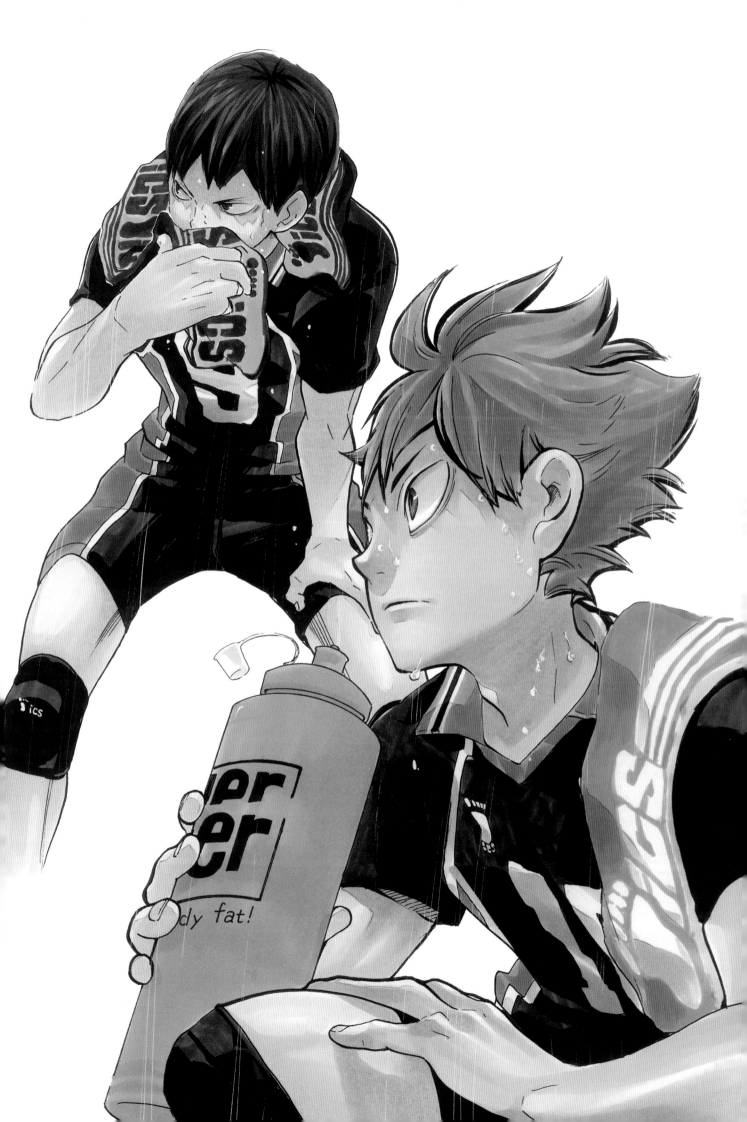

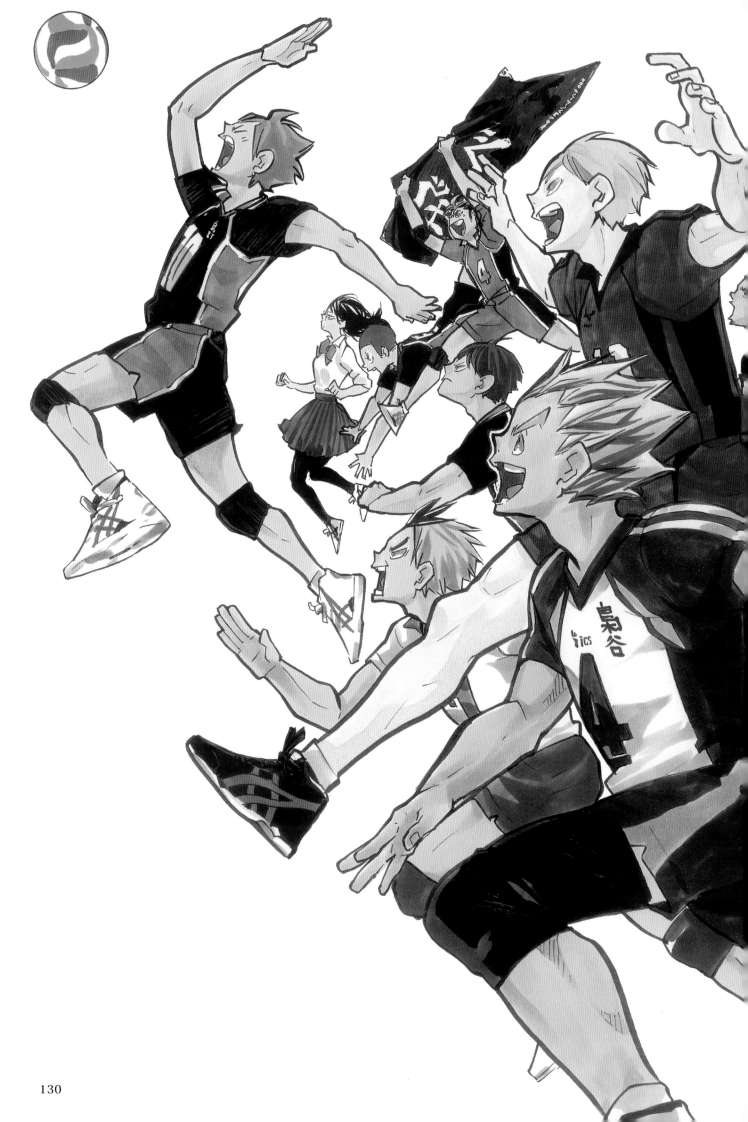

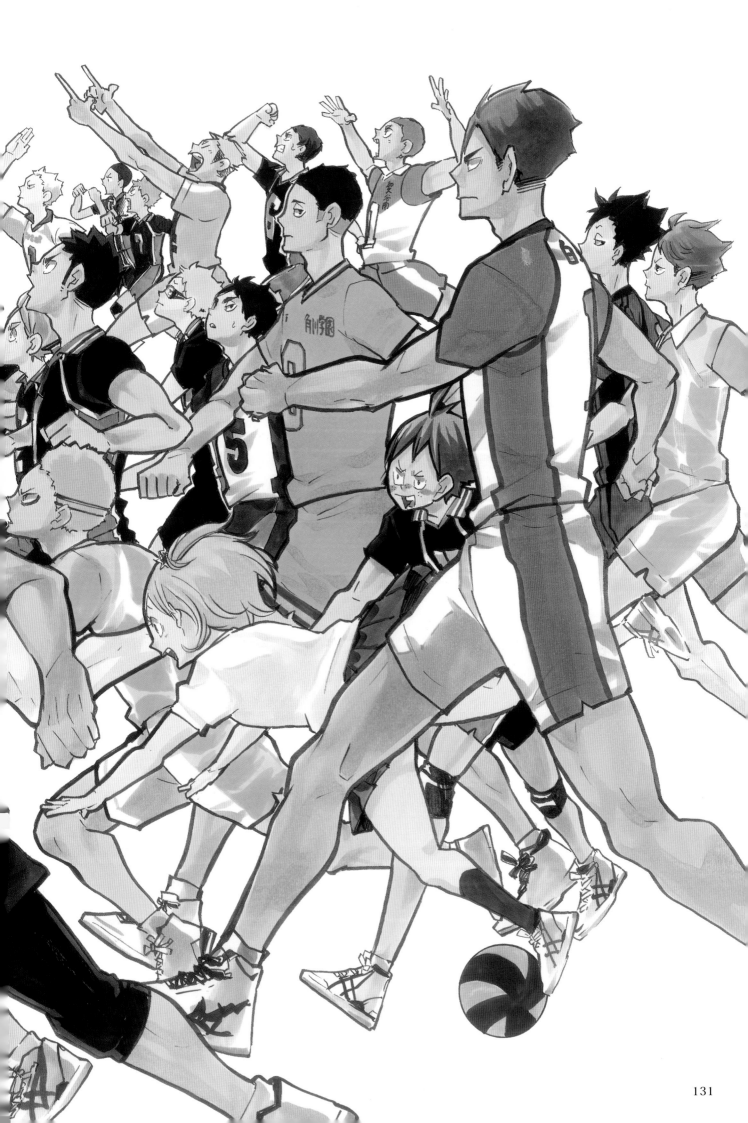

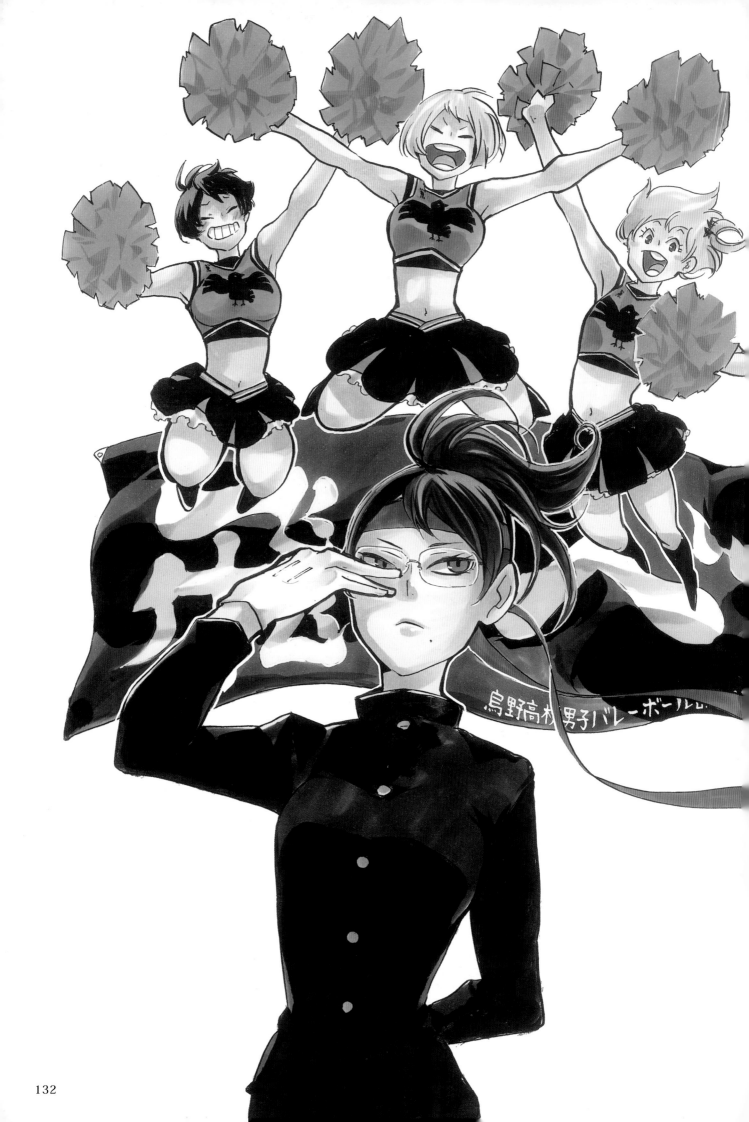

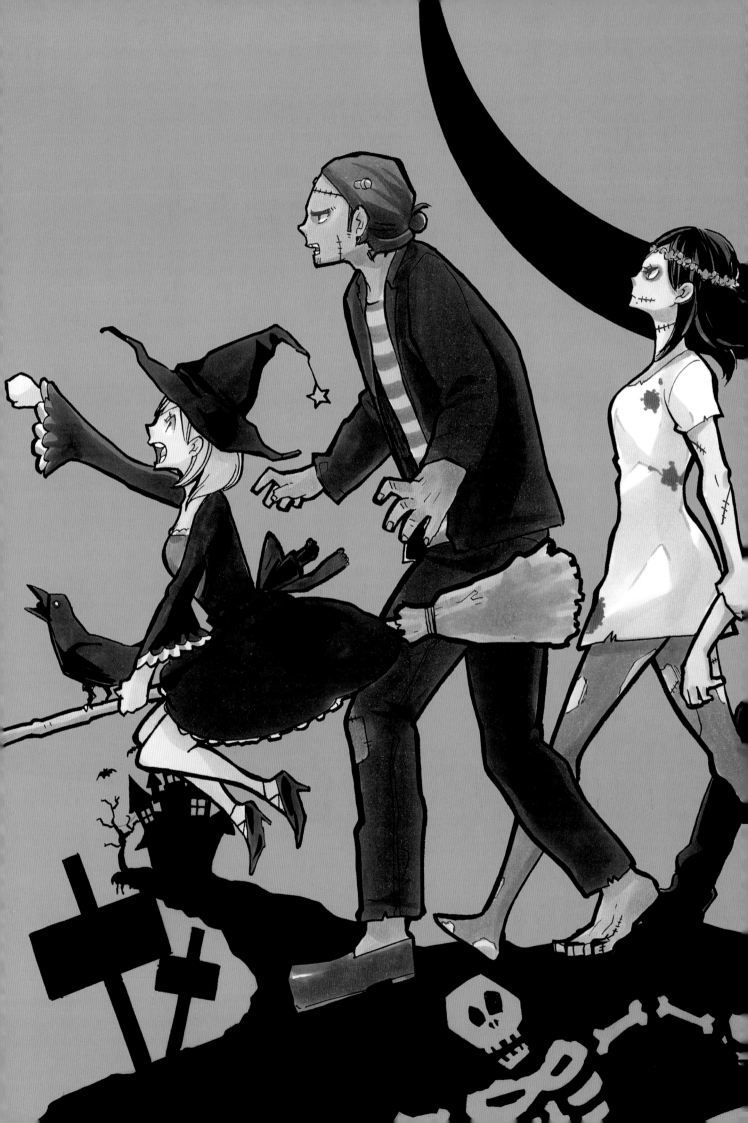

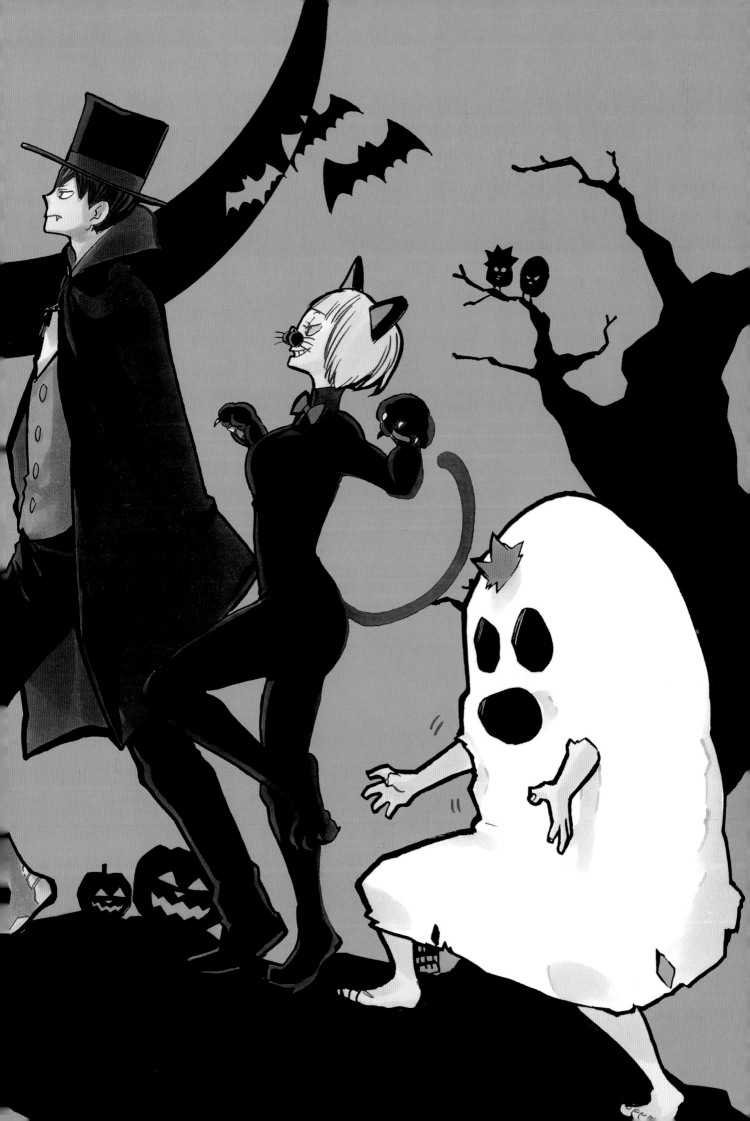

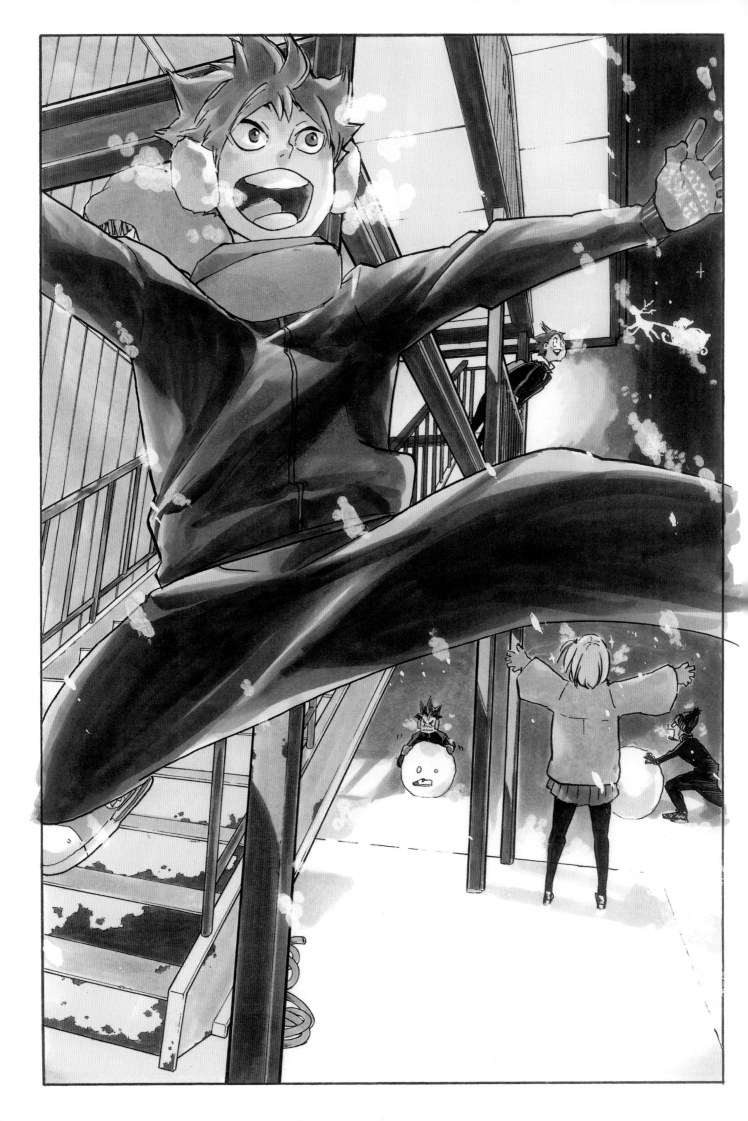

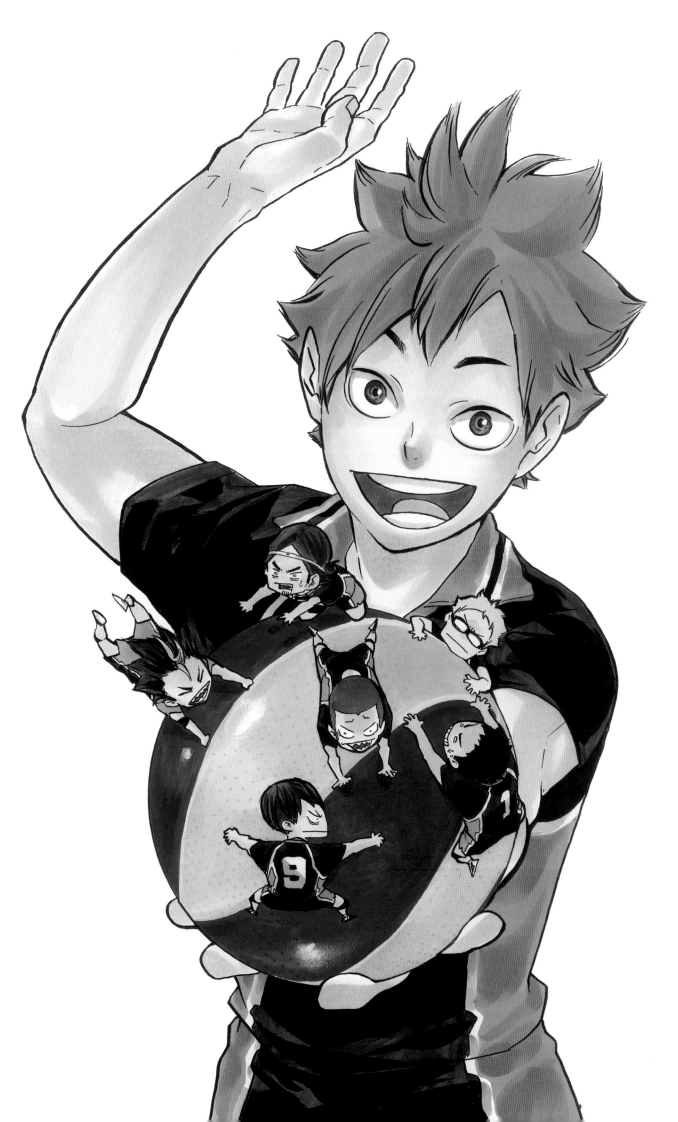

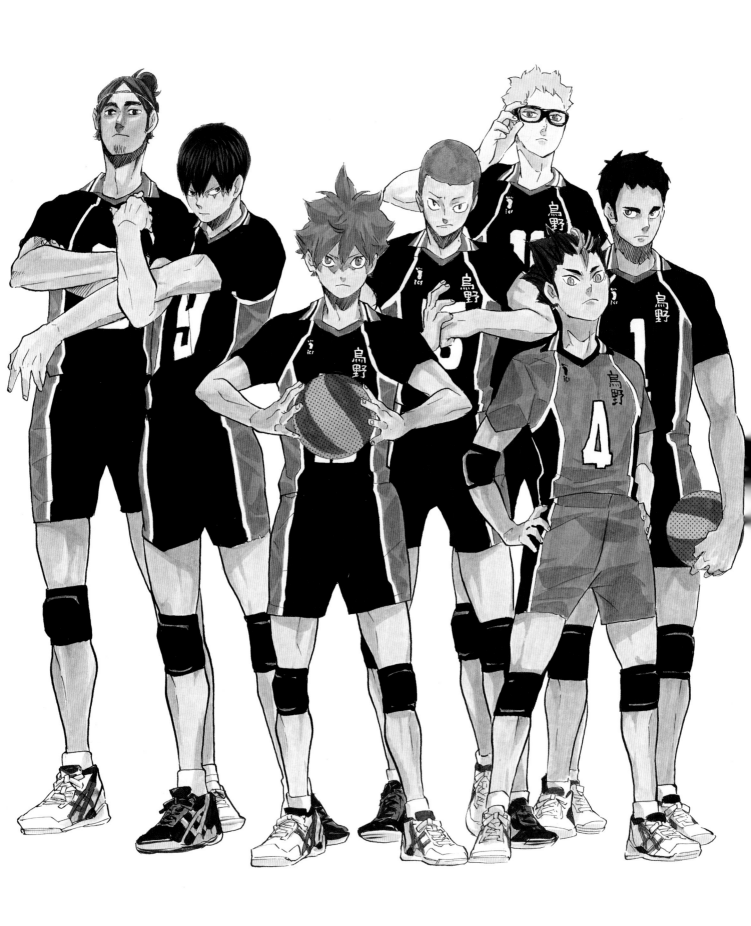

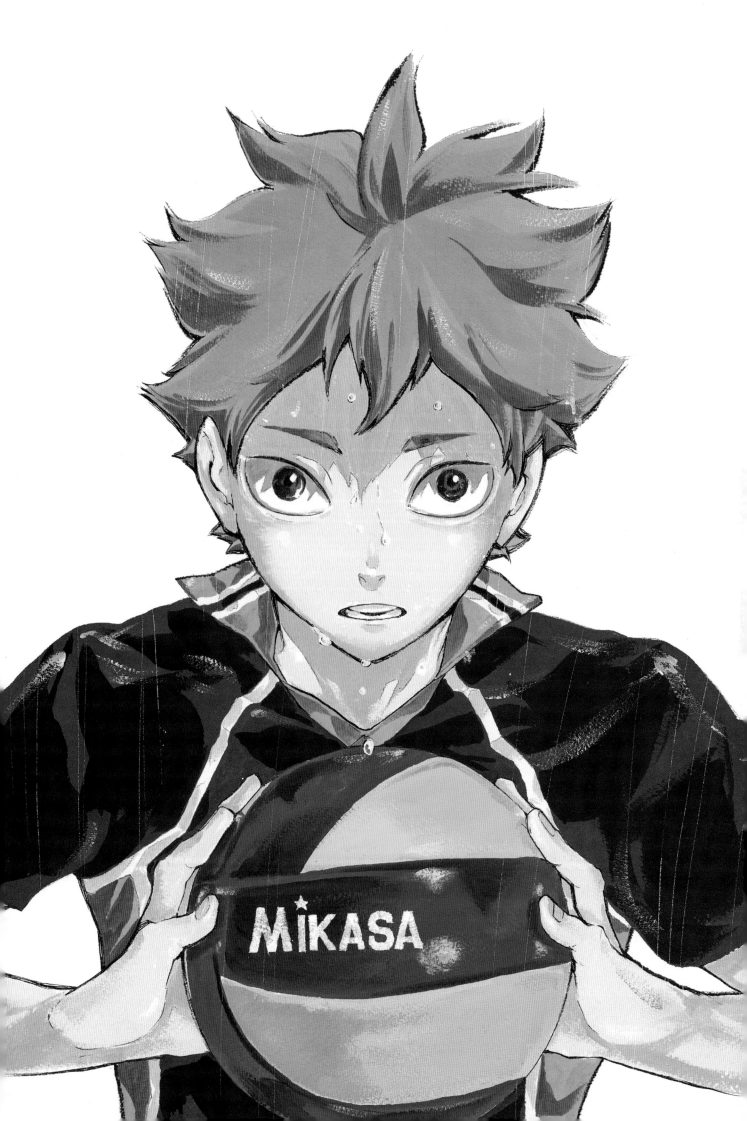

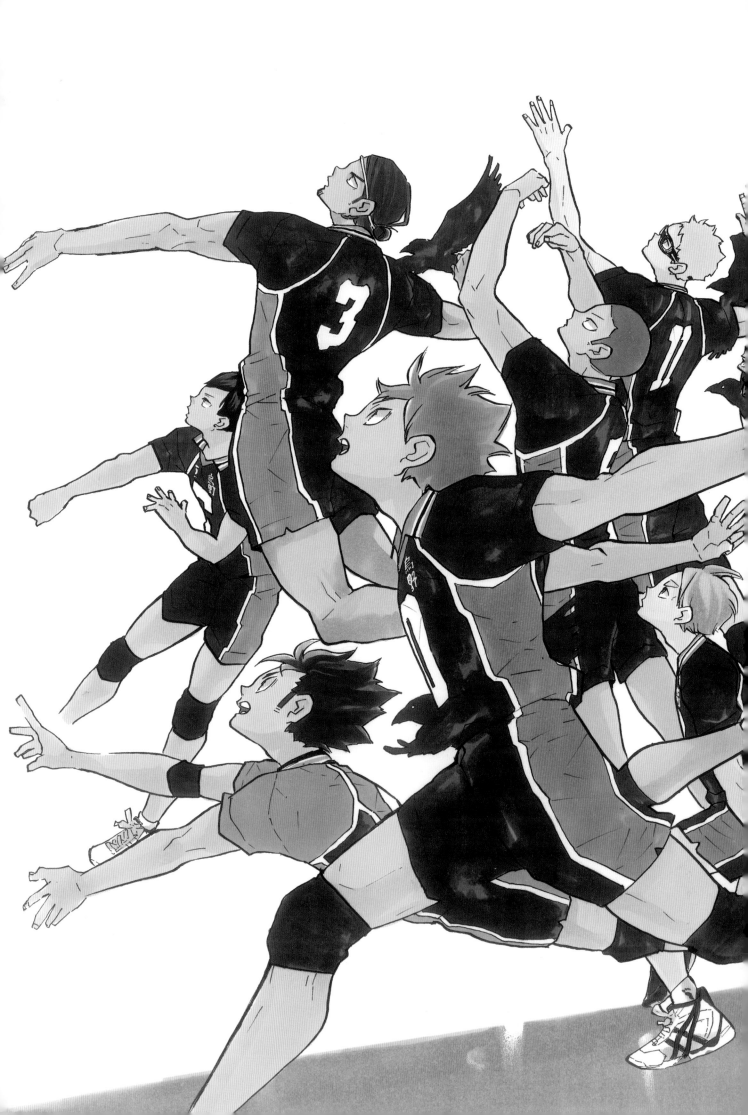

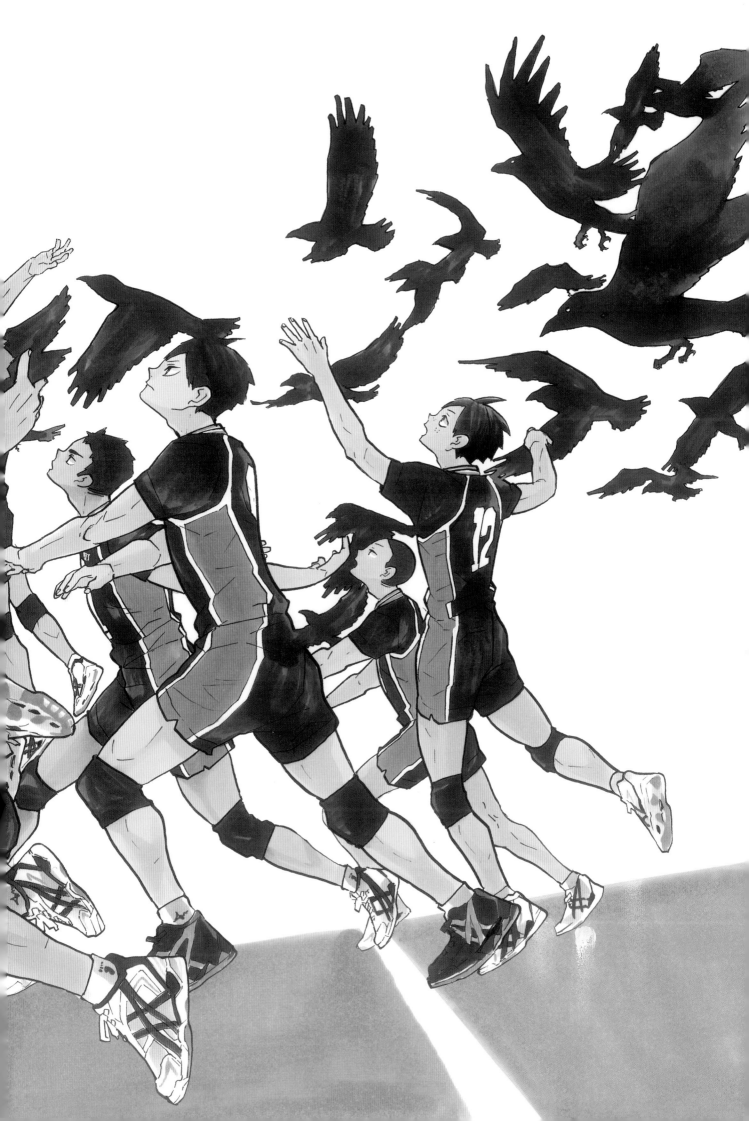

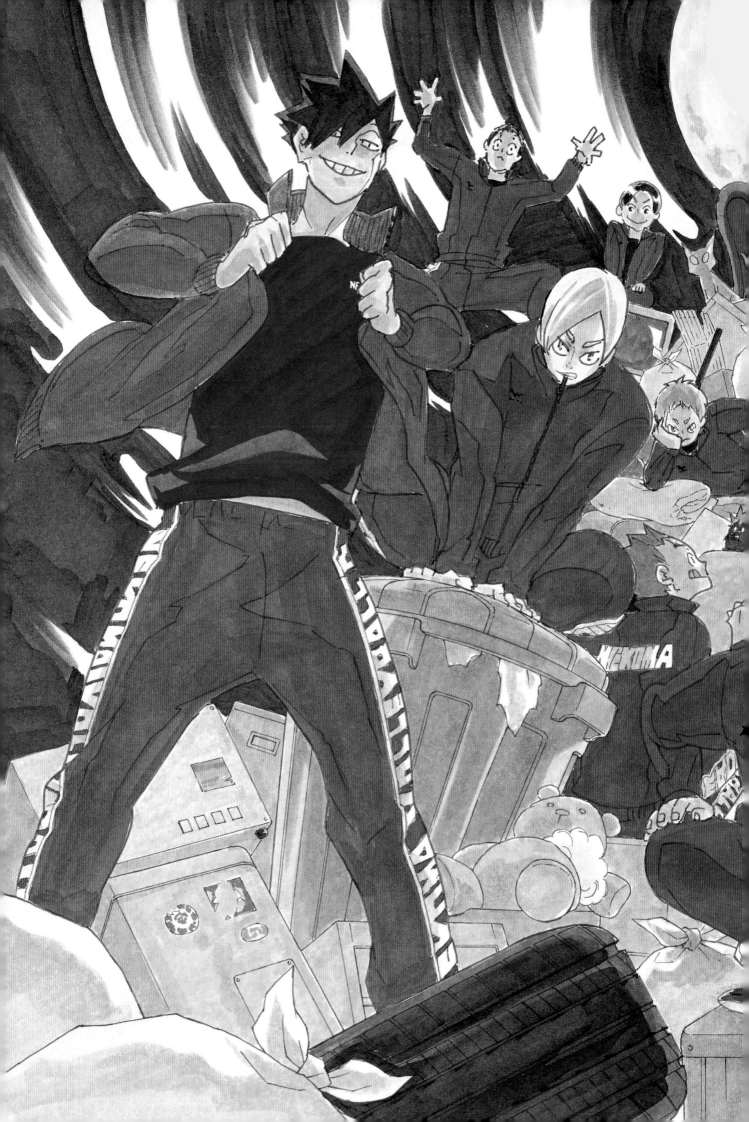

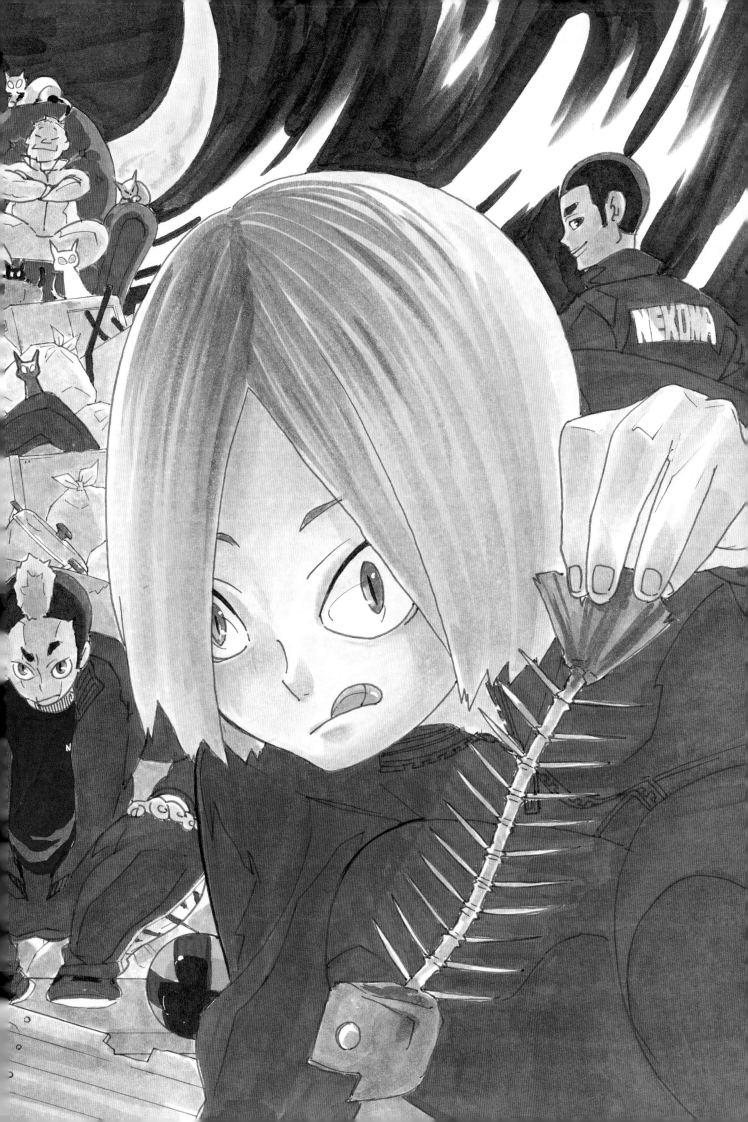

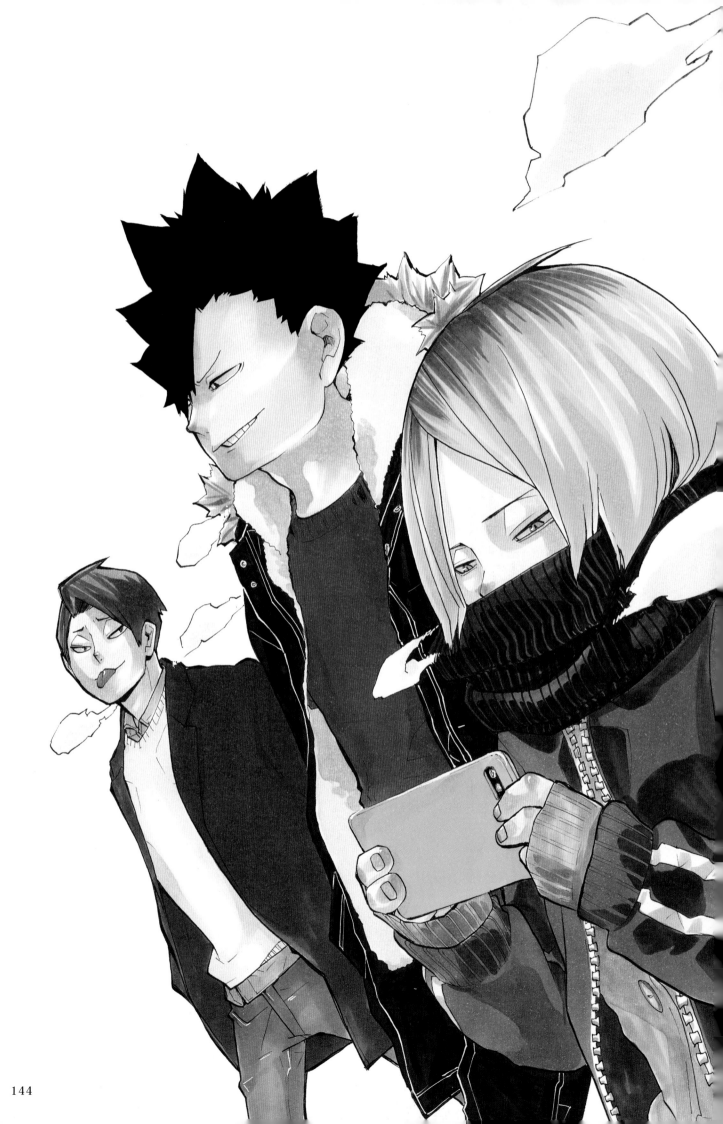

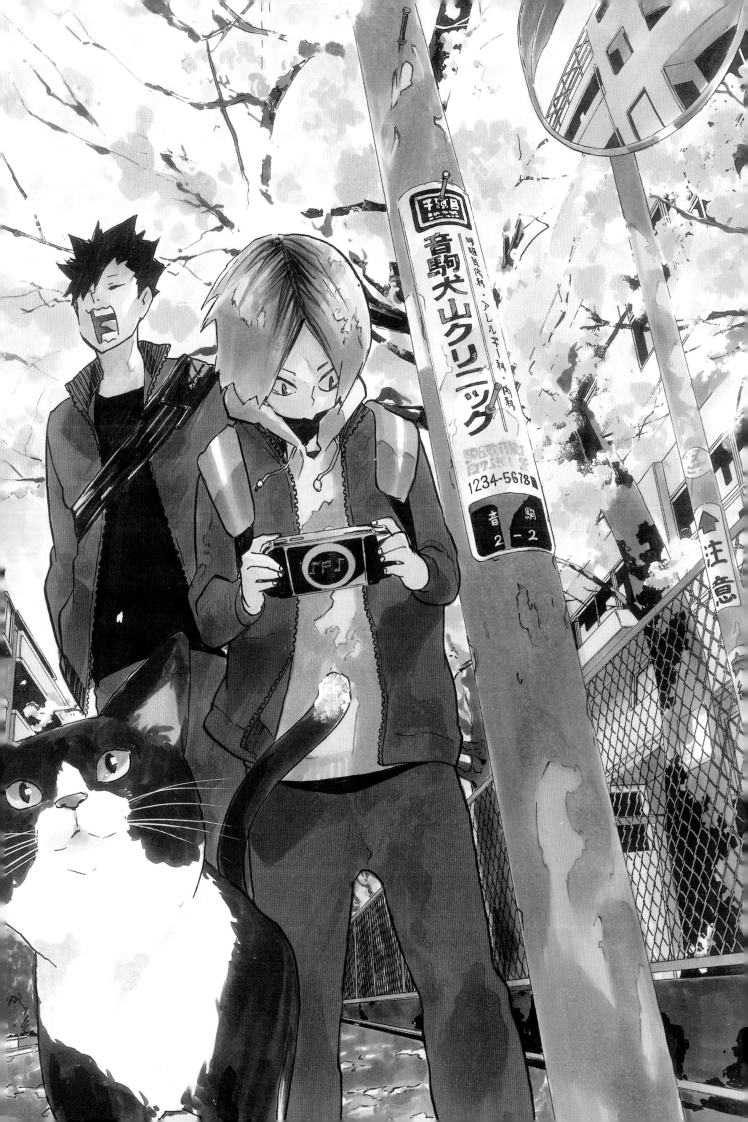

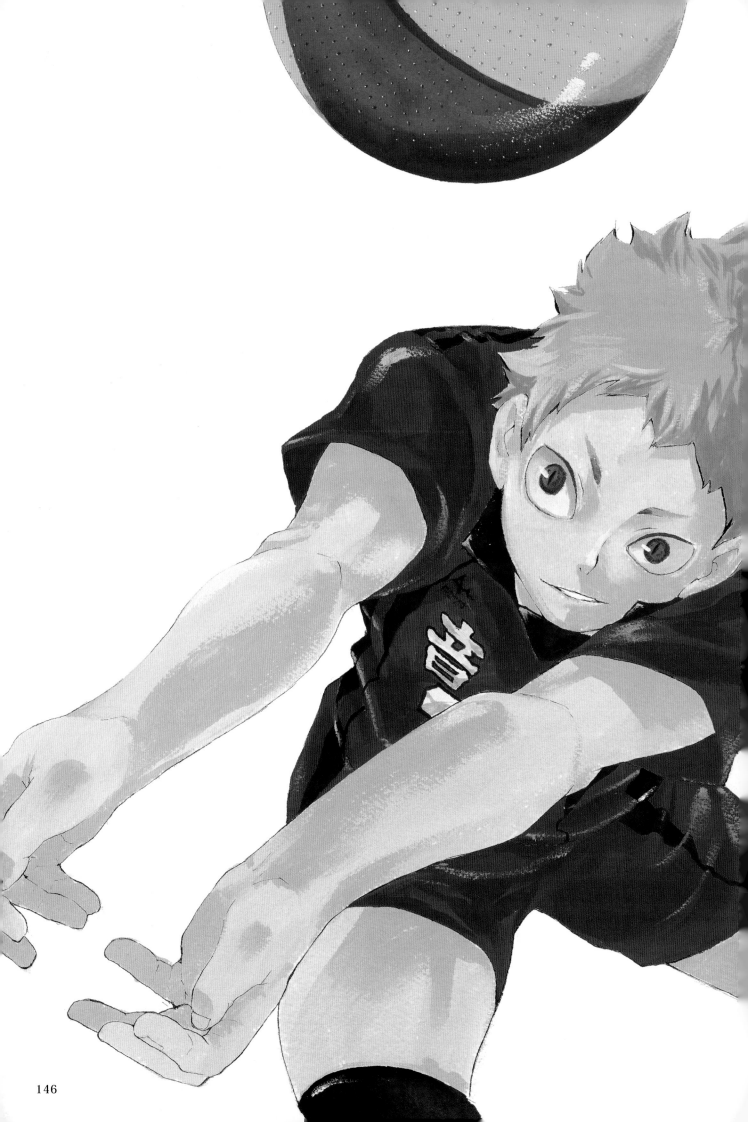

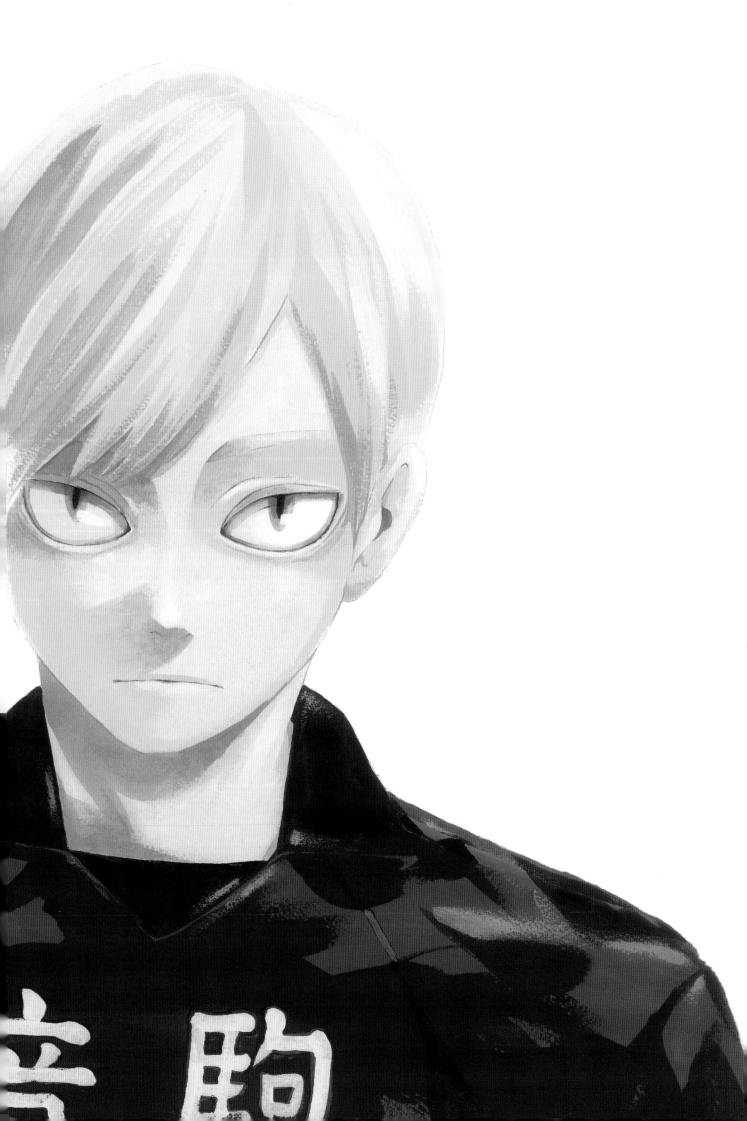

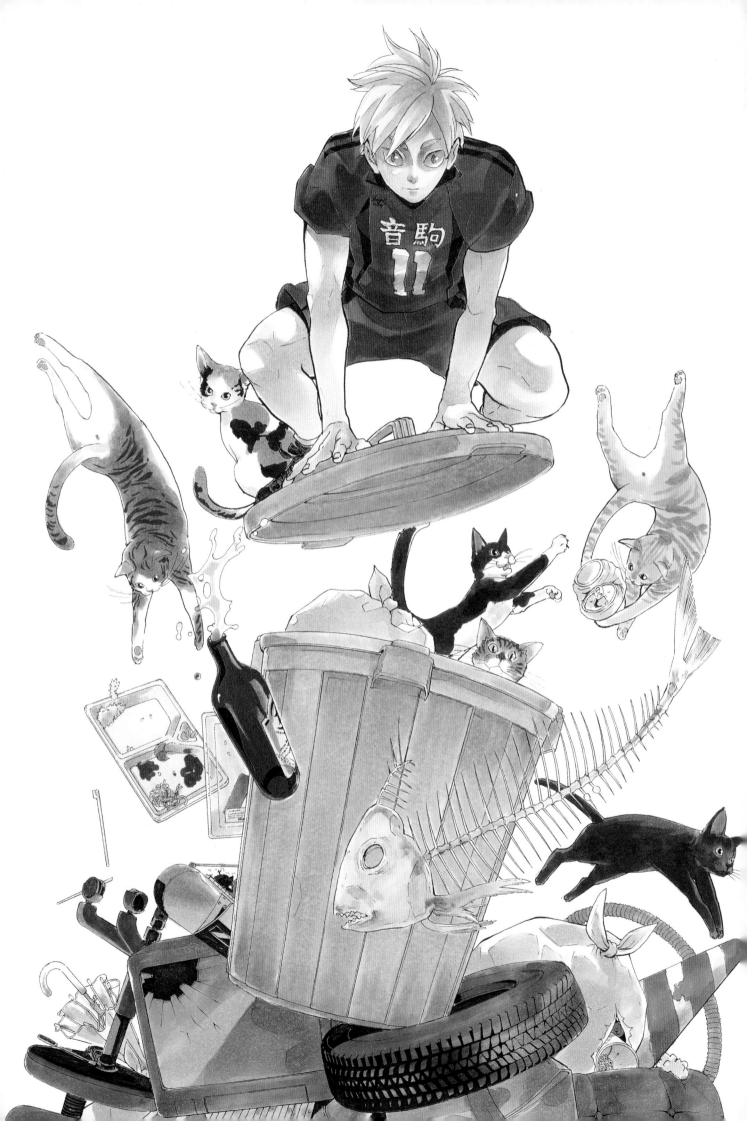

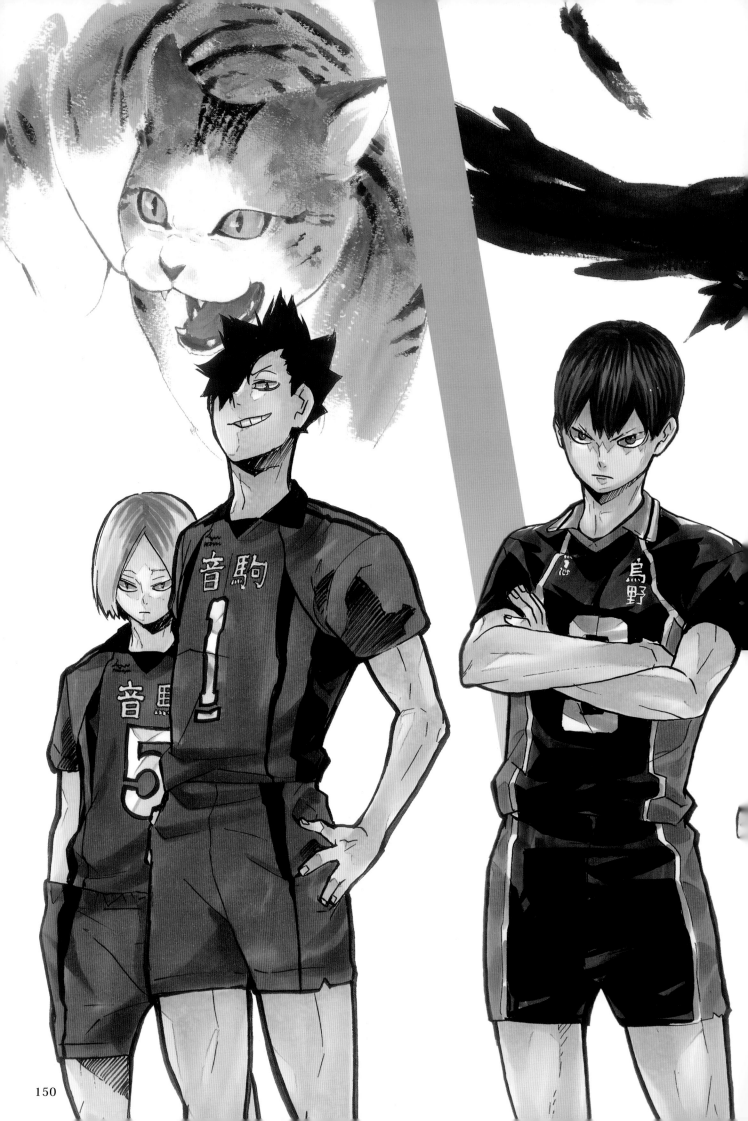

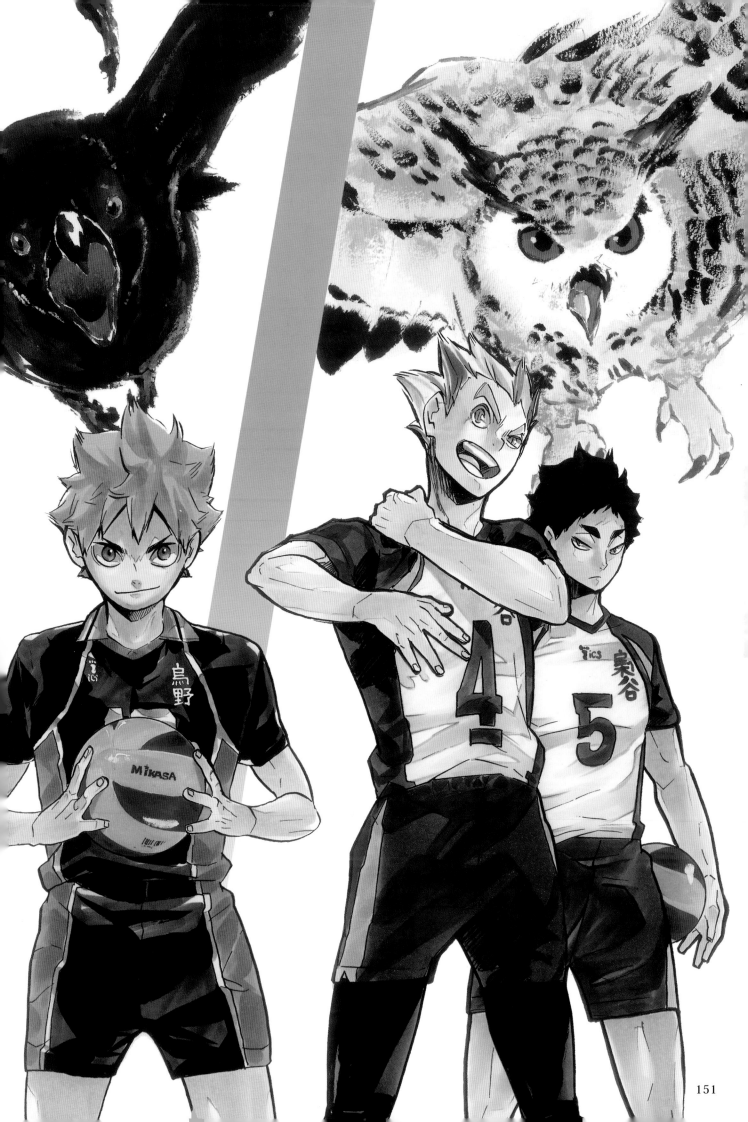

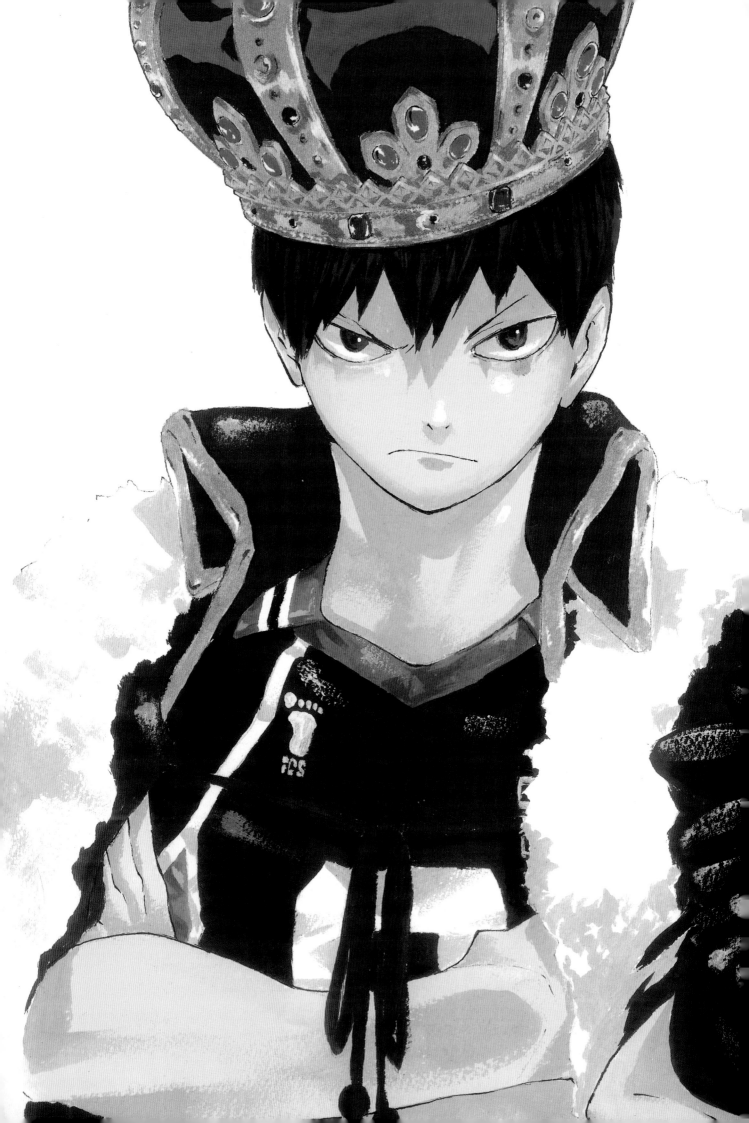

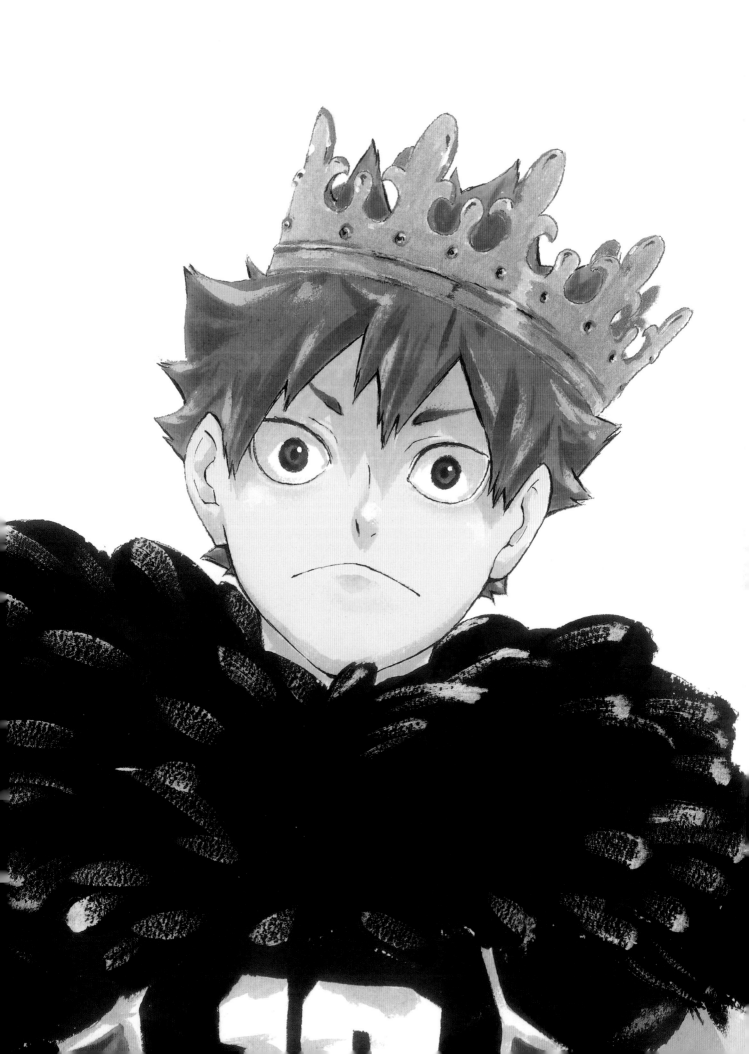

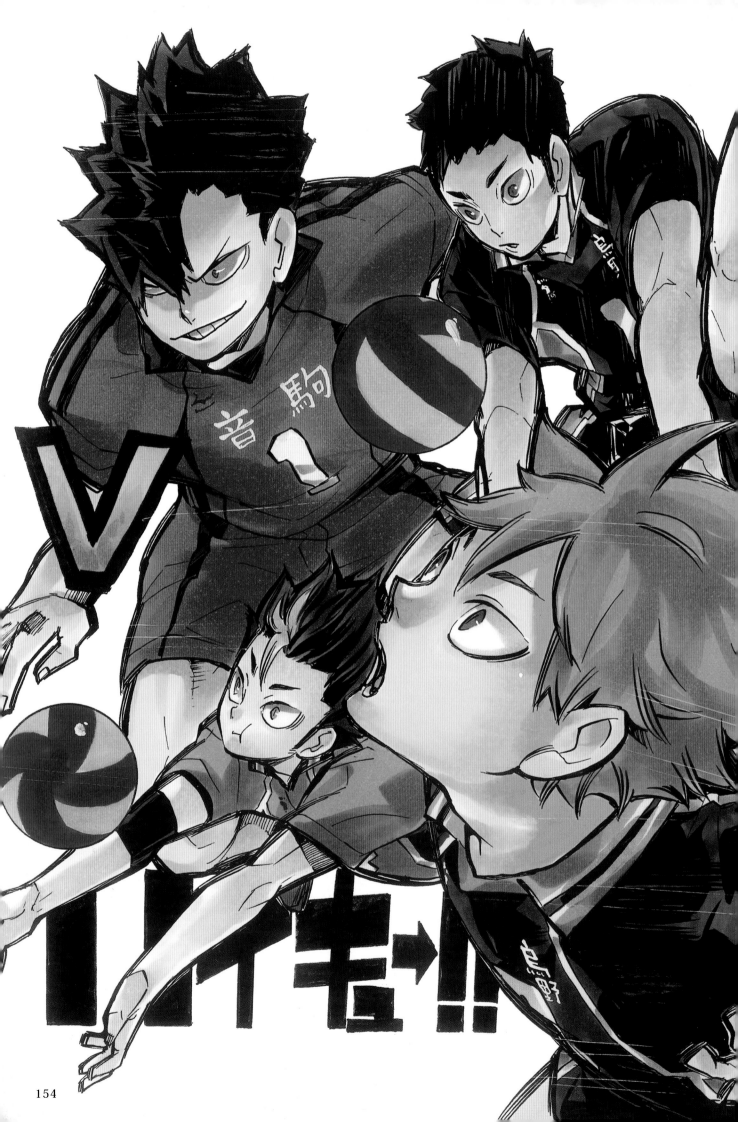

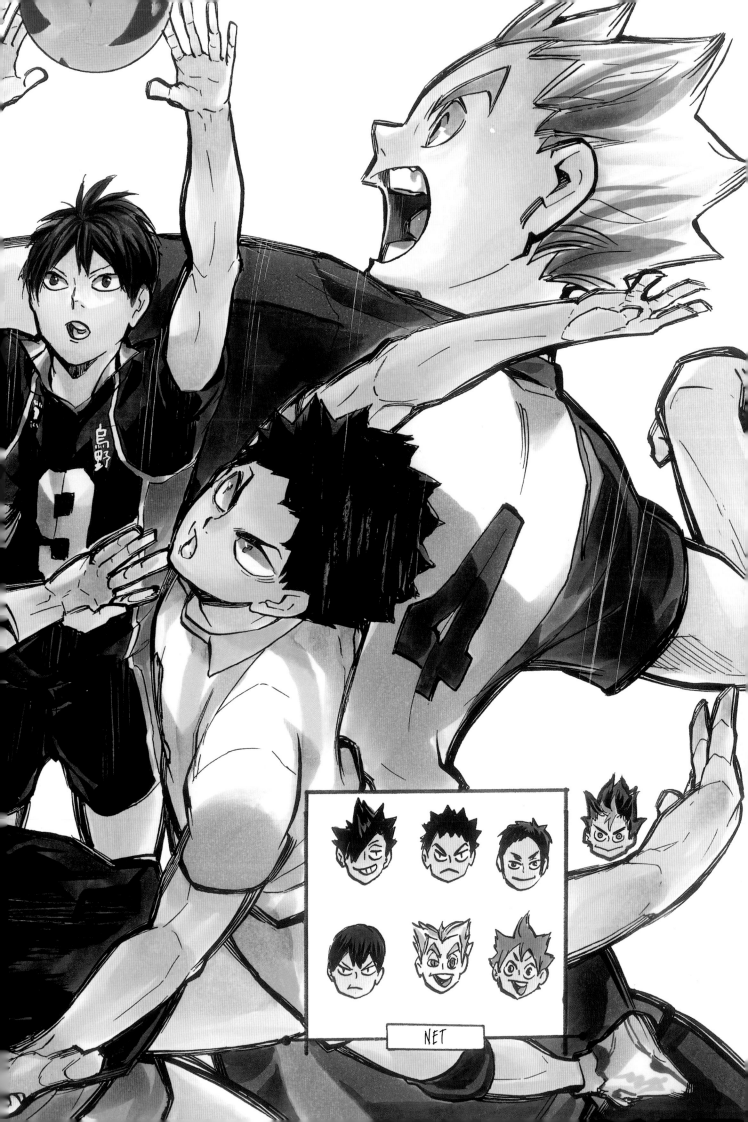

NET

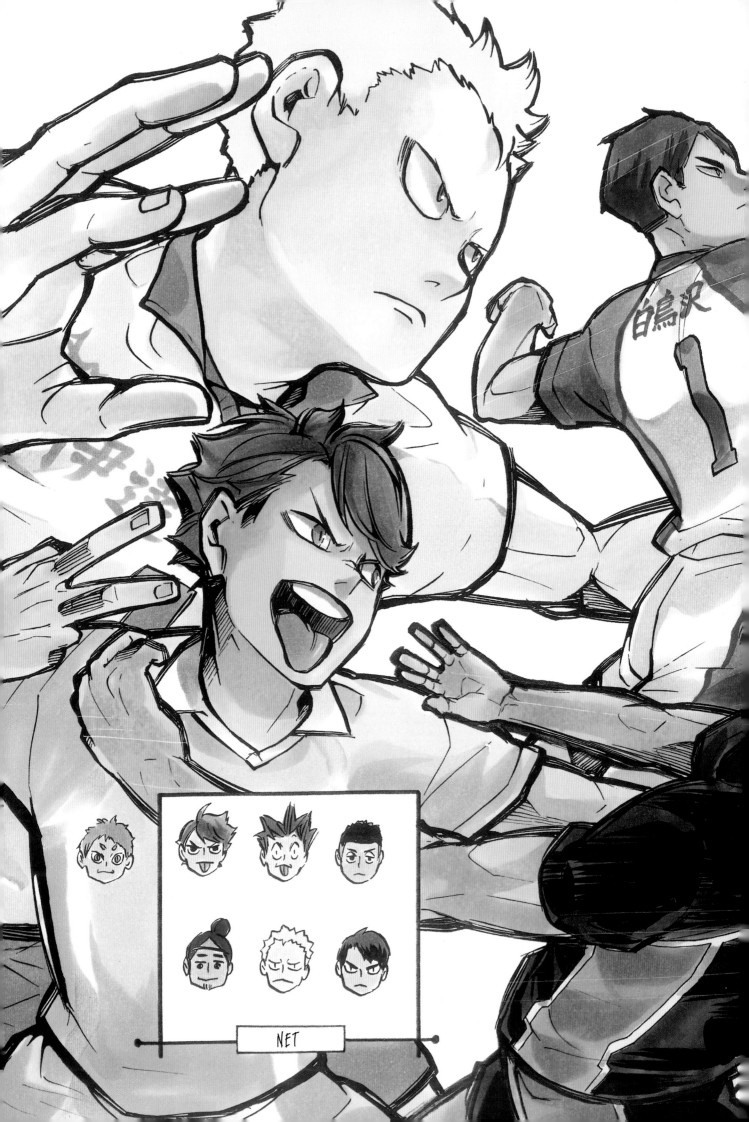

NET

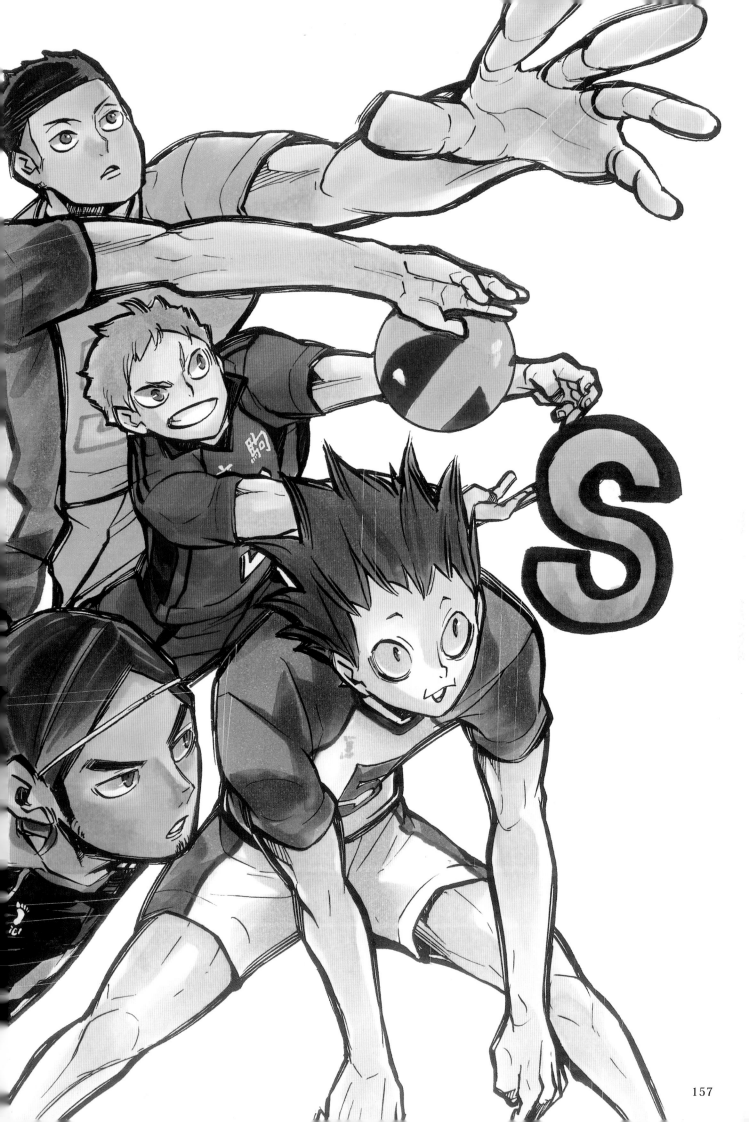

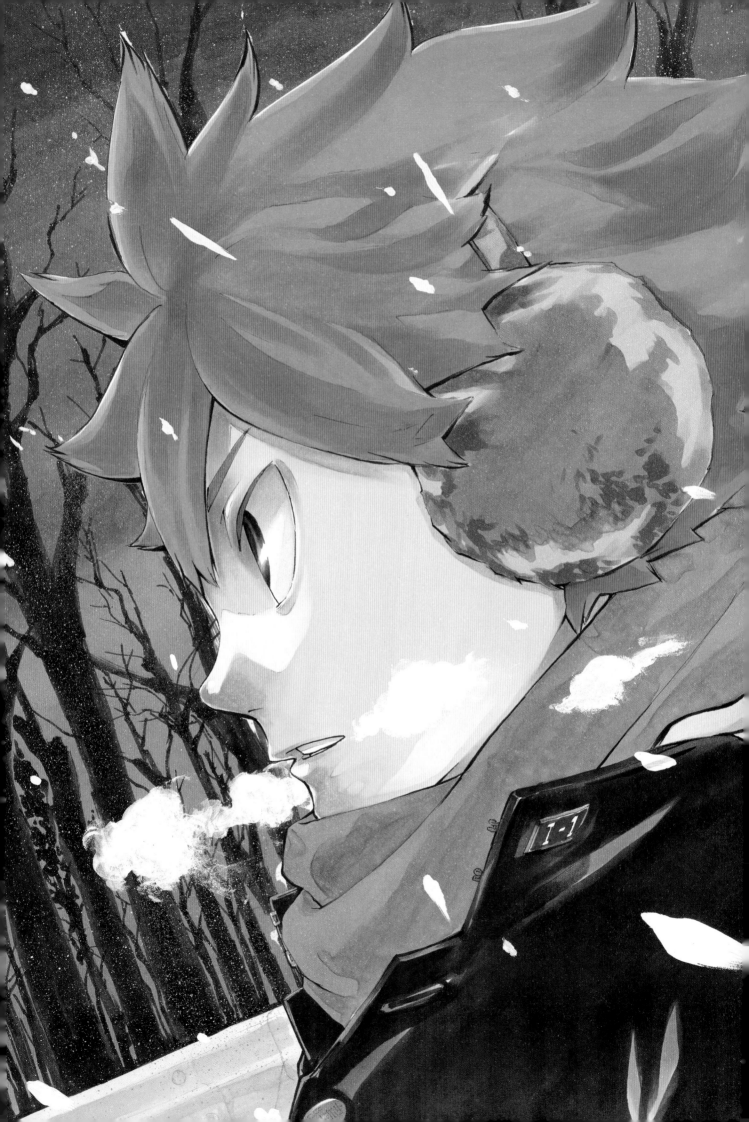

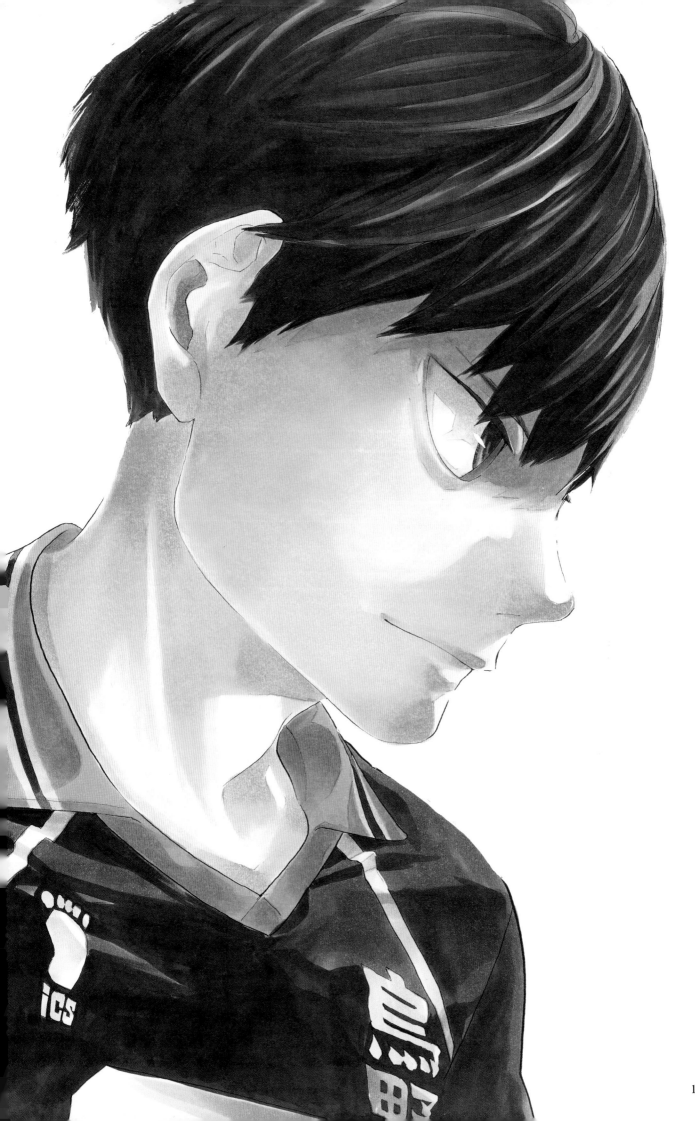

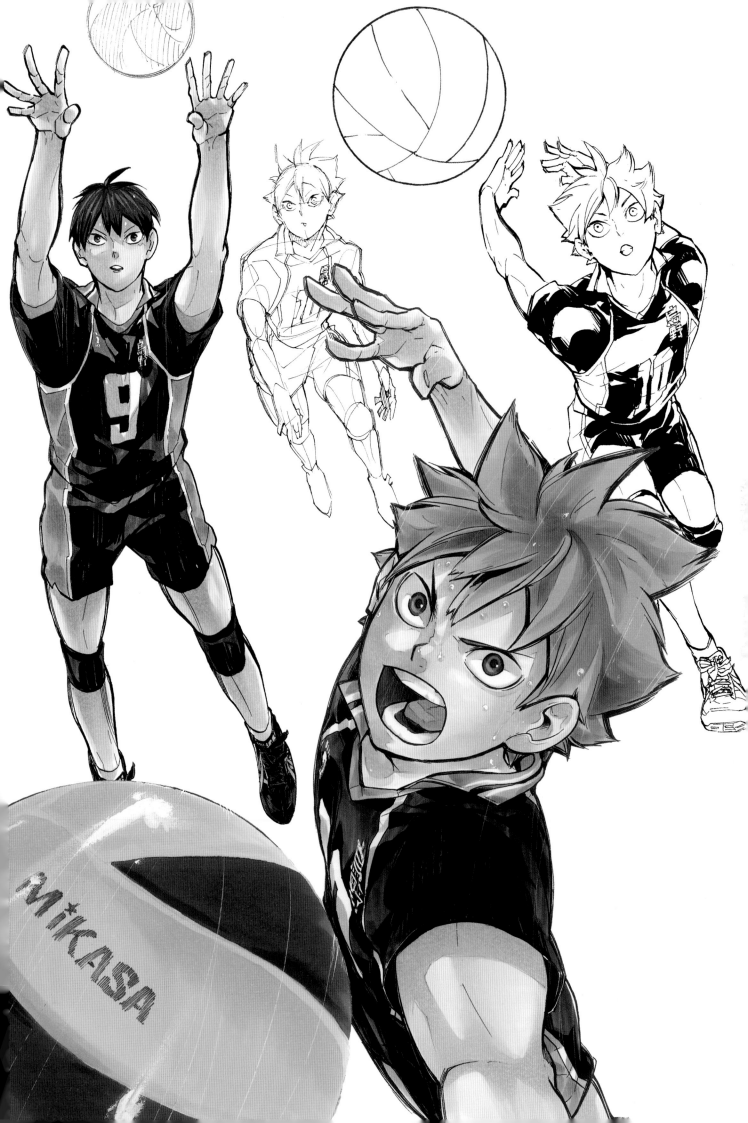

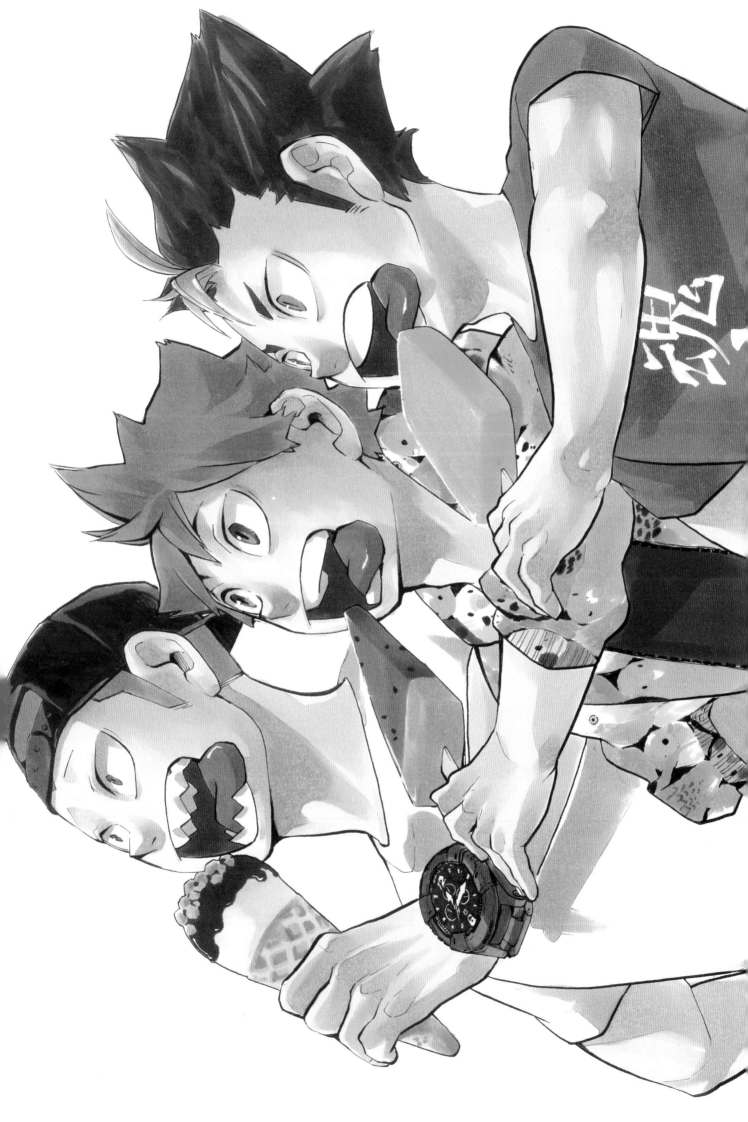

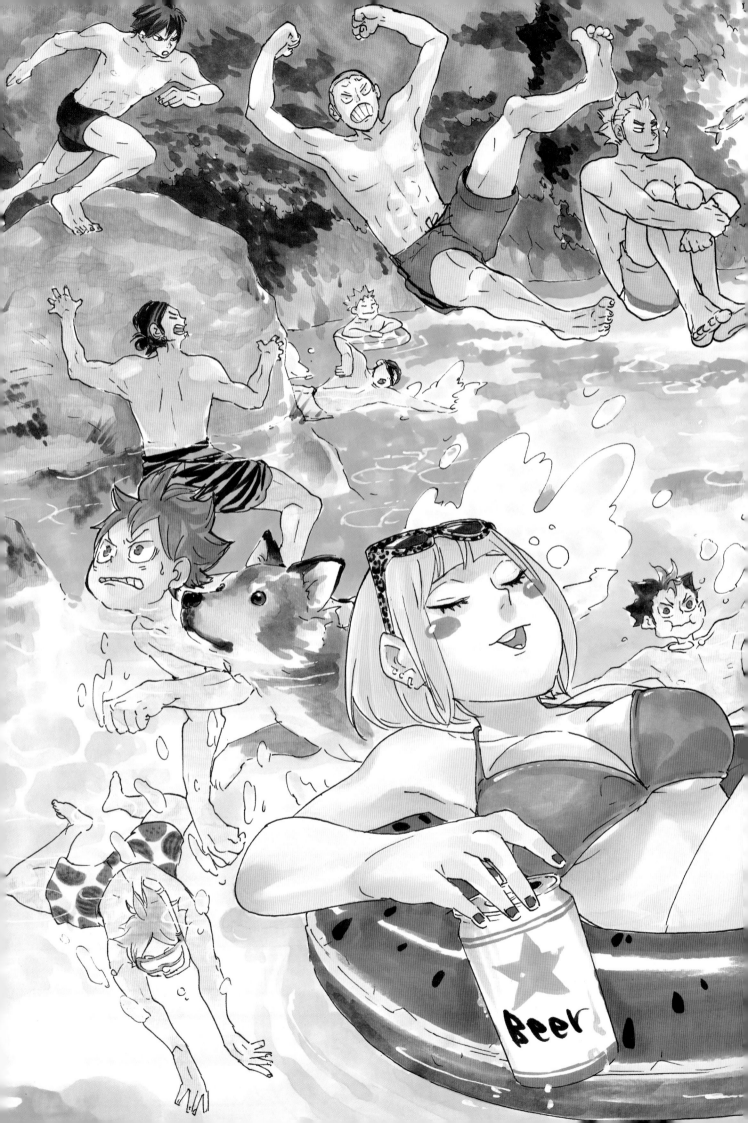

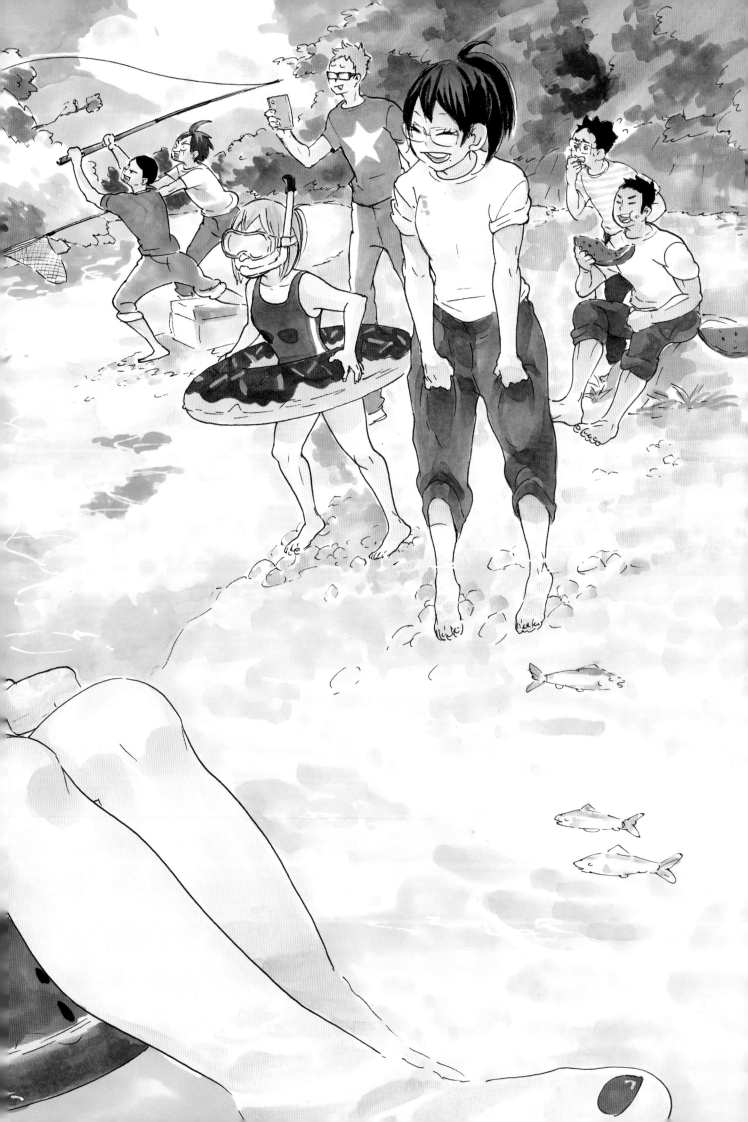

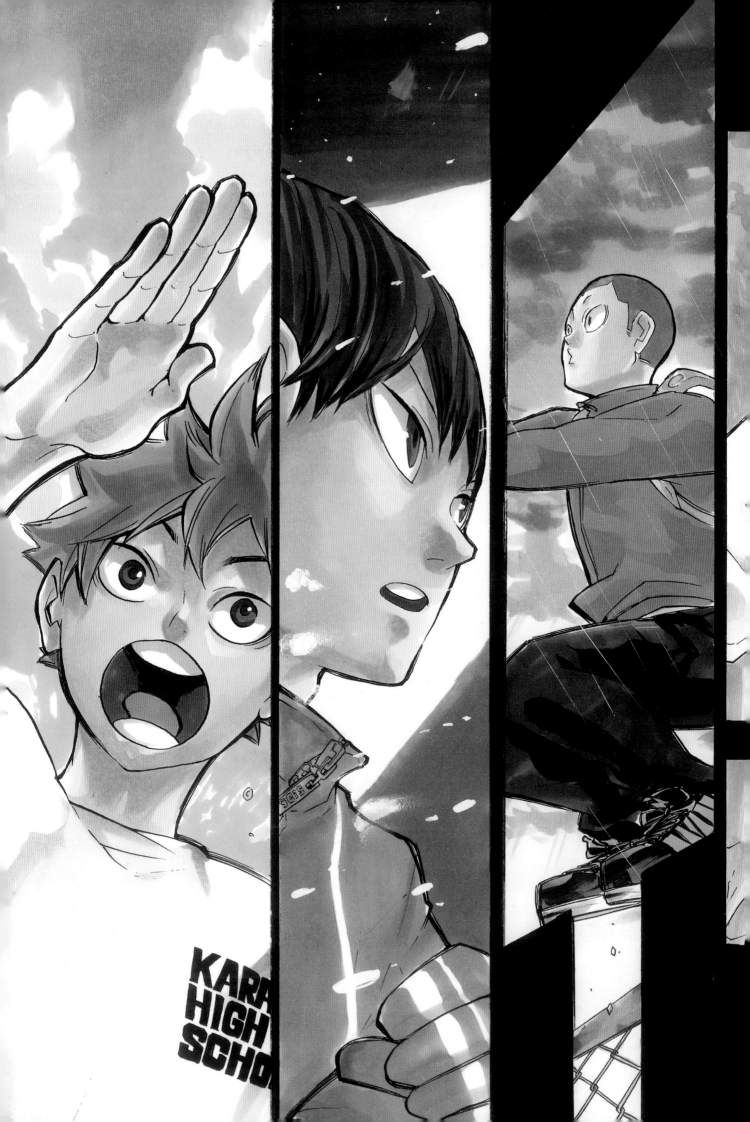

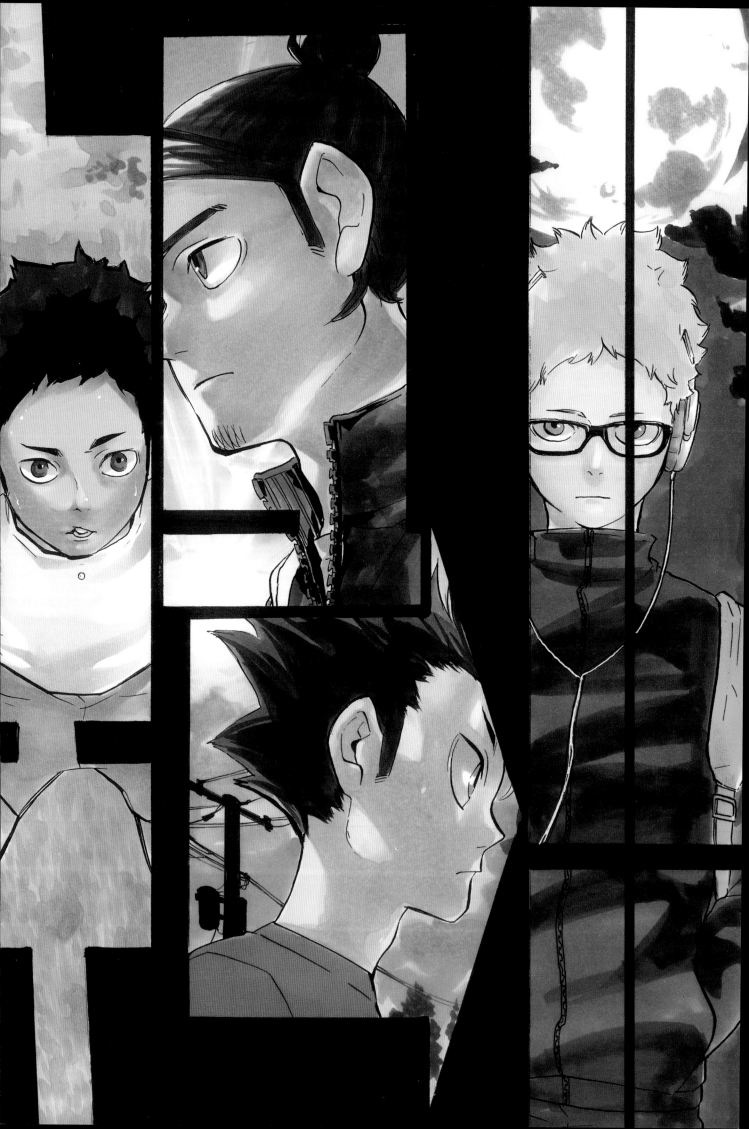

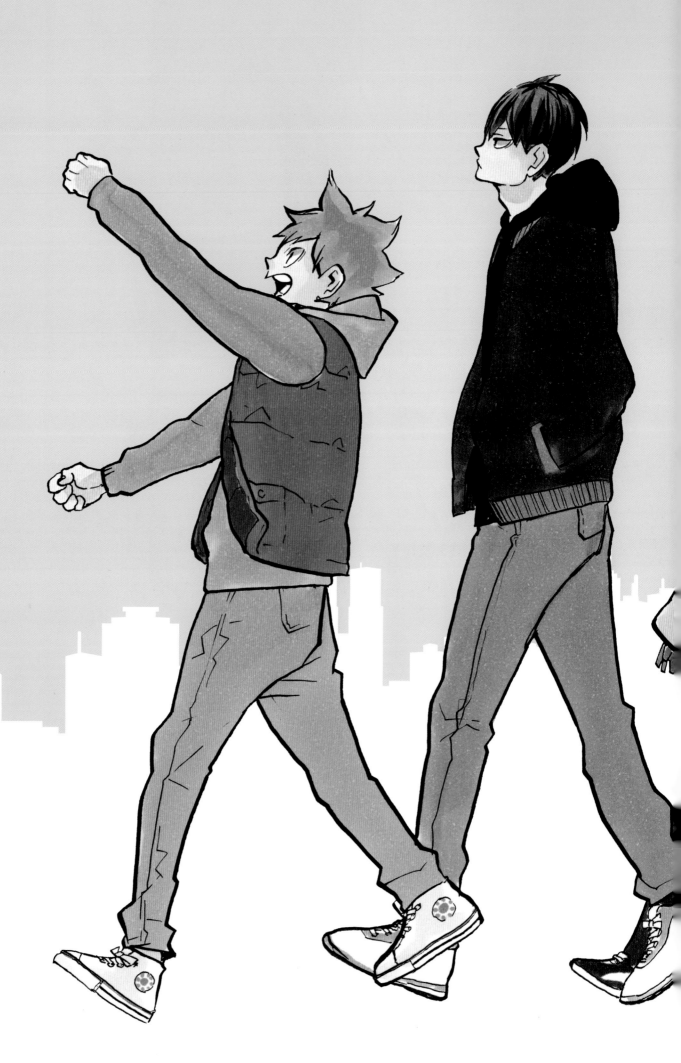

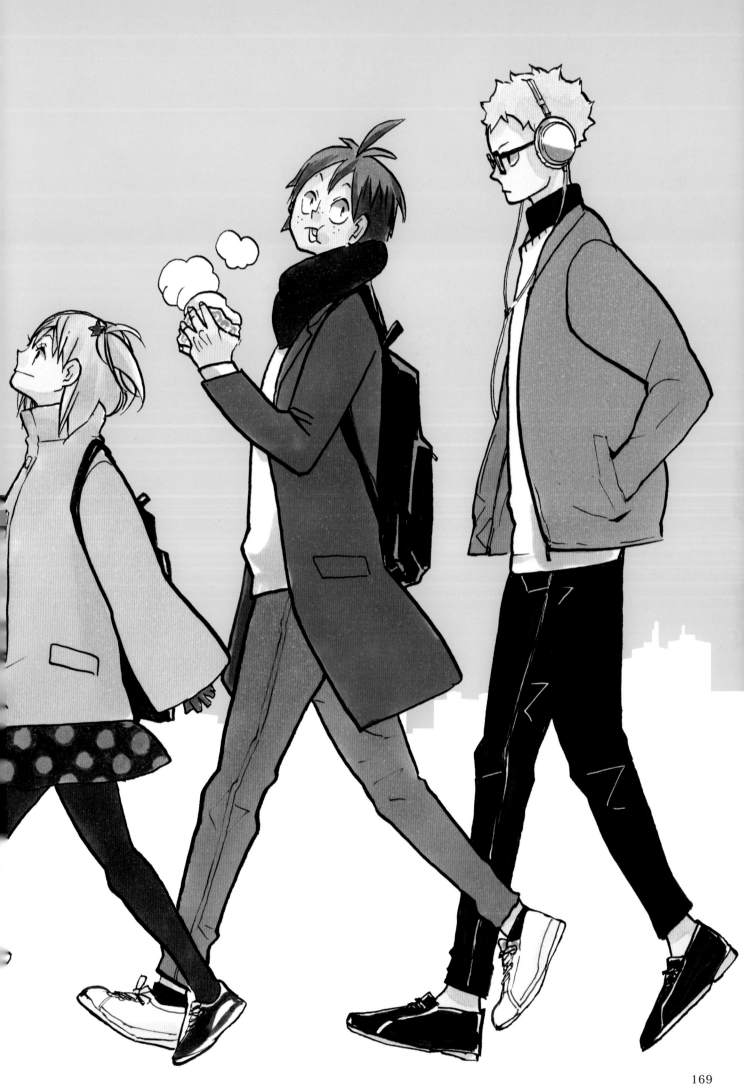

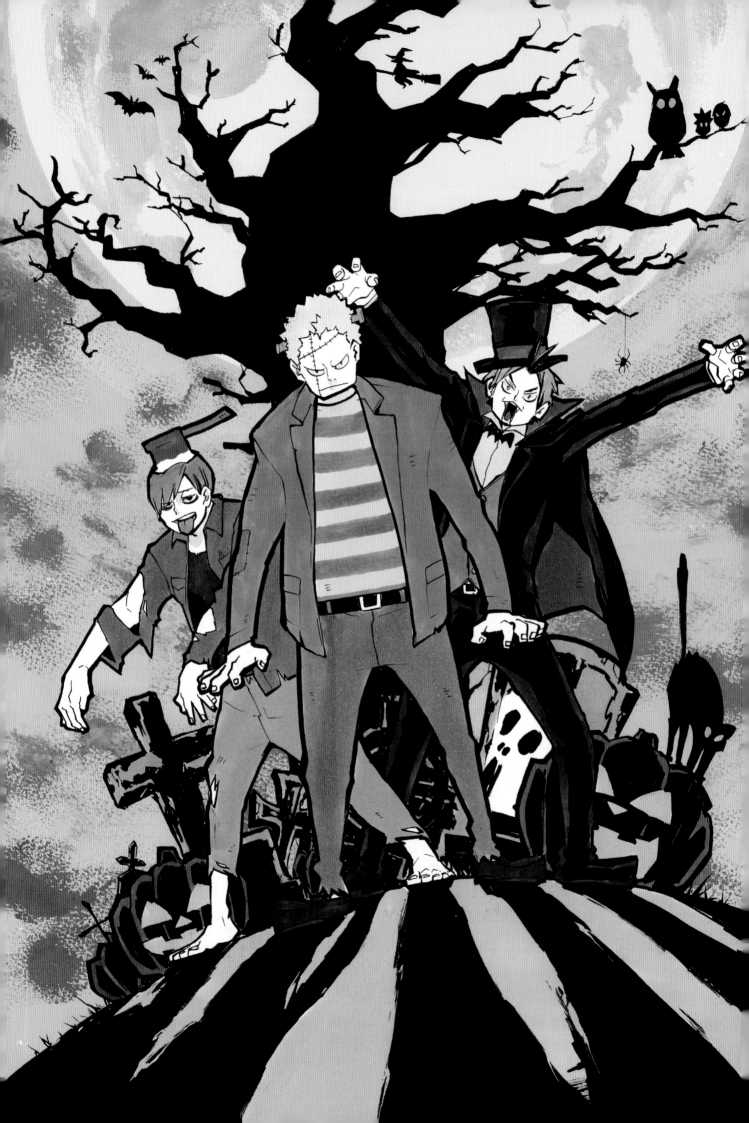

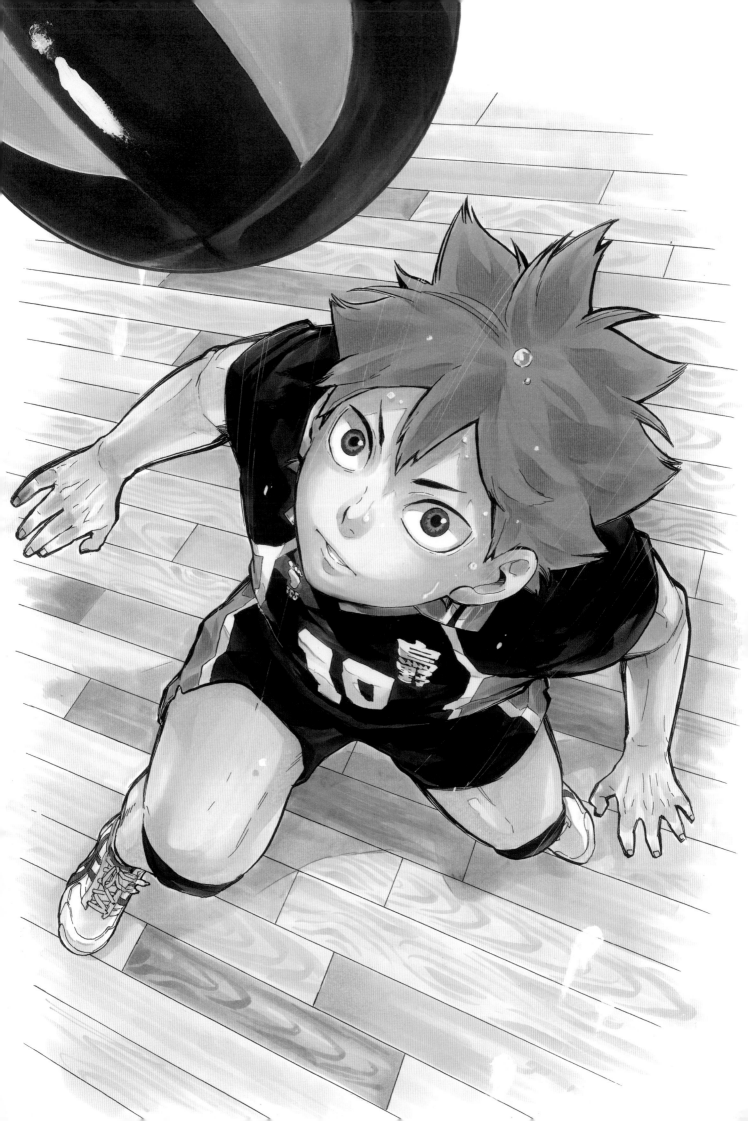

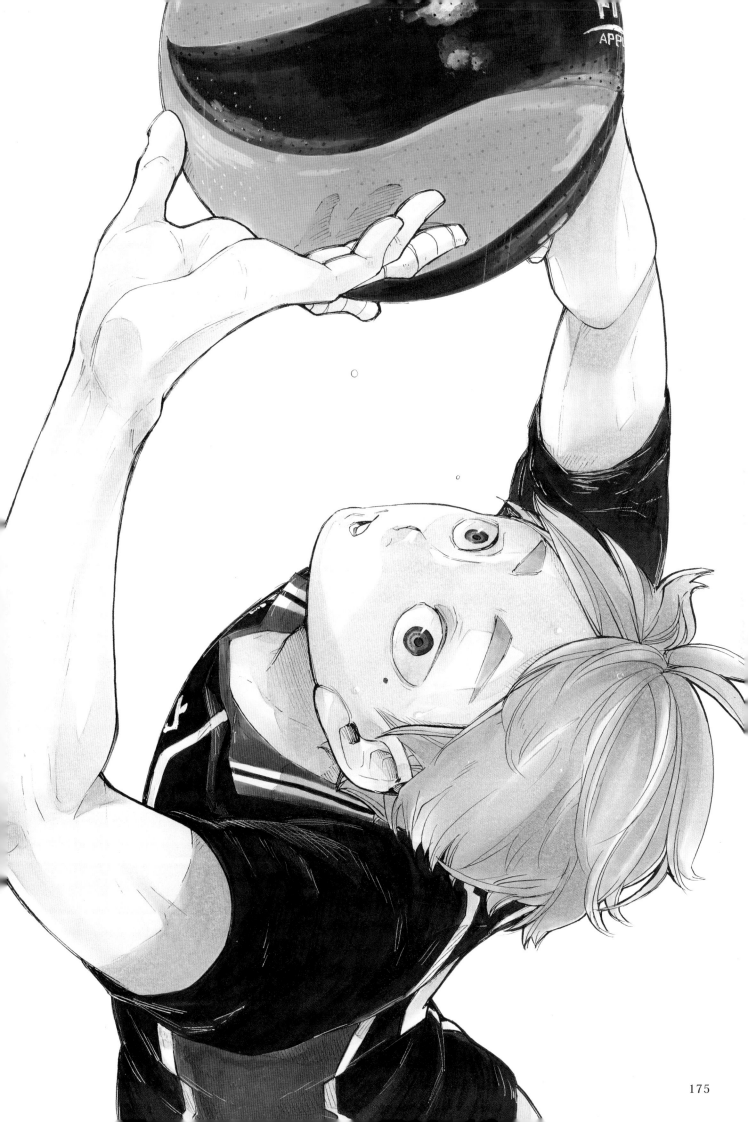

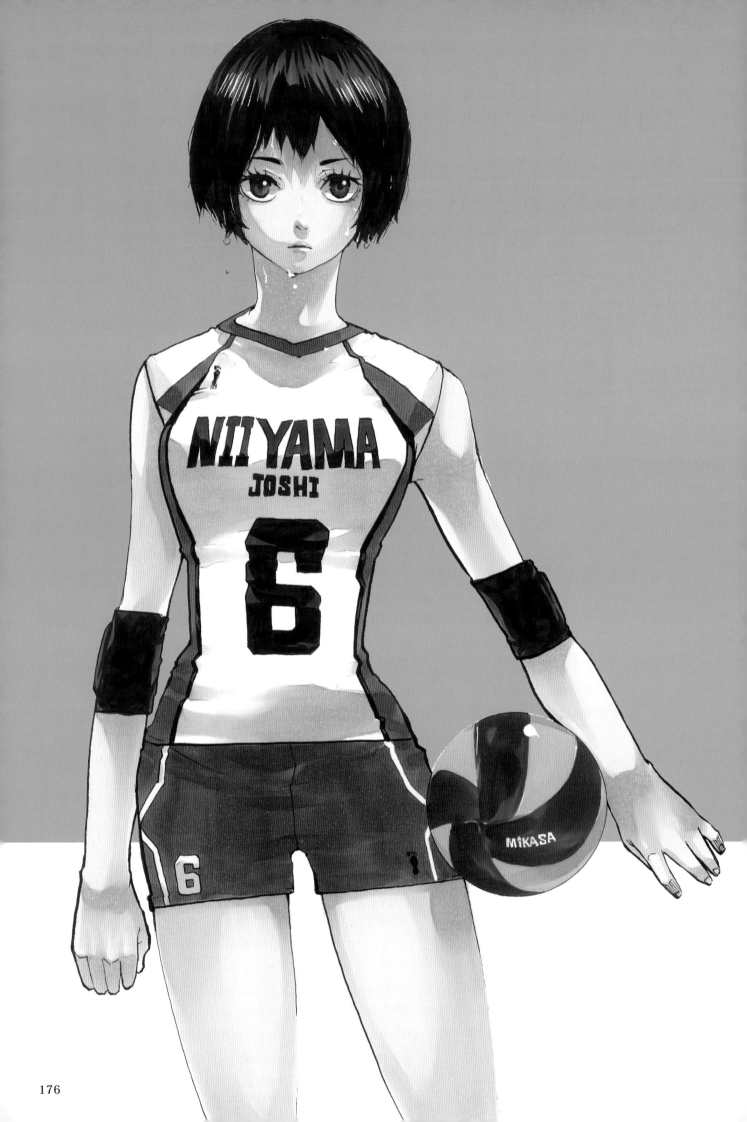

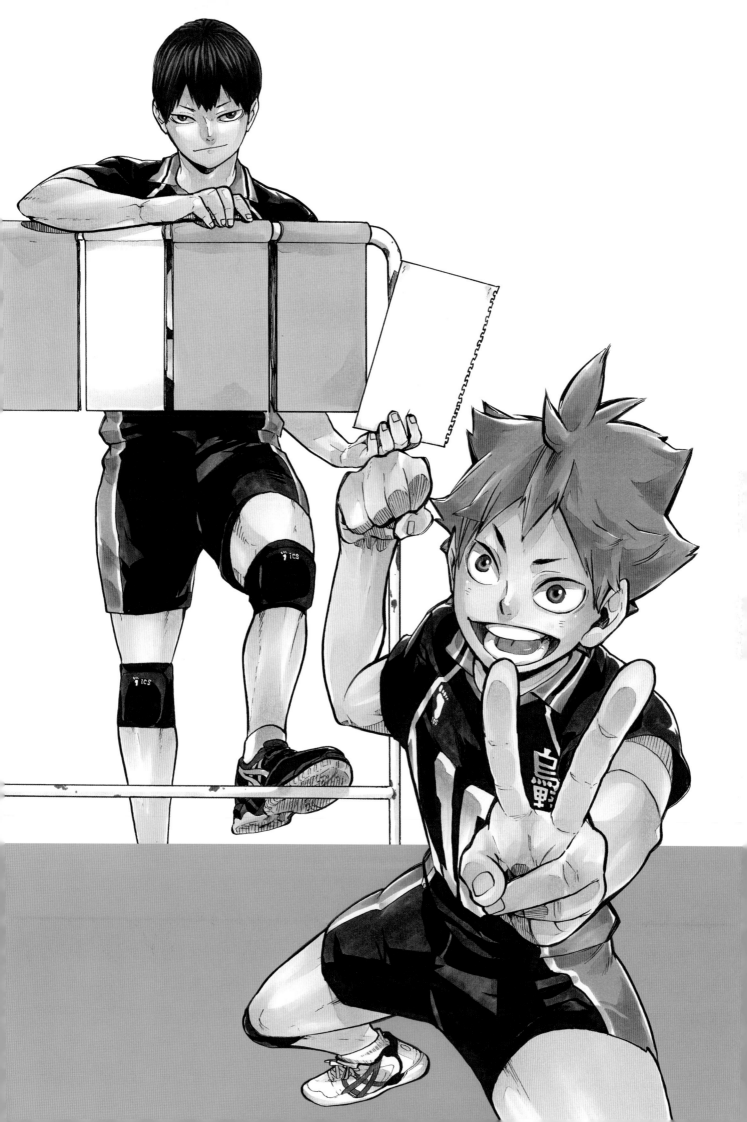

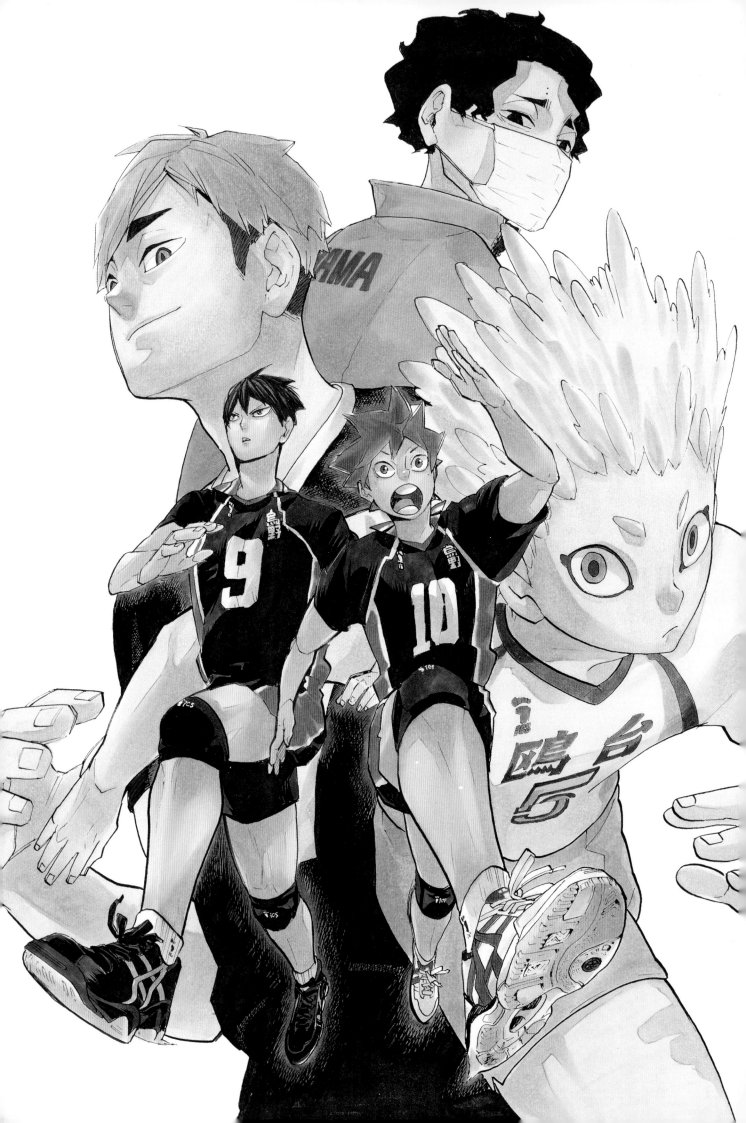

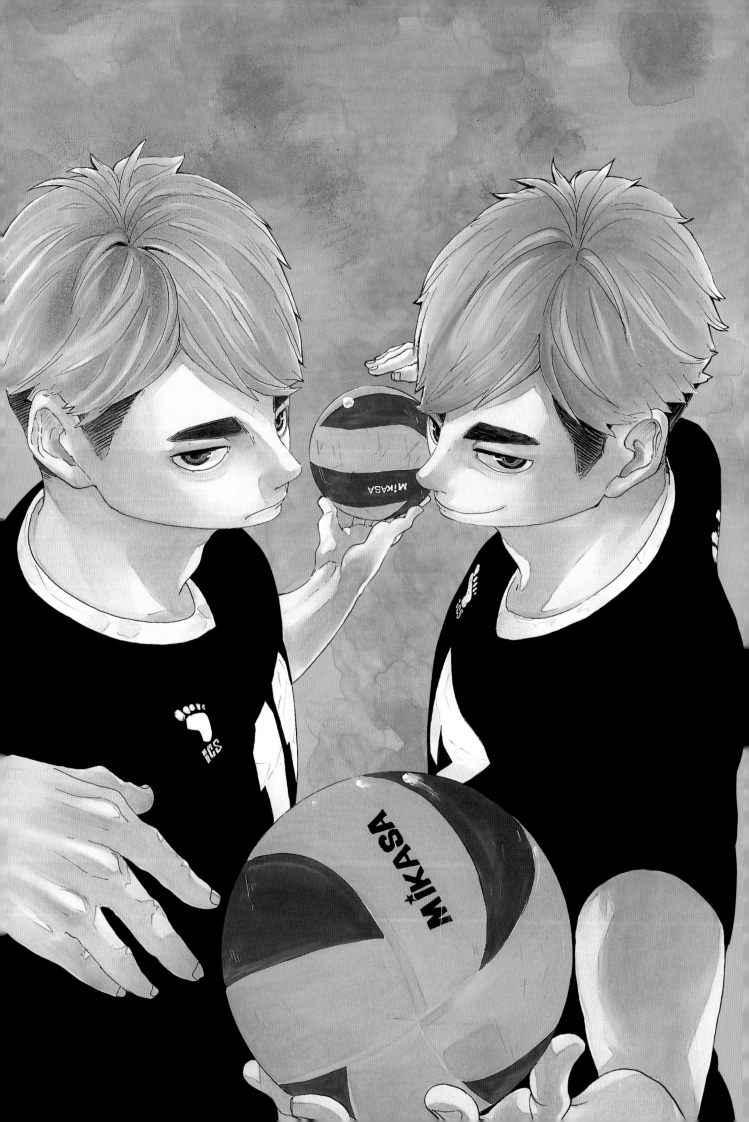

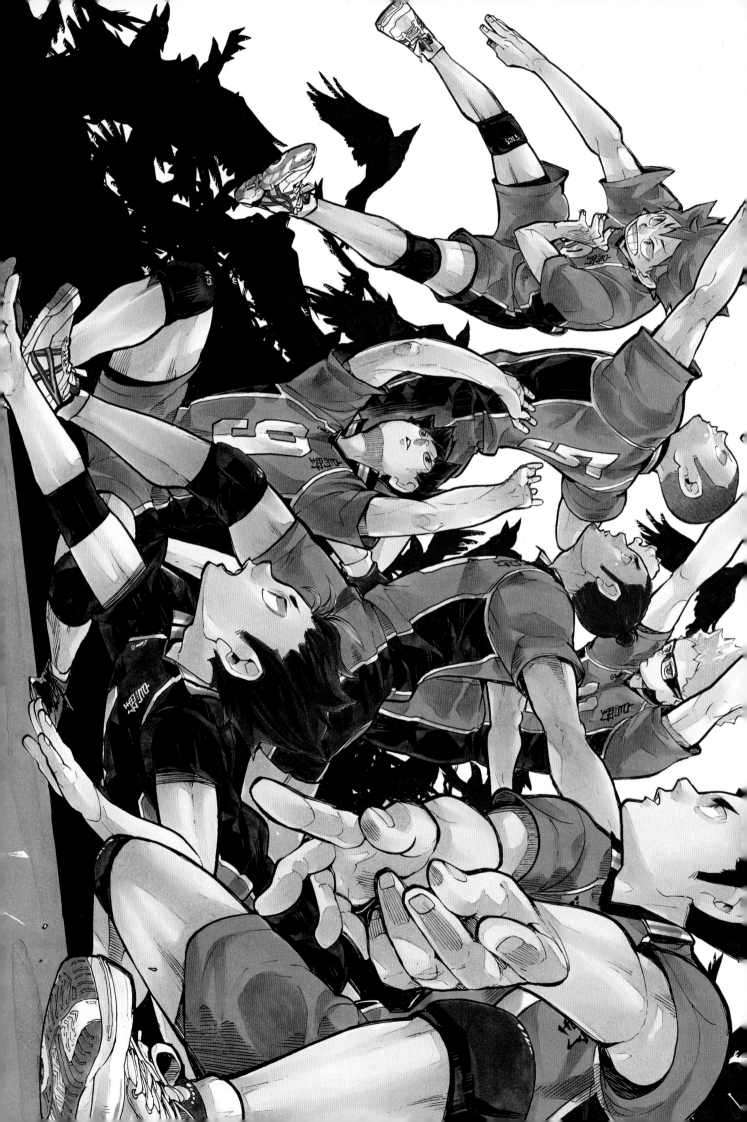

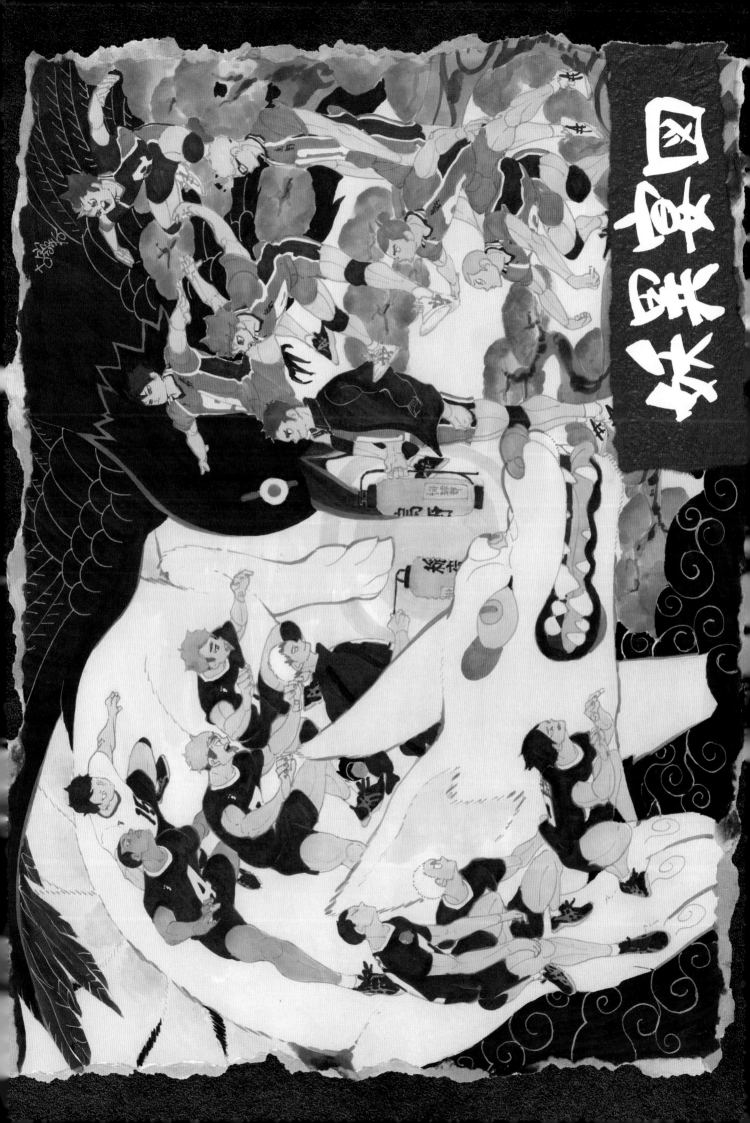

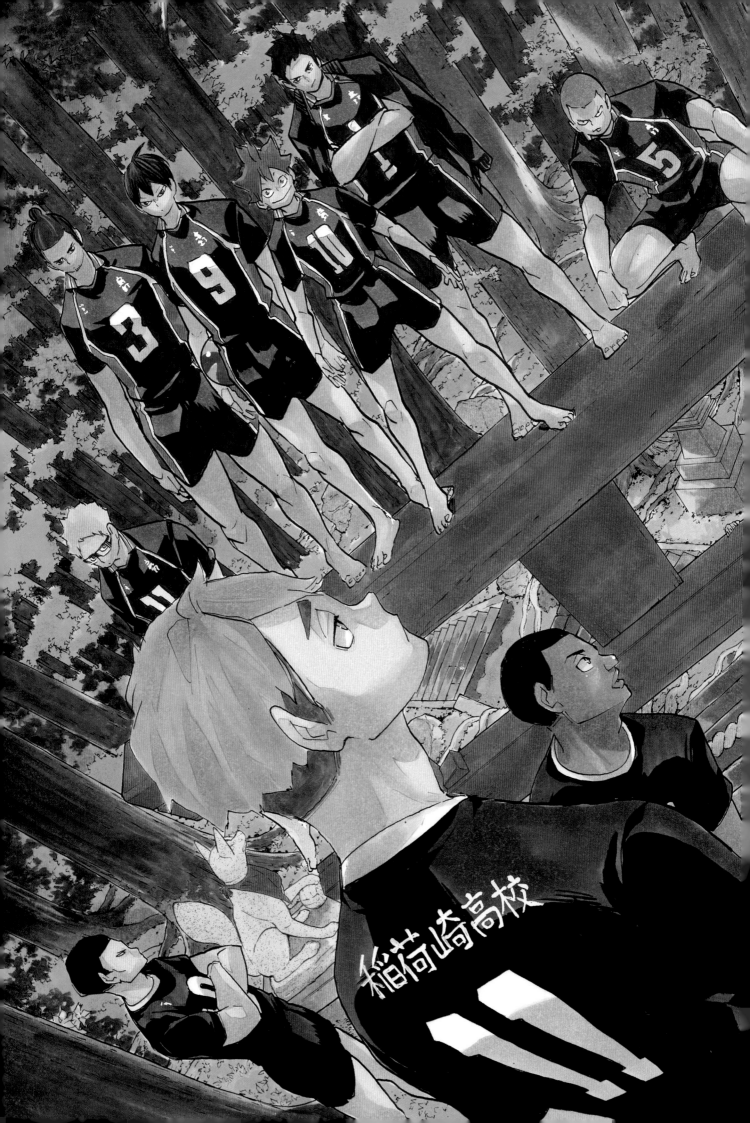

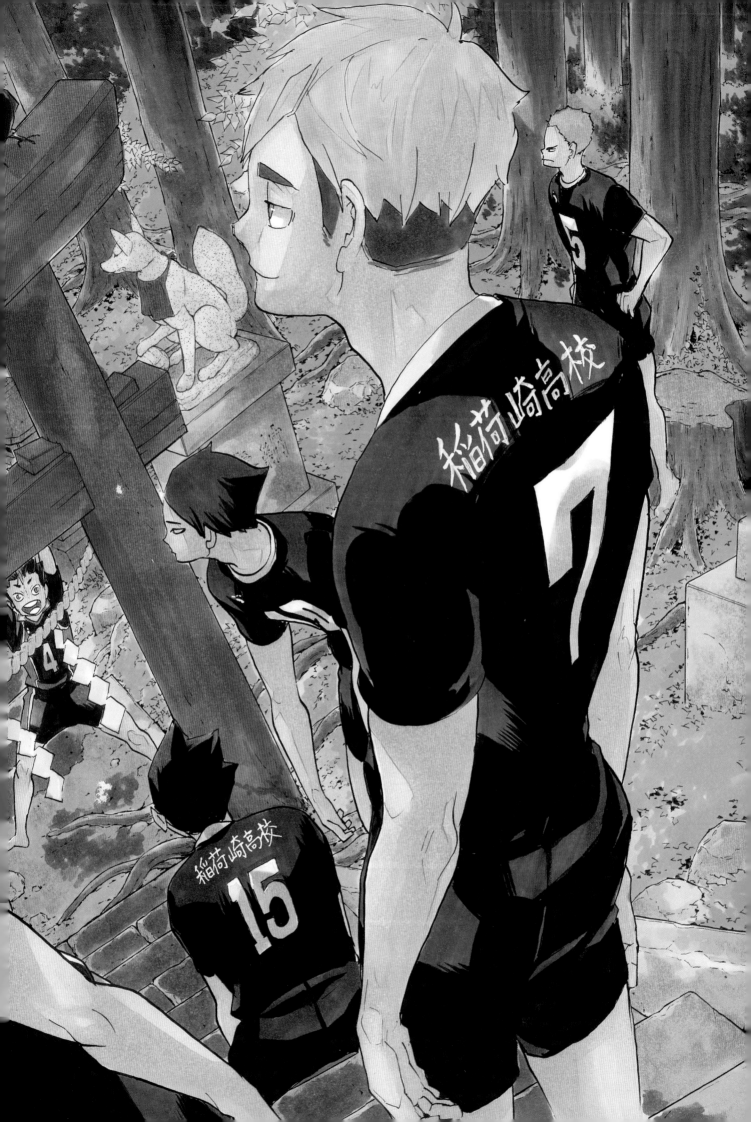

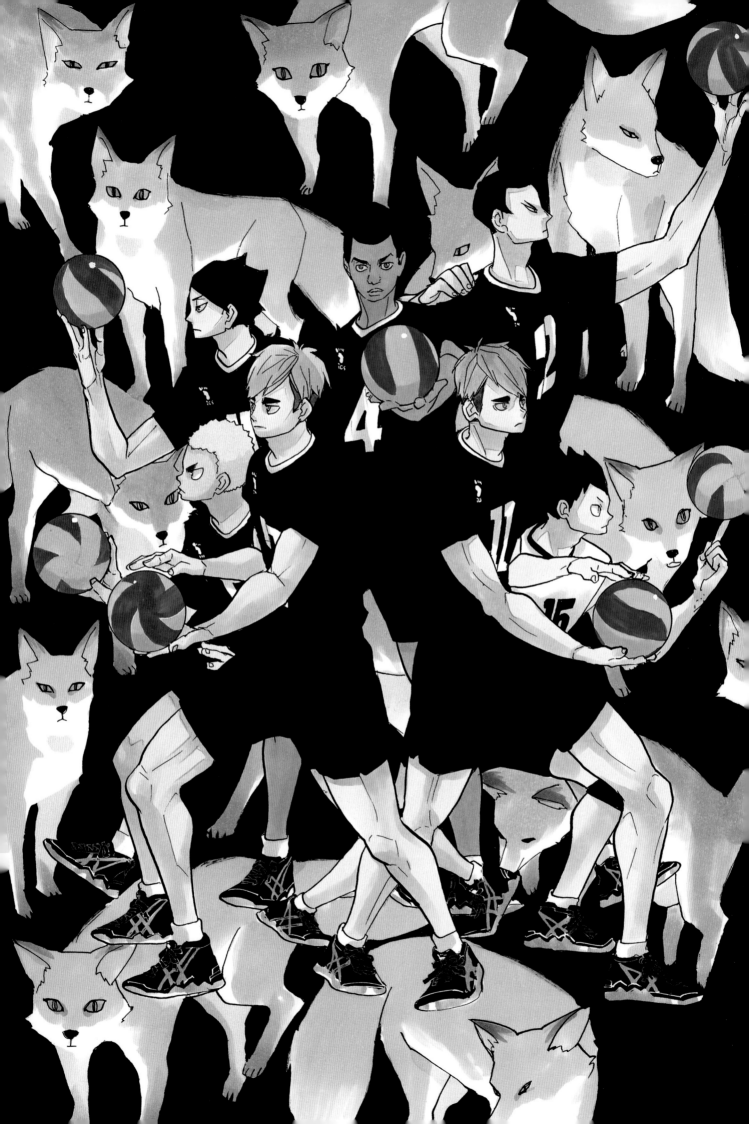

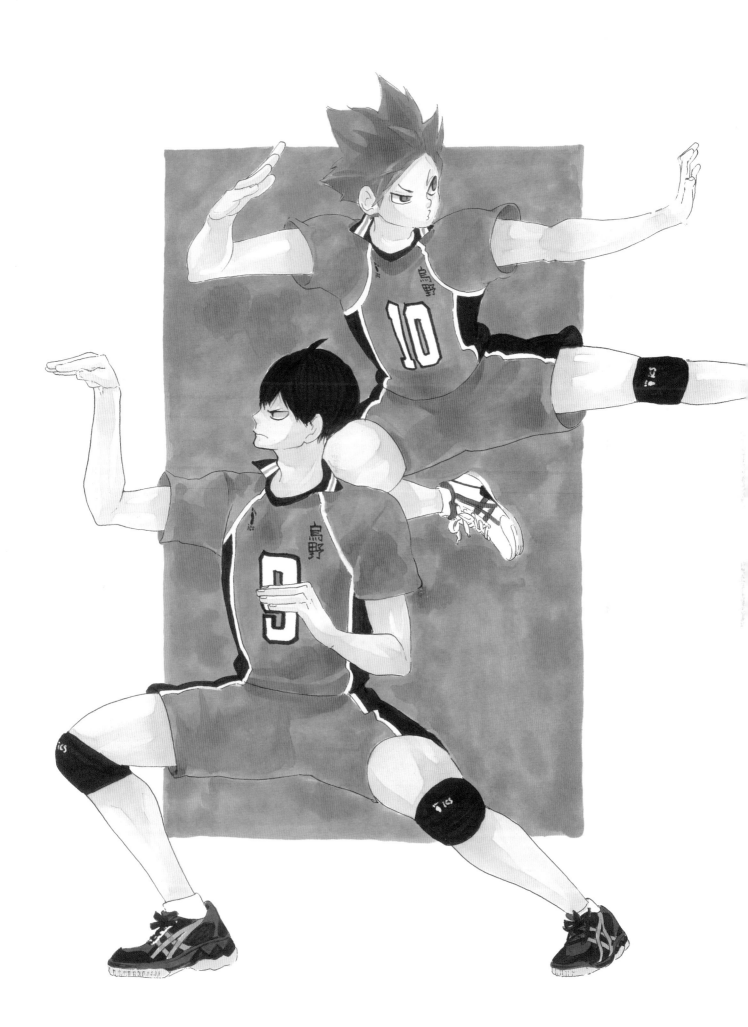

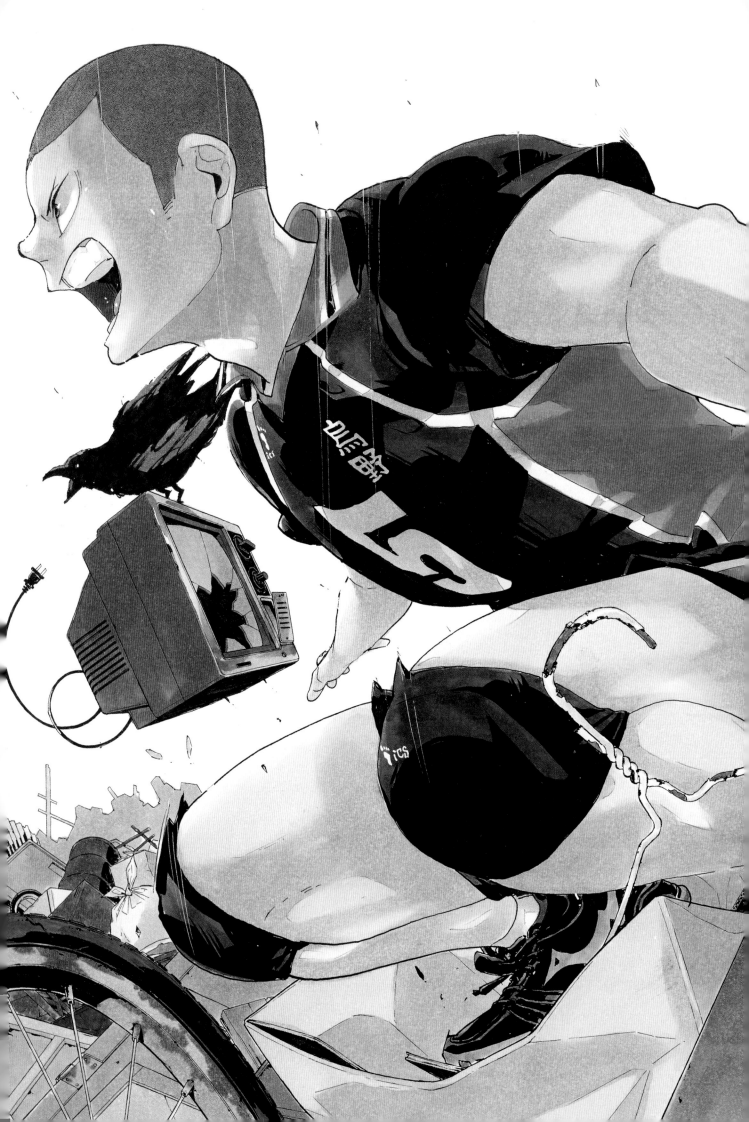

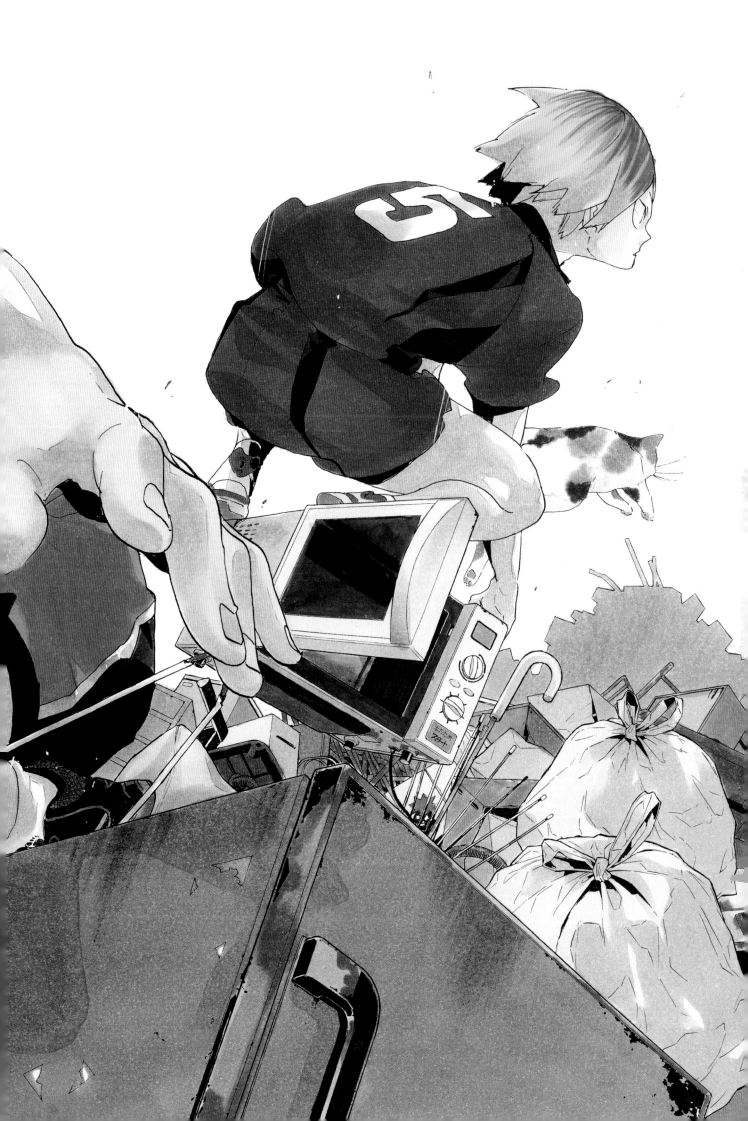

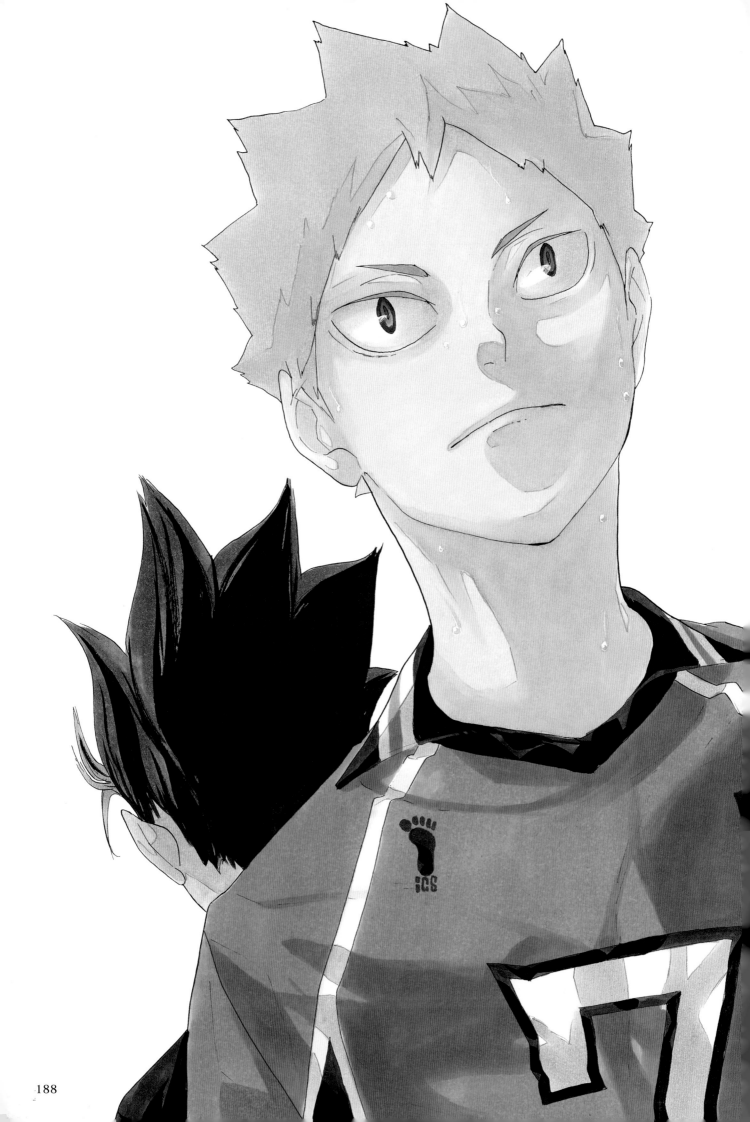

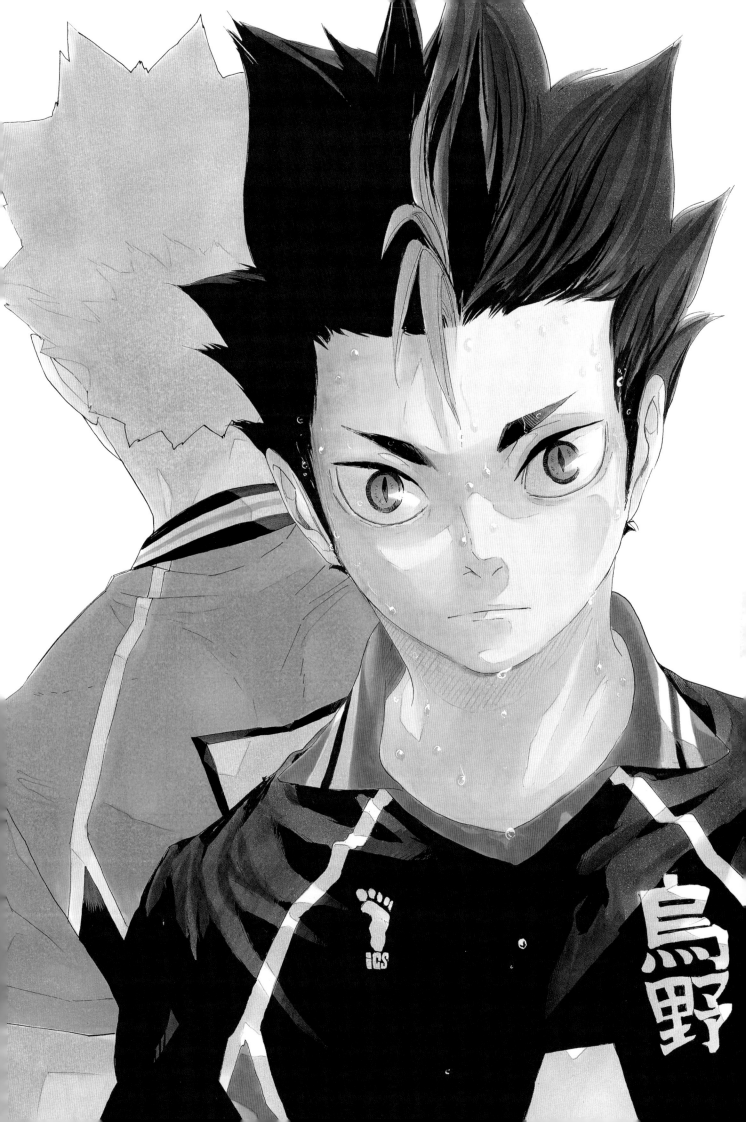

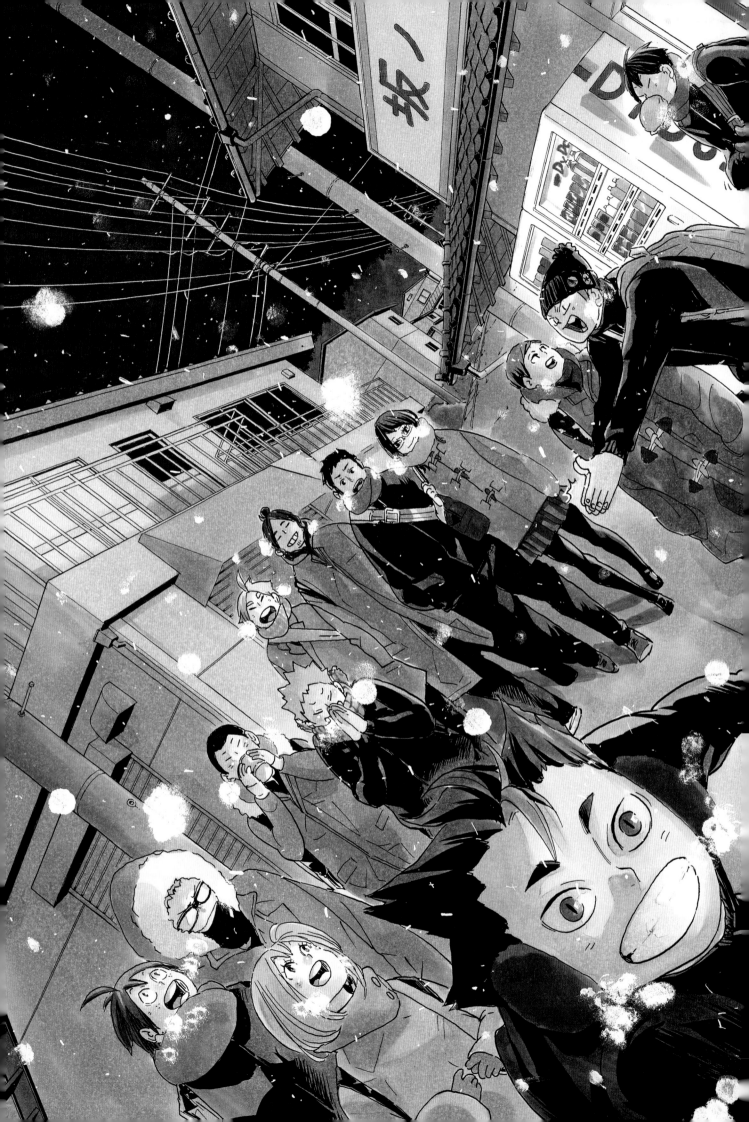

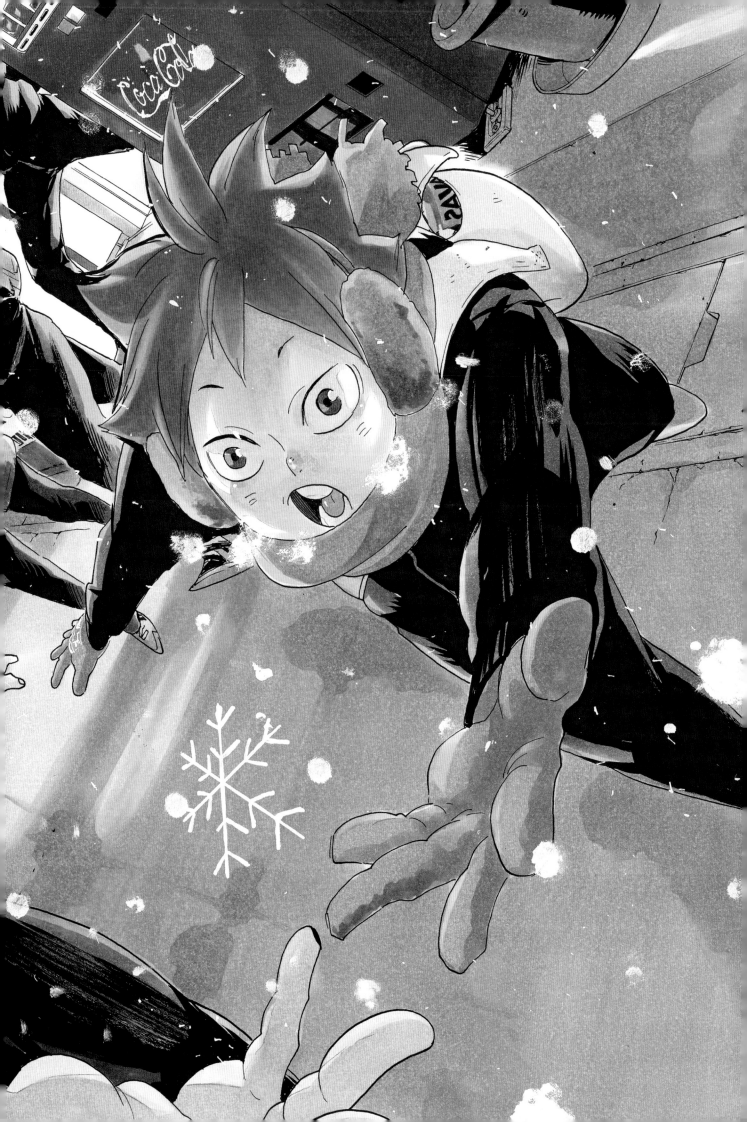

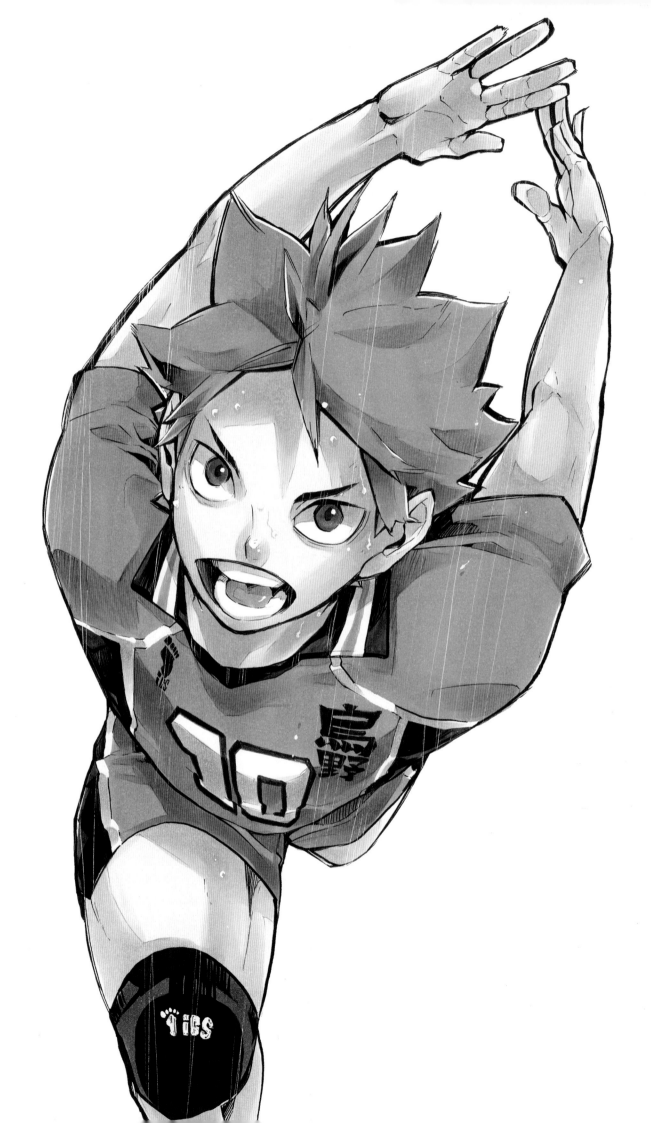

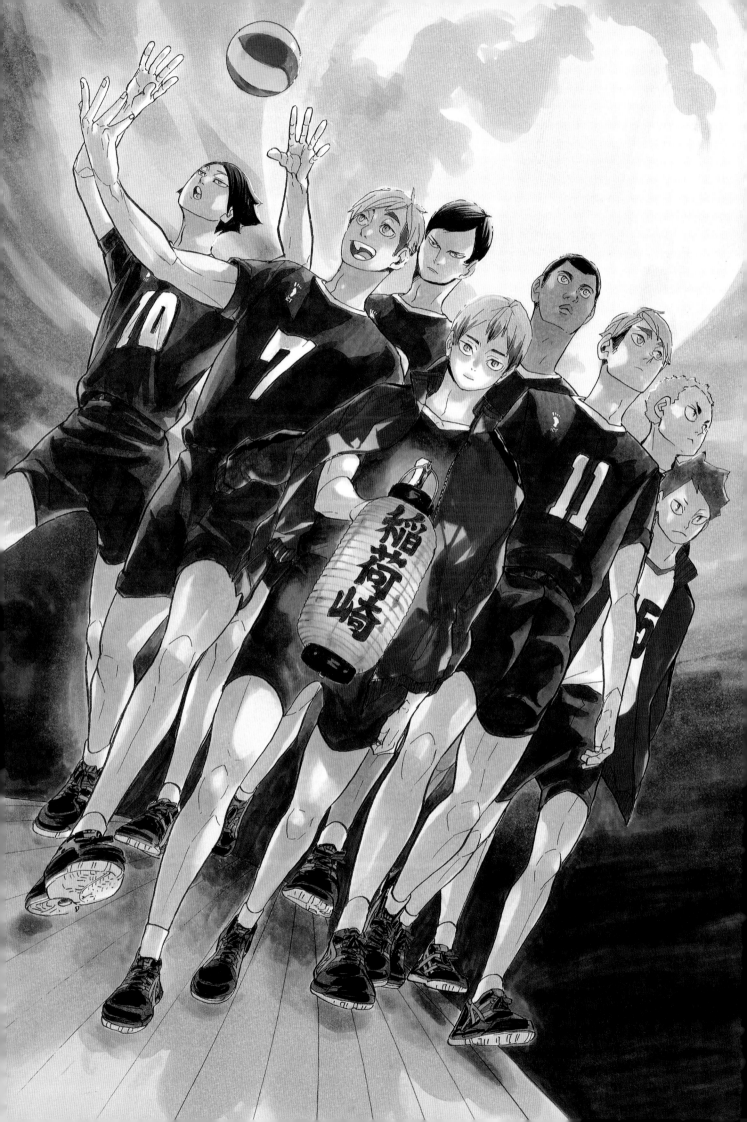

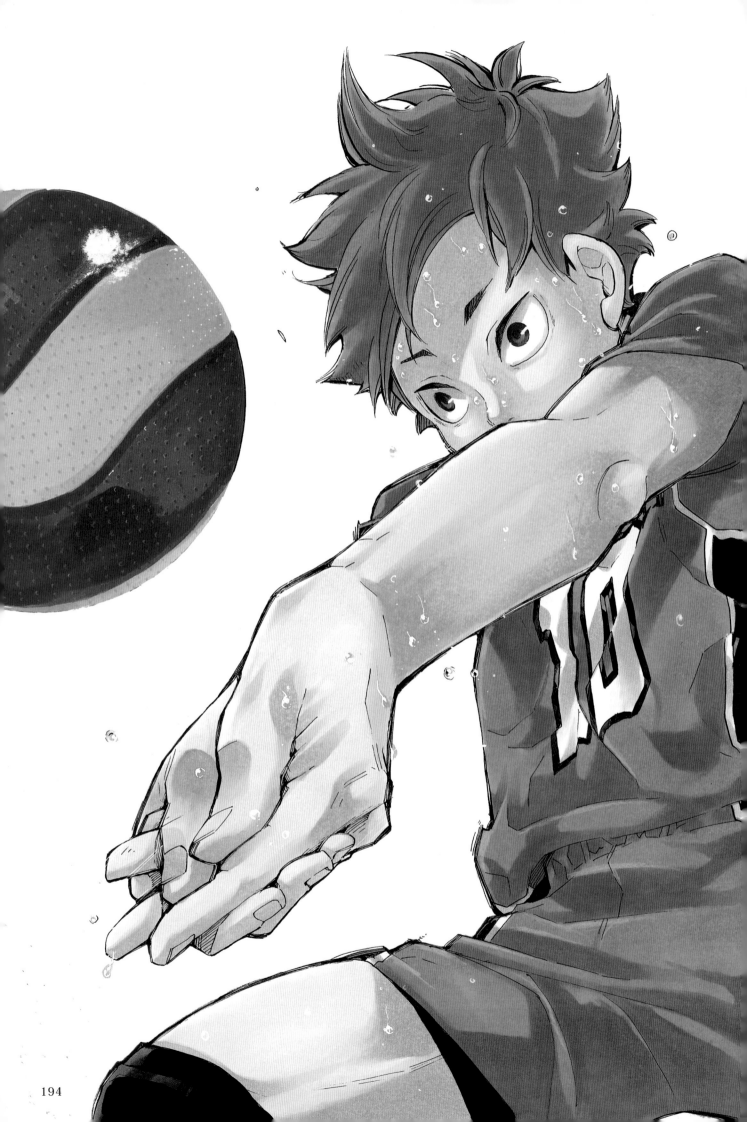

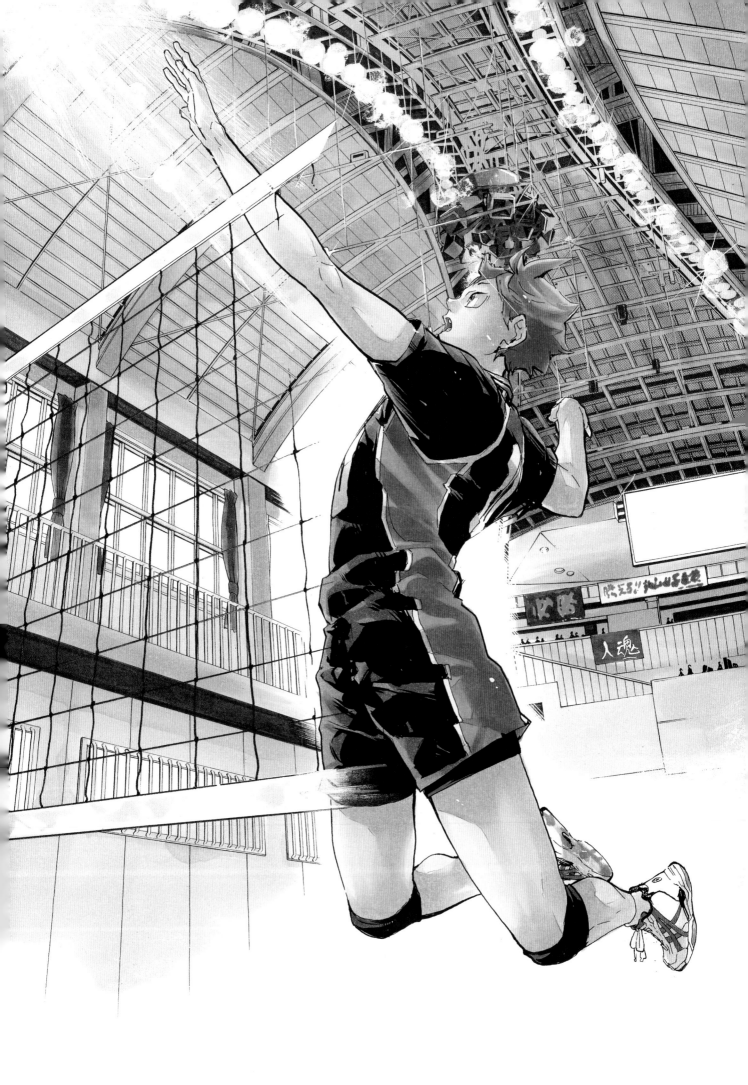

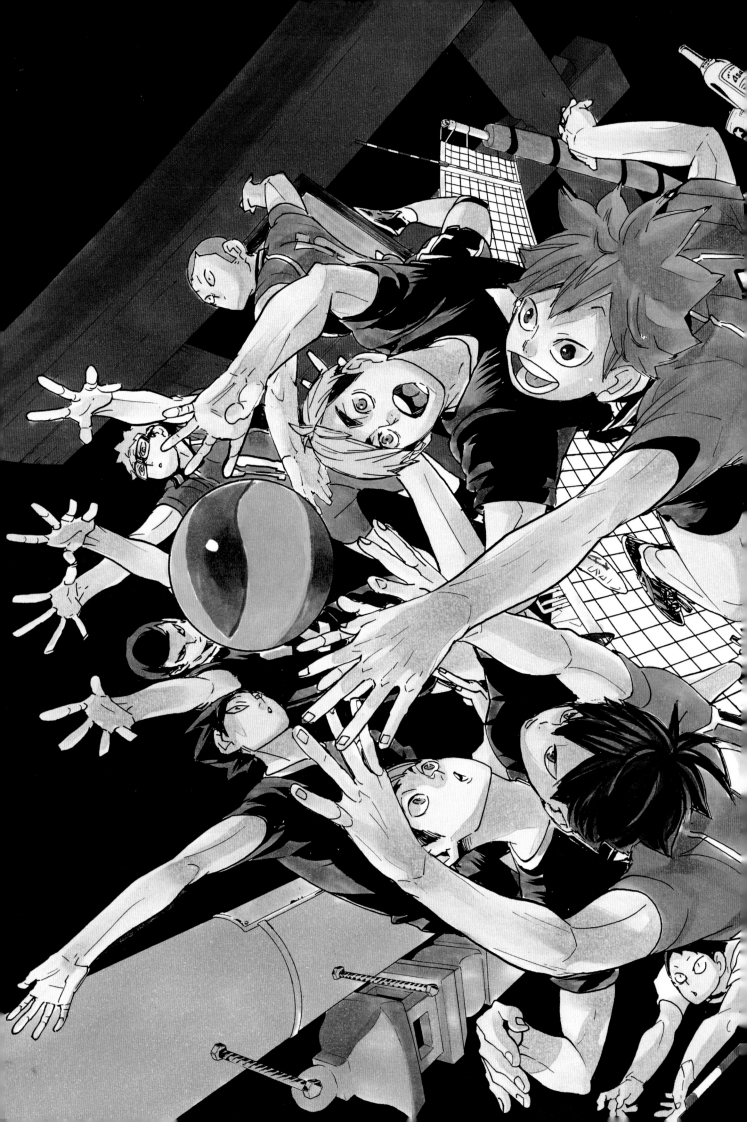

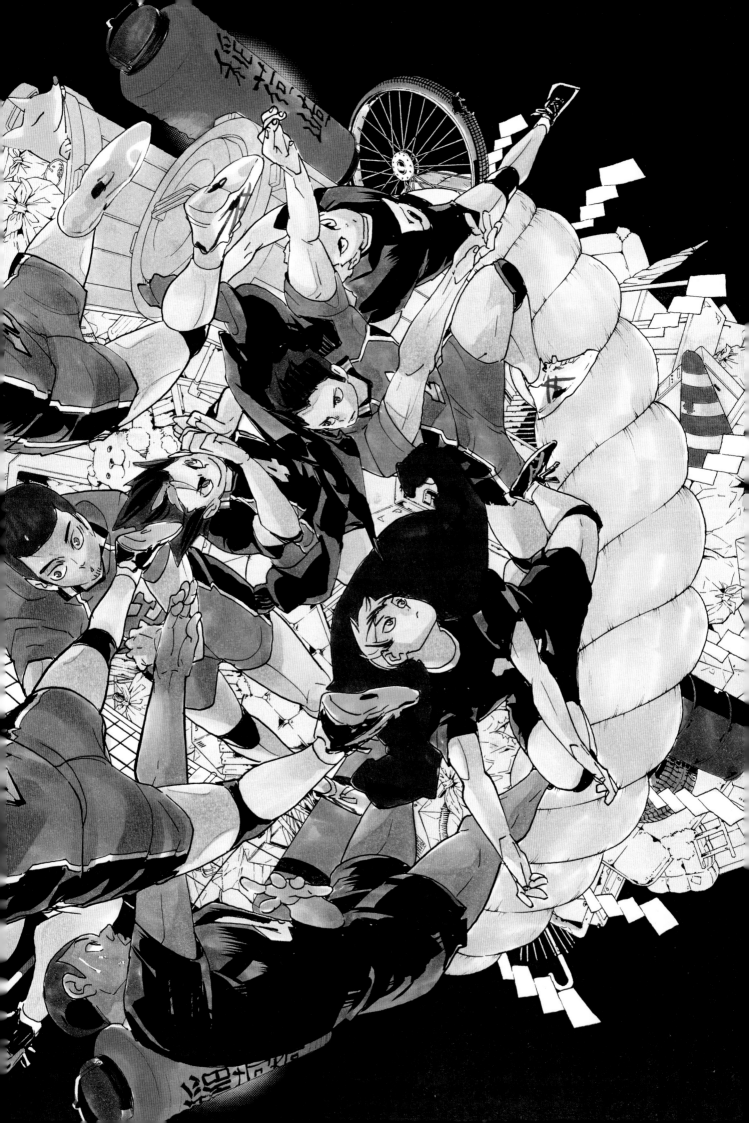

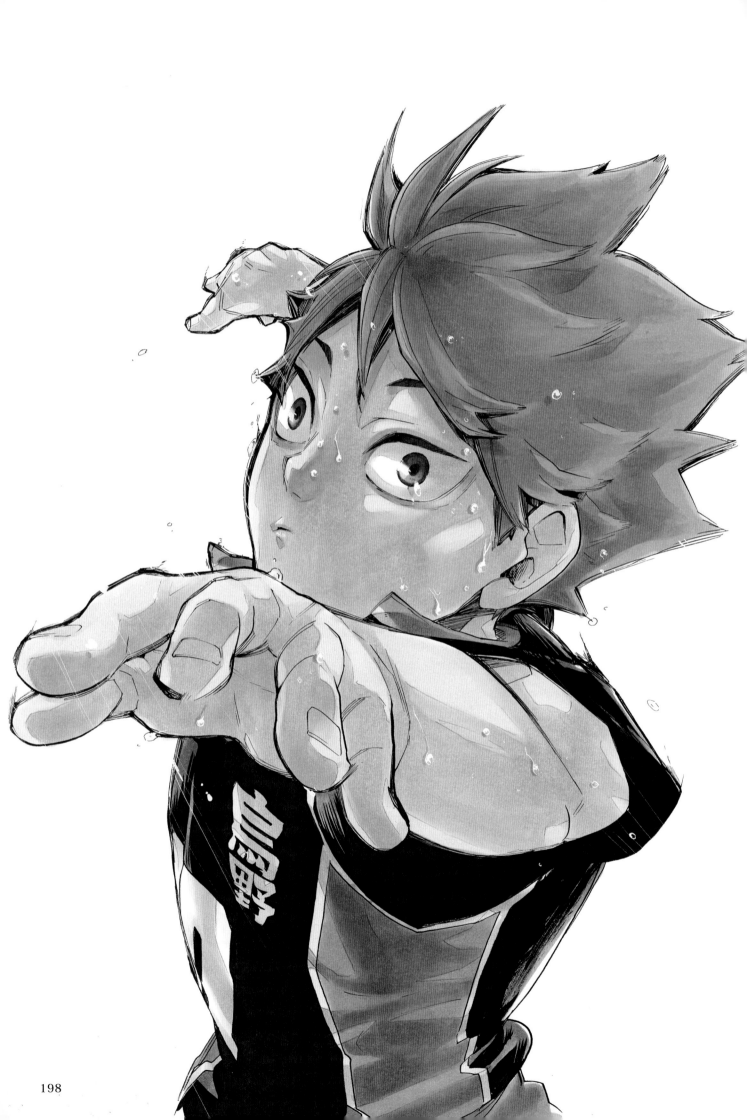

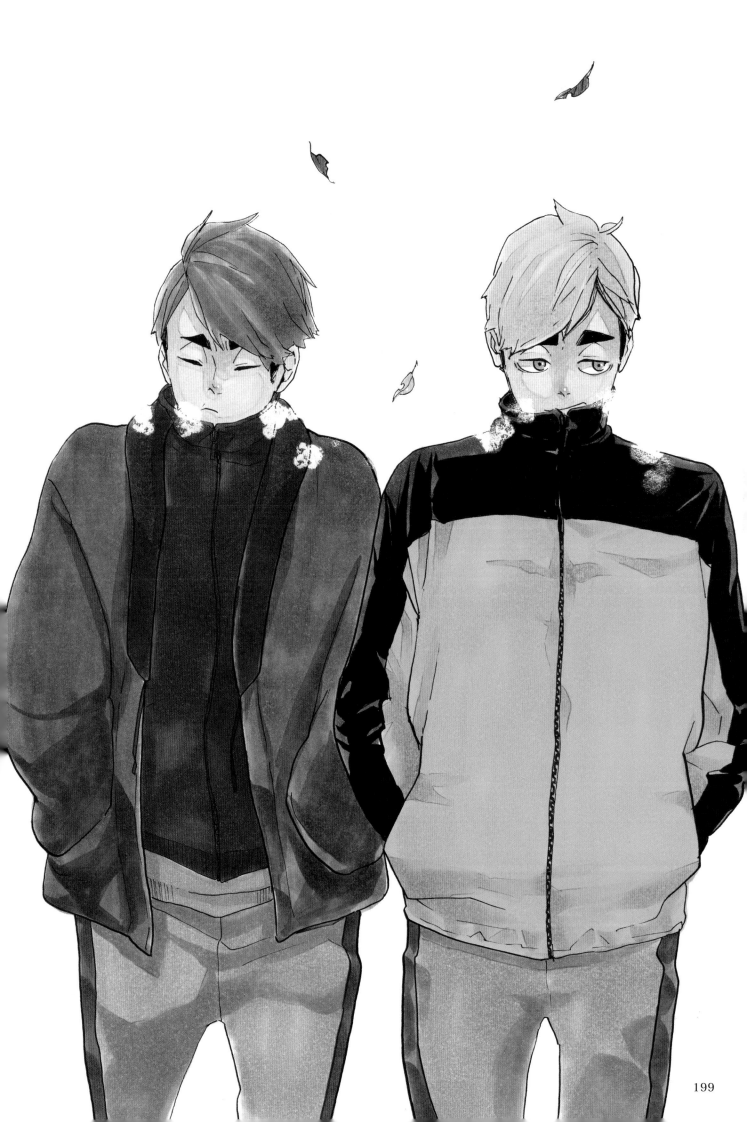

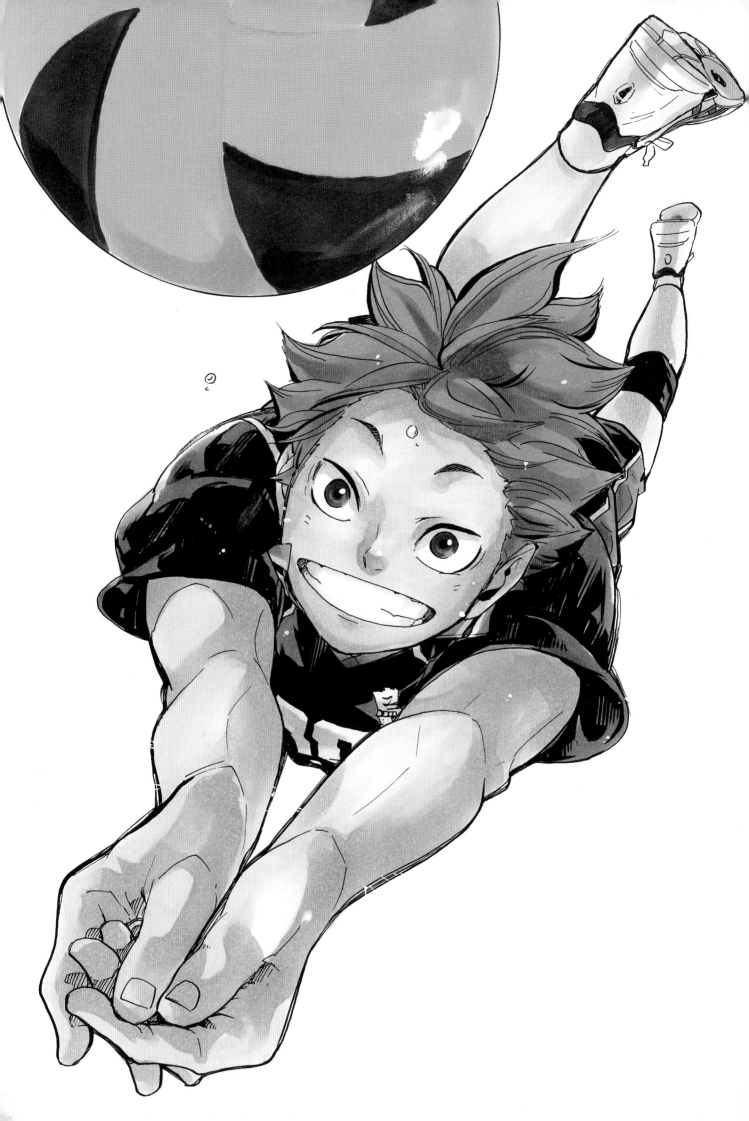

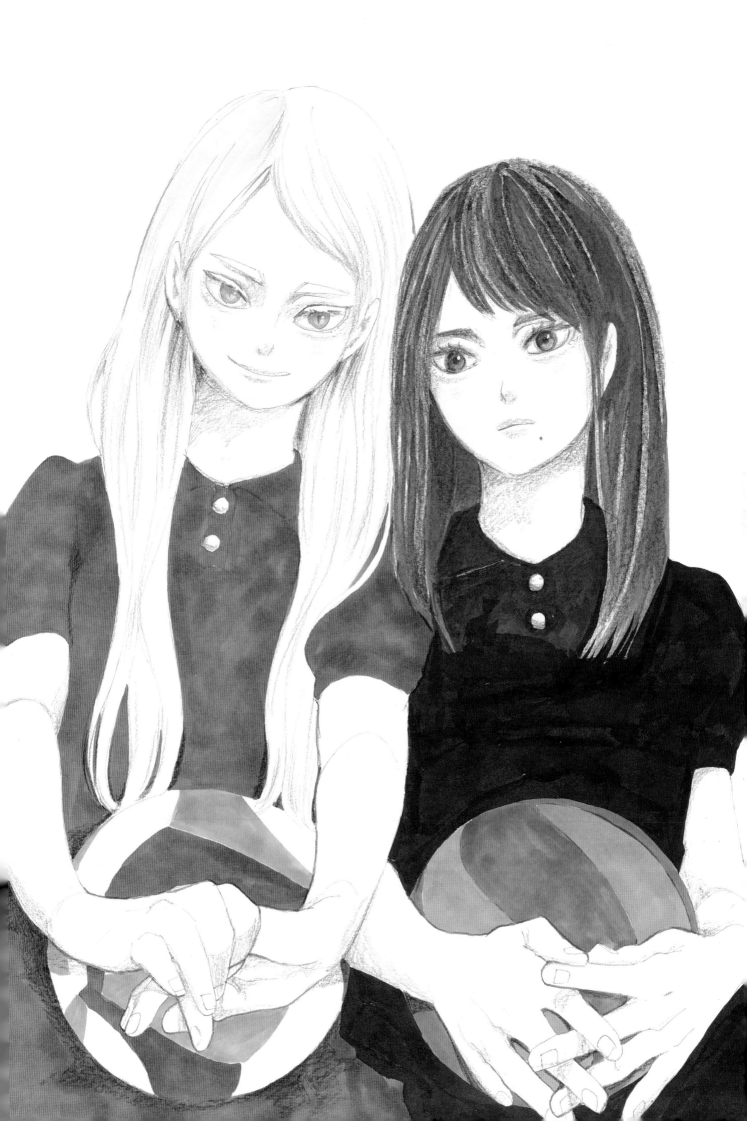

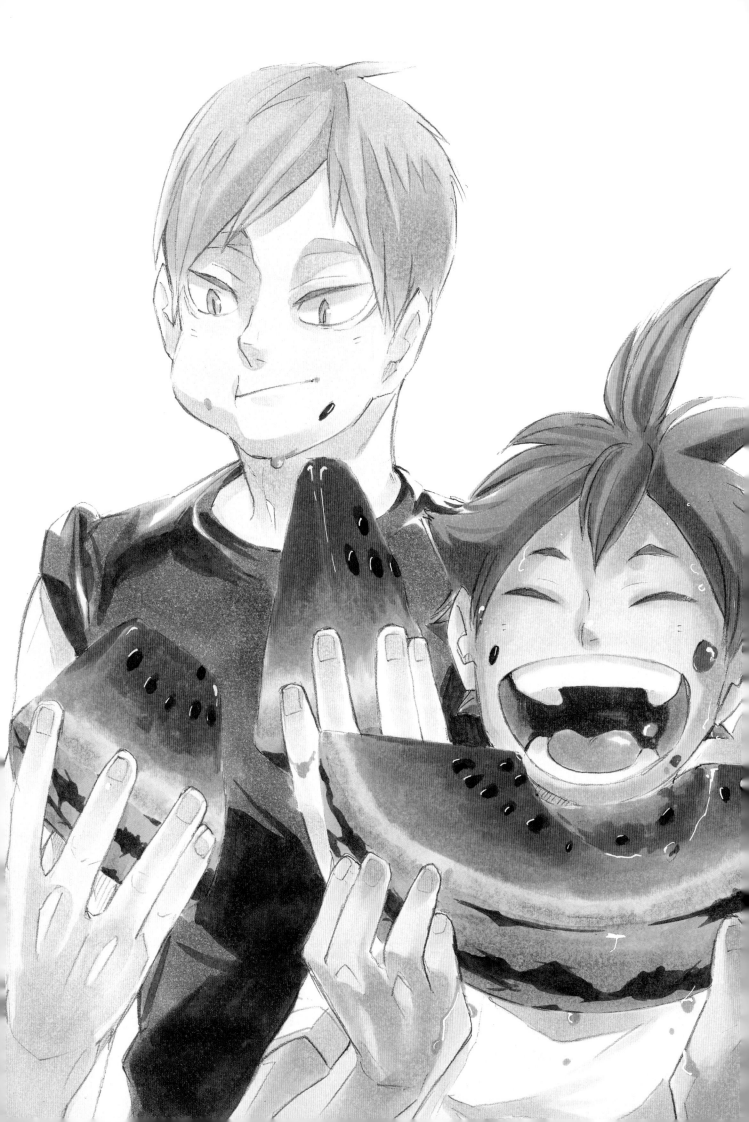

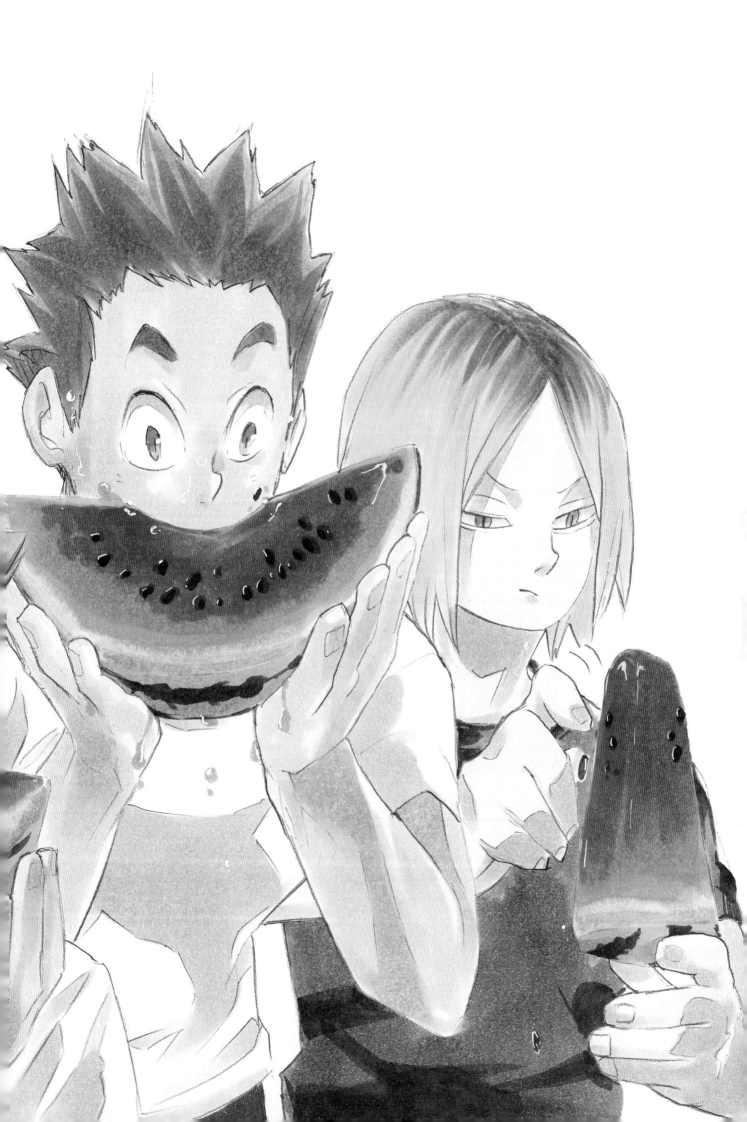

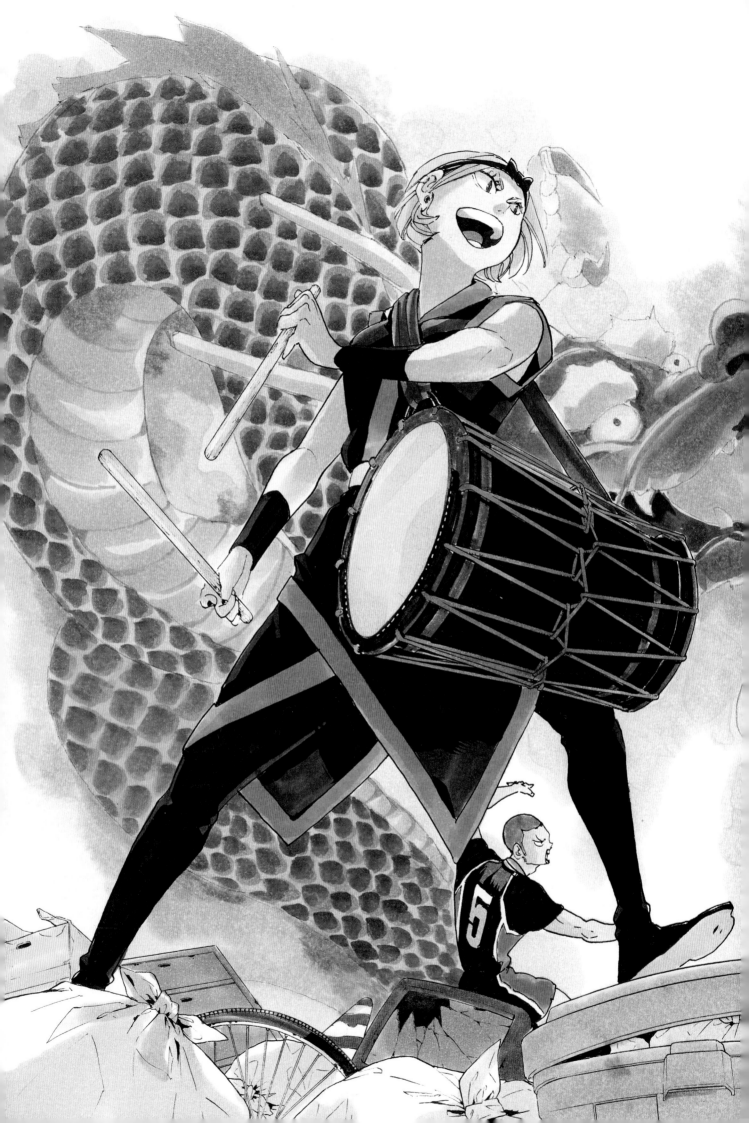

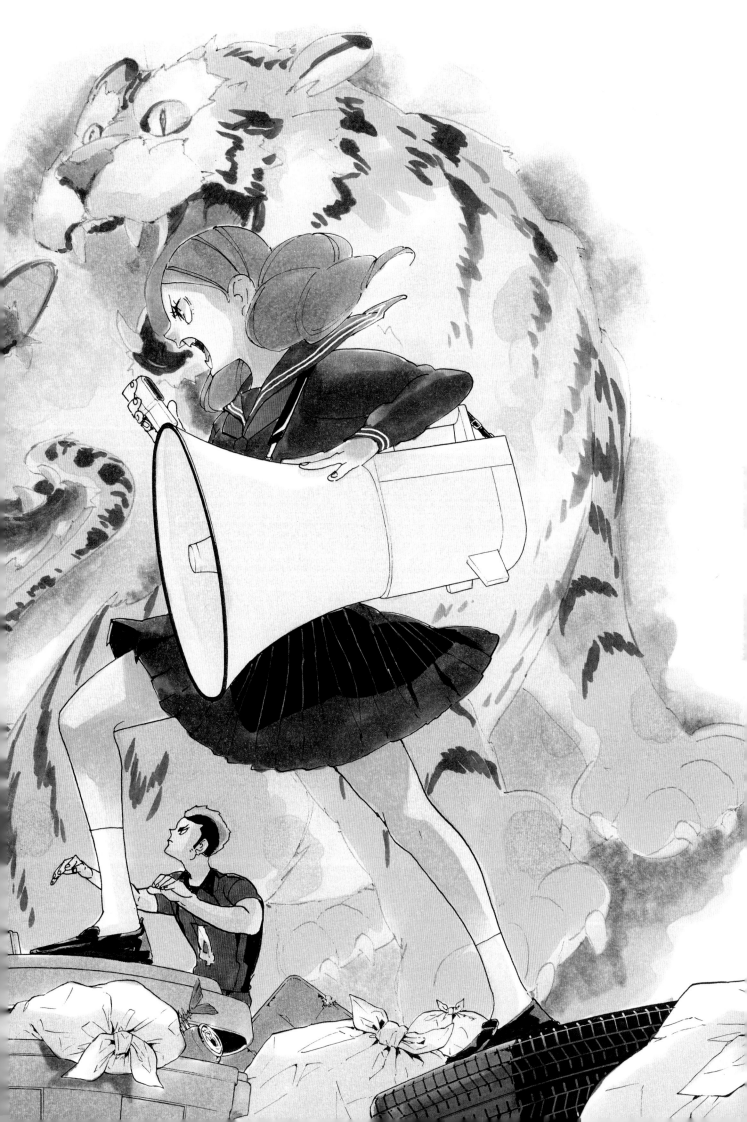

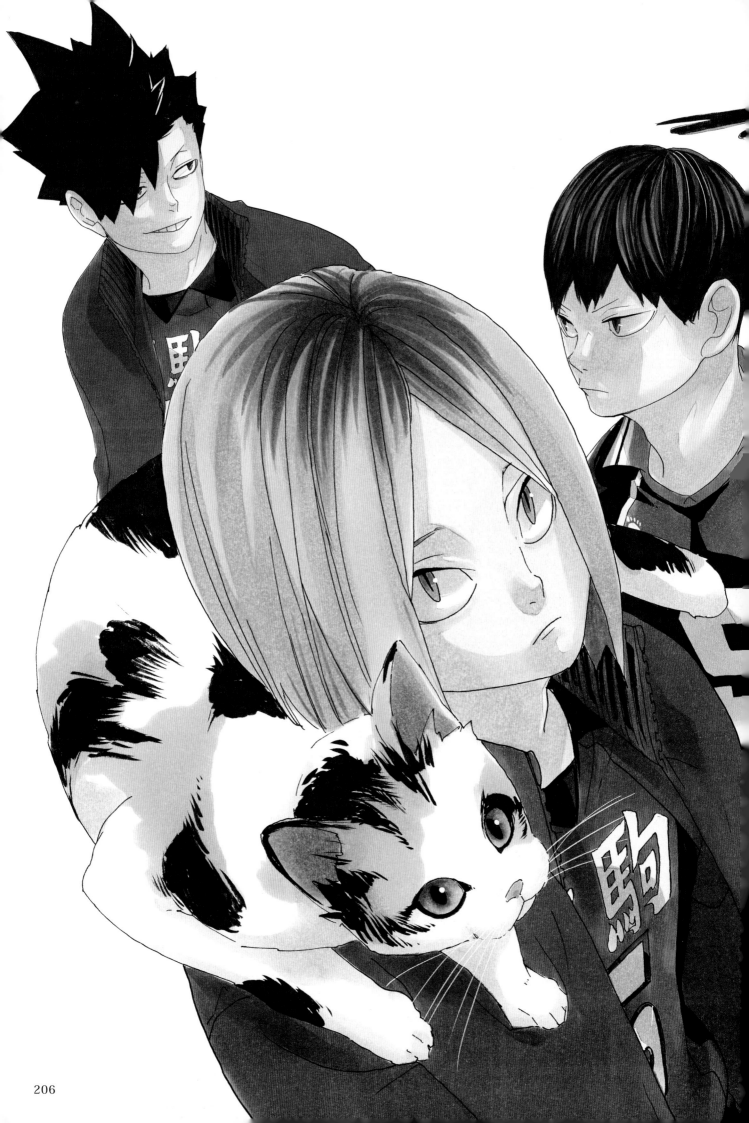

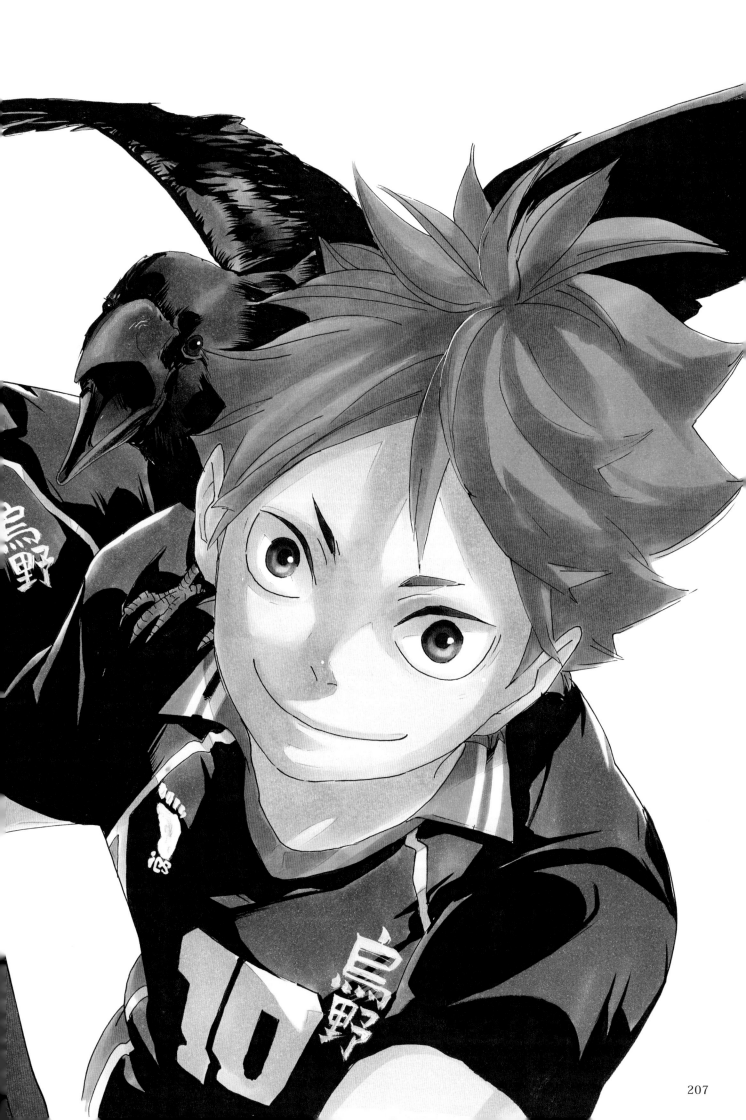

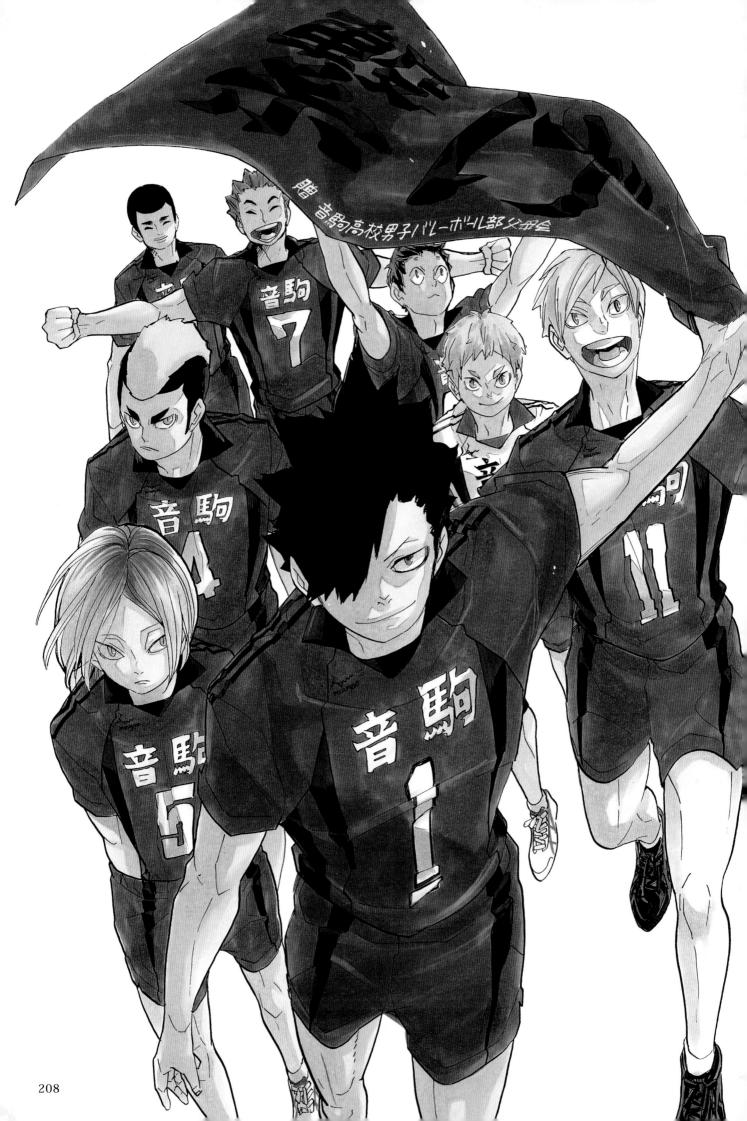

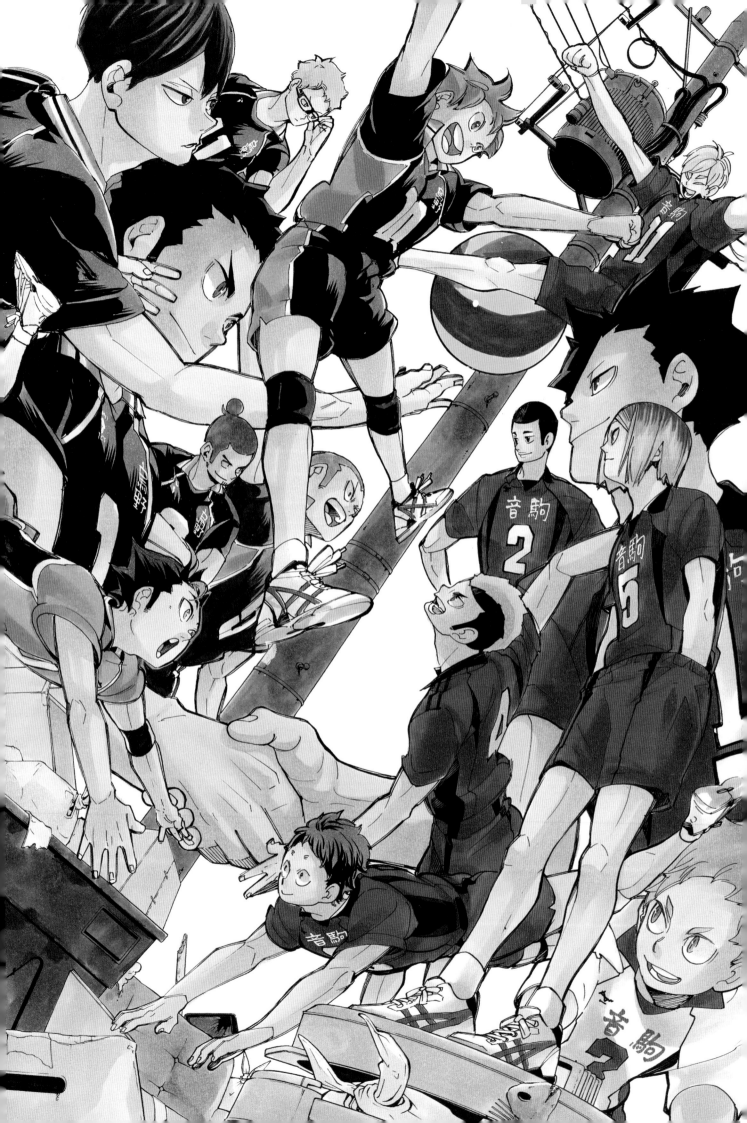

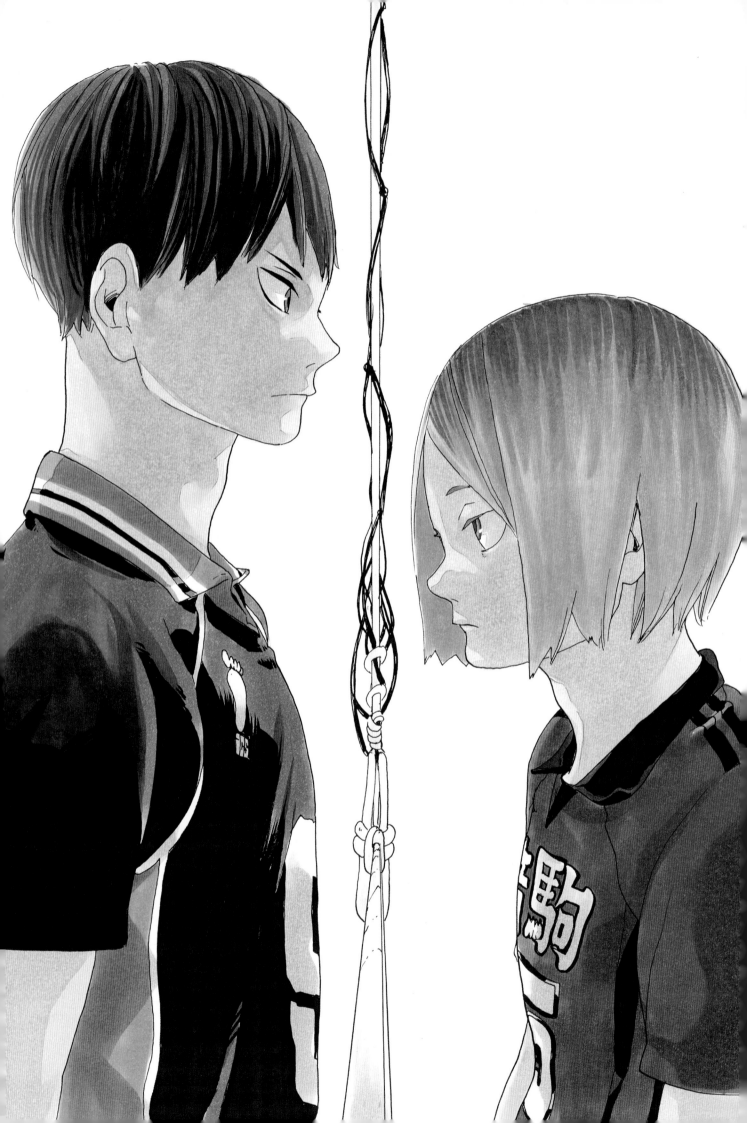

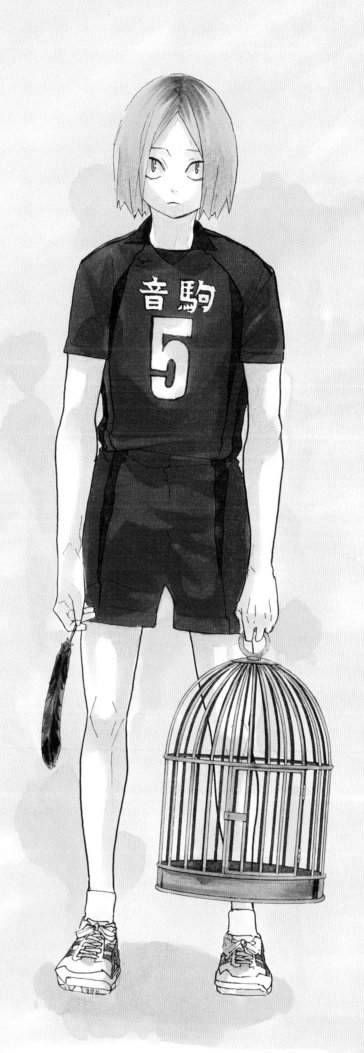

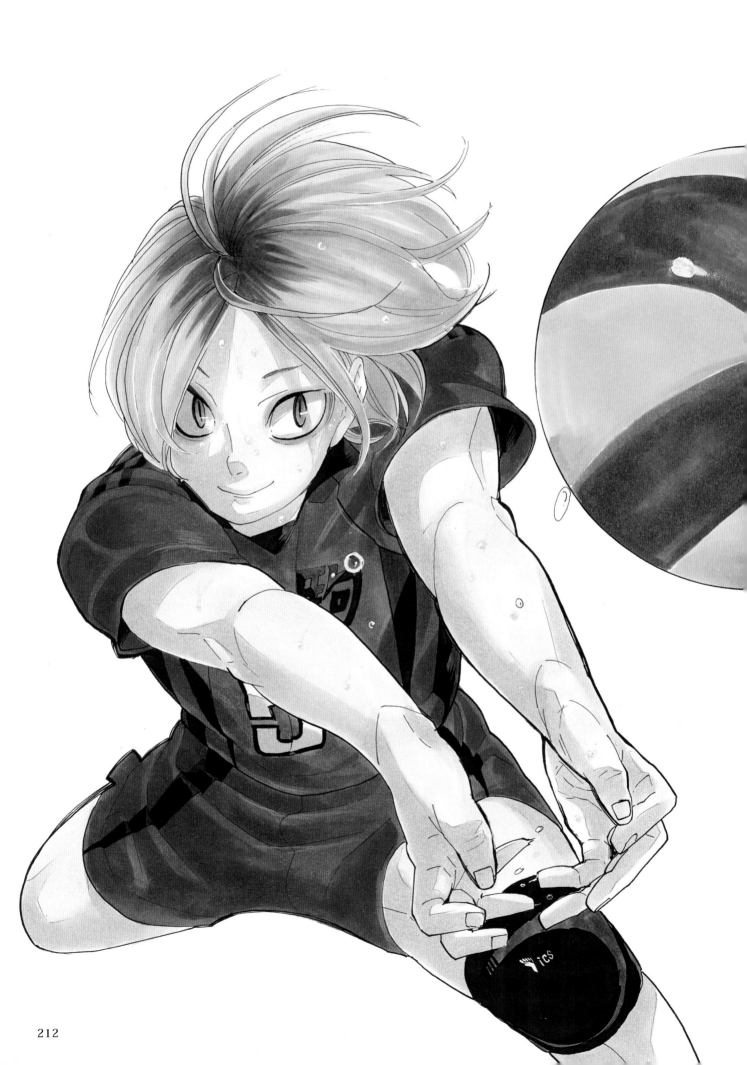

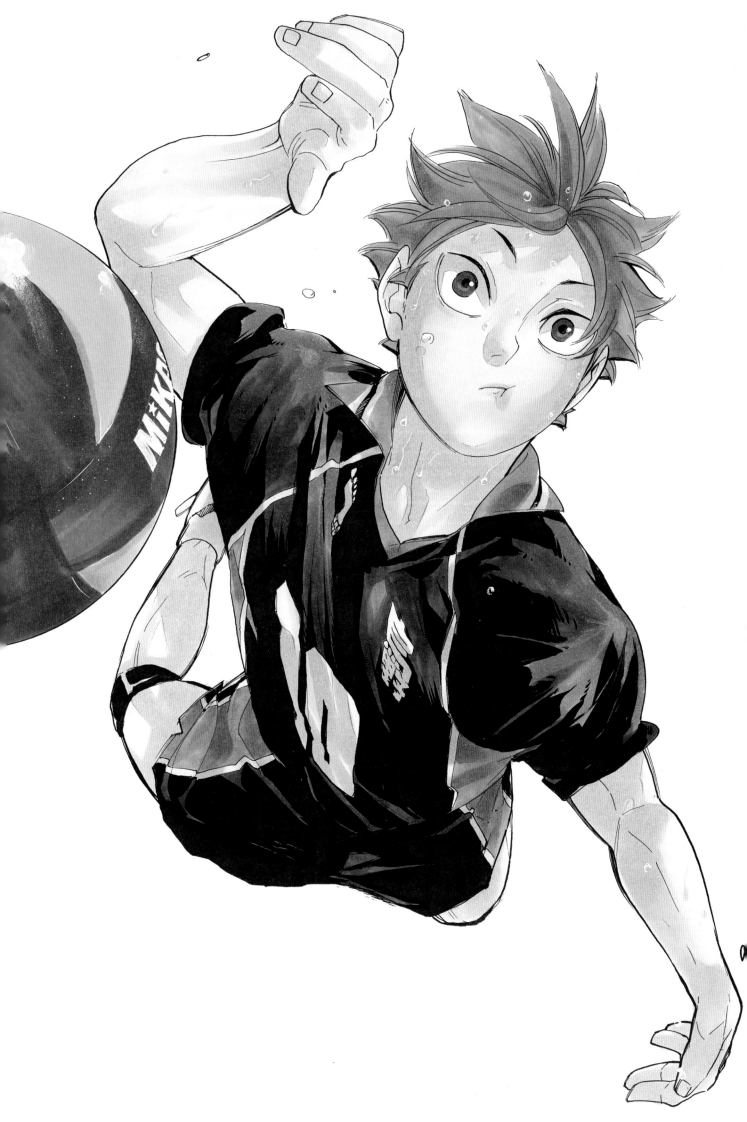

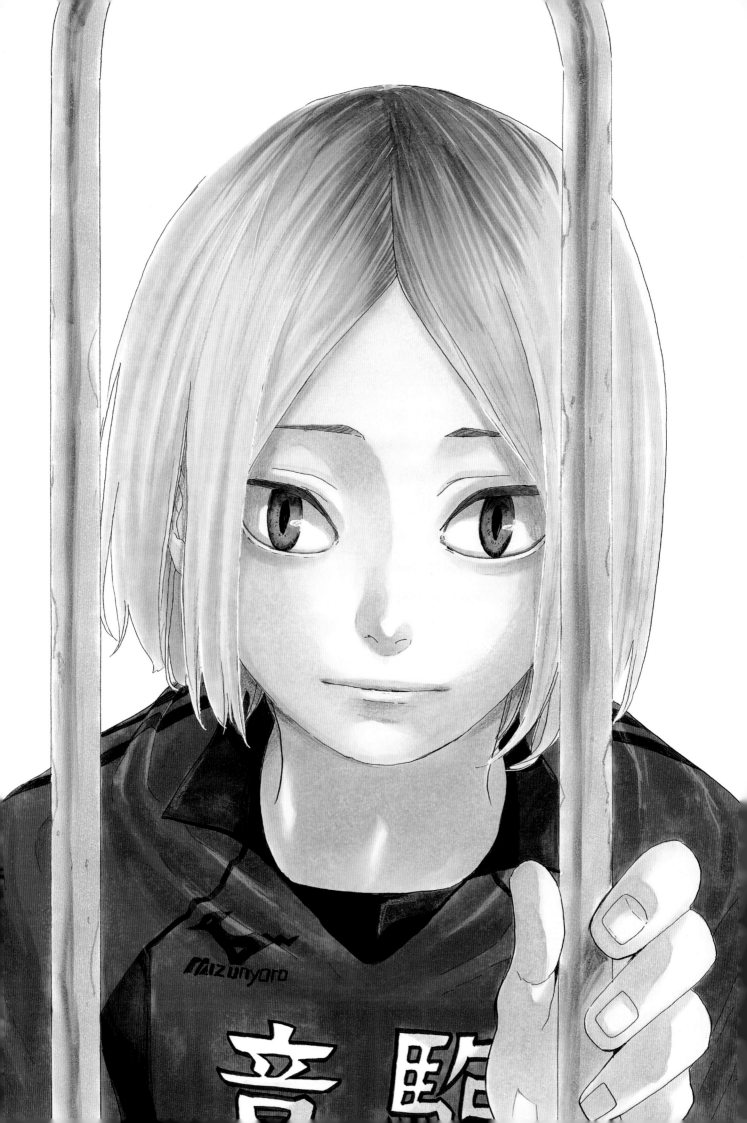

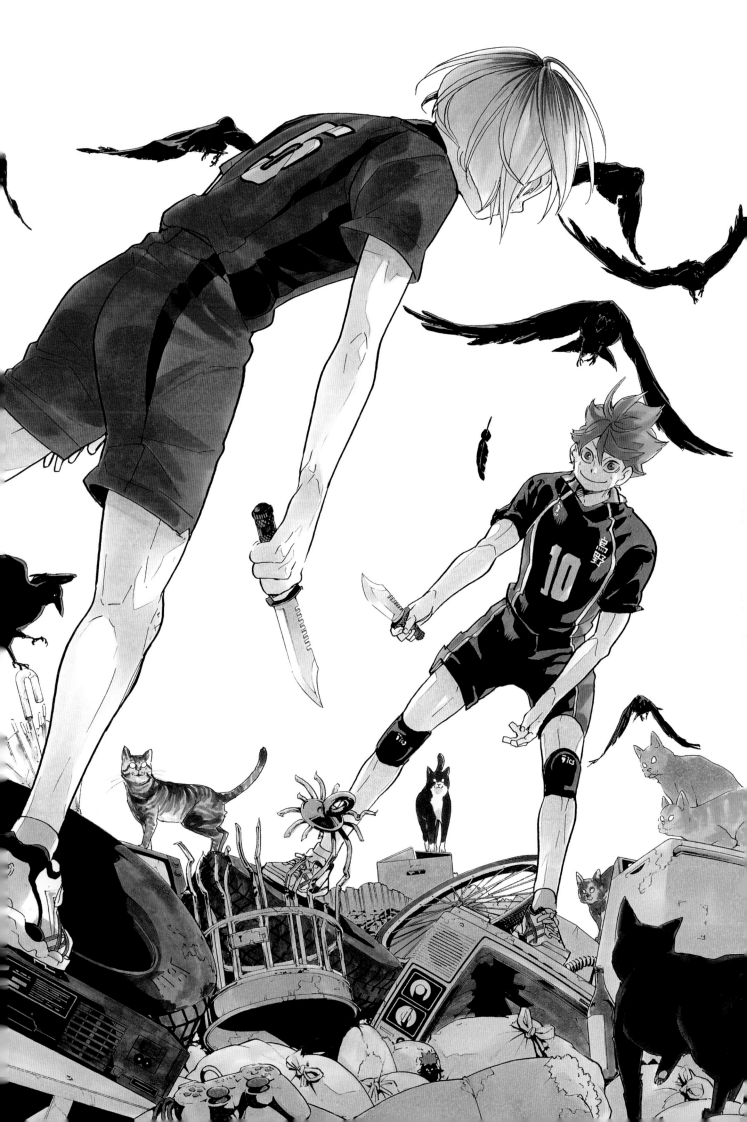

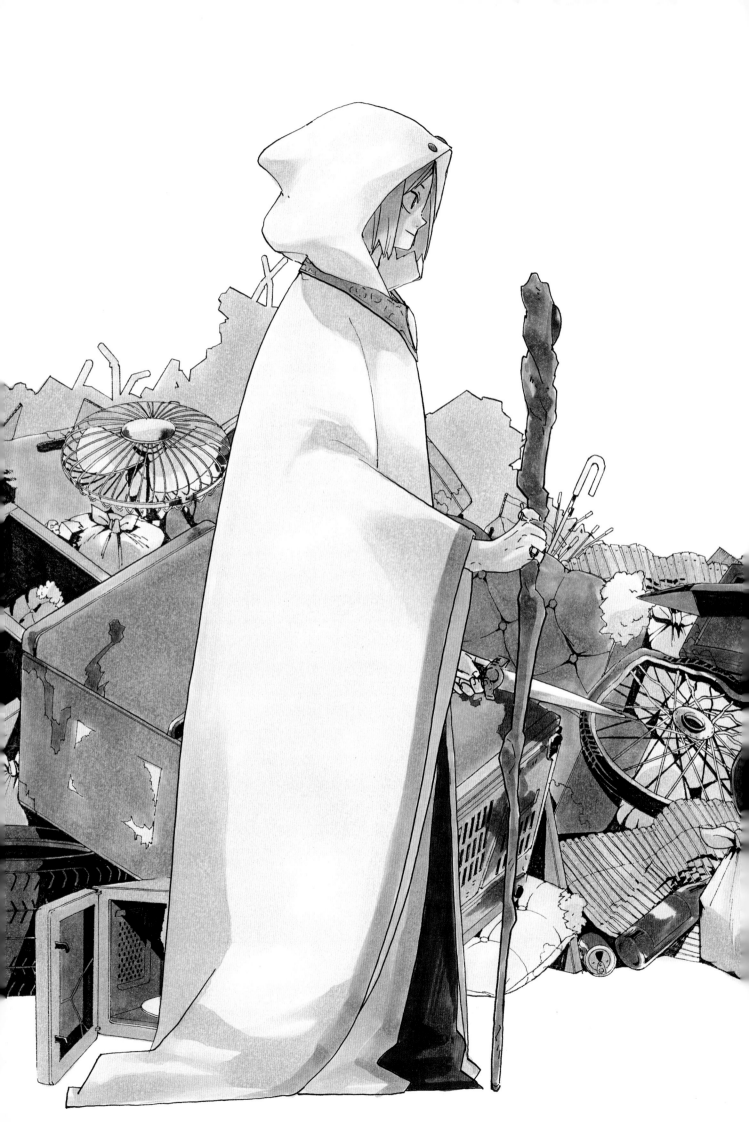

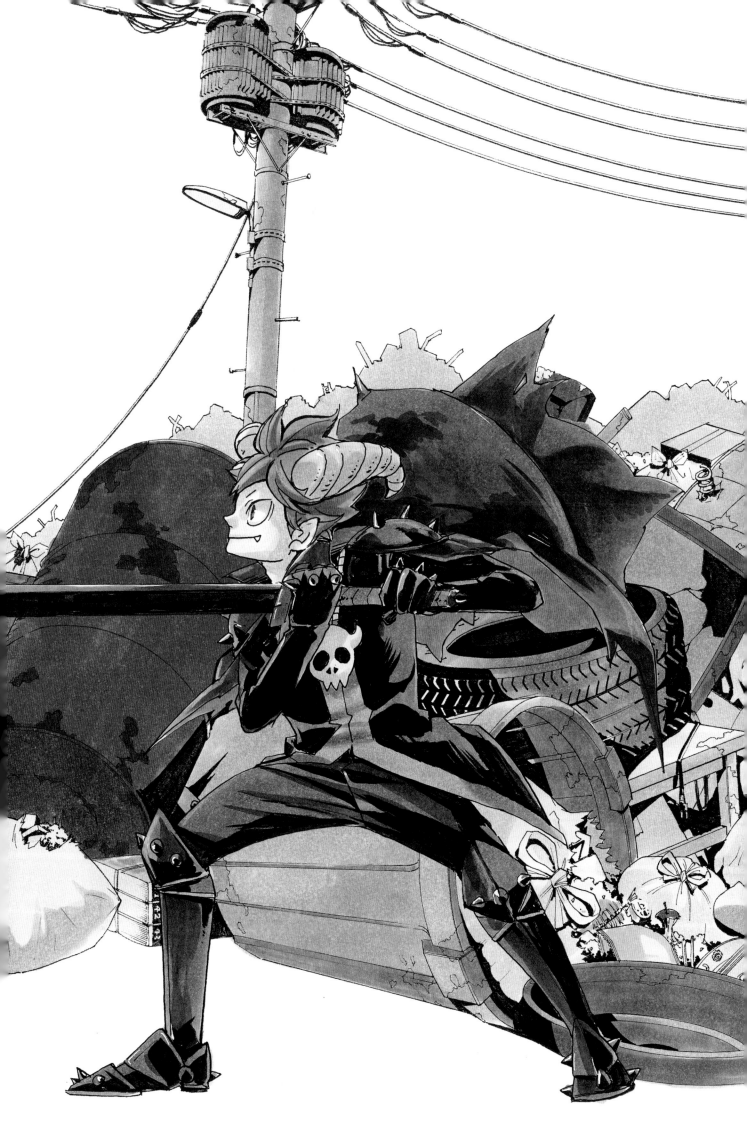

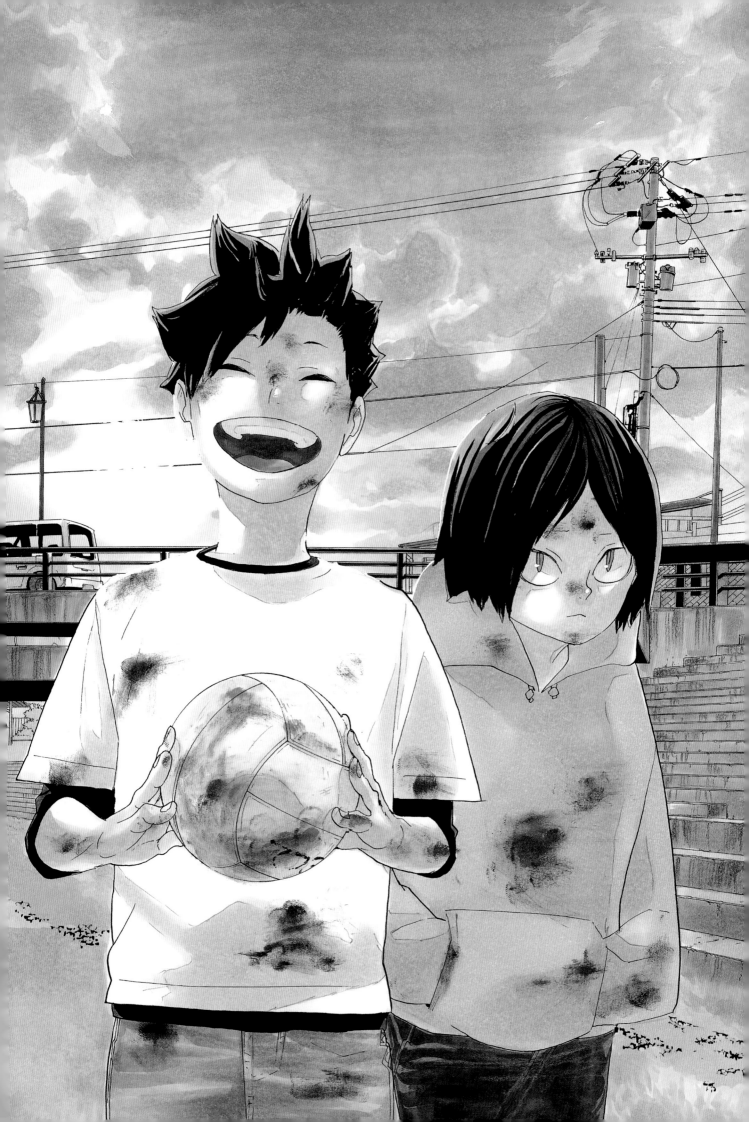

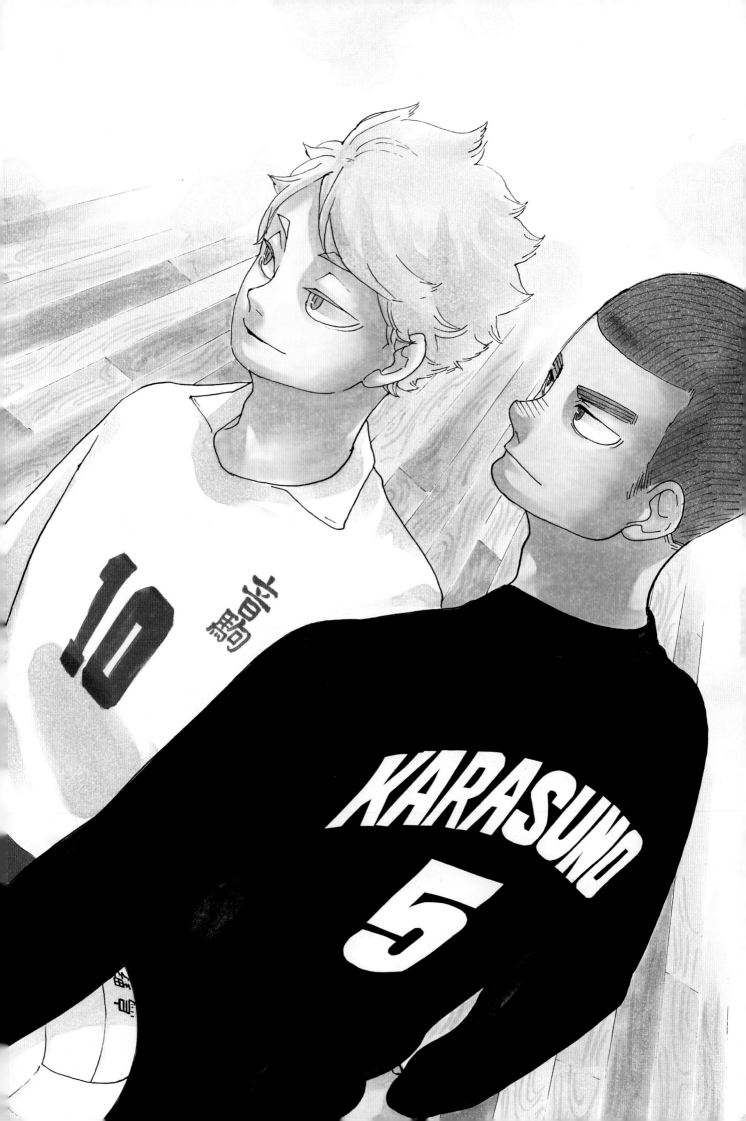

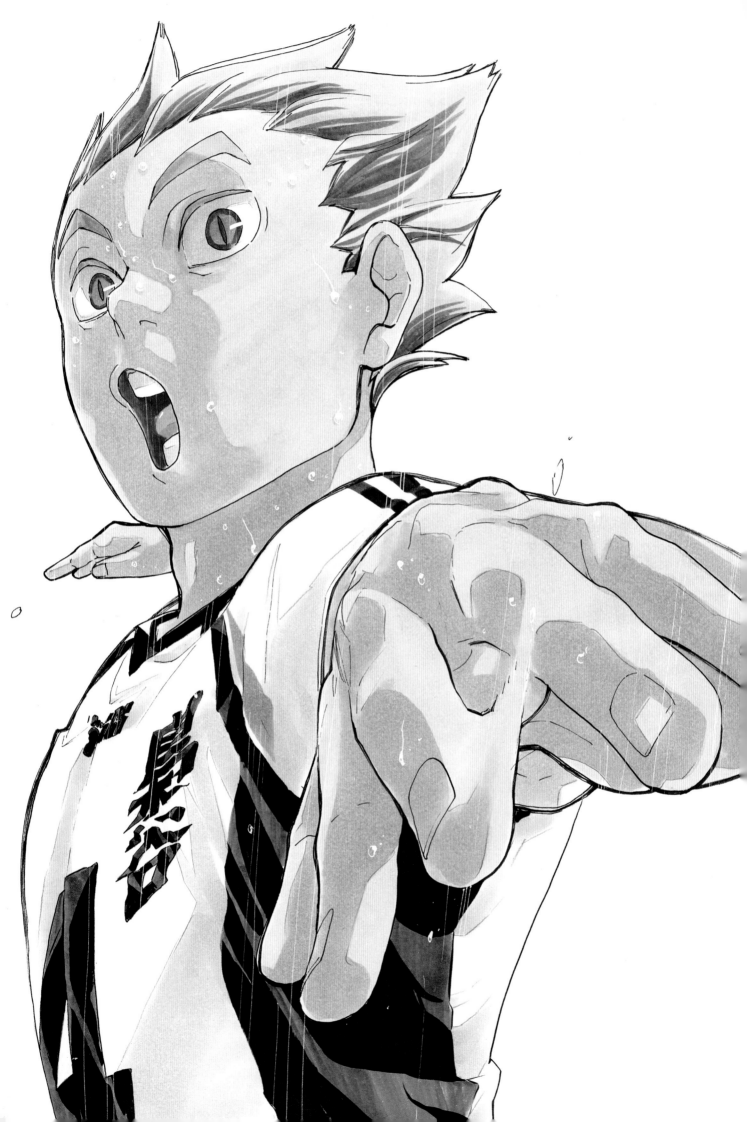

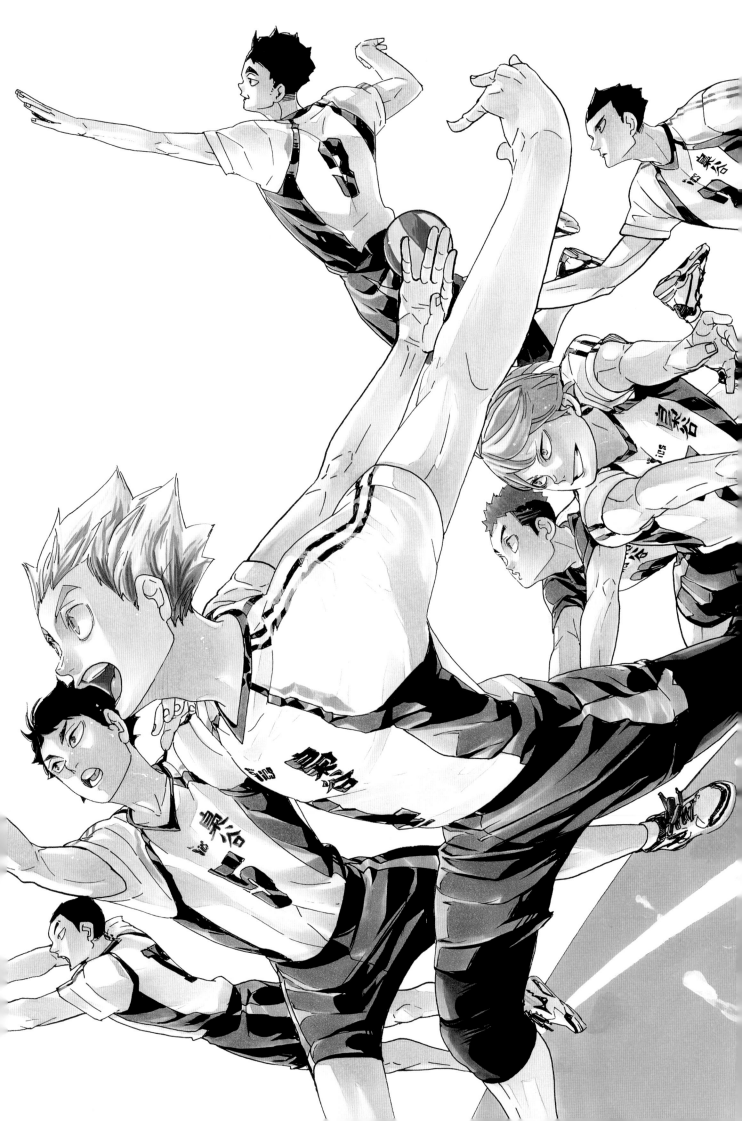

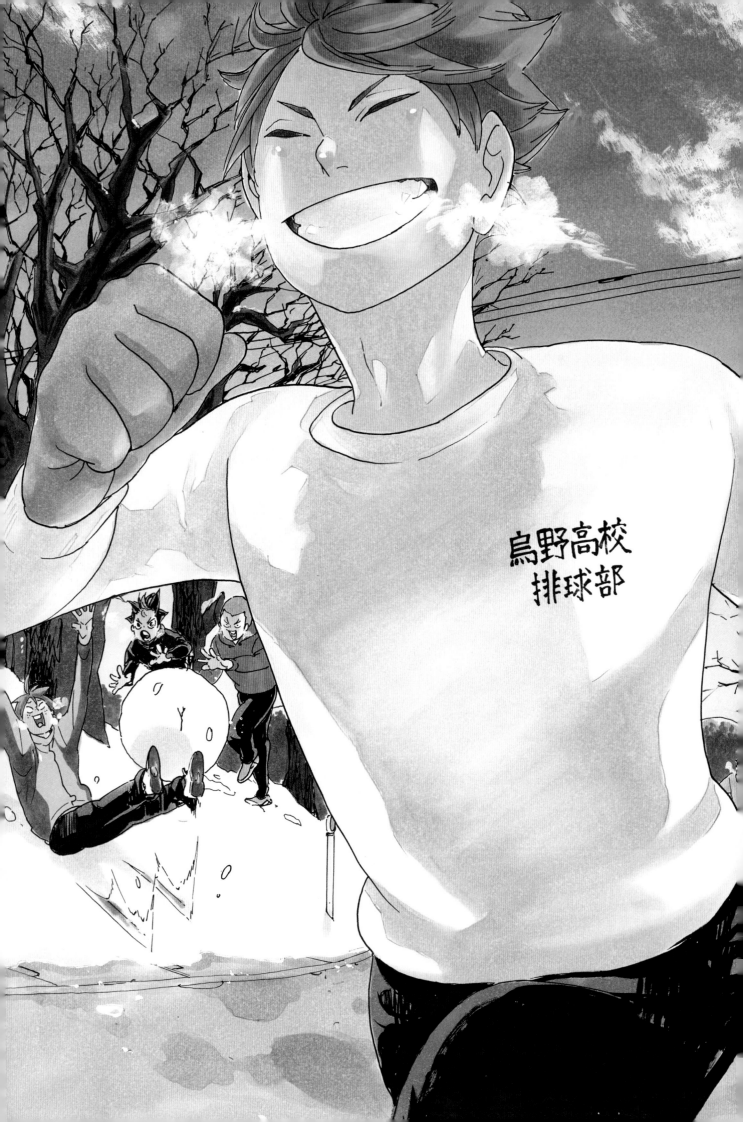

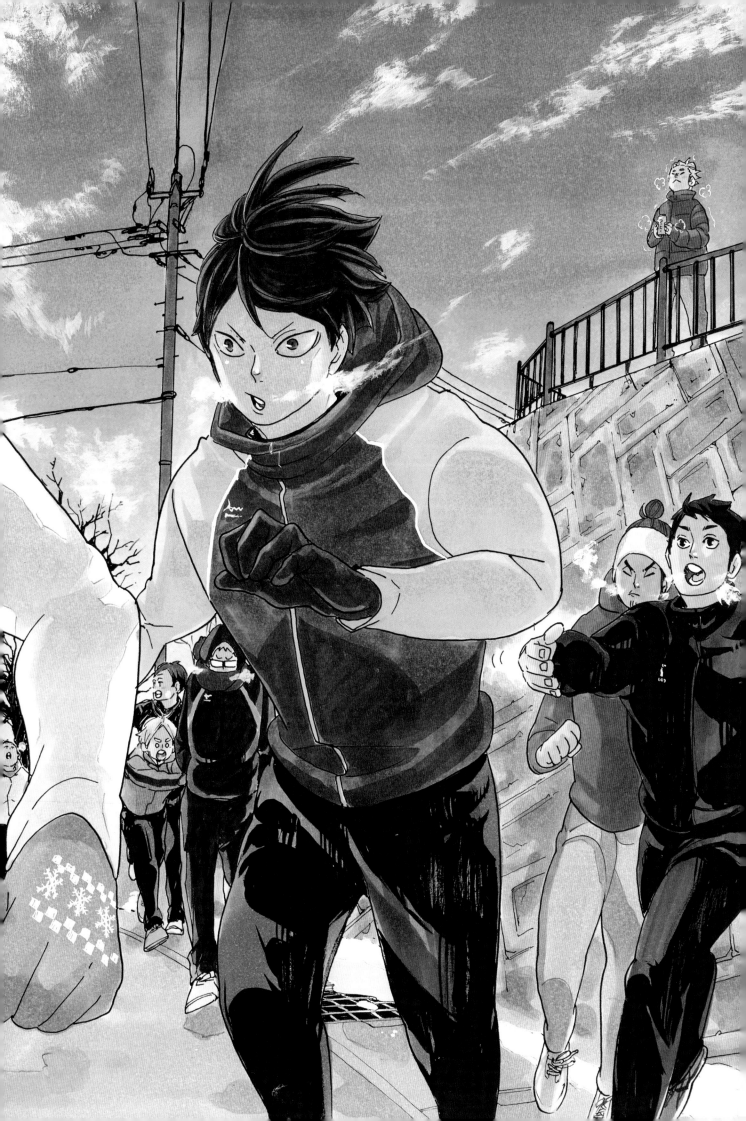

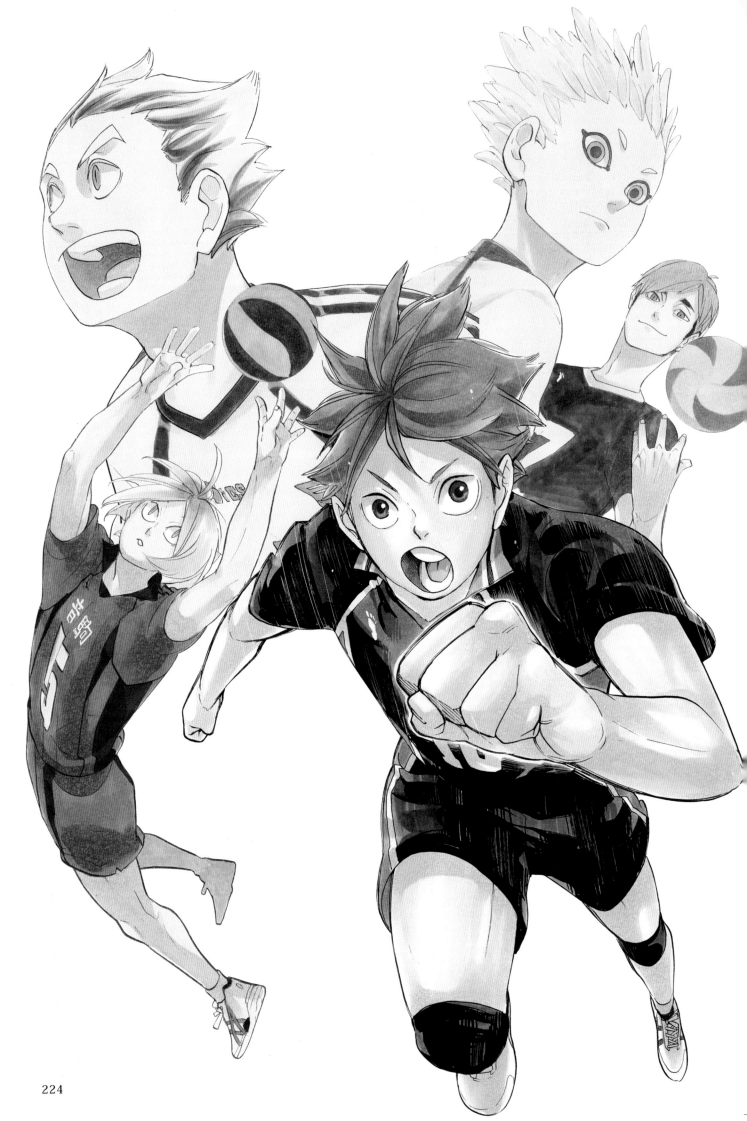

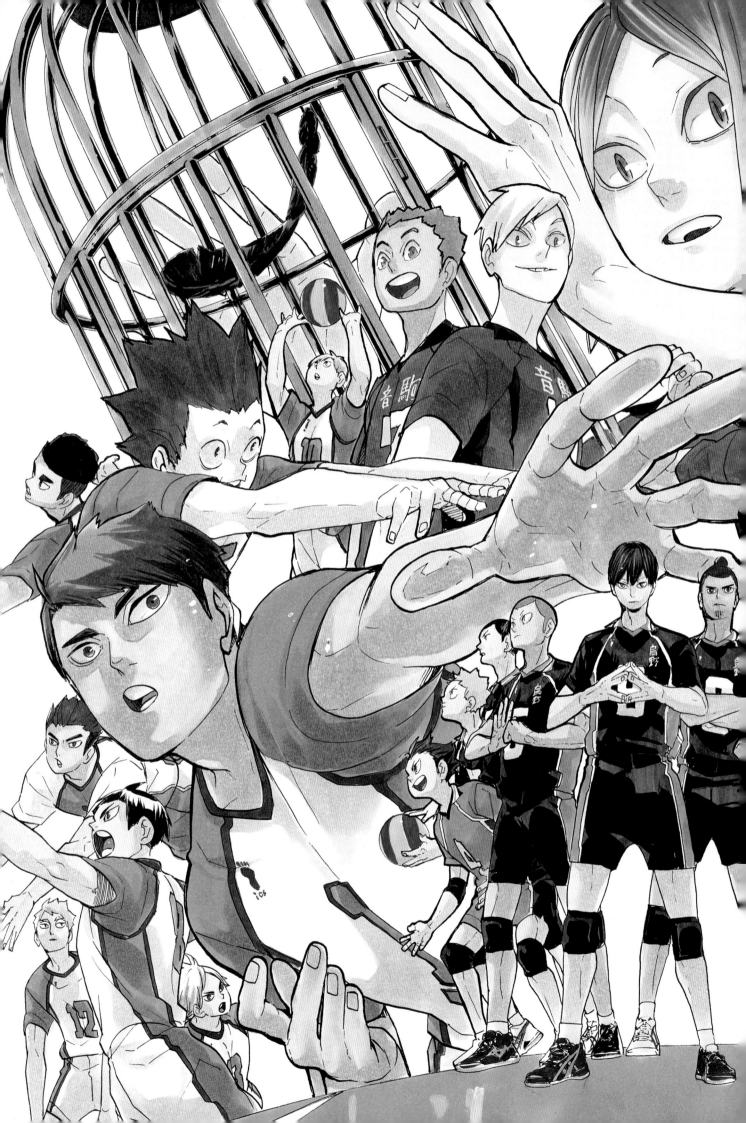

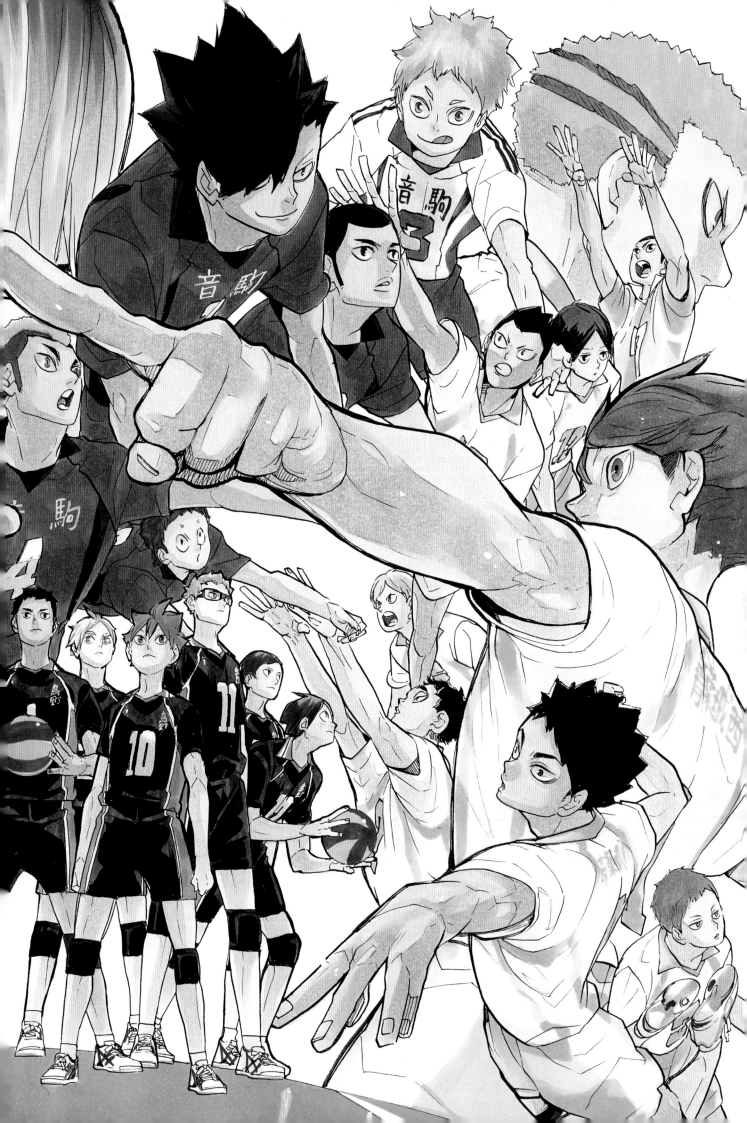

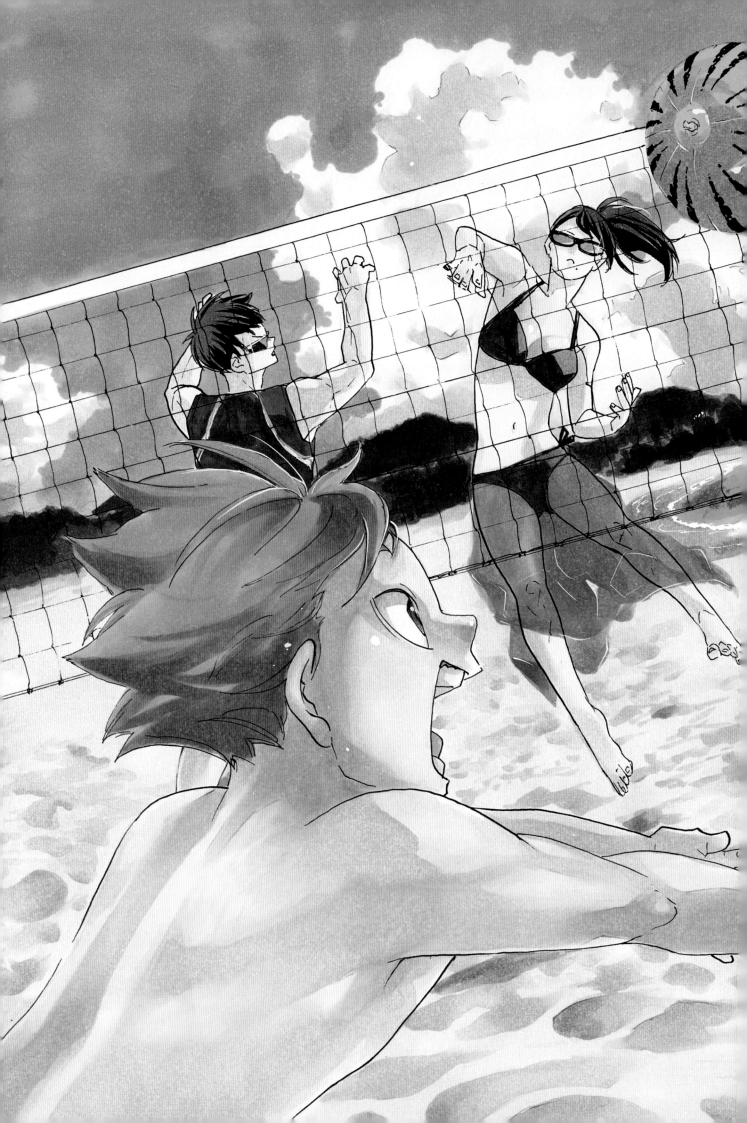

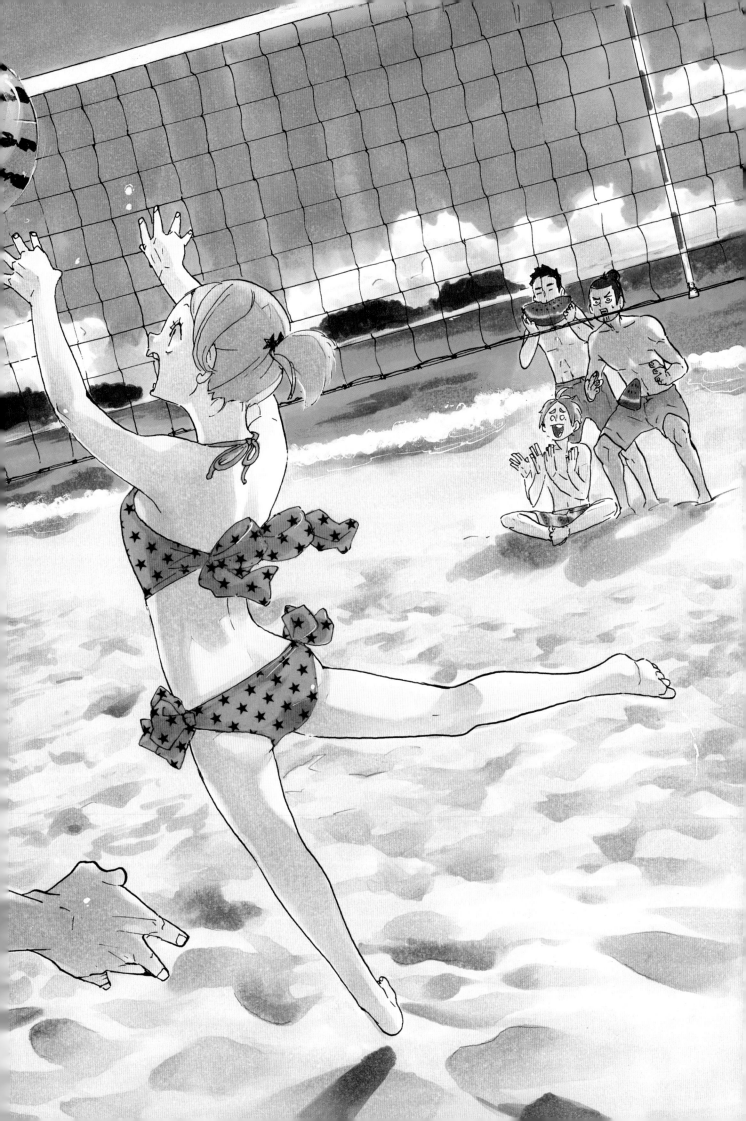

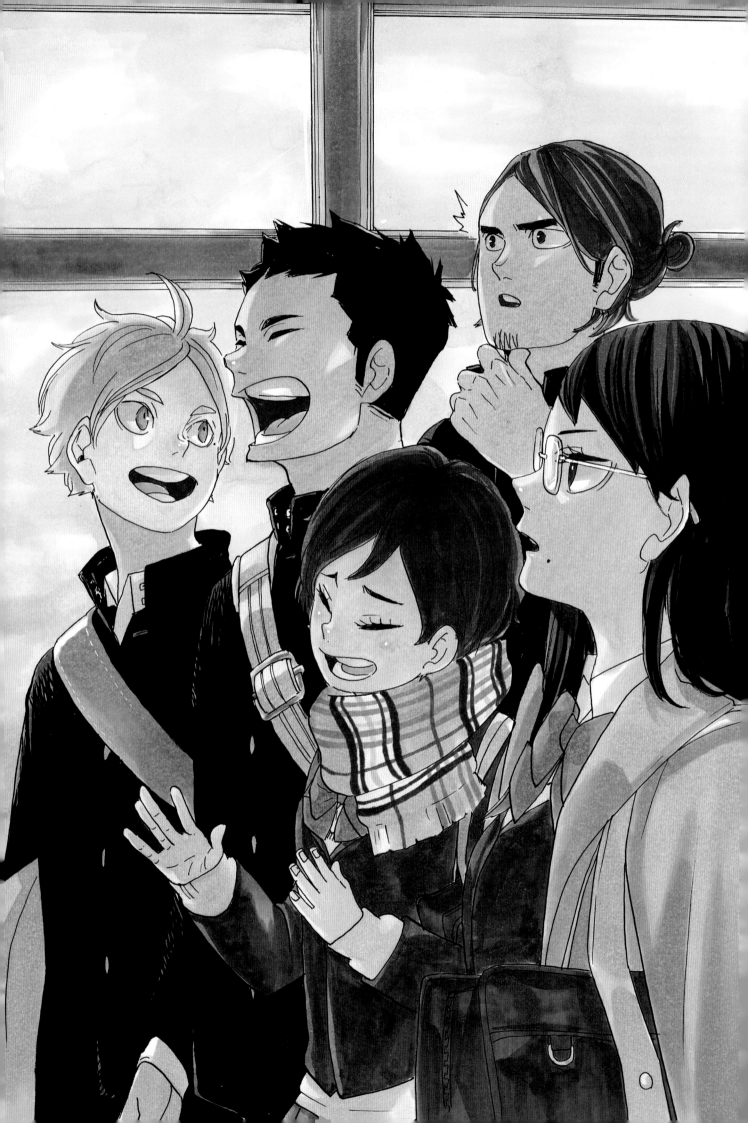

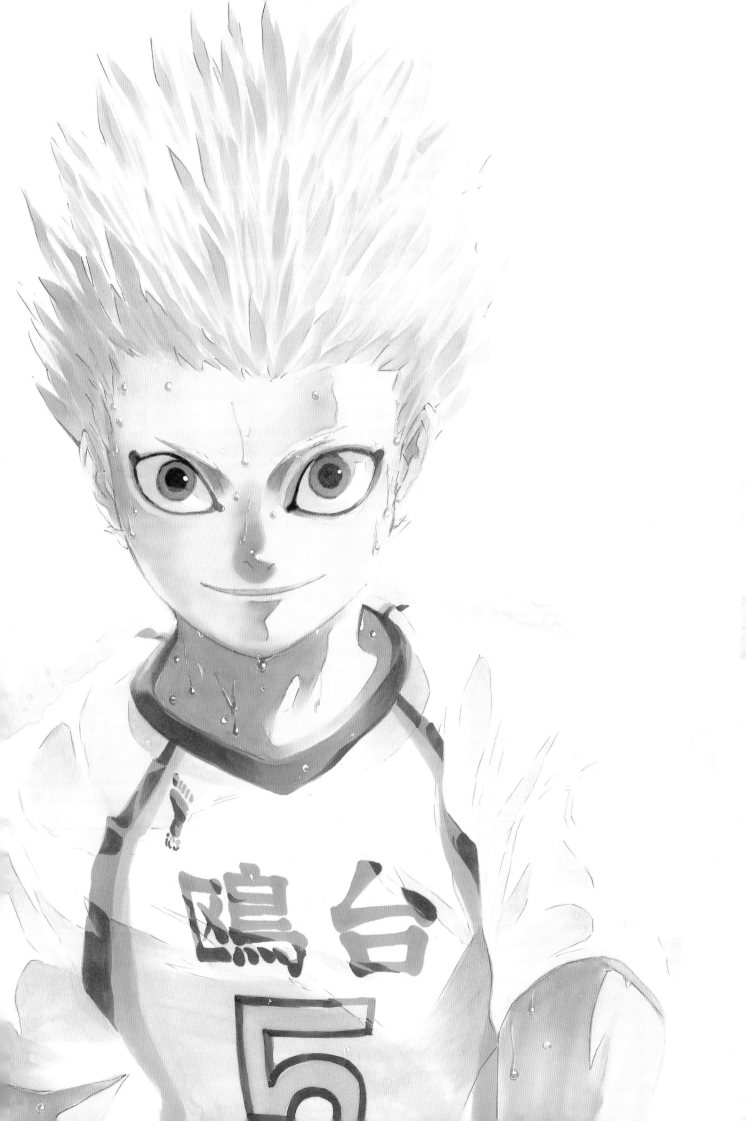

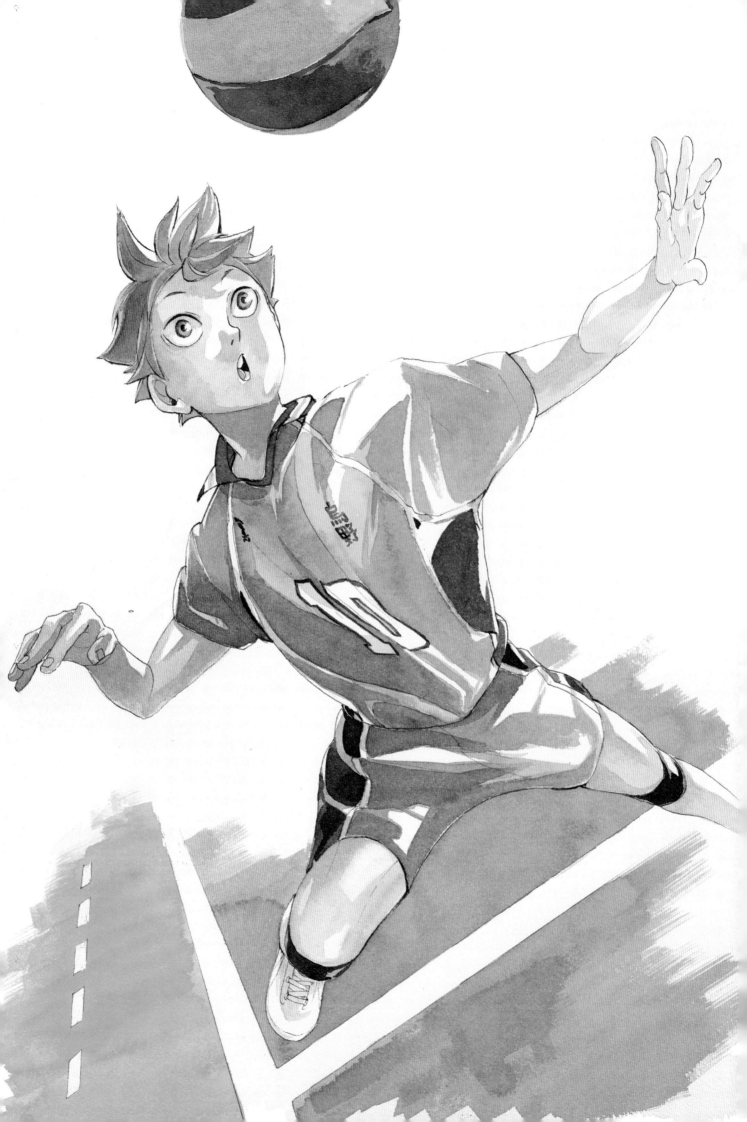

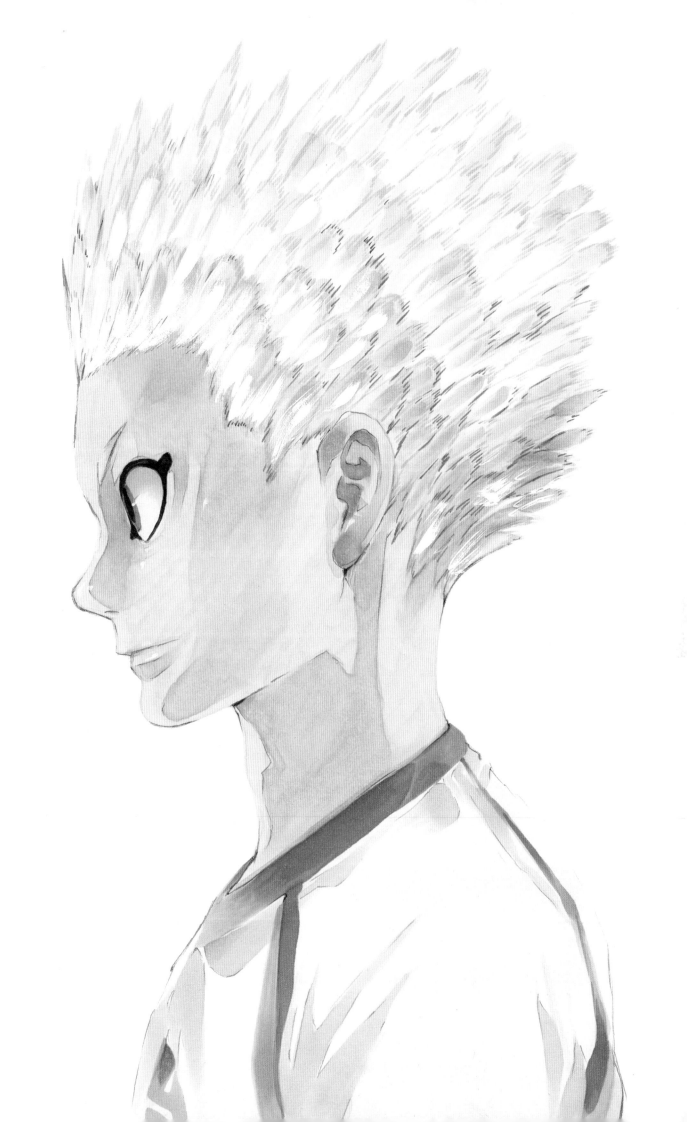

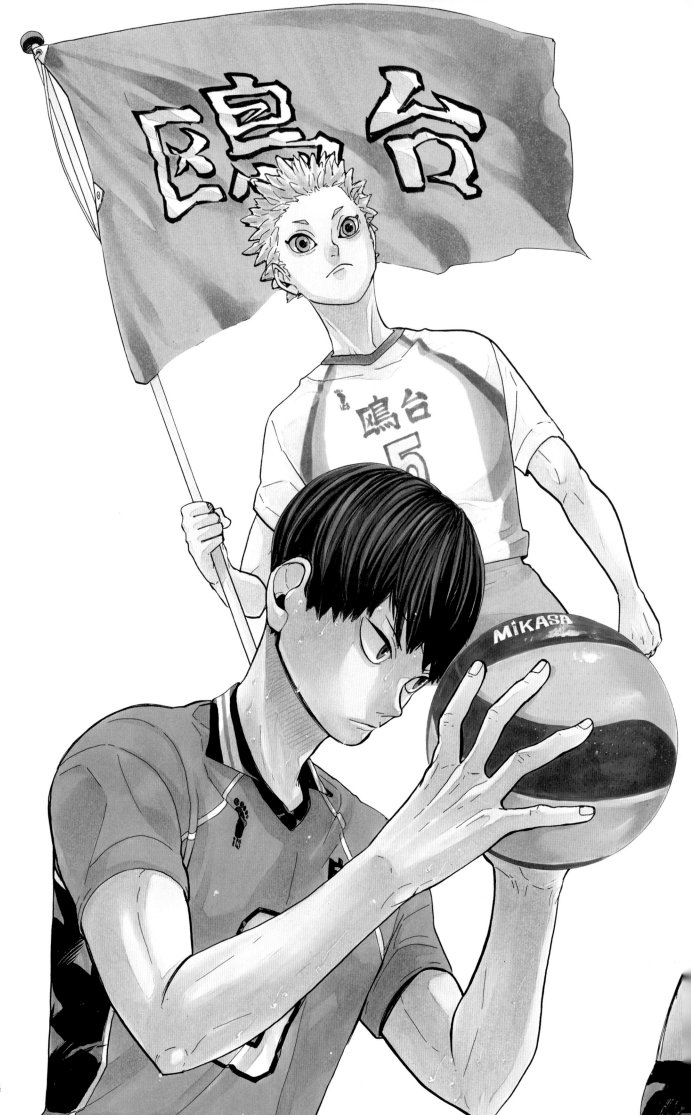

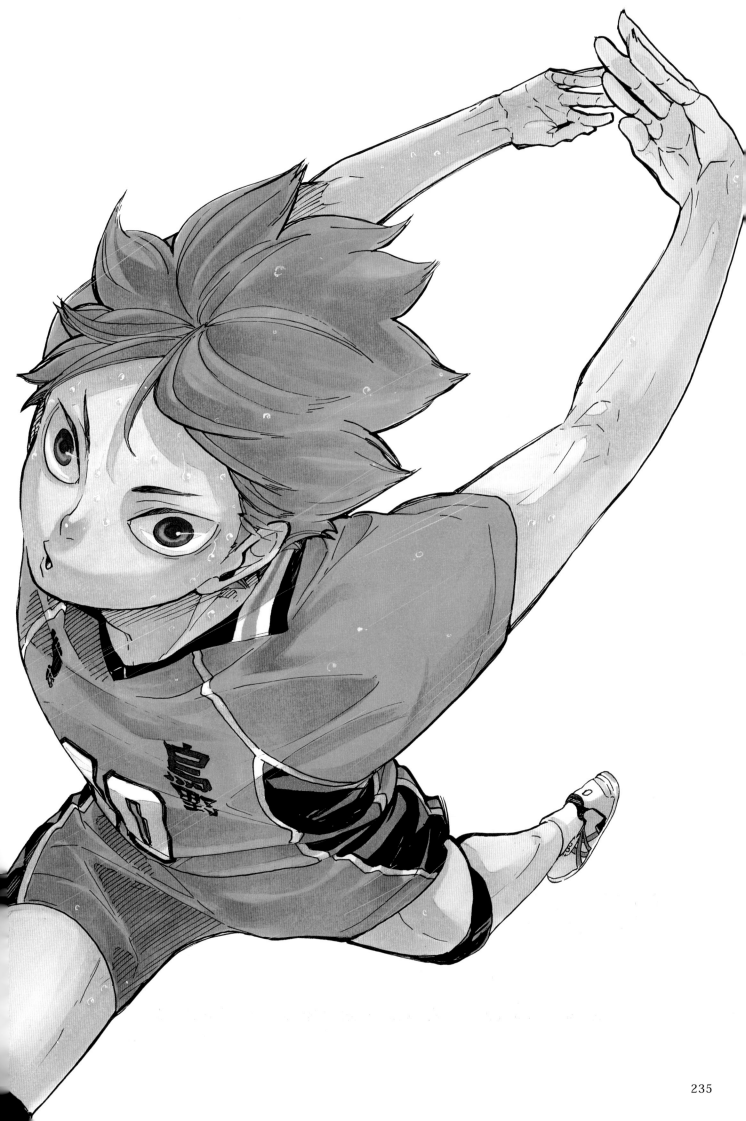

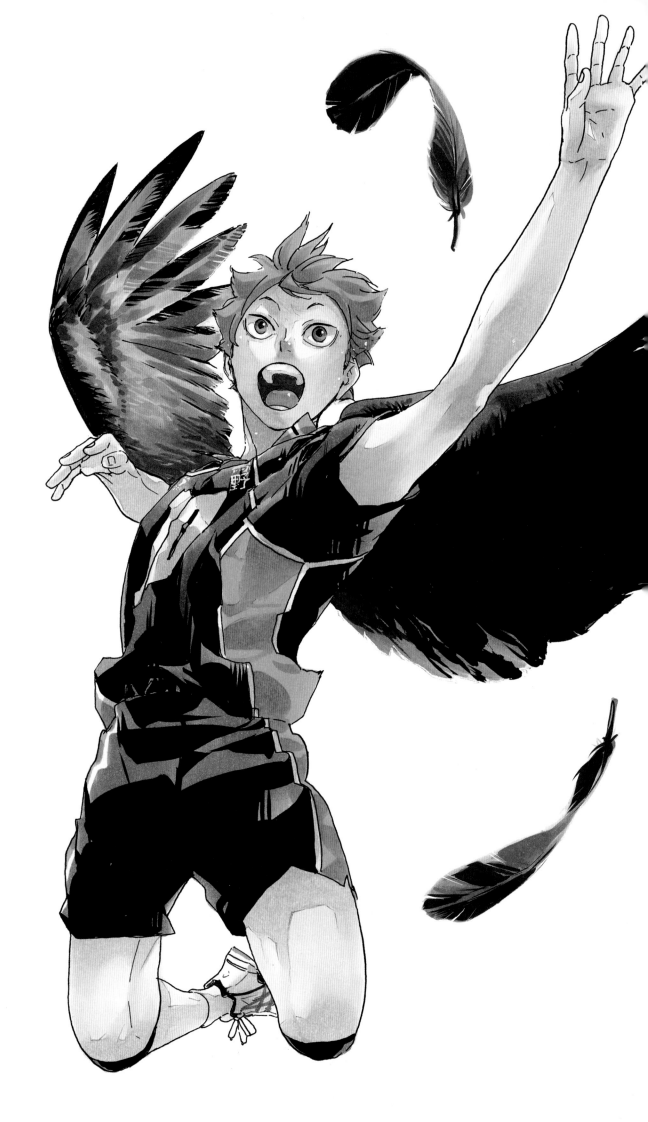

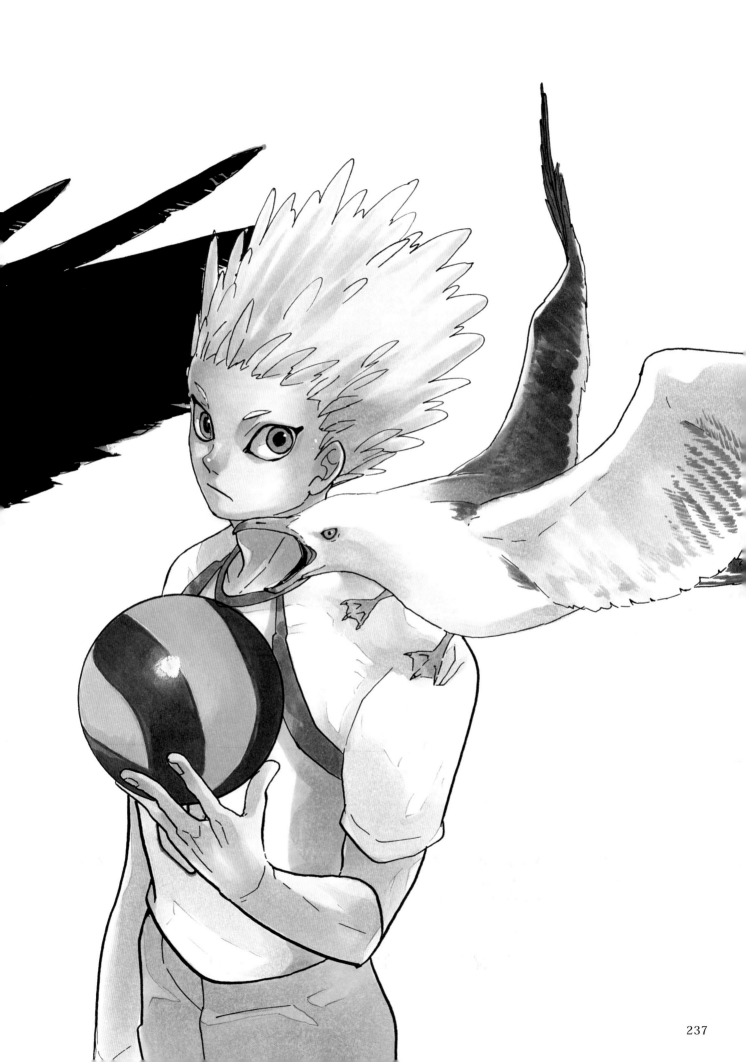

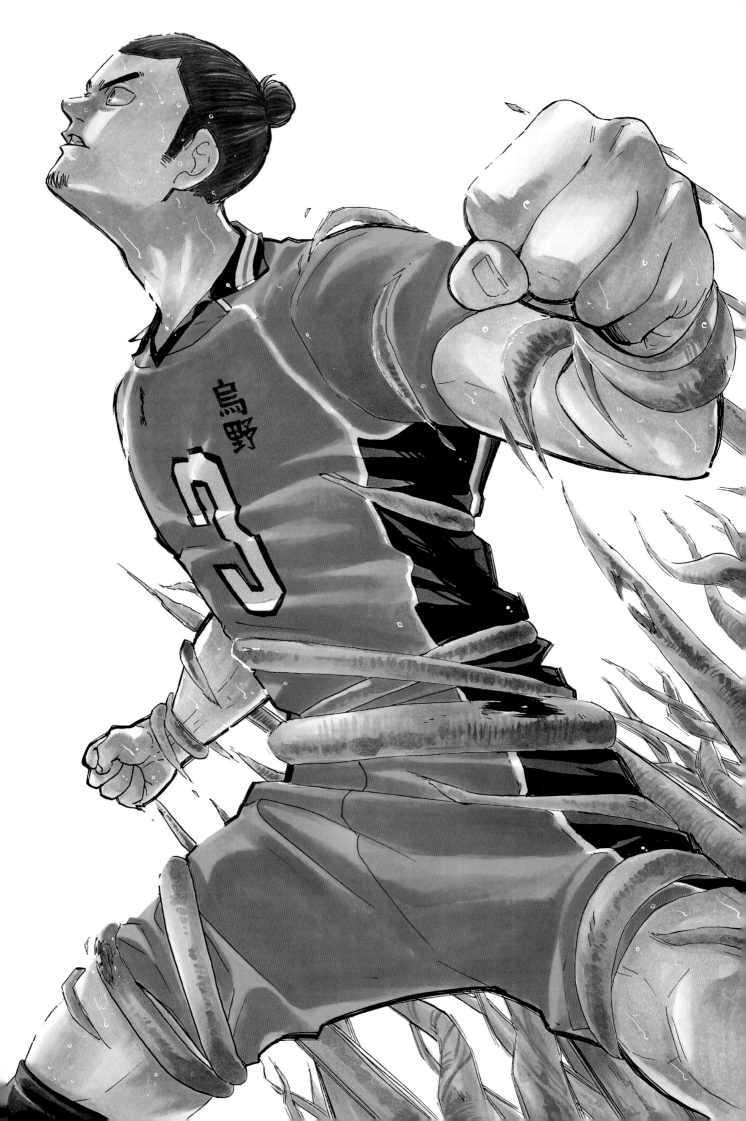

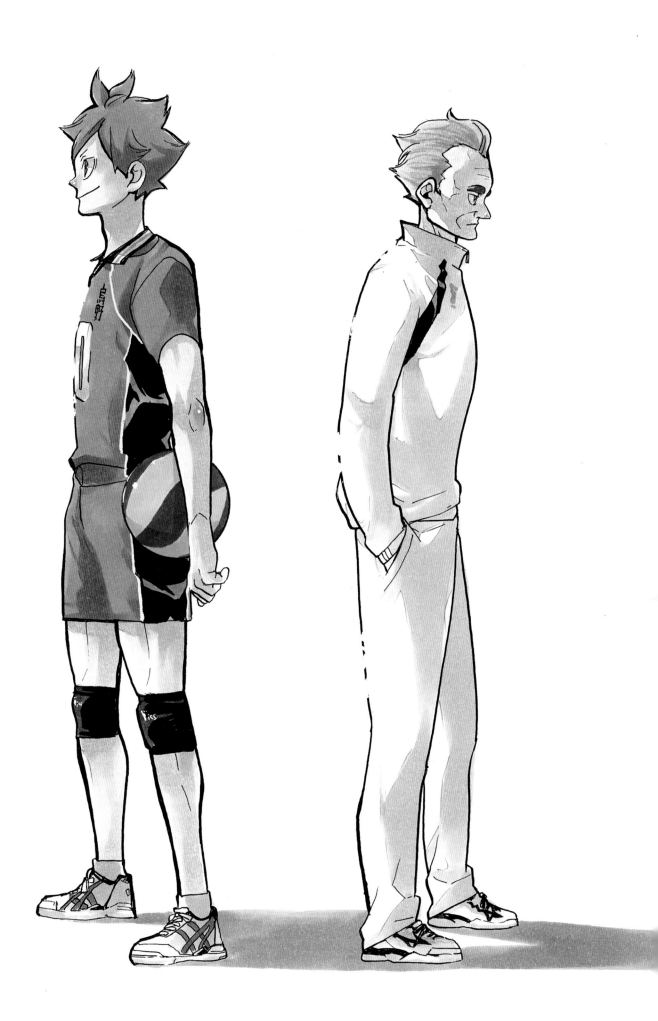

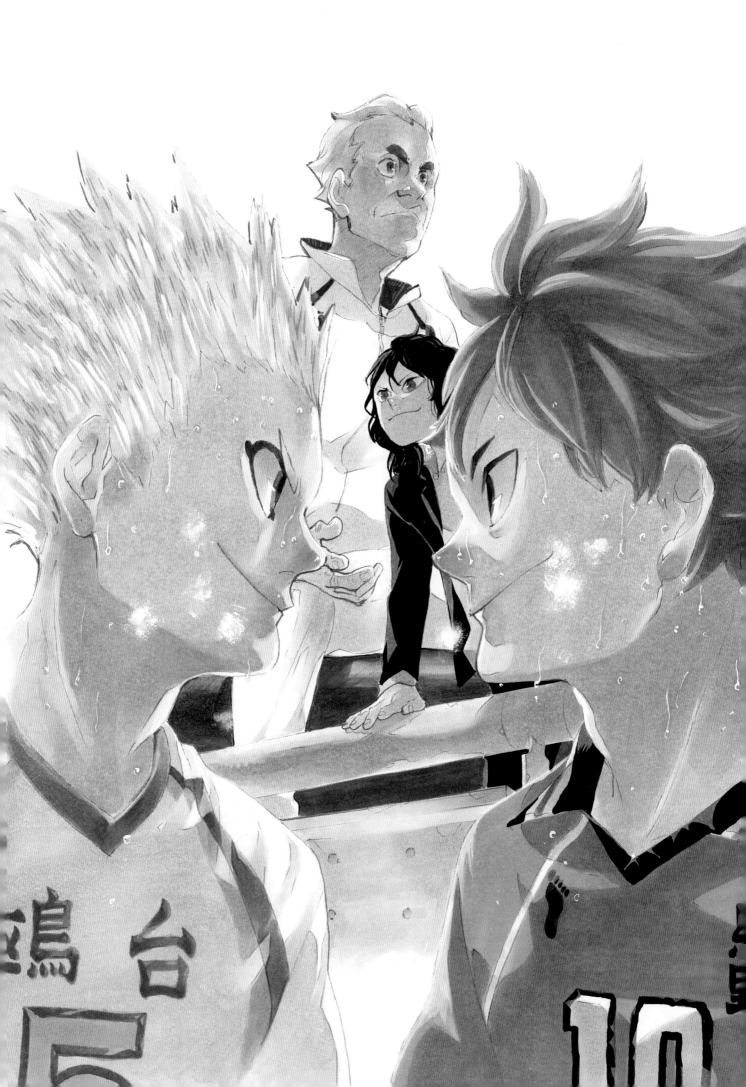

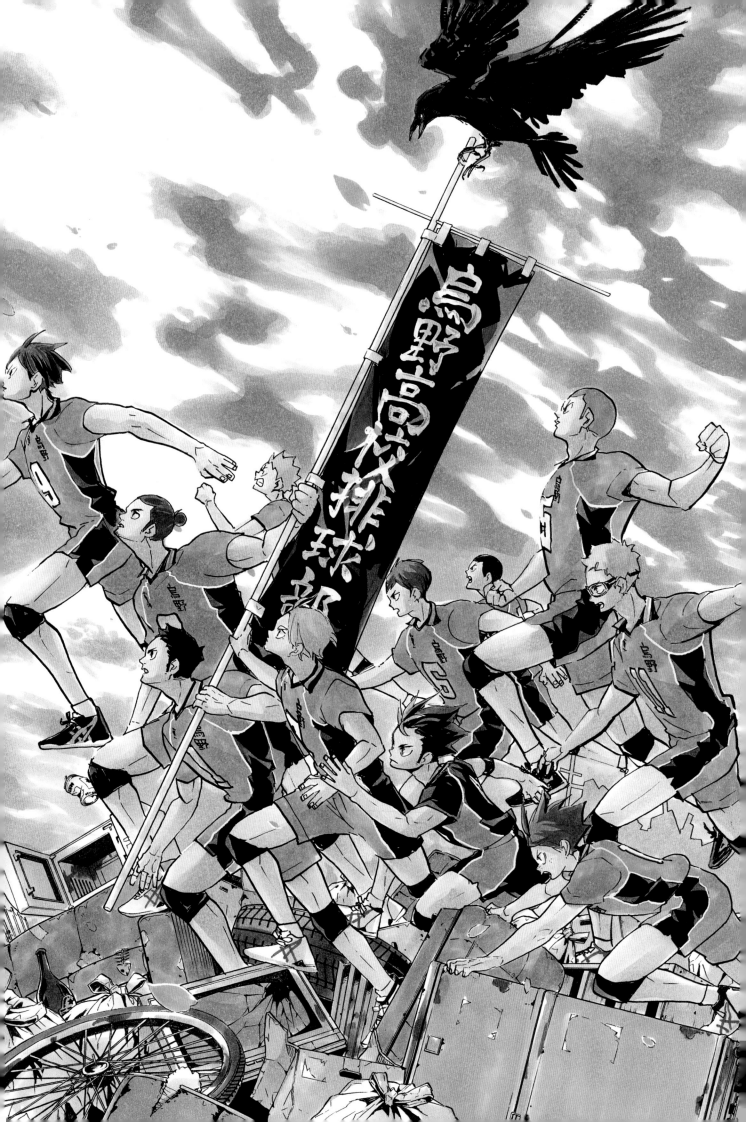

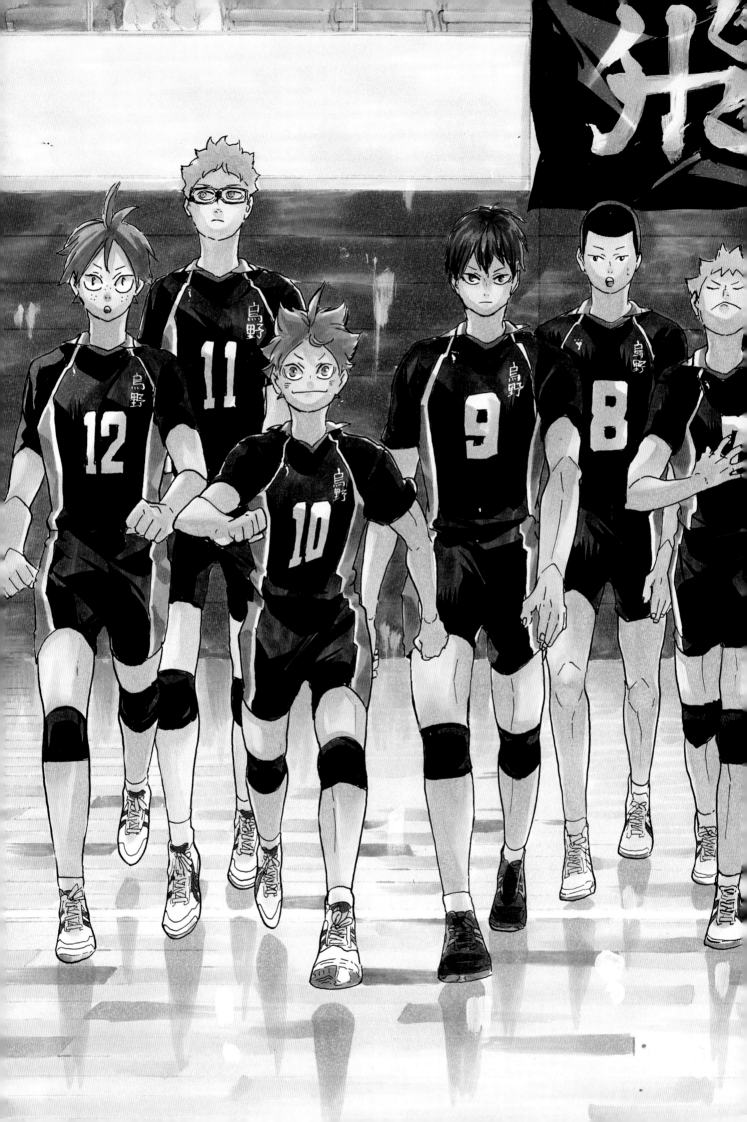

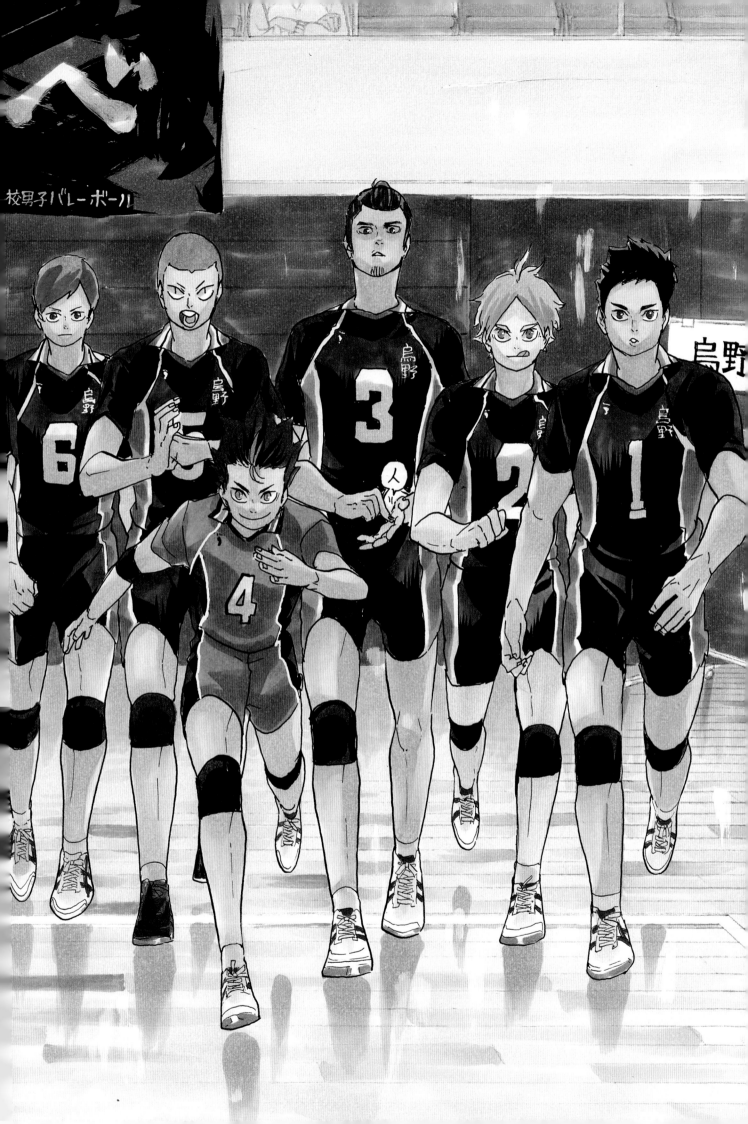

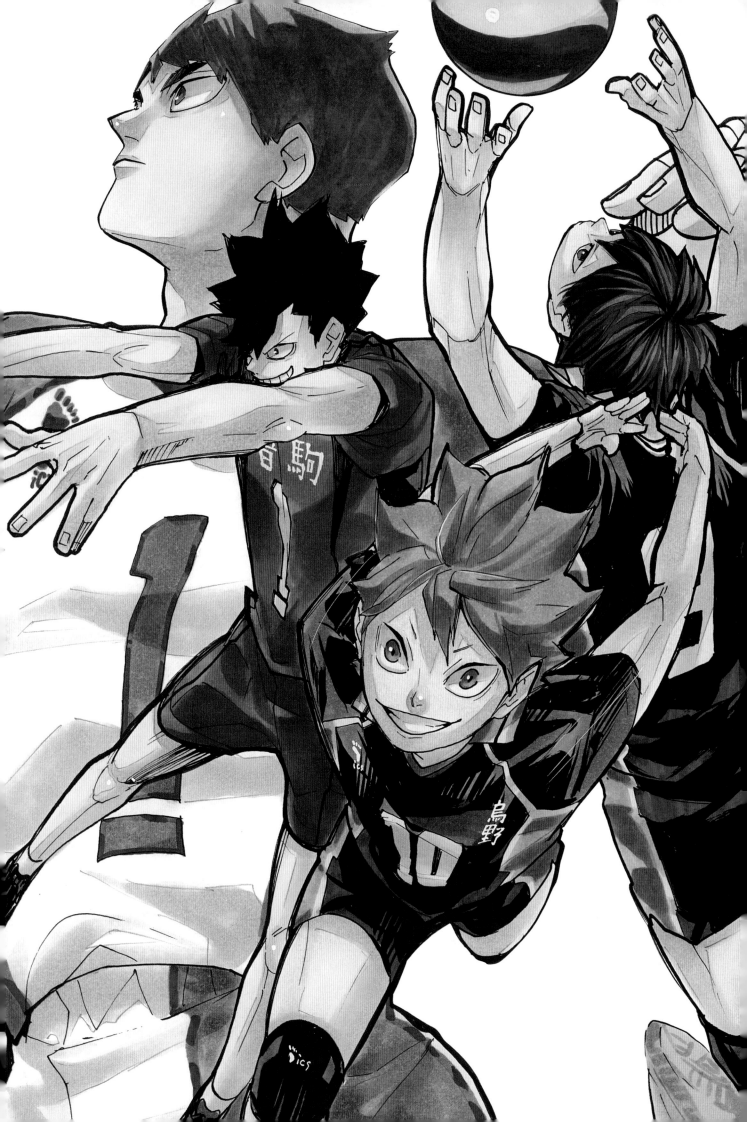

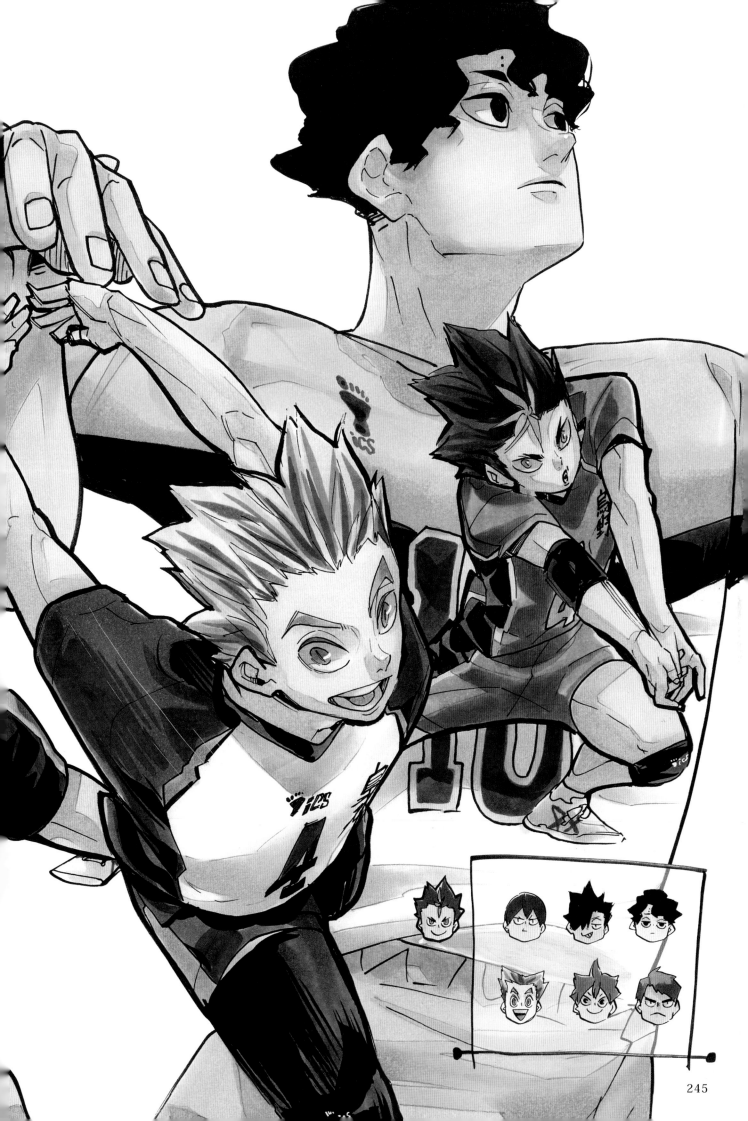

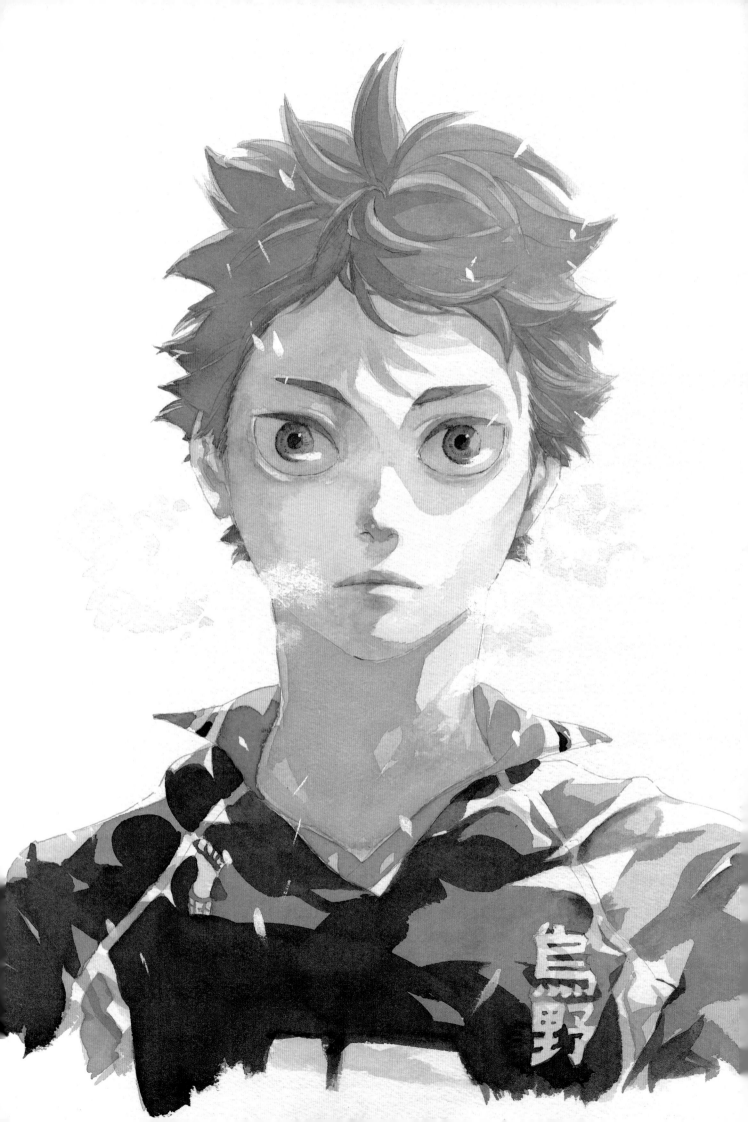

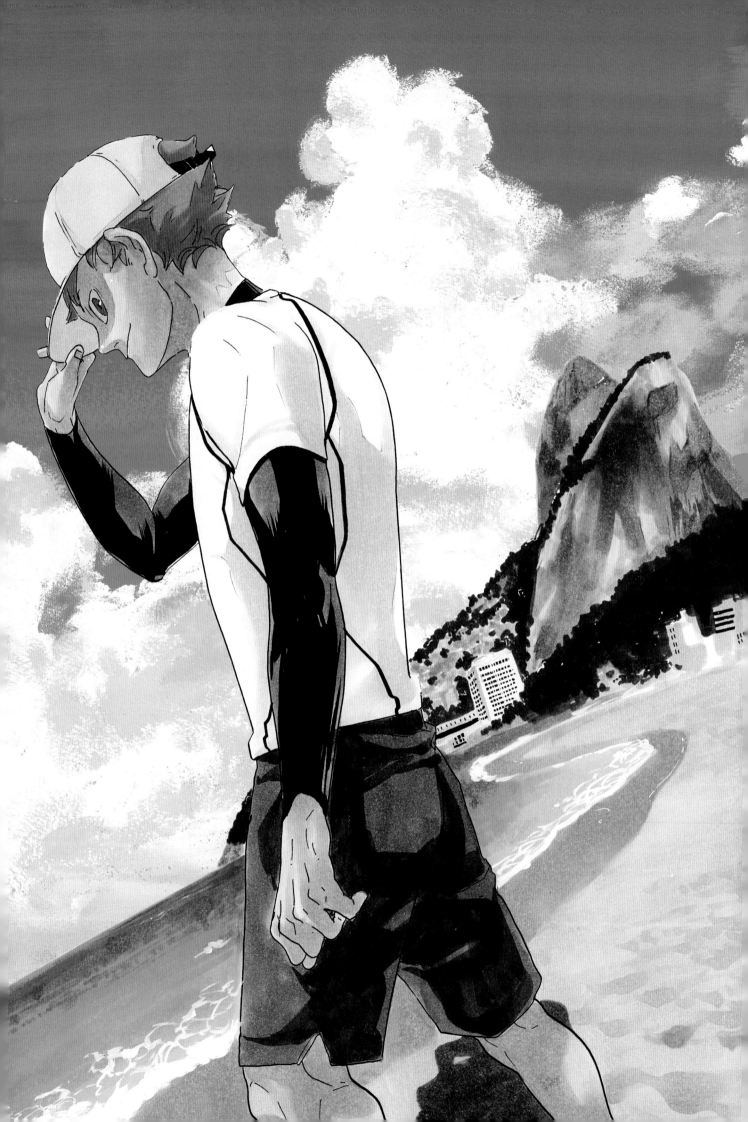

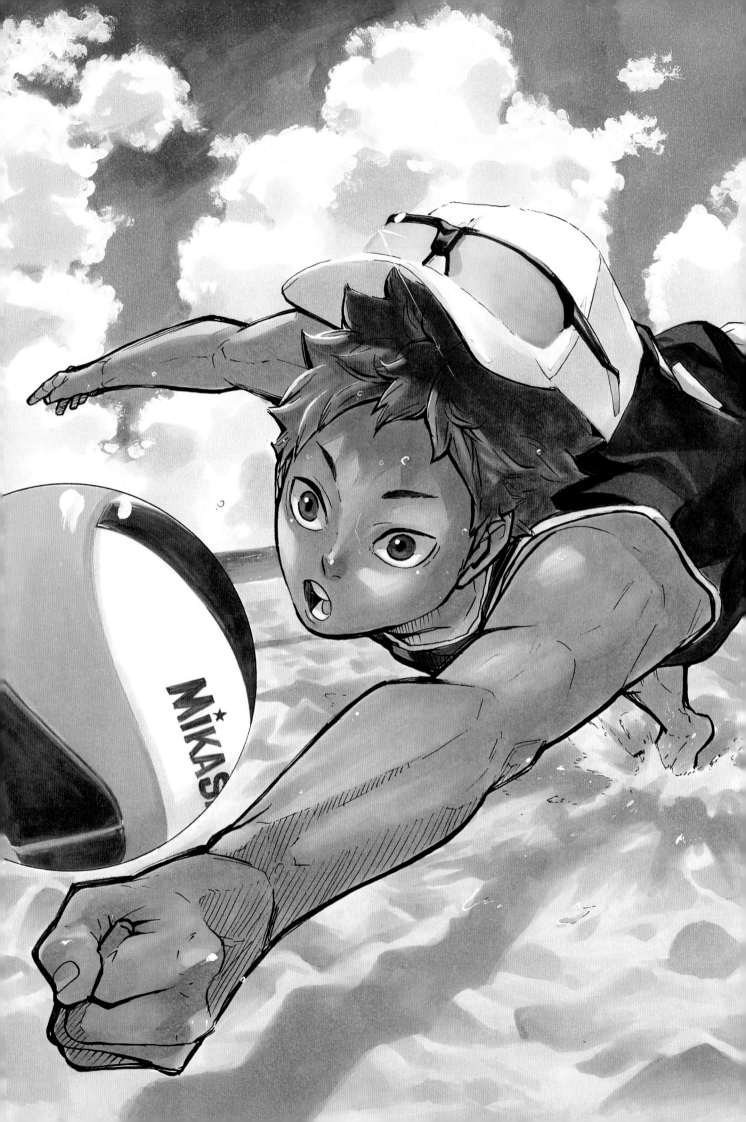

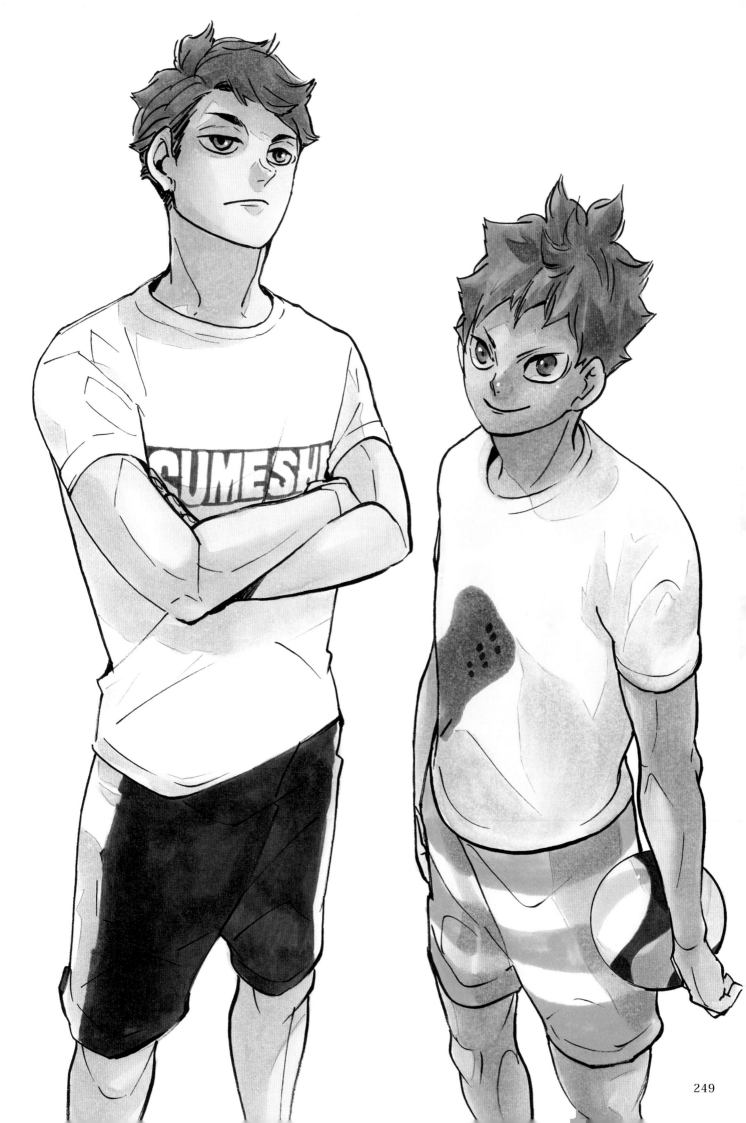

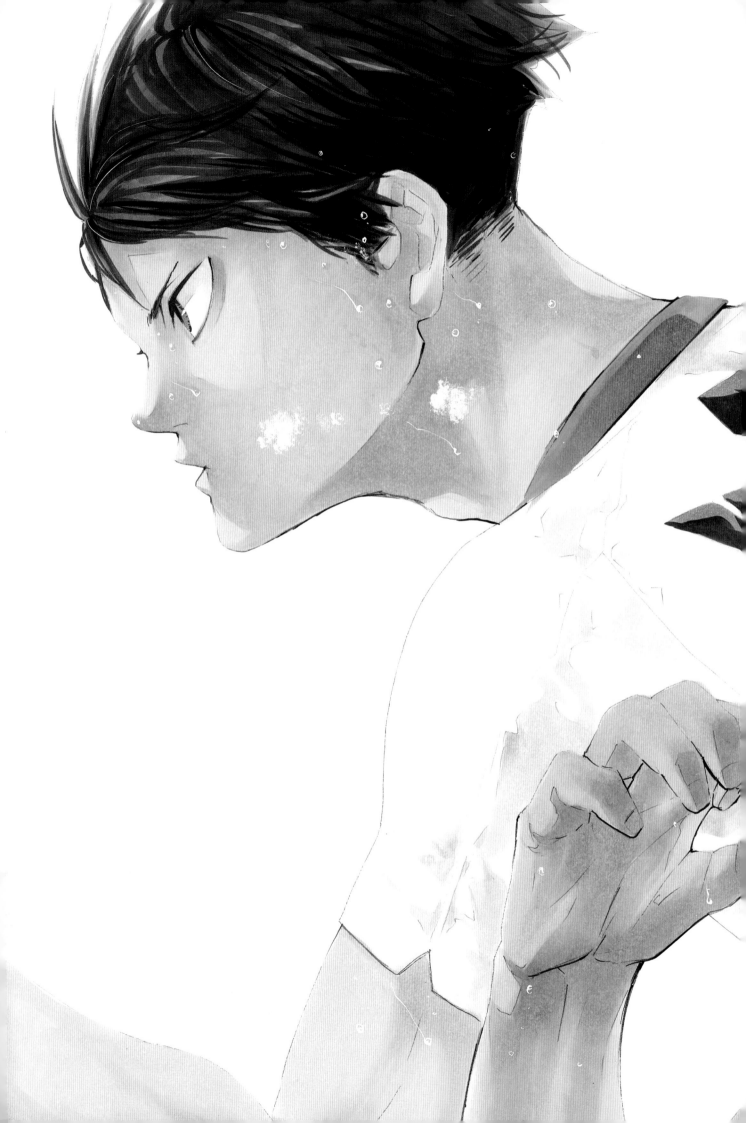

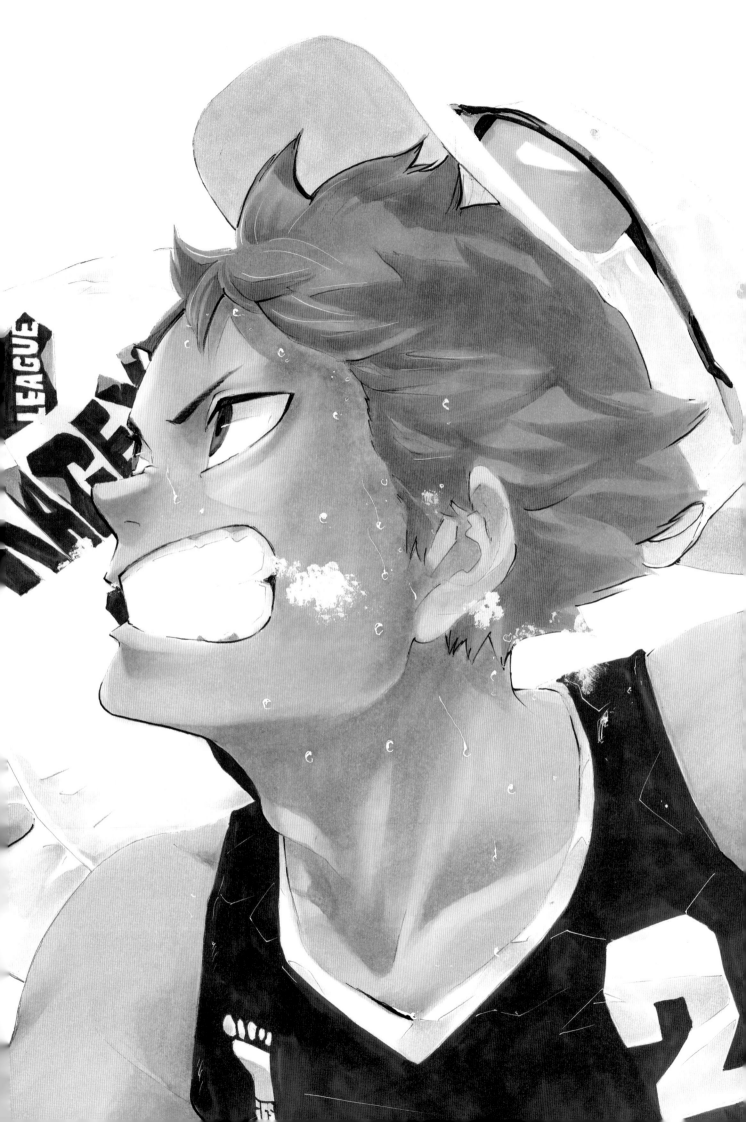

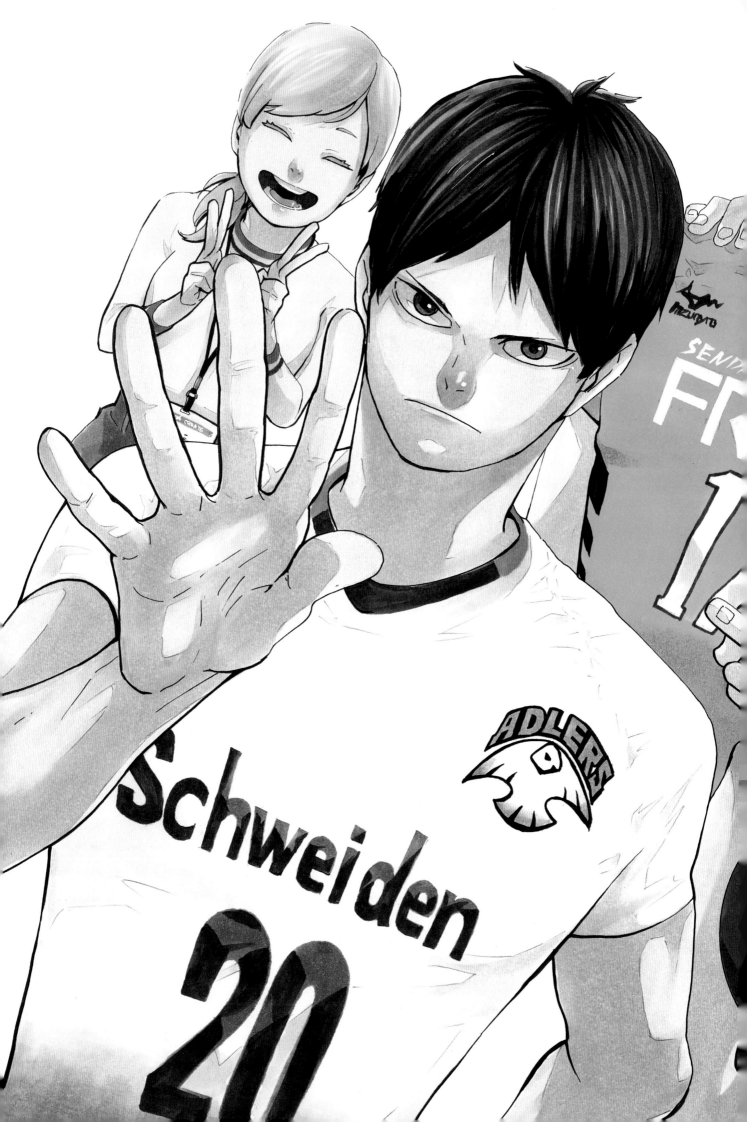

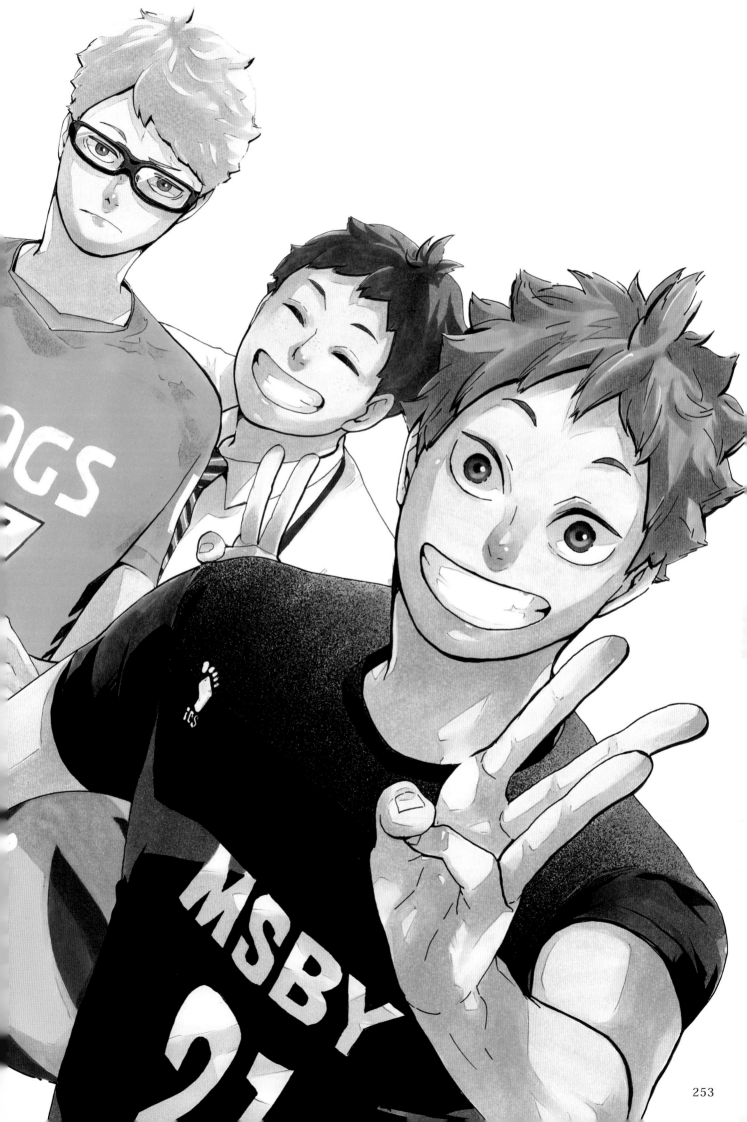

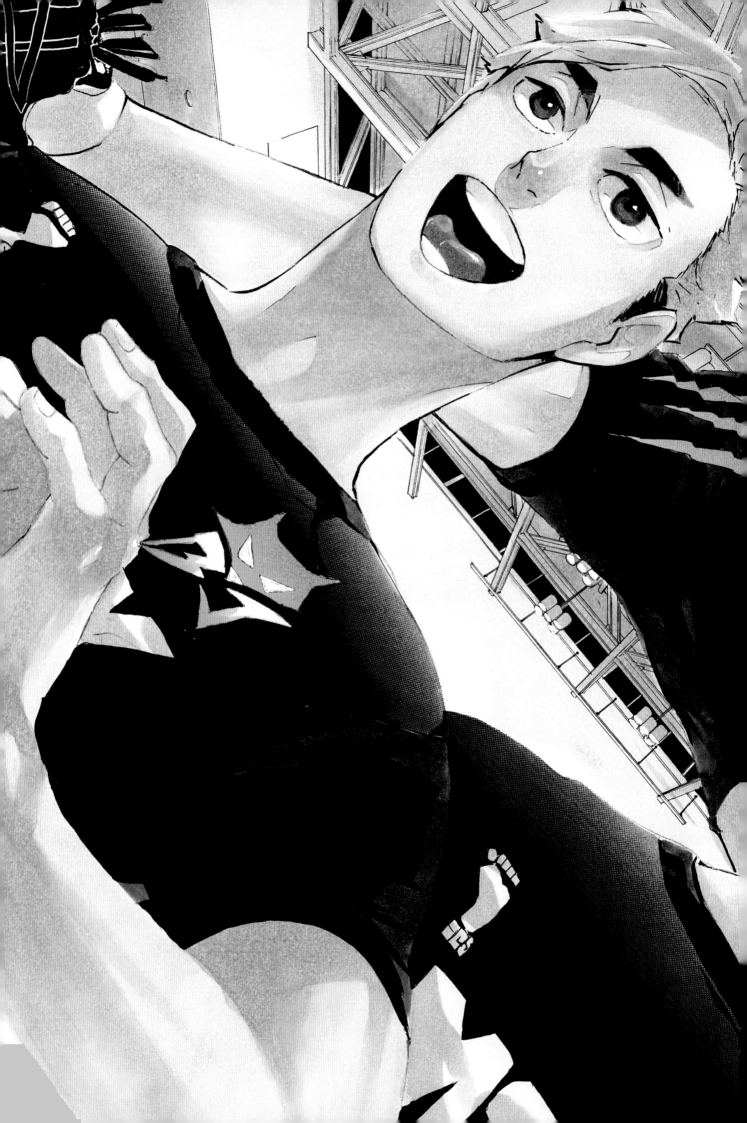

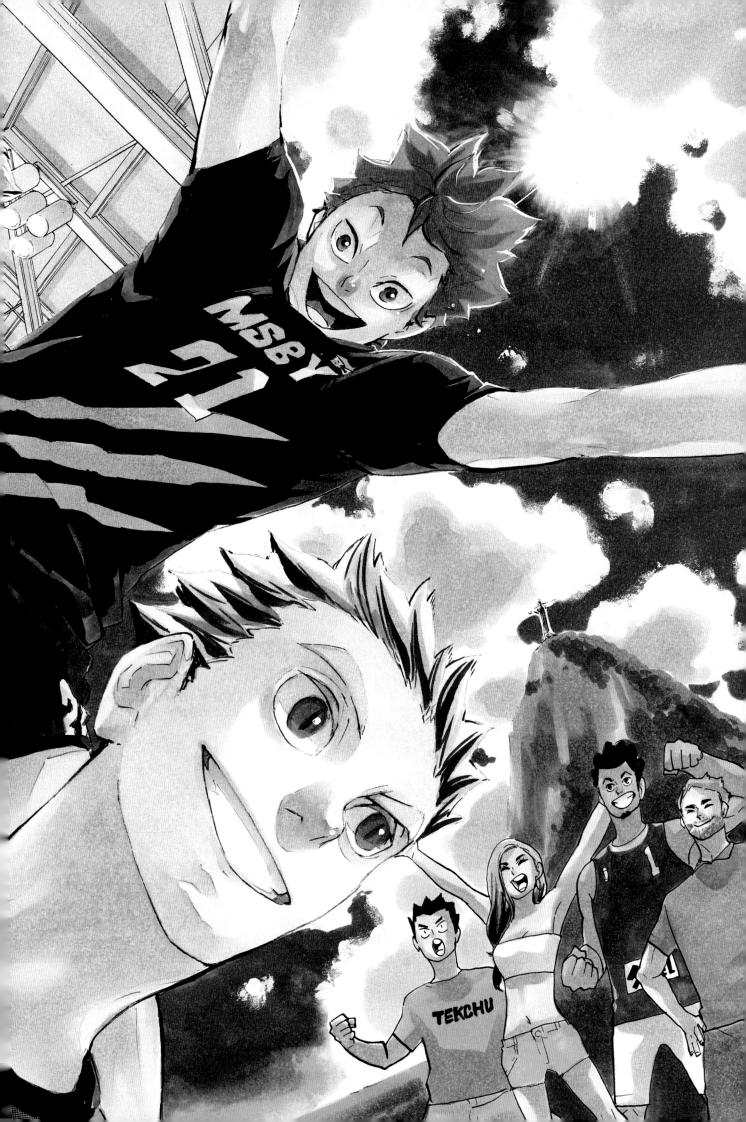

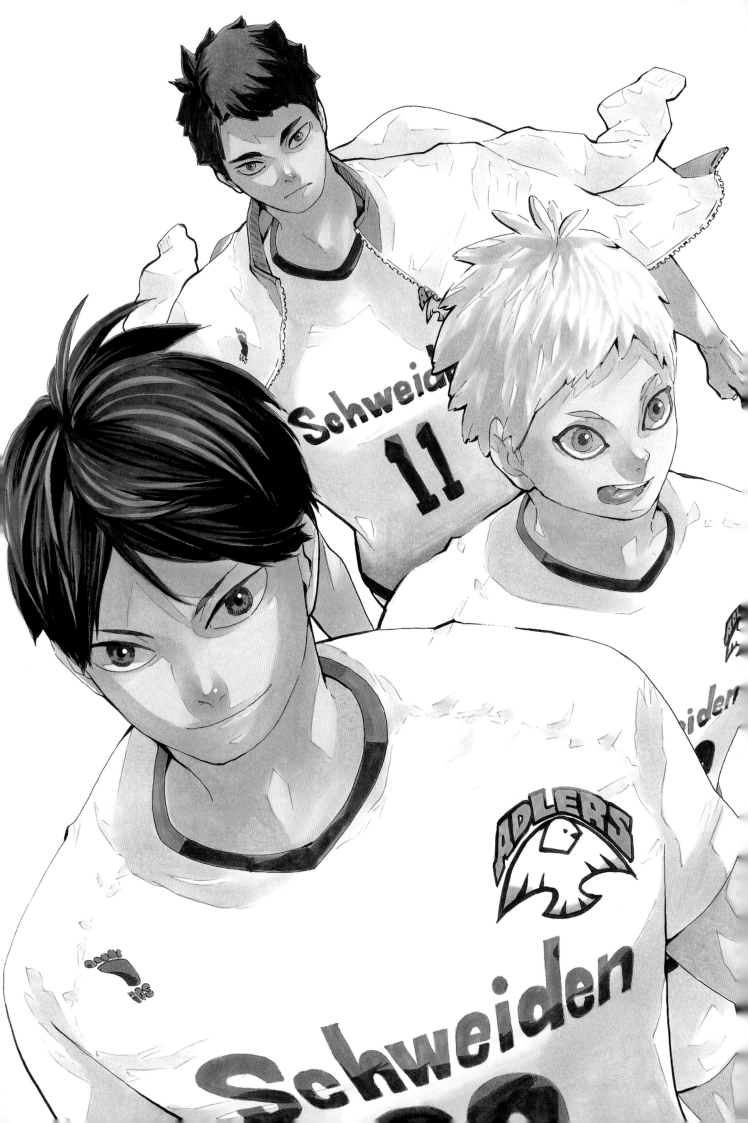

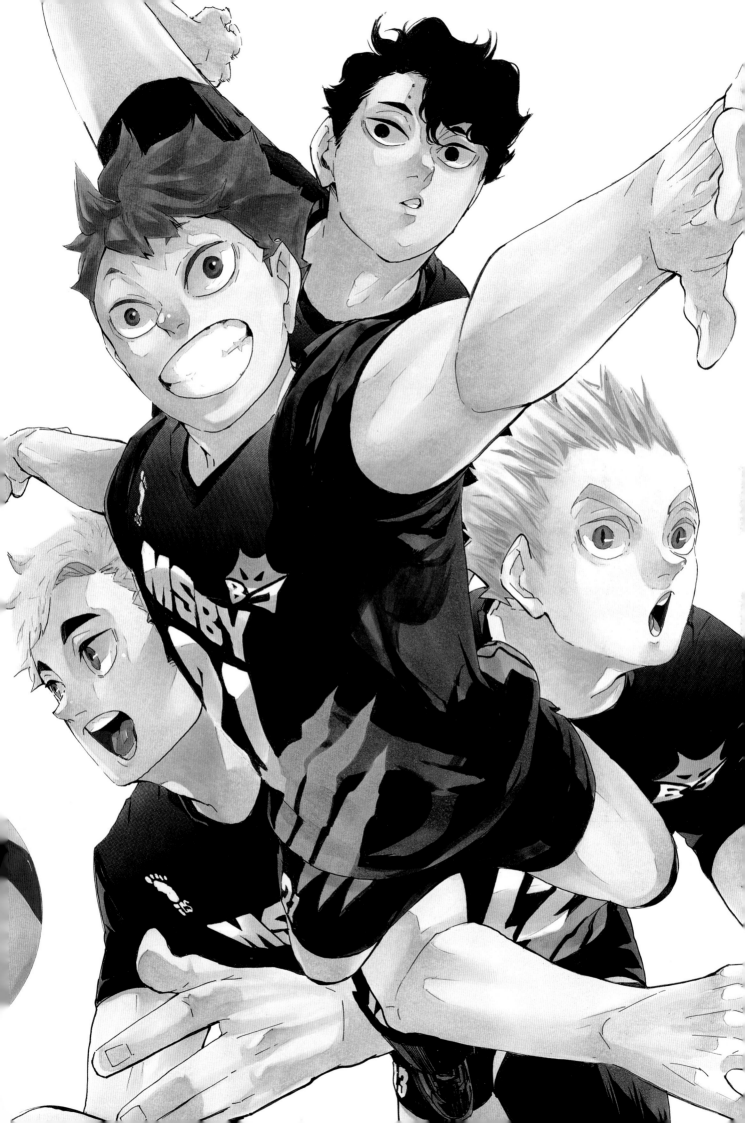

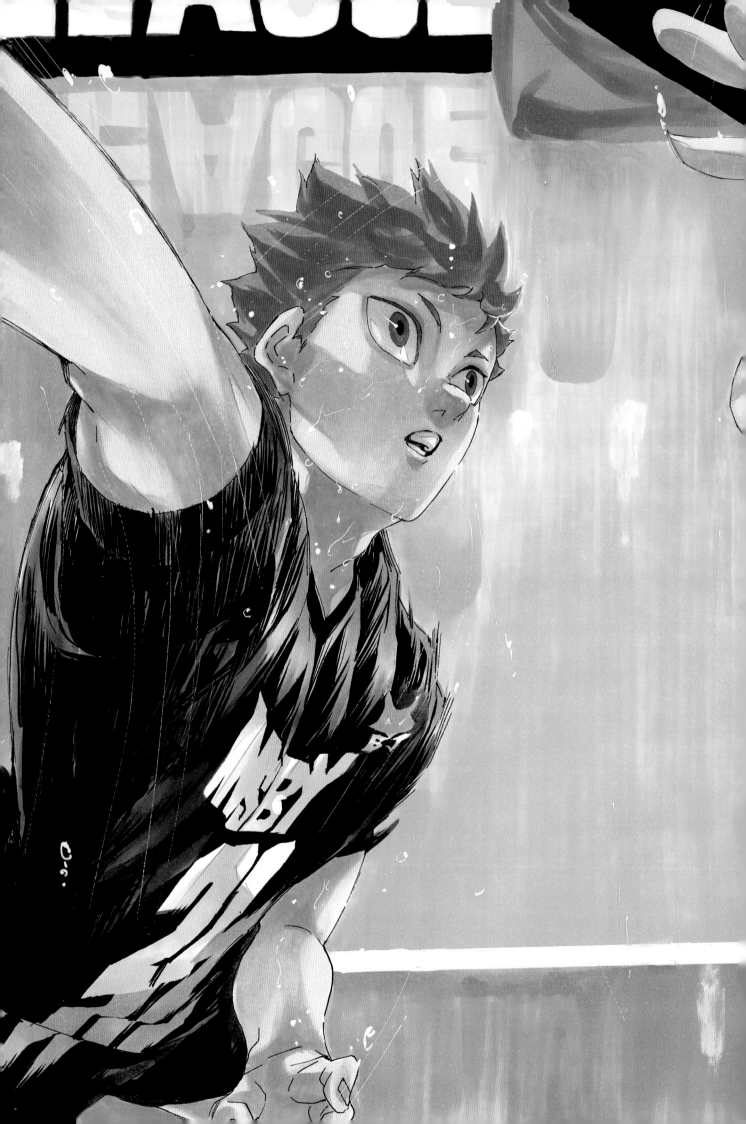

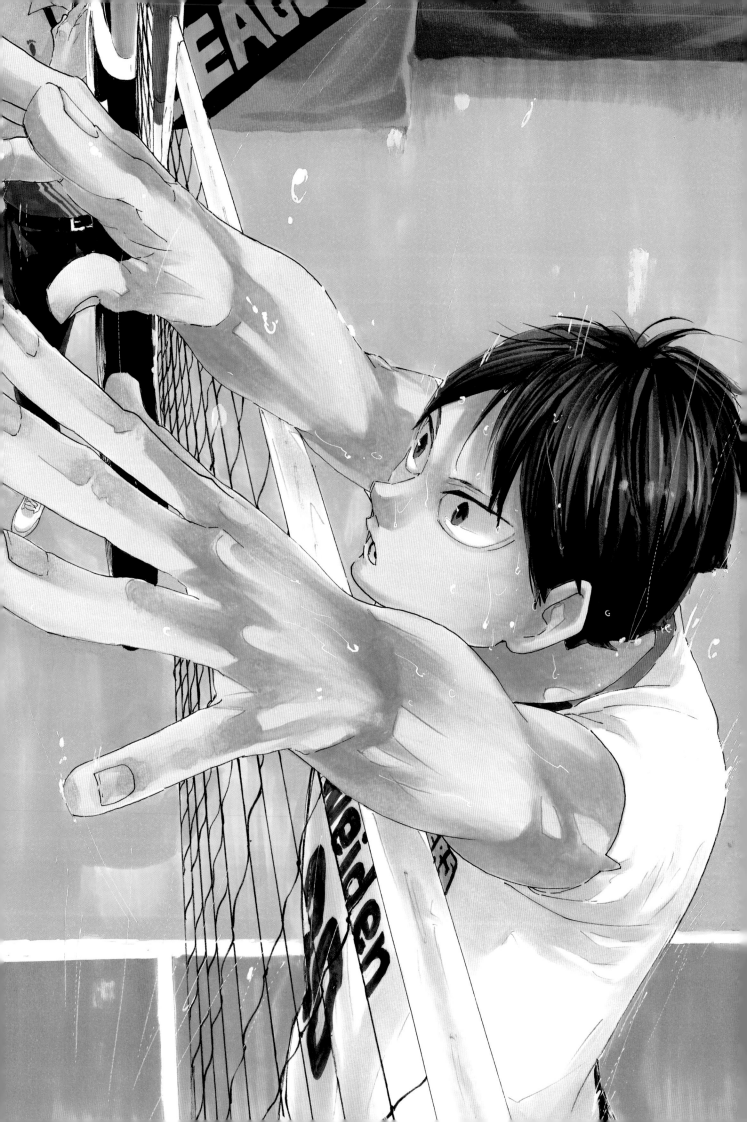

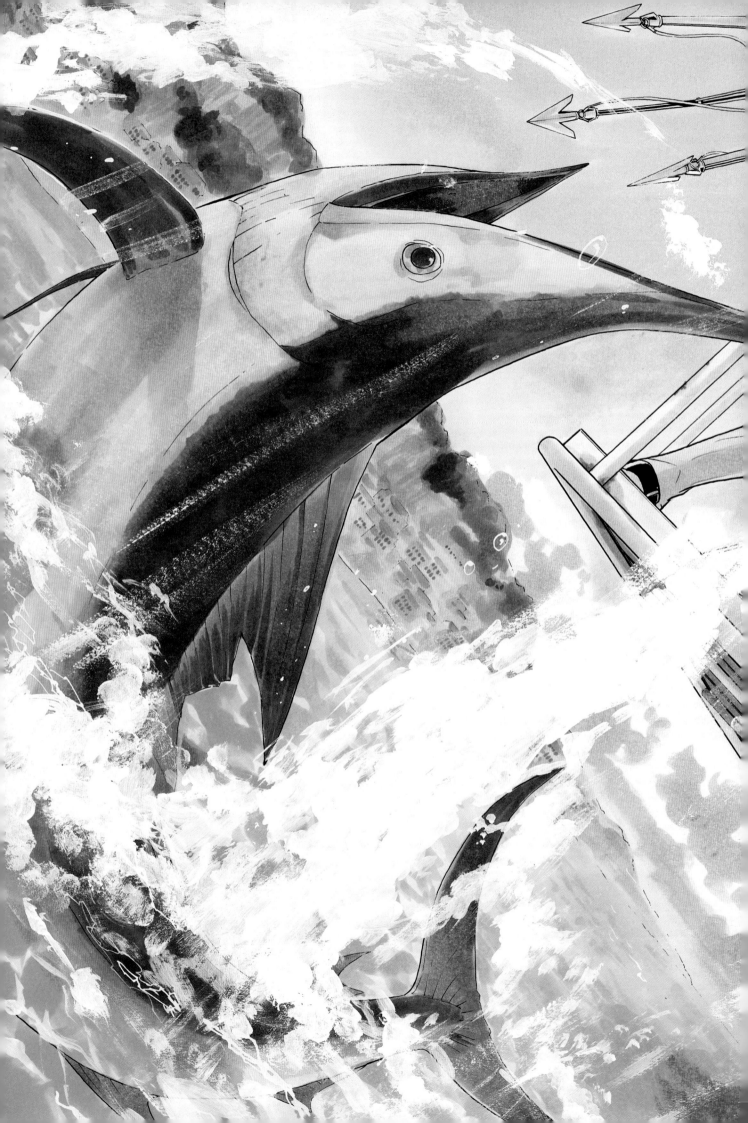

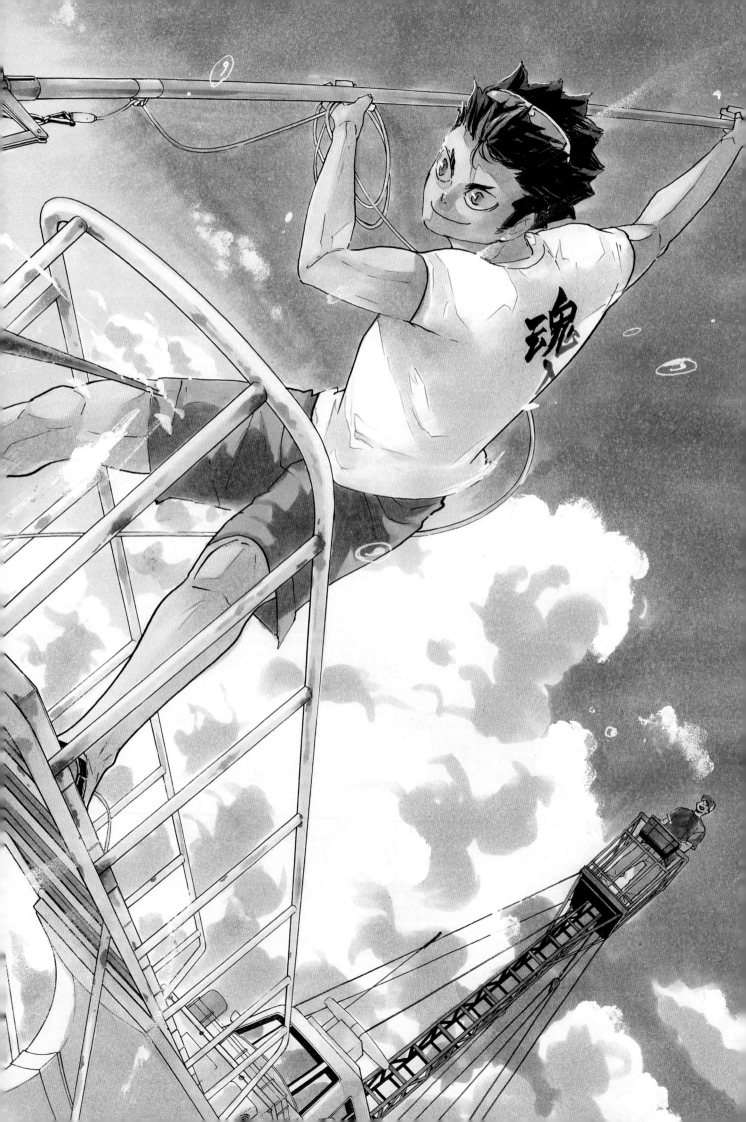

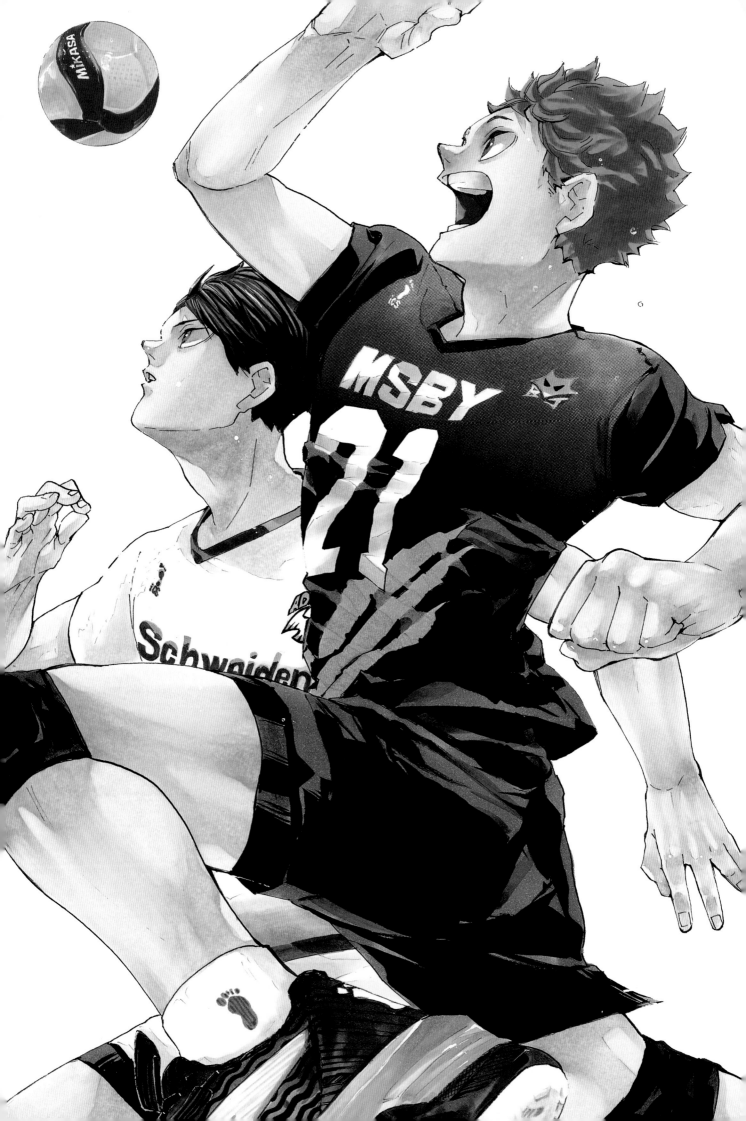

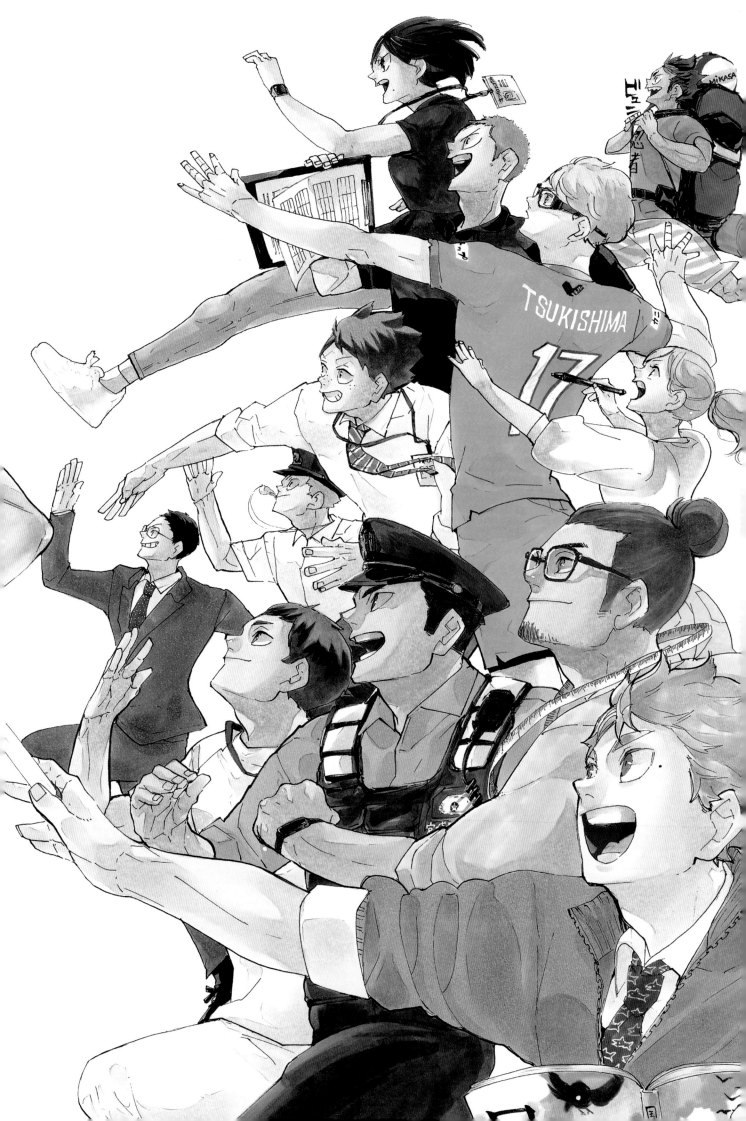

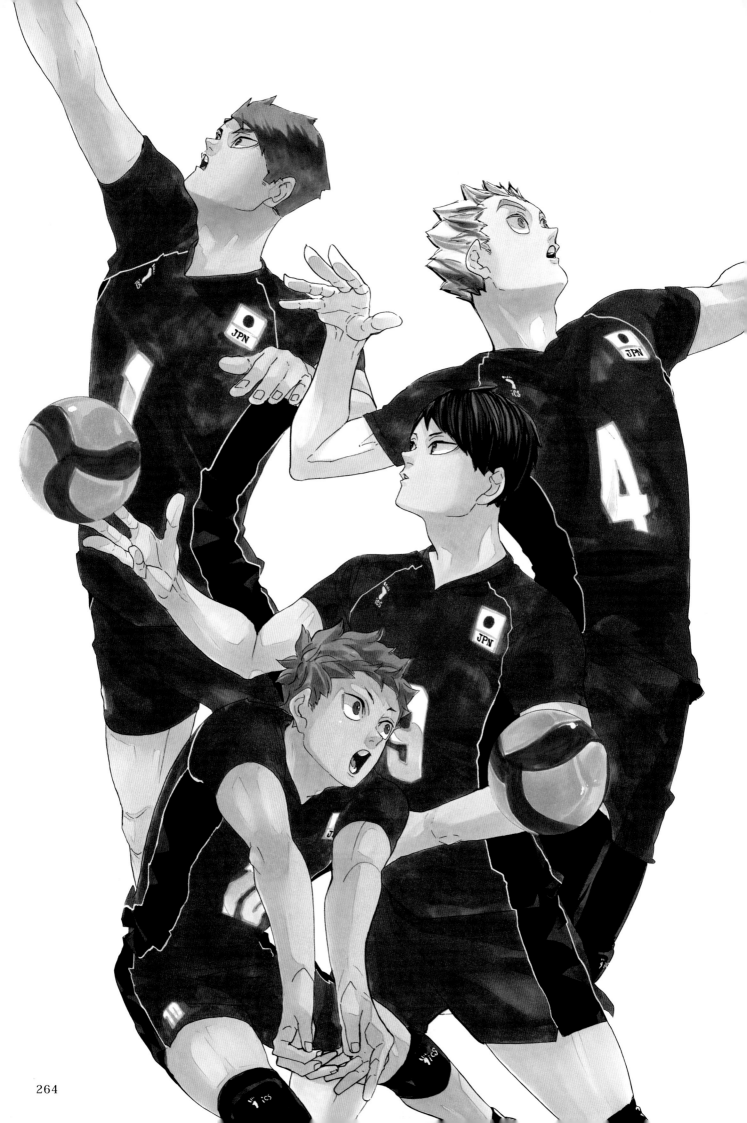

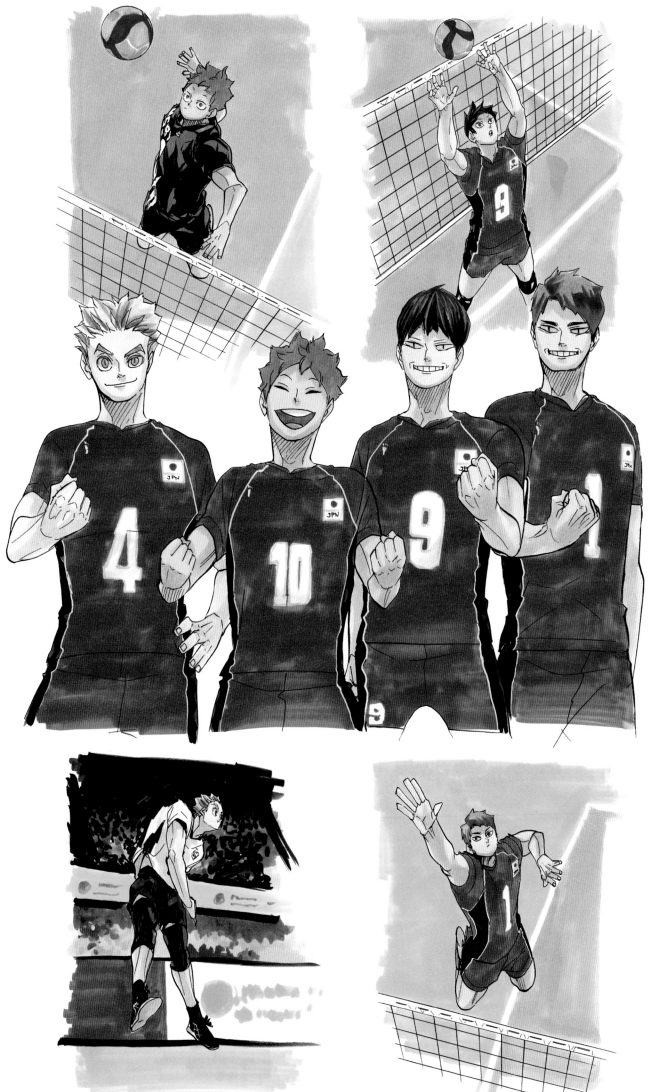

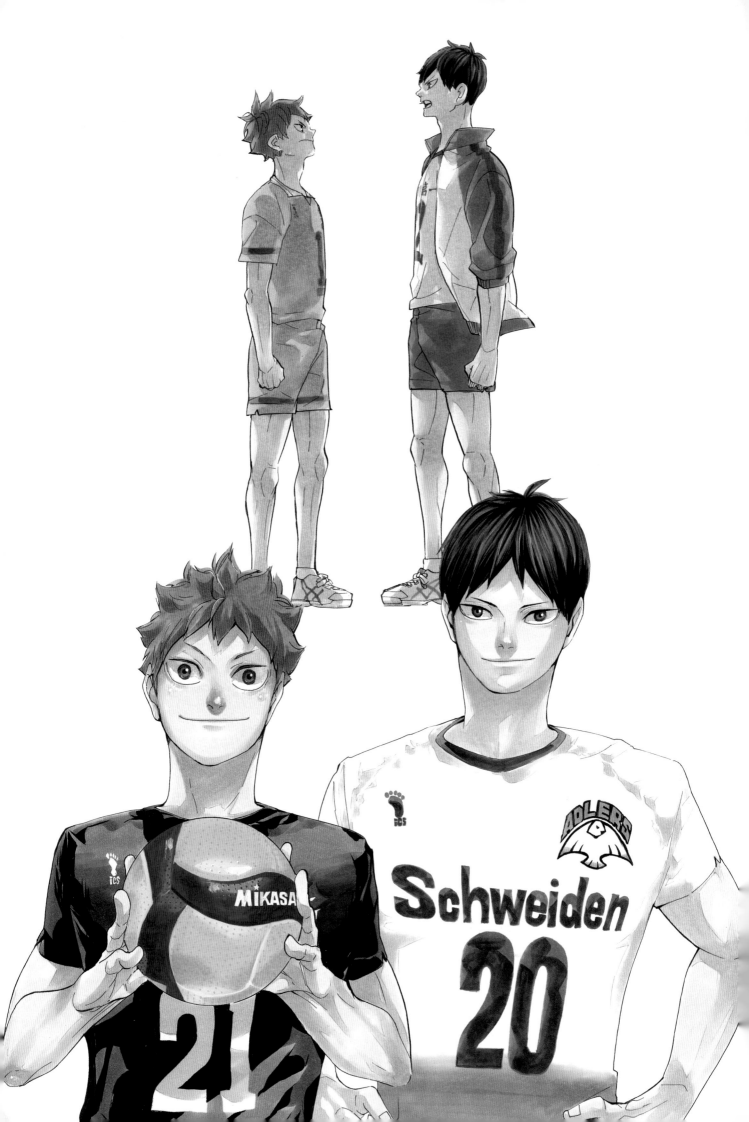

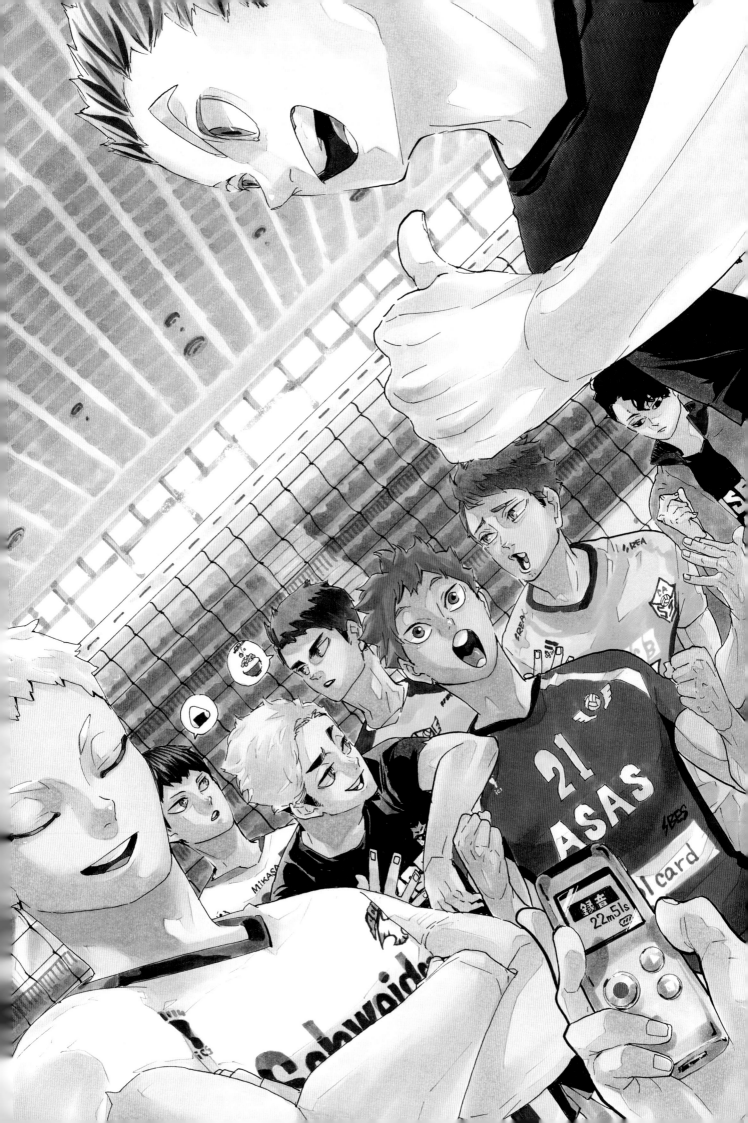

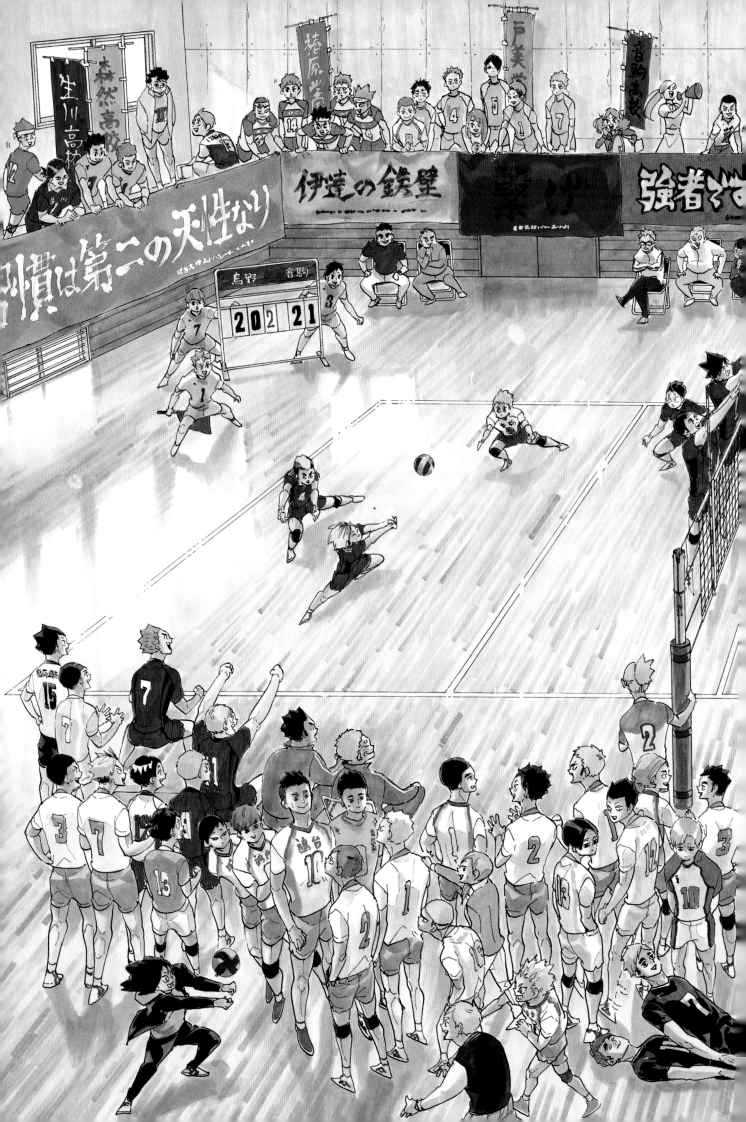

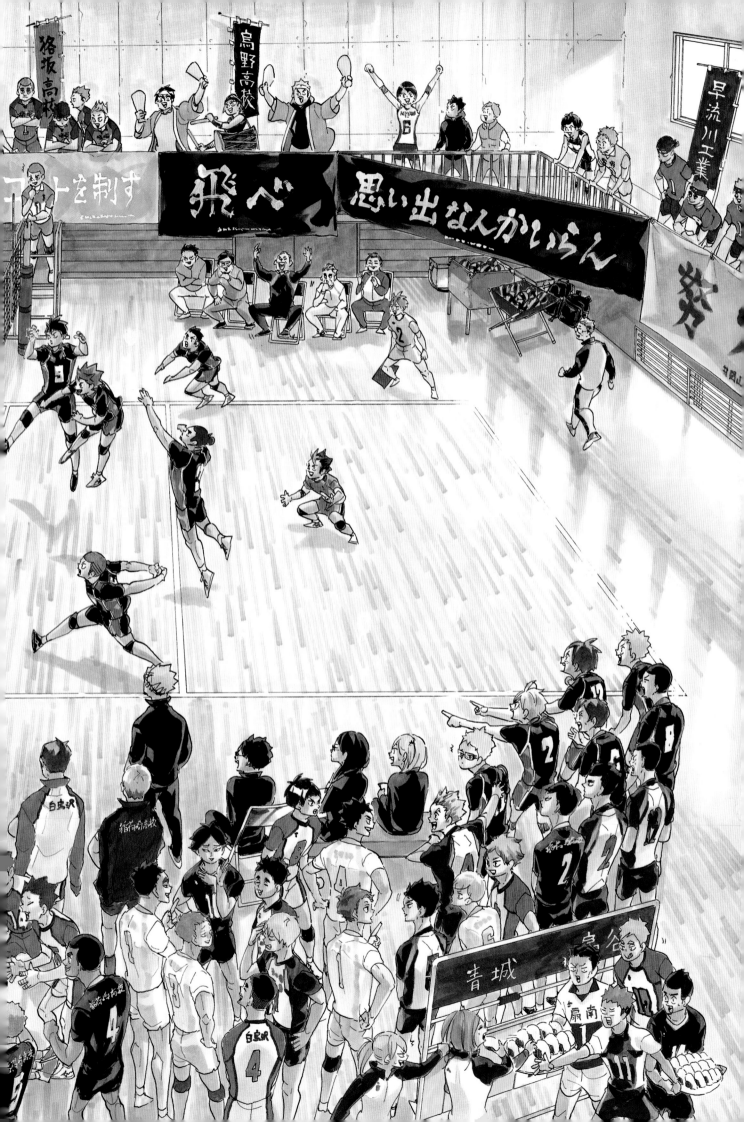

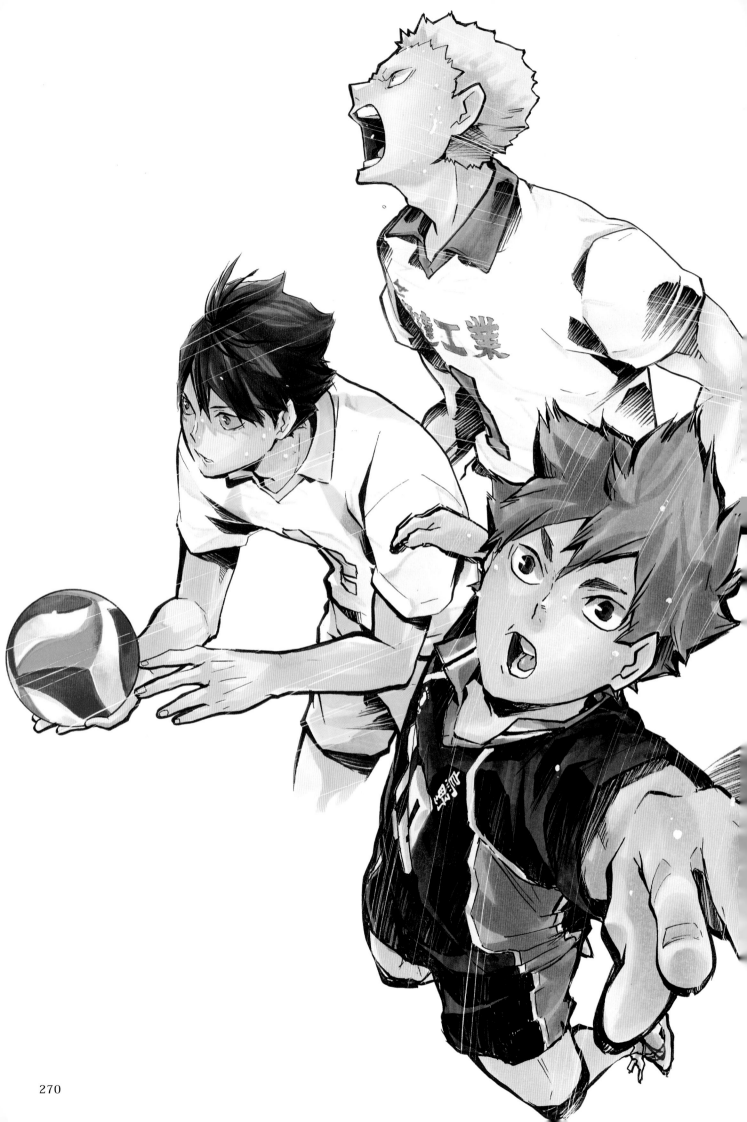

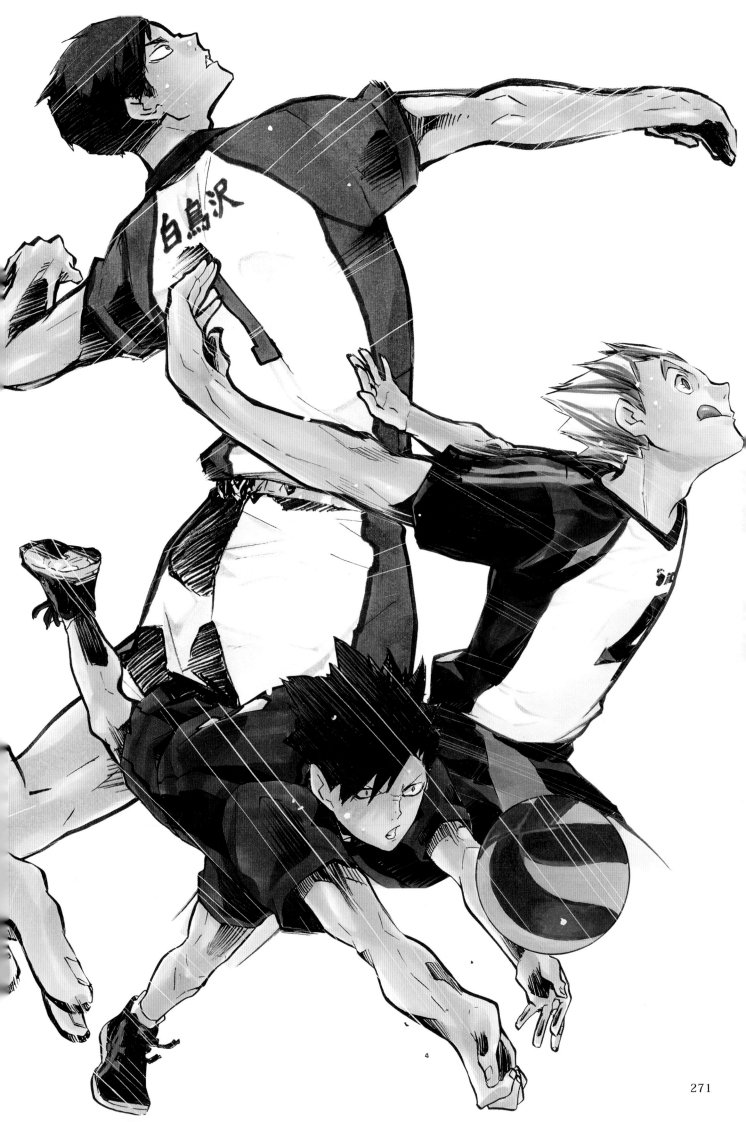

271

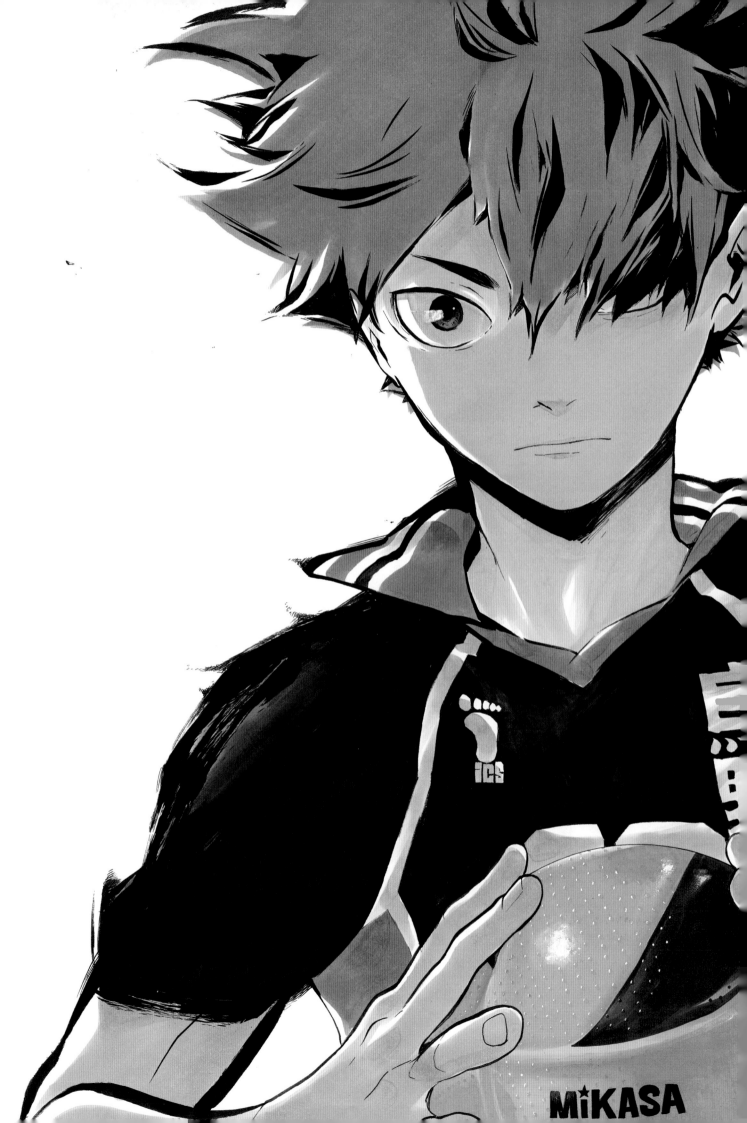

MiKASA

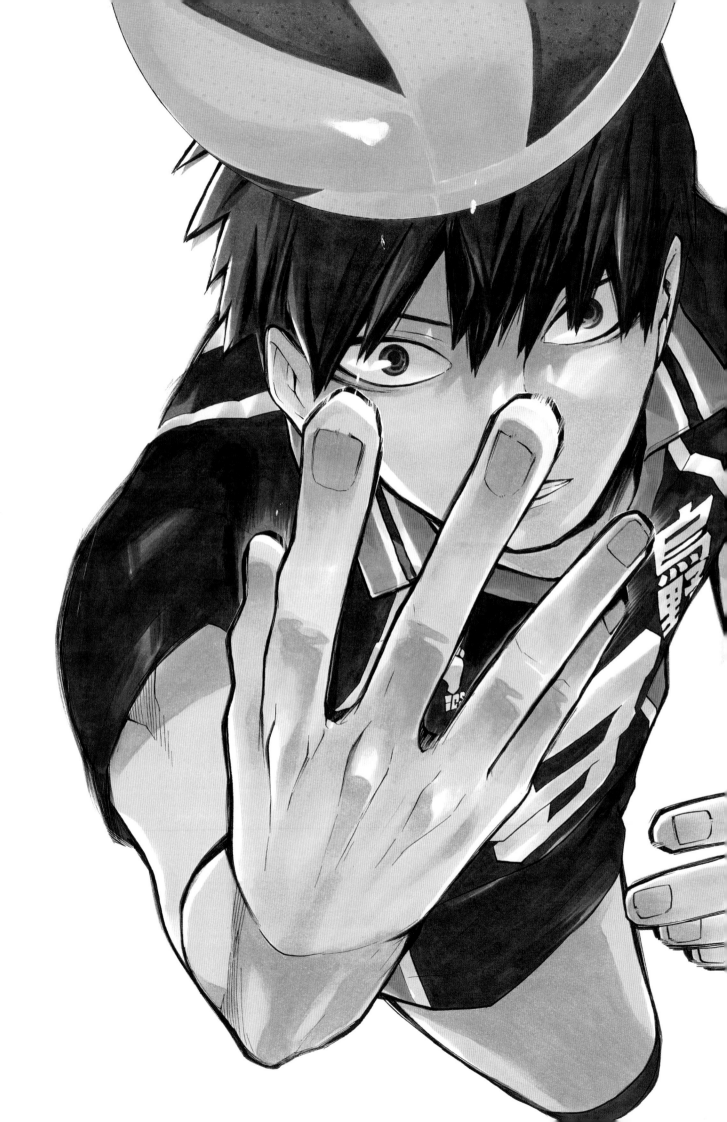

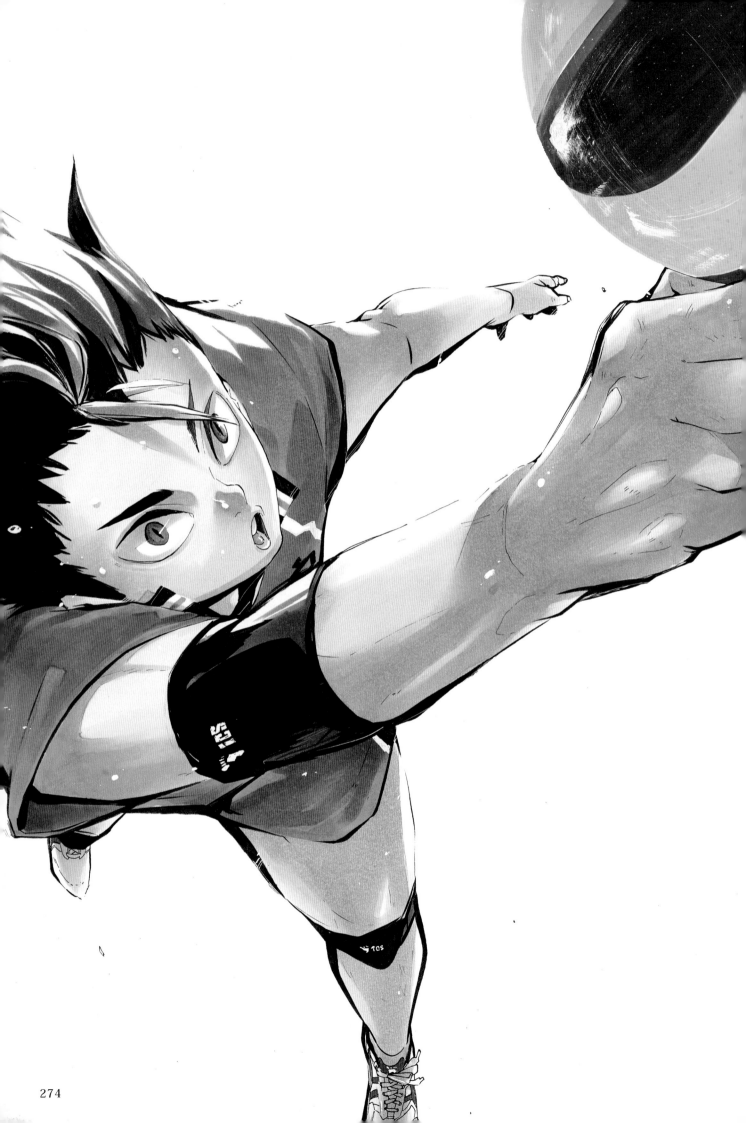

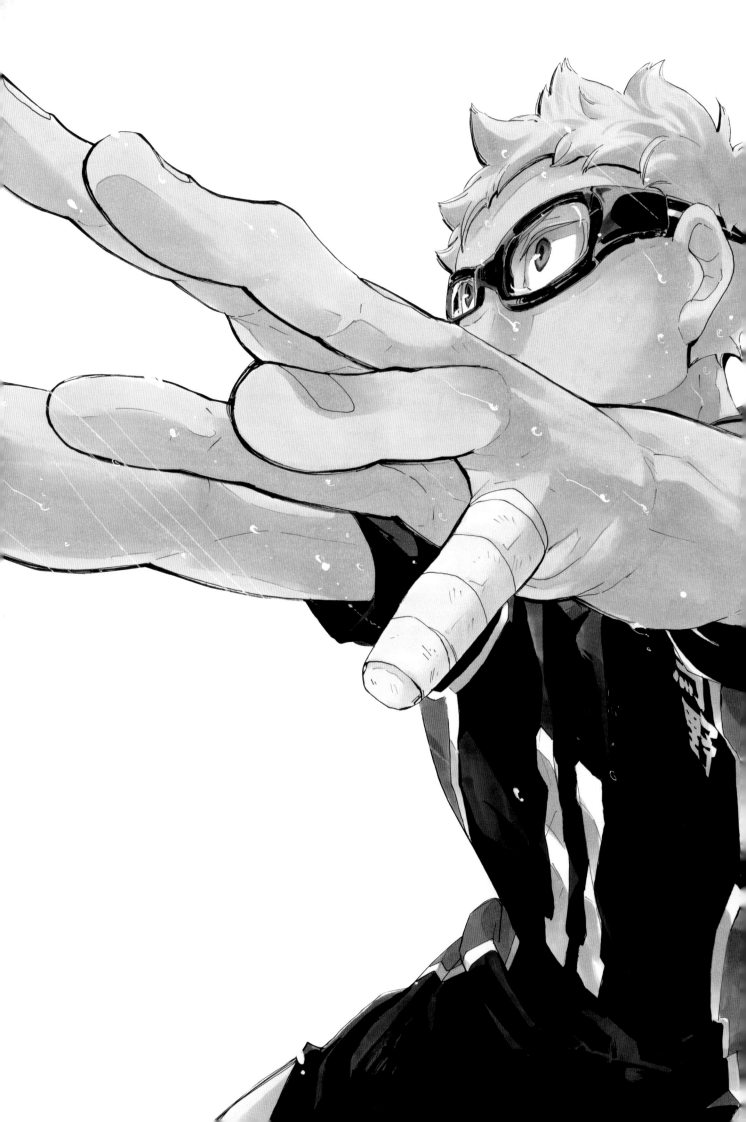

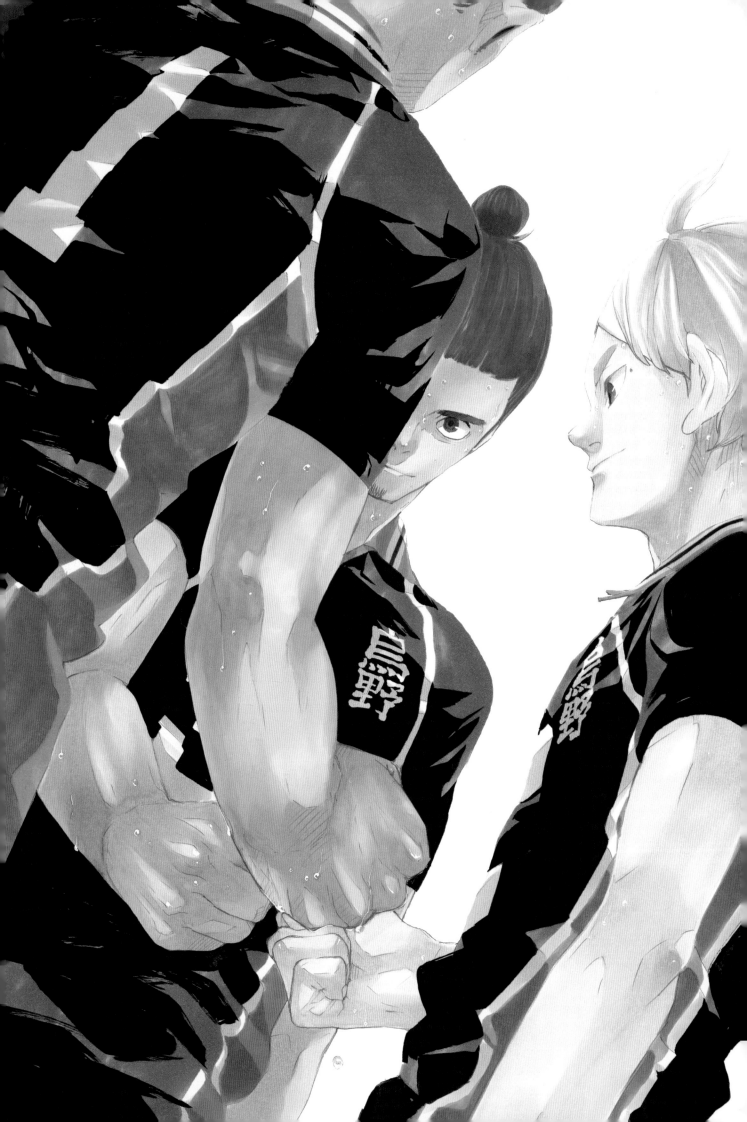

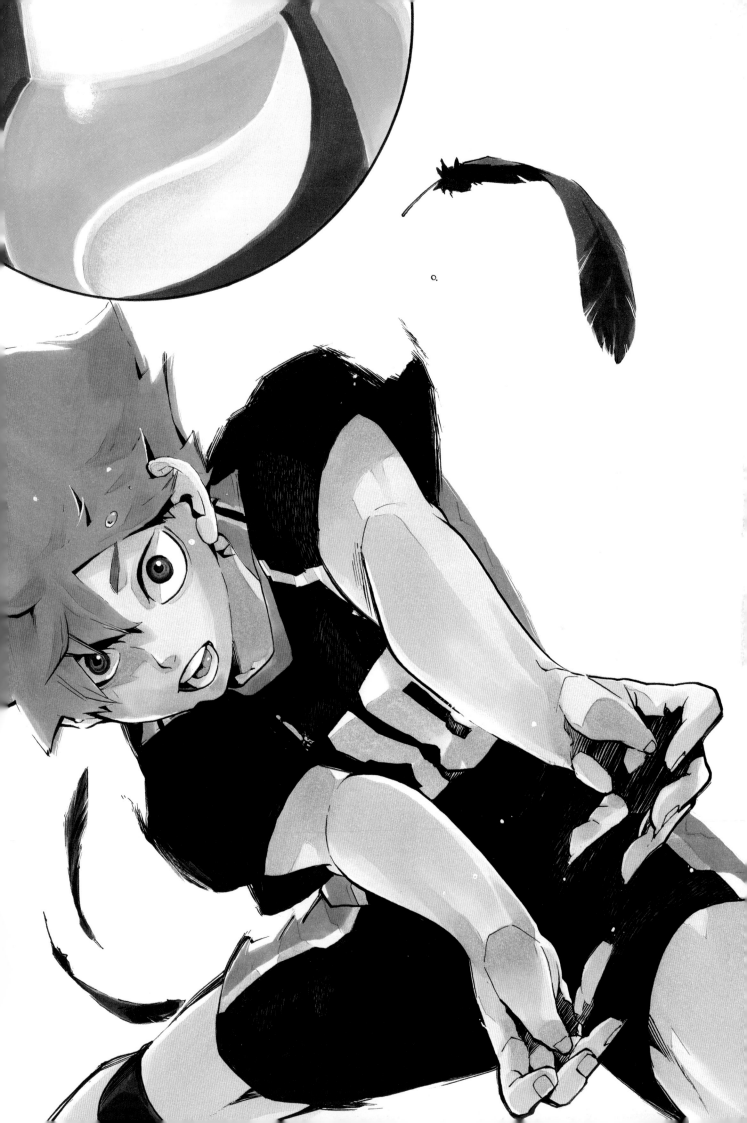

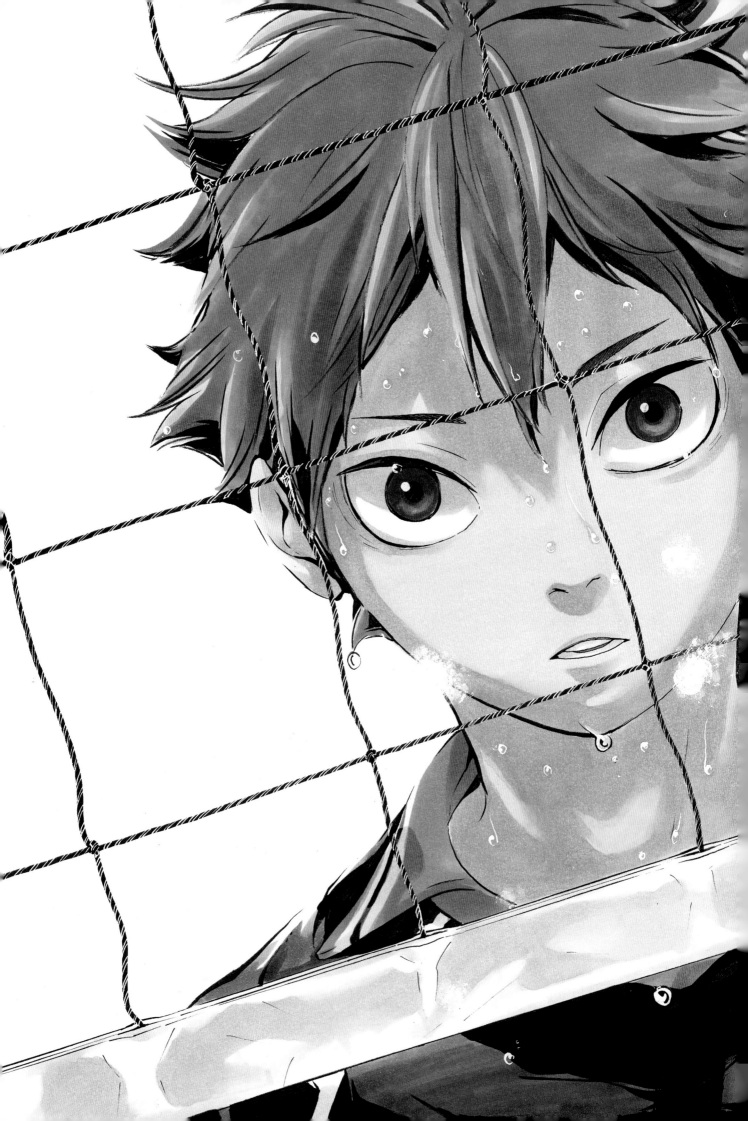

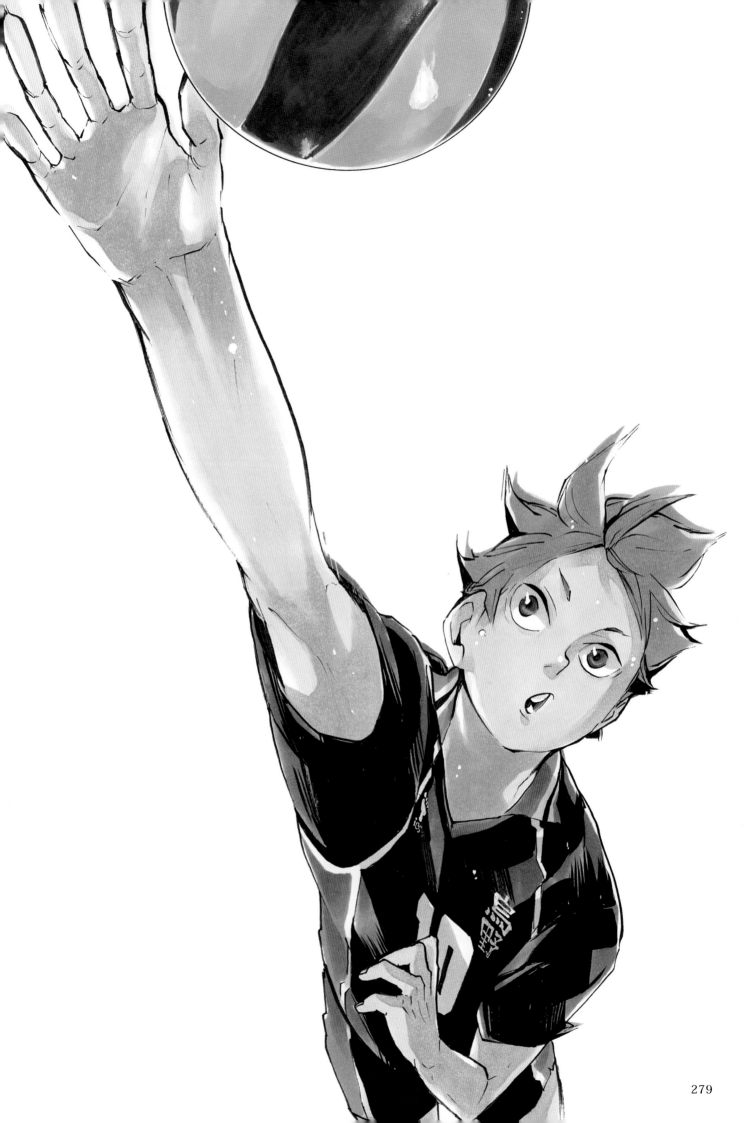

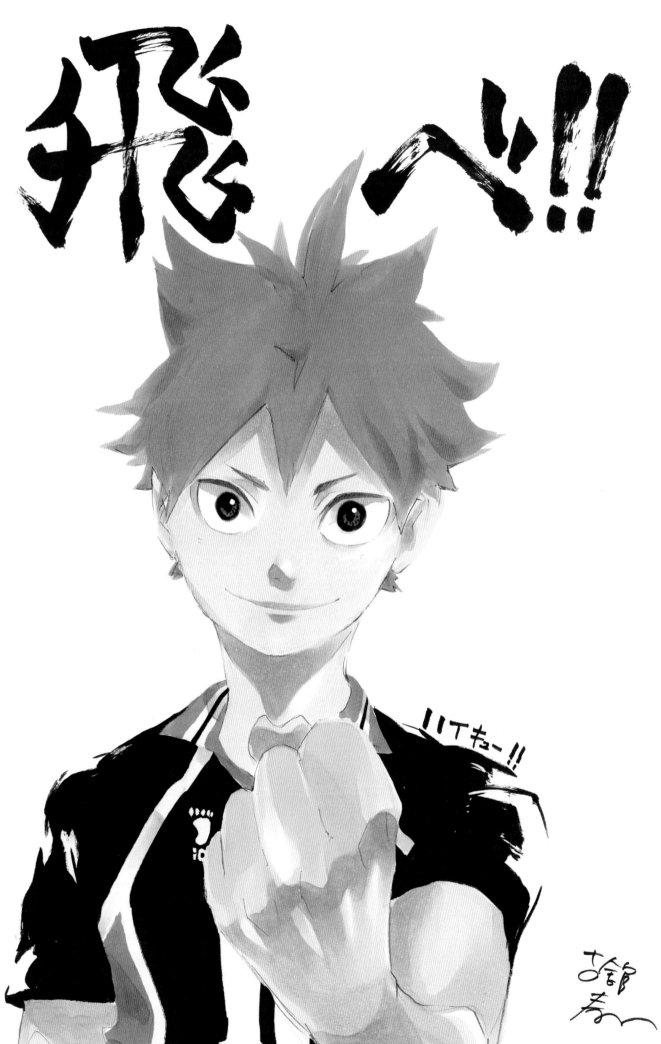

280

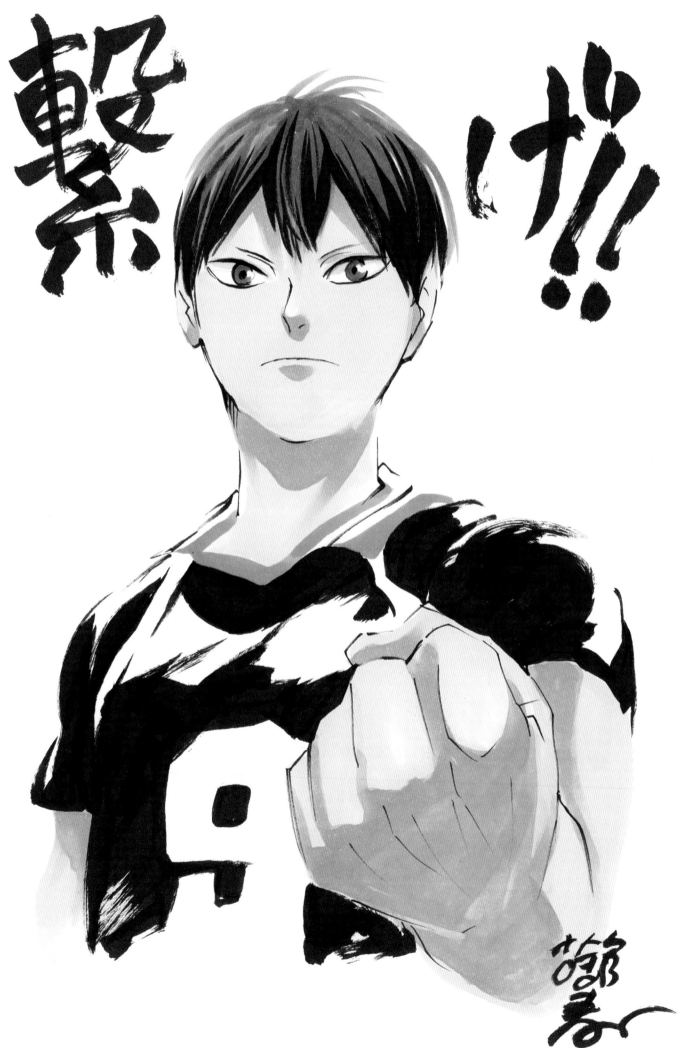

コートを制す

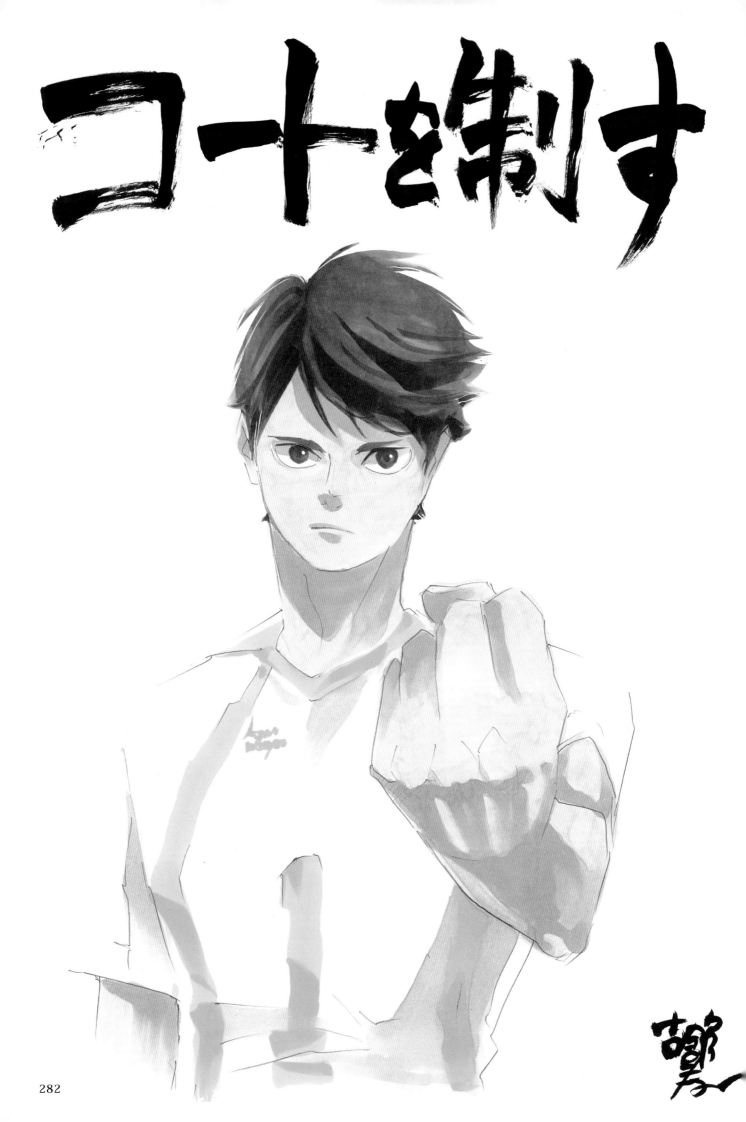

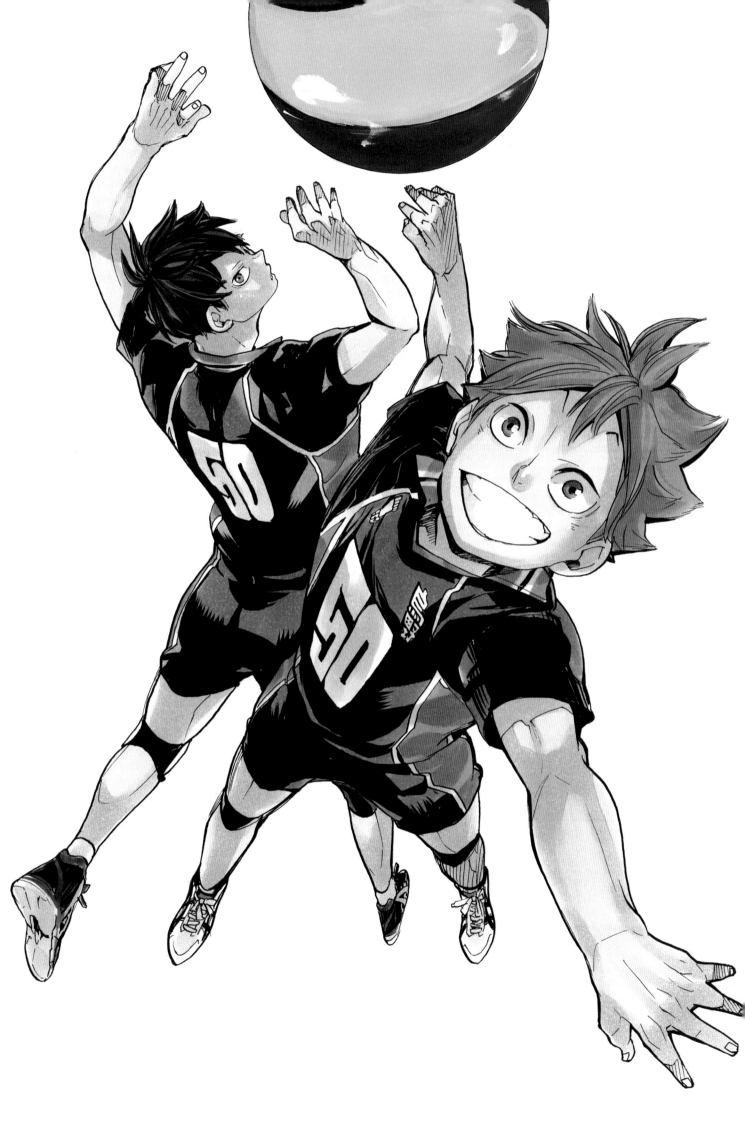

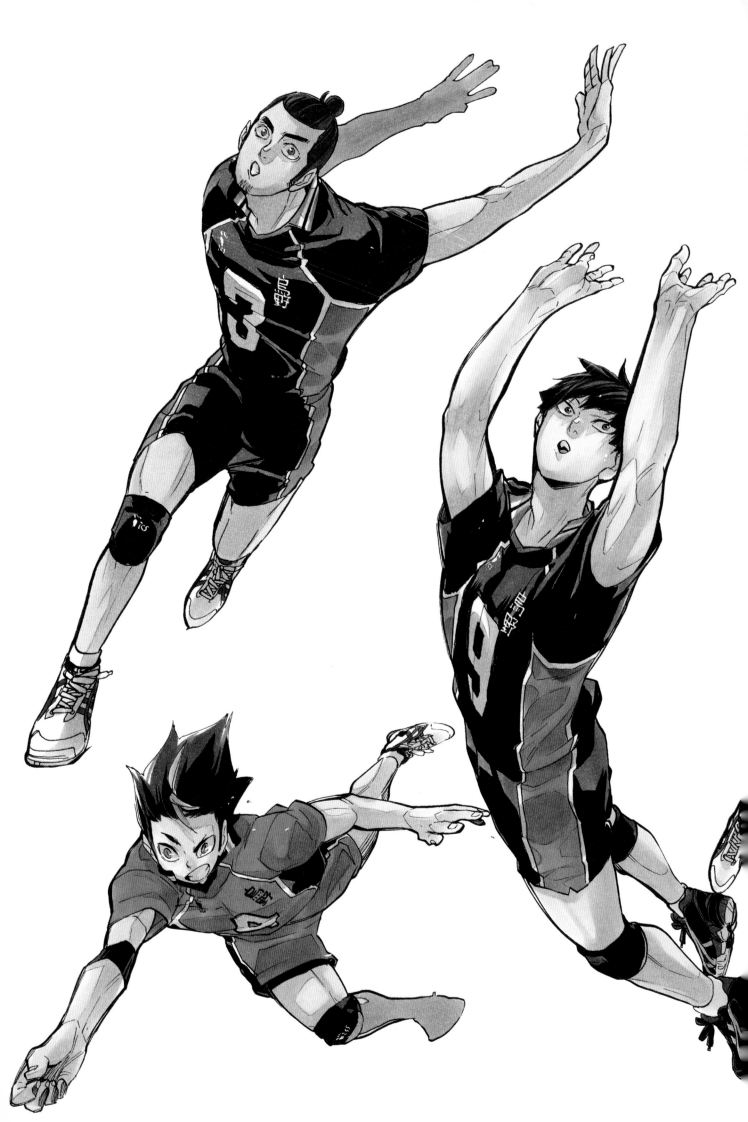

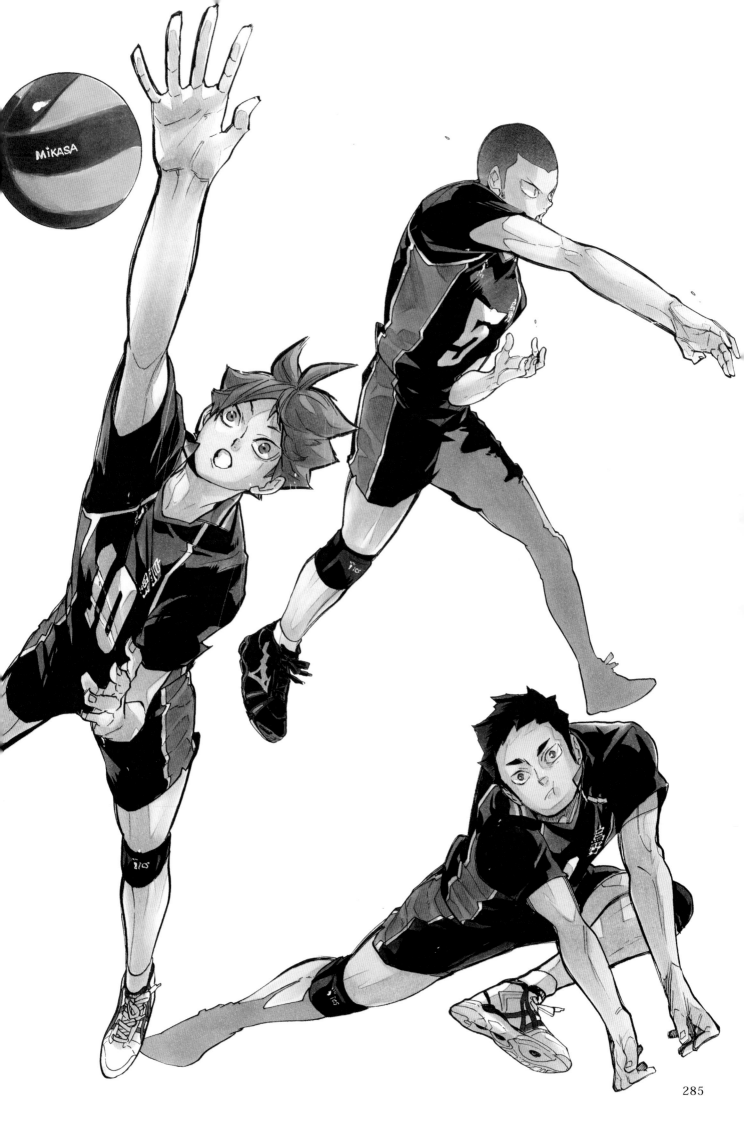

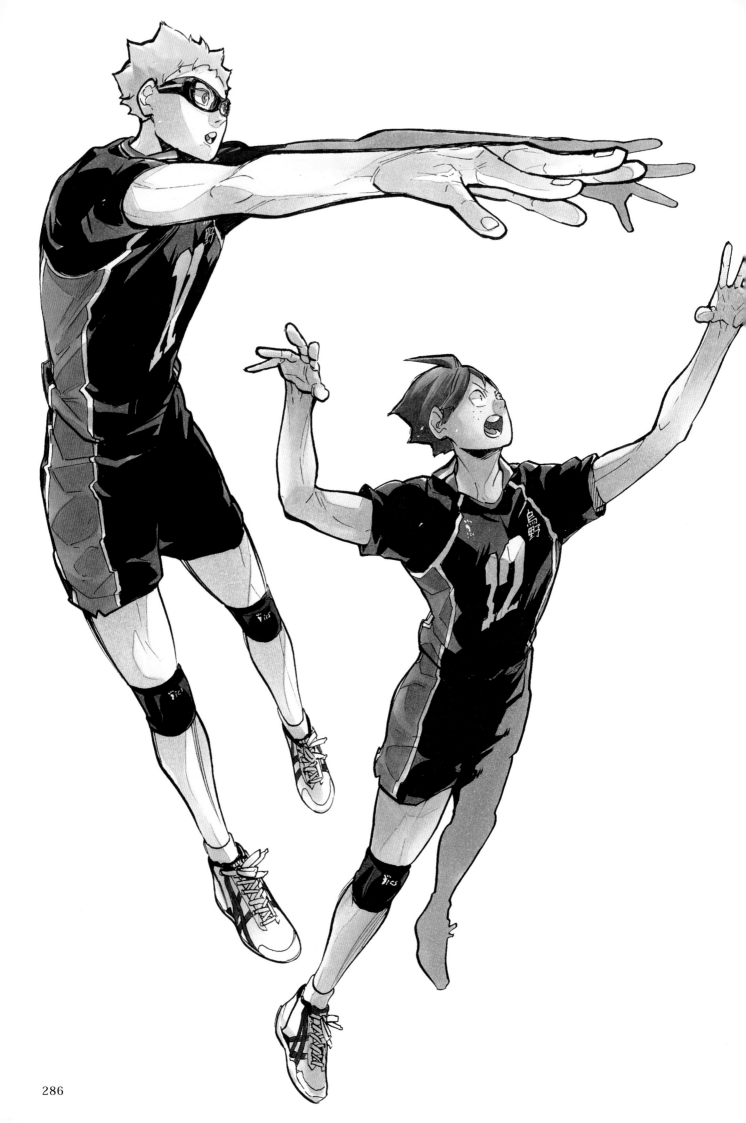

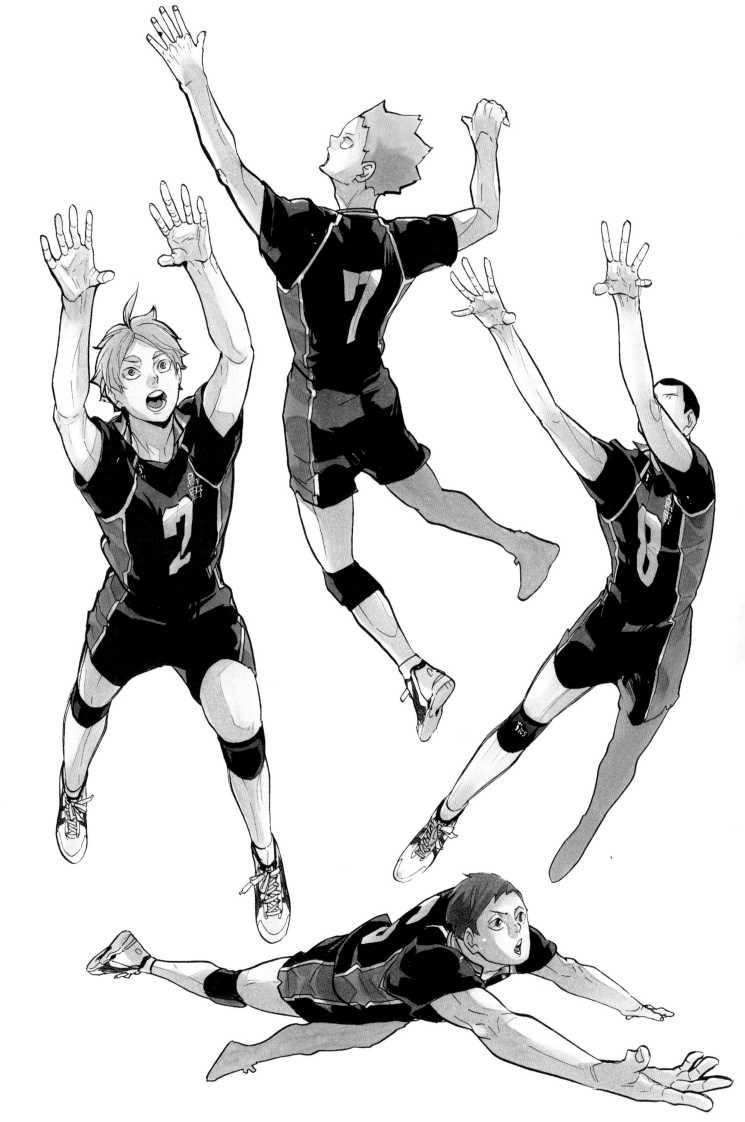

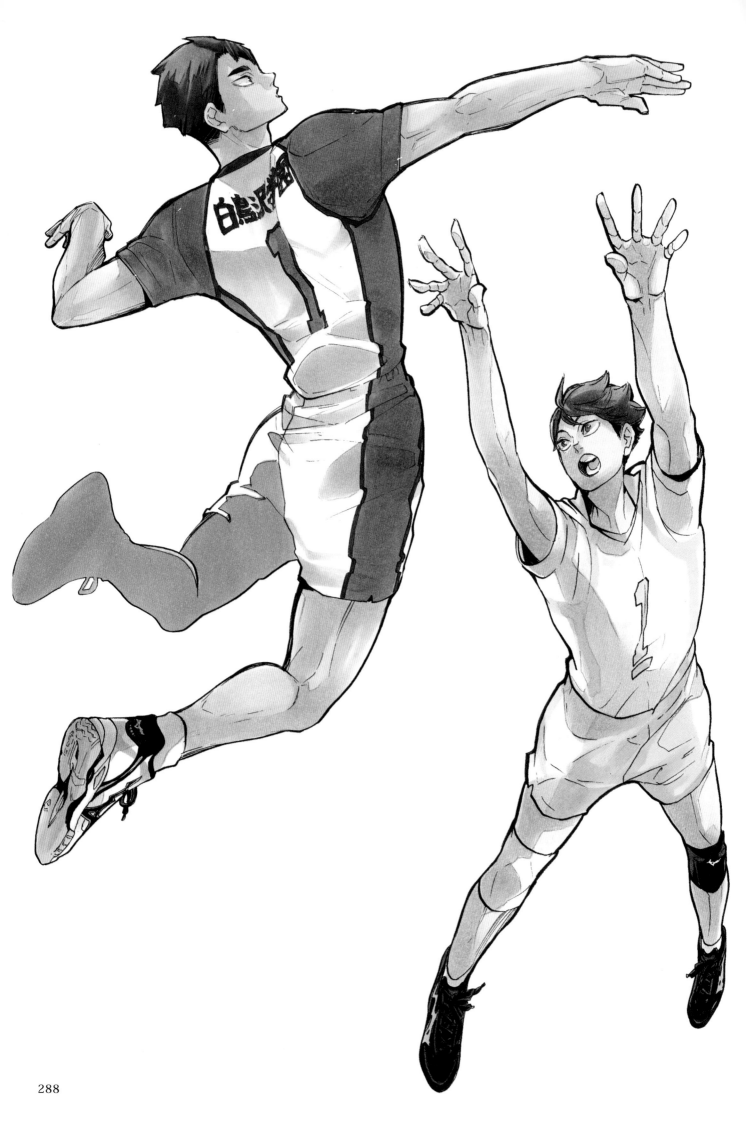

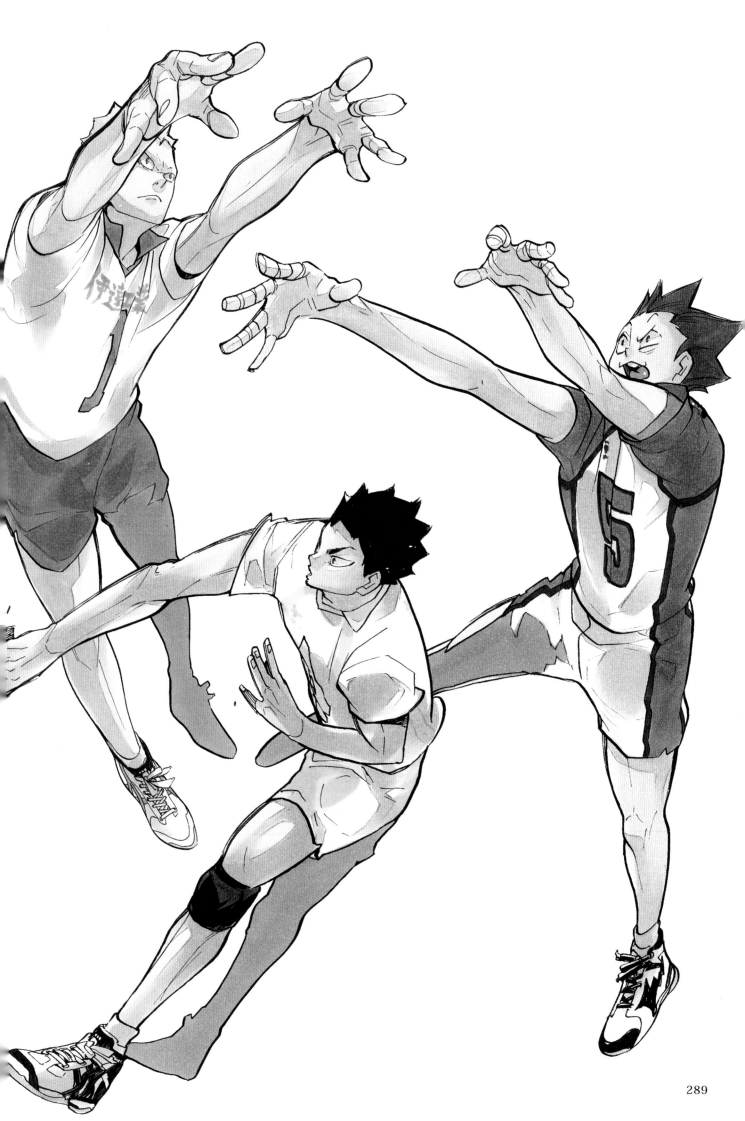

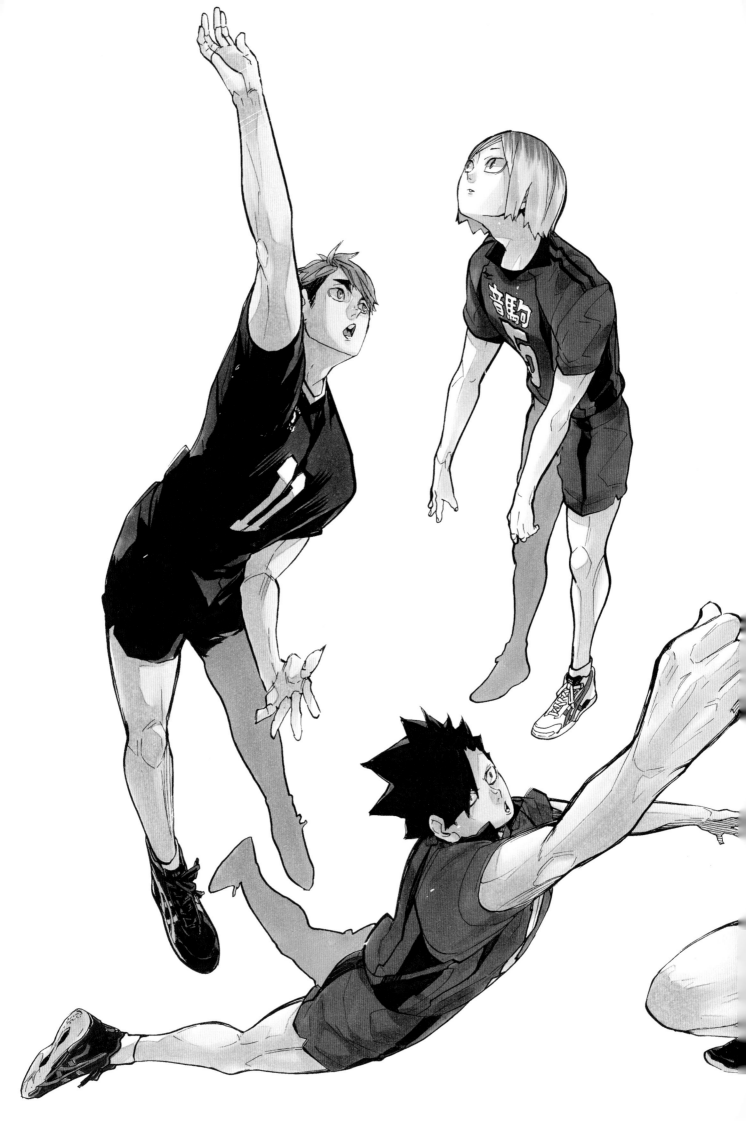

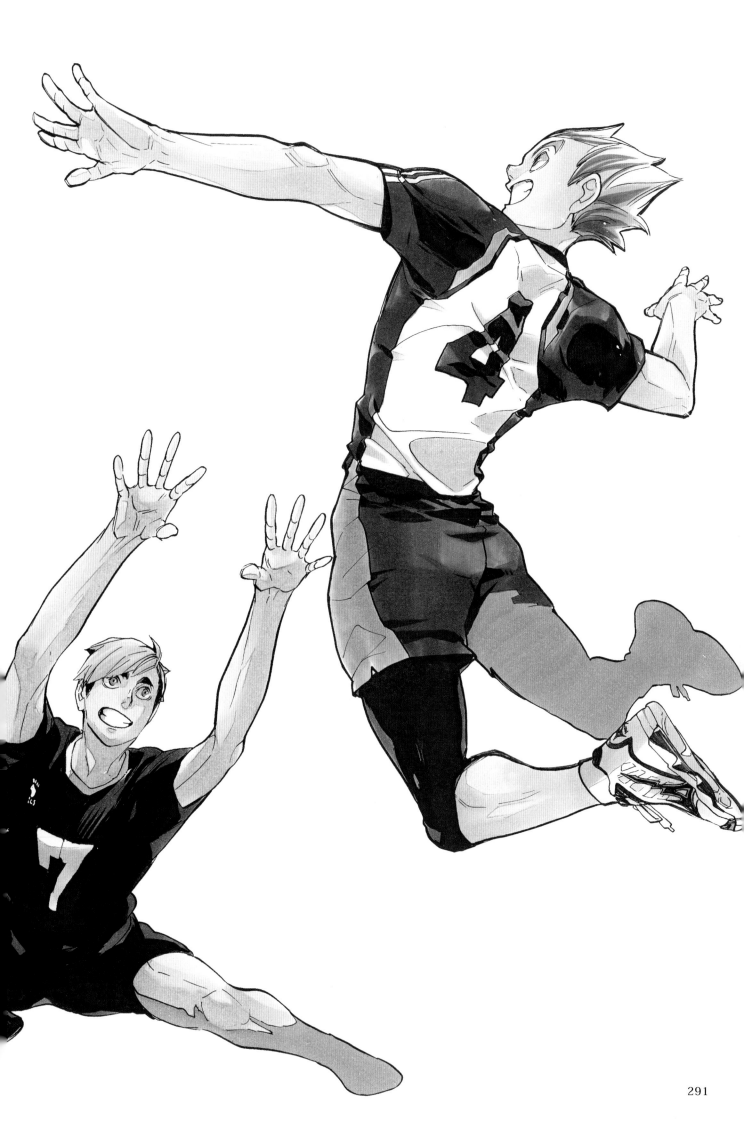

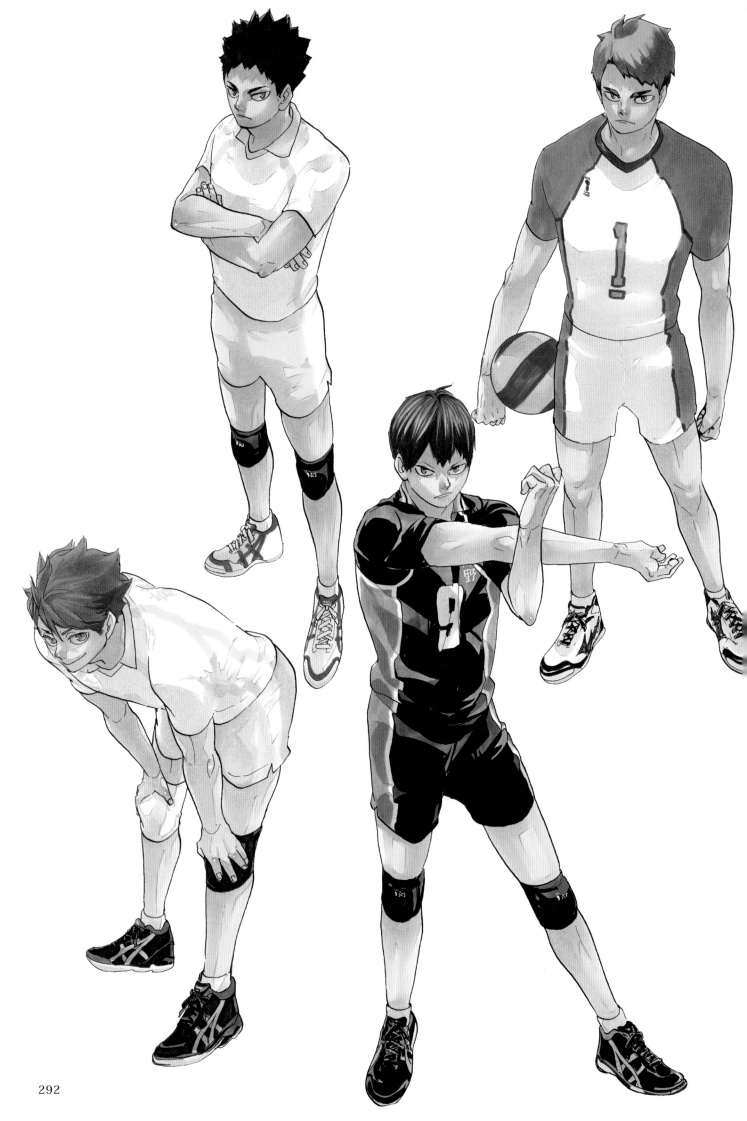

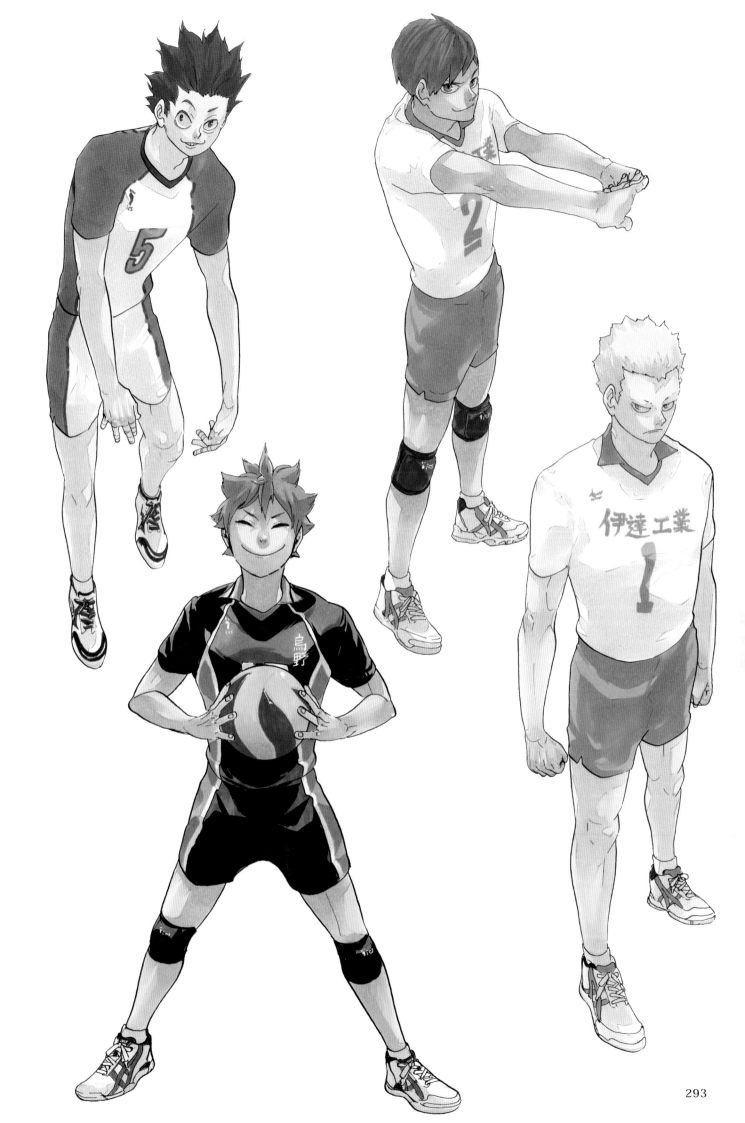

293

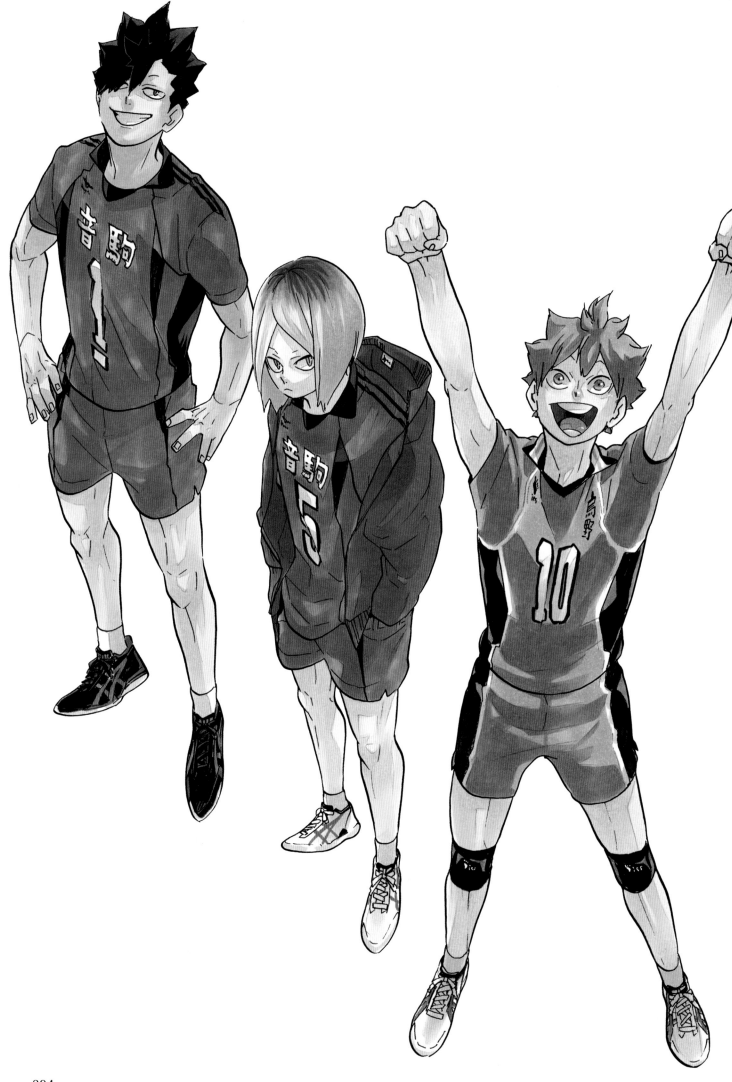

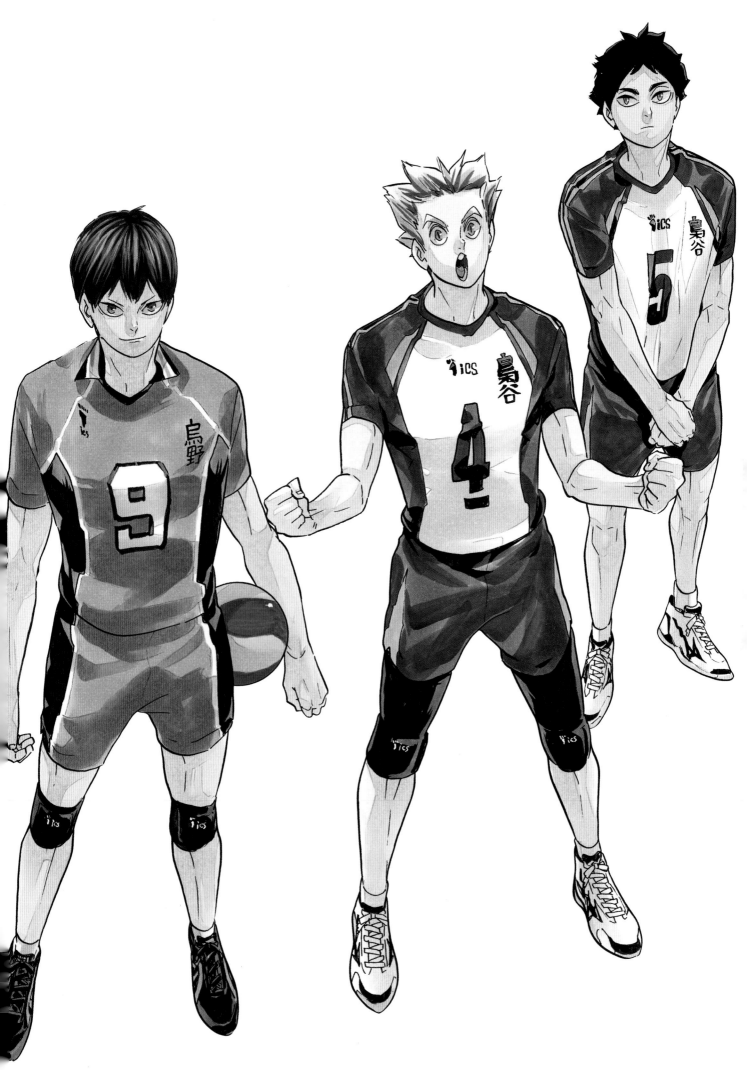

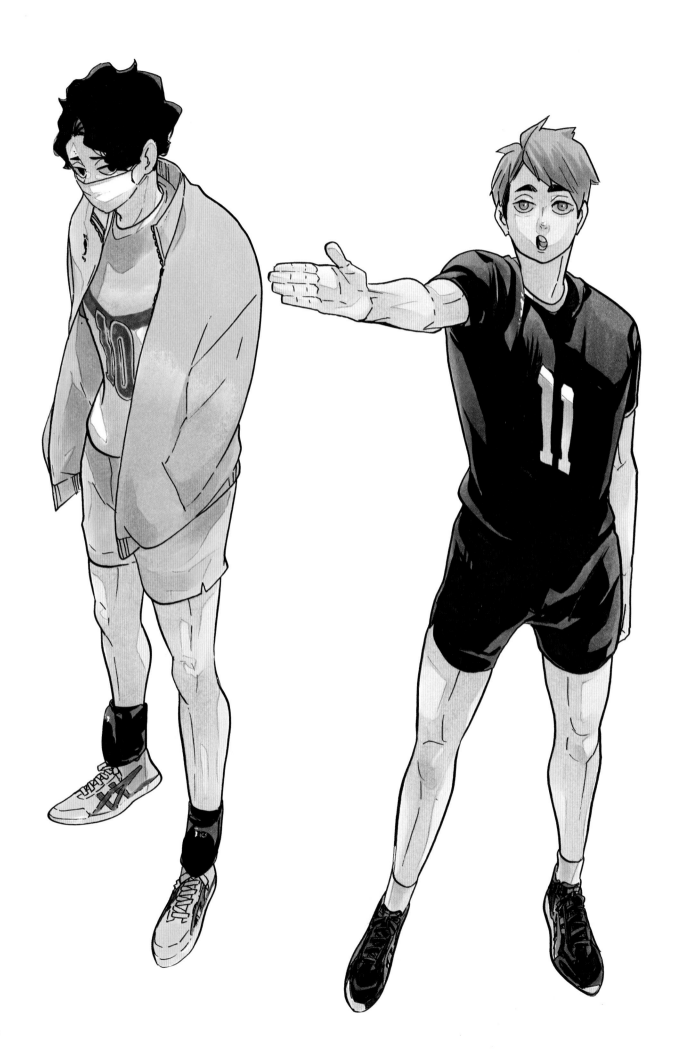

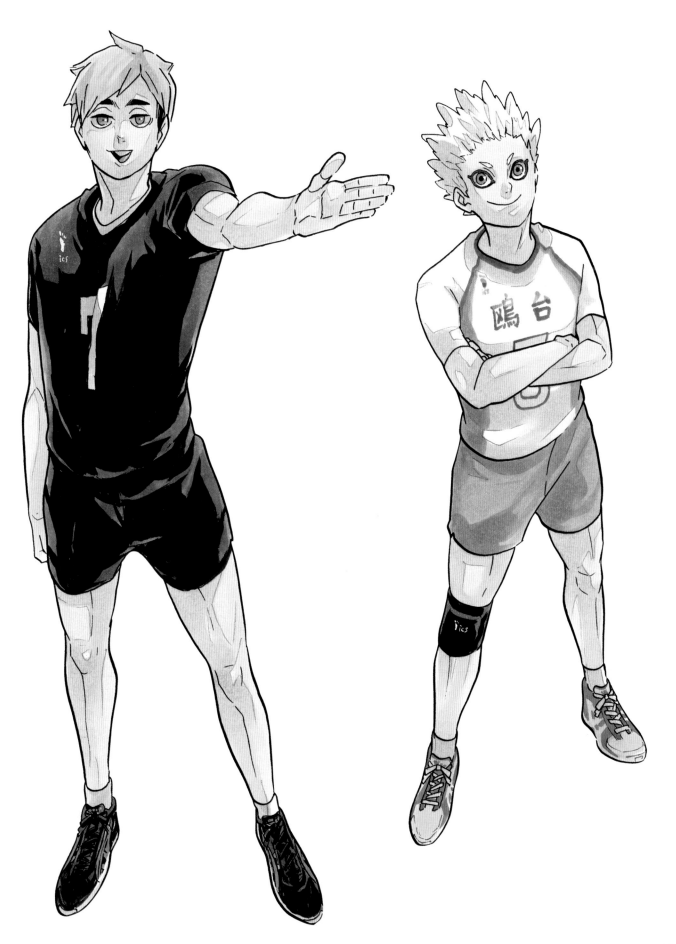

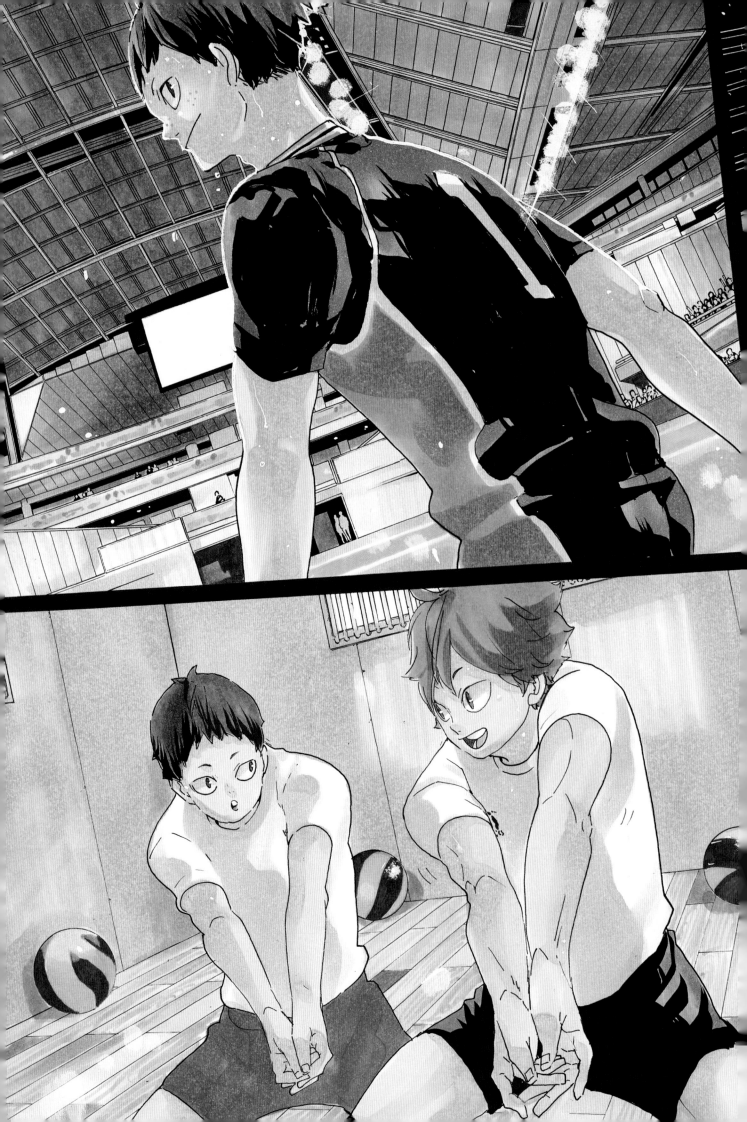

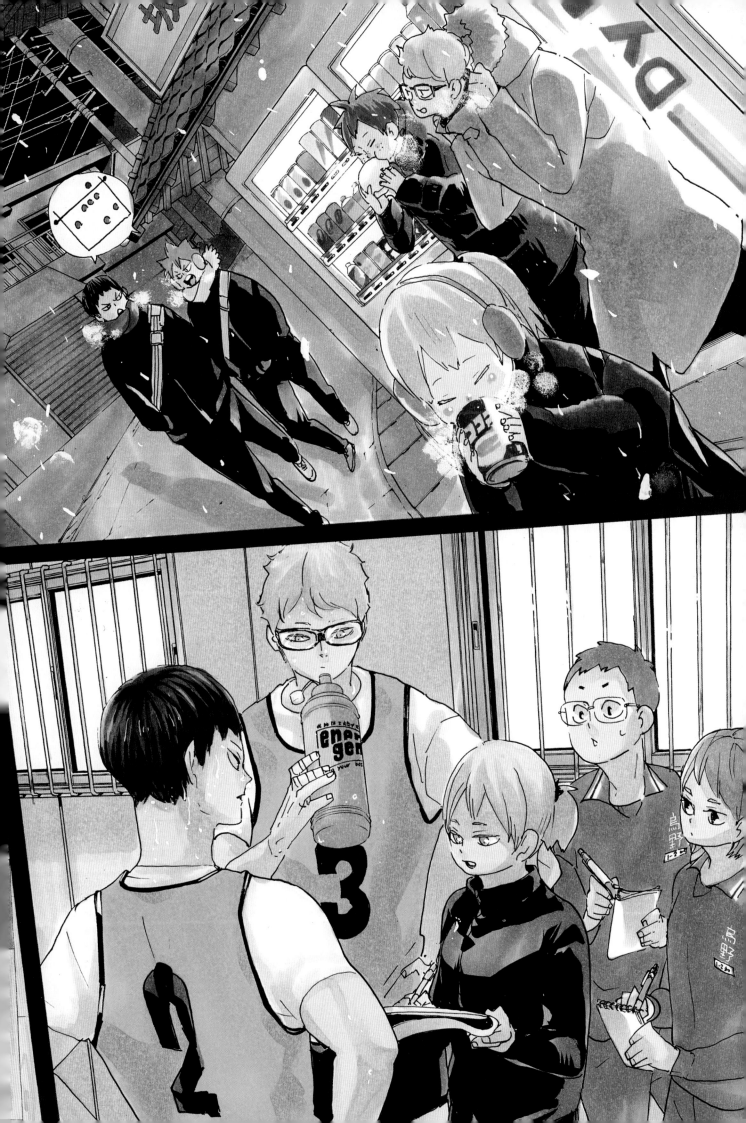

PLAYER

SETTER
ONIGASHIRA
Aritsura
- Tachibana Red Falcons
- 02/19/1987
- 5'11" / 168 lbs.

SETTER
KAGEYAMA
Tobio
- Ali Roma (Italy)
- 12/22/1996
- 6'2" / 181 lbs.

SETTER
MIYA
Atsumu
- MSBY Black Jackals
- 10/05/1995
- 6'2" / 176 lbs.

SETTER
NAKISUNA
Ao
- Chuo University Athletics, second year
- 04/02/1999
- 6'4" / 174 lbs.

OUTSIDE HITTER
BOKUTO
Kotaro
- MSBY Black Jackals
- 09/20/1994
- 6'3" / 192 lbs.

OUTSIDE HITTER
SAKUSA
Kiyoomi
- MSBY Black Jackals
- 03/20/1996
- 6'4" / 176 lbs.

OUTSIDE HITTER
TSUETATE
Wasei
- DESEO Hornets
- 03/26/1985
- 6'1" / 172 lbs.

OUTSIDE HITTER
OJIRO
Aran
- Tachibana Red Falcons
- 04/04/1994
- 6'1" / 194 lbs.

OUTSIDE HITTER
CHITA
Tomomichi
- VC Kanagawa
- 12/05/1997
- 6'2" / 165 lbs.

OUTSIDE HITTER
SARUKUI
Nagito
- EJP Raijin
- 08/09/1997
- 6'2" / 170 lbs.

OUTSIDE HITTER
HOSHIUMI
Korai
- Schweiden Adlers
- 04/16/1995
- 5'8" / 152 lbs.

OUTSIDE HITTER
KUNOHE
Masahiko
- Ganji University, third year
- 01/13/2000
- 6'3" / 165 lbs.

OUTSIDE HITTER
KIRYU
Wakatsu
- Azuma Pharmacy Green Rockets
- 04/08/1994
- 6'2" / 198 lbs.

OUTSIDE HITTER
NISHIURA
Keigo
- Schweiden Adlers
- 09/30/1992
- 6'2" / 174 lbs.

OUTSIDE HITTER
SUZUKI
Nao
- Sannomiya Technical High School, third year
- 07/07/2002
- 6'3" / 163 lbs.

OPPOSITE
USHIJIMA
Wakatoshi
- Orzeł Warszawa (Poland)
- 08/13/1994
- 6'4" / 198 lbs.

OPPOSITE
INUBOUSAKI
Terutsugu
- Schweiden Adlers
- 02/24/1999
- 6'4" / 198 lbs.

OPPOSITE
HINATA
Shoyo
- Asas São Paulo (Brazil)
- 06/21/1996
- 5'8" / 154 lbs.

MIDDLE BLOCKER
NITTA
Tomohiro
- VC Hiroshima
- 10/21/1992
- 6'5" / 198 lbs.

MIDDLE BLOCKER
HAKUBA
Gao
- Tachibana Red Falcons
- 06/27/1995
- 6'10" / 220 lbs.

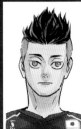

MIDDLE BLOCKER
HYAKUZAWA
Yudai
- Japan Railway Warriors
- 04/03/1996
- 6'8" / 212 lbs.

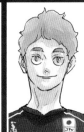

MIDDLE BLOCKER
SOKOLOV
Sakuma
- Azuma Pharmacy Green Rockets
- 05/19/1990
- 6'8" / 183 lbs.

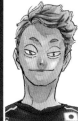

MIDDLE BLOCKER
MARUO
Noritsune
- Koukai University, second year
- 09/30/2000
- 6'7" / 196 lbs.

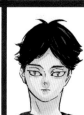

MIDDLE BLOCKER
SUNA
Rintaro
- EJP Raijin
- 01/25/1996
- 6'3" / 176 lbs.

LIBERO
HEIWAJIMA
Toshiro
- Schweiden Adlers
- 02/01/1988
- 5'11" / 163 lbs.

LIBERO
YAKU
Morisuke
- Tigr Ekaterinburg (Russia)
- 08/08/1994
- 5'6" / 141 lbs.

LIBERO
KOMORI
Motoya
- EJP Raijin
- 07/30/1995
- 5'11" / 159 lbs.

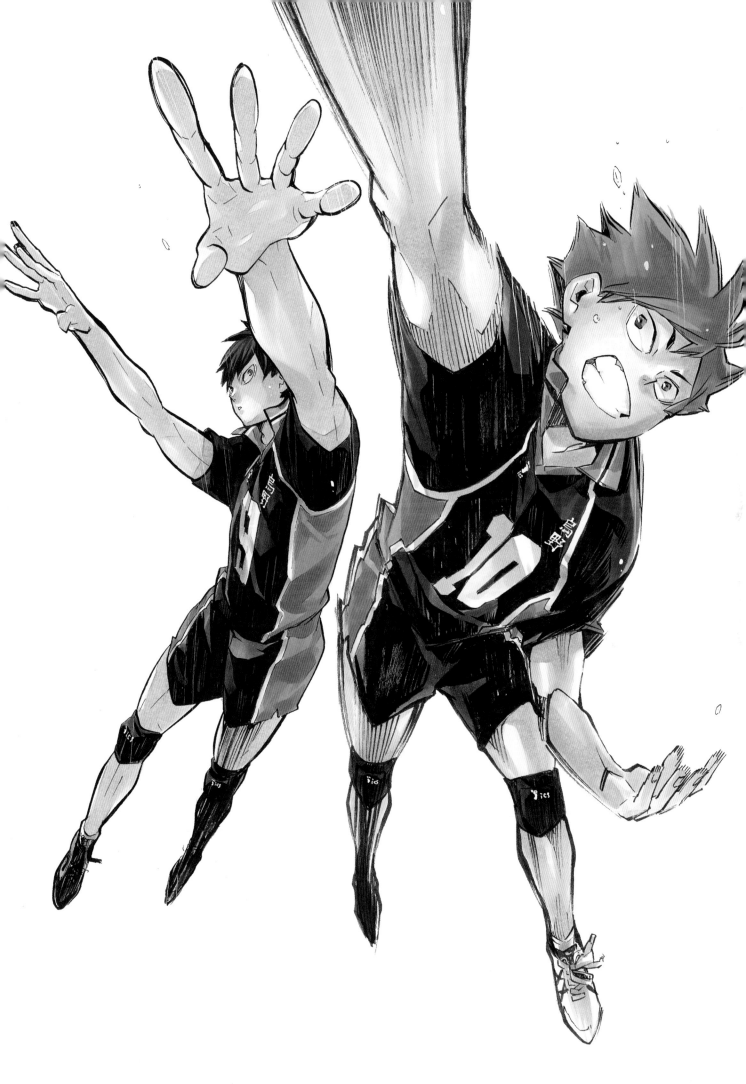

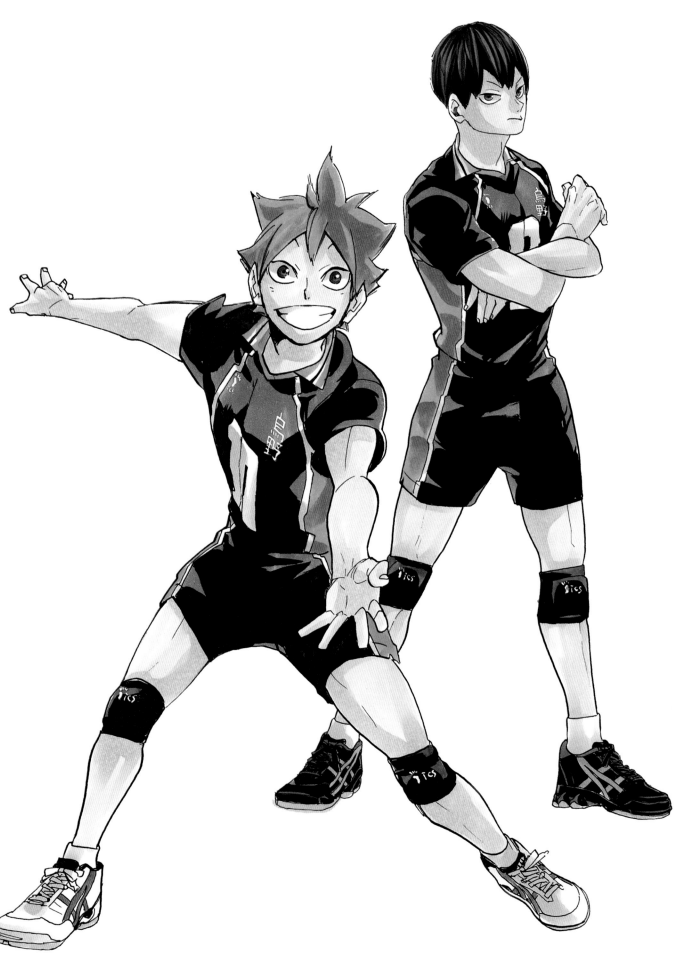

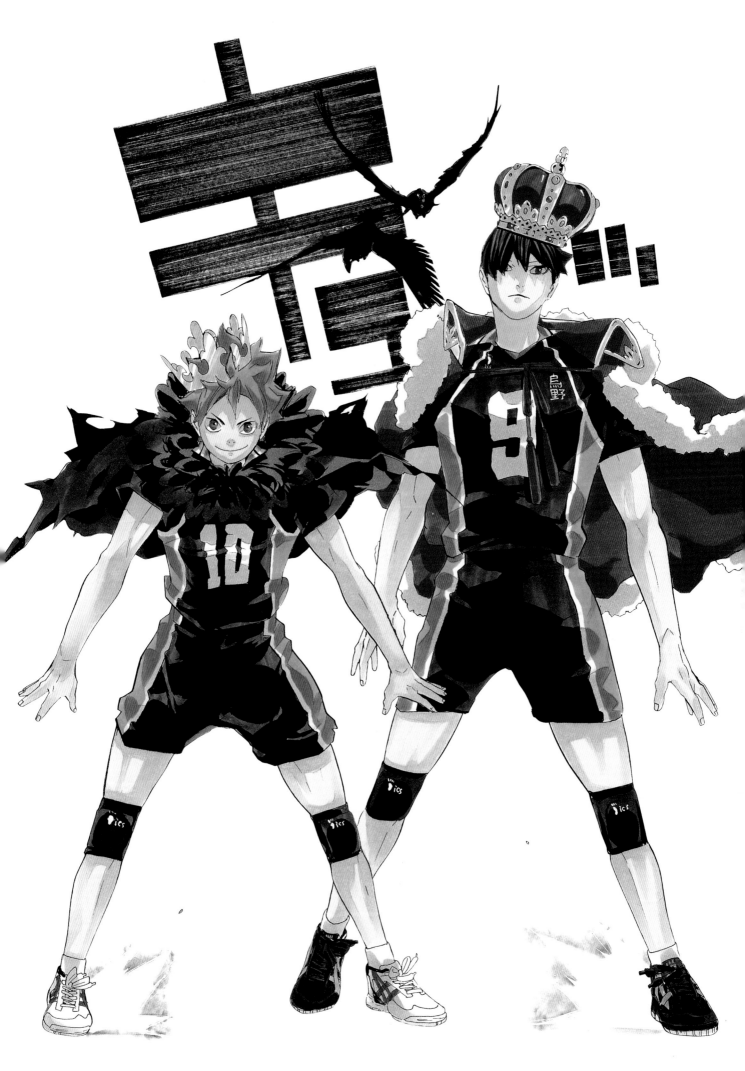

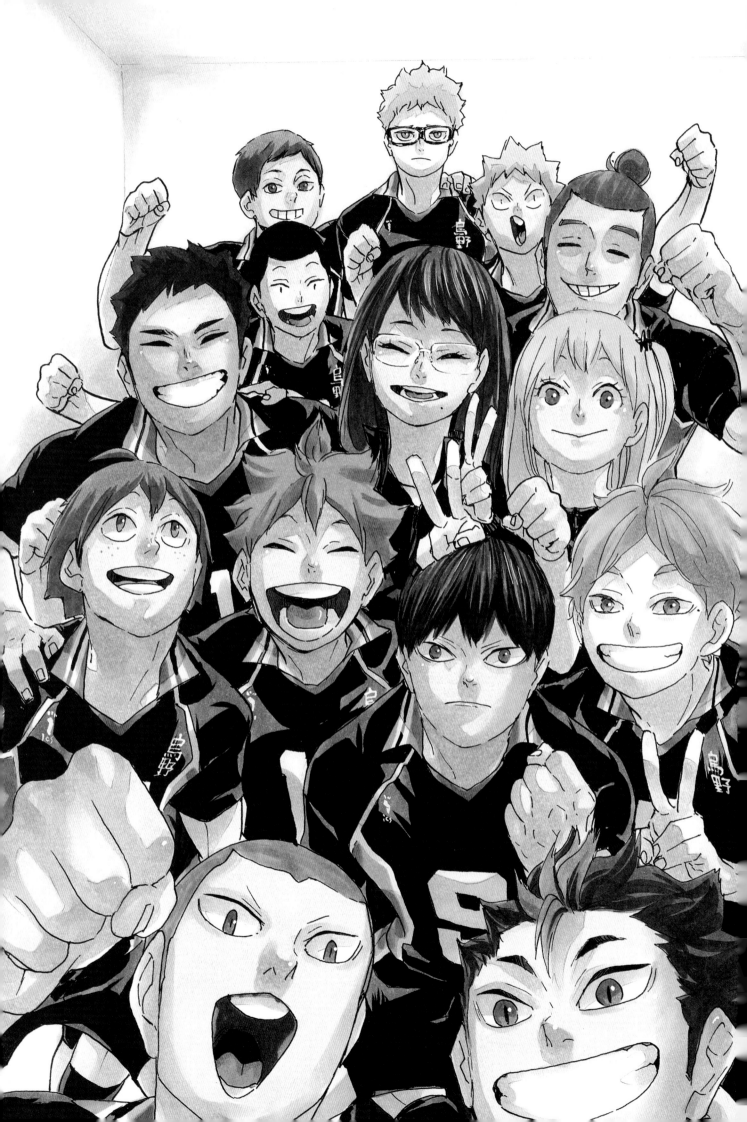

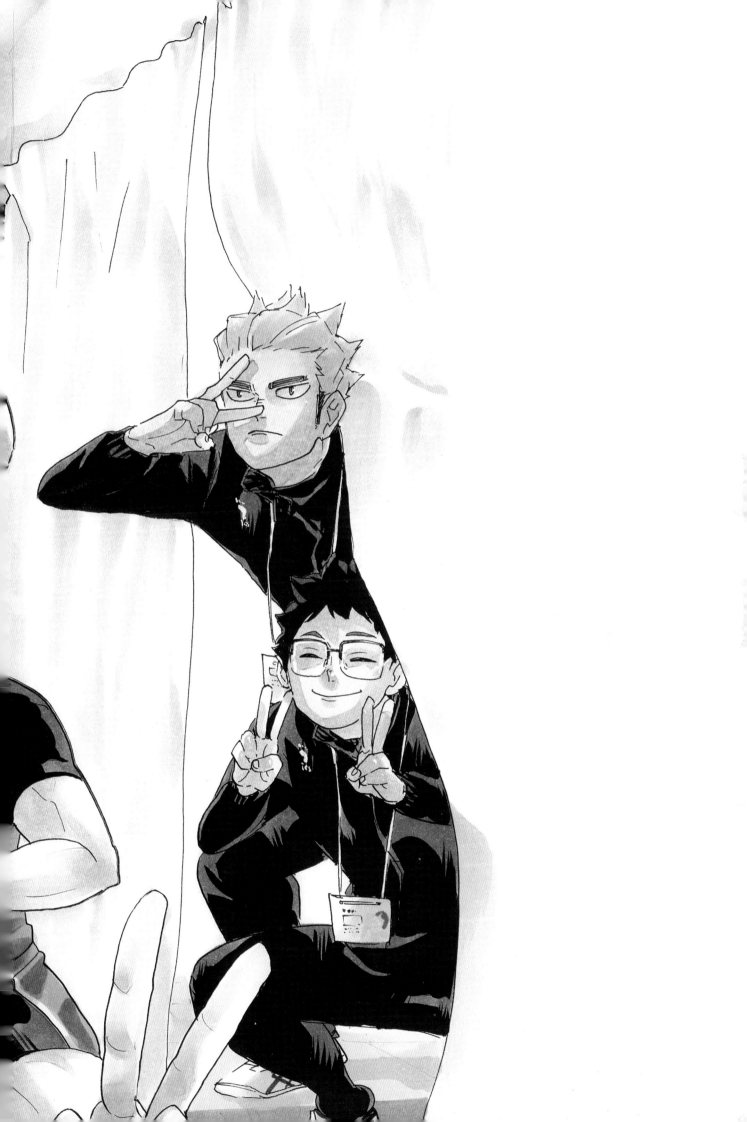

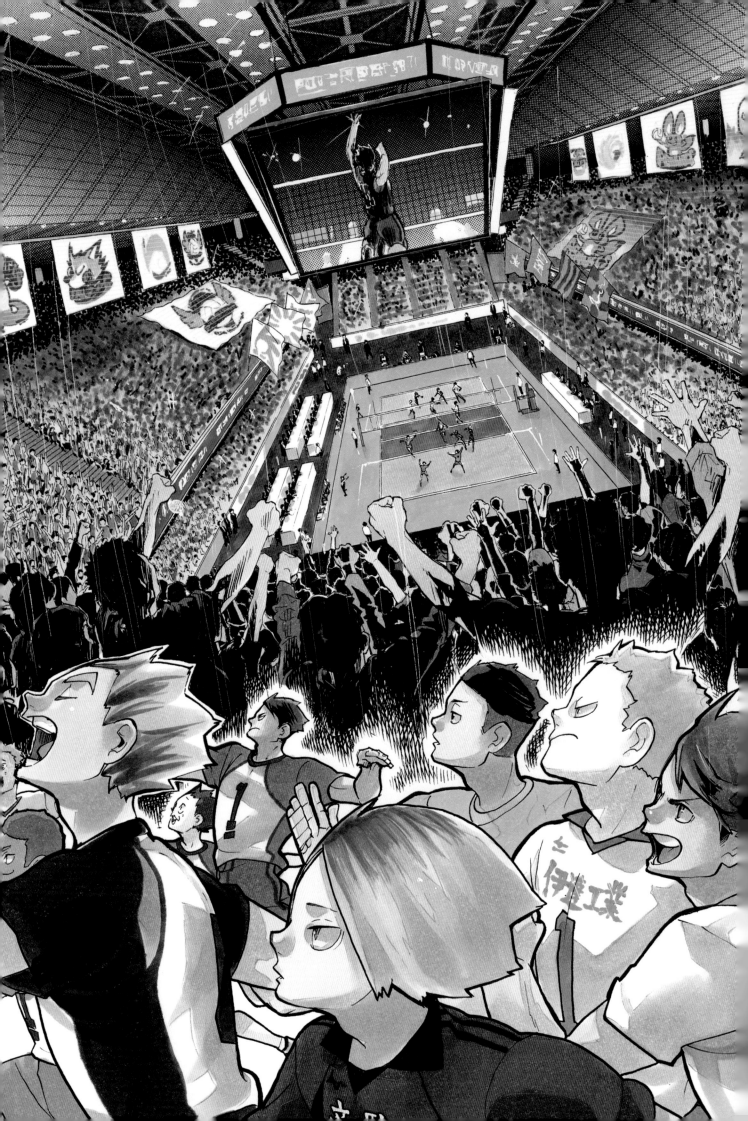

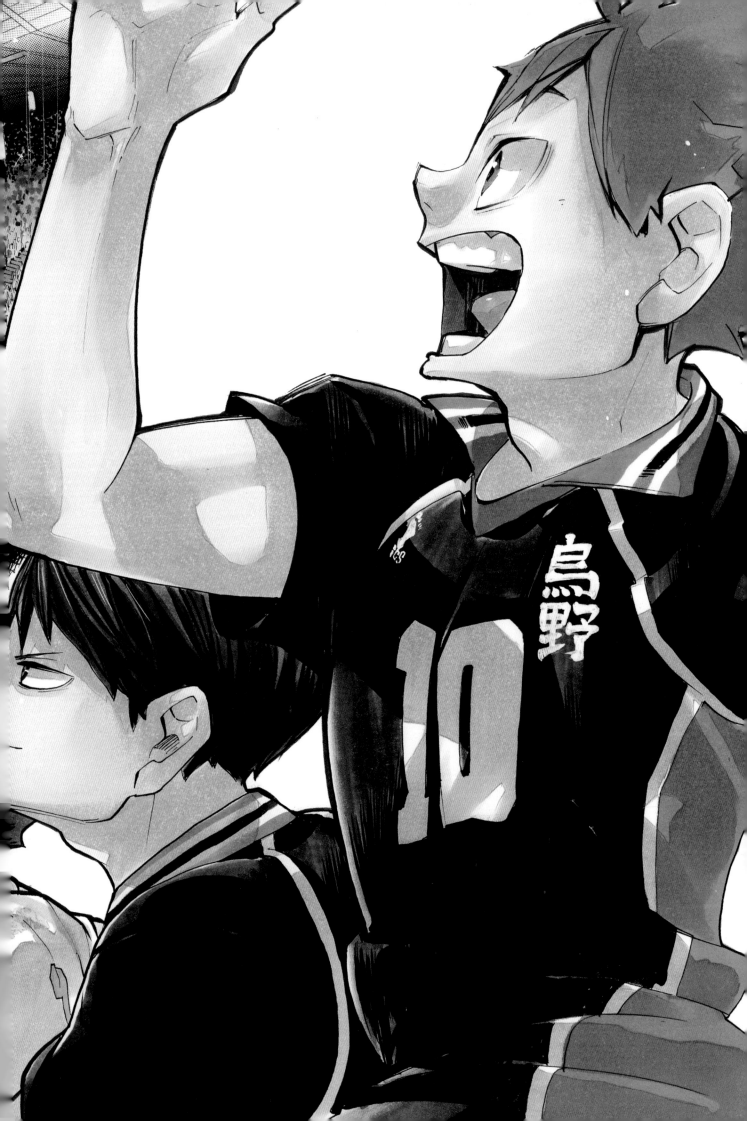

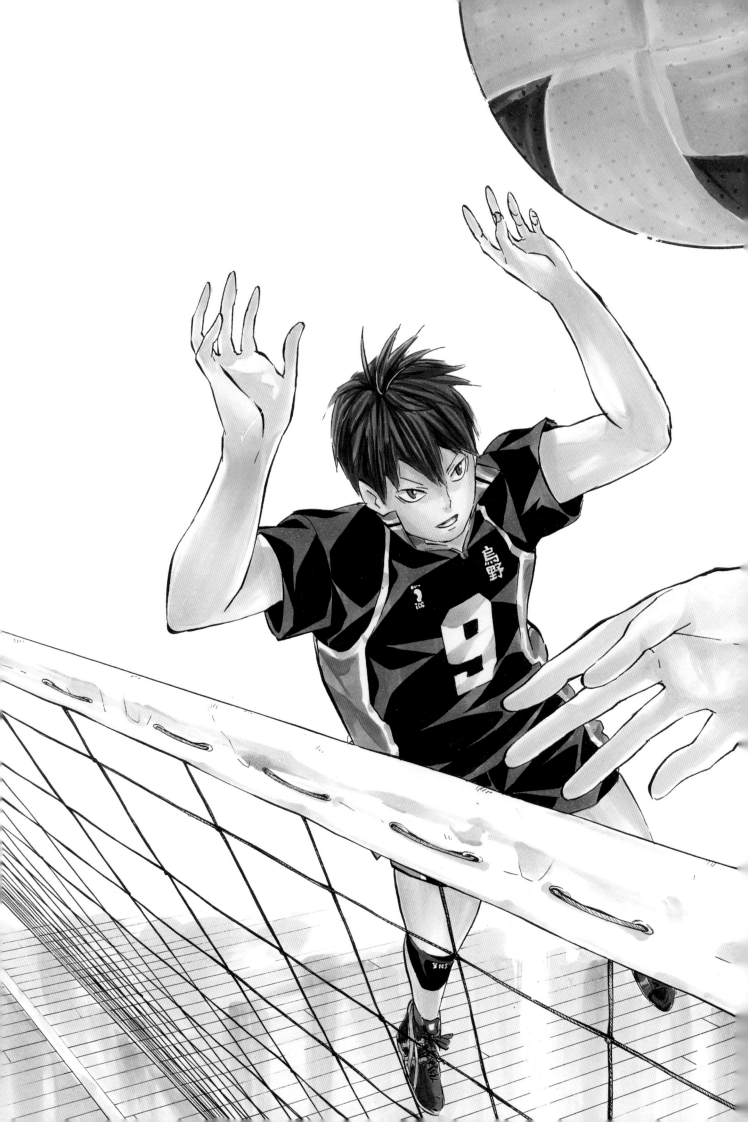

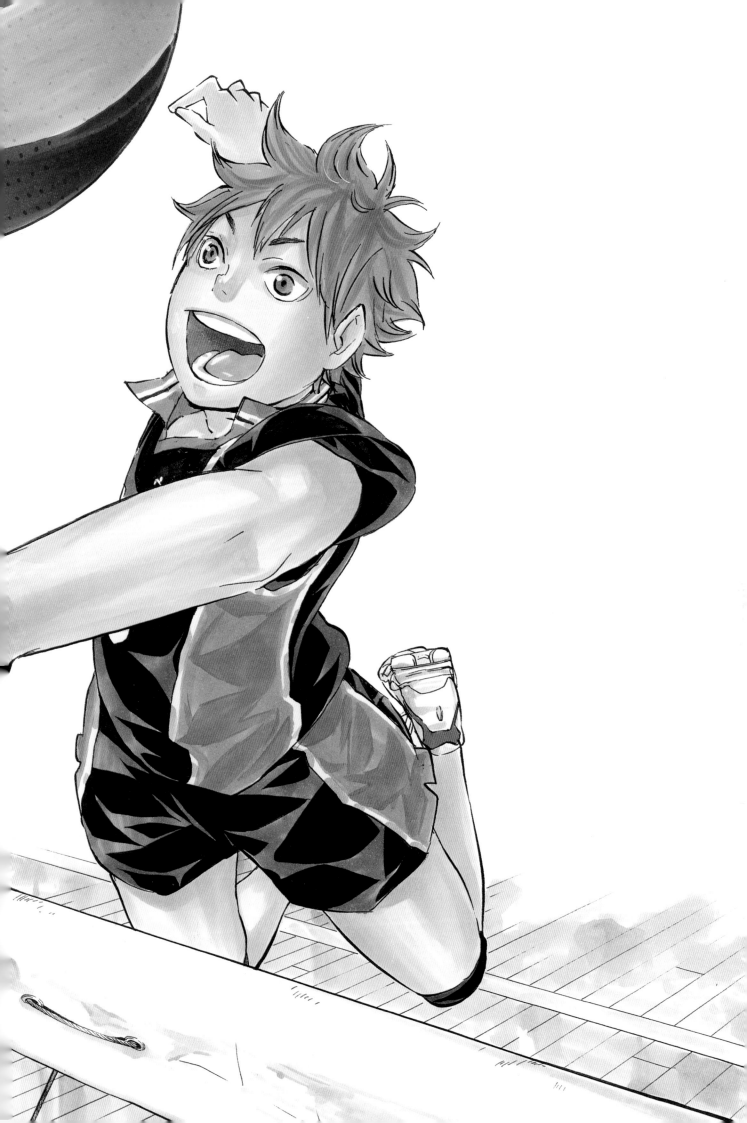

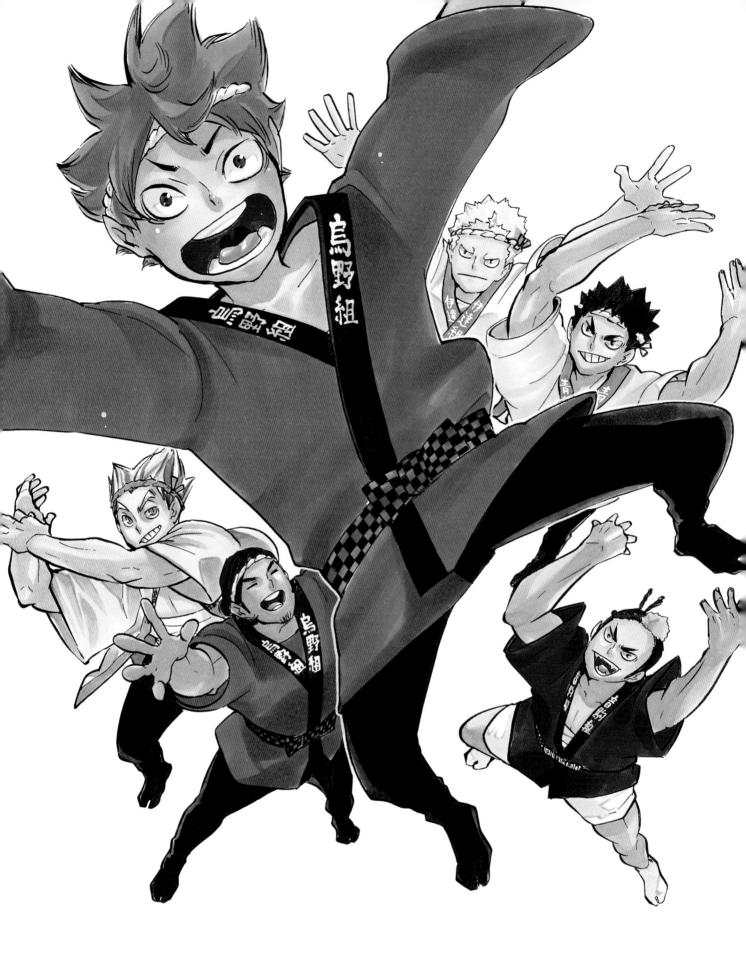

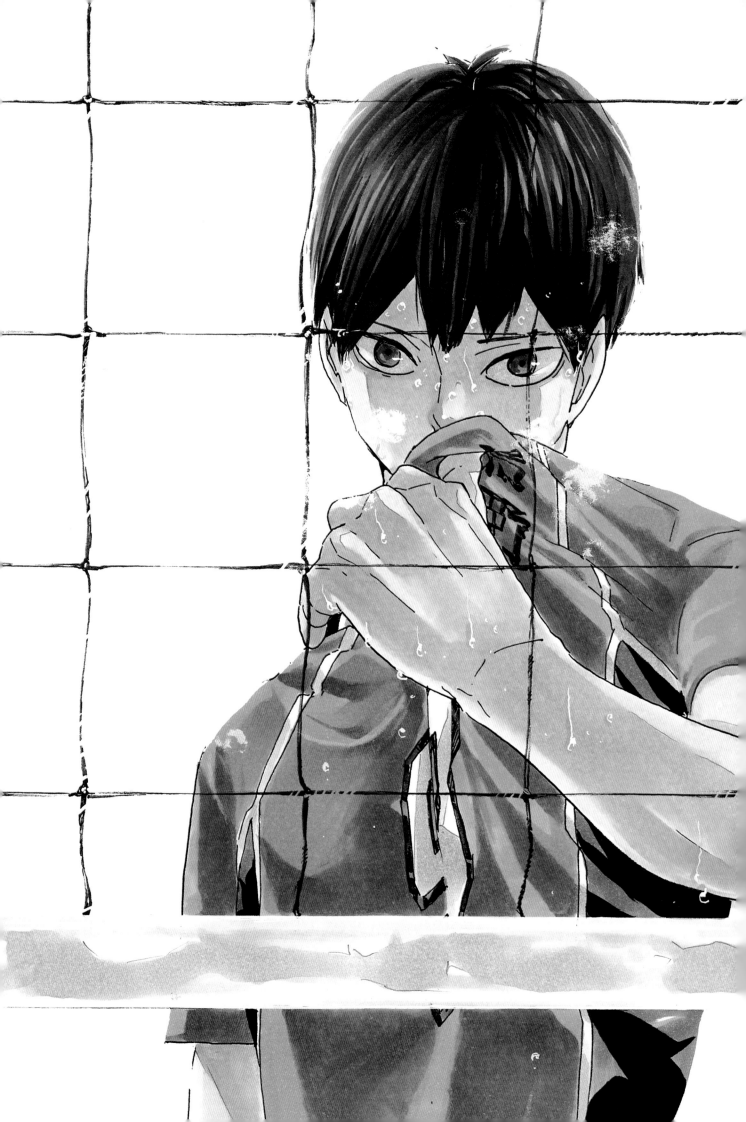

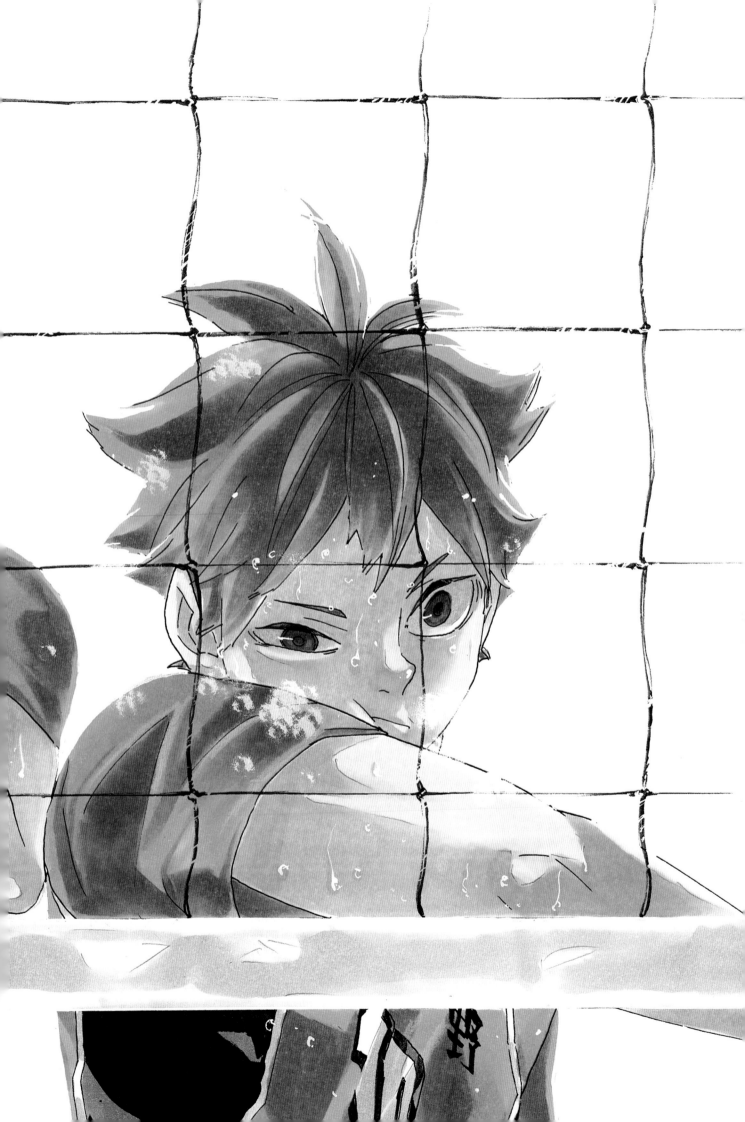

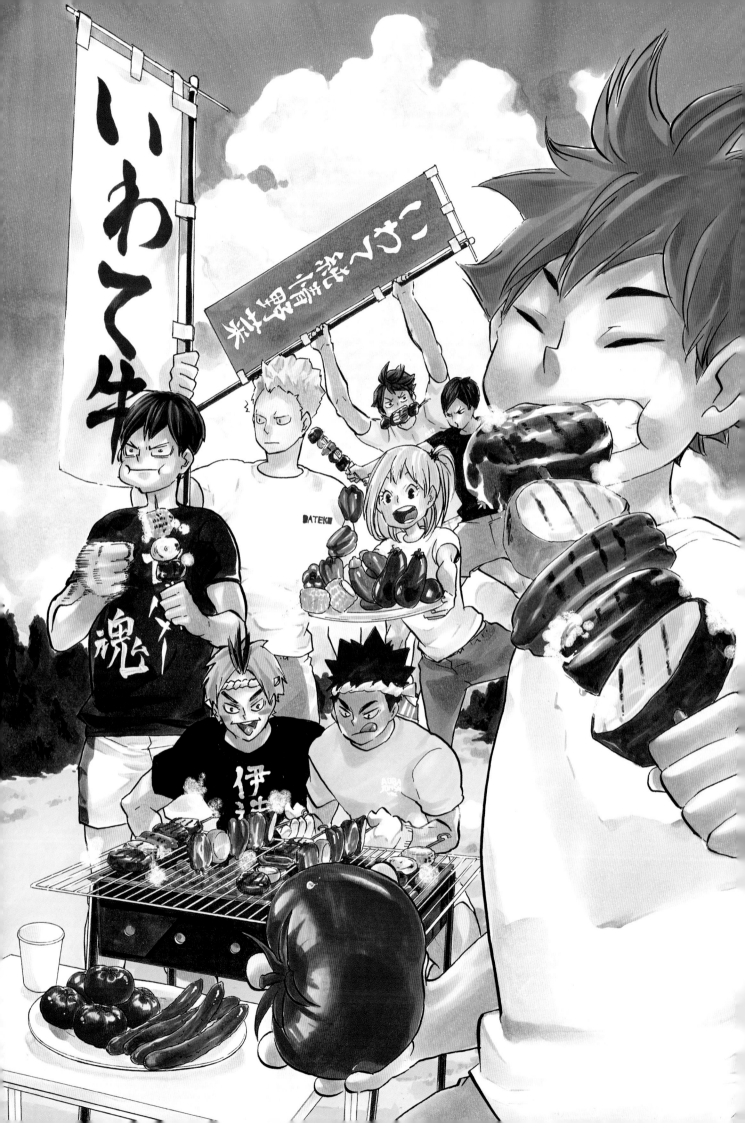

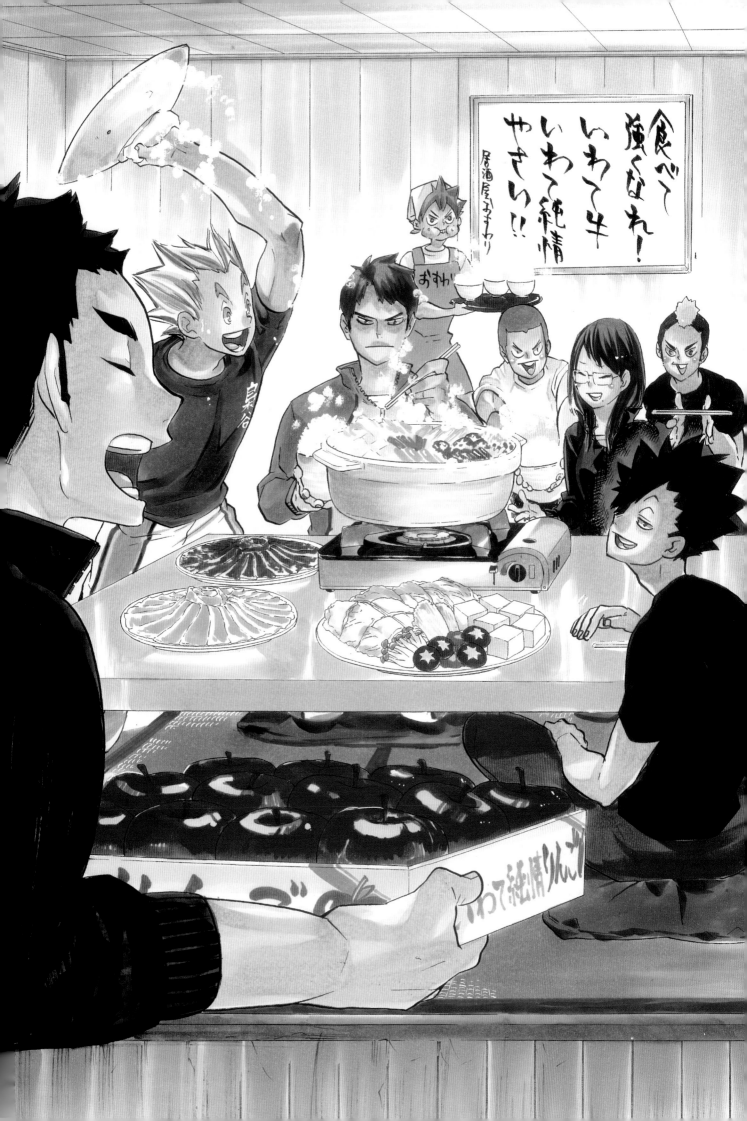

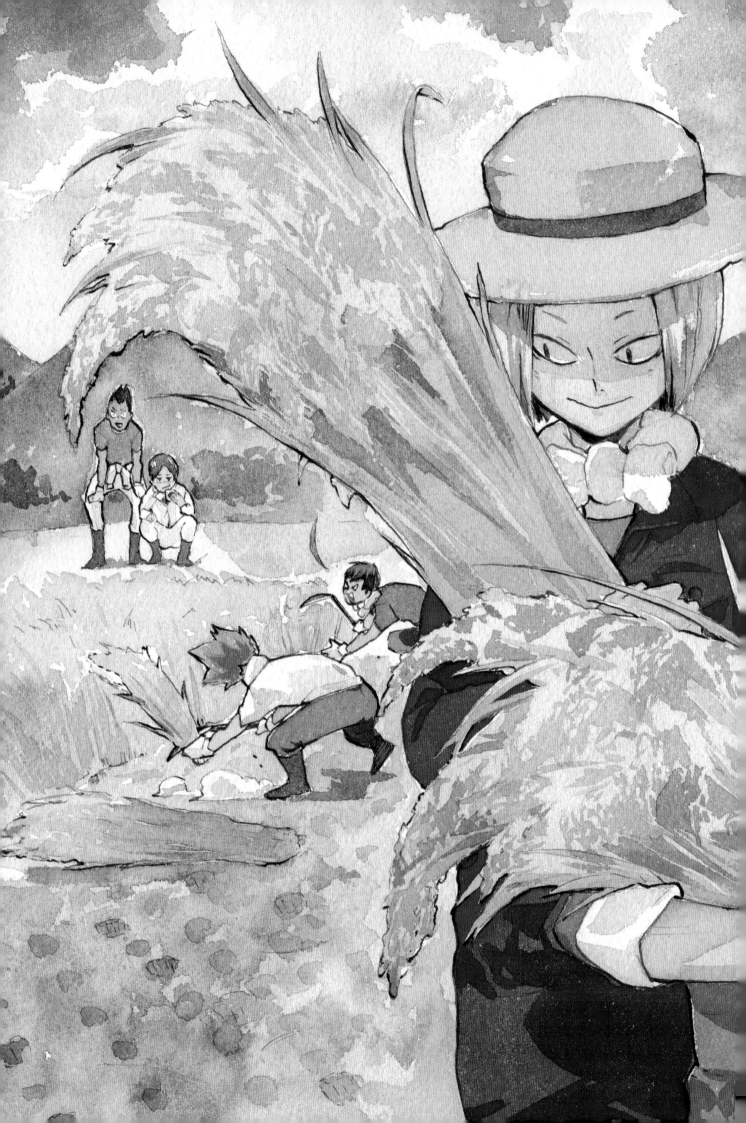

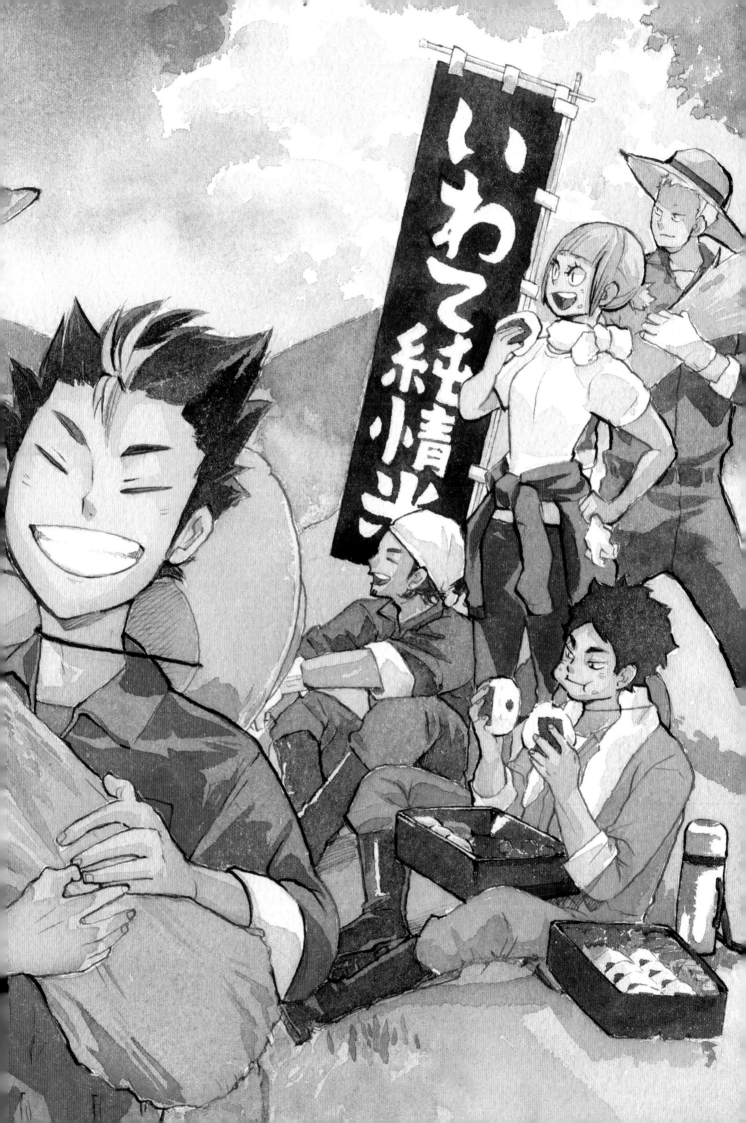

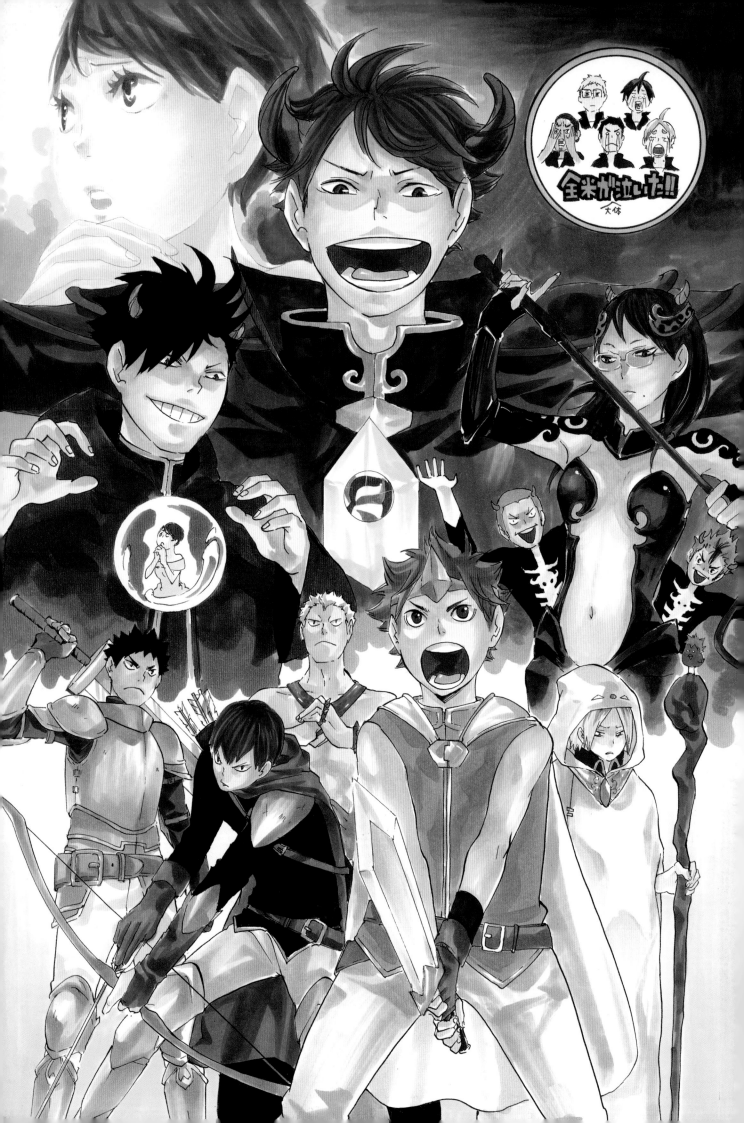

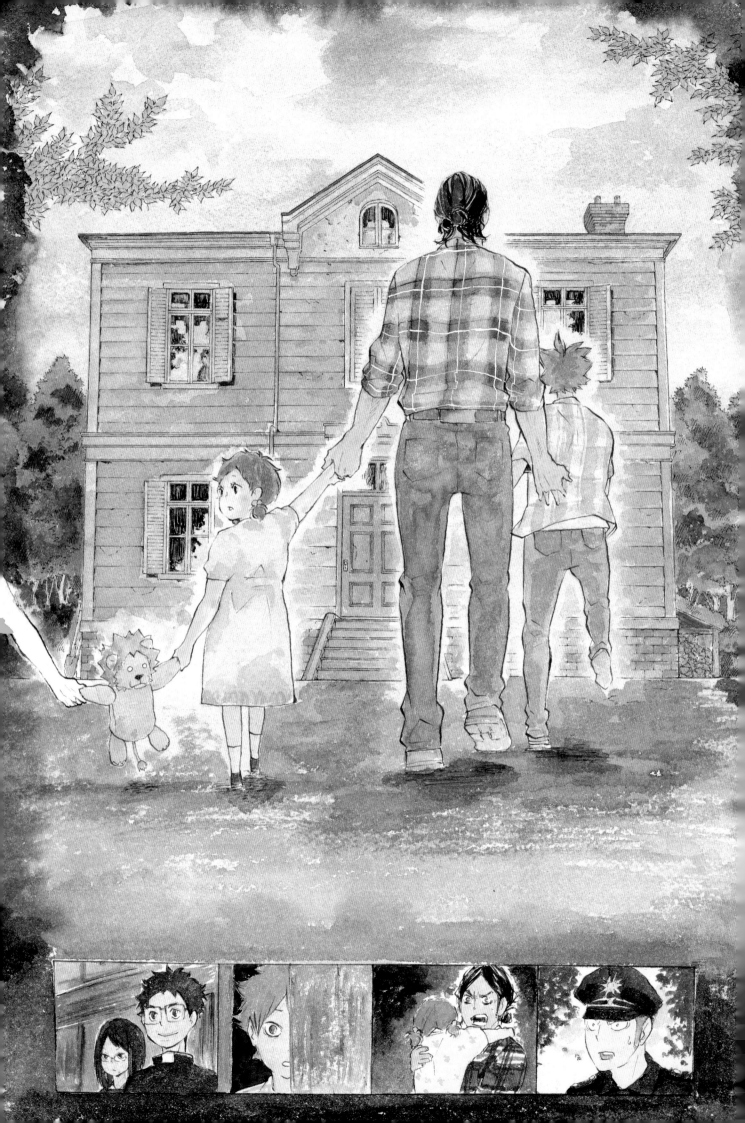

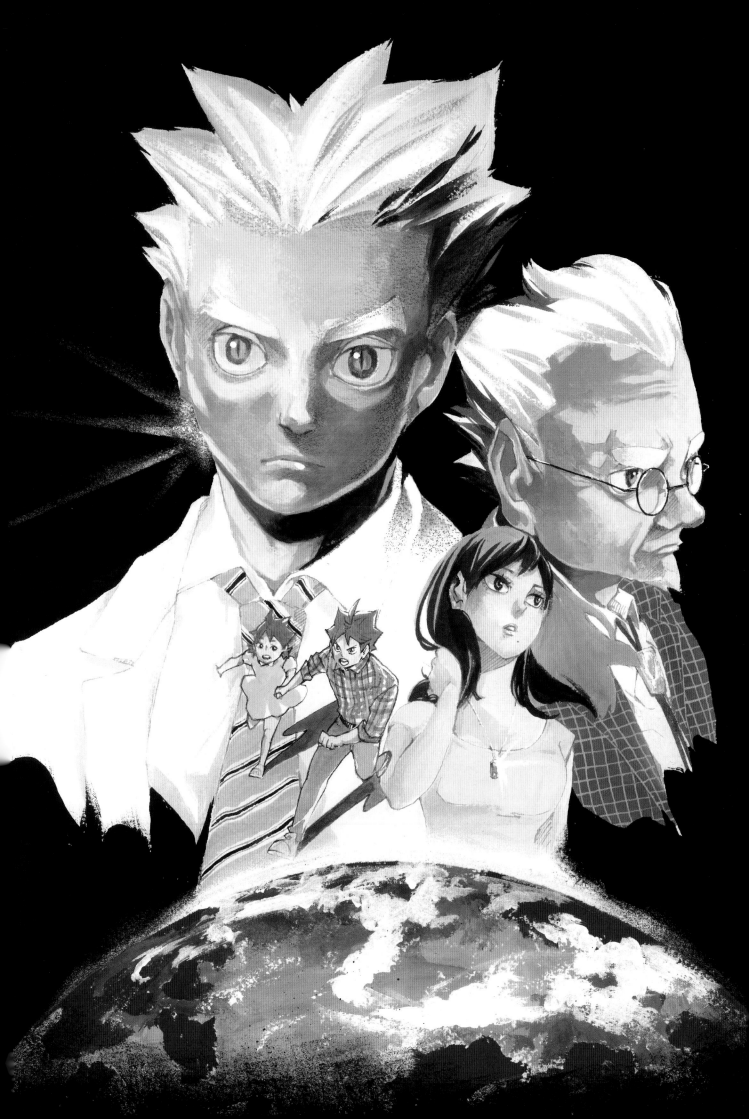

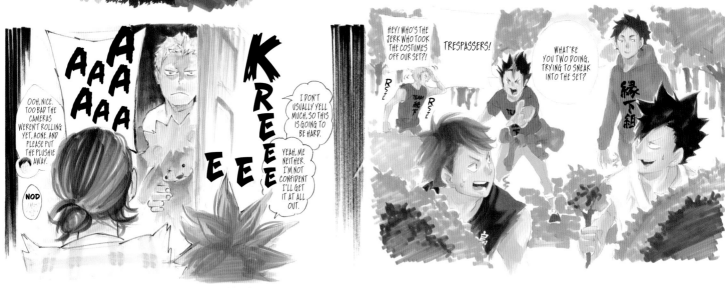

JOHN BONSLEY (ASAHI AZUMANE)
SUPPORT STAFF WHO HELPS THE ANGELS
FROM THE CROW DETECTIVE AGENCY.

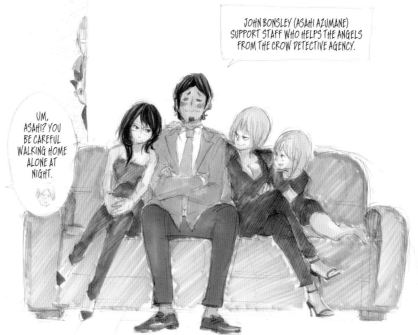

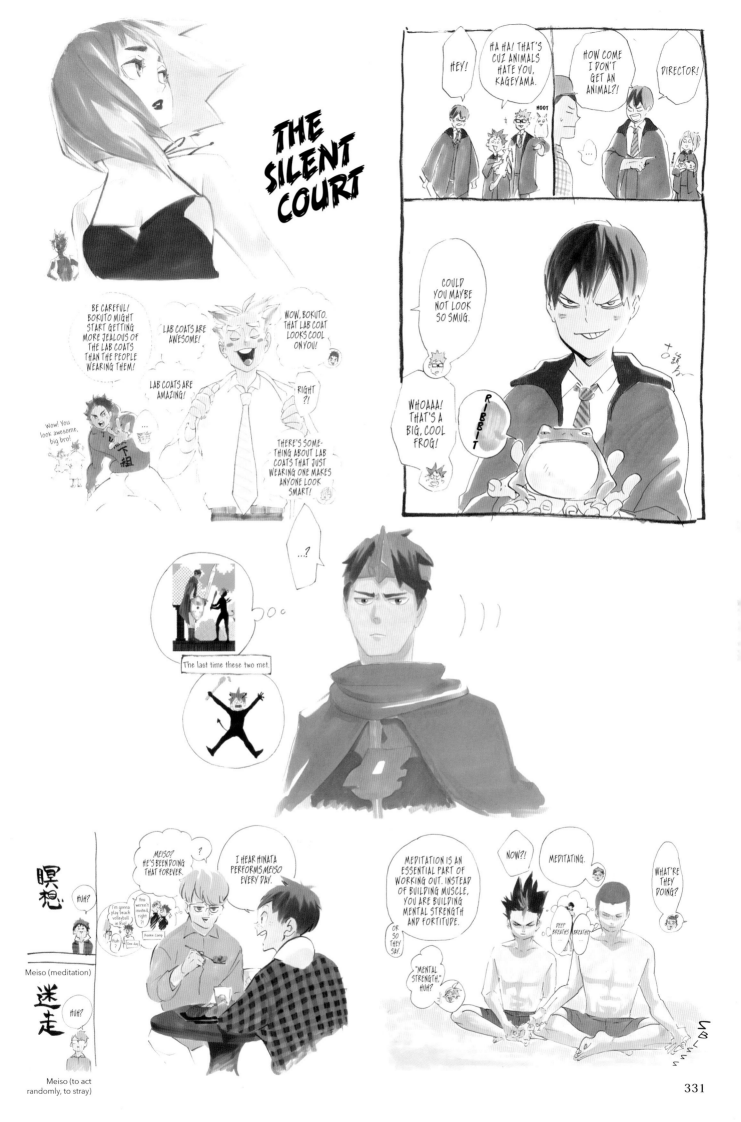

THE SILENT COURT

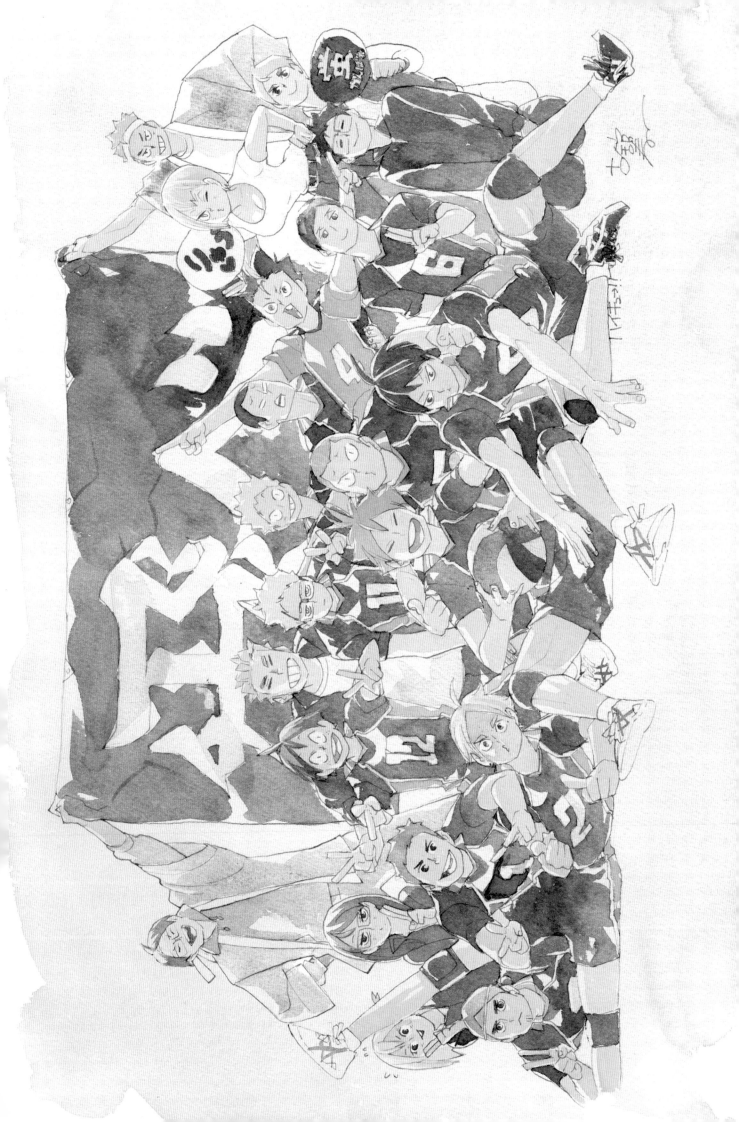

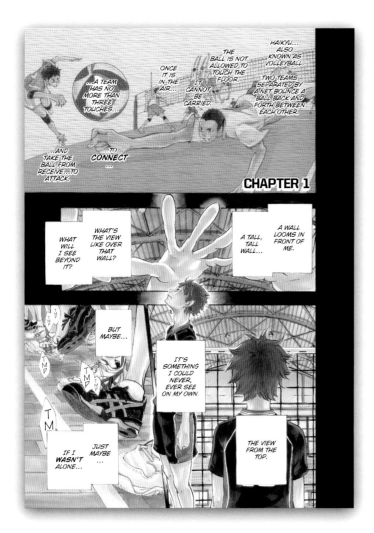

Once it is in the air... it cannot be carried.

The ball is not allowed to touch the floor.

Haikyu... also known as volleyball. Two teams separated by a net bounce a ball back and forth between each other.

...A team has no more than three touches...

...and take the ball from receive... to attack.

TO CONNECT...

CHAPTER 1

What will I see beyond it?

What's the view like over that wall?

A tall, tall wall...

A wall looms in front of me.

But maybe...

It's something I could never, ever see on my own.

If I wasn't alone...

Just maybe...

The view from the top.

TM
TMP
TMP
TM

They're suffocating us.

They're figuring us out.

They're chasing us down.

Slowly, little by little...

Hey!

CHAPTER 30

There's no such thing as an unblockable spike. Don't let it get to you.

We just have to take the next set!

You can't afford to stand around and mope after each little screw-up.

Fweeee

You'll get 'em next time, Hinata! We know you will!

Right!

SET 2 START

CRAP! THEY GOT HIM AGAIN!

BAT

WHAP

CLENCH

YEAH!!

NICE BLOCK, INUOKA!!

He's acclimated to the way Hinata moves!

That was no fluke by No. 7.

In his first and only middle school tournament game, Hinata was completely shut out.

Even now, in high school, he can't compete against Tsukishima and his height. But...

But now... one that let him go up against blockers much bigger than him with no fear.

It was only one attack, but it was a powerful one...

He'd finally found a weapon.

That attack is getting shut down by a single blocker.

Are you okay?

Hinata...

...

...

Give it to me again.

Kageyama.

TMP

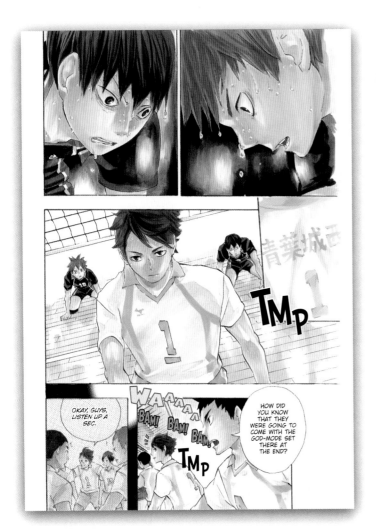

OKAY, GUYS, LISTEN UP A SEC.

HOW DID YOU KNOW THAT THEY WERE GOING TO COME WITH THE GOD-MODE SET THERE AT THE END?

WAAAAA BAM! BAM! BAM!

TMP
TMP

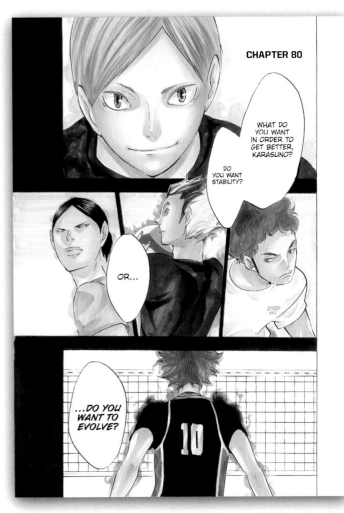

CHAPTER 80

WHAT DO YOU WANT IN ORDER TO GET BETTER, KARASUNO?

DO YOU WANT STABILITY?

OR...

...DO YOU WANT TO EVOLVE?

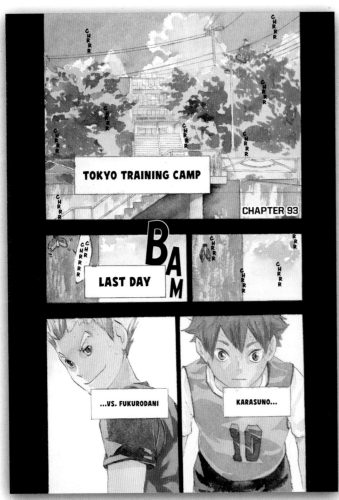

TOKYO TRAINING CAMP

CHAPTER 93

CHRR

BAM

LAST DAY

RRR

...VS. FUKURODANI

KARASUNO...

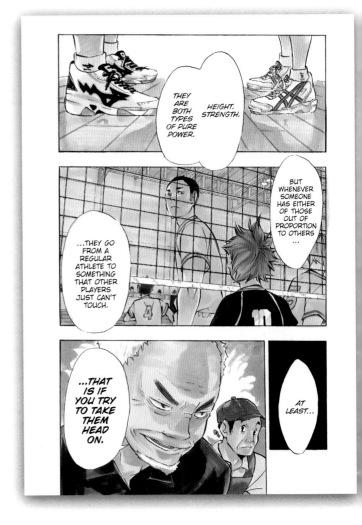

THEY ARE BOTH TYPES OF PURE POWER.

HEIGHT. STRENGTH.

BUT WHENEVER SOMEONE HAS EITHER OF THOSE OUT OF PROPORTION TO OTHERS...

...THEY GO FROM A REGULAR ATHLETE TO SOMETHING THAT OTHER PLAYERS JUST CAN'T TOUCH.

...THAT IS IF YOU TRY TO TAKE THEM HEAD ON.

AT LEAST...

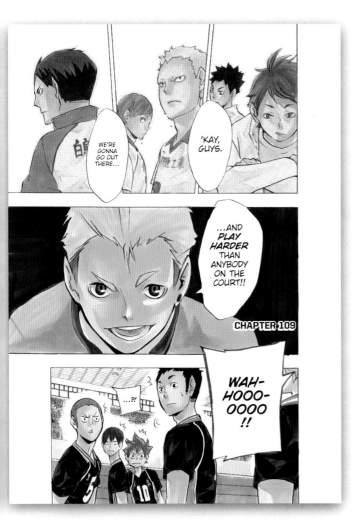

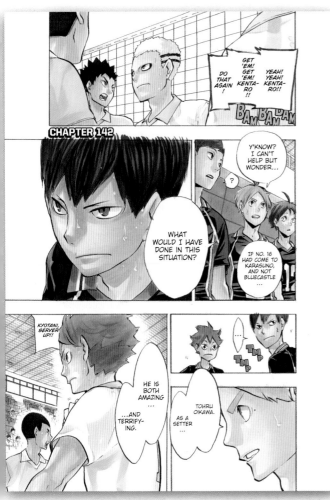

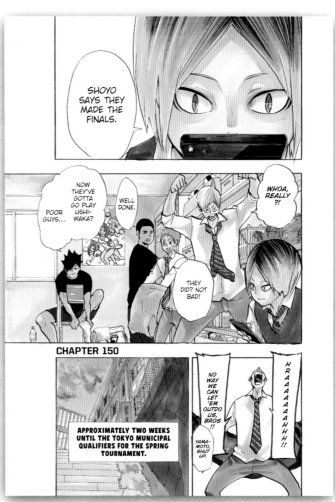

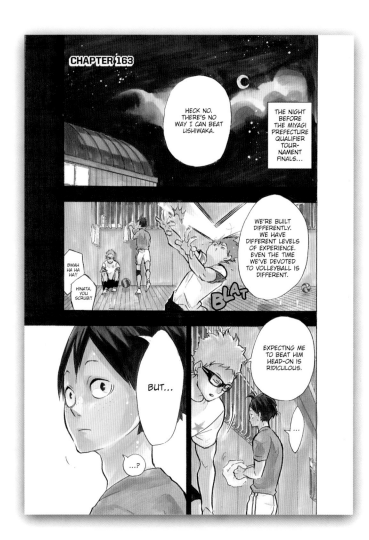

CHAPTER 163

THE NIGHT BEFORE THE MIYAGI PREFECTURE QUALIFIER TOURNAMENT FINALS...

HECK NO. THERE'S NO WAY I CAN BEAT USHIWAKA.

WE'RE BUILT DIFFERENTLY. WE HAVE DIFFERENT LEVELS OF EXPERIENCE. EVEN THE TIME WE'VE DEVOTED TO VOLLEYBALL IS DIFFERENT.

BWAH HA HA!!

HINATA, YOU SCRUB!!

BLAT

BUT...

EXPECTING ME TO BEAT HIM HEAD-ON IS RIDICULOUS.

...?

...

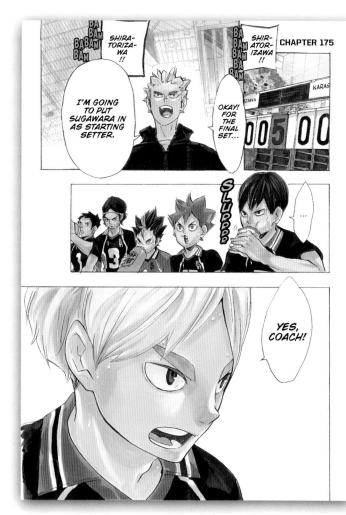

CHAPTER 175

BABAM BAM BAM

SHIRA-TORIZA-WA!!

I'M GOING TO PUT SUGAWARA IN AS STARTING SETTER.

BABAM BAM BAM

SHIR-ATOR-IZAWA!!

OKAY! FOR THE FINAL SET...

00 5 00

KARAS

SLURPP

YES, COACH!

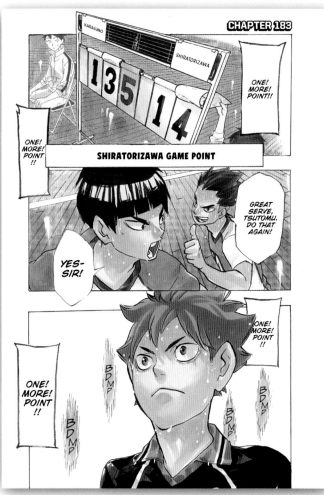

CHAPTER 183

KARASUNO

SHIRATORIZAWA

13 5 14

ONE! MORE! POINT!!

ONE! MORE! POINT!!

SHIRATORIZAWA GAME POINT

GREAT SERVE, TSUTOMU. DO THAT AGAIN!

YES-SIR!

ONE! MORE! POINT!!

ONE! MORE! POINT!!

BDMP

BDMP

BDMP

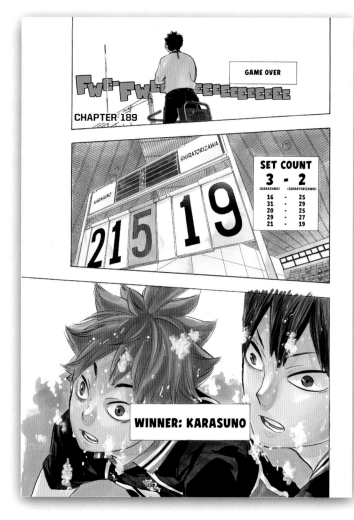

FWEE FWEE EEEEEEEEEEEE

GAME OVER

CHAPTER 189

SHIRATORIZAWA

KARASUNO

21 5 19

SET COUNT	
3 - 2	
(KARASUNO)	(SHIRATORIZAWA)
16	25
31	29
20	25
29	27
21	19

WINNER: KARASUNO

CHAPTER 209

MIYAGI PREFECTURE ROOKIE SELECT TRAINING CAMP

KANJI KOGANEKAWA
DATE TECH
1ST YEAR / S
6'4"

TSUTOMU GOSHIKI
SHIRATORIZAWA ACADEMY
1ST YEAR / WS
5'11"

AOBA JOHSAI HIGH SCHOOL

AKIRA KUNIMI
1ST YEAR / WS
6'0"

YUTARO KINDAICHI
1ST YEAR / MB
6'3"

KEI TSUKISHIMA
KARASUNO HIGH SCHOOL
1ST YEAR / MB
6'3"

...?! ...?

YUDAI HYAKUZAWA
KAKUGAWA ACADEMY
1ST YEAR / WS
6'8"

I DON'T THINK YOU WERE INVITED?

WAIT A MINUTE...

SHOYO HINATA
KARASUNO HIGH SCHOOL
1ST YEAR / MB
5'5"

BEST LINEUP VOTING RESULTS!!

BUT I GET IT, Y'KNOW? IF I'M SITTING OUT HERE, THAT MEANS I DIDN'T GET PICKED.

SO YEAH. THIS IS THE GREAT, GRAND ANNOUNCEMENT OF THE WINNERS OF THE BEST LINE-UP POLL AND STUFF.

RIGHT? RIGHT. I KNOW.

GUYS, LOOK! IT'S THE RECLINING BUDDHA!

THE WHATSIT?

TANAKA, COULD YOU DO THE ANNOUNCE-MENT, PLEASE?

BUT I DON'T CARE. I'VE STILL GOT MY HEALTH. I'LL BE FINE.

THE RESULTS ARE...

CLAP CLAP

AWWRIIIIIIGHT, EVERYONE! LET'S GET FIRED UP!!

CHAPTER 220

DECEMBER 10 (MON.) 6:45 A.M.

CHAPTER 224

ME, NOT USH-IJIMA-SAN!! I, TSUTOMU GOSHIKI, AM HONORED TO PRESENT TO YOU THIS OFFICIAL ANNOUNCE-MENT!

IN USHI-JIMA-SAN'S STEAD...

THANKS TO EVERYONE'S SUPPORT, THE THIRD SEASON OF THE ANIME, HAIKYU!!: KARASUNO VS. SHIRATORIZAWA, WILL GO ON AIR STARTING OCTOBER 7, 2016!

SENO-RITY WINS!

BOM

OOH! ANNOUNCING? I WANNA DO IT! I WANNA DO IT!! LEMME DO IT!

NOW THEN...

IT'LD BE A THREE-PARTER! "WAKATOSHI-KUN IS ACTUALLY ALMOST 40 YEARS OLD?!" "COACH WASHIJO AND OLD COACH UKAI'S GATEBALL CLASH!" AND... "HINATA LEARNS THE LEVITATION TECHNIQUE!" CHECK IT OUT!!

HEY, FOLKS! HAIKYU!! SEASON 3, EPISODE 1 WILL BE GOING ON AIR SOON!!

*THE CONTENTS OF THESE EPISODES MAY CHANGE BEFORE BROADCAST WITHOUT NOTICE.

*THIS ANNOUNCEMENT WAS FROM OCTOBER, 2016.

CHAPTER 250

SO THANKS!

THANKS TO ALL OF YOU, HAIKYU!! JUST HIT IT'S FIFTH ANNIVERSARY!

YEAH. I THOUGHT HINATA HAD BEEN SCHEDULED TO DO IT.

HM? WHY IS TENDO-SAN DOING THIS ANNOUNCEMENT?

SENPAI, STOP IT! WHAT ARE YOU GOING TO DO IF SOMEONE SUBMITS A CLAIM FOR FALSE ADVERTISING?!

UM! TENDO-SAN?! ARE YOU SURE YOU SHOULD BE LYING LIKE THAT?!

?!

IN CELEBRATION OF FIVE WHOLE YEARS OF SERIALIZATION, THIS WEEK'S HAIKYU!! CHAPTER WILL BE DONE ENTIRELY IN REAL PHOTOGRAPHS!!

HEY, DIDJA KNOW THEY CHANGED THE VENUE?

?

CONGRATS 5TH ANNIVERSARY

?!

HURRY! GO GET USHIJIMA-SAN OR REON-SAN!

AWWWW!

BY THE WAY, MR. AVERAGE ME.

CHAPTER 264

DO YOU REALLY HAVE THE TIME TO BE LOOKIN' DOWN RIGHT NOW?

AND IT WASN'T JUST ANY SET, IT WAS A PERFECT COPY OF KARASUNO'S MINUS TEMPO QUICK!

OSAMU MIYA—A HITTER—SETS THE BALL FOR ATSUMU MIYA—THE SETTER—TO SPIKE!

UN! BELIEVABLE!!

THE MIYA TWINS TRULY ARE A TERRIFYING TANDEM TO FACE!

I AIN'T A SETTER, Y'KNOW!

HEY! QUIT ASKIN' FOR THE UNIVERSE!

THAT WAS LOW AND SHORT.

GEEZ!

WHAT THE HELL WAS THAT...?!

CHAPTER 290

INARIZAKI KARASUNO

KARASUNO SET AND GAME POINT

BUT THAT'S NO PROBLEM.

CREATING BREATHING SPACE FOR YOUR TEAMMATES MEANS ALSO GIVING YOUR OPPONENTS THAT SAME SPACE.

COME ON. BRING IT ON.

CHAPTER 297

WHO'S IN THE LEAD?!

WHAT'S THE SCORE?!

!!

SAEKO-CHAN, YOU LOOK GREAT!

THANKS! ♡

WHOA, WHOA! CALM DOWN, WOULDJA?! THE GAME JUST STARTED.

AAAUGH! I WANTED TO WATCH THEIR WARMUPS TOO!

BUT MY SHIFT RAN LATE AT WORK...

WELL AREN'T YOU BUSY?

STILL...

I JUST HAD TO WATCH THIS GAME IN PERSON.

DUH? IT'S NATIONALS. IF HE WANTS TO WIN, OF COURSE HE'S GOING TO TRY FOR REAL.

...?

Y'KNOW, SHORTY IS GONNA BE DEAD SERIOUS THIS TIME. HE'LL BE OUT TO BEAT YOU FOR REAL.

I'M SAYING HE'S COMING FOR YOU.

THAT'S NOT WHAT I MEANT.

CHAPTER 322

I DON'T GET IT.

...?

BUT I WANNA WIN! I'M GONNA BEAT HIM, NO MATTER WHAT!

I BETCHA KENMA WON'T REALLY CARE EITHER WAY IF HE WINS OR LOSES...

HEY, KAGE-YAMA?

WHAT'S HE GOING ON ABOUT?

I HOPE YOU'LL ALL KEEP CHEERING FOR US!

THANKS TO YOUR GENEROUS SUPPORT, HAIKYU!! HAS REACHED ITS SEVENTH ANNIVERSARY!

CHAPTER 338

SEVEN ANNIVERSARIES CELEBRATING THE COMING OF THE EIGHTH YEAR OF ANNI-VERSARIES.

WHY MUST YOU CONFUSE THINGS ALL THE TIME?

UM, NO? IT'S THE START OF THE EIGHTH YEAR.

HEY. QUESTION. DOES "SEVENTH ANNIVERSARY" MEAN IT'S THE SEVENTH YEAR OF THIS?

SEVEN YEARS HAVE PASSED.

HUH?

YEAH!!

LET'S KEEP GOING FULL STEAM AHEAD, FOR YEAR 7 AND YEAR 8!

OH, WHAT-EVER! WHO CARES?!

HI, EVERYONE! THANKS SO MUCH FOR ALL YOUR VOTES IN THE HAIKYU!! BEST GAME POLL! WE'VE TALLIED THEM UP AND NOW IT'S TIME TO ANNOUNCE THE RESULTS! LET'S START WITH TENTH TO FOURTH PLACE!

THE RESULTS OF THE BEST GAME POLL!

OOH! OOH! THREE OF OUR GAMES MADE IT!

YER KIDDIN'! FOURTH PLACE IS JUST AS BAD AS, LIKE, 100TH PLACE?

WHAT THE HECK? WE'RE DOWN IN FOURTH PLACE?

4TH PLACE: KARASUNO VS. INARIZAKI 2,840 VOTES (SPRING TOURNAMENT)

5TH PLACE: FUKURODANI VS. NEKOMA 1,142 VOTES (TOKYO SPRING TOURNAMENT QUALIFIER SEMIFINALS)

6TH PLACE: SHIRATORIZAWA VS. AOBA JOHSAI 920 VOTES (MIYAGI PREFECTURE INTER-HIGH QUALIFIER FINALS)

7TH PLACE: FUKURODANI VS. MUJINAZAKA 854 VOTES (SPRING TOURNAMENT QUARTER FINALS)

8TH PLACE: KARASUNO VS. AOBA JOHSAI 705 VOTES (MIYAGI PREFECTURE INTER-HIGH-QUALIFIER)

9TH PLACE: OWLS VS. CATS 3-ON-3 365 VOTES (TOKYO TRAINING CAMP, DAY 5)

10TH PLACE: NEKOMA VS. NOHEBI 258 VOTES (TOKYO SPRING TOURNAMENT QUALIFIER 3RD PLACE GAME)

FIRST THROUGH THIRD PLACE ARE ON THE NEXT PAGE.

THE CAT VS. THE CROW

THAT WAS A REAL-LIFE, EAT-OR-BE-EATEN BATTLE.

UH, THAT WASN'T A VOLLEYBALL GAME, Y'KNOW.

HONORABLE MENTION

(GOT ONLY 1 VOTE)

CHAPTER 354

IT WAS LIKE I CAUGHT A GLIMPSE OF WHAT IT'S LIKE WHERE MONSTERS LIVE.

I COULD FEEL THE NERVOUS TENSION DRAIN OUT OF ME.

KARASUNO KAMOMEDAI

OKAY, GUYS.

ONE POINT. I THINK WE CAN GET THAT.

CHAPTER 364

THIS IS FUN.

OH MAN...

THIS IS SO MUCH FUN!

FWEEEE

THE SCHWEIDEN ADLERS CALL THEIR SECOND TIME-OUT OF SET 1.

GO! GO! ADLERS!

GO! GO! ADLERS!

SO YEAH.

WHERE'S NISHINOYA? WHAT'S HE UP TO NOWADAYS?

You were about to say something earlier...

CHAPTER 386

...

OH, RIGHT.

Lemme get my phone.

WHAT?

HE'S OUT FISHING FOR MARLINS OFF THE COAST OF ITALY.

WHICH PLAYERS MADE THE CUT? FIND OUT ON THE NEXT PAGE. DU-DU-DUN.

LADIES AND GENTLEMEN, THANK YOU FOR ALL YOUR VOTES IN THE HAIKYU!! BEST LINEUP POLL.

TRY TO SOUND EXCITED!

BONUS! SENIORS TEAM

AARON MURPHY
SUN HILLS ALUMNUS
MB / 6'2"

TANJI WASHIJO
SHIRATORIZAWA ALUMNUS
OH / 5'6"

YASUFUMI NEKOMATA
NEKOMA ALUMNUS
S / 5'6"

YUMIE KITA
FUENEKU ALUMNA
L / 5'0"

MINEO NISHINOYA
CHIDORIYAMA MIDDLE SCHOOL ALUMNUS
OH / 4'11"

KAGEYAMA WASHIJO NEKOMATA

KITA

UKAI NISHINOYA MURPHY

IKKEI UKAI
KARASUNO ALUMNUS
OP / 5'11"

NET

KAZUYO KAGEYAMA
SHIRATORIZAWA ALUMNUS
MB / 6'1"

THE MAIN CONCERN WILL BE HOW TO COVER FOR BEGINNERS KITA AND NISHINOYA. ALSO, NISHINOYA WILL PROBABLY IGNORE ALL THE RULES, SO WATCH OUT.

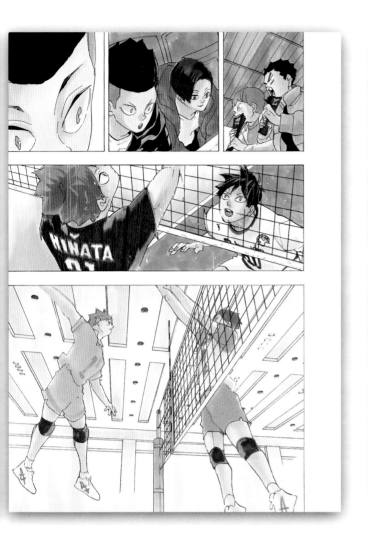

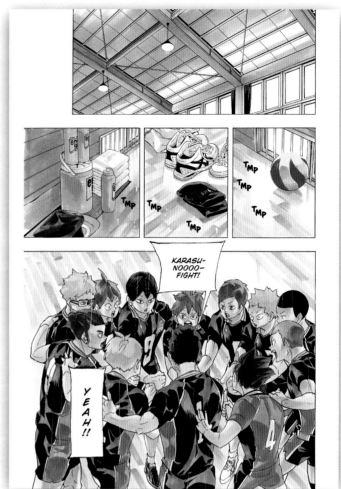

KARASU-NOOOO-FIGHT!

YEAH!!

S.DAICHI SAKOUSHI A.ASAHI N.YUU T.RYUNOSUKE

H.SHOUYOU K.TOBIO T.KEI Y.TADASHI

嶋田マート

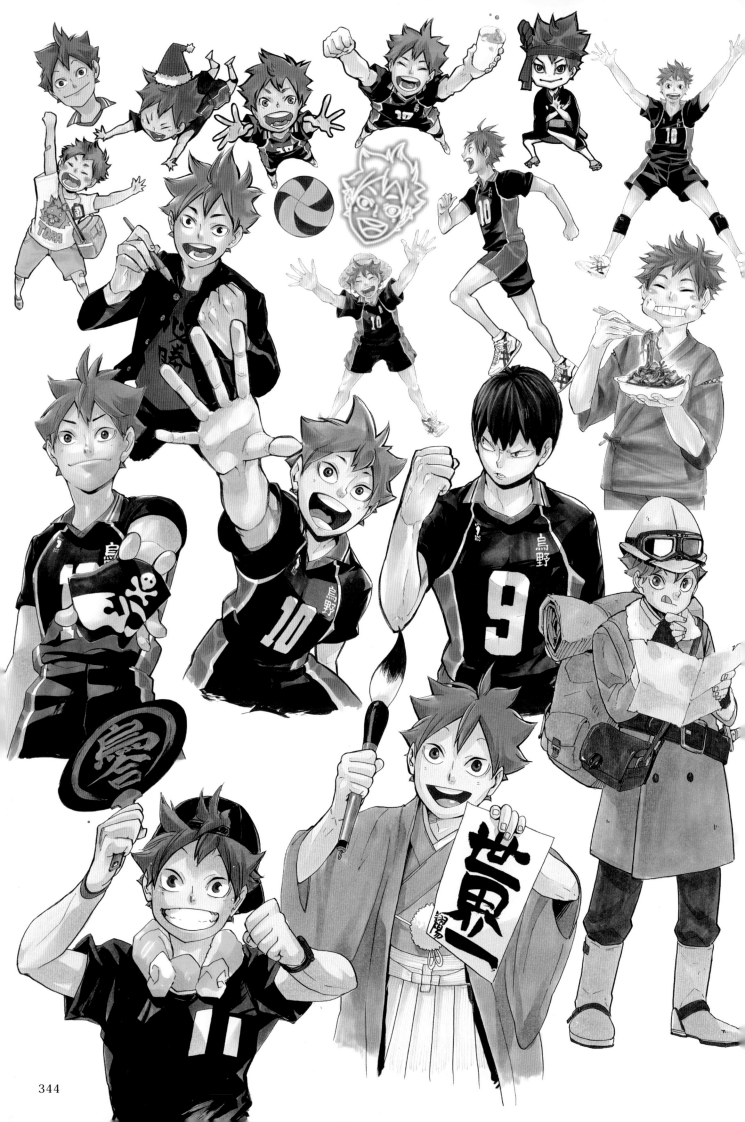

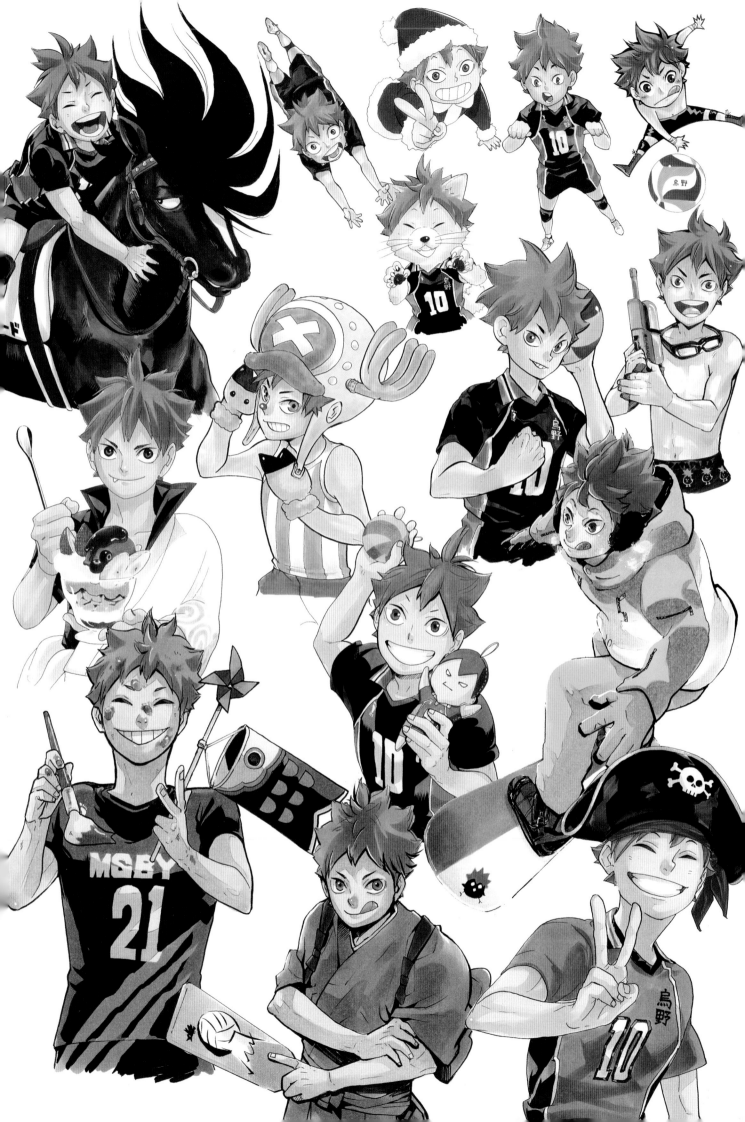

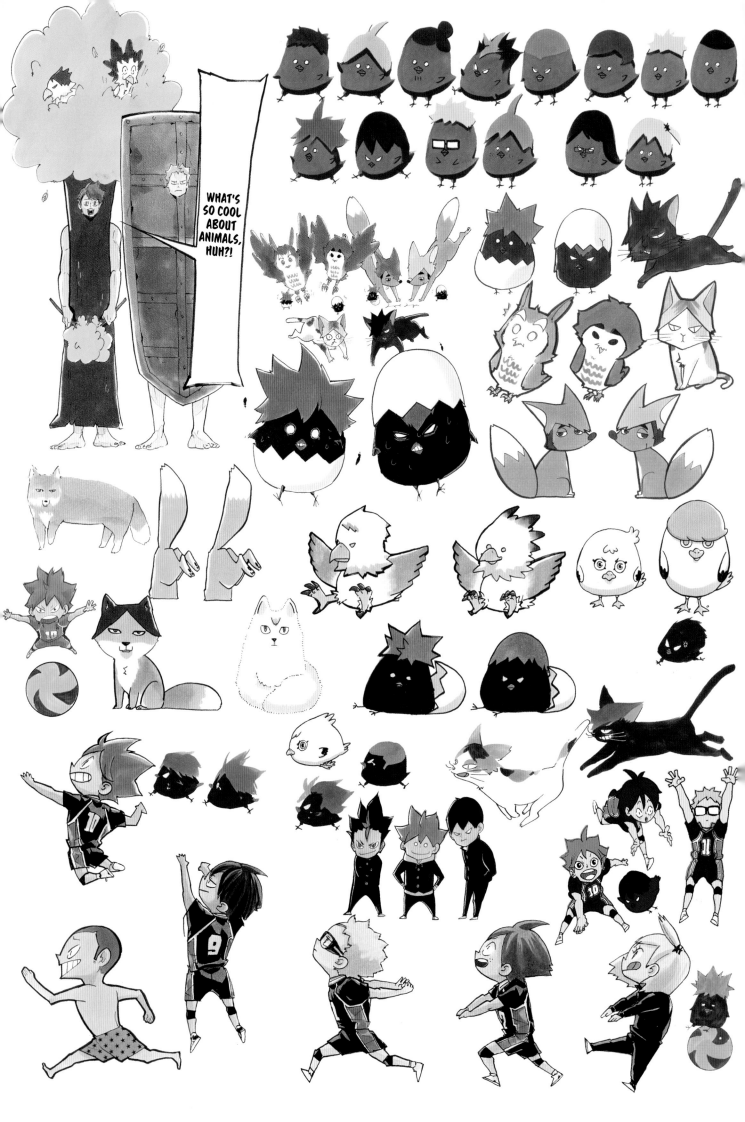

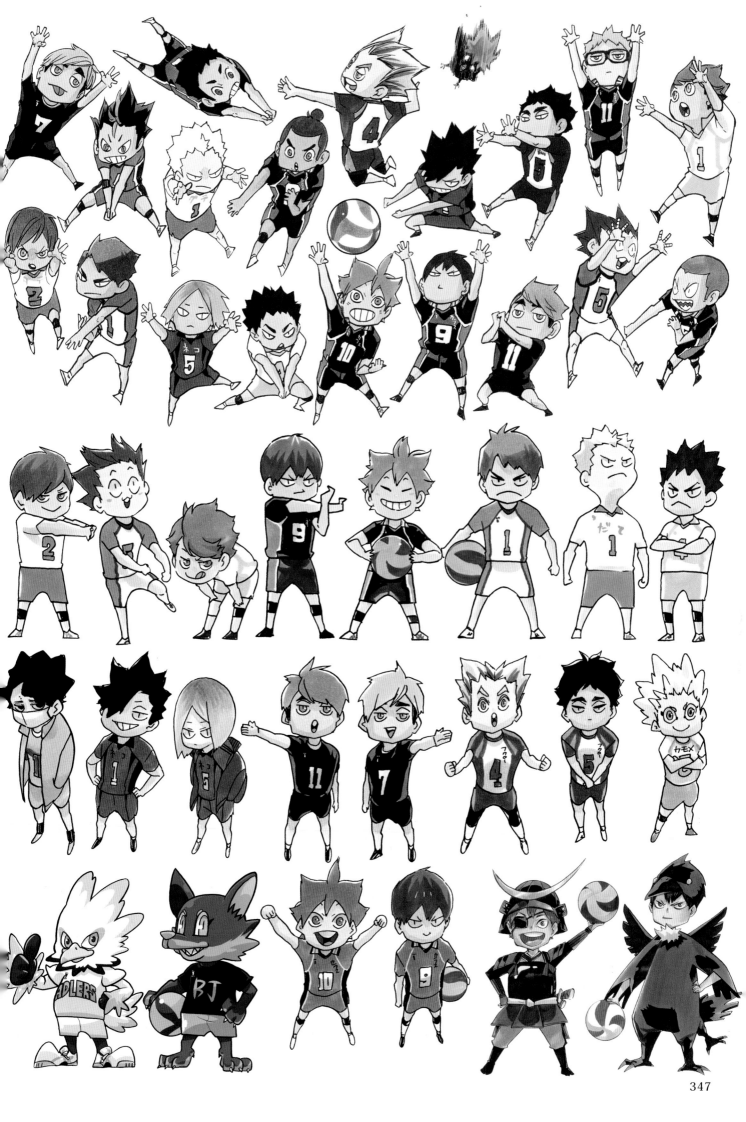

347

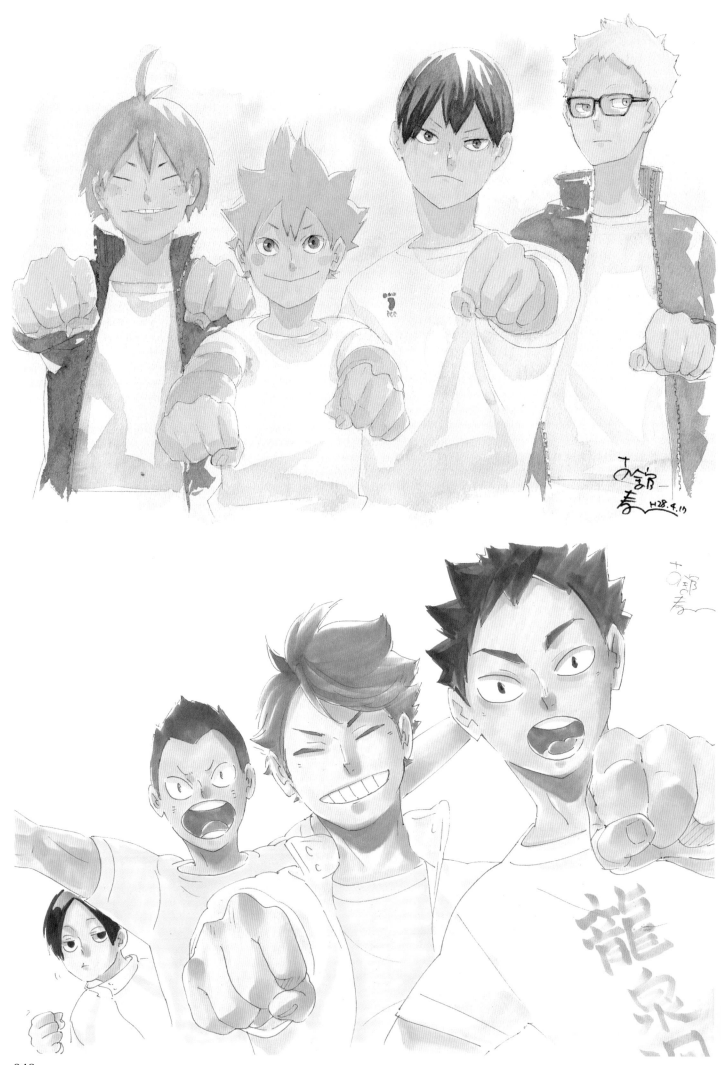

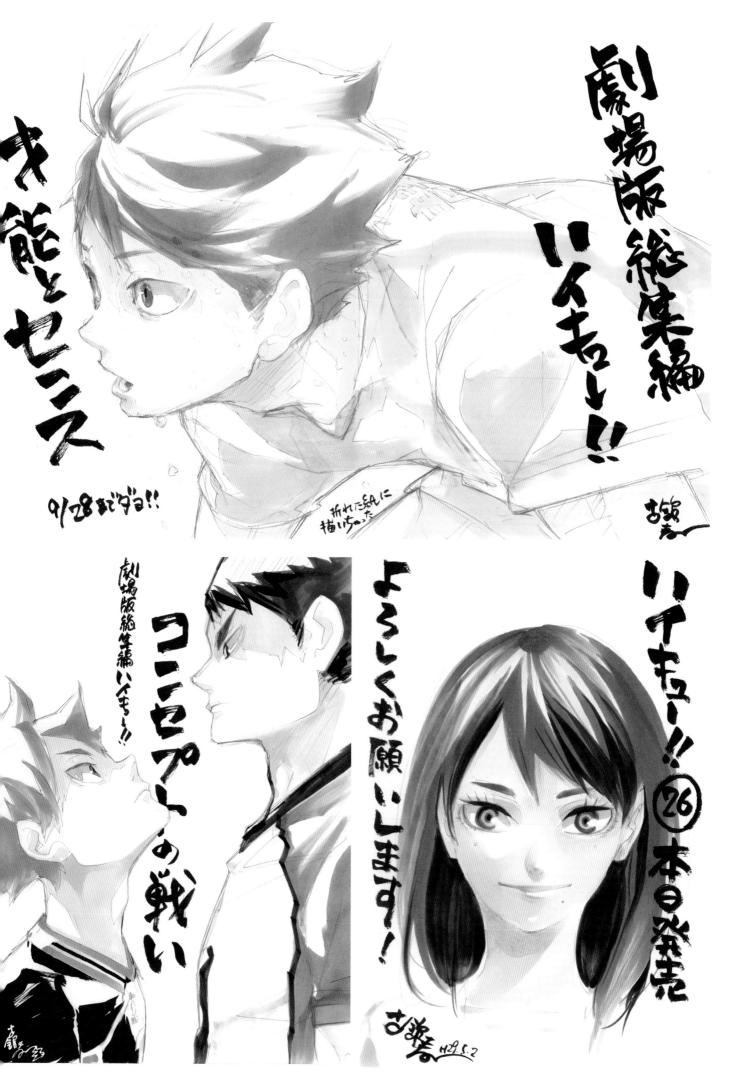

劇場版総集編 ハイキュー!!

才能とセンス

9/28までダゾ!!

折れた紙に描いちゃった

劇場版総集編 ハイキュー!!

コンセプトの戦い

劇場版総集編 ハイキュー!!

よろしくお願いします!

ハイキュー!! ㉖ 本日発売

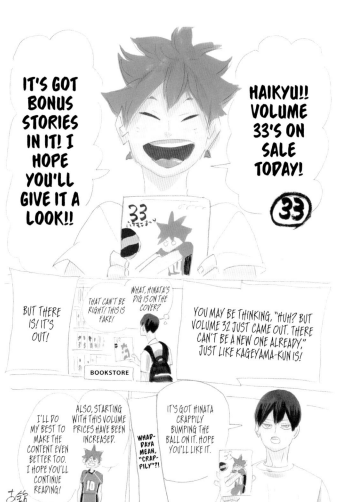

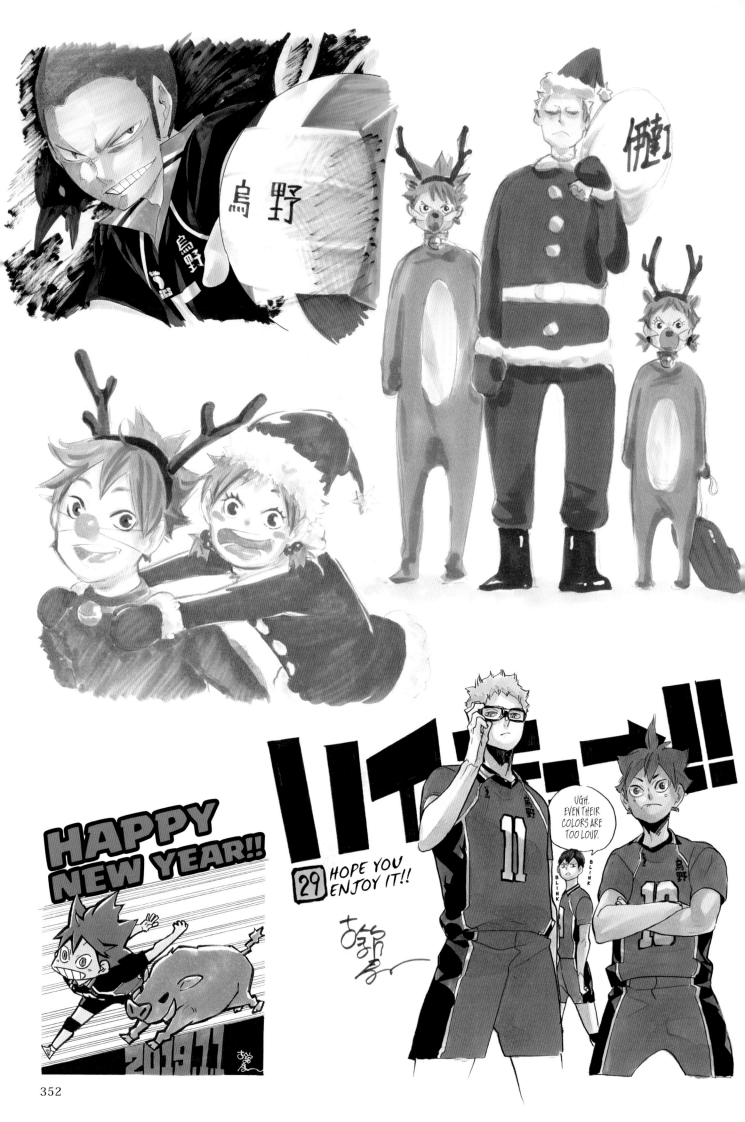

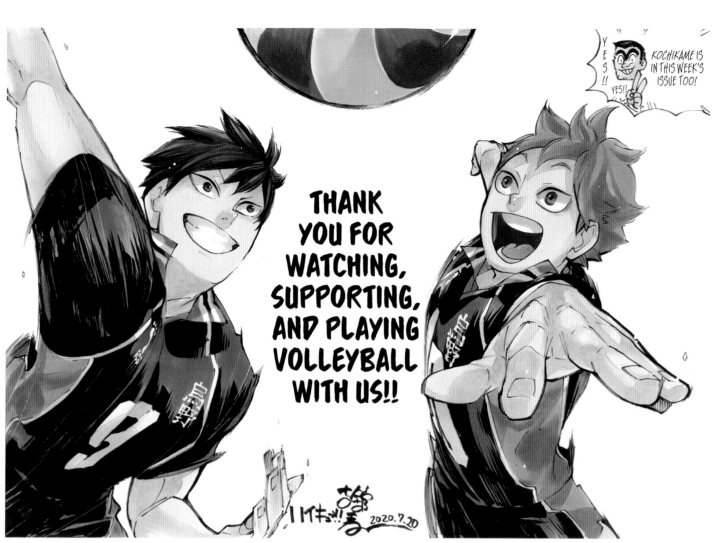

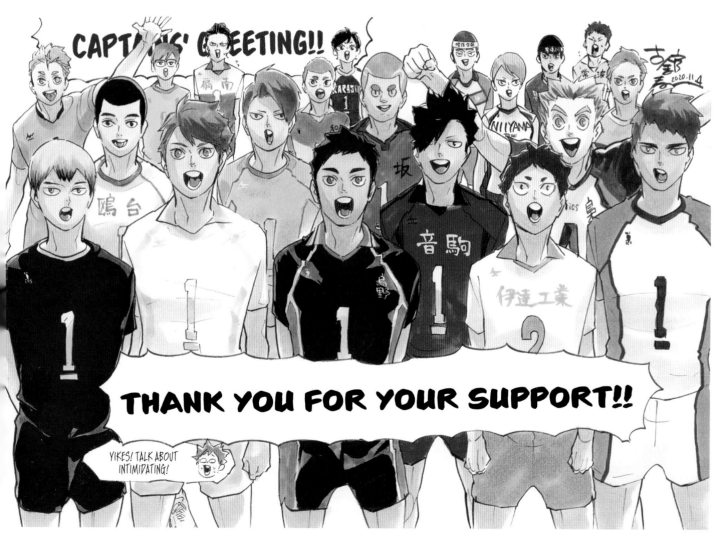

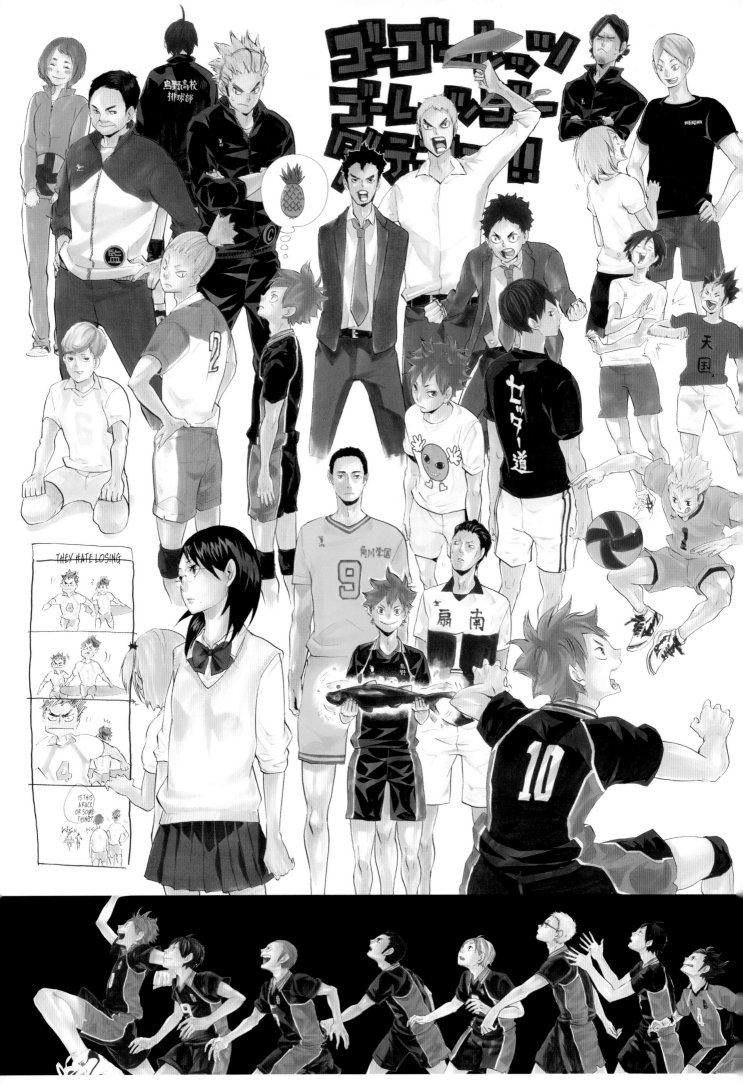

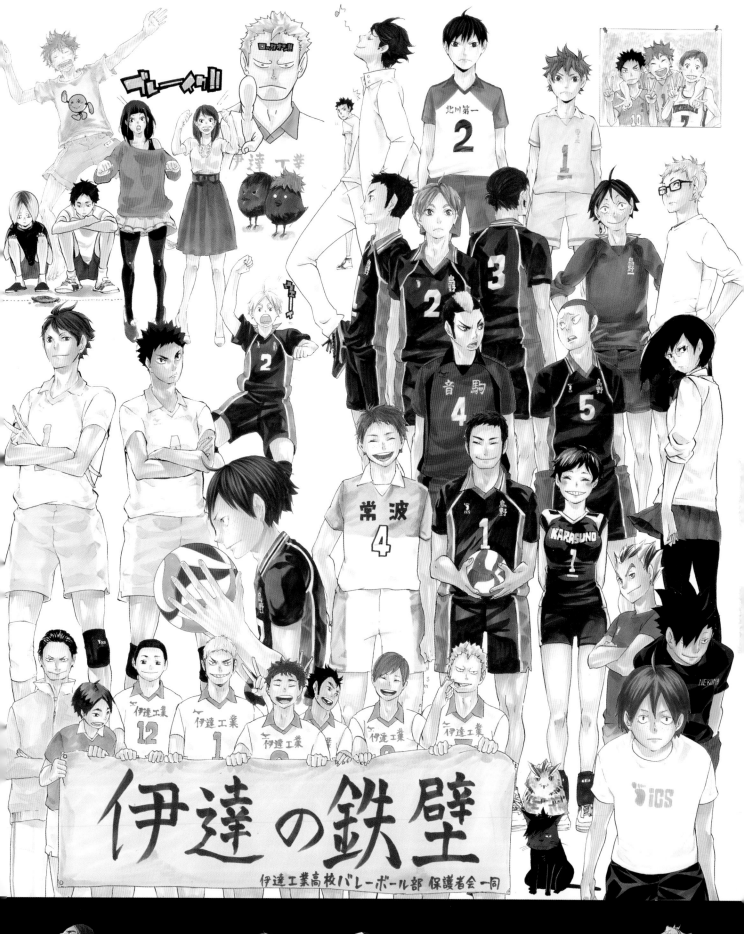

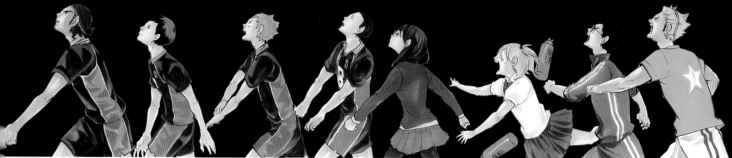

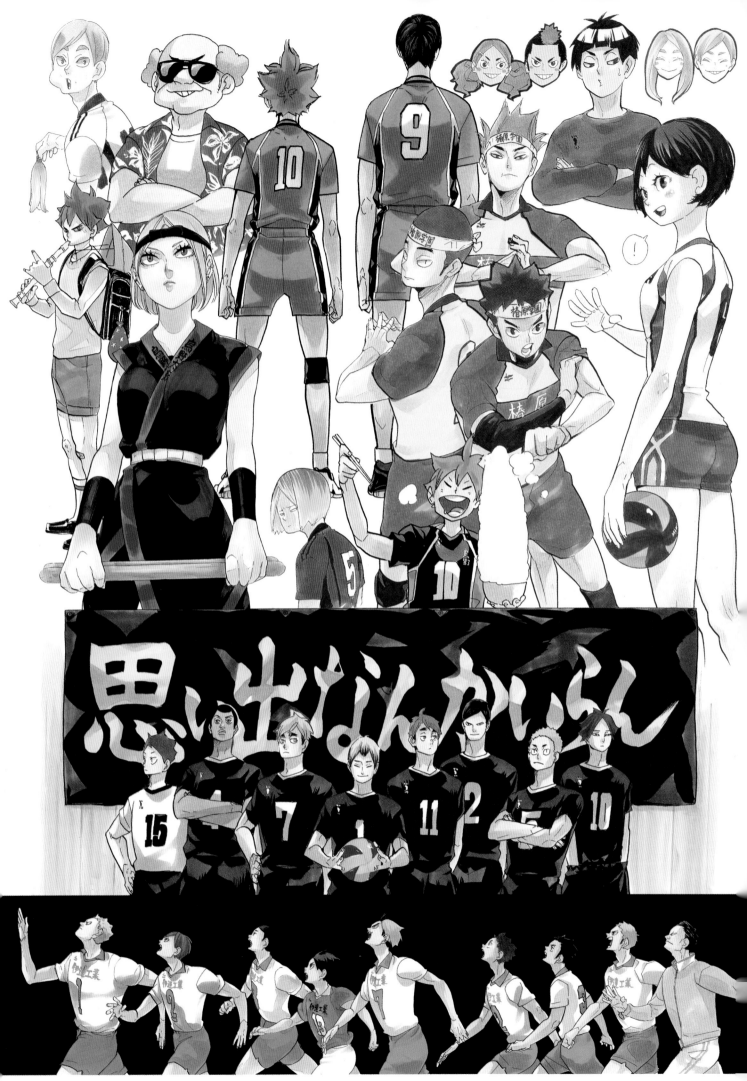

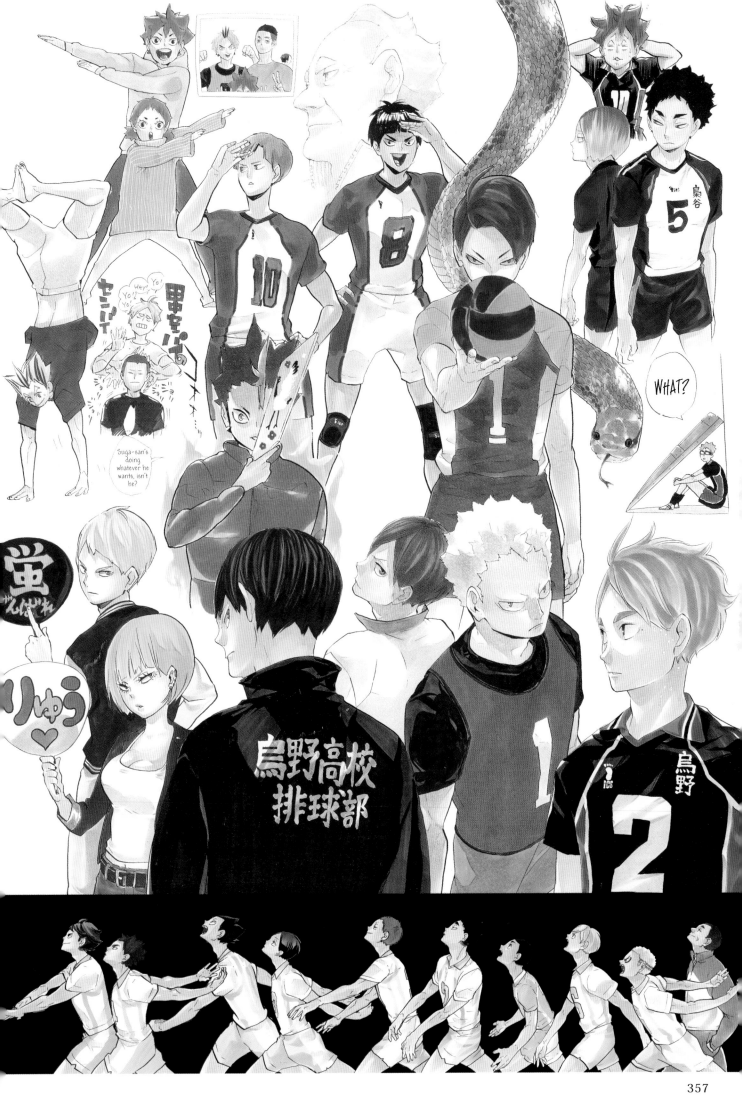

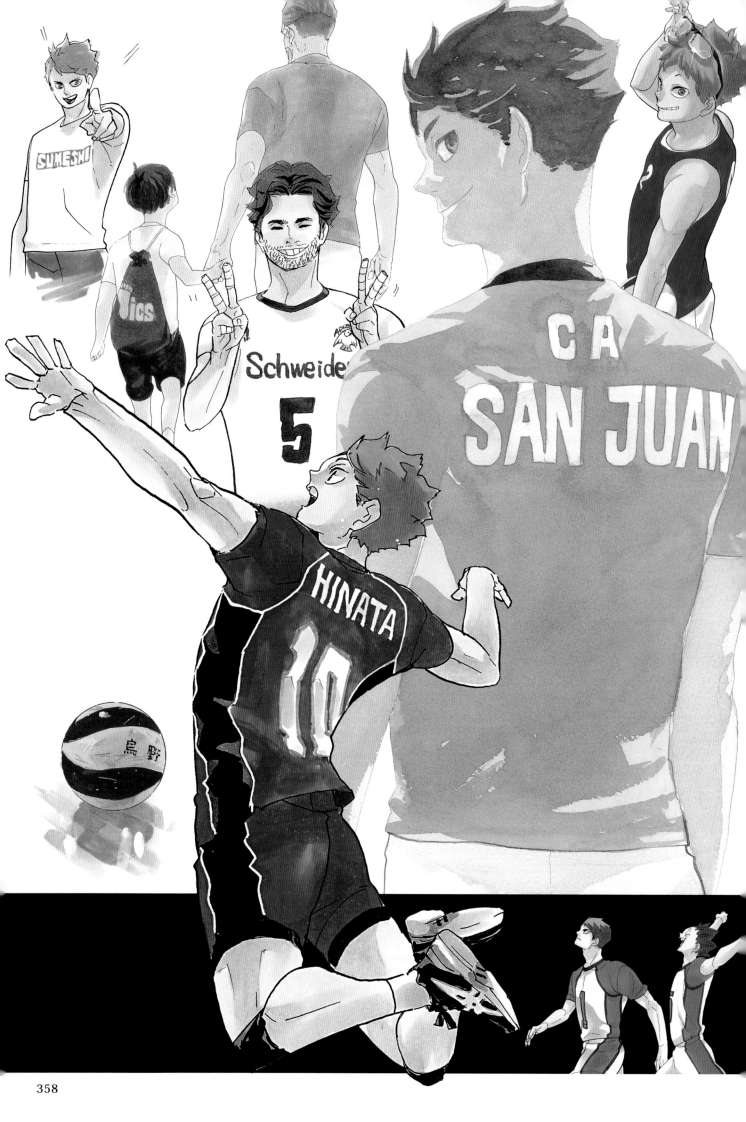

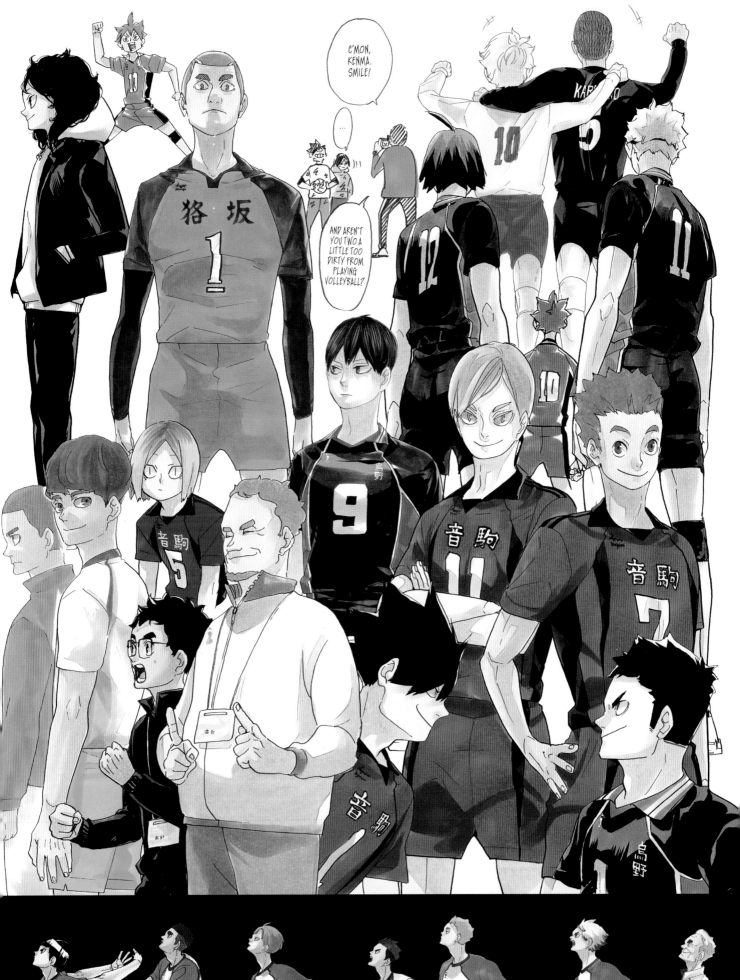

STOP

THE NEXT FEW PAGES ARE A SHORT MANGA ABOUT OUR RESEARCH TRIP TO BRAZIL!

Manga pages are read right to left. Use the graphic here to help guide you.

READ THIS WAY

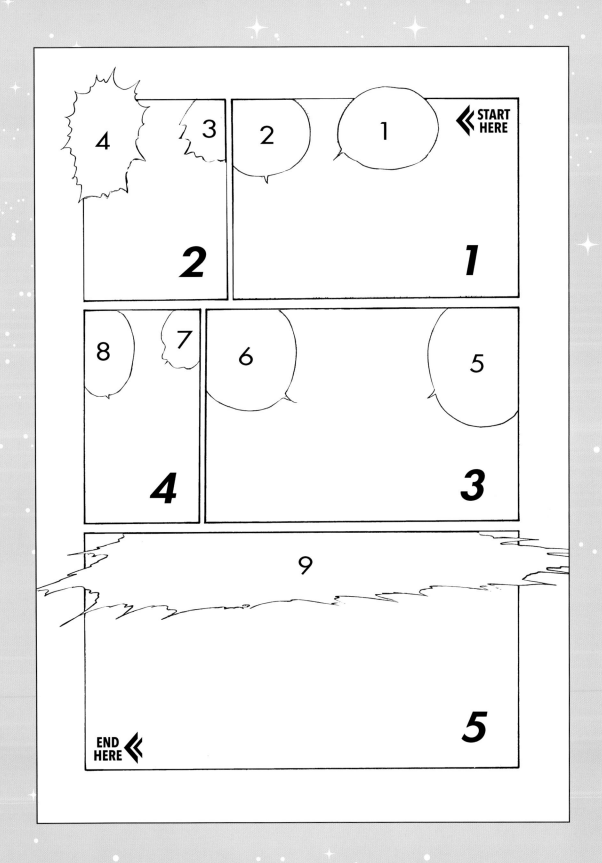

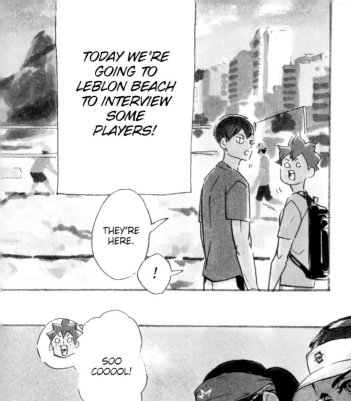

TODAY WE'RE GOING TO LEBLON BEACH TO INTERVIEW SOME PLAYERS!

THEY'RE HERE.

!

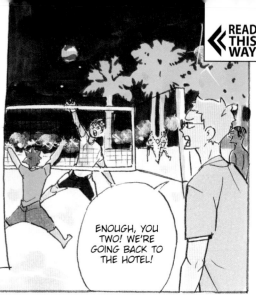

THE BEACH IS STILL BUSTLING EVEN AT NIGHT! PEOPLE ARE AROUND ESPECIALLY LATE ON FRIDAY NIGHTS!

ENOUGH, YOU TWO! WE'RE GOING BACK TO THE HOTEL!

SOO COOOOL!

SHE'S TALLER THAN ME.

AFTER WE WATCHED THEM PRACTICE, WE GOT TO INTERVIEW THEM!

BÁRBARA SEIXAS (5'10") AND FERNANDA BERTI (6'2")

APPARENTLY DRAGON BALL AND SAINT SEIYA ARE REALLY POPULAR IN BRAZIL!

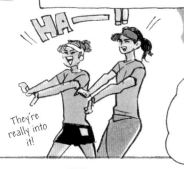

They're really into it!

OOH! THE KAME-HAME-HA!

AFTER PRACTICE, THE PLAYERS HAD A SHOWER AND WENT TO LUNCH!

BOY, THIS REPORTER IS SUPER NICE. I WONDER IF I CAN GET HINATA IN TOUCH WITH HER WHEN HE COMES TO BRAZIL...

THOROUGHLY CONFUSING FICTION WITH REAL LIFE.

WHAT BRINGS YOU TO RIO?

WILL ANY REAL-LIFE PLAYERS APPEAR IN YOUR MANGA?

FURUDATE

WELL, AFTER THE LOCAL SPORTS SITE GOT DONE INTERVIEWING THE JAPANESE MANGA CREATOR WHO WAS HERE TO INTERVIEW ATHLETES...

TELL ME ABOUT THE SPONSORS.

HOW DO THE CIRCUITS WORK?

HOW ARE PAIRS FORMED?

WHO TURNED AROUND AND INTERVIEWED THEM RIGHT BACK.

FURUDATE

KUBO-SAN! ERI! THANK YOU SO MUCH FOR COORDINATING THIS!!

Eri-san

Kubo-san

BRAZIL RESEARCH TRIP REPORT MANGA!!
(TWO EDITORS AND ONE CREATOR WENT. I'LL REPRESENT THEM WITH HINATA, KAGEYAMA, AND TSUKISHIMA.)

◀◀ START HERE

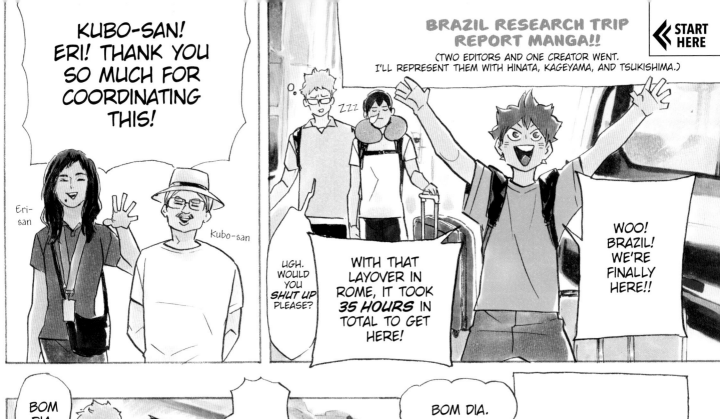

ZZZ

UGH. WOULD YOU *SHUT UP* PLEASE?

WITH THAT LAYOVER IN ROME, IT TOOK *35 HOURS* IN TOTAL TO GET HERE!

WOO! BRAZIL! WE'RE FINALLY HERE!!

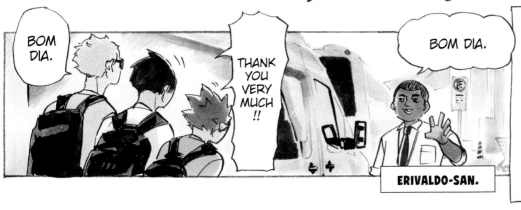

BOM DIA.

THANK YOU VERY MUCH!!

BOM DIA.

ERIVALDO-SAN.

THEY RENTED A LARGE TAXI AND TOOK US ALL KINDS OF PLACES!

COPACABANA BEACH

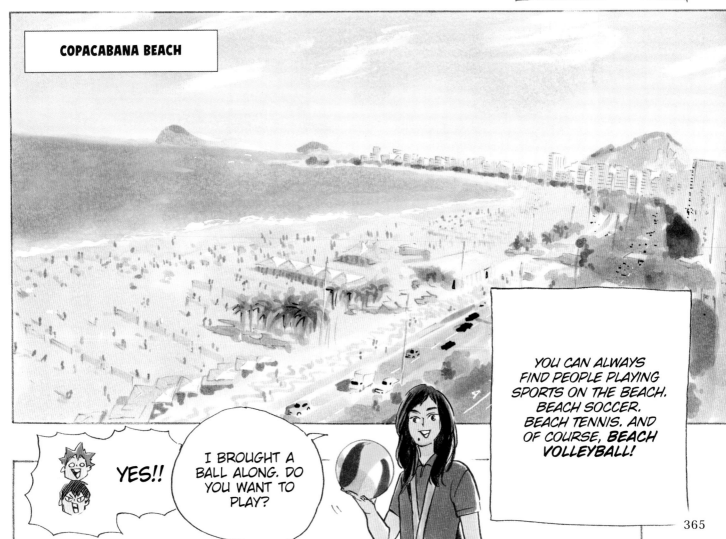

YOU CAN ALWAYS FIND PEOPLE PLAYING SPORTS ON THE BEACH. BEACH SOCCER. BEACH TENNIS. AND OF COURSE, *BEACH VOLLEYBALL!*

YES!!

I BROUGHT A BALL ALONG. DO YOU WANT TO PLAY?

TODAY WE GET TO OBSERVE BOTH MEN'S AND WOMEN'S SCRIMMAGES! THE WOMEN'S TEAM PLAYED A SWISS AND FINNISH PAIR. THE MEN'S TEAM PLAYED A CANADIAN ONE!

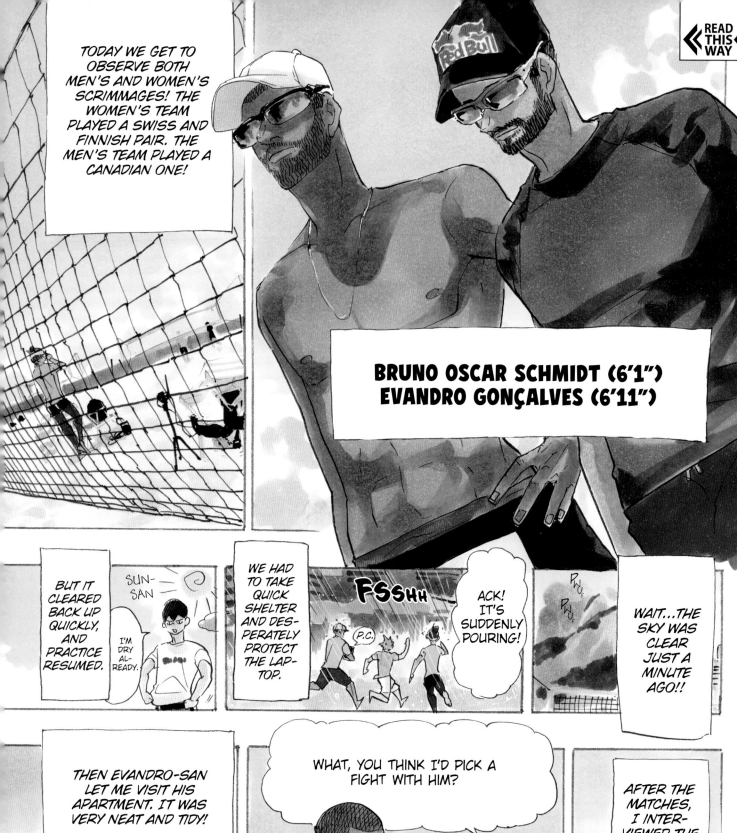

BRUNO OSCAR SCHMIDT (6'1")
EVANDRO GONÇALVES (6'11")

BUT IT CLEARED BACK UP QUICKLY, AND PRACTICE RESUMED.

SUN-SAN

I'M DRY ALREADY.

WE HAD TO TAKE QUICK SHELTER AND DESPERATELY PROTECT THE LAPTOP.

FSShh

P.C.

ACK! IT'S SUDDENLY POURING!

PWUF PWUF

WAIT...THE SKY WAS CLEAR JUST A MINUTE AGO!!

THEN EVANDRO-SAN LET ME VISIT HIS APARTMENT. IT WAS VERY NEAT AND TIDY!

C'mon in.

WHAT, YOU THINK I'D PICK A FIGHT WITH HIM?

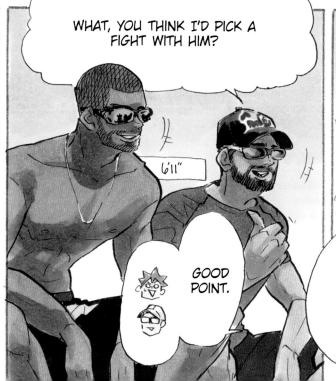

6'11"

GOOD POINT.

AFTER THE MATCHES, I INTERVIEWED THE PLAYERS.

Kubo-san kindly translated for me.

BDMP BDMP

SINCE IT'S JUST THE TWO OF YOU, DO YOU EVER CLASH OVER OPINIONS? GET INTO ARGUMENTS?

I USED THIS MEAL AS THE MODEL (WELL OKAY, I JUST TRACED IT) FOR THE ONE HINATA AND OIKAWA HAD IN THE STORY.

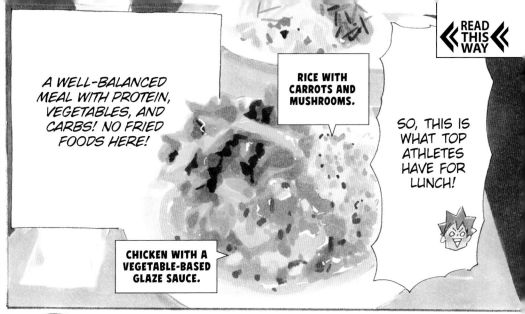

A WELL-BALANCED MEAL WITH PROTEIN, VEGETABLES, AND CARBS! NO FRIED FOODS HERE!

RICE WITH CARROTS AND MUSHROOMS.

SO, THIS IS WHAT TOP ATHLETES HAVE FOR LUNCH!

CHICKEN WITH A VEGETABLE-BASED GLAZE SAUCE.

THERE'S SOMETHING REASSURING IN KNOWING THAT YOU, AT LEAST, ARE PROPERLY SHOCKED.

ARE WE REALLY GOING TO THE HOME OF AN *OLYMPIC* ATHLETE?

Sure thing!

RIO OLYMPICS BEACH VOLLEYBALL SILVER MEDALIST

OOH, CAN I?! YAAAY!

AFTERWARD, WE GOT TO VISIT BÁRBARA-SAN'S HOME!

THE NEXT DAY, WE GOT TO INTERVIEW THE PLAYERS FROM THE MEN'S TEAM!

THIS IS THE FIRST MEDAL I EVER WON, BACK IN 2003. I WAS 16 OR 17.

THIS ONE IS FROM WHEN I WAS 18... THIS ONE WHEN I WAS 20... WHEN I WAS 21... AND SO MANY MORE.

...

THANK YOU SO MUCH!!

I'LL GO TO TOKYO TOO!

THEN SHE WAS KIND ENOUGH TO GIVE US A HOUSE TOUR!

I built the shelves myself.

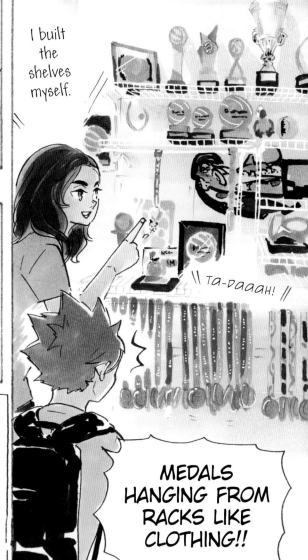

Ta-Daaah!

MEDALS HANGING FROM RACKS LIKE CLOTHING!!

I USED THIS AS INSPIRATION FOR HINATA AND PEDRO'S APARTMENT, AND HEITOR AND NICE'S APARTMENT!

Heitor

Hinata

Evandro

Thanks!

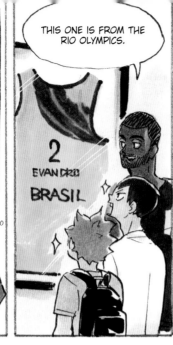

THIS ONE IS FROM THE RIO OLYMPICS.

2 EVANDRO BRASIL

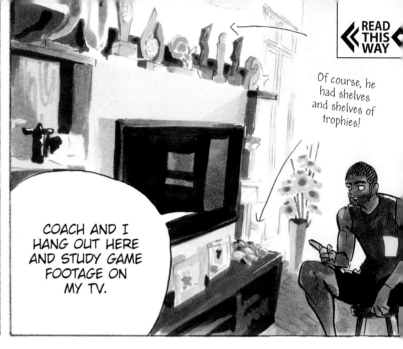

COACH AND I HANG OUT HERE AND STUDY GAME FOOTAGE ON MY TV.

Of course, he had shelves and shelves of trophies!

WHOA! THIS STATUE IS HUUUGE!

Person

AFTER THE INTERVIEWS,, WE HEADED FOR CORCOVADO MOUNTAIN!

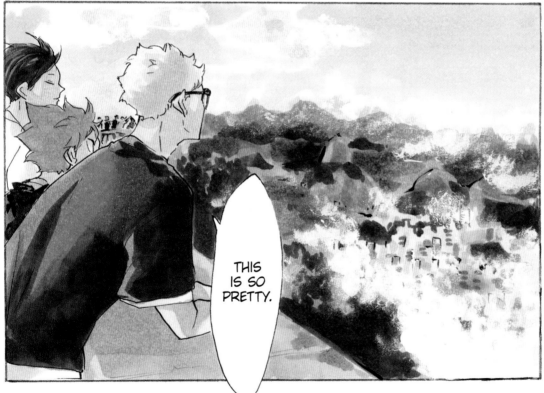

THIS IS SO PRETTY.

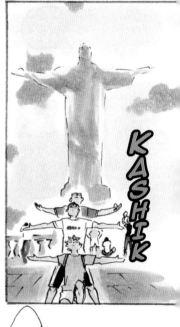

KASHIK

...

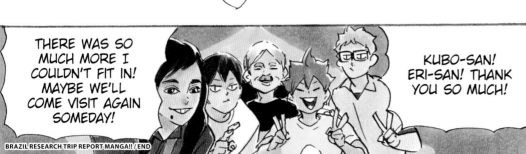

THERE WAS SO MUCH MORE I COULDN'T FIT IN! MAYBE WE'LL COME VISIT AGAIN SOMEDAY!

KUBO-SAN! ERI-SAN! THANK YOU SO MUCH!

BRAZIL RESEARCH TRIP REPORT MANGA!! / END

HAIKYU!!

HARUICHI FURUDATE SENSEI'S WORKPLACE REVEALED!

In July, 2020, Furudate Sensei brought *Haikyu!!* to an end after eight and a half years of serialization in *Weekly Shonen Jump*. Now let's visit the workplace where the series was created for so long! We'll not only see various tools and materials central to the game of volleyball, we'll also show off some special items that'll give you a glimpse into Sensei's personality.

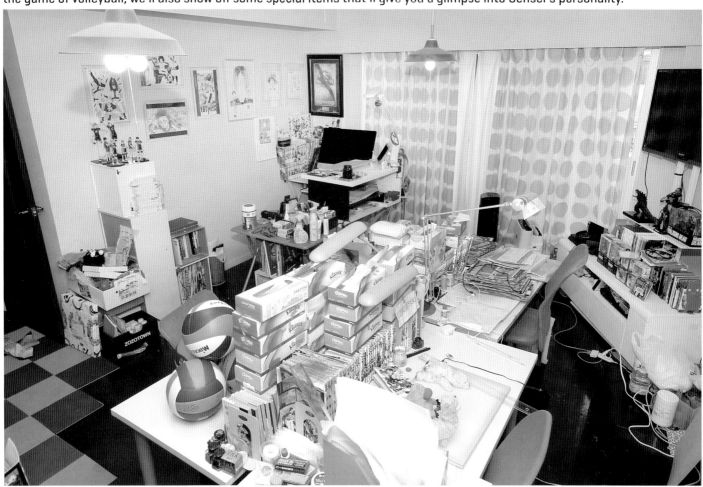

In the center of a one-floor office stand four staff desks. They aren't shown in the photo, but another three desks are located to the left of center. Furudate Sensei's desk is in the back, right by the window curtains, where it has a view of the entire room. Directly visible from the desk is a large flat-screen TV.

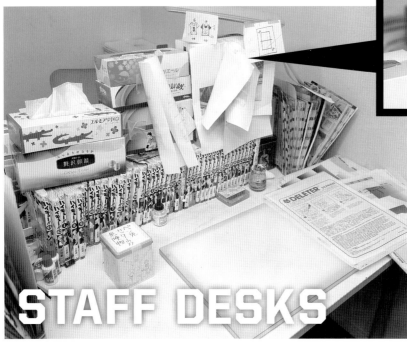

STAFF DESKS

A full collection of the manga volumes sit on the staff desks. Above them are stacked piles of tissue boxes. When we asked why there were so many tissue boxes, the answer was that they're an impromptu partition. Furudate always meant to buy a proper divider but kept forgetting. The staff members must've felt awkward facing each other with nothing in between, because at some point there was suddenly a stack of tissue boxes there. Furudate decided there wasn't any further need to buy a proper partition, and so the stack remained.

Stuck to the tissue boxes are pictures of a school gymnasium from every angle, hand-drawn sketches of game uniforms, notes on volleyball courts, and more. Furudate says they made a point of using simple uniform designs so they weren't a hassle to draw. Inarizaki's uniforms started with a line across the shoulders, but two to three chapters into the Inarizaki vs. Karasuno game, they decided it was too much of a pain to keep drawing them. The design was quickly changed to have straight black shoulders. According to Furudate, the most annoying thing to draw in the series was Hinata's head!

FURUDATE SENSEI'S DESK

Furudate Sensei's workspace isn't just one desk, but two stacked on top of each other. Not only that, a mini stepper machine is placed on the floor underneath. Believe it or not, Sensei would work while using the stepper! Why? Sensei heard that Google employees do their work at standing desks. Inspired, Sensei wanted to do things in the same way as one of the top companies in the world. It's an unusual setup for making art, but Furudate doesn't have any of the lower-back pain that bothers many manga artists, so it must have some beneficial effect!

Sensei's top desk has the board and supplies needed for drawing manga pages. Furudate used G-Pens almost exclusively. Since the pen nibs squish with use, Sensei keeps two copies of each type of pen on hand: a new one and a well-used one. New ones have firmer nibs, which are useful for drawing thinner lines for things like facial details. Well-used pens are softer, making it easier to draw thicker lines. Those can be used to capture the motion in action pieces. Sensei strongly recommends the *Fudenosuke* brand of thin brush marker pens. One of the series staff even drew the entire Tokyo Gymnasium ceiling using nothing but *Fudenosuke* pens. Sensei says, "The nibs are particularly firm. They don't just do thin lines, but thick ones too. They're really, really convenient!" Apparently Sensei goes through quite a lot of them.

Other well-used supplies include blue pencils for adding directions, mechanical pencils, brush-pens, and fineliners. Sensei often used fineliners when drawing balls, and Mckee markers for filling in space or writing large letters. Both brand-new markers and nearly-used-up ones are kept on hand. The almost-dry ones are denoted by yellow tape on their caps. Sensei keeps the old ones to use when they want to fill in space, but not with thick color. Believe it or not, the cotton swabs in the photo below are actually pet ear cleaners! When doing colors, Sensei would dip them in white and use them as brushes. An example is Hinata's breath in chapter 368's "What will you become tomorrow" scene, or the fur trim on Kageyama's King of the Court mantles. Sensei even used the same technique for Hinata's breath in the cover illustration of this very art book.

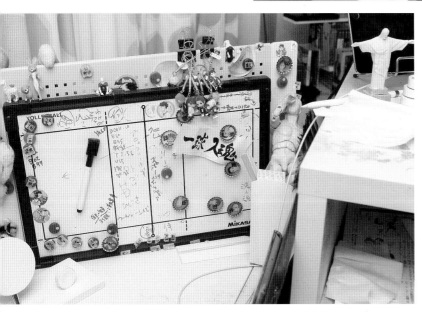

To the left of Sensei's desk is a mini volleyball whiteboard. They would move magnets of characters around it to plan how a game might progress. Looking closer, you'll find things like notes on Oikawa's and Futakuchi's hair parts, as well as strings of numbers and letters that only Furudate understands. On the far right of the photo is a small Cristo Redentor figurine that Sensei got on a research trip to Brazil.

Next to Sensei's desk is a shelf dedicated solely to Copic markers. It is filled to the brim with them. Unless it's something that has set colors already, like a uniform, Sensei often uses Copic Sketch BG72 and Copic Sketch E04 to color. Copic Sketch BG72 is frequently used for Hintata's T-shirts. Copic Sketch E04 is a go-to for hair color and for characters like Hanamaki and Nakashima. As a side note, when we came back to visit the office later, there was a box of plastic wrap there. Confused, we asked why. The answer was that the night sky in the Kageyama sketch used for this art book's back cover was too big to color in with Copics without getting streaky, so Sensei thought to use acrylics instead. But acrylics don't come off once they dry, making it impossible to clean the palette. To prevent that, Sensei wraps the palette in plastic wrap first and puts the paints on top. Afterward, the wrap can be discarded, and the palette is clean! Convenient! Also, Sensei will change paper stock depending on the inks being used. For Copics, they'll do the inks on writing paper and then copy it onto copy paper to fill in the colors. For watercolors, they'll use watercolor paper. When asked about using a drawing board, Sensei did buy one ten years ago. But using Copics on it tended to make the piece streaky, and the surface was too slippery for using paints well. Thus, Furudate didn't use it much. For this

recent Kageyama sketch, though, Furudate had already used Copics on details like his face. Figuring acrylics would work for the rest, Sensei dusted off the drawing board for the first time in years.

While many manga series these days finalize the art digitally, for *Haikyu!!* Sensei would calculate the size of the copy on a calculator, then print each piece out on the spot and paste it onto the manga pages. When we expressed surprise at the labor-intensive process, Sensei joked that the most critical office supply in their workplace was paper cement.

AROUND FURUDATE SENSEI'S DESK

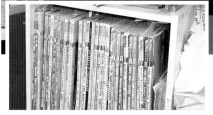

Next to the Mikasa volleyballs are two pairs of sports shoes Sensei uses for reference. The black ones are Hinata's, the white Kageyama's. Only the largest size of the white ones was available, which don't fit Sensei's feet, so they never actually get worn.

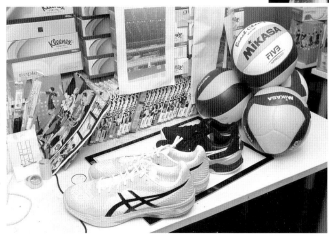

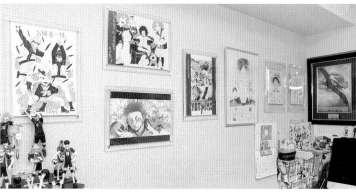

Beside the Copic shelf are two shelves filled with dozens of issues of *Volleyball Monthly* and other materials on volleyball. In the photo to the right, the "shelf" on the top is actually a cardboard box.

The wall is decorated with fan art that fans and staff have sent. There are also pieces of fan art sent from Eiichiro Oda, Masashi Kishimoto, and Kohei Horikoshi. A framed *Jurassic Park* poster hangs on the wall as well. We were told *Jurassic Park* is Sensei's favorite movie, and it was playing in the background instead of music while they were drawing the final chapter.

OTHER THINGS

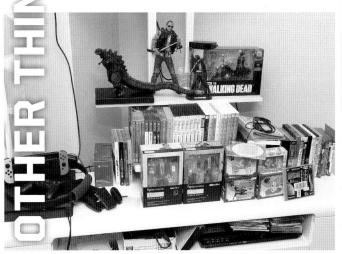

Underneath the TV sit figurines from *Godzilla* and foreign TV shows, along with video game consoles and games, DVDs, and other things that give a glimpse into Furudate's hobbies. We asked about music in the office, and were told typically the radio would be on from the start of work until evening, when they'd switch over to the TV. For all-nighters, they would put on TV shows they'd recorded or movies. Here are some of Sensei's favorite movies: Japanese horror movies *The Grudge*, *The Ring*, and *One Missed Call*. Some other favorites are *REC*, *Zombieland*, *The Mist*, and *The Conjuring*, which are all horror films as well! Now that serialization has completed, maybe Furudate will get more free time to enjoy games there wasn't a chance to play before.

Endings and Beginnings

Winners and Losers

Talent and Instinct

Battle of Concepts

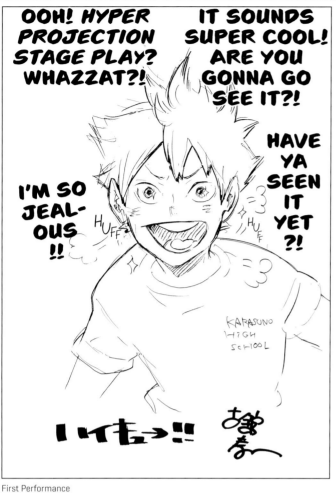

First Performance

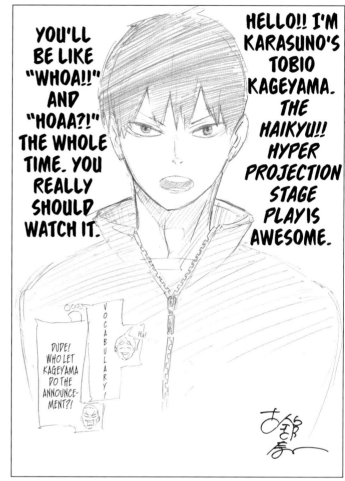

The View from the Top

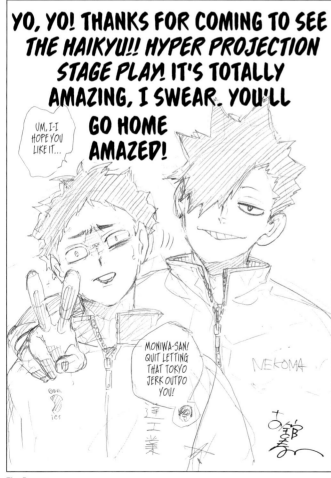

The Return

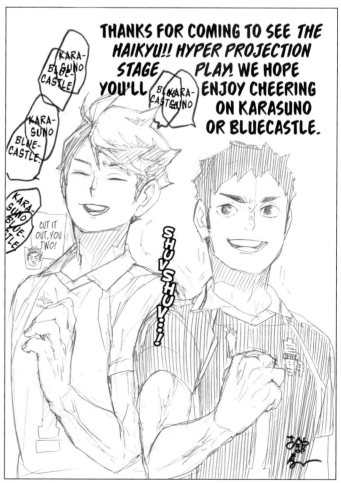

Winners and Losers

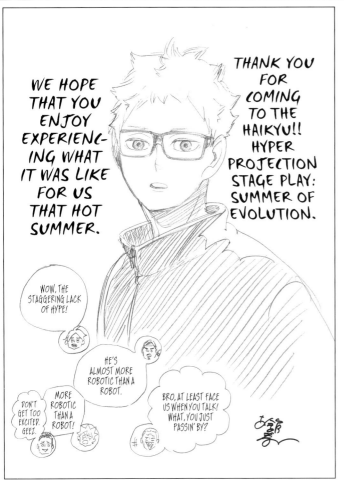

Summer of Evolution

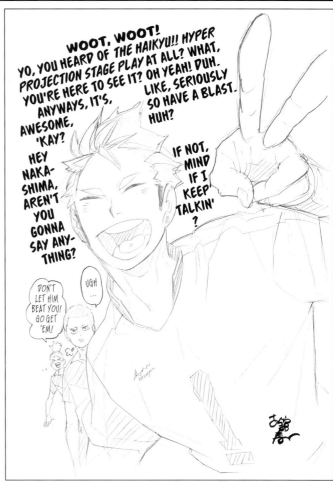

The First Giant

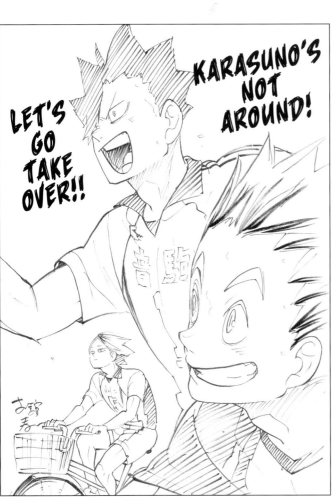

The Tokyo Teams

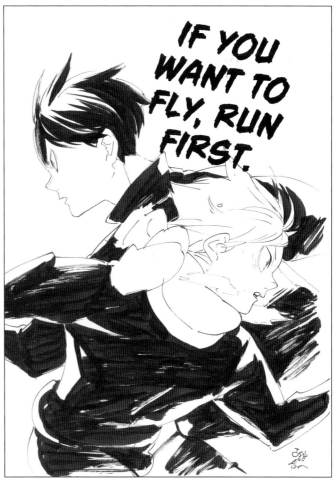

Flight

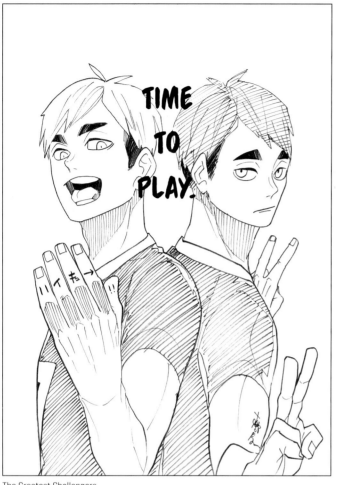

The Greatest Challengers

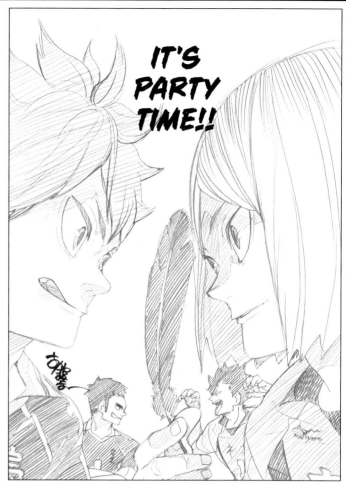

The Dumpster Battle

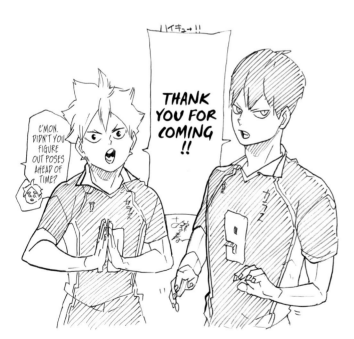

Karasuno: Hinata / Kageyama

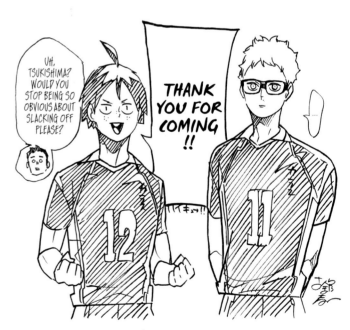

Karasuno: Yamaguchi / Tsukishima

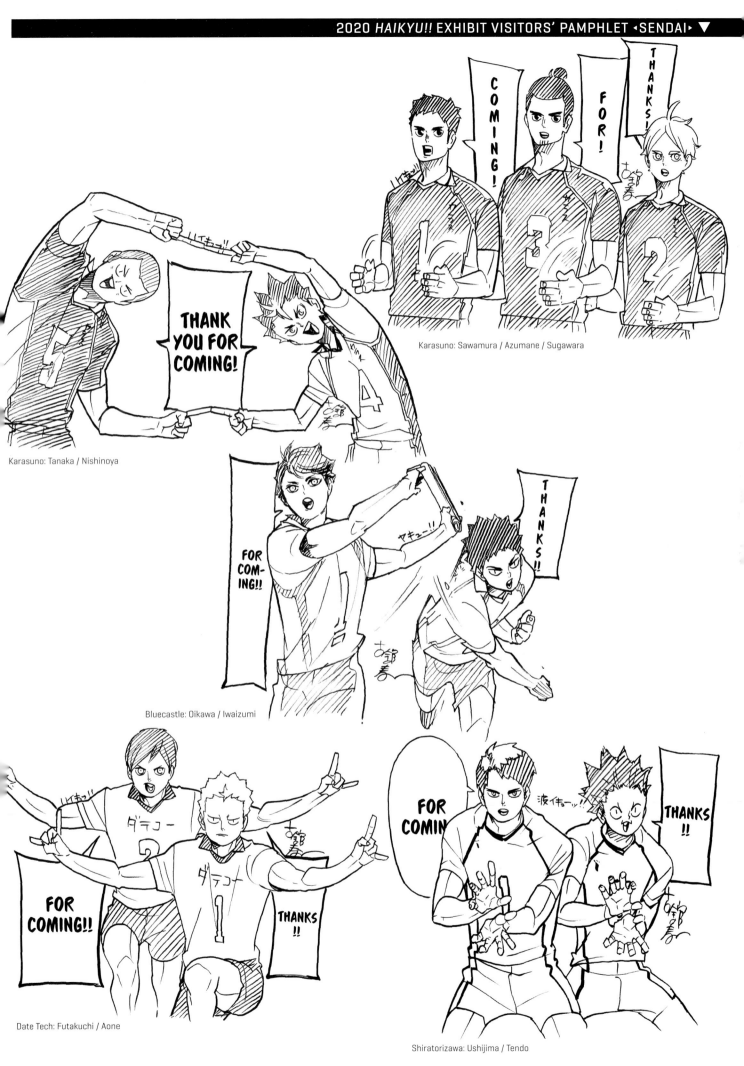

Karasuno: Sawamura / Azumane / Sugawara

Karasuno: Tanaka / Nishinoya

Bluecastle: Oikawa / Iwaizumi

Date Tech: Futakuchi / Aone

Shiratorizawa: Ushijima / Tendo

377

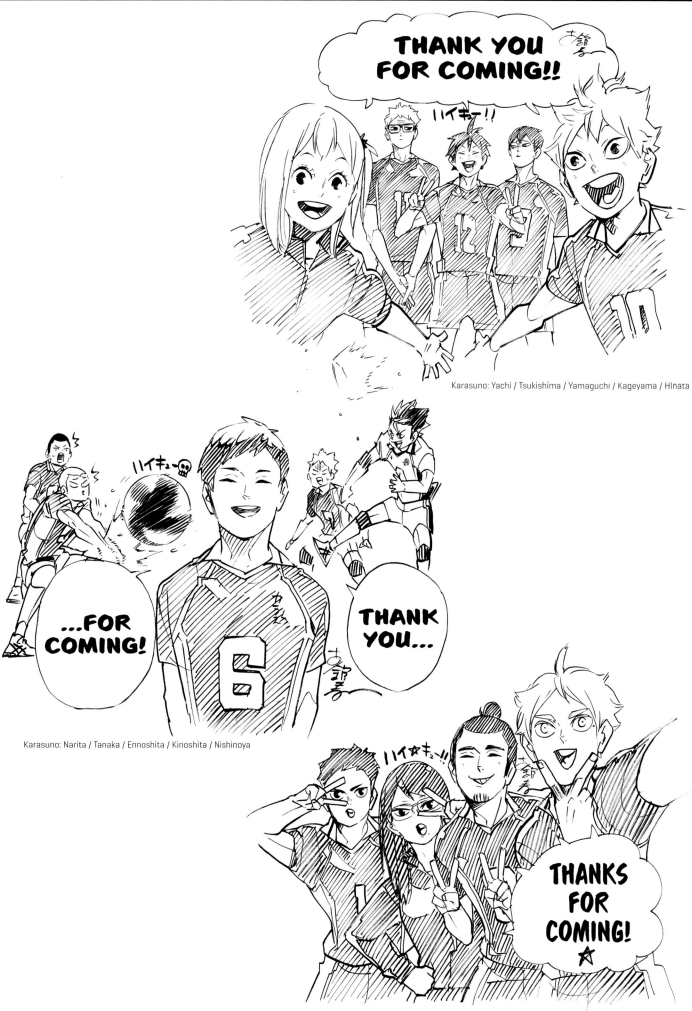

Karasuno: Yachi / Tsukishima / Yamaguchi / Kageyama / Hlnata

Karasuno: Narita / Tanaka / Ennoshita / Kinoshita / Nishinoya

Karasuno: Sawamura / Kiyoko / Azumane / Sugawara

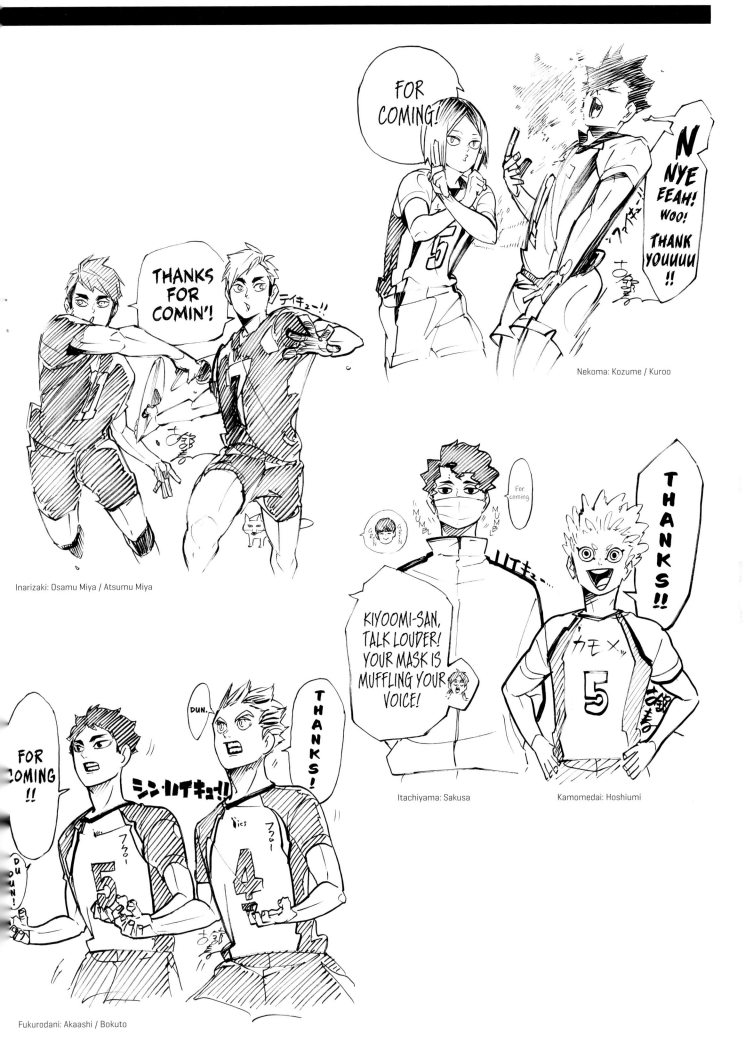

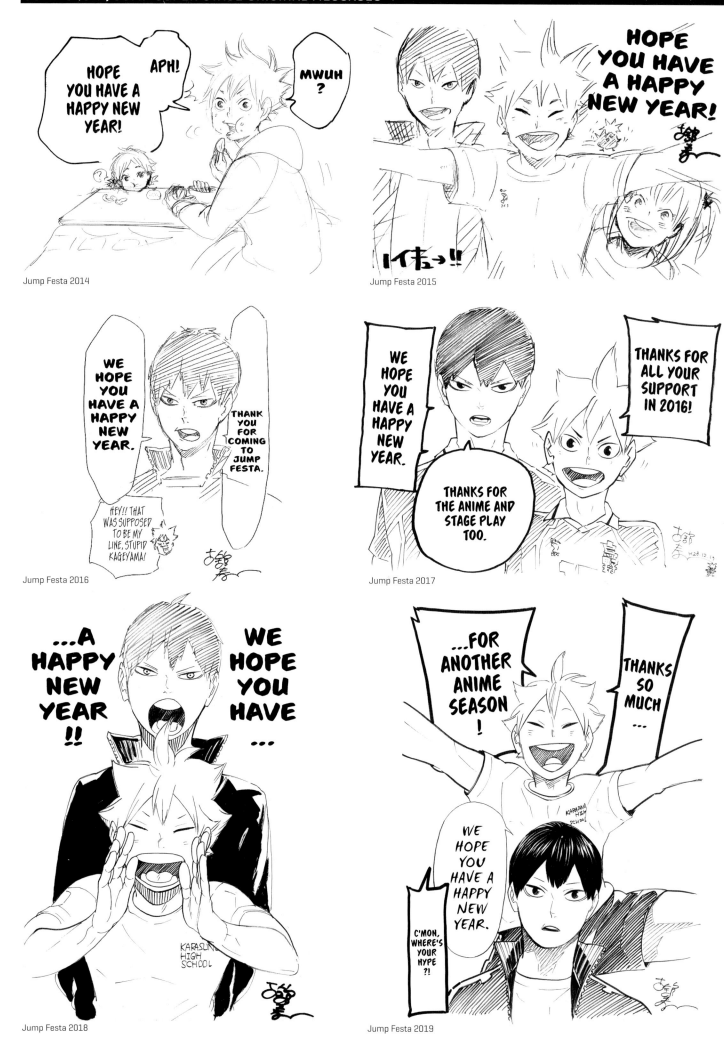

Jump Festa 2014

Jump Festa 2015

Jump Festa 2016

Jump Festa 2017

Jump Festa 2018

Jump Festa 2019

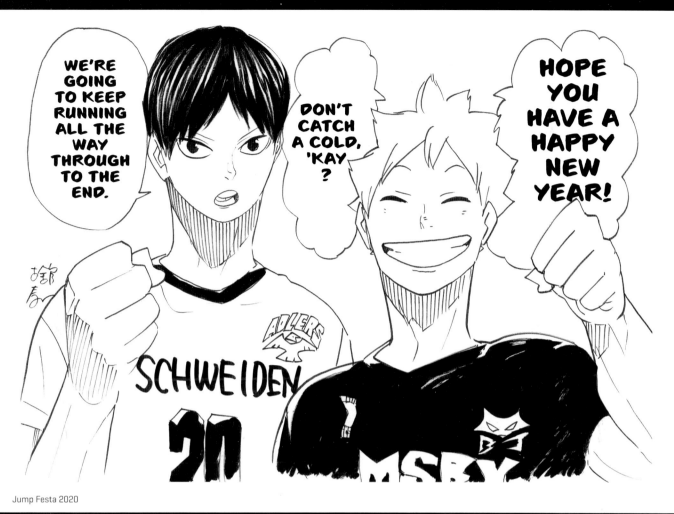

Jump Festa 2020

HAIKYU!! × V.LEAGUE COLLABORATION ▼

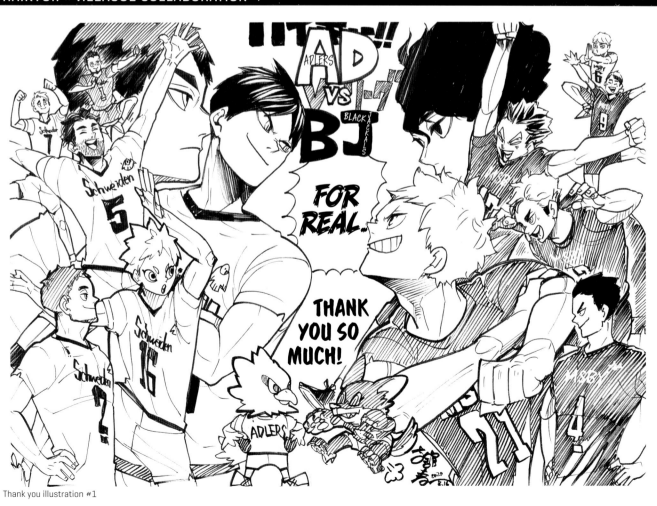

Thank you illustration #1

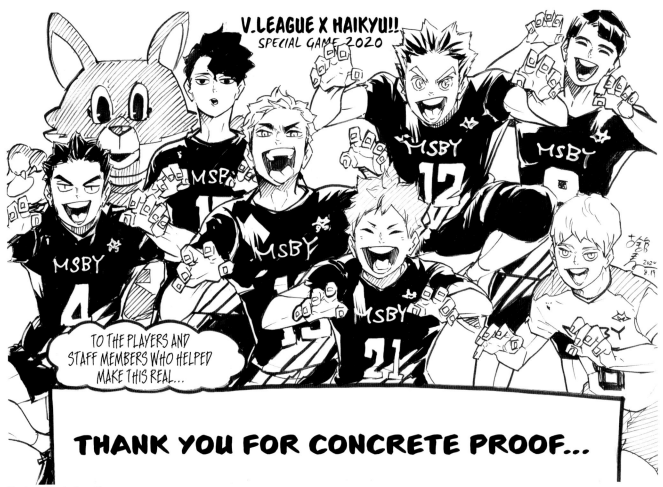

Thank you illustration #2

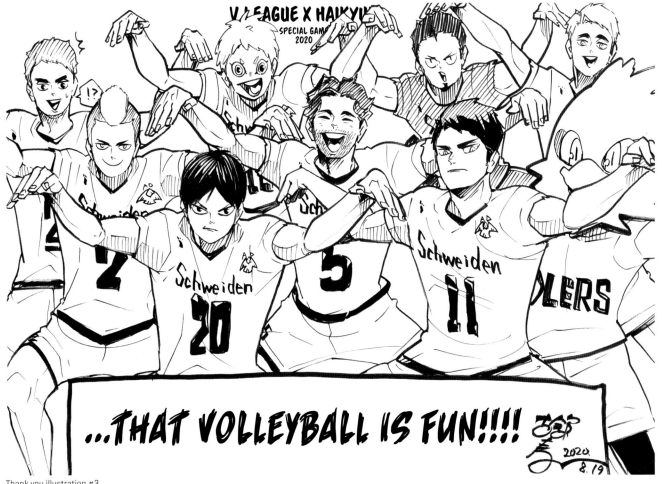

Thank you illustration #3

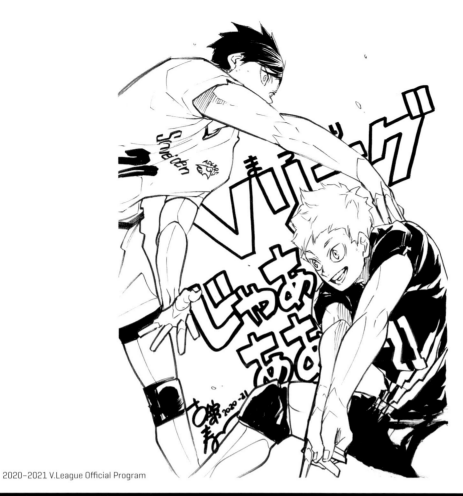

2020-2021 V.League Official Program

ILLUSTRATIONS FROM *THE NOVEL!!* ▼

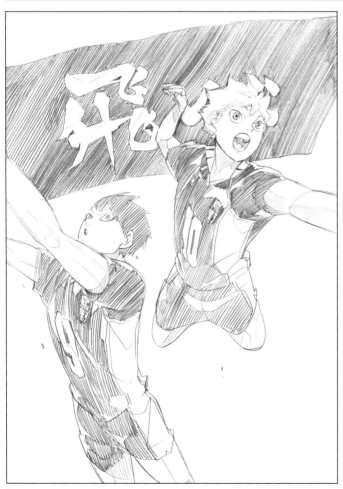

Karasuno

Date Tech / Karasuno

ART INDEX AND COMMENTS FROM FURUDATE SENSEI

◄ Cover
▶ Cover, Art Book Original

It's similar to the volume 24 cover, but that one was about challenging the cold. This one's about knowing and accepting the cold. On the back is Kageyama, who still looks up despite the chill.

◄ Pages 2–3
▶ Weekly Shonen Jump, 2019, Issue 30, Color Page
*Kanji added in Haikyu!! Final Guidebook.

I didn't have time to do anything fancy for this color page, so I leaned on the power of words. It turned out to be so fun I knew I had to do it for other positions.

◄ Pages 4–5
▶ Haikyu!! Final Guidebook, Original Pinup

"Play styles," setter version. For these illustrations I start by doing the colors. Then I add in the minimum number of major lines needed.

◄ Pages 6–7
▶ 2020 Haikyu!! Tokyo Art Exhibit, Original Art

"Play styles," libero and opposite version. Nishinoya and Bokuto are those rare characters who can carry a scene with just a shot of their backs.

◄ Pages 8–9
▶ Original art from this artbook.

"Play styles," outside hitter version. I had trouble narrowing down who to put on this one. I wanted to add Goshiki and Iwaizumi too. Should've just drawn another...

◄ Pages 10–11
▶ Title, Art Book Original

"Endings and Beginnings"

◄ Page 12
▶ Graphic Novel, Volume 1, Cover

It doesn't seem like an odd design, but I thought really, really hard about the composition for this one.

◄ Page 13
▶ Weekly Shonen Jump, 2012, Issue 13, Center Color Page

This is the color cover I did for the manga's second chapter. It feels really stiff. You can tell how nervous I was when I drew it.

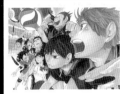
◄ Pages 14–15
▶ Weekly Shonen Jump, 2012, Issue 12, Color Title Page

The celebratory first color page for the first chapter. At this point I hadn't yet finalized the designs for Azumane or Nishinoya.

◄ Page 16
▶ Weekly Shonen Jump, 2012, Issue 12, Cover

The color cover for the first issue of Haikyu!'s serialization. Even looking at it now, it's easily one of my top three favorite Hinata drawings.

◄ Page 17
▶ Weekly Shonen Jump, 2012, Issue 25, Center Color Page

I did this one in watercolors. I normally do my color art with Copic markers, but sometimes I change things up and use watercolors.

◄ Page 18
▶ Graphic Novel, Volume 2, Cover

I tried way too hard on this composition.

◄ Page 19
▶ Weekly Shonen Jump, 2012, Issue 20, Center Color Page

My second center color page, something that any creator who's suffered early cancellation will have strong feelings about. I thought hard about what to draw, eventually going with what had happened in that week's chapter. The result? A color page with nothing but black!

◄ Page 20
▶ Weekly Shonen Jump, 2012, Issue 28, Center Color Page

There's still a sense of stiffness to this one.

◄ Page 21
▶ Weekly Shonen Jump, 2012, Issue 43, Cover

One of my first covers for Jump. I tried to draw a slide, but the movement is so stiff...!

◄ Page 22
▶ Graphic Novel, Volume 3, Cover

A pinup cover that completely ignores the main character.

◄ Page 23
▶ Weekly Shonen Jump, 2012, Issue 29, Center Color Page

I put a lot of effort into Nishinoya's T-shirt.

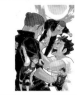
◄ Page 24
▶ Graphic Novel, Volume 42, Stop-Motion Anime DVD, Cover

This was the cover illustration for the stop-motion DVD bundle that came with volume 42. It was fun to draw some old scenes.

◄ Page 25
▶ Weekly Shonen Jump, 2012, Issue 32, Center Color Page

You can really feel how scared I was to go all out with the color on this one.

◄ Page 26
▶ Weekly Shonen Jump, 2012, Issue 44, Center Color Page

Urgh! That weird pose! I was so far behind and out of time that I panicked and drew that weird thing! Geez. Look at it. It's so weird. I used a precious color page on that...

◄ Page 27
▶ Haikyu!! The Novel, Volume 1, Cover

This is the cover of the first volume of the Haikyu!! novel. You can feel I kinda didn't know what to do with it.

◄ Page 28
▶ Weekly Shonen Jump, 2012, Issue 36/37, Center Color Page

I can't believe I misspelled something on that big a color page.

*See Manga, Volume 3, page 196, for a full explanation!

◄ Page 29
▶ Weekly Shonen Jump, 2012, Issue 49, Poster

The "dumpster" theme for a background was starting to become standard, even back then.

◄ Page 30
▶ Weekly Shonen Jump, 2012, Issue 49, Center Color Page

Watercolor. I think I brought out the feeling of early summer in this one well.

◄ Page 31
▶ Haikyu!! The Novel, Volume 2, Cover

The cover was done primarily with watercolors. The rest was done using Copics.

◄ Page 32
▶ Graphic Novel, Volume 9, Drama CD, Cover

Unlike the cover to the main manga, I made the cover to the drama CD that came with it more comical.

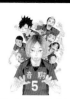

◀ Page 33

▶ Graphic Novel, Volume 4, Cover

I think the composition came together nicely.

◀ Pages 34-35

▶ Weekly Shonen Jump, 2012, Issue 43, Color Title Page

My extremely exciting second color title page. I remember my editor calling at an unusual time, all out of breath, saying, "You got a color title page!"

◀ Pages 36-37

▶ Jump NEXT!, 2012, Autumn, Alternate Cover

I like the idea of a single motion performed by multiple characters. I want to experiment with it more in the future.

◀ Page 38

▶ Jump NEXT!, 2012, Autumn, Cover

I'm so bad at these kinds of straight, upright, "Strike a pose!" cuts. I drew this ages ago, and I'm still bad at them.

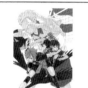

◀ Page 39

▶ Weekly Shonen Jump, 2013, Issue 4/5, Center Color Page

I like how Aone feels like a "boss battle" character here.

◀ Page 40

▶ Graphic Novel, Volume 5, Cover

Second overly ambitious composition.

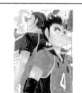

◀ Page 41

▶ Weekly Shonen Jump, 2013, Issue 9, Center Color Page

The tournament arcs spend so much time inside gyms that it makes me really want to draw clear blue skies.

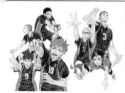

◀ Pages 42-43

▶ Weekly Shonen Jump, 2013, Issue 12, Cover

Drawing the moment of a set or a block are some of the hardest to do.

◀ Pages 44-45

▶ Graphic Novel, Volume 6, Promotional Poster

I'm sorry!! I honestly forgot to draw Tsukishima!!

◀ Page 46

▶ Weekly Shonen Jump, 2013, Issue 20, Center Color Page

This was the chapter that had the results of the first character popularity poll. I was picky about how the cardboard boxes came out.

◀ Page 47

▶ Jump NEXT!, 2013, Autumn, Cover

I used this color illustration for that year's Spring Tournament too.

◀ Page 48

▶ Weekly Shonen Jump, 2013, Issue 22/23, Hero/Rival Collective Cover

This issue's cover had the theme of heroes and heels. Poor Oikawa was put in the "heel" slot by (probably) the designer.

◀ Page 49

▶ Graphic Novel, Volume 6, Cover

This cover is kind of spoilery. I've since learned my lesson.

◀ Pages 50-51

▶ Weekly Shonen Jump, 2013, Issue 12, Color Title Page

It was like this every time, but cramming all the starting players into a single layout is hard.

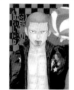

◀ Page 52

▶ Weekly Shonen Jump, 2013, Issue 15, Center Color Page

Black and pink and Tanaka. No hesitation.

◀ Page 53

▶ Graphic Novel, Volume 7, Cover

The "boss" feeling Sugawara has.

◀ Page 54

▶ Weekly Shonen Jump, 2013, Issue 17, Center Color Page

Watercolor. Back when Sugawara really was still Mr. Pleasant.

◀ Page 55

▶ Weekly Shonen Jump, 2013, Issue 24, Center Color Page

It's a shot of the characters in middle school, so I added a faint blur effect around them to evoke a feeling of being in the past.

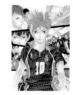

◀ Page 56

▶ Weekly Shonen Jump, 2013, Issue 29, Center Color Page

I really went into detail on this one!

◀ Page 57

▶ Weekly Shonen Jump, 2013, Issue 31, Center Color Page

You can feel how I was pushing myself to add this and that and the other.

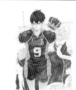

◀ Page 58

▶ Graphic Novel, Volume 8, Cover

The cover was done primarily with watercolors. The rest was done using Copics.

◀ Page 59

▶ Weekly Shonen Jump, 2013, Issue 33, Center Color Page

Looking back on it now, I got so many color pages in a row I should've tried something completely different.

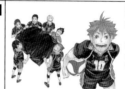

◀ Page 60

▶ Weekly Shonen Jump, 2013, Issue 45, Cover

I think the big cloth in the middle was where some important announcement or other went.

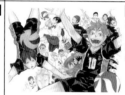

◀ Page 61

▶ Weekly Shonen Jump, 2013, Issue 45, Color Title Page

I tried to cram too much into this one. I kinda went a little too crazy.

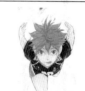

◀ Page 62

▶ Graphic Novel, Volume 9, Cover

The cover was done primarily with gouache. The rest was done using Copics.

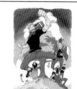

◀ Page 63

▶ Graphic Novel, Volume 15, Anime DVD Bundle, Cover

Nekoma's colors, base red and black, fit together really easily, which is a big help.

◀ Page 64

▶ Weekly Shonen Jump, 2013, Issue 43, Center Color Page

My previous three color pages were serious ones, so I had a blast doing a fun color page like this.

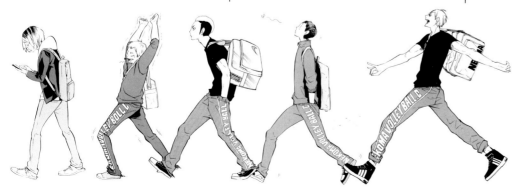

◀ Page 65

▶ Graphic Novel, Volume 21, Anime DVD Bundle, Cover

I'm happy I got to draw a cover with Saeko.

◀ Page 75

▶ Haikyu!! The Novel, Volume 4, Cover

The colors and shapes of ice cream are so fun. It's an excellent, versatile prop.

◀ Pages 86–87

▶ Weekly Shonen Jump, 2014, Issue 25, Color Title Page

I designed this color page to look like a strategy board.

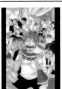
◀ Page 66

▶ Weekly Shonen Jump, 2013, Issue 50, Center Color Page

I tried my best to bring out the bouncy energy of the training camp.

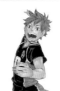
◀ Page 76

▶ Weekly Shonen Jump, 2014, Issue 18, Cover

I did the skin tones with Copic markers. At this point it feels like I'm finally getting some consistency.

◀ Pages 88–89

▶ Weekly Shonen Jump, 2014, Issue 30, Center Color Poster

This color page is a bit unusual because it's a full two-page spread.

◀ Page 67

▶ Weekly Shonen Jump, 2013, Issue 51, Center Color Page

I got two center color pages in a row, so this was "bouncy camp energy," take two.

◀ Page 77

▶ Haikyu!! The Novel, Volume 5, Cover

Cover that tells you absolutely nothing serious happens in this volume, take two.

◀ Page 90

▶ Graphic Novel, Volume 13, Cover

The cover was done primarily with gouache. The rest was done using Copics. I like the rough texture that black gets on this paper with this type of watercolor ink.

◀ Page 68

▶ Graphic Novel, Volume 10, Cover

The cover was done primarily with gouache. The rest was done using Copics. It's unusual for me to do a piece with a pure-black background.

◀ Pages 78–79

▶ Weekly Shonen Jump, 2014, Issue 18, Color Title Page

My first watercolor in a while. Around this time, I found a type of paper I really liked, so I started doing a lot more of them.

◀ Page 91

▶ Graphic Novel, Volume 14, Cover

This might be the plainest cover yet.

◀ Page 69

▶ Weekly Shonen Jump, 2014, Issue 6/7, Center Color Page

A rare color page with only characters from other teams. I think it turned out cool.

◀ Page 80

▶ Graphic Novel, Volume 12, Cover

The cover was done primarily with watercolors. The rest was done using Copics.

◀ Page 92

▶ Graphic Novel, Volume 15, Cover

There was so much going on in this volume that I had trouble figuring out what to do with the cover.

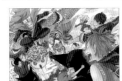
◀ Pages 70–71

▶ Weekly Shonen Jump, 2014, Issue 8, Color Title Page

A fantasy-like setting this time, to de-stress.

◀ Page 81

▶ Jump NEXT!!, 2014, Volume 2 Poster

The theme of the poster was famous scenes. I think the background was left open for flashbacks.

◀ Page 93

▶ Weekly Shonen Jump, 2014, Issue 43, Center Color Page

Date Tech vs. Bluecastle. I had fun drawing this one.

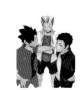
◀ Page 72

▶ Haikyu!! The Novel, Volume 3, Cover

The cover tells you there is absolutely nothing serious happening in this volume.

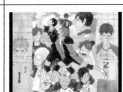
◀ Pages 82–83

▶ Weekly Shonen Jump, 2014, Issue 19, Center Color Poster

Watercolor. It's been a while since I last drew middle school Hinata and Kageyama.

◀ Pages 94–95

▶ Weekly Shonen Jump, 2014, Issue 40, Extra-Large Center Color Page

The results of a popularity poll were announced this chapter. The top ten were really well-balanced.

◀ Page 73

▶ Graphic Novel, Volume 11, Cover

Bokuto, no hesitation. Of all the characters who "went monster" on me, he's one of my top three faves.

◀ Page 84

▶ Weekly Shonen Jump, 2014, Issue 25, Cover

Drawing characters straight on in a square stance is really hard.

◀ Page 96

▶ Weekly Shonen Jump, 2014, Issue 49, Center Color Page

Is it me, or are Date Tech's and Bluecastle's uniforms kinda similar?

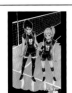
◀ Page 74

▶ Weekly Shonen Jump, 2014, Issue 14, Center Color Page

I love how the girls' uniforms turned out. They're supercool.

◀ Page 85

▶ Weekly Shonen Jump, 2014, Issue 32, Center Color Page

Watercolor. I think I can bring out the vibrancy of nature better with watercolors.

◀ Page 97

▶ Haikyu!! The Novel, Volume 6, Cover

I'm allowed to play around on the novel covers.

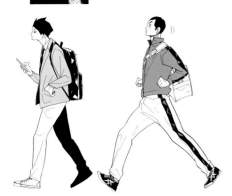
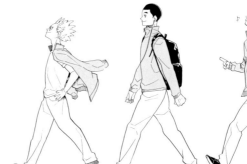

◀ **Page 98**

▶ *Weekly Shonen Jump*, 2014, Issue 48, Center Color Page

A color page done around Halloween. The background was drawn separately and added later.

◀ **Page 99**

▶ *Weekly Shonen Jump*, 2015, Issue 4/5, Center Color Page

This issue announced the second season of the anime.

◀ **Pages 100–101**

▶ *Jump NEXT!*, 2014, Volume 1 Cover

This has such an exciting composition, with the star player of each school. I like it.

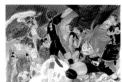

◀ **Pages 102–103**

▶ *Weekly Shonen Jump*, 2015, Issue 9, Color Title Page

A color page for the beginning of Karasuno's rematch against Bluecastle.

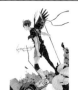

◀ **Page 104**

▶ Graphic Novel, Volume 16, Cover

I hit on this perfect composition without having to think too long about it at all. It's a favorite.

◀ **Page 105**

▶ *Weekly Shonen Jump*, 2015, Issue 13, Center Color Page

Rumor has it that my editor was this close to putting "Farewell Oikawa" in the splash text for this color page. He's not dying.

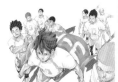

◀ **Pages 106–107**

▶ Graphic Novel, Volume 17, Cover

My first cover art that wrapped around from front to back.

◀ **Pages 108–109**

▶ *Weekly Shonen Jump*, 2015, Issue 17, Color Title Page

The amazing line art in the background was done by an amazing assistant who does amazing work.

◀ **Page 110**

▶ *Weekly Shonen Jump*, 2015, Issue 9, Cover

It's really difficult to make a setter's form look as cool as it really is.

◀ **Page 111**

▶ *Weekly Shonen Jump*, 2015, Issue 17, Cover

The theme for this cover layout was "getting your photo taken at a purikura photo booth."

◀ **Page 112**

▶ Graphic Novel, Volume 19, Cover

I really like this composition, but it couldn't surpass volume 16's.

◀ **Page 113**

▶ Graphic Novel, Volume 18, Cover

When I colored this one, I tried toning down the luster of the characters' skin.

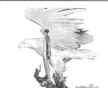

◀ **Pages 114–115**

▶ *Weekly Shonen Jump*, 2015, Issue 26, Center Color Poster

Watercolor. Raptors are cool. I like them.

◀ **Pages 116–117**

▶ *Weekly Shonen Jump*, 2015, Issue 31, Cover

No matter which frame of the motion you focus on, the spike is just so cool.

◀ **Pages 118–119**

▶ *Weekly Shonen Jump*, 2015, Issue 31, Color Title Page

I usually put a lot of thought into the composition for a color title page, but I started drawing this one without any hesitation. I really like it.

◀ **Page 120**

▶ *Weekly Shonen Jump*, 2015, Issue 43, Extra-Large Center Color Page

Put characters up against each other in a battle of expressions and it helps you realize just how much you understand each of them. I think it's fun.

◀ **Page 121**

▶ Graphic Novel, Volume 20, Cover

The cover was done primarily with gouache. The rest was done using Copics. Tendo, no hesitation.

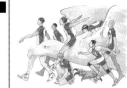

◀ **Pages 122–123**

▶ *Weekly Shonen Jump*, 2015, Issue 52, Color Title Page

Watercolor. I used purple in the shadows to match the Shiratorizawa uniforms.

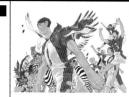

◀ **Pages 124–125**

▶ Graphic Novel, Volume 21, Cover

Gouache. Coach Washijo [page 358] was done with watercolors.

◀ **Page 126**

▶ *Weekly Shonen Jump*, 2015, Issue 39, Center Color Page

An entirely analog piece. I even cut and pasted tone stamps to make the background look like pixel art.

◀ **Page 127**

▶ *Haikyu!! The Novel*, Volume 7, Cover

A running Iwaizumi, to send a little in the way of good wishes to the city of Iwaizumi in Iwate, my home prefecture.

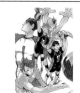

◀ **Page 128**

▶ Graphic Novel, Volume 27, Anime DVD Bundle, Cover

It's been a while since I last did Oikawa in color.

◀ **Page 129**

▶ *Weekly Shonen Jump*, 2015, Issue 52, Cover

I really like this color cover.

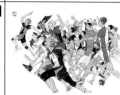

◀ **Pages 130–131**

▶ *Weekly Shonen Jump*, 2015, Issue 44, Color Title Page

Karasuno is base black, so I love getting a chance to do more colorful uniforms.

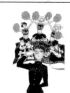

◀ **Page 132**

▶ *Weekly Shonen Jump*, 2015, Issue 35, Center Color Page

Kiyoko is tightly on guard.

◀ **Page 133**

▶ *Weekly Shonen Jump*, 2015, Issue 44, Cover

Tanaka and Nishinoya lying down wound up being completely covered by the Weekly Shonen Jump logo.

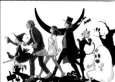

◀ **Pages 134–135**

▶ *Weekly Shonen Jump*, 2015, Issue 48, Center Color Page

A Halloween-themed center color page. Things were getting really fun.

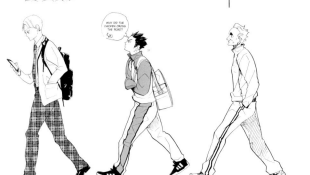
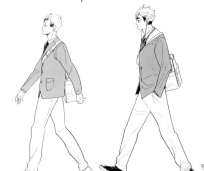

◀ Page 136

▶ *Weekly Shonen Jump*, 2016, Issue 3/4, Center Color Page

I drew this color page right around Christmastime.

◀ Page 137

▶ *Weekly Shonen Jump*, 2016, Issue 7, Cover

I'm not good at drawing two-head-height characters. You can feel how unused to it I am in this.

◀ Page 138

▶ *Weekly Shonen Jump*, 2016, Issue 16, Cover

I like Azumane in this.

◀ Page 139

▶ *Jump GIGA*, 2016, Volume 1 Cover

Gouache.

◀ Pages 140–141

▶ *Weekly Shonen Jump*, 2016, Issue 7, Color Title Page

I wanted to draw the black of the birds like they were merging with the black of the uniforms.

◀ Pages 142–143

▶ *Weekly Shonen Jump*, 2016, Issue 16, Color Title Page Poster

Copic markers on Kent paper, take two. It's not the most consistent, but it creates some unique and interesting shades.

◀ Page 144

▶ *Haikyu!! The Novel*, Volume 8, Cover

It isn't the easiest to figure out what kind of street clothes a guy like Kuroo, who's hard to read, would wear.

◀ Page 145

▶ *Weekly Shonen Jump*, 2015, Issue 21, Center Color Page

The cherry blossoms near my house were really beautiful, so I put them in this color page.

◀ Page 146

▶ Graphic Novel, Volume 22, Cover

The cover was done primarily with gouache. The rest was done using Copics. Am I getting addicted to gouache?

◀ Page 147

▶ *Weekly Shonen Jump*, 2016, Issue 21/22, Center Color Page

Gouache. I'd used it for manga volume covers before, but this is the first time I used it for an anthology color page.

◀ Page 148

▶ Graphic Novel, Volume 23, Cover

I decided on the composition for this without a second thought.

◀ Page 149

▶ *Weekly Shonen Jump*, 2016, Issue 12, Center Color Page

I usually use copy paper when doing colors with Copic markers, but this time I used Kent paper.

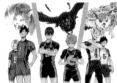

◀ Pages 150–151

▶ *Weekly Shonen Jump*, 2016, Issue 28, Cover

The characters I did in the usual Copic markers. The animals are done in gouache.

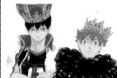

◀ Pages 152–153

▶ *Weekly Shonen Jump*, 2016, Issue 28, Color Title Page

Gouache.

◀ Pages 154–155

▶ *Weekly Shonen Jump*, 2016, Issue 32, Wide Color Title Page

This is a theme I'd wanted to do on a color page for a while. They let me use four pages for it too!

◀ Pages 156–157

▶ *Weekly Shonen Jump*, 2016, Issue 32, Wide Color Title Page

I had a blast drawing this.

◀ Page 158

▶ Graphic Novel, Volume 24, Cover

Hinata in the "night."

◀ Page 159

▶ Graphic Novel, Volume 25, Cover

Kageyama, making his way toward "morning."

◀ Page 160

▶ *Weekly Shonen Jump*, 2016, Issue 23, Center Color Page

Watercolor.

◀ Page 161

▶ *Weekly Shonen Jump*, 2016, Issue 44, Cover

The character moves through the spike motion as the art goes from rough sketch to finished colors.

◀ Page 162

▶ *Weekly Shonen Jump*, 2016, Issue 39, Center Color Page

The season in the story hardly ever matches up with the season in real life, so getting to draw a seasonal piece is lots of fun.

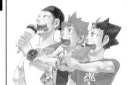

◀ Page 163

▶ *Weekly Shonen Jump*, 2017, Issue 25, Center Color Page

I remember having fun drawing the ice cream in this one.

◀ Pages 164–165

▶ *Weekly Shonen Jump*, 2016, Issue 40, Color Title Page

Copic markers on drawing paper. Drawing paper has a rough surface that lets the colors bleed easily, and they come out looking so vibrant.

◀ Pages 166–167

▶ *Weekly Shonen Jump*, 2016, Issue 44, Color Title Page

If you look closely, they panels spell out "Haikyu!!" in Japanese.

◀ Pages 168–169

▶ *Weekly Shonen Jump*, 2017, Issue 8, Center Color Page

Thinking up each character's street clothes style is fun.

◀ Page 170

▶ *Weekly Shonen Jump*, 2016, Issue 45, Center Color Page

A third Halloween color page already.

◀ Page 171

▶ *Weekly Shonen Jump*, 2016, Issue 40, Cover

This wound up with a greater three-dimensional feeling to it than I expected.

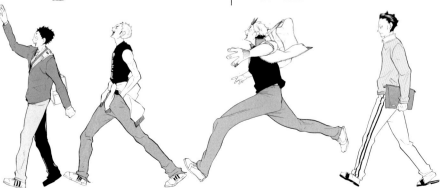

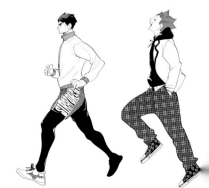

◀ Page 172

▶ *Haikyu!! The Novel*, Volume 9, Cover

I've realized that, whether for my outfits or other things, I just like using the color orange.

◀ Page 173

▶ Graphic Novel, Volume 26, Cover

The colors for the Tokyo Gymnasium turned out colder than expected.

◀ Page 174

▶ *Weekly Shonen Jump*, 2017, Issue 11, Center Color Page

Watercolors are pretty good for giving a piece a nostalgic air.

◀ Page 175

▶ Graphic Novel, Volume 27, Cover

I accidentally colored the wrong part of his uniform orange and didn't notice until finalization. To fix it, I just colored over it in black. The result? A deeper, nicer black than usual.

◀ Page 176

▶ *Weekly Shonen Jump*, 2017, Issue 16, Center Color Page

The girls' uniforms are so cool!

◀ Page 177

▶ *Weekly Shonen Jump*, 2017, Issue 20, Cover

Fifth-year anniversary color page. I was very grateful for it.

◀ Page 178

▶ Graphic Novel, Volume 28, Cover

It's unusual for me to do a "heroes and the adversaries they must overcome" sort of composition.

◀ Page 179

▶ Graphic Novel, Volume 29, Cover

I tried to use the colors to evoke a feeling of dread.

◀ Page 180

▶ *Weekly Shonen Jump*, 2017, Issue 20, Color Title Page

I put extra effort into my line work on this one. Probably because I did it while watching *Gegege no Nyobo*.

◀ Page 181

▶ Anime, *Haikyu!! To the Top*, Season 4 Second Half Prerelease Visual

Copic markers on regular drawing paper. I used ink bleed and a flat scene to give it the look of an old Japanese painting. I ripped the edges by hand and added color to make it look like they'd been burned.

◀ Pages 182–183

▶ *Weekly Shonen Jump*, 2017, Issue 35, Color Title Page

I was thinking of a slightly scary Japanese folktale when I drew this one.

◀ Page 184

▶ *Weekly Shonen Jump*, 2017, Issue 44 Center Color Page

I started this one with the intent to make it cool, but in the end it wound up kind of interesting instead.

◀ Page 185

▶ *Weekly Shonen Jump*, 2017, Issue 38, Center Color Page

Copic markers on drawing paper. The inconsistency I normally abhor looks nice on this paper.

◀ Pages 186–187

▶ Graphic Novel, Volume 30, Cover

Tanaka and Kozume, since they're the stars of the volume. Of all the wraparound covers I've done, I like the composition of this one best.

◀ Pages 188–189

▶ Graphic Novel, Volume 31, Cover (Front/Back)

It's a simple design, but I think the orange and black work perfectly.

◀ Pages 190–191

▶ *Weekly Shonen Jump*, 2018, Issue 1, Color Title Page

I worked hard to evoke the feeling of a brightly lit night.

◀ Page 192

▶ *Jump GIGA*, 2017, Volume 2, Cover

So much orange!

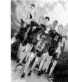

◀ Page 193

▶ Graphic Novel, Volume 32, Cover

I went for an ominous feel with this one. Inarizaki is always ominous. They're the Ominous High School.

◀ Page 194

▶ Graphic Novel, Volume 33, Cover

Such bright orange! I thought really hard about what composition would best convey the power of this dig.

◀ Page 195

▶ *Weekly Shonen Jump*, 2018, Issue 1, Cover

This is a pose I do often, but that doesn't make it any less difficult to draw.

◀ Pages 196–197

▶ *Weekly Shonen Jump*, 2018, Issue 12, Color Title Page

A rare vertical layout for this spread. I knew I wanted to title it "Monster's Ball," so I didn't have to think long about the composition.

◀ Page 198

▶ *Weekly Shonen Jump*, 2018, Issue 12, Center Color Page

On a base of standard skin tone, I tried adding a very faint layer of tan. The result feels like it has more depth to me.

◀ Page 199

▶ *Haikyu!! The Novel*, Volume 10, Cover

Osamu will go to the mini mart in whatever clothes he grabs first as soon as he wakes up. Atsumu will put effort into his looks just to go next door.

◀ Page 200

▶ *Jump GIGA*, 2018, Summer, Volume 2, Cover

This has great velocity to it! I like it!

◀ Page 201

▶ *Weekly Shonen Jump*, 2018, Issue 29, Center Color Page

I was in the mood to try something a little different. I went for a look kind of like those scary-cute picture books. I was fussy about their hands.

◀ Pages 202–203

▶ *Weekly Shonen Jump*, 2018, Issue 40, Center Color Page

I avoided thick black lines in this one, hoping to evoke a brighter, lighter feeling.

◀ Pages 204–205

▶ *Weekly Shonen Jump*, 2018, Issue 16, Center Color Page

This is a composition I knew I wanted to do when the game against Nekoma finally came.

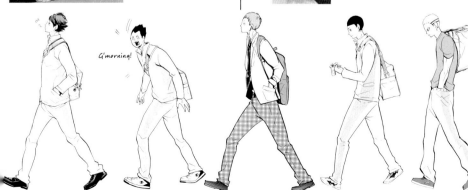

G'morning!

ART INDEX AND COMMENTS FROM FURUDATE SENSEI

◄ Pages 206–207
► *Weekly Shonen Jump*, 2018, Issue 19, Cover

For the front cover of Weekly Shonen Jump. Drawing the animals was fun.

◄ Page 208
► Graphic Novel, Volume 34, Cover

The red really pops, doesn't it?

◄ Page 209
► *Weekly Shonen Jump*, 2018, Issue 19, Color Title Page

I think I've gotten better at fitting a lot of characters into one frame!

◄ Page 210
► *Weekly Shonen Jump*, 2018, Issue 24, Center Color Page

Net. Oh, net. I put so much work into you, but you've done much to help me in return (compositionwise).

◄ Page 211
► *Weekly Shonen Jump*, 2018, Issue 35, Center Color Page

When Kozume's alone, all of a sudden the piece has a tinge of horror to it.

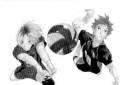

◄ Pages 212–213
► *Weekly Shonen Jump*, 2018, Issue 12, Cover

I think I nailed the movement in this one really well.

◄ Page 214
► Graphic Novel, Volume 35, Cover

Kozume alone equals horror atmosphere, take two. Though I think he just felt like being shut in somewhere.

◄ Page 215
► Graphic Novel, Volume 36, Cover

Volume 36, the cover whose composition I decided on really quickly. The awesome garbage mountain is the awesome work of my awesome assistants.

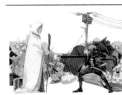

◄ Pages 216–217
► *Weekly Shonen Jump*, 2018, Issue 46, Color Title Page

Kozume is standing there in pure, innocent mage's robes, holding a knife in his left hand like it's natural. He's definitely out for blood.

◄ Page 218
► Graphic Novel, Volume 37, Cover

Adding the dirt smudges during final touches was so fun that I overdid it.

◄ Page 219
► *Weekly Shonen Jump*, 2018, Issue 49, Center Color Page

I tried to bring out an old-timey feeling in this one with the long-sleeve uniforms and pure-white ball.

◄ Page 220
► *Weekly Shonen Jump*, 2019, Issue 1, Center Color Page

I came down with the flu near the deadline for this one. Left with little time, I went with a pinup of Mr. Attention Grabber, Bokuto.

◄ Page 221
► Graphic Novel, Volume 38, Cover

I think this one turned out well—with the series logo added, and even without it.

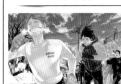

◄ Pages 222–223
► *Weekly Shonen Jump*, 2019, Issue 12, Color Title Page

I really think I nailed the feel of a cold, clear winter sky in this one!

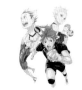

◄ Page 224
► *Weekly Shonen Jump*, 2019, Issue 12, Cover

For the Weekly Shonen Jump cover. I remember getting a little lost on the colors in this one.

◄ Page 225
► *Weekly Shonen Jump*, 2019, Issue 9, Center Color Page

I think it was winter when I drew this, so I decided to make it a scene with a character going out shopping in winter. I draw so many scenes in gyms that doing a seasonal piece is a nice change.

◄ Pages 226–227
► *Weekly Shonen Jump*, 2019, Issue 21, Extra-Large Center Color Page

I really like this composition. I designed Ushijima, Kozume, and Oikawa's hand positions to be symbolic of the games against them.

◄ Pages 228–229
► *Weekly Shonen Jump*, 2019, Issue 33, Center Color Page

I drew this one right after coming back from my research trip to Brazil. You can tell how much I was still in the Rio Olympics mood.

◄ Page 230
► *Haikyu!! The Novel*, Volume 11, Cover

A moment in time, as everyone leaves class and heads to club. The hall is cold too.

◄ Page 231
► Graphic Novel, Volume 39, Cover

I tried to bring out the white of seagulls and the sharpness of their eyes.

◄ Page 232
► *Weekly Shonen Jump*, 2019, Issue 24, Center Color Page

My first watercolor in a while. I tried to make it feel like a brief moment of calm before a storm.

◄ Page 233
► *Weekly Shonen Jump*, 2019, Issue 17, Center Color Page

I wanted to draw Hoshiumi looking cool.

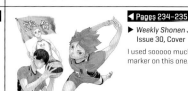

◄ Pages 234–235
► *Weekly Shonen Jump*, 2019, Issue 30, Cover

I used sooooo much orange Copic marker on this one.

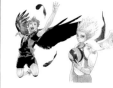

◄ Pages 236–237
► *Weekly Shonen Jump*, 2019, Issue 41, Cover

I remember thinking it'd be hard for seagulls to sit on a person's shoulder with their feet. After the instant of this shot, I guarantee that bird is flailing, trying to regain its balance.

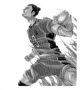

◄ Page 238
► Graphic Novel, Volume 40, Cover

The cover of volume 40 is all about ripping free! I made the purple shadow deeper, to really sell the feeling of Azumane pulling himself up out of a pit.

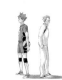

◄ Page 239
► *Weekly Shonen Jump*, 2019, Issue 38, Center Color Page

Haikyu!'s number one *tsundere* character by a country mile, Coach Washijo!

◄ Page 240
► Graphic Novel, Volume 41, Cover

I decided on the composition for volume 41's cover from the positioning of the volume's subtitle (The Little Giant vs....). Unusual, for me.

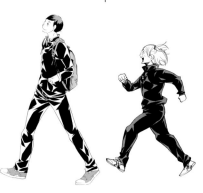
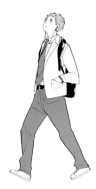

◀ Page 241

▶ *Weekly Shonen Jump*, 2019, Issue 44, Center Color Page

A center color without Hinata. To give a sense of unity to the characters and background, I used the same color for both the sky and the characters' shadows.

◀ Pages 242-243

▶ *Weekly Shonen Jump*, 2019, Issue 41, Color Title Page

Thinking of when Hinata was hyped the most, I drew the start of Karasuno's first-round Inter-High game against Tokonami. There aren't many spectators.

◀ Pages 244-245

▶ *Weekly Shonen Jump*, 2020, Issue 27, Center Color Page

The color illustration for the announcement of the best lineup poll. I put Ushijima and Sakusa on the edges to bring out the feeling of "wing" (spiker).

◀ Page 246

▶ Graphic Novel, Volume 42, Cover

Like with the Hinata on the cover of this art book, here is a Hinata who's learned that things aren't always going to be okay.

◀ Page 247

▶ *Weekly Shonen Jump*, 2019, Issue 48, Center Color Page

The cap was white at first, but that made him look like a baseballer, so I made it green instead. The background sky is acrylic gouache.

◀ Page 248

▶ *Weekly Shonen Jump*, 2019, Issue 51, Cover

The pose is similar to the one on the first cover I did near the start of serialization. I put a lot of work into the tan skin tone.

◀ Page 249

▶ *Haikyu!! The Novel*, Volume 12, Cover

Hinata and "Ken Watanabe," getting ready to take on the "Buy Me a Drink" brothers.

◀ Pages 250-251

▶ *Weekly Shonen Jump*, 2019, Issue 51, Color Title Page

Hinata, trying desperately to catch up to Kageyama. I tried to contrast Hinata's tanned skin with Kageyama's white uniform.

◀ Pages 252-253

▶ *Weekly Shonen Jump*, 2020, Issue 16, Cover

Some of the characters, all grown up. The green of Tsukishima's uniform really fits.

◀ Pages 254-255

▶ *Weekly Shonen Jump*, 2020, Issue 4/5, Color Title Page

A color title page for the return from Rio! It's also a move from the beach (open sky) to the indoor court (gym ceiling).

◀ Page 256

▶ Graphic Novel, Volume 43, Cover

I tried to bring out the aura of "perennial champions."

◀ Page 257

▶ Graphic Novel, Volume 44, Cover

The feel of this one is "the greatest challengers."

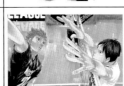

◀ Pages 258-259

▶ *Weekly Shonen Jump*, 2020, Issue 32, Color Title Page

The final color title page! Copic markers aren't the best for filling in big spaces evenly, but swipe them vertically and the color inconsistencies work as a kind of speed line! I think!

◀ Pages 260-261

▶ *Weekly Shonen Jump*, 2020, Issue 16, Color Title Page

Nishinoya vs. Marlin! I just knew I had to do this for a color title page someday, but it got dangerously close to ending up as the final one. I was willing to let it be that, if necessary.

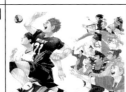

◀ Pages 262-263

▶ Graphic Novel, Volume 45, Cover

The final manga cover! I used the same composition as for volume 1. That volume's cover only had Hinata and Kageyama, but the others said "We won't let them outdo us!" and all piled onto the back of this cover!

◀ Page 264

▶ *Weekly Shonen Jump*, 2020, Issue 32, Poster [Front]

A poster for the weekly anthology. I picked four characters with ties to Miyagi Prefecture. Their uniforms are the red of the Japan national team!

◀ Page 265

▶ *Weekly Shonen Jump*, 2020, Issue 32, Poster [Back]

I'm fully confident that I managed to capture just how bad Kageyama and Ushijima are at smiling.

◀ Page 266

▶ *Weekly Shonen Jump*, 2020, Issue 32, Cover

The final cover for the weekly anthology! I'd been drawing them as adults for a while, so their skinnier middle school bodies were suddenly pretty difficult.

◀ Page 267

▶ *Haikyu!! The Novel*, Volume 13, Cover

Yaku's participating too. Via the remote.

◀ Pages 268-269

▶ *Weekly Shonen Jump*, 2020, Issue 33/34, Extra-Large Center Color Page

The color page for the final chapter. When I thought about what to draw for it, this popped immediately to mind. And once it was in my head, I just had to draw it.

◀ Pages 270-271

▶ 2015 Spring Tournament Collaboration, Poster

My second poster for the Spring Tournament.

◀ Page 272

▶ 2016 Spring Tournament Collaboration, Poster

I tried making the line work look like brushstrokes and making the colors extra crisp.

◀ Page 273

▶ 2017 Spring Tournament Collaboration, Poster

The serve toss is such a cool moment that's also so hard to capture in a drawing.

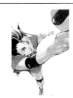

◀ Page 274

▶ 2018 Spring Tournament Collaboration, Poster

I paid particular attention to the lighting.

◀ Page 275

▶ 2019 Spring Tournament Collaboration, Poster

Another poster for the Spring Tournament. I tried to emphasize how scary the hands of a blocker are.

◀ Page 276

▶ 2020 Spring Tournament Collaboration, Poster

Unlike the earlier posters I did, which focused on cool moments of play, this one centers around a moment on the bench.

◀ Page 277

▶ 2017 Inter-High Collaboration, Poster

I was so excited to get to collaborate with the Inter-High tournament. A rare shot of Hinata passing a serve.

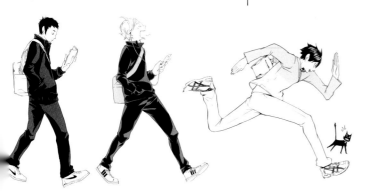

ART INDEX AND COMMENTS FROM FURUDATE SENSEI

◀ **Page 278**

▶ 2018 Inter-High Collaboration, Poster

I tried to make the lines look brushlike.

◀ **Page 279**

▶ 2019 Inter-High Collaboration, Poster

I tried to bring out the feel of Hinata reaching the top of a max jump by making his hair look floaty.

◀ **Page 280**

▶ 2017 Inter-High Collaboration, Support Color

Pencil and Copic on copy paper.

◀ **Page 281**

▶ 2018 Inter-High Collaboration, Support Color

I drew this piece for the players participating in the volleyball events of that year's Inter-High.

◀ **Page 282**

▶ 2019 Inter-High Collaboration, Support Color

Like I did for the "play styles" series, I tried dialing back the black lines and changing up my touch a little bit.

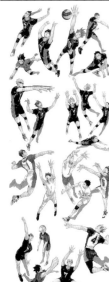

◀ **Page 283**

▶ Weekly Shonen Jump 50th Anniversary Exhibition, Volume 3 Exhibit

A super-vertical quick set! I think this composition works quite neatly for that.

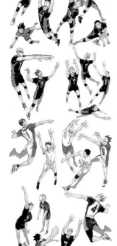

◀ **Pages 284–291**

▶ 2018 Haikyu!! Exhibition Genga X Taikan, Key Visuals

Once again, I learned just how difficult to draw the various poses for the various positions can be.

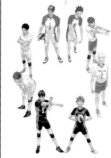
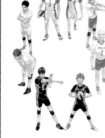

◀ **Pages 292–293**

▶ 2020 Haikyu!! Exhibition Sendai, Key Visuals

I think I've gotten a little better at the plain standing poses I've always been so bad at.

◀ **Pages 294–297**

▶ 2020 Haikyu!! Exhibition Tokyo, Key Visuals

The Miya Twins are like, "Hey, whoa! Over here!" Akaashi probably thinks they didn't fit him in the shot.

◀ **Pages 298–299**

▶ 2020 Haikyu!! Exhibition Sendai, On-Site Original Art

Hinata and the others as third years. Hinata actually teaching others how to receive. Kageyama actually talking game strategy with others.

◀ **Page 300**

▶ 2020 Haikyu!! Exhibition Tokyo, On-Site Original Art

The Bokuto/Kuroo center color page I did right around the Tokyo Training Camp arc, just with both of them as adults.

◀ **Page 301**

▶ 2020 Haikyu!! Exhibition Sendai, On-Site Original Art

Watercolor. CA San Juan's main sponsors are a credit card company and an electric company.

◀ **Page 302**

▶ Art Book Original

I asked a huge favor and got to draw the lineup for the 2021 men's national team! Everyone on it is a monster!

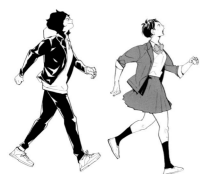

◀ **Page 303**

▶ Complete Guidebook Volleyball Book!, Cover

I think I managed to convey their momentum well.

◀ **Page 304**

▶ Message Card Book Volleyball Letters!, Cover

It does feel a little like Hinata is supposed to be holding something. Kageyama is trying too hard to look cool.

◀ **Page 305**

▶ Official Color Illustration Collection Haikara!, Cover

The only reason they're wearing crowns was because I was like, "I wanna use gold!"

◀ **Pages 306–307**

▶ Final Guidebook Volleyball Ultimate!, Cover

I drew the "Spring Tourney fever!" photo scene.

◀ **Pages 308–309**

▶ Japan Volleyball League 50th Anniversary Magazine

A piece I had the honor of contributing to the V.League's fiftieth anniversary magazine. The background is what I hope things will look like in the near future.

◀ **Pages 310–311**

▶ Haikyu!! 2013 Calendar, Cover

I think I managed to convey the feeling of "He's flying!" pretty well.

◀ **Page 312**

▶ Haikyu!! Festival!! Event Attendee Costume-Change Booklet, Cover

Not your typical character lineup.

◀ **Page 313**

▶ Haikyu!! 2015 Calendar, Cover

Japanese clothes are hard to draw.

◀ **Pages 314–315**

▶ Haikyu!! 2020 Calendar, Cover

The freak twins, opponents players don't want to see on the other side of the net.

◀ **Page 316**

▶ 2015 Haikyu!! X JA Zen-Noh Group, Iwate (Iwate Prefecture Food Boxes, Round 1)

I got to collaborate with my home prefecture, Iwate! Of course I put a ton of effort into the vegetables.

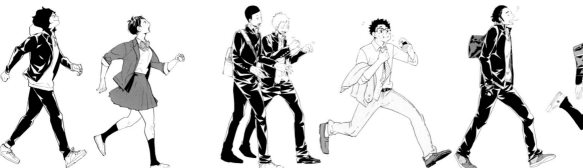

◄ **Page 317**

▶ 2015 *Haikyu!!* X JA Zen-Noh Group, Iwate [Iwate Prefecture Food Boxes, Round 3]

Collaboration with my home prefecture, Iwate, take three! Daichi is definitely that neighbor who shares so much out of their garden that you're like, "Really?! That much?!"

◄ **Pages 318–319**

▶ 2015 *Haikyu!!* X JA Zen-Noh Group, Iwate [Iwate Prefecture Food Boxes, Round 2]

Collaboration with my home prefecture, Iwate, take two. I think I did the colors on this one really well.

◄ **Page 320**

▶ *Jump NEXT!*, 2013, Summer, Joke Movie Poster

My celebratory first movie-style poster.

◄ **Page 321**

▶ *Jump NEXT!*, 2014, Volume 1 Joke Movie Poster

I have fun with these every time.

◄ **Page 322**

▶ *Jump NEXT!*, 2014, Volume 4 Joke Movie Poster

Watercolor. I love horror. I want to do another poster like this one.

◄ **Page 323**

▶ *Jump NEXT!*, 2015, Volume 1 Joke Movie Poster

I don't usually draw scenes like this. Their outfits were great stress relief.

◄ **Page 324**

▶ *Jump NEXT!*, 2015, Volume 3 Joke Movie Poster

I stuck too close to the original inspiration on this one.

◄ **Page 325**

▶ *Jump NEXT!*, 2015, Volume 6 Joke Movie Poster

I think I did a good job on the explosion.

◄ **Page 326**

▶ *Jump GIGA*, 2016, Volume 3 Joke Movie Poster

I think I did a good job on the explosion, take two.

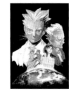

◄ **Page 327**

▶ *Jump GIGA*, 2017, Volume 1 Joke Movie Poster

Gouache. I'd just admired a collection of Drew Struzan posters before I drew this.

◄ **Page 328**

▶ 2014 VJB *Haikyu!! Connect!! The View from the Top!!* Quick Attack Guide Poster

It's fun to draw motion that's not connected to volleyball too.

◄ **Page 328**

▶ 50th Anniversary Jump Music Festa

Musical instruments are so hard!

◄ **Page 328**

▶ *Jump NEXT!*, 2015, Volume 5 Costume-Change Cover

I can't for the life of me remember why I chose that for his shirt pattern.

◄ **Page 329**

▶ *Monthly Volleyball*, 2018, April Issue

Something I drew for the players who were graduating that year.

◄ **Page 329**

▶ *Monthly Volleyball*, 2020, August Issue

Monthly Volleyball did an amazing special feature to commemorate the end of Haikyu!!'s serialization. This is from that. Thank you so much!!

◄ **Page 329**

▶ 2017 *Haikyu!! Hyper Projection Stage Play* Exhibit

I tend toward tilted layouts.

◄ **Page 330**

▶ *Haikyu!! The Novel*, Volume 1, Pinup

I tend to use pink around Kageyama.

◄ **Page 330**

▶ *Haikyu!! The Novel*, Volume 3, Pinup

For the reverse side of the pinup, I used fewer black lines to bring out the feeling of it being a rough sketch.

◄ **Page 330**

▶ *Haikyu!! The Novel*, Volume 4, Pinup

Aone does good work.

◄ **Page 330**

▶ *Haikyu!! The Novel*, Volume 5, Pinup

A Charlie's Angels parody. Has everyone seen the latest one? Bosley...

◄ **Page 331**

▶ *Haikyu!! The Novel*, Volume 6, Pinup

If Kageyama could open up to an animal, I think he'd make a wonderful partner for it. Of course, that's if he could open up.

◄ **Page 331**

▶ *Haikyu!! The Novel*, Volume 8, Pinup

I was able to draw this quickly and smoothly with a light touch.

◄ **Page 331**

▶ *Haikyu!! The Novel*, Volume 9, Pinup

It's been a while since we last saw him. How can someone be jealous of a coat?

◄ **Page 331**

▶ *Haikyu!! The Novel*, Volume 10, Pinup

Level 99 hero.

◄ **Page 331**

▶ *Haikyu!! The Novel*, Volume 11, Pinup

Meditation is a workout for your brain!

◄ **Page 331**

▶ *Haikyu!! The Novel*, Volume 13, Pinup

Playing on the "meiso" pun from the previous one.

◄ **Page 332**

▶ *Jump Style!*, Volume 9, Original Art

◀ **Page 333**

▶ *Haikyu!! Hyper Projection Stage Play* The Greatest Team Pamphlet

Sugawara usually pays close attention to others, but at times like this he's not thinking about the people behind him at all.

Page 334

 ▶ *Weekly Shonen Jump,* 2012, Issue 13, ①

 ▶ *Weekly Shonen Jump,* 2012, Issue 12

 ▶ *Weekly Shonen Jump,* 2012, Issue 43, ③

 ▶ *Weekly Shonen Jump,* 2012, Issue 43, ②

Page 335

 ▶ *Jump NEXT!,* 2012, Summer, ②

 ▶ *Jump NEXT!,* 2012, Summer, ①

 ▶ *Weekly Shonen Jump,* 2013, Issue 12

 ▶ *Weekly Shonen Jump,* 2014, Issue 4/5, J Stars Christmas

Page 336

 ▶ *Weekly Shonen Jump,* 2013, Issue 45

 ▶ *Weekly Shonen Jump,* 2013, Issue 33, Center Color Page

 ▶ *Weekly Shonen Jump,* 2014, Issue 18

 ▶ *Weekly Shonen Jump,* 2014, Issue 8

Page 337

 ▶ *Weekly Shonen Jump,* 2014, Issue 40

 ▶ *Weekly Shonen Jump,* 2014, Issue 25

 ▶ *Weekly Shonen Jump,* 2015, Issue 17

 ▶ *Weekly Shonen Jump,* 2015, Issue 9

Page 338

 ▶ *Weekly Shonen Jump,* 2015, Issue 44

 ▶ *Weekly Shonen Jump,* 2015, Issue 31

 ▶ *Weekly Shonen Jump,* 2016, Issue 7

 ▶ *Weekly Shonen Jump,* 2015, Issue 52

Page 339

 ▶ *Weekly Shonen Jump,* 2016, Issue 32

 ▶ *Weekly Shonen Jump,* 2016, Issue 28

 ▶ *Weekly Shonen Jump,* 2016, Issue 44

 ▶ *Weekly Shonen Jump,* 2016, Issue 40

Page 340

 ▶ *Weekly Shonen Jump,* 2017, Issue 35

 ▶ *Weekly Shonen Jump,* 2017, Issue 20

▶ *Weekly Shonen Jump,* 2018, Issue 12

▶ *Weekly Shonen Jump,* 2018, Issue 1

Page 341

▶ *Weekly Shonen Jump,* 2018, Issue 46

▶ *Weekly Shonen Jump,* 2018, Issue 19

▶ *Weekly Shonen Jump,* 2019, Issue 21

▶ *Weekly Shonen Jump,* 2019, Issue 12

Page 342

 ▶ *Weekly Shonen Jump,* 2019, Issue 41

▶ *Weekly Shonen Jump,* 2019, Issue 30

 ▶ *Weekly Shonen Jump,* 2020, Issue 27

▶ *Weekly Shonen Jump,* 2020, Issue 16

Page 343

 ▶ *Weekly Shonen Jump,* 2020, Issue 33/34

▶ *Weekly Shonen Jump,* 2020, Issue 32

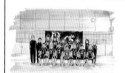

◀ **Page 343**

▶ *Monthly Volleyball,* 2017, January Issue, Collaboration

They're really tiny, but I put a lot of effort into each person's expression.

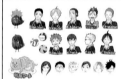

◀ **Page 343**

▶ *Jump NEXT!,* 2013, Winter Stickers

It's fun to draw things like this that are tiny and complete in one go.

◀ **Page 343**

▶ *Jump GIGA,* 2016, Volume 1 Costume-Change Cover

Drawing animals is fun.

◀ **Page 343**

▶ *Weekly Shonen Jump,* 2014, Issue 11, Valentine's Give and Get Poster

◀ **Page 343**

▶ *Weekly Shonen Jump,* 2013, Issue 6/7, Nisekoi Collaboration, Center Color Page

◀ **Page 343**

▶ 2015 Summer Comic Market Pin

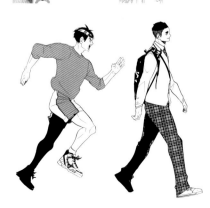

Page 344

▶ *Weekly Shonen Jump*, 2013, Issue 33, Cover

▶ *Weekly Shonen Jump*, 2015, Issue 6/7, Cover

▶ *Weekly Shonen Jump*, 2015, Issue 19 cover

▶ *Weekly Shonen Jump*, 2014, Issue 37/38, Cover

▶ *Weekly Shonen Jump*, 2015, Issue 4/5, Cover

▶ *Weekly Shonen Jump*, 2017, Issue 36/37, Cover

▶ *Weekly Shonen Jump*, 2013, Issue 37/38, Cover

▶ *Weekly Shonen Jump*, 2014, Issue 4/5, Cover

▶ *Weekly Shonen Jump*, 2016, Issue 3/4, Cover

▶ *Weekly Shonen Jump*, 2012, Issue 36/37, Cover

▶ *Weekly Shonen Jump*, 2016, Issue 5/6, Cover

▶ *Weekly Shonen Jump*, 2014, Issue 22/23, Cover

▶ *Weekly Shonen Jump*, 2019, Issue 22/23 cover

▶ *Weekly Shonen Jump*, 2017, Issue 21/22, Cover

▶ *Weekly Shonen Jump*, 2017, Issue 35, Cover

▶ *Weekly Shonen Jump*, 2019, Issue 6/7, Cover

▶ *Weekly Shonen Jump*, 2018, Issue 36/37, Cover

Page 345

▶ *Weekly Shonen Jump*, 2012, Issue 21/22, Cover

▶ *Weekly Shonen Jump*, 2016, Issue 21/22, Cover

▶ *Weekly Shonen Jump*, 2018, Issue 2/3, Cover

▶ *Weekly Shonen Jump*, 2016, Issue 36/37, Cover

▶ *Weekly Shonen Jump*, 2018, Issue 4/5, Cover

▶ *Weekly Shonen Jump*, 2018, Issue 33 Cover

▶ *Weekly Shonen Jump*, 2015, Issue 37/38, Cover

▶ *Weekly Shonen Jump*, 2017, Issue 4/5, Cover

▶ *Weekly Shonen Jump*, 2017, Issue 2/3, Cover

▶ *Weekly Shonen Jump*, 2018, Issue 21/22, Cover

▶ *Weekly Shonen Jump*, 2020, Issue 4/5, Cover

▶ *Weekly Shonen Jump*, 2019, Issue 4/5, Cover

▶ *Weekly Shonen Jump*, 2020, Issue 23, Cover

▶ *Weekly Shonen Jump*, 2019, Issue 36/37, Cover

▶ *Weekly Shonen Jump*, 2020, Issue 6/7, Cover

◀ **Page 346**

▶ *Jump GIGA*, 2019, Winter, Volume 1 Stickers

I love looking at all the baby crows that fans draw on things like their fan letters and stuff.

◀ **Page 346**

▶ *Jump GIGA*, 2017, Volume 4 Stickers

The trick to drawing chibi animals is to not put too much effort into it.

◀ **Page 346**

▶ *Jump GIGA*, 2018, Winter, Volume 3 Costume-Change Cover

I can't draw cute animals.

◀ **Page 346**

▶ *Jump GIGA*, 2020, Spring, Stickers

The Miya Twins are in the middle of hunting. No matter how hard I try, I keep drawing them as real Tibetan foxes.

◀ **Page 346**

▶ *Jump GIGA*, 2019, Summer, Volume 3 Costume-Change Cover

I managed to draw cute animals.

◀ **Page 346**

▶ *Weekly Shonen Jump*, 2018, Issue 6, 2018 *Shonen Jump hanafuda* playing card

◀ **Page 346**

▶ *Jump GIGA*, 2019, Summer, Volume 2 Clear File

For a proper approach, it's important to get enough distance!

◀ **Page 346**

▶ *Volleyball Book!*, Cover Spine

◀ **Page 347**

▶ *Volleyball Book!*, Cover flap

◀ **Page 347**

▶ 2018 *Haikyu!!* Exhibition Genga X Taikan, Original Chibi Art

I almost never get a chance to draw two-head-height characters, so this was fun.

◀ Page 347

▶ 2020 *Haikyu!!* Exhibition Sendai, On-Site Original Chibi Art

Tendo, what's that pose? [LOL]

◀ Page 347

▶ 2020 *Haikyu!!* Exhibition Tokyo, On-Site Original Chibi Art

I used to be really bad at drawing chibi characters, but since this I've gotten better.

◀ Page 347

▶ *Weekly Shonen Jump*, 2015, Issue 22/23, Jump Special Map of Japan Poster

◀ Page 347

▶ 8/16/2020, V.League Collaboration, Original Art

◀ Page 348

▶ 4/17/2016, Twitter

There are times when you're so down, you don't want to hear "cheer up." At times like that, some happy people can just bring out the happiness in you.

◀ Page 348

▶ 9/5/2016, Twitter

Happy people bringing out the happiness, Aoba Johsai version.

◀ Page 349

▶ 9/22/2017, Twitter

I drew this on folded paper.

◀ Page 349

▶ 5/2/2017, Twitter

Kiyoko, getting ready to run.

◀ Page 349

▶ 10/2/2017, Twitter

I gave the lines on this a very brushlike feel.

◀ Page 350

▶ 1/1/2017, Twitter

I really tend to use green around Tsukishima.

◀ Page 350

▶ 1/2/2018, Twitter

This was hard because I'm not used to drawing kimono.

◀ Page 350

▶ 1/3/2019, Twitter

New Year's makes me giddy, so my art is full of energy too.

◀ Page 351

▶ 8/3/2018, Twitter

Kageyama hasn't read volume 32 yet, has he.

◀ Page 351

▶ 1/3/2020, Twitter

I think this turned out to be a good New Year's illustration, if I do say so myself.

◀ Page 351

▶ 7/20/2020, Twitter

If you wonder why he showed up here, look closely at the color page of the final chapter and you'll understand.

◀ Page 351

▶ Original Art Card for Store Sales

I drew this way back at the beginning of the beginning.

◀ Page 351

▶ Graphic Novel, Volume 15, and *Let's Haikyu?!*, Volume 1, Commemorative Art Card

I drew this around the middle of things.

◀ Page 351

▶ 2019 Jump Festa, Art Card

I think I've gotten a bit more consistent at faces.

◀ Page 351

▶ *Weekly Shonen Jump*, 45th Anniversary Art Card

The more time passes, the more economical my art cards become...

◀ Page 351

▶ *Weekly Shonen Jump*, 50th Anniversary Art Card

I really can't draw the same face... I'm a manga artist, but I just can't draw consistently neat, clean faces...

◀ Page 352

▶ 2015, Jump Festa, Limited Edition Original Art Card

Reindeer are dignified.

◀ Page 352

▶ 2013 Jump Festa, Limited Edition Original Art Card

Wow, the pattern of that ball is old! This must be something I drew near the beginning.

◀ Page 352

▶ 2014 Jump Festa, Limited Edition Original Art Card

No sleigh needed.

◀ Page 352

▶ Graphic Novel, Volume 29, In-Store Purchase Special Paper

I think Kageyama-san makes a very good point.

◀ Page 352

▶ 2019 Jump Artists New Year's Greetings Card

Hinata and a boar. They go so well together.

◀ Page 353

▶ 7/20/2020, Twitter

It would be my last official post, so I went into it intending to make a proper illustration... But I've done this composition so many times it doesn't feel all that original.

◀ Page 353

▶ Graphic Novel, Volume 45, In-Store Purchase Special Paper

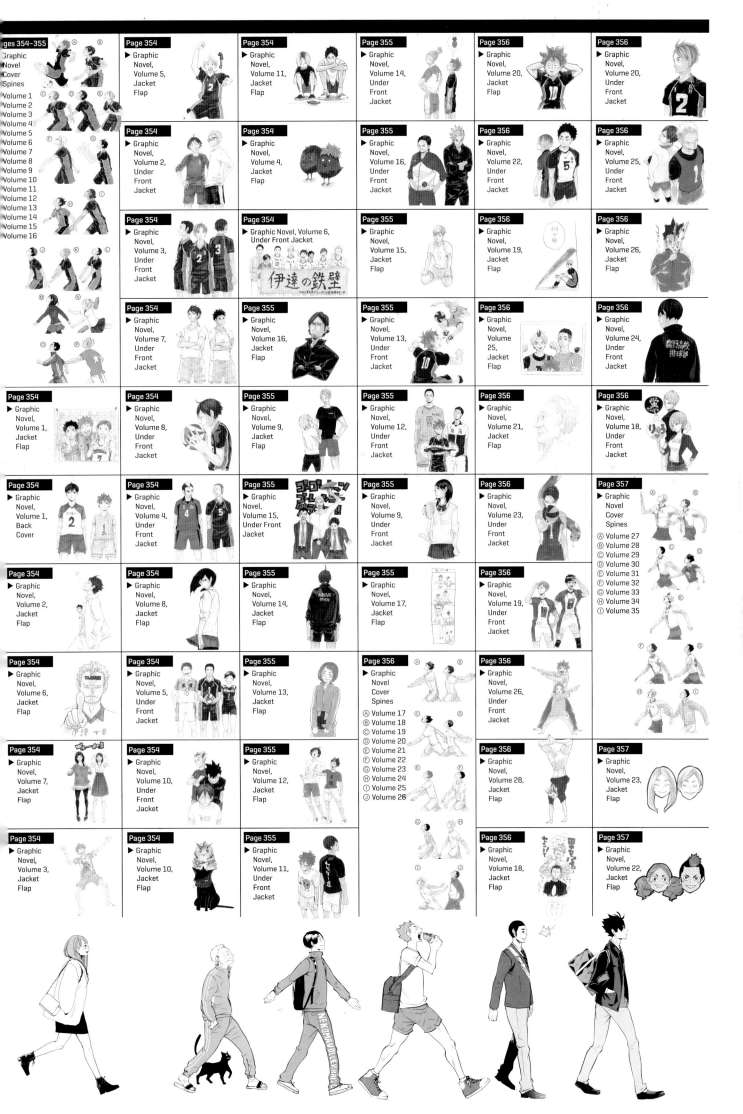

Pages 354–355

Graphic Novel Cover Spines

Volume 1
Volume 2
Volume 3
Volume 4
Volume 5
Volume 6
Volume 7
Volume 8
Volume 9
Volume 10
Volume 11
Volume 12
Volume 13
Volume 14
Volume 15
Volume 16

Page 354
▶ Graphic Novel, Volume 1, Jacket Flap

Page 354
▶ Graphic Novel, Volume 1, Back Cover

Page 354
▶ Graphic Novel, Volume 2, Jacket Flap

Page 354
▶ Graphic Novel, Volume 6, Jacket Flap

Page 354
▶ Graphic Novel, Volume 7, Jacket Flap

Page 354
▶ Graphic Novel, Volume 3, Jacket Flap

Page 354
▶ Graphic Novel, Volume 5, Jacket Flap

Page 354
▶ Graphic Novel, Volume 2, Under Front Jacket

Page 354
▶ Graphic Novel, Volume 3, Under Front Jacket

Page 354
▶ Graphic Novel, Volume 7, Under Front Jacket

Page 354
▶ Graphic Novel, Volume 8, Under Front Jacket

Page 354
▶ Graphic Novel, Volume 4, Under Front Jacket

Page 354
▶ Graphic Novel, Volume 8, Jacket Flap

Page 354
▶ Graphic Novel, Volume 10, Under Front Jacket

Page 354
▶ Graphic Novel, Volume 10, Jacket Flap

Page 354
▶ Graphic Novel, Volume 11, Jacket Flap

Page 354
▶ Graphic Novel, Volume 4, Jacket Flap

Page 354
▶ Graphic Novel, Volume 6, Under Front Jacket

伊達の鉄壁

Page 354
▶ Graphic Novel, Volume 5, Under Front Jacket

Page 355
▶ Graphic Novel, Volume 16, Jacket Flap

Page 355
▶ Graphic Novel, Volume 9, Jacket Flap

Page 355
▶ Graphic Novel, Volume 15, Under Front Jacket

Page 355
▶ Graphic Novel, Volume 14, Jacket Flap

Page 355
▶ Graphic Novel, Volume 13, Jacket Flap

Page 355
▶ Graphic Novel, Volume 12, Jacket Flap

Page 355
▶ Graphic Novel, Volume 11, Under Front Jacket

Page 355
▶ Graphic Novel, Volume 14, Under Front Jacket

Page 355
▶ Graphic Novel, Volume 16, Under Front Jacket

Page 355
▶ Graphic Novel, Volume 15, Jacket Flap

Page 355
▶ Graphic Novel, Volume 13, Under Front Jacket

Page 355
▶ Graphic Novel, Volume 9, Under Front Jacket

Page 355
▶ Graphic Novel, Volume 12, Under Front Jacket

Page 355
▶ Graphic Novel, Volume 17, Jacket Flap

Page 356
▶ Graphic Novel Cover Spines
A Volume 17
B Volume 18
C Volume 19
D Volume 20
E Volume 21
F Volume 22
G Volume 23
H Volume 24
I Volume 25
J Volume 26

Page 356
▶ Graphic Novel, Volume 18, Jacket Flap

Page 356
▶ Graphic Novel, Volume 20, Jacket Flap

Page 356
▶ Graphic Novel, Volume 22, Under Front Jacket

Page 356
▶ Graphic Novel, Volume 19, Jacket Flap

Page 356
▶ Graphic Novel, Volume 25, Jacket Flap

Page 356
▶ Graphic Novel, Volume 21, Jacket Flap

Page 356
▶ Graphic Novel, Volume 23, Under Front Jacket

Page 356
▶ Graphic Novel, Volume 19, Under Front Jacket

Page 356
▶ Graphic Novel, Volume 26, Under Front Jacket

Page 356
▶ Graphic Novel, Volume 28, Jacket Flap

Page 356
▶ Graphic Novel, Volume 20, Under Front Jacket

Page 356
▶ Graphic Novel, Volume 25, Under Front Jacket

Page 356
▶ Graphic Novel, Volume 19, Jacket Flap

Page 356
▶ Graphic Novel, Volume 26, Jacket Flap

Page 356
▶ Graphic Novel, Volume 24, Under Front Jacket

Page 356
▶ Graphic Novel, Volume 18, Under Front Jacket

Page 357
▶ Graphic Novel Cover Spines
A Volume 27
B Volume 28
C Volume 29
D Volume 30
E Volume 31
F Volume 32
G Volume 33
H Volume 34
I Volume 35

Page 357
▶ Graphic Novel, Volume 23, Jacket Flap

Page 357
▶ Graphic Novel, Volume 22, Jacket Flap

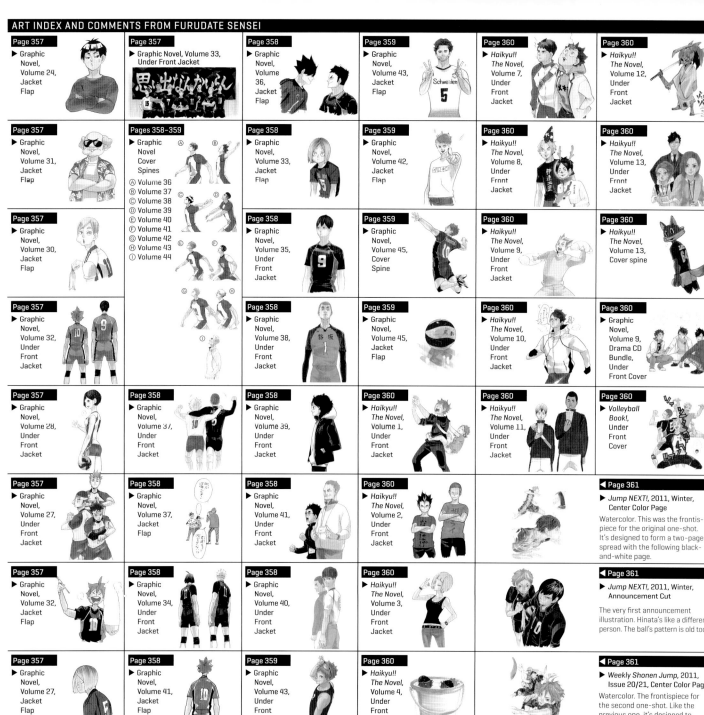

ART INDEX AND COMMENTS FROM FURUDATE SENSEI

Page 357
▶ Graphic Novel, Volume 24, Jacket Flap

Page 357
▶ Graphic Novel, Volume 33, Under Front Jacket

Page 358
▶ Graphic Novel, Volume 36, Jacket Flap

Page 359
▶ Graphic Novel, Volume 43, Jacket Flap

Page 360
▶ Haikyu!! The Novel, Volume 7, Under Front Jacket

Page 360
▶ Haikyu!! The Novel, Volume 12, Under Front Jacket

Page 357
▶ Graphic Novel, Volume 31, Jacket Flap

Pages 358–359
▶ Graphic Novel Cover Spines
Ⓐ Volume 36
Ⓑ Volume 37
Ⓒ Volume 38
Ⓓ Volume 39
Ⓔ Volume 40
Ⓕ Volume 41
Ⓖ Volume 42
Ⓗ Volume 43
Ⓘ Volume 44

Page 358
▶ Graphic Novel, Volume 33, Jacket Flap

Page 359
▶ Graphic Novel, Volume 42, Jacket Flap

Page 360
▶ Haikyu!! The Novel, Volume 8, Under Front Jacket

Page 360
▶ Haikyu!! The Novel, Volume 13, Under Front Jacket

Page 357
▶ Graphic Novel, Volume 30, Jacket Flap

Page 358
▶ Graphic Novel, Volume 35, Under Front Jacket

Page 359
▶ Graphic Novel, Volume 45, Cover Spine

Page 360
▶ Haikyu!! The Novel, Volume 9, Under Front Jacket

Page 360
▶ Haikyu!! The Novel, Volume 13, Cover spine

Page 357
▶ Graphic Novel, Volume 32, Under Front Jacket

Page 358
▶ Graphic Novel, Volume 38, Under Front Jacket

Page 359
▶ Graphic Novel, Volume 45, Jacket Flap

Page 360
▶ Haikyu!! The Novel, Volume 10, Under Front Jacket

Page 360
▶ Graphic Novel, Volume 9, Drama CD Bundle, Under Front Cover

Page 357
▶ Graphic Novel, Volume 28, Under Front Jacket

Page 358
▶ Graphic Novel, Volume 37, Under Front Jacket

Page 358
▶ Graphic Novel, Volume 39, Under Front Jacket

Page 360
▶ Haikyu!! The Novel, Volume 1, Under Front Jacket

Page 360
▶ Haikyu!! The Novel, Volume 11, Under Front Jacket

Page 360
▶ Volleyball Book!, Under Front Cover

Page 357
▶ Graphic Novel, Volume 27, Under Front Jacket

Page 358
▶ Graphic Novel, Volume 37, Jacket Flap

Page 358
▶ Graphic Novel, Volume 41, Under Front Jacket

Page 360
▶ Haikyu!! The Novel, Volume 2, Under Front Jacket

◀ **Page 361**
▶ Jump NEXT!, 2011, Winter, Center Color Page

Watercolor. This was the frontispiece for the original one-shot. It's designed to form a two-page spread with the following black-and-white page.

Page 357
▶ Graphic Novel, Volume 32, Jacket Flap

Page 358
▶ Graphic Novel, Volume 34, Under Front Jacket

Page 358
▶ Graphic Novel, Volume 40, Under Front Jacket

Page 360
▶ Haikyu!! The Novel, Volume 3, Under Front Jacket

◀ **Page 361**
▶ Jump NEXT!, 2011, Winter, Announcement Cut

The very first announcement illustration. Hinata's like a different person. The ball's pattern is old too.

Page 357
▶ Graphic Novel, Volume 27, Jacket Flap

Page 358
▶ Graphic Novel, Volume 41, Jacket Flap

Page 359
▶ Graphic Novel, Volume 43, Under Front Jacket

Page 360
▶ Haikyu!! The Novel, Volume 4, Under Front Jacket

◀ **Page 361**
▶ Weekly Shonen Jump, 2011, Issue 20/21, Center Color Page

Watercolor. The frontispiece for the second one-shot. Like the previous one, it's designed to form a two-page spread with the following black-and-white page.

Page 357
▶ Graphic Novel, Volume 29, Jacket Flap

Page 358
▶ Graphic Novel, Volume 38, Jacket Flap

Page 359
▶ Graphic Novel, Volume 42, Under Front Jacket

Page 360
▶ Haikyu!! The Novel, Volume 5, Under Front Jacket

◀ **Page 361**
▶ Weekly Shonen Jump, 2011, Issue 20/21, Announcement Cut

The announcement illustration for the second one-shot.

Page 357
▶ Graphic Novel, Volume 29, Under Front Jacket

Page 358
▶ Graphic Novel, Volume 36, Under Front Jacket

Page 359
▶ Graphic Novel, Volume 44, Under Front Jacket

Page 360
▶ Haikyu!! The Novel, Volume 6, Under Front Jacket

◀ **Page 361**
▶ Weekly Shonen Jump, 2011, Issue 11, Announcement Cut

Kageyama's very first mystery pose. (Well, I think it's supposed to be kind of a reach-over pose, but I'll categorize it as "mystery.")

◀ **Pages 364–368**
▶ Brazil Research Trip Report Manga!!, Art Book Original

AFTERWORD

AROUND THE TIME I WAS WORKING ON THE CHAPTERS FOR VOLUME 10, *WEEKLY SHONEN JUMP*
RAN A SURVEY ABOUT SERIES READERS LIKED FOR THEIR ART, AND ONES THEY LIKED FOR THEIR
STORY. *HAIKYU!!* RANKED THIRD ON THE LIST OF SERIES THAT HAD (I CAN'T REMEMBER THE EXACT
WORDING, BUT IT WAS SOMETHING LIKE) GREAT STORIES BUT TERRIBLE ART. I WAS ALREADY
AWARE THAT I DIDN'T HAVE THE BEST ART IN *WEEKLY SHONEN JUMP*, BUT TO HAVE IT GIVEN A
CLEAR RANK LIKE THAT MADE ME GO, "I'VE GOT TO FIX THIS." I STARTED EXPERIMENTING MORE
WITH WAYS TO IMPROVE MY STYLE. UNFORTUNATELY, THAT SURVEY WAS A ONCE-AND-DONE THING,
SO I CAN'T SAY IF THE CHANGES I MADE WERE FOR THE BETTER. THAT SAID, I DID DRAW A WHOLE
LOT FOR EIGHT AND A HALF YEARS, SO I'M SURE I'VE BUILT SOME ART MUSCLES! (YES, I'M AWARE
I MAKE EVERYTHING SOUND LIKE WEIGHT TRAINING THESE DAYS.) ANYWAY, I DO KNOW THAT MY
STYLE HAS EVOLVED, AND ART IS A LITTLE MORE FUN FOR ME NOW.

HARUICHI FURUDATE

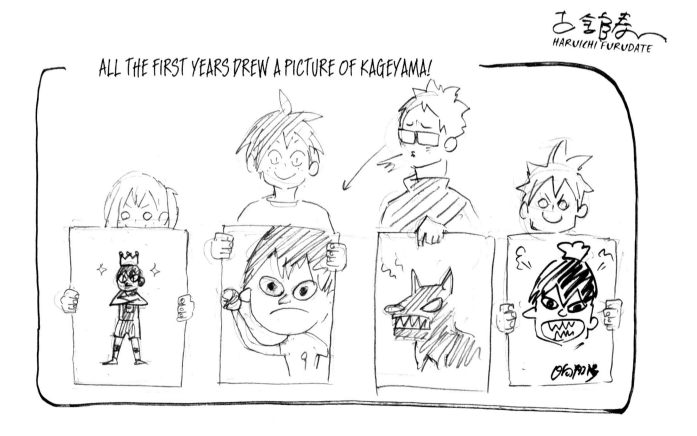

ALL THE FIRST YEARS DREW A PICTURE OF KAGEYAMA!

HARUICHI FURUDATE

THE ART OF

HAIKYU!!

ENDINGS AND BEGINNINGS

SHONEN JUMP EDITION

TRANSLATION Adrienne Beck

ENGLISH ADAPTATION Ari Yarwood

TOUCH-UP ART & LETTERING Erika Terriquez

DESIGN & LAYOUT Francesca Truman

ENGLISH MANGA SERIES EDITOR Rae First

ART BOOK EDITOR Joel Enos

We have made a concerted effort to retain the original artwork in the VIZ edition of *THE ART OF HAIKYU!!* Some text has been left in the original Japanese for authenticity or when changing it would have required altering the original art.

JAPANESE EDITION

EDITING/LAYOUT Shizuka Hama (Kisousha)

DESIGN Yuki Yamamoto (Freiheit)

HAIKYU!! LOGO DESIGN Kazuki Katsumata

HAIKYU!! COMPLETE ILLUSTRATION BOOK OWARI TO HAJIMARI
© 2020 by Haruichi Furudate
All rights reserved.
First published in Japan in 2020 by SHUEISHA Inc., Tokyo.
English translation rights arranged by SHUEISHA Inc.

Library of Congress Cataloging-in-Publication Data available.

Printed in China

Published by VIZ Media, LLC
P.O. Box 77010 | San Francisco, CA 94107

10 9 8 7 6 5 4 3 2 1
First printing, March 2023

viz.com